The Drawings of Thomas Gainsborough

The Drawings of
Thomas Gainsborough

John Hayes

Text

Published for
The Paul Mellon Centre for Studies in British Art (London), Ltd
by Yale University Press, New Haven and London, 1971

Library of Congress catalog card number: 78-140108
International standard book number: 0-300-01425-2

Designed by Graham Johnson/Lund Humphries
and printed in England by Lund Humphries.

Distributed in Canada by McGill-Queen's University Press, Montreal;
in Mexico by Centro Interamericano de Libros Académicos, Mexico City;
in Central and South America by Kaiman & Polon, Inc., New York City.

For Robert Wark

Contents

Preface

This study originated in 1960, when I was invited by the Arts Council to select and catalogue an exhibition of Gainsborough drawings. During the course of this agreeable task I soon became aware that many drawings were not only unrecorded in the previous literature but practically unknown beyond limited circles. This, and the simple fact that a high proportion of drawings recorded or engraved in the eighteenth or early nineteenth centuries had not reappeared, led me to suppose that many more drawings must still await rediscovery; and such has proved to be the case. The number of drawings catalogued here is something like double what was known to scholars in 1939, when Mary Woodall published her pioneer catalogue, and this quantity of fresh material provides in itself some justification for the present work.

The completion of a book of this kind would be impossible without the friendly co-operation of a great many people, who will, I hope, forgive me for not being able to thank them all here individually, as I should like to do. My first debt is of course to the photographic collection in the Witt Library, and the continual kindness of its staff. Without the benefits of this incomparable library, I could scarcely have begun work. I also received much initial help from members of the art trade, in particular from Agnew's, Colnaghi's, and Spink's; and in the process of detecting missing drawings I must have importuned literally hundreds of people with letters and enquiries. I am exceedingly grateful to those numerous kind persons who furthered my searches. My greatest debt, however, is to all the private collectors and owners who so readily allowed me to study their drawings, in several cases at some inconvenience to themselves, and it is a particular pleasure for me to record my gratitude to them here for their generosity and hospitality. If I might be allowed to single out two who have been especially kind, I would mention Mr Paul Mellon and Mrs and the late Mr W. W. Spooner.

I am deeply grateful to Her Majesty The Queen for her gracious permission to reproduce the paintings and drawing illustrated on Plates 337, 338 and 346, and to quote from *The Farington Diary*; no less to all those owners and curators who so kindly allowed me to reproduce works in their possession or charge, and to quote (where I have done so *in extenso*) from manuscripts. I must also record a debt of a more literal kind, and thank the Paul Mellon Foundation for British Art, which financed a number of journeys in this country and a long period of travel in the United States and Canada in the winter of 1964; this support was the more

generous in that publication was not to be under the auspices of the Foundation.

Mary Woodall has watched over my progress with her customary kindness, and helped me to track down a number of drawings. Frank Simpson has been a continual source of information and practical help on all matters relating to provenance. Christie's have kindly allowed me to study in their muniment room. My colleagues in print rooms all over the world have been unfailingly helpful in providing both information and access to drawings, and if I make special mention of my friends in the British Museum (where work among the drawings has been a constant pleasure over many years), the Courtauld Institute Galleries, the Birmingham City Art Gallery, the Berlin Kupferstichkabinett, the Morgan Library, the Mellon Collection and the Henry E. Huntington Library and Art Gallery, it is because the holdings in these collections have provided me with more occasion for trying their patience. The text has been skillfully typed from a difficult manuscript by Miss M. J. Harrison and Mrs J. Gudgeon. Andrew Wilton kindly read proofs and made some valuable suggestions for improvement. Miss Sophie Crombie generously agreed to check proofs of the entire volume, and Miss Joan Pollard kindly undertook the preparation of the index. Graham Johnson, at Lund Humphries, has coped cheerfully with all those irksome problems of detail attendant on endeavours to improve; and the patience, tact, and good humour of my publisher, Desmond Zwemmer, have made the task of seeing the book through the press a much lighter one than is often the case. Finally, Robert Wark has not only talked over countless problems with me on a variety of occasions both in London and California, but read and criticized the typescript; the whole book, but in particular my treatment of the drawings of Gainsborough Dupont (both here and in a previous article), owes much to his impeccable judgement and sense of logic. My debt to him is a considerable one, and most happily expressed, I hope, in the form of a dedication.

The book is divided into three parts. The first contains a biographical sketch and a short but self-contained study of the drawings, which, taken in conjunction with the plates, may prove an acceptable survey for the non-specialist. The second, in which individual strands from this survey are detached and treated at greater length, and where every reference known to me which bears on the drawings is cited, is designed more for the student. Connoisseurs and collectors will find the last two chapters of this section of particular interest, though for them the heart of the matter will no doubt be the third part, the Catalogue Raisonné. This arrangement of the material necessarily involves, I am afraid, a certain amount of repetition, but it is hoped that the benefits resulting will outweigh this disadvantage.

Gainsborough was not only a draughtsman of immense stature by European standards, but one of the most lovable persons who has ever lived, and it is with genuine sadness that, at last, I must give up research and allow this book to go forward on its way.

J.H.
December, 1969

I

Biographical Sketch

Gainsborough (Pls.237–8) was born in the market town of Sudbury in Suffolk, the youngest of a family of nine children, and was baptized there on 14 May 1727 at the Independent meeting house in Friars Street.[1] He was descended from a Nonconformist family long connected with the wool trade in those parts, and his father, John Gainsborough, was a manufacturer of woollen fabrics and a man of considerable prosperity until his business fell on hard times in the early 1730's.[2] Thomas was sent to school at Sudbury Grammar School, where his uncle, the Rev. Humphrey Burroughs, curate of St Gregory's, was the master, but he was never a bookish kind of person at the best of times, and seems often to have played truant so that he could go off into the country. He later told his close friend Philip Thicknesse 'that during his *Boy-hood*, though he had no Idea of becoming a Painter then, yet there was not a Picturesque clump of Trees, nor even a single Tree of beauty, no, nor hedge row, stone or post, at the corner of the Lanes, for some miles round about the place of his nativity, that he had not so perfectly in his *mind's eye*, that had he known he *could use* a pencil, he could have perfectly delineated.'[3]

He took to sketching at an early age, and when he was 13 prevailed upon his father to send him up to London to become an artist. There he seems to have lived initially with a silversmith,[4] who was an intimate friend of the family,[5] and 'made his first essays in the art by modelling figures of cows, horses, and dogs, in which he attained very great excellence', but soon after 'became a pupil to Mr. Gravelot, under whose instructions he drew most of the ornaments which decorate the illustrious heads, so admirably engraved by Houbraken.'[6] He is supposed to have been

[1] C. Partridge, 'Gainsborough's Paternal Ancestry' (four articles in *The East Anglian Times*, January–February 1929, bound as a volume in the Victoria and Albert Museum Library).

[2] Whitley, p.4. Gainsborough's father is presumably to be identified with the 'John Gainsborough of Sudbury, in the County of Suffolk, Clothier' who was declared bankrupt in 1733 (*The London Gazette*, 16–20 October 1733).

[3] Thicknesse, pp.5–6. It is interesting to compare this statement with Constable's similar experience: 'I had often thought of pictures of them (the scenes of his boyhood) before I had ever touched a pencil' (Graham Reynolds, *Constable the natural painter*, London, 1965, p.19).

[4] *The Morning Herald*, 4 August 1788.

[5] According to Gainsborough's niece, Mrs Sophia Lane (see her manuscript notes inserted in Colonel Cunningham's annotated copy, now in the Victoria and Albert Museum Library, of the lives of Wilson and Gainsborough from Allan Cunningham's *The Lives of the most eminent British Painters, Sculptors and Architects*, London, 1829).

[6] *The Morning Chronicle*, 8 August 1788. For a discussion of this issue, see p.55.

introduced by Gravelot to the St Martin's Lane Academy,[7] but there is some doubt on this point, as his name was not included in the list of students drawn up in 1823 by W. H. Pyne, with the assistance of 'the pupil of Frank Hayman, *John Taylor*, who knew them all.'[8] Hayman, who also taught at the St Martin's Lane Academy, he must certainly have known quite early on, as this artist collaborated with Gravelot on a number of enterprises in the early 1740's (the illustrations to the 1742 edition of Richardson's *Pamela* being an important instance); but there is no support for the statement first made by Edwards that he was actually placed under Hayman.[9]

Gravelot left England to return to Paris in October 1745,[10] and Gainsborough probably set up on his own a little before this event – his earliest datable canvas, the portrait in little of the dog *Bumper*, was painted in 1745.[11] 'His first efforts were small landscapes, which he frequently sold to the dealers at trifling prices, and when he afterwards engaged in portraits, his price was from three to five guineas.'[12] His output in these early days was about equally divided between small-scale portraits and landscapes, and he also drew landscape compositions for the print trade, four of his drawings being engraved by Boydell in 1747 (Pls.10, 240 and 243). In addition to this, he probably undertook restoration work for the art dealers, as there is record of his repairing a Dutch landscape, and putting figures into a landscape by Wijnants.[13]

It is not known where Gainsborough had his studio, but years later he said that he had once lived in Hatton Garden,[14] and this fits with the address of St Andrew's, Holborn he gave at the time of his marriage. This event took place at Dr Keith's notorious Mayfair Chapel on 15 July 1746,[15] and the match was probably, therefore, one which his parents would not have approved; his bride was Margaret Burr, a beautiful Scots girl a little younger than himself who was 'a natural daughter of Henry, Duke of Beaufort, who settled £200 a yr. upon Her.'[16] This two hundred pounds a year continued to be paid through Hoare's Bank until June 1798 (Mrs Gainsborough died in December of that year), and was a vital source of income during Gainsborough's early career.

[7] *The Morning Herald*, 4 August 1788.

[8] Ephraim Hardcastle (=W. H. Pyne), *Wine and Walnuts*, London, 1823, Vol.1, pp.176–80 note.

[9] Edward Edwards, *Anecdotes of Painters*, London, 1808, p.130.

[10] H. A. Hammelmann, 'First Engraver of the Royal Academy', *Country Life*, 14 September 1967, p.618.

[11] Waterhouse No.817; the inscription and date on the relining canvas were clearly carefully copied from the back of the picture.

[12] *The Morning Chronicle*, 8 August 1788.

[13] Mr Oldfield sale, Prestage, 7–8 February 1766 (Lugt 1497): 1st Day Lot 17 and 2nd Day Lot 56.

[14] Gainsborough to James Unwin, Bath, 25 May 1768: Woodall *Letters*, No.90, p.165; see also Edwards, op. cit., p.130.

[15] 'Mr Thomas Gainsborough, of St Andrew's, Holborn, and Mrs Margaret Burr, of St. George's, Hanr Sq.' (*ed.* George J. Armytage, *The Register of Baptisms and Marriages at St George's Chapel, May Fair*, The Harleian Society, London, 1889, p.66).

[16] *The Farington Diary*, 15 February 1799 (from the typescript in the British Museum Print Room, pp.1458–9).

Gainsborough did not remain in the metropolis, and was exceptional among London-trained artists in moving away from the centre of patronage. It is possible that he was not too successful in London – one source has it that 'he did not sell six pictures a year'[17] – but against this is the evidence of *The Charterhouse*, the roundel he painted for the Foundling Hospital in 1748, which was singled out for praise by Vertue.[18] Actually he seems to have been unambitious, and thinking of himself 'as one, among a crowd of young Artists, who might be able in a country town (by turning his hand to every kind of painting) to pick up a decent livelihood'[19] he returned to his native Sudbury in 1748. The move probably followed the death of his father, which occurred on 29 October, and his first child, Mary, was certainly born there that year.[20]

It is difficult to know what kind of a practice any artist could have hoped to establish in Sudbury, which (in the early eighteenth century at any rate) was far from being a wealthy place, though populous;[21] and Gainsborough is known to have had money troubles, as there is evidence of his friend and banker James Unwin procuring a loan of four hundred pounds for him on the security of his wife's annuity in November 1751.[22] Nevertheless he stayed there three or four years all told, and his other daughter, Margaret, was also born in Sudbury, in 1752.[23] By the beginning of that year, however, he had started looking round for better opportunities, and eventually decided upon Ipswich, which was a fairly flourishing seaport in the mid-eighteenth century and certainly much livelier than Sudbury. An advertisement inserted in *The Ipswich Journal* in January 1752 states that the house 'in the Key Parish, facing the Shire Hall' known to have been taken by Gainsborough was 'now in the occupation of the Rev. Mr. Broom' and would be vacant in June;[24] June, therefore, or soon after, was presumably the time he moved in. The house was of a fair size, 'consisting of a Hall, and two Parlours, a Kitchen, Wash-house, with a Garden and Stable, good Cellars, and well supply'd with Cock-water, five Chambers and Garrets, with other Conveniences',[25] and possessed a frontage of some thirty feet onto Foundation Street.[26]

The earliest record of Gainsborough in Ipswich is provided for us by Philip Thicknesse, who visited the painter's studio soon after his own appointment as Lieutenant Governor of Landguard Fort in February 1753. The portraits he saw ranged along the walls he thought 'perfectly like, but stiffly painted, and worse coloured . . . but when I turned my eyes to his little landscapes, and drawings, I

[17] *The Town and Country Magazine*, September 1772, p.486.

[18] *Vertue Note Books*, Vol.3, Walpole Society, Vol.22, 1934, p.157.

[19] Thicknesse, p.8.

[20] William T. Whitley, 'The Gainsborough Family Portraits', *The Studio*, August 1923, p.66.

[21] Daniel Defoe, *A Tour Thro' . . . Great Britain*, London, 1724–7, Vol.1, p.70.

[22] Sydney E. Harrison, 'New Light on a Gainsborough Mystery', *The Connoisseur*, January 1922, p.5.

[23] Whitley, 'The Gainsborough Family Portraits', op. cit., p.66.

[24] Whitley, p.25.

[25] *The Ipswich Journal*, 9 February 1760.

[26] Whitley, p.23.

was charmed, those were the works of fancy and gave him infinite delight; MADAM NATURE, not MAN, was then his only study.'[27]

Gainsborough's clientèle in Ipswich was chiefly among the local gentry and the professional classes: lawyers, teachers and clergymen. He was never able to raise his prices from eight guineas for a head and fifteen for a half-length, and even at these rates found it difficult to attract sufficient work – in March 1758 he wrote to a patron in Colchester, apologizing for not being able to make a promised visit, 'but business comes in, and being chiefly in the Face way, I'm afraid to put people off when they are in the mind to sit.'[28] Thus he still found it hard to make ends meet, was in difficulties with his rent from time to time,[29] and in February 1755 borrowed a further three hundred pounds from James Unwin, which he repaid, however, two years later out of his wife's annuity.[30]

He secured an important commission for a couple of decorative landscapes from the Duke of Bedford in 1755,[31] which must have given him special satisfaction, but for the most part his landscapes did not sell locally, and he was obliged to send them up to London, where they were handled by Panton Betew, an art dealer in Old Compton Street, Soho. This worthy later told Nollekens, 'I have had many and many a drawing of his in my shop-window before he went to Bath; ay, and he has often been glad to receive seven or eight shillings from me for what I have sold: Paul Sandby knows it well.'[32]

Gainsborough visited London himself on occasion. Nathaniel Dance said he had become acquainted with him during the two years he (Dance) spent with Hayman before going to Italy in 1755;[33] and it is known that he was up for the purpose of etching two or three of his landscapes, with the aid of Wood and Grignion, at just about this time.[34] But he never seems to have considered going back for good, being still unduly modest about his abilities, and Thicknesse eventually persuaded him that it might be worth trying Bath, where the only serious competitor would be William Hoare, a rather stiff and uninspired portraitist whose particular forte was pastels. Accordingly, in October 1759, he sold the contents of his house in Ipswich, together with 'some PICTURES and Original DRAWINGS, in the Landskip Way, by his own Hand; which, as he is desirous of leaving amongst his Friends, will have the lowest Price set upon them;'[35] and removed to Bath.

Thicknesse says that he 'accompanied him in search of lodgings, where a good painting room as to light, a proper access, &c. could be had, and upon our return to

[27] Thicknesse, p.11.

[28] Gainsborough to (probably) William Mayhew, Ipswich, 13 March 1758: Woodall *Letters*, No.25, p.61.

[29] See Woodall *Letters*, Nos.104 and 105, p.179.

[30] Harrison, op. cit., p.5.

[31] First described by Gladys Scott Thomson, 'Two Landscapes by Gainsborough', *The Burlington Magazine*, July 1950, pp.201–2; see also my article, 'Gainsborough and the Bedfords', *The Connoisseur*, April 1968, pp.219–21.

[32] J. T. Smith, *Nollekens and his Times*, ed. G. W. Stonier, London, 1949, p.92.

[33] *The Farington Diary*, 6 January 1808 (p.3939).

[34] See my forthcoming study of Gainsborough's prints.

[35] *The Ipswich Journal*, 20 October 1759.

my house, where his wife was impatiently awaiting the event, he told her he had seen lodgings of fifty pounds a year, in the Church yard, which he thought would answer his purpose.'[36] It is not known whether he *did* take up residence in the fashionable Abbey Churchyard, but what is quite certain is that his style in portraiture so exactly suited the tastes of the smart, rich people who thronged Bath that he never again suffered from lack of clients. Rather the reverse. 'Business came in so fast'[37] that he soon raised his prices from eight to twenty guineas for a head, and from fifteen to forty guineas for a half-length. Ten years more and he was charging thirty and sixty guineas, and a full hundred for a whole length;[38] in a letter to his most intimate friend, William Jackson, the composer, he exclaimed: 'I might add perhaps in my red hot way that damn me Exeter is no more a place for a Jackson, than Sudbury in Suffolk is for a G—.'[39] But the pressure took its toll of his health, which was never robust,[40] and in the summer and autumn of 1763 he was seriously ill: 'The truth is, I have apply'd a little too close for these last 5 years, *that* both my Doctors and Friends really think.'[41] As soon as he had recovered, he took a house with a pleasant garden in Lansdown Road, which was then out of town, with the idea of letting part of it in order to ease himself 'of as much Painting work as the Lodgings will bring in.'[42] Here he stayed for a little over three years, before moving, at the beginning of 1767, into the Circus.[43]

Curiously, his landscapes were no more popular with the *cognoscenti* of Bath than they had been in the obscurity of Suffolk, and, according to Prince Hoare, he 'was so disgusted at the blind preference paid to his powers of portraiture, that, for many years of his residence at Bath, he regularly shut up all his landscapes in the back apartments of his house, to which no common visitors were admitted.'[44] Some of his finer pieces he sent up to London to the annual exhibitions first of the Society of Artists, then of the Royal Academy; and it was probably in connection with these exhibitions, as well as with portrait commissions of various kinds, that he now began to make frequent visits to London. Both there and at Bath he had far greater opportunities for indulging his tastes for music and the theatre than ever he had had in Ipswich; he met David Garrick, with whom he became fast friends, and he lived 'in great Intimacy'[45] with the Linleys, in whose house Giardini, Abel, J. C. Bach and other leading performers were usually to be seen during the season. In spite of illness, overwork, and the public's disregard of what he set most store by, his land-

[36] Thicknesse, pp.15–16.

[37] Ibid., p.17.

[38] Waterhouse, p.19.

[39] Gainsborough to William Jackson, Bath, 14 September (year unknown): Woodall *Letters*, No.51, p.103.

[40] His daughter said he 'had not strong health and frequently complained' (*The Farington Diary*, 5 February 1799: p.1458).

[41] Gainsborough to James Unwin, Bath, 15 September 1763: Woodall *Letters*, No.84, p.149.

[42] Gainsborough to James Unwin, 30 December 1763; Woodall *Letters*, No.87, p.157.

[43] Whitley, p.33.

[44] Prince Hoare, *Epochs of the Arts*, London, 1813, pp.76–7.

[45] Ozias Humphry, 'Biographical Memoir', MSS., *c.*1802 (*Original Correspondence of Ozias Humphry, R.A.*, Vol.1: Royal Academy Library).

scapes, there is no doubt that the fifteen years he spent at Bath were among his happiest.

Towards the end of 1774 Gainsborough left the west country and moved to London, taking a tenancy of the west wing of Schomberg House, Pall Mall.[46] This seems to have been quite a sudden decision, as in March he had had a harpsichord sent down from Broadwood's,[47] surely not the kind of object he would have had delivered to Bath if he had been planning his removal at that time. And the reasons for his going are obscure.[48] He had quarrelled with the Academy in 1773,[49] and was withholding his pictures from the annual exhibition, while the situation in London was none too promising as regards patronage; Sir William Chambers was of the opinion that 'we are over-stock'd with Artists of all Sorts',[50] and Gainsborough must have felt the pinch when he first arrived. Thicknesse said that of all the men he ever knew, 'he possessed least of that worldly knowledge, to enable him to make his own way into the notice of the GREAT WORLD';[51] comparatively few portraits can be dated to the period 1774–6; and we are told that he passed 'a short time in town not very profitably.'[52]

By the end of 1775, however, he seems to have established himself successfully, as he wrote to his sister at Christmas time: 'my present situation with regard to encouragement is all that heart can wish . . . I live at a full thousand pounds a year expense.'[53] In 1777 he received the first of a long series of commissions from the Royal Family, and he returned triumphantly to the Academy exhibition in that year with perhaps the finest group of canvases he ever painted, which included the magnificent full length of *Abel* and *The Watering Place*: from this moment both his financial circumstances and his position as one of the leading painters in the capital were assured. He added a separate studio to the back of his house, two large rooms, an upper and a lower, each fifteen feet high, with single large windows overlooking the gardens of Marlborough House.[54] He kept a footman, and a coach;[55] and from

[46] The tenancy did not date from mid-summer, as stated by Whitley, p.107. The collector noted in the rate-book for this year (Westminster Records D561) 'Tho.ˢ Gainsbury Entᵈ Xmas 74', which implies that his tenancy began sometime after Michaelmas, when the previous quarter's rates were collected.

[47] Whitley, p.107.

[48] Thicknesse (pp.18 and 31) alleged that it was due entirely to a personal quarrel with himself, which is not very convincing; and the generally accepted view is that it followed a period of declining business. Joseph Wright of Derby, who decided to settle in Bath in 1775 as a result of Gainsborough's departure, found scarcely any work during the first season he spent there, and wrote that he had 'heard from London, and by several gentlemen here, that the want of business was the reason of Gainsborough's leaving Bath' (Wright to an unknown recipient, Bath, 9 February 1766: published in William Bemrose, *The Life and Works of Joseph Wright, A.R.A.*, London, 1885, p.45). On the other hand, it is difficult to believe that Gainsborough would have raised his prices substantially between 1770 and 1772 if business had been slack at this time, and there are quite enough portraits dating from the early 1770's to suggest that he was as busy then as at any other time in the Bath period.

[49] Whitley, p.95.

[50] Chambers to Lord Grantham, London, 29 April 1774 (British Museum Add. MSS.41, 135).

[51] Thicknesse, p.32.

[52] *The Morning Herald*, 4 August 1788.

[53] Gainsborough to Mary Gibbon, 26 December 1775: Woodall *Letters*, No.36, p.79.

[54] See *Survey of London*, Vol.29, 1960, p.377 and ground plan on p.370.

1777 onwards made frequent and very considerable investments in Government stock.[56] Now fully independent, he felt able to branch out more freely into experimental work. He began to paint portraits (especially of women) so romanticized and ethereal as to recall the Arcadian never-never land of Watteau; he produced a series of fancy pictures in which many of the little figures from his landscapes took on the scale of life; he took up print-making, mostly in aquatint and soft-ground etching; he constructed a peep-show box[57] in which he showed transparencies lit by flickering candles, learning thus to heighten his effects; he did his first seascapes; and he concentrated more than ever he had been able to before on landscapes. He was clearly bitterly disappointed at his not being made Portrait Painter to the King on the death of Ramsay in 1784;[58] but on the other hand there is no doubt that his last ten years were enormously fruitful, and he was still developing in new and exciting directions when he was struck down by illness in April 1788. What was at first taken to be a swollen gland proved to be cancer, and he weakened steadily. In an infinitely moving letter written at the end of July he begged from his rival Sir Joshua Reynolds 'a last favour, which is to come once under my Roof and look at my things';[59] and on 2 August he died, aged 61.

Most of what we know of Gainsborough as a man we owe to his two most intimate friends, Thicknesse and Jackson, but there is supporting evidence from other sources, notably his daughter Margaret. Temperamentally, he was 'of a modest, shy, reserved disposition',[60] excitable, however, and highly strung (we might guess this from Zoffany's portrait of him (Pl.238)), deeply impressionable, much affected by adverse criticism, impulsive in all his actions, and incurably generous – which last was a substantial cause of friction in his married life, as Mrs Gainsborough was both mean and frugal.

'He had two faces, his studious & Domestic & His Convivial one . . . He was passionately fond of music as well as drawing – and this led him much into company with Musicians, with whom he often exceeded the bounds of temperance & His Health suffered from it, being occasionally unable to work for a week afterwards. He was irregular in his application, sometimes not working for 3 or 4 weeks together, and then for a month wd. apply with great diligence. He often wondered at Sir Joshua Reynolds *equal* application.'[61] His old friend Samuel Kilderbee said that

[55] See Gainsborough to William Jackson, London, 25 January 1777: Woodall *Letters*, No.60, p.121; and Gainsborough to Mary Gibbon (autumn 1777): Woodall *Letters*, No.39, p.85.

[56] His investments in 1777 and 1778 were quite small (see Gainsborough's account at Hoare's Bank 1762–85, which I examined through the kindness of the archivist, Mr R. M. Winder), but from 1782 until the year of his death they were more frequent and on a much larger scale (see Gainsborough's account at Drummond's Bank 1782–8, which I examined through the kindness of Mr J. R. Cuthbertson).

[57] Now in the Victoria and Albert Museum: see Jonathan Mayne, 'Thomas Gainsborough's Exhibition Box', *Victoria and Albert Museum Bulletin*, Vol.1, No.3, July 1965, pp.17–24.

[58] See his letter to the Earl of Sandwich, 29 November 1784: Woodall *Letters*, No.71, p.133.

[59] Gainsborough to Sir Joshua Reynolds (mid-July 1788): Woodall *Letters*, No.67, p.127.

[60] Thicknesse, p.8.

[61] *The Farington Diary*, 29 January 1799 (pp.1458 and 1454).

7

B

in his last illness he regretted the dissolute life he had led, but added, 'They must take me altogether, liberal, thoughtless, and dissipated.'[62]

Original in everything he did, 'he had, and used, a nomenclature purely his own, for everybody and everything.'[63] 'His conversation was sprightly, but licentious – his favourite subjects were music and painting, which he treated in a manner peculiarly his own. The common topics, or any of a superior cast, he thoroughly hated, and always interrupted by some stroke of wit or humour . . . so far from writing, (he) scarcely ever read a book – but, for a letter to an intimate friend, he had few equals, and no superior. It was like his conversation, gay, lively – fluttering round subjects which he just touched, and away to another.'[64]

And like his music making, too. Though 'he himself thought he was not intended by nature for a painter, but a musician',[65] he admitted that 'there never was a poor Devil so fond of Harmony, with so little knowledge of it',[66] and Jackson, who acknowledged that he was 'possessed of ear, taste, and genius', declared that 'he never had application enough to learn his notes. He scorned to take the first step, the second was of course out of his reach; and the summit became unattainable.'[67] But he was evidently a fine extempore player. 'His performance on the Viol de Gamba was, in some movements, equal to the touch of Abel. He always played to the feelings',[68] and 'his chief forte consisted in modulating upon the harpsichord . . . his ear was so good, and his natural taste so refined, that these important adjuncts led him far beyond the mechanical skill of the mere performer who relies only upon technical knowledge.'[69] His musical style was in line with advanced contemporary thinking, which taught 'that music must, first and foremost, stir the heart . . . it is principally in improvisations or fantasias that the keyboardist can best master the feelings of his audience.'[70] And it is perhaps the truest key to the essentials of his style as painter and draughtsman. There is a sense in which Abel and J. C. Bach were the greatest formative influences on Gainsborough the artist.

[62] See Anon. (=Thomas Green), 'The Diary of a Lover of Literature', 12 May 1809 (*The Gentleman's Magazine*, February 1835, p.130).

[63] Anon. (=W. H. Pyne), 'The Greater and Lesser Stars of Pall Mall', ch.2, *Fraser's Magazine*, November 1840, p.551.

[64] William Jackson, *The Four Ages; together with Essays on Various Subjects*, London, 1798, pp.160 and 183.

[65] *The Morning Chronicle*, 8 August 1788.

[66] Gainsborough to William Jackson, 4 June (year unknown): Woodall *Letters*, No.56, p.115.

[67] Jackson, op. cit., p.154.

[68] *The Morning Herald*, 11 August 1788.

[69] Edward F. Rimbault, 'Gainsborough as a Musician', *Notes and Queries*, 13 January 1871, p.39.

[70] C. P. E. Bach, *Essay on the true Art of Playing Keyboard Instruments* (ed. and trans. William J. Mitchell, 2nd edn, 1951, pp.16 and 152). The radical changes effected in English musical style (and life) by J. C. Bach and C. F. Abel have recently been summarized by Owain Edwards, 'Revolution in 18th-Century Music', *History Today*, November 1968, pp.755-9.

2

Gainsborough's Drawings

On any count Gainsborough was one of the greatest draughtsmen of his age. Through his temperament as an artist he was able to express to perfection that peculiar blend of delight in nature, sentiment, and elegant sophistication so characteristic of the eighteenth century. Technically, he was a master of his craft, brilliant, assured, prolific. 'If I were to rest his reputation upon one point, it should be on his Drawings', wrote William Jackson in his *Character of Gainsborough*, published in 1798. 'No man ever possessed methods so various in producing effect, and all excellent . . . The subject, which is scarce enough for a picture, is sufficient for a drawing, and the hasty loose handling, which in painting is poor, is rich in a transparent wash of bistre and Indian ink.'[1]

In the annals of the British school, he must be ranked with Constable, and perhaps rather above his contemporaries Wilson and Alexander Cozens, in the sphere of landscape drawing; as a figure draughtsman, he is in a class with Fuseli, Whistler, and the two Johns, Augustus and Gwen. Not that Gainsborough would have cared a rap himself where anyone might place him in the hierarchy. He had sought neither fame nor advancement in his career, and probably the only genuine disappointment he suffered as a professional man was to have been 'very near being King's painter only Reynolds' Friends stood in the way.'[2]

In his portraiture, which constitutes by far the bulk of his output as a painter, Gainsborough was too impetuous not to attack the canvas direct (*pentimenti*, now frequently visible to the naked eye, reveal the drastic changes he could make in the course of painting); and it is probably for this reason, rather than that they have been destroyed, that very few preparatory drawings survive. The contrast with a contemporary like Ramsay, who worked out every detail beforehand, is complete. In fact, Gainsborough was far less concerned about the design and structure of his portraits than he was about likeness and immediacy, and these qualities are amply evident in the drawings; indeed his ability to portray character and physical presence was perhaps most marked in this more intimate medium. He was equally at home with the reserve of aristocracy (Pl.116), the bluff geniality of a Dutch sea captain (Pl.49), or the gentleness of young womanhood (Pl.115); while one of his most captivating drawings is a sheet of studies of a cat (Pl.99), sketched as it lay in front of him, watchful or purring and licking itself, curled up on the hearth-rug.

[1] William Jackson, *The Four Ages*, London, 1798, p.157.
[2] Gainsborough to the Earl of Sandwich, 29 November 1784: Woodall *Letters*, No.71, p.133.

9

He could convey the repose of a sleeping child with a few quick lines (Pl.159); and in his brilliant sketch of a music party (Pl.122), the movements, concentration, and to a certain extent character of the four musicians are all effectively suggested by equally simple means, contours as bold and free as Chardin's, with supporting hatching to indicate light and shade, the whole drawing done probably in a few short moments.

Gainsborough had been brought up in the London of the 1740's in the invigorating artistic world of Hogarth and Roubiliac and Vauxhall genre, that is to say, a circle which believed in naturalistic, informal portraiture and realistic subject painting executed in a wholly vernacular idiom.[3] The experience of these early years was never to desert him, and though he was later to fall under the spell of Van Dyck, the principles taught by Hogarth continued to influence his portraiture throughout his life, Reynolds and the Grand Manner notwithstanding.

They also affected his attitude towards landscape, though to a lesser extent. Sketching direct from nature was a habit he never quite abandoned, and Reynolds tells us how 'he brought into his painting-room, stumps of trees, weeds, and animals of various kinds; and designed them, not from memory, but immediately from the objects'.[4] Such concern for verisimilitude in detail would have been totally foreign to his predecessors, painters such as Wootton or even Lambert, who was a member of the Hogarth set. Most of Gainsborough's drawings from nature date from the period of his youth, the years he spent in Suffolk; they were usually done in pencil in medium-sized sketch-books (now, alas, all broken up), and embraced a wide variety of subjects: animals, trees, plants, cottages, gates and fences, woods, banks, streams, and stretches of open country.

Some of his Suffolk sketches are already quite generalized (Pl.61), and obviously represent ideas for compositions. In drawings of this type, an oak or beech will tend to lose its identity and become submerged in the wider category 'tree' – in other words, nature may have been the basis but it was not the purpose of Gainsborough's art, and the trees (and certain other features) in his drawings are far more Gainsboroughesque in character than they are specific trees. Further, his compositions as a whole may certainly be broadly recognizable as Suffolk or Somerset, but they are rarely to be interpreted, save by partisan enthusiasts, as Sudbury or Hampton Rocks.[5] Paradoxical as it must seem, Gainsborough in his landscapes was far closer to Sir Joshua Reynolds and the classical canon than he was to Constable; and like the Rev. William Gilpin, that inveterate traveller and draughtsman of English picturesque beauty, he took his ideas 'from the *general face of the country*; not from any *particular scene*' – following Gilpin's principle, that 'portraits may be faithful: but

[3] On this circle, see, in particular, Mark Girouard, 'English Art and the Rococo', *Country Life*, 13 and 27 January, and 3 February 1966 (pp.58–61, 188–90, and 224–7). See also my article 'English Painting and the Rococo', *Apollo*, August 1969, p.120.

[4] Sir Joshua Reynolds, *Discourses on Art*, ed. Robert R. Wark, San Marino, 1959, p.250.

[5] From the point of view of the history of the attitude towards landscape, it is interesting to note that informed critics of sixty years ago assumed that Gainsborough's compositions *did* represent particular places (see Armstrong, 1904, pp.49–50 and 91). See also under Cat. No.318.

they are rarely in every part beautiful.'[6] Pure topography, that staple of the English eighteenth-century landscapist, we know he scorned: 'with respect to *real Views* from Nature in this Country', he once declared to an aristocratic patron, Lord Hardwicke, 'he has never seen any Place that affords a Subject equal to the poorest imitations of Gaspar or Claude. Paul Sanby is the only Man of Genius, he believes, who has employ'd his Pencil that way.'[7] One other man of genius who did, of course, was Wilson. But Wilson used topography, the British scene no less than the Italian, largely for evocative or compositional purposes, and, like Gilpin, was quite prepared to distort and re-arrange, within limits. The constituents of his style may have been as different as could be from Gainsborough's, but his principles and his interests, in particular his feeling for the play of light, were not so far removed.

What, then, *were* the elements of Gainsborough's landscape drawings? Probably the best way to discover is to analyse in some detail several of his compositions; and in so doing perhaps we can reach a little closer, too, to the heart of his landscape style, and thus his artistic imagination.

A typical example of his mature work, and one which happens also to be precisely dated, is the grey wash drawing of a river scene in the Huntington Art Gallery inscribed as done at Windsor on 17 September 1782 (Pl.163), no doubt as relaxation from the job he was there for, which was painting portraits of the entire royal family.[8] The subject matter of this drawing is diffuse and imaginary: a man fishing from a rowing boat, another pushing a boat out from the bank, and a cow on a promontory with a girl sitting in rather uncomfortable proximity to its backside. Comparison with Constable, who preferred not to invent but to wait as he sketched for 'the appearance of some living thing that will in all probability accord better with the scene and time of day',[9] is revealing; and we are reminded at once that, in the middle years of his career at any rate, Gainsborough thought of the figures he used to people his landscapes as there principally to 'fill a place (I won't say stop a Gap) or to create a little business for the Eye to be drawn from the Trees in order to return to them with more glee.'[10] Sometimes, features in a composition will even look quite out of keeping: the cows on the shore in the coastal scene in the British Museum (Pl.212) are a case in point.

In the centre of the Huntington drawing is a large white building difficult to construe in terms either of architecture or practicality. These deficiencies, however, are irrelevant to its purpose. For it is there, in fact, entirely for its shape and its whiteness, as a source of sensitive reflections in the water and the fulcrum of the

[6] William Gilpin, *Observations ... on ... the Mountains, and Lakes of Cumberland, and Westmoreland*, London, 1786, Vol.I, p.xxv. This theory of landscape painting was enthusiastically endorsed by Sir George Beaumont in a letter he sent to Gilpin in 1801 (quoted in C. P. Barbier, *William Gilpin*, Oxford, 1963, p.107).

[7] Gainsborough to the Earl of Hardwicke, n.d.: Woodall *Letters*, No.42, pp.87 and 91.

[8] 'Mr. *Gainsborough* is now down at Windsor painting half length portraits of the whole Royal Family' (*The Morning Herald*, 14 September 1782).

[9] C. R. Leslie, *Memoirs of the Life of John Constable*, ed. Jonathan Mayne, London, 1951, p.6.

[10] Gainsborough to William Jackson, Bath, 23 August (no year): Woodall *Letters*, No.49, p.99.

lighting in the drawing, which is perhaps its chief beauty. Compositionally, the cow, this building in the centre, and the cottage on the right all serve as accents, helping and pointing the flow of the drawing: 'one part of a Picture ought to be like the first part of a Tune, that you could guess what follows, and that makes the second part of the Tune . . .'[11]

It is significant that Gainsborough drew his analogy from the abstract discipline of music, an art he loved quite as much as he did painting. In a landscape by Constable, all the features would relate to each other as they should in actuality, one however subordinate to another in accordance with its importance in the design: contradictory as it may appear, a fully-wrought Constable landscape has more in common with Poussin than it has with almost any other painter one can name. In the Gainsborough, nothing relates; yet everything is in its rightful place. The spectator is not left with any feeling of discord in front of the Huntington drawing. The tree on the left is linked to those on the right by the shapes of the clouds. There is an exact equipoise of thrust and counter-thrust. Take away the cow on the left, for example, and the tree is thrown off compositional balance, while the promontory becomes no more than a traditional painter's device. But Gainsborough's art is so consummate in this instance that the composition hardly obtrudes; and in a sense his structure is unimportant anyway. The drawing is not a view of the Thames at Windsor, nor a miracle of organization by Seurat or Cézanne; it is an evocation of mood, in which the light suffusing the landscape plays much the largest part. What the spectator is left with is a feeling of calm, relaxation, and utter peace with the world. Need one wonder why Gainsborough's drawings have always touched a sympathetic chord in people's hearts, and never been out of favour with collectors from his day until ours?

A typical example of another kind is the drawing in black and white chalks now in the Ponce Museum in Puerto Rico (Pl.181), which Gainsborough did in the autumn of 1783 following his trip to the Lakes, and which he used for the subject of one of his most important late works, the mountain landscape exhibited in 1784 and bought by the Prince of Wales. Here the ostensible subject is a shepherd with his flock of sheep, the latter little more than shapes, scarcely defined at all. The tuneful, rhythmical composition characteristic of the Huntington drawing has been energized in this case into a bounding lateral flow to which all the forms, mountains, trees and rocks, are completely subordinated: the foliage is resilient, soft, and woolly and the mountains no romantic crags but softened as in the wake of some fantastic storm. The chalkwork is appropriately quick and nervous, accentuating this feeling of pulsating rhythm, which seems to animate the landscape almost as in a Van Gogh. Even apart from this brilliant highlighting, light is again the unifying factor, and the contrast between the horizon, aglow with the setting sun, and the gloomy darkness of the dell in the centre of the landscape combine with the grey bleakness of the scene to evoke a mood of melancholy, gentle however more than profound. Romantic despair was not within Gainsborough's range of expression, and it is

11 Gainsborough to Jackson, n.d.: Woodall *Letters*, No.53, p.109.

interesting to see that just as Constable failed to exploit the sublimity of the Lakes because he was not in sympathy with mountains, so Gainsborough, in a drawing done on the spot which was his source for the mountains in the Ponce Museum drawing (Pl.179), unconsciously softened the peaks of Langdale Pikes.

The beautiful oil sketch owned by George D. Widener (Pl.214), probably dating from the mid-1780's, combines mountains with a more well-defined pastoral subject, a herdsman and three cows beside a pool. Many of Gainsborough's creations were in what the eighteenth century would have called a mixed mode, neither heroic nor pastoral; but formal categories meant no more to Gainsborough than did poetry or philosophy. Compositionally, this sketch combines the rhythmic power and flow of the drawing just analysed with the subtler thrust and counter-thrust of the Huntington river scene. The white cow provides the focal point towards which the eye is first directed and finally comes to rest; but the landscape itself seems to be in perpetual motion. The tree stump on the right arches over and leads the eye across towards the wiry, windswept trees on the left, whence it is returned immediately by the trees behind in the direction of the rapidly moving clouds. The forms are all suggested more than modelled, and enlivened with brilliantly placed highlights; indeed, Gainsborough's extraordinary dexterity and sureness of touch are nowhere more apparent than in the background of this sketch, where distance is created almost effortlessly in carefully graded tones ranging from pale yellow-green to blue, beautifully set off by the dark browns of the leaves of the tree overhanging, while the mountain itself is suggested in similar hues, subtly modulated to create at the same time both form and depth. In landscapes of this calibre, and happily there are many of them, we are at the summit of Gainsborough's achievement, both as an artist and as a technician.

As a final example we may take the chalk drawing in the Aberdeen Art Gallery, which is of particular interest in demonstrating, in an only partially finished sketch on the *verso*, the genesis of one of Gainsborough's drawings. The *recto* (Pl.132) is filled with a typical Gainsborough subject, cows being driven along a path winding past banks and trees towards a distance closed not in this instance by a mountain, as is usually the case, but by a building possibly intended to be a church, possibly a mansion of some kind. The composition is simplified into broad masses, with strong light flowing across from behind the trees on the left and unifying the scene; and the handling is sketchy in the extreme: banks are hardly more than blocked out in stump, the direction of the path is indicated by a couple of short curving lines, and the trees are only vaguely suggested with rough hatching and a few scallops here and there, the tall tree on the right appearing to be an afterthought, added to enliven the silhouette.

The sketch on the *verso* (Pl.133), a jumble of shapes partially blocked out in stump and of odd, apparently meaningless lines in black chalk, seems to be the starting-point for a rapidly drawn landscape of the type seen on the recto, but clearly abandoned at an early stage. Hardly any sketches of this embryonic sort survive. Either they were normally thrown away at once, without resorting to the other side of the paper (and we know that Gainsborough was accustomed to throw beneath

the table the sketches which fell short of his standards of perfection),[12] or on the whole his compositions usually worked out better than this one. In this sketch, the rocks on the right, with trees above, have begun to take shape, but the trees on the left and the mountains in the distance are hardly even massed. There is something curiously suggestive of Alexander Cozens's 'blot' technique (Pl.306) in the way Gainsborough seems to have allowed lines and shapes to doodle across the paper in the hope that invention would flow; and it is possible that a good many of his drawings started off in such a way, without his having any very clear notion of his intentions at the outset.

Certain of his finished compositions, notably some of those strange brown wash drawings done over what looks like an offset outline, were left at a stage which would seem scarcely more advanced (Pl.208). A beautiful and unusual example of a drawing not of this particular impressionistic type, and which one would certainly have expected to be carried forward further, is the study of a clump of trees on a hillock, with four cows silhouetted against the skyline, now in the National Gallery of Scotland (Pl.305). None of the forms in this sketch is more than blocked out, but just as successive owners and admirers of the drawing have been, Gainsborough must suddenly have felt satisfied with it as it was.

Concentration on a limited number of drawings may have helped perhaps to isolate some of the essential characteristics of Gainsborough's style: his technical virtuosity and rapidity of handling, his feeling for rhythm, his absorption in effects of light (which led him also towards the theatrical), his detachment from the topographical or the particular view and free use of subject matter in the service of composition or mood, his love for the lazy, peaceful qualities of the English countryside, a certain melancholy. Some of these aspects of his genius we should study further, until a fully rounded picture of the man begins slowly to emerge.

Technical virtuosity, whether it be in painting or in music, is partially a matter of application, but fundamentally a heaven-sent gift. Gainsborough, like Mozart, possessed this gift: indeed the work of these two great contemporaries displays a facility and felicity unequalled in the eighteenth century in their respective arts, though Mozart was of course the profounder genius, master not only of his medium but of the extremes of comedy and tragedy, each (and increasingly in his late works) subtly veiled within the other. Gainsborough may have lacked such range of expression, but his technique was astonishing. His use of chalk or the tip of the brush was rapid and descriptive (Pl.150), his application of wash unerring whether as shape (Pl.216) or an element in modelling (Pl.151), his highlights sure and brilliant (Pl.215). It is significant that pencil, which could not be manipulated with quite the ease of chalk, he gave up in his maturity, and he rarely used pen. Nothing was to impede the flow of his hand, the free rein of his imagination as it poured out the raw material of his invention, and many unorthodox instruments, such as his fingers or bits of sponge, were constantly employed.

His imagination readily embraced new techniques. He was constantly experimenting with media, partly because he could see how they might improve particu-

[12] Allan Cunningham, *The Lives of the Most Eminent British Painters*, London, 1829, Vol.1, p.339.

lar effects, but to a certain extent also for experiment's sake – one is reminded of his childlike desire to possess some new musical instrument, which he supposed would at long last yield him the perfection he sought for in his playing.[13] He was one of the very first artists to experiment with soft-ground etching (Pl.300), among the first to use aquatint, and both processes he brought rapidly to a pitch of technical mastery and artistic expressiveness unequalled till Cotman in the one field, Goya in the other. He evolved a complicated process, which (fortunately for posterity) he explained in detail to his friend Jackson,[14] whereby he could combine the sensitivity of his drawings with the strength of oil – something that was increasingly to preoccupy the practitioners of English watercolour in the years ahead. He also experimented with offset, with the purpose, it seems, of producing some unexpected combination of lines that would spur on his invention rather than of making replicas: these drawings he finished in brown (or sometimes grey) washes applied often in a loose, apparently haphazard way (Pls.208 and 393), anticipating to some degree the suggestiveness of late Turner. Even critics accustomed to polish and high finish were ready to acknowledge the inimitable merit of Gainsborough's odd shapes and scratches, but as a unique phenomenon, not to be copied.[15] In the development of his craft Gainsborough was far ahead of his time, using processes and techniques associable with the visual world of romanticism; but he was also in advance of himself, employing them to depict a range of subjects and ideas very firmly eighteenth century in character, and more suited, one might think, to the gentler draughtsmanship of an artist such as Thomas Hearne (Pl.415).

Gainsborough's rhythmic sense, so largely responsible for the trees and rocks and sheep in his later drawings being more Gainsboroughesque than they are trees or rocks or sheep (Pl.181), was another legacy of his student days, of his association in the 1740's with rococo artists such as Hogarth, Gravelot, and Roubiliac. And his early appreciation of the importance of light as the unifying factor in landscape (Pl.249) was no less undoubtedly due to his close and sympathetic study of Dutch seventeenth-century landscapists, notably Ruisdael and Waterloo. Both qualities were transformed, however, through the influence of Rubens, whom he discovered in the 1760's. In a famous and much quoted letter to Garrick, he besought his friend 'to call *upon any pretence* any day after next Wednesday at the Duke of Montagu, because you'd see the Duke & Dutchess in my *last* manner; but not as if you thought any thing of mine worth that trouble, only to see his Grace's Landskip's of Rubens, and the 4 Vandyke's whole length in his Graces dressing Room.'[16] Rubens's bounding lateral rhythms, to a certain extent even his complex compositions, his wiry but sturdy trees which seem almost to be wrenching themselves out of the ground, his strong and dramatic effects of light (Pl.308), all affected Gainsborough profoundly and were responsible ultimately for what may be regarded as

[13] Jackson, op. cit., pp.148–54.

[14] Gainsborough to Jackson, Bath, 29 January 1773: Woodall *Letters*, No.103, pp.177 and 179.

[15] See the author of 'The Rise and Progress of Water-Colour Painting in England', No.VII, *The Somerset House Gazette*, 20 December 1823, p.162.

[16] Gainsborough to David Garrick, n.d.: Woodall *Letters*, No.27, p.67.

excesses or indolence in his later style: the overlighting, the overdependence on sunset effects, the too facile undulating line (Pls.222 or 223).

Gainsborough must certainly have made thousands of drawings, though only between eight and nine hundred are known of today. Jackson said he 'must have seen at least a thousand, not one of which but possess merit, and some in a transcendent degree'.[17] Naturally, he drew for many distinct purposes, but primarily it was for recreation, as a means of release from the tensions and frustrations inseparable from the life of any great portraitist constantly at the mercy of the fashionable world. We are told that he loved nothing better than to sit at home in the evenings and make sketches of landscape scenery,[18] either from imagination or else from models he prepared made up of bits of cork and glass, lumps of coal, and vegetables.[19] But drawing was more than just recreation. It was also a compulsive activity, so much so that he suffered from nervous fatigue as a result of it and found himself unable to sleep at night, it being difficult to divest himself entirely of the ideas that had been teeming through his brain.[20]

Obviously, our understanding of Gainsborough's artistic personality depends upon an analysis of exactly this compulsive type of drawing. As his hand moved swiftly across the paper, there began to take shape simple country scenes, wooded landscapes with a country track winding between banks and trees, with perhaps hills and a church tower in the distance – scenes enlivened with familiar country events, a herdsman driving cattle, a shepherd and his flock of sheep, cows stopping to drink at some sequestered watering place, a peasant family grouped outside their thatched cottage, a woodman returning home from the day's labours: themes which he repeated over and over again because they so exactly suited his vision of the English landscape, and certain of which (a clue to their importance for him) he decided to reproduce in soft-ground etching and aquatint.

Uvedale Price informs us how, in the course of their rides together, Gainsborough's face would light up with 'an expression of particular gentleness and complacency' at the sight of such peaceful scenes,[21] and there is no doubt that he was genuinely moved by the everyday simplicities of country life. Gainsborough may have been a countryman himself, born and brought up in a remote and rural part of East Anglia, but his vision was strangely like a townsman's idyll of the countryside (hence its perennial appeal), and took small account, save in its obstinate conservatism, of the disturbances that were shaking the very foundations of rural society as a result of the enclosure of more and more land for sheep farming and the disruptive impact of the Industrial Revolution. There is no real parallel between Gainsborough's landscapes and the ideas behind Goldsmith's *The Deserted Village*, though the nostalgia they both reflect for what was slowly passing is much the same.

[17] Jackson, op. cit., p.182.

[18] Cunningham, op. cit., p.339.

[19] Jackson, op. cit., pp.167–8; Reynolds, *op. cit.*, p.250; and Ephraim Hardcastle (=W. H. Pyne), *The Somerset House Gazette*, 6 March 1824, p.348.

[20] *The Farington Diary*, 30 January 1799 (from the typescript in the British Museum Print Room, p.1455).

[21] Uvedale Price, *Essays on the Picturesque*, London, 1810, Vol.2, p.368.

It was Gainsborough's friend Jackson who first criticized him for artificiality, and he was no doubt thinking of such peasant girls as the glamorous redhead in the picture at Royal Holloway College (Pl.301), when he pointed out that a town girl with her clothes in rags is not at all the same thing as a ragged country girl.[22] The criticism is a valid one, and needs explanation.

It was not that Gainsborough was shut off from the country after he left Suffolk. At Bath he was within easy riding distance of some of the most picturesque country in England. And during his residence in London he had a house in Richmond[23] (he may possibly also have had a cottage in Essex),[24] and travelled widely in the summer months, to the West Country, the Lakes and no doubt elsewhere: his seascapes, and those coastal backgrounds which seem sometimes such an incongruous accompaniment to certain of his pastorals, were stimulated by a visit to the Devonshire coast in 1779.[25]

The answer is that he was not drawing even an idyll of the countryside, but an embodiment, derived from memories of the countryside, of the peace that was denied him for so much of his life: by the pressure of his practice, by the incompatibility of his wife, by his own highly strung, nervous temperament. His temperament, perhaps, above all. In 1763, when he was 36, he collapsed from overstrain, and almost died: 'I have had a most terrible attack of a Nervous Fever so that for whole nights together I have thought it impossible that I could last 'til the morning.'[26] Gainsborough's themes are nearly all associated with repose or gentlest activity, with summertime or the peace of evening. No action more vigorous than chopping wood (Pl.196) seems ever to disturb his landscapes: even the plough-team of his early drawings (Pl.29) was excluded from his later work.[27] This slight unreality of his thematic material was well suited, of course, to the facility of his style: as in Constable, the close and tireless transcription of natural detail and phenomena which lay behind every brush-stroke in his finished work expressed a deep preoccupation with the normal, everyday activity of the land, especially that particular stretch of land along the banks of the Stour he knew so intimately.[28] Gainsborough wanted to take up his viol-da-gamba and walk off to some sweet village where he could be at peace,[29] but I doubt if that village ever really existed save in his own imagination.

This introspective attitude of mind also explains the air of melancholy which

[22] Jackson, op. cit., p.156. Hazlitt made a similar point when he wrote that Gainsborough gave 'the air of an Adonis to the driver of a hay-cart, and models the features of a milk-maid on the principles of the antique' (William Hazlitt, *Criticisms on Art*, London, 1843, p.195).

[23] Whitley, p.251.

[24] There is a Rowlandson drawing so entitled (Hay sale, Sotheby's, 18 November 1953, Lot 31): see p.84.

[25] Gainsborough to Jackson, Bath, 8 July 1779: Woodall *Letters*, No.62, p.123.

[26] Gainsborough to James Unwin, n.d.: Woodall *Letters*, No.84, p.149.

[27] This would certainly have been approved by Gilpin, who called 'cottages – hay-making – harvesting – and other employments of husbandry' 'low vulgarisms' suited only to 'inferior modes of landscape' (*Instructions for Examining Landscape*, quoted in C. P. Barbier, *William Gilpin*, Oxford, 1963, p.112).

[28] On this aspect of Constable's philosophy of landscape painting, see Graham Reynolds, *Constable the natural painter*, London, 1965, pp.16–20.

[29] Gainsborough to Jackson, Bath, 4 June (no year): Woodall *Letters*, No.56, p.115. Goldsmith expressed a similar desire in *The Deserted Village*.

pervades certain of his drawings: the preoccupation with ruins (Pl.114), dark and densely wooded dells (Pl.220), bleak upland scenes (Pl.181). In actual fact, much of his repertoire was close to the imagery of Gilpin and the 'Picturesque'[30] (Pl.304); so much so that one writer claimed that it was really Gainsborough's sketches which created the love for the picturesque.[31] Gainsborough never actually knew Gilpin,[32] and it is unlikely that he read his books (which began to come out very late in Gainsborough's life, anyway). But he visited many of those places that were the mecca of the picturesque tourists: the Lakes (Pls.179–80), Lulworth, Tintern (Pl.178), and Glastonbury (Pl.177), which Gilpin called the finest ruins in England.[33] His letter to William Pearce before he set off for the Lake District, telling him that his plan was 'to mount all the Lakes at the next Exhibition, in the great stile',[34] suggests a certain light-heartedness in his approach to this subject-matter. With Gainsborough gaiety was not far off from sadness. But we must remember of course that melancholy was fashionable in the eighteenth century: it is reflected in poetry and the Gothic novel, it pervaded garden design, it explains the cult of ruins. Gainsborough's town-bred rustic figures are not far removed in spirit from the idea of the paid hermit. For the eighteenth-century garden was also an escape from reality, artifice imposed upon nature. It too sought to stir the heart gently.[35] But just as in gardens like William Kent's there was a delicate balance between the claims of fashion and the real qualities of his imagination, so Gainsborough's drawings ring true because they fulfilled a need within his own nature.

Gainsborough's imagery, like that of many great artists, was limited. Strangely, perhaps, since it would obviously have suited both his temperament and his technique, he never attempted the gallant type of subject so popular with Boucher and Fragonard: either the delicate suggestion or the abandon and disarray of love. But certain themes were gradually developed in the course of time. The idea of silhouetting cows or horses against a bright horizon reached its final apogee in Lord Eccles's drawing (Pl.156), where riders going home tired from market are seen passing over the crest of a hill, their shapes beautifully outlined against the setting sun. And the cottage half hidden among trees, familiar from Gainsborough's earliest drawings (Pl.11), eventually became one of his principal and most obsessional themes, the 'cottage door' (Pl.147), a subject praised fulsomely by Mary Hartley for its human and affecting qualities.[36]

[30] See my article 'The Holker Gainsboroughs', 'Notes on British Art 1', *Apollo*, June 1964, p.2.

[31] The author of 'Observations on the Rise and Progress of Painting in Water Colours', *The Repository of Arts*, April 1813, p.219. Christopher Hussey was the first modern writer to see that 'Gainsborough was the founder of the "rough" picturesque' (*The Picturesque*, 2nd. ed., London, 1967, pp.13 and 246).

[32] This transpires from the way in which Gilpin refers to Gainsborough in letters, for example, to Edward Forster, 17 May 1789 and to Mary Hartley, 16 February 1790 (quoted in Barbier, op. cit., pp.24, note 5 and 114 respectively).

[33] Gilpin, op. cit., Vol.2, p.179.

[34] Gainsborough to William Pearce, n.d.: Woodall *Letters*, No.64, p.125.

[35] There are some illuminating comments on the mid-eighteenth-century English garden, ideally 'formed on what we feel in ourselves, at the sight of different scenes in nature' and adapted 'to that variety of passions and sensations which distinguish the human heart', in Batista Angeloni (=John Shebbeare), *Letters on the English Nation*, London, n.d. (=1756), Vol.2, esp. pp.270–2.

[36] In a letter to Gilpin, written in 1790 (quoted in Barbier, op. cit., p.114).

We have seen that to a large extent Gainsborough thought of his subject matter as incidental, accents in a landscape rather than anything more, but a number of themes central to his vision he sought to elevate in character. In particular, the woodmen who appeared in so many of his 'cottage door' drawings he began in the 1780's to treat as figures in their own right, symbols of honest toil, sometimes trudging along with a bundle of faggots upon their shoulder (Pl.233), sometimes resting momentarily on a pile of wood (Pl.232). This subject was still uppermost in his mind at the time he died, and in that last pathetic letter to Reynolds he implored him 'to come once under my Roof and look at my things, my Woodman you never saw'.[37] A mother surrounded by her small children, a girl going with her pitcher to the well, a housemaid sweeping, tattered beggar children lazing on the ground (the latter stimulated by his admiration for Murillo) were among other of Gainsborough's late figure subjects; and they proved popular, since they caught to perfection the mood of the age which delighted in the sentiment of Greuze and Wheatley (Pl.302). Not that they slipped into sentimentality: the technical brilliance and verve of the drawings saved them from that.

Gainsborough also tried some more ambitious subjects in the last decade of his life, in a deliberate attempt to demonstrate the variousness of his style and raise his landscapes onto a plane approaching that of history. Those strange country house idylls, with their complicated terraces, and sometimes peasants seated at the bottom of a flight of steps to point the contrast with the life within (Pl.167), clearly mark an attempt to evolve a grander type of composition, but they are uncomfortably artificial, and the intrusion of the genteel strikes a somewhat discordant note in Gainsborough's landscapes. Three splendid preparatory drawings survive for his *Diana and Actaeon* (Pls.343–5), a subject however which he treated in a lyrical rather than dramatic way, the figures being swept up into a rhythmical, rococo composition worthy of Fragonard himself (Pl.348). He was not an intellectual, or even a reading man, and the obituary in *The Morning Chronicle* stated that his figure of Lavinia was not based on Thomson's character but drawn from his own imagination; though his scene in a country churchyard, on the other hand, with a peasant reading the legend on a tombstone (Pl.300), was certainly derived from Gray.[38]

Perhaps our greatest loss is that Gainsborough never carried through (apparently) the large composition, a companion to *The Mall*,[39] for which his matchless drawings of ladies walking among trees (Pls.204–6), usually described as the Duchess of Devonshire, were preliminary studies. This canvas would have exhibited on an even grander scale than the enchanting *Morning Walk* that Arcadian vision of the world, elements of which Gainsborough scattered for our delight among hundreds of his landscape drawings. Constable's well-known words as he stood in front of one of Lord Egremont's Gainsborough landscapes at Petworth still sum up perfectly for us Gainsborough's whole achievement in this field: 'With

[37] Gainsborough to Sir Joshua Reynolds, n.d.: Woodall *Letters*, No.67, p.127.

[38] *The Morning Chronicle*, 8 August 1788.

[39] Mentioned by Bate-Dudley in *The Morning Herald*, 20 October 1785. For a fuller account of this project see my article in *The Burlington Magazine*, January 1969, pp.28–31.

particulars he had nothing to do; his object was to deliver a fine sentiment, and he has fully accomplished it.'[40]

[40] Constable to C. R. Leslie, n.d. (=1834) (ed. R. B. Beckett, 'John Constable's Correspondence III', *Suffolk Records Society*, Vol.8, 1965, p.116).

3
Techniques and Methods of Work

Materials

Gainsborough, though apt to be hasty and impatient, was undoubtedly one of the most brilliant and original technicians that the British school has ever produced, and like most good technicians, was deeply concerned about the quality and suitability of his materials. When he discovered a colour that was better than the pigment he had used up-to-date there was no rest until he had obtained a supply: 'to say the truth of your Indigo', he once wrote to Jackson, 'tis delightful, so look sharp for some more (& I'll send you a drawing).'[1]

So, too, he cared about the drawing paper he used. Finding that the paper upon which Anstey's *New Bath Guide* of 1767 was printed exactly suited his needs 'for making wash'd Drawings upon', he wrote off at once to Dodsley, the publisher, to secure half a dozen quires of it: 'There is so little impression of the Wires, and those so very fine, that the surface is like Vellum . . . I have some of your fine Writing Paper but this made for Printing is much superior for the use I want it on account of the substance & not having so much of the Glaze upon it . . . it really comes up to the Italian drawing Paper such as they made formerly.'[2] The sample with which Dodsley obliged him, however, proved to be differently woven, as we learn from Gainsborough's next letter, in which he sent his 'sincerest thanks for the favor you have done me concerning the Paper for Drawings; I had set my Heart upon getting some of it, as it is so compleatly what I have long been in search of: the mischief of that you were so kind to inclose, is not only the small Wires, but a large cross wire . . . which the other has none of, nor hardly any of the impression of the smallest Wire. I wish Sir, that one of my Landskips, such as I could make you upon that paper, would prove a sufficient inducement for you to make still further enquiry . . . I am this moment viewing the difference of that you send & the Bath guide holding them Edgeways to the light, and could cry my Eyes out to see those furrows; upon my honor I would give a guinea a Quire for a Doz.ᵣ quire of it.'[3]

Nearly all of Gainsborough's early drawings, and a good proportion of the later,

[1] Gainsborough to Jackson, n.d.: Woodall *Letters*, No.53, p.107.

[2] Gainsborough to Dodsley, Bath, 10 November 1767: this letter, formerly in the Jupp collection (see *A Descriptive List of Original Drawings, Engravings, Autograph Letters, and Portraits illustrating the Catalogues of the Society of Artists of Great Britain . . . in the possession of Edward Basil Jupp, F.S.A.*, 1871, p.8), is now owned by Gainsborough's House, Sudbury.

[3] Gainsborough to Dodsley, Bath, 26 November 1767: Woodall *Letters*, No.21, p.59 (this letter is now also at Gainsborough's House, and extracts from both documents are quoted by kind permission of Gainsborough House Society).

are on fine white laid paper; and in the early pencil drawings he often used the wiremarks to positive effect as an instrument of modelling (Pl.32). Such furrows, however, were an impediment to the flow of wash or watercolour,[4] and it is in the context of his watercolours of the 1760's that the correspondence with Dodsley should be understood. Though it is hard to point to any example of his having used this particular paper, which is characterized by a slightly flecked texture and almost complete absence of wiremarks, it is clear that he eventually obtained what he required, as many of his late drawings (Pl.225) are executed on very smooth paper without wiremarks.

For many of his later chalk drawings, on the other hand, which depended upon texture and unevenness of surface for much of their brilliance of effect, he used a fairly coarse blue paper (Pl.159) which, in numerous cases, as a result of exposure to light, has long since faded to grey – in perhaps equally many more, even to brown (the original blue is often to be seen at the edges of drawings, where it has been preserved by mount or frame). The falsification of Gainsborough's tonal values resulting from this chemical change is usefully studied in the mountain landscape in the Victoria and Albert Museum (Pl.352), which can be compared with another version far less ravaged by time (Pl.351).

Gainsborough also, on occasion, employed a coarse buff paper, like Wilson; a particularly striking example from the point of view of texture is the sheet upon which he drew the studies of goats now in the Victoria and Albert Museum (Pl.227). His later sketch-books, of which one at least was acquired by George Hibbert, were made up of coloured paper; and he is known to have used green paper for certain of his early sketches (Pls.13 or 14), though the Suffolk period drawings now in the British Museum, from the sketch-book acquired by Payne Knight, are all on white laid paper, and the evidence points towards this being his more usual practice at this period. For certain of his varnished drawings he used a special preparation of his own, white paper pasted onto 'a spongy purple paper'.[5]

Media

His media were very varied, and often highly personal. Edwards was correct, however, in saying that his early drawings 'were mostly in black lead, and some in black Italian chalk'.[6] Pencil was his normal medium for landscape sketches in the Suffolk period, though there are a few in which he used black chalk or black and white chalks on coloured paper (Pls.14 or 12), and others in which he added watercolour to a pencil outline (Pl.39); this latter technique was more characteristic of the 1760's, when he also used a good deal of bodycolour, mainly lead white, in such drawings (Pl.83). After about 1770 he ceased to use pencil even for outlines, and Margaret Gainsborough tells us that 'He scarcely ever in the advanced part of his life drew with black lead pencil as He cd. not with sufficient expedition make out

[4] A point made by the author of 'Observations on the Rise and Progress of Painting in Water Colours', *The Repository of Arts*, February 1813, p.92.

[5] Gainsborough to Jackson, Bath, 29 January 1773: Woodall *Letters*, No.103, p.177. 'A pair of Landscapes on blotting paper' were in the Thomas Monro sale, Christie's, 26 June 1833 ff. (Lugt 13354), 5th Day, Lot 166.

[6] Edward Edwards, *Anecdotes of Painters*, London, 1808, p.139.

his effects.'[7] Black Italian chalk, if we may judge from the few surviving examples, seems to have been his medium for the portrait studies of the 1750's (Pl.255), which were executed in a much broader style, though it should be noted also that many of his rough sketches of poses and drapery dating from the 1760's are in fact in pencil (Pl.327). The landscapes of the early 1760's were mostly done in watercolour, often with bodycolour added; grey or brown wash drawings became customary from the latter part of this decade, but black and white chalks, though occasionally to be met with, were not commonly employed until the mid-1770's. It was in the early 1770's that he began experimenting with varnished drawings. Many water-colourists were now trying to raise their status, and to win acclaim at the annual exhibitions (the first exhibition of the Society of Artists was held in 1760), by giving their drawings something of the strength of oil paintings;[8] and Gainsborough exhibited a series of drawings in imitation of oil paintings in 1772. The type of varnished drawing he sent to the Academy that year has long been familiar from a number of examples datable to this period (Pls.284 or 286), but it was only recently, with the discovery of a letter to Jackson on the subject dated 1773, that the details of his technique have become known.

There are precise instructions in this letter as to the preparation of the paper and its tightening on a frame so that 'it may be like a drum', but the crucial part of the formula was evidently the substitution of a particular type of white lead for white chalk, as Gainsborough declared 'the *fixing the White Chalk* previous to tinging the Drawing with waterColors, you find I am determin'd never to tell to any body; and here you'l get off, for no Chalk is used, and so keep it close for your own use'. The essentials of the process were as follows: 'make the black & white of your drawing, the Effect I mean, & disposition in rough, Indian Ink shaddows & your lights of *Bristol* made *white lead* which you buy in lumps at any house painters . . . the Bristol is harder and more the temper of chalk than the London. when you see your Effect, dip it all over in skim'd milk; put it wet on (your) Frame just glued as before observed let it dry, and then you correct your (Effects) with Indian Ink when dry & if you want to add more lights or alter, do it and dip again, til all your Effect is to your mind; then tinge in your greens your browns with sap green & Bistre, your yellows with Gall stone & blues with fine Indigo &c &c – when this is done, float it all over with Gum water, 3 ounces of Gum Arabic to a pint of water with a Camels pencil let that dry & varnish it 3 times with Spirit Varnish such as I sent you; tho only Mastic & Venice Turpentine is sufficient, then cut out your drawing but observe it must be Varnishd both sides to keep it flat trim it round with a pen Knife & Ruler, and let any body produce the like if they can; stick them upon a white paper leaving a Margin of an Inch & half round. Swear now never to impart my secret to any one living —.'[9] The process is involved, and may only have been one

[7] *The Farington Diary*, 29 January 1799 (from the typescript in the British Museum Print Room, p. 1455).

[8] Martin Hardie, *Water-colour Painting in Britain 1. The Eighteenth Century*, London, 1966, pp.102 and 38.

[9] Gainsborough to Jackson, Bath, 29 January 1773: Woodall *Letters*, No.103, pp.177–9 (this letter is now owned by Messrs. Bennett and Marshall, Los Angeles, to whom I am indebted for kind permission to quote *in extenso*). Even his varnishes seem to have been of his own preparation (see his letter to an unknown recipient, dated 1763: Woodall *Letters*, No.100, p.173). A technical analysis of this process is being undertaken by Miss Sophie Crombie.

of a number of similar experiments, of which, however, the results were undeniably effective. In many of these drawings there is also an admixture of oil to give added richness and strength (Pl.120)[10]; and this addition is especially evident in his later work, where the pigment is usually thicker and worked into an impasto (Pls.210–5).

The method Gainsborough used to block out his effects in these drawings of around 1770 was probably similar to the one he is reported to have used for his 'moppings', which are supposed also to date from the Bath period. Edwards described his drawings of this period as 'more indeterminate, and . . . more licentious' than his earlier work, and wrote that they 'were executed by a process rather capricious, truly deserving the epithet bestowed upon them by a witty lady, who called them moppings. Many of these were in black and white, which colours were applied in the following manner: a small bit of sponge tied to a bit of stick, served as a pencil for the shadows, and a small lump of whiting, held by a pair of tea-tongs was the instrument by which the high lights were applied; beside these, there were others in black and white chalks, India ink, bister, and some in a slight tint of oil colours'.[11]

There is a somewhat similar description of Gainsborough's methods at this period by Angelo, who claims to have seen him at work in 1768. As Angelo was no more than 8 at the time, a schoolboy at Eton, and notoriously unreliable about dates, this claim is probably unfounded, but he could have seen Gainsborough at Bath if he had visited him with his father Domenico, who was one of the painter's friends. Angelo also uses the term 'moppings', and it seems likely that his account is at least partially derived from Edwards. 'Not acknowledgeing bounds to his freaks, instead of using crayons, brushes, or chalks, he adopted for his painting tools his fingers and bits of sponge. His fingers, however, not proving sufficiently eligible, one evening, whilst his family and friends were taking coffee, and his drawing thus proceeding, he seized the sugar-tongs . . . He had all the kitchen saucers in requisition; these were filled with warm and cold tints, and dipping the sponges in these, he mopped away on cartridge paper, thus preparing the masses, or general contours and effects; and drying them by the fire, (for he was as impatient as a spoiled child waiting for a new toy,) he touched them into character, with black, red, and white chalks.'[12]

Gainsborough increasingly used a mopping technique as a rapid means of roughing out a compositional idea (Pl.225), and also employed stump for the same purpose (Pl.229). His principal media in his late drawings were grey and grey-black washes, with contours put in with the tip of the brush rather than with pen, though in some cases (Pl.145) it is difficult to be quite certain about this; his own special formula, sometimes with really thick highlights in oil; and black and white chalks.

Some of the late chalk drawings are reputed to have been executed 'with *true*

[10] A drawing of this description (Cat. No.734) is described on an old label as *Begun in Water Color/completed in Oil—*, and it was presumably works of a similar nature that a painter who claimed to have learnt from Gainsborough described as 'studies on a tempera ground commenced and carried far in water colours, and finished in oil' (W. Holman Hunt, *Pre-Raphaelitism and the Pre-Raphaelite Brotherhood*, London, 1905, Vol.I, p.44). The reference to a tempera ground is however difficult to explain.

[11] Edwards, op. cit., p.139.

[12] Henry Angelo, *Reminiscences*, Vol.I, London, 1828, pp.218–19.

Italian black chalk, the last vein of which was presented to him by his friend Cipriani.'[13] In many cases their effect has been reduced when the lead whites have oxidized, and such deterioration may often have occurred within a relatively short space of time, as an example in Lawrence's collection was described in the sale of 1830 as 'the white somewhat changed.'[14] He also used coloured chalks a certain amount, and Bate-Dudley is not quite correct in stating that the twelve drawings of which ten were acquired by Queen Charlotte were the only works in coloured chalks that Gainsborough finished.[15]

One of the most teasing problems in Gainsborough's late technique is that of the numerous drawings in brown or grey wash which look as though they were done over a faint offset outline or with a greasy type of chalk (Pls.188 or 397). It was Binyon who first observed that these outlines 'were certainly produced by transference and not by direct touches',[16] and in the case of two Hoppner drawings with precisely similar outlines he described what he believed to be the process, 'brown oil colours pressed, while wet, between two sheets, producing a peculiar grained effect',[17] a technique first used by Castiglione in the seventeenth century. Examination under a magnifying glass suggests that the outlines in the Gainsborough drawings may also be in oils, similarly transferred; but the purpose of such a technique is obscure. No duplicates of these designs are known, and if it were the texture Gainsborough required, surely this could have been produced more easily in chalk; possibly it was the uncertainty of the effects that would result that he relished, a stimulus to his imagination akin to 'blotting'. Offsetting from already finished drawings for the purpose of reproduction was a contemporary French practice, and used often by Rowlandson.[18] The only Gainsborough offset of this kind at present known is the coloured chalk drawing of a timber waggon in Budapest (Pl.461), a faint shadow in reverse of the original now at Leeds (Pl.462), and questionably produced by Gainsborough himself.

Signatures

Gainsborough rarely signed his drawings. In a number of cases he signed with initials in ink, and very occasionally, as in the sheet of studies of a cat in the Rijksmuseum (Pl.99), he used a full signature. It is next to certain that he only signed drawings he gave away, perhaps on request, and it is significant that the gold stamped monogram[19] he seems first to have employed in the later 1750's (see Cat. No. 189) but more consistently during and after the 1760's occurs, in the majority of cases, on precisely those finished watercolours which one would expect

[13] Anon. (=W. H. Pyne), *The Greater and Lesser Stars of Pall Mall*, ch.2, *Fraser's Magazine*, November 1840, p.552.

[14] Sir Thomas Lawrence sale, Christie's 20 May 1830 (Lugt 12380), Lot 127.

[15] Whitley, p.327.

[16] Laurence Binyon, *Catalogue of Drawings by British Artists . . . in the British Museum*, Vol.2, London, 1900, p.176.

[17] Ibid., p.357, note.

[18] See Robert R. Wark, *Rowlandson's Drawings for the English Dance of Death*, San Marino, 1966, pp.15–19.

[19] Frits Lugt, *Les Marques de Collections, Supplément*, The Hague, 1956, No.1217a, and assumed to be a collector's mark; the monogram is noted by Edwards, op. cit., p.142, as employed by Gainsborough.

to be presentation drawings (Pl.94).[20] In the wash drawings with faint outlines discussed above, he usually used a gold stamped signature (sometimes his initials in ink, occasionally both), placed between two ruled lines outside which he pasted a decorative gold tooled border (Pls.208–9). Though these drawings are sketchy and impressionistic in character, quite the reverse of his Bath period watercolours, the presumption must be that they were the kind of work he particularly favoured as presentation drawings in his later years:[21] in other words, suggestiveness became increasingly a positive quality for him. On the other hand, of course, quantities of drawings he gave away were in different media, and bore no signatures of any sort.

From this discussion of media and techniques, the foundations of style, we can now turn to the broader subjects of his methods of work and the purposes of his different kinds of drawing: in particular, the thorny problem of which exactly among Gainsborough's drawings were done from nature must be faced at this point.

Studies from Nature

A great deal of helpful evidence survives about Constable's habits of work, chiefly from his own letters; but in the case of Gainsborough, there is very little to go on. Fulcher, his earliest biographer, was embroidering from local East Anglian tradition, but nevertheless probably gave a correct impression of the young Gainsborough, when he wrote that 'the Suffolk ploughmen often saw him in the early morning, sketch-book in hand, brushing with hasty steps the dews away; and lingering in the golden light of evening, taking lessons from the sun-set clouds.'[22] Gainsborough must have spent a good deal of his time sketching in the Suffolk countryside in his early days, but none of his sketches is dated or annotated in his own hand, and scarcely any evidence of value has come down to us of where he actually went to draw, the only useful scrap of information being gleaned by Constable, who tried to discover (in 1797) what he could about Gainsborough's life in Suffolk, and recounts that 'There is a place up the river side (the Orwell) where he often sat to sketch, on account of the beauty of the landscape, its extensiveness, and richness in variety, both in the fore and back grounds. It comprehended Bramford and other distant villages on one side; and on the other side of the river extended towards Nacton, &c.'[23] This would have to have been about a mile or two south of Ipswich, on the left bank of the Orwell, close to Freston, where he is supposed to have met Joshua Kirby.[24] One can well imagine panoramic drawings like the sheet in Yale (Pl.21) being produced at leisure in such a spot; and the sketch in the British Museum in which Gainsborough has introduced a young couple sketching together on the banks of a river (Pl.22) obviously represents some similar vantage point.

[20] Three of the drawings he gave to his friend Goodenough Earle were so stamped (see my article, 'The Gainsborough Drawings from Barton Grange', *The Connoisseur*, February 1966, p.91 and figs.10, 11 and 12).

[21] Binyon also observed with regard to the drawings of this type in the British Museum that the 'gilt border and signature . . . suggest that Gainsborough prepared them as presents for friends' (op. cit., Vol.2, p.176).

[22] Fulcher, p.32.

[23] Constable to J. T. Smith, East Bergholt, 7 May 1797, 'John Constable's Correspondence II', *Suffolk Records Society*, Vol.6, 1964, p.11.

[24] Fulcher, p.39.

Most of the early sketches are studies of trees, sometimes individual trees, oaks, alders, pines,[25] more often groups of trees or woodland thickets. But there are also sketches of cottages; of figures, a girl with a basket on her arm or a wood-cutter carrying a pile of faggots; and of animals, especially cows and goats. What is interesting to note is that, unlike Constable, Gainsborough was already generalizing in many of his drawings from nature. There is not a great deal in his approach to landscape which would have been foreign to de Piles, whose *Principles of Painting* first appeared in English in 1743, when Gainsborough was a student; and later he would have had the support of Reynolds: 'A Landscape-Painter . . . works not for the Virtuoso or the Naturalist, but for the common observer of life and nature. When he knows his subject, he will know not only what to describe, but what to omit.'[26] Even Gainsborough's studies of individual trees are often hard to identify (Pls.63 or 65), and there is no doubt that in his sketches of more general motifs he was concerned chiefly with variety of effect (not precision of detail) and in stimulating his pictorial invention; some drawings are no more than the most summary notation of scenes that appealed to him as compositional ideas, cottages nestling among trees, or cows watering at a wooded pool (Pls.33 or 66). Many of these sketches must have been quite ephemeral, and no doubt only the merest fraction survives today. Drawing, for Gainsborough, was always more an act of love than a means of storing up ideas and information, and Thicknesse describes a whole pile of sketches which the painter happily gave him at this time, 'sketches of Trees, Rocks, Shepherds, Plough-men, and pastoral scenes, drawn on slips of paper, or old dirty letters, which he called his riding School,[27] and which have all been given, borrowed, or *taken away* from me.'[28]

Some sketches Gainsborough kept by him, chiefly those more careful studies of animals, details and motifs that could be incorporated directly in his landscape compositions. Examples of this type of drawing are the study of light playing over a mossy bank in the British Museum (Pl.31), the elaborate sketches of mallows in the Torbock collection (Pl.57) and of burdock leaves in the British Museum (Pl.19), and the more summary sketch of a piece of fencing in the Witt collection (Pl.50).

In one or two instances we can point to the use of such studies. Two sketches of sheep in Berlin (Pls.323–4) were incorporated in a composition study (Pl.325) for the picture in Toledo (Pl.326), and it is instructive to compare these studies from life with the more generalized sheep in the composition drawing. The reclining cow

[25] I am much indebted to Mr Patrick Synge, of the Royal Horticultural Society, for identifying certain trees and for his advice on the general problem of the exactitude (or otherwise) with which Gainsborough drew from nature.

[26] Sir Joshua Reynolds, *Discourses on Art*, ed. Robert R. Wark, San Marino, 1959, p.199. An early source noted that Gainsborough 'was not the painter for the botanist, he did not minutely describe every fibre of a dock leaf, but gave those general resemblances which strike every eye' (*The London Chronicle*, 7–9 August 1788).

[27] Nollekens must also have heard Gainsborough use this expression, as a drawing of his he owned was so entitled (Nollekens sale, Christie's, 5 July 1823, Lot 97).

[28] Thicknesse, p.7. Mary Woodall seems to suggest that some of these still survive (*Thomas Gainsborough: His Life and Work*, London, 1949, pp.21–2), but nothing with a provenance going back to Thicknesse has so far come to light. A portfolio containing studies of farm implements, ploughs, rakes, spades, etc., drawn on small scraps of paper, reputedly by Gainsborough, was formerly in the Nichols collection at Lawford Hall (kindly communicated to me by Lady Conesford).

in the Oppé collection (Pl.316), another example, was included without the slightest alteration of pose in one of Gainsborough's most elaborate compositions of this period, the landscape with cattle and buildings owned by F. Bulkeley Smith (Pl.315), and then reversed for the painting in Lord Howe's possession (Pl.318).[29] Two other studies can also be related to this composition, which is actually an amalgam of an extraordinary number of Gainsborough's early motifs: a study of a cow in the British Museum (Pl.317) which is almost but not quite identical in pose with that in the Bulkeley Smith drawing, and a sheet of studies of church towers seen beyond trees (Pl.314), also in the British Museum, which is the type of sketch Gainsborough is likely to have used for the church tower in the drawing. The Suffolk-type wheel plough which features on the left of the Bulkeley Smith drawing was clearly derived, too, from sketches made from an actual implement, but, as in the composition drawing for the Toledo picture referred to above, the detail is less convincing at this remove from the original sketch: among other inaccuracies, the mould board and coulter have been blended together. One may fairly assume that studies of a similar nature intervened between Gainsborough's first rough outline of a farmyard scene (Pl.319) and the translation of this subject into paint in the landscape in the Mellon collection (Pl.321).

Few examples of studies of effects seem to exist, though studies of reflections or sunlight playing on foliage are introduced incidentally (Pl.56), and it is tantalizing that two drawings formerly in the possession of the Edgar family the object of which, so we are told, was 'to illustrate the effect of sunbeams piercing through clouds in opposite directions',[30] drawings that sound remarkably like the studies of Alexander Cozens, no longer survive.

Reynolds, writing of Gainsborough as he knew him in full maturity, said that 'Among others he had a habit of continually remarking to those who happened to be about him, whatever peculiarity of countenance, whatever accidental combination of figures, or happy effects of light and shadow, occurred in prospects, in the sky, in walking the streets, or in company.'[31] Though it is usually assumed that he did not draw from nature much, if at all, in his later years, it would be hard, in view of Reynolds's remarks and indeed from all we know of Gainsborough's delight in observing at first hand, to believe that this could really be the case. In fact, there is good evidence that Gainsborough continued to sketch out of doors, in the intervals of a busy career, pretty well throughout his life, and the references that exist may conveniently be gathered together here.

Uvedale Price wrote of making 'frequent excursions with him into the country'[32] during his youth, which would mean the 1760's; and Ozias Humphry, referring to the period about 1763, said that 'When the Summer advanced, and the Luxuriance of Nature invited and admitted of it, he accompanied M. Gainsborough in his Afternoon Rides on Horseback to the circumjacent Scenery, which was in many

[29] Waterhouse, No.845; see also *The Connoisseur*, February 1966, op. cit., p.89.

[30] Fulcher, p.39, note.

[31] Reynolds, op. cit., p.250.

[32] Uvedale Price, *Essays on the Picturesque*, London, 1810, Vol.2, p.368.

Parts, picturesque, and beautiful in a high Degree. – To those and succeeding Excursions the Public are indebted, for the greater Part of the Sketches, and more finished Drawings from time to time made public by that whimsical, ingenious, but very deserving Artist'.[33] The woods at Claverton and Warley were said to be his favourite sketching localities near Bath, and 'he frequently passed the day with only a sandwich or some bread and cheese in his pocket'.[34]

Gainsborough also made (or planned) summer expeditions farther afield. In May 1768 he wrote to his friend Unwin, then in Derbyshire: 'I suppose your Country is very woody – pray have you Rocks and Water-falls! for I am as fond of Landskip as ever.'[35] And in July 1779 to Jackson: 'I hope to see you in about a fortnight, as I purpose spending a month or six weeks at Tingmouth or other places round Exeter – get your Chalks ready, for we must draw together.'[36] A number of drawings of coastal scenes datable to about 1780 (Pl.140) could well be the fruits of this visit, and two such sketches are traditionally described as being views on the Devonshire coast.[37]

In about 1782 he made a tour through the West Country in the company of Gainsborough Dupont, and though few details of this tour are given he is noted as having stopped at Lulworth Castle;[38] it may have been on this trip (though more likely, perhaps, during his residence at Bath) that he visited Lynton, on the edge of Exmoor on the north Devonshire coast.[39] He seems to have been familiar with Wales, where de Loutherbourg went for inspiration in 1786.[40] And in the late summer of 1783 he was certainly in the Lake District, as he wrote to William Pearce a few weeks before going: 'I don't know if I told you that I'm going along with a Suffolk friend [Samuel Kilderbee] to visit the Lakes in Cumberland and West-morland, and purpose, when I come back, to show you that your Grays and Dr. Brownes are tawdry fan-painters. I purpose', he declared, 'to mount all the Lakes at the next Exhibition in the great stile.'[41]

There are a small number of sketches from nature surviving from the Bath period which are not markedly different from those done earlier, except that they are in watercolour or other media in addition to pencil or black chalk: examples are the study of foliage in the Witt Collection (Pl.91) and the drawing of a boulder and some dock leaves owned by Mr and Mrs Paul Mellon (Pl.107). The brilliant pen

[33] Ozias Humphry, 'Biographical Memoir', MSS., c.1802 (*Original Correspondence of Ozias Humphry, R.A.,* Vol.1: Royal Academy Library).

[34] Whitley, p.390.

[35] Gainsborough to Unwin, Bath, 25 May 1768: Woodall *Letters,* No.90, p.167.

[36] Gainsborough to Jackson, Bath, 8 July 1779: Woodall *Letters,* No.62, p.123.

[37] These were catalogued as such in the Henry J. Pfungst sale, Christie's, 15 June 1917, Lot 60.

[38] Whitley, p.355.

[39] He described the scenery of this area in a letter to Uvedale Price, now lost (see letter from Uvedale Price to Sir George Beaumont, 17 September 1816, in the Morgan Library: I am indebted to Mrs Felicity Owen for this reference).

[40] One of Gainsborough's landscapes, No.52 in the Schomberg House sale, was noted as having been painted after the artist had returned from a tour of Wales (*The Diary,* 8 April 1789 and *The Morning Post,* 6 April 1789); for de Loutherbourg's visit, see *Newspaper Cuttings: Art 1744–1822,* p.42 (Colnaghi's Library).

[41] Gainsborough to Pearce, London, n.d.: Woodall *Letters,* No.64, p.125.

and wash sketch of a boy reclining in the back of a cart and staring cheekily back-wards (Pls.104–5) also gives the impression of being a drawing done on the spot and *con amore*. But in addition to these there are a number of more elaborate water-colours and gouache drawings which *may* have been executed out of doors, though more likely perhaps from slighter sketches done on the ground: the evidence is inconclusive.

The earliest of these drawings is the study of beech trees signed and dated 1760 (Pl.80) which is described on the original label as 'A study from nature . . . when on a visit to Foxley', the Herefordshire seat of Gainsborough's friend Sir Robert Price, father of Uvedale Price. If this highly finished watercolour were indeed carried out actually on the ground, rather than from sketches, then so probably were a good many others. On the other hand, there is no reason to presume, with an artist such as Gainsborough, that even so sensitive an evocation of sunlight playing over a woodland glade as the watercolour in the British Museum (Pl.267) should not have been made at home in the evening. Such convincing recreation from memory, aided by the simplest of pencil jottings, was habitual with Turner.

With the chalk drawings we are on slightly more certain ground. Gainsborough refers to his practice of sketching outdoors in chalks in his letter to Jackson of 1779,[42] and we know, too, that Wilson thought 'the best & most expeditious Mode of drawing Landskips from Nature is wth Black Chalk & a Stump on Brownish paper touch'd up wth White'.[43] Two black and white chalk drawings on paper with a middle tint certainly done on the spot are his sketches of the ruins at Glastonbury (Pl.177), not much more than a fairly rapid notation of the main features of the buildings. Similar in style are several other late sketches, such as the study of a group of houses beyond a pond in the Huntington Art Gallery (Pl.175) and the river scene in the California Palace of the Legion of Honor (Pl.176): the trees here are only roughly noted, and neither drawing can have taken the artist very long to complete. One other chalk drawing which is actually inscribed as having been done from nature (and afterwards given to Hoppner, in whose presence it was made), the drawing owned by the Pennsylvania Academy of the Fine Arts (Pl.359), is more of a landscape composition; and it is conceivable that other drawings of this character usually accepted as studio compositions may also have been done out of doors.

Only one of Gainsborough's late wash drawings is known to have been done on the spot, and that is the view of Langdale Pikes (Pl.179), presumably executed on his trip to the Lakes with Kilderbee in 1783. It is much more carefully drawn than his imaginary wash drawings, and apart from a deliberate softening of the silhou-ette of the mountains, is an accurate delineation of the scene as it would appear from Elterwater. Subtle though it is also in conveying the atmosphere of the Lakes, it cannot, of course, compare with the acutely sensitive studies of effects of light, rain and mist made by Constable in the same area nearly a quarter of a century later. Gainsborough was content to suggest; Constable sought to embrace, with

[42] Gainsborough to Jackson, Bath, 8 July 1779: Woodall *Letters*, No.62, p.123.
[43] *Memorandum Book of Ozias Humphry 1772–97* (British Museum Add. MSS.22, 949, p.111).

precision. Another wash drawing of Lakeland scenery (Pl.180) is very similar in execution and must surely have been done in front of the *motif*, but in this case the exact view has not so far been identified.

Gainsborough also continued to sketch figures and animals from the life, and Reynolds tells us that 'if, in his walks he found a character that he liked, and whose attendance was to be obtained, he ordered him to his house: and from the fields he brought into his painting-room, stumps of trees, weeds, and animals of various kinds; and designed them, not from memory, but immediately from the objects.'[44] In other words, his usual practice in later life was to bring what he required to draw from nature into the studio, whenever it was practicable to do so, rather than sketch out of doors. His studies of beggar children in different poses (Pls.158 or 296), some apparently made from a beggar boy whose pitch was St James's Street,[45] and the three fine drawings of woodmen (Pls.231–3), all done from the same model, 'a poor smith worn out by labour' whom Gainsborough took home and supported,[46] fall into this class. And of his few surviving late drawings of animals, there are several of goats (Pls.226–7), some of which were probably intended as studies for his picture of *The Prodigal Son*.[47]

Studies from other Masters

As well as working from nature, Gainsborough also copied the work of earlier artists, especially, of course, in his youth. There is an elaborate black and white chalk copy of a picture by Ruisdael in the Whitworth Art Gallery (Pl.248); and a number of early sketches employing a distinctive nervous, staccato technique (Pl.249) are exceedingly close to the manner of Waterloo, and may be copies of Dutch drawings. There are also two instances of his copying Van Dyck, one of which (Pl.269) seems to have been done from a Van Dyck drawing. Hoppner, speaking of his late work, refers to 'studies he made at this period of his life, in chalks, from the works of the more learned painters of landscape, but particularly from Gasper Poussin',[48] and one of the sketch-books sold in 1799 contained fifty-eight Italian scenes of architecture and landscape,[49] none of which can be identified today. A sketch-book of 'imitations from antique vases and sculpture' was also sold in 1799,[50] and one such drawing does survive (Pl.312).[51]

Studio Compositions

But the vast majority of Gainsborough's later landscapes were done from imagina-

[44] Reynolds, op. cit., p.250.

[45] Whitley, p.238. Jack Hill, a child who lived near Gainsborough's house in Richmond, was a later model (Whitley, pp.292–3).

[46] Whitley, p.285.

[47] An unpublished painting formerly with Colnaghi's.

[48] *The Quarterly Review*, February 1809, p.48.

[49] Christie's, 11 May 1799 (Lugt 5917), Lot 89.

[50] Ibid., Lot 90.

[51] Others appear to have been owned by Fairfax Murray (see Sir J. C. Robinson sale, Christie's, 21 April 1902, Lot 37, bt. F. Murray).

tion, or with artificial aids, and were either drawings in their own right or else composition studies intended for use in pictures. Allan Cunningham is the source for the familiar story that 'he loved to sit by the side of his wife during the evenings, and make sketches of whatever occurred to his fancy, all of which he threw below the table, save such as were more than commonly happy, and these were preserved, and either finished as sketches or expanded into paintings.'[52] These studio drawings can usually be distinguished by the summary character of the detail (trees are suggested rather than modelled, and figures and animals and such features as wheels of carts are much abbreviated), also by the introduction of various of his favourite motifs in different and generally very artificial combinations.

Comparatively few such drawings date from the Suffolk period, but a number do. Some of these, such as the drawing owned by Douglas Everett (Pl.61), are rapid jottings of compositional ideas, while others are more elaborate: the drawing in Sir John Witt's collection (Pl.70) is a fully wrought composition of the kind familiar from his Suffolk oils, and the river scene in Gerald Bronfman's collection (Pl.246) includes a figure evidently drawn from a jointed doll (Gainsborough did a number of figure drawings, studies for his landscapes, from such dolls). Certain of his more elaborate early Suffolk drawings evince a greater attention to detail than to the composition as a whole, a fault Gainsborough was later to eradicate. In the Morgan Library drawing, for example (Pl.40), there are obvious disparities in scale, emphasizing the treatment of the subject matter as separate vignettes: the ploughing scene being dissociated from the cottage by the tree stump that dominates the foreground, the twisting rococo forms of which Gainsborough has delineated with such loving care. It is clear from the evidence of an unfinished early watercolour (Pl.39), where he is seen working in the technique of the tinted drawing, that at this stage in his development Gainsborough might well finish part of a drawing completely before the rest of it was more than outlined.

Many of the Bath period drawings, and most of his later drawings, are studio works; and of these many more than has usually been supposed, about thirty-five at present known, were used as subjects for his landscape paintings.[53] The relationship between such sketches and the finished paintings can be summarized briefly. In the Suffolk period it seems likely that Gainsborough occasionally produced finished drawings independent of his paintings which were afterwards adapted for the latter purpose. The drawing owned by F. Bulkeley Smith, for instance, as noted already, was used with alterations and in reverse for the left half of the landscape owned by Lord Howe (Pls.315 and 318).[54]

In the work of his maturity, however, the connection between a sketch for a painting and the finished picture itself is usually close (Pls.334 and 336). In certain cases, to be sure, there are a number of significant differences (Pls.349–50), while in one of his coastal scenes he used a composition in reverse (Pl.151).[55] But for the

[52] Allan Cunningham, *The Lives of the Most Eminent British Painters*, London, 1829, Vol.1, pp.339–40.

[53] These are listed on pp.38–40.

[54] See also *The Connoisseur*, February 1966, op. cit., p.89.

[55] The finished painting was owned by the late Mrs Mellon Bruce (Waterhouse, 954, repr. pl.224).

most part alterations are generally slight, amounting to no more than the addition of a figure or some modification in detail such as one might well expect during the process of translating a composition onto canvas. In one case, that of Mrs Argenti's drawing (Pl.333), Gainsborough seems to have elaborated a composition of which he had already completed a painting (Pl.335).

There is no reason to suspect that the drawings went into portfolio and were sifted through when Gainsborough wished to paint a picture; indeed, such a procedure would have been quite alien to his temperament. More likely, as Pyne said of his transparencies,[56] that when he had produced a drawing that was to his satisfaction, he would rush to work it out on canvas. In one instance, it can be stated with some certainty that painting quickly followed drawing: for the composition sketch in the Ponce Museum (Pl.181) is evidently a product of his tour to the Lakes in the late summer of 1783, the mountains being based on his study of Langdale Pikes (Pl.179), while the finished picture is documented to the autumn of 1783.[57]

Gessner tells us how, in his own work, a stone might give him the idea for a rock;[58] and Gainsborough, in composing his landscapes, often had recourse (as did Sandby)[59] to models. These have been described by several of his contemporaries. Pyne said that he had 'more than once sat by him of an evening, and seen him make models, or rather thoughts, for landscape scenery, on a little, old-fashioned folding oak table, which stood under his kitchen dresser . . . This table, held sacred for the purpose, he would order to be brought to his parlour, and thereon compose his designs. He would place cork or coal for his foregrounds, and set up distant woods of brocoli.'[60] Reynolds corroborates this account, but describes his model as 'composed of broken stones, dried herbs, and pieces of looking-glass, which he magnified and improved into rocks, trees, and water'.[61] Jackson recounted that 'He modelled his horses and cows, and knobs of coal sat for rocks', adding that 'he carried this so far, that he never chose to paint any thing from invention, when he could have the objects themselves. The limbs of trees, which he collected, would have made no inconsiderable wood-rick, and many an ass has been led into his painting-room.'[62] Some of his drawings do seem to betray the use of such models, and there is little difficulty in recognizing, for instance, lumps of coal in some of his rock formations (Pl.112). Margaret Gainsborough said that he 'had drawn much by Candle Light towards the latter part of his life when He thought he did not sleep so well after having applied to drawing in the evening not being able to divest him-

[56] Ephraim Hardcastle (=W. H. Pyne), *Wine and Walnuts*, London, 2nd edn., 1824, Vol.2, p.197.

[57] Whitley, p.325.

[58] Solomon Gessner, *A Letter . . . on Landscape Painting*, Edinburgh, 1798, p.122.

[59] Landscape models 'designed to draw from' were in the Sandby sale, Christie's, 2 May 1811 ff. (Lugt 7983) 1st Day Lots 81–4 and 3rd Day Lots 84–7.

[60] Ephraim Hardcastle (=W. H. Pyne), *The Somerset House Gazette*, 6 March 1824, p.348.

[61] Reynolds, op. cit., p.250.

[62] William Jackson, *The Four Ages*, London, 1798, pp.167–8. It may be recalled that Gainsborough had been in the practice of modelling animals during his youth (*The Morning Chronicle*, 8 August 1788), and a number of casts 'from an old horse that he modelled' are recorded in the early literature (see Mary Woodall, 'Gainsborough's use of models', *Antiques*, October 1956, pp.363–5, where an example that had formerly belonged to Constable is reproduced).

self of the ideas which occupied his mind, He therefore amused himself with Music.'[63]

Gainsborough's more highly finished landscape drawings fall into two classes: those he did for engraving, and those he intended for sale or presentation. Neither the drawings he did for Boydell in 1747 nor those for William Elliot in the mid to late 1750's survive, but there are a number of large late Ipswich period pencil drawings (Pls.68–9) in which the clarity yet breadth of detail, the care taken over the gradation of tones, and such features as the cross-hatching in the sky, suggest that they were intended for translation into prints. Corroborative evidence comes from the fact that one of these (Pl.74) is inscribed beneath *Gainsborough fec.1759* and marked with the number *1*, presumably the first in a projected series. An equally carefully delineated pen and watercolour drawing has a similar inscription beneath *Thomas Gainsborough inv.et delineavit 1759* (Pl.77), and was clearly also meant for engraving. Why these were never carried into execution is unknown. The drawings he did later for his own aquatints and soft-ground etchings were freer sketches of his usual type, fully worked out ideas rather than exact models from which to copy (Pl.218).

Gainsborough did not sell any of his drawings in later years, but it is known that the London dealer Panton Betew stocked them in the 1750's;[64] and it was presumably finished drawings, usually in watercolour with pencil or chalk outlines, such as the landscape with calves in a cart in Washington (Pl.41), the landscape with a plough-team in the Morgan Library (Pl.40), or the landscape with a figure crossing a footbridge over a stream in the Victoria and Albert Museum (Pl.42), which has a double-ruled border suggestive of such an intention, that he tried to sell through Betew. Many of his Bath period watercolours were highly finished, and a number of these, stamped in gold with his initials, seem to have been intended for presentation; several such (Pl.94) were certainly given to his host at Barton Grange, a house near Taunton where he is known to have stayed.[65] Fewer finished drawings date from the late period, but certain of his mountain landscapes in black chalk and stump are very highly wrought (Pl.194).

Though it is certainly not what one might have expected from Gainsborough (as opposed to, say, Wilson or Rowlandson), it is a matter of certainty that on occasion he made replicas of his own drawings[66], presumably on the insistence of a friend. The late upland scene with sheep of which one version is owned by E. A. Mott (Cat. No.652) and the other by Mrs Kenneth Potter (Pl.405) is perhaps the most significant example, since both drawings have an excellent provenance, having descended from members of the Gainsborough family. Both are of equally high quality, but the latter is a little more summary in treatment and there are exactly those slight differences in detail and touch which indicate that it is not a copyist at work[67].

[63] *The Farington Diary*, 30 January 1799 (p.1455).

[64] J. T. Smith, *Nollekens and his Times*, ed. G. W. Stonier, London, 1949, p.92.

[65] *The Connoisseur*, February 1966, op. cit., figs. 10, 11, and 12.

[66] See also Woodall, p.100.

[67] The two versions are reproduced together in Woodall, pls93 and 94.

Portrait Drawings

Gainsborough's portrait drawings have never been studied, so that the range and purpose of these drawings has hitherto remained unexamined. Sufficient examples survive, however, to reach valid conclusions about his practice as a portrait painter.

In the first place, Gainsborough seems never to have made preliminary drawings of a sitter's head, and his drawings of heads are all independent works. Composition studies he did prepare, but not for his simpler designs and probably with increasing rarity. These studies are usually very summary in character. There are some less sketchy studies of whole figures, principally as they involved female costume; weaknesses in certain of these drawings, notably in connection with the relationship of feet to the rest of the body (Pl.78), indicate what rather bored him, namely, structure and anatomy. Studies of detail are extremely rare: an occasional sketch of some element of costume, a coat or cuff (Pl.259), one lone drawing of hands (Pl.123).

Only a handful of studies survive from his Suffolk period. Connected with the early portrait-in-a-landscape compositions are the enchanting drawing of a courting couple (Pls.7 and 8) which is related in theme to, and probably the first idea for, the canvas at Versailles,[68] and the three preparatory sketches (Pls.309–11) for the portrait of *Miss Lloyd* (Pl.313): a first rough sketch in which the figure is no more than indicated, and set against a tree with an urn on a plinth behind; a second in which the plinth has been brought into the centre of the composition; and a third in which the arrangement is filled in a little more. One may reasonably conclude that similar sketches were made for many of these works. For his full-scale portraits of this date, there is only the splendid study in black chalks for the pose and arrangement of the coat in the portrait of the *Hon. Richard Savage Nassau* (Pls.320 and 322), and an equally vigorous sketch of part of the costume for a figure in an unidentified portrait group (Pl.259). More routine portraits were probably worked out directly upon the canvas, even in these early years.

Gainsborough only began to undertake full-lengths as normal practice after his arrival at Bath;[69] and from this period date a number of drawings almost certainly made from his articulated dolls dressed-up (Pls.78–9 and 95), with the aid of which he learnt to cope with the disposition of the folds and flounces of ladies' dresses. Some of these studies demonstrably include the same costume (compare Pls.78 and 79), and it is probable therefore that this constituted part of the wardrobe belonging to his dolls. The generalized, classical kind of costume favoured by Reynolds Gainsborough only rarely used, as he always preferred to paint his sitters in contemporary dress; his fancy dress portraits, notably those in 'Vandyke' costume, generally reflected the tastes of sitters rather than his own.

When he painted his first equestrian piece, the *General Honywood*, which was based on the Van Dyck equestrian portrait of Charles I now in the National Gallery, his preoccupation with the mount led him to make equally careful studies, as we

[68] Waterhouse 752, repr. pl.17.

[69] Though he *may* have done a few in the later Ipswich years (see my article 'Some Unknown Early Gainsborough Portraits', *The Burlington Magazine*, February 1965, p.73).

know from a letter to a friend Unwin, in which he wrote that he had been on a visit to Wilton, 'partly for my amusement, and partly to make a Drawing from a fine Horse of L.^d Pembroke's, on which I am going to set General Honeywood, as large as life'.[70]

Composition sketches survive for several of his more complex or important later portraits, notably for *Mrs Thicknesse* (Pl.327) and the *Duke and Duchess of Cumberland* (Pls.337 and 339). In his portrait of *Mrs Thicknesse* (Pl.328), the setting was completely changed in the course of developing his idea. With the sitter brought into more immediate contact with the spectator, and the folds of the dress modified to accentuate the spiralling serpentine movement, it became essential to stabilize the composition, and this was achieved by means of a series of emphatic vertical features: the viol da gamba, the table leg, and the fold in the curtain above. But the essence of this splendid invention was already stated in his first rough sketch.

His portrait of the Cumberlands was originally conceived in terms of the conversation piece, with Lady Elizabeth Luttrell, the lady-in-waiting, seated on a garden bench a little way behind; but though this latter idea was retained, the informal conception eventually gave way to a grander design in which the format was changed, an elaborate background of trees provided, the poses given a more formal emphasis and the rakish tilt of the hats abandoned. In the finished picture (Pl.338), the format was changed once more, this time to an oval, and other alterations, notably the introduction of an urn on a pedestal, were made in the background.

Some insight into his actual procedure in carrying a composition forward is provided in another letter, this time to Garrick, concerning his portrait of the great actor beside Shakespeare's bust. 'I'm going to dinner, and after, I'll try a sketch', he wrote; with regard to the bust, 'I intend with your approbation, my dear Friend, to take the form from his Pictures & statues just enough to preserve his likeness *past the doubt of all blockheads*, at first sight, and supply *a Soul* from his Works.'[71] Much of his designing was usually done on the canvas itself, as is shown by the numerous *pentimenti* in his portraits, and in a further letter to Garrick he complains, 'I have been several days rubbing in & rubbing out my design for Shakespeare.'[72]

A small number of portrait drawings survive not intended as studies for pictures, among these a delightful sketch of a sleeping child (Pl.159) and a study of his nephew Gainsborough Dupont, then only a boy (Pl.125), swiftly executed in coloured chalks, with some red wash splashed across beneath to suggest the coat. He also did a number of more formal pastels, mostly in ovals (Pls.116 or 124), which display considerable dexterity and accomplishment. Perhaps the most enchanting and sensitive of these works is his gentle portrait of Caroline, Duchess of Marlborough, sitting lost in thought, a book in her lap (Pl.115). One or two of his pastels are now badly rubbed, and Gainsborough himself refers to this danger in a letter of 1771 to

[70] Gainsborough to Unwin, n.d.: Woodall *Letters*, No.86, p.155.

[71] Gainsborough to Garrick, n.d.: Woodall *Letters*, No.27, p.67.

[72] Gainsborough to Garrick, Bath, 22 August 1768: Woodall *Letters*, No.28, p.67.

Edward Stratford: 'I'm sorry your Chalk Drawings got Rubbd as they were muzzy enough at first, as indeed all Chalk Drawings of Portraits must be so small and the Chalk so soft.'[73] Nearly all the pastels extant now were executed in the late 1760's or early 1770's, at Bath; in later years he seems to have preferred the medium of oil on paper for smaller portraits of this sort.

As a postscript, it may be noted that Gainsborough was accustomed to embellishing his correspondence with drawings; he once ended a letter to Jackson, 'I can't think of any more Nonsense and you don't admit of *Drawing* in Letters, or else I could add a trifle more for your amusement.'[74] Nothing of this description survives today except a couple of rough landscape sketches in a letter dated 1763,[75] but sketches of figures, dogs being scolded, coaches and other detail are supposed to have adorned the pages of a series of letters to Lady Tynte which, unfortunately, perished in a country house fire.[76] It was probably in a letter, too, if Fulcher can be relied upon, that Gainsborough sent Fischer a reconstruction of a riding accident which the latter had described to him, 'a rough sketch, wherein his own prostrate form, the broad-wheeled waggon, the grinning waggoner, and the retreating horse, made a picture worthy of Bunbury.'[77]

[73] Gainsborough to the Hon. Edward Stratford, Bath, 21 March 1771: Woodall *Letters*, No.79, p.143.

[74] Gainsborough to Jackson, Bath, 9 June 1770: Woodall *Letters*, No.61, p.123.

[75] Gainsborough to an unknown recipient, Bath, 28 July 1763: Woodall *Letters*, No.100, p.173 and repr. facing p.161.

[76] I am indebted to the late Lord Wharton for this information (letter dated 4 June 1965). Lady Tynte was the wife of Sir Charles Kemeys Tynte (1710-85) of Halsewell, Somerset.

[77] Fulcher, p.76.

4

Chronology and Stylistic Development

So few of Gainsborough's drawings, even the portrait drawings, are either dated or closely datable that it is worth making a list of those that are:

1743–4 Pair of portraits of an unknown man and his wife (National Gallery of Ireland: Cat. Nos.1–2).

1759 Landscape with figures and donkey, intended for engraving (Witt Collection, Courtauld Institute of Art: Cat. No.238).

1759 Mountain landscape, intended for engraving (D. J. Morris: Cat. No.243).

1760 Beech trees at Foxley (Whitworth Art Gallery: Cat. No.248).

1760 Study for the portrait of *Mrs Thicknesse* painted in 1760 (British Museum: Cat. No.16).

1763 (July) Two small landscapes drawn in a letter (R. E. D. Rawlins: Cat. Nos.262–3).

1767 Studies of the waggon and the figure group for *The Harvest Waggon* exhibited S.A. 1767 (Viscount Knutsford: Cat. No.284; and Mrs Mark Hodson: Cat. No.825).

1769 (January) (*terminus ante quem*) Landscape with a country cart, given to Colonel St Paul (W. A. Brandt: Cat. No.301).

1770 (September) (*terminus ante quem*) Four landscapes, given to Lord Bateman (Mrs R. Peyton-Jones: Cat. Nos.312 and 316; Mrs Edmund Wood: Cat. No.299; and Cleveland Museum of Art: Cat. No.325).

1778 Landscape with country cart and cottage (National Gallery of Victoria: Cat. No.464).

1780 Study for the landscape with horses watering at a trough exhibited R.A.1780 (formerly Schniewind collection: Cat. No.480).

1781 Landscape with a figure and dog (The Earl of St Germans: Cat. No.494).

1781 Studies for the two seascapes exhibited R.A.1781 (Bolton Art Gallery: Cat. No.481; R. L. Burnett: Cat. No.485; and Detroit Institute of Arts: Cat. No.486).

1781 Study for the landscape with cattle being driven across a bridge exhibited R.A.1781 (Witt Collection, Courtauld Institute of Art: Cat. No.498).

1781 Studies for *A Shepherd* exhibited R.A. 1781 (National Gallery of Victoria: Cat. No.827; and Victoria and Albert Museum: Cat. No.828).

1782 (September) Pair of river scenes drawn at Windsor (Huntington Art Gallery: Cat. Nos.513–4).

1783 Study for the mountain landscape exhibited R.A.1783 (Cecil Higgins Art Gallery: Cat. No.564).

1783 (summer) Langdale Pikes (Dr C. B. M. Warren: Cat. No.577).

1783 (autumn) Study for the mountain landscape painted in the autumn of 1783 (Ponce Museum of Art: Cat. No.590).

1785 Study for the portrait of *Mrs Siddons* painted in 1785 (Dr W. Katz: Cat. No. 64).

1787 (summer) Three studies related to *The Woodman* painted in the summer of 1787 (The Hon. K. R. Thomson: Cat. No.850; University of Saskatchewan, Regina: Cat. No.851; and Mrs Cecil G. Keith: Cat. No.852).

1788 (spring) Studies for the *Peasant Smoking at a Cottage Door* painted in the spring of 1788 (Mr and Mrs Paul Mellon: Cat. No.803; and Mrs Cecil G. Keith: Cat. No.852).

Dated drawings that are now missing are the four landscape compositions engraved by Boydell in 1747 (Cat.Nos.73–6), the portrait of his father done in 1751,[1] the book of drawings exhibited R.A.1770, three of the landscapes given to Lord Bateman in September 1770, and the drawings in imitation of oil painting exhibited R.A.1772.

It would obviously be difficult to establish a useful chronology from the limited evidence of this list; and, of course, the dates for the drawings given to Colonel St Paul and Lord Bateman, and to a lesser extent of the studies for pictures, should be regarded only as *termini ante quem*.

Fortunately, however, this group can be supplemented in two ways. In the first place, most of the portrait drawings (some of them with substantial landscape backgrounds) and certain of the figure drawings can be dated within five, or at the outside ten, years on the evidence of costume, so that the development of Gainsborough's figure style presents few problems. Secondly, about thirty-five drawings are studies for, or the subjects of, landscape paintings that can be dated within the following rough brackets:[2]

*c.*1744–6 Study of three figures (Morgan Library: Cat. No.72).

*c.*1747 Landscape with figures and cattle after Ruisdael (Whitworth Art Gallery: Cat. No.80).

*c.*1754–6 Study of a girl with a basket on her arm (British Museum: Cat. No.820).

*c.*1754–6 Drover's cart with calves (National Gallery of Art, Washington: Cat. No.152).

*c.*1754–6 Study of a farmyard (British Museum: Cat. No.212).

*c.*1755–7 Study of a cow (Oppé collection: Cat. No.860).

[1] Fulcher, p.210.

[2] The detailed arguments for dating the landscape paintings will be published in my forthcoming Catalogue Raisonné of *Gainsborough's Landscape Paintings*; in fairness, it should be stated that certain of the brackets here proposed differ considerably from those suggested by Waterhouse.

*c.*1755–7 Study of a milkmaid climbing a stile (Keith Wallis: Cat. No.824).

*c.*1755–7 Landscape with herdsman and cattle (F. Bulkeley Smith: Cat. No.158).

*c.*1757–9 Studies of sheep (Ehemals Staatliche Museen, Berlin-Dahlem: Cat. Nos. 863–4).

*c.*1757–9 Study of a shepherd boy and sheep (Sir Siegmund Warburg: Cat. No.865).

*c.*1762–5 Landscape with distant mountain (Ashmolean Museum: Cat. No.265).

*c.*1771–4 Landscape with figures and cattle (formerly J. P. Heseltine: Cat. No.368).

*c.*1771–4 Landscape with milkmaid, figures and cattle (Ashmolean Museum: Cat. No.328).

*c.*1774–80 Landscape with herdsman and cattle (Nelson Gallery, Kansas City: Cat. No.402).

*c.*1774–80 Landscape with figures, cattle and sheep (Mrs Cecil G. Keith: Cat. No.378).

*c.*1774–80 Landscape with cottage, peasant, cows and sheep, and cart travelling down a slope (Mrs N. Argenti: Cat. No.424).

*c.*1774–80 Landscape with figures at a cottage door (H.R.H. The Duchess of Kent: Cat. No.478).

*c.*1774–80 Landscape with figures round a camp fire (Mr and Mrs Paul Mellon: Cat. No.436).

*c.*1780–2 Coastal scene (Eva Andresen: Cat. No.487).

*c.*1780–2 Landscape with shepherd, sheep and cart horses (Guy Millard: Cat. No.473).

*c.*1780–2 Landscape with herdsman, cows and sheep (Mrs W. W. Spooner: Cat. No.512).

*c.*1782–4 Coastal scene with cattle on a high bank (Anon. sale, Charpentier, 12 June 1959, Lot 96 *bis*: Cat. No.758).

*c.*1782–4 Mountain landscape with figures and fountain (Arnold Haskell: Cat. No.602).

*c.*1782–4 Country cart crossing a ford (E. Blaiberg: Cat. No.666).

*c.*1782–4 Mountain landscape (Lord Methuen: Cat. No.655).

*c.*1782–4 Mountain landscape with bridge over a river (Victoria and Albert Museum: Cat. No.769; and John Wright: Cat. No.768).

*c.*1782–4 Mountain landscape with bridge over a river (Christian Mustad: Cat. No.779).

*c.*1784–5 Three studies for the *Diana and Actaeon* (The Marchioness of Anglesey: Cat. No.810; Huntington Art Gallery: Cat. No.811; and Cecil Higgins Art Gallery: Cat. No.812).

*c.*1786 Mountain landscape with bridge over a river (Sir William Walton: Cat. No.771).

*c.*1786 Landscape with herdsman, cows and sheep (Ehemals Staatliche Museen, Berlin-Dahlem: Cat. No.687).

*c.*1786 Mountain landscape with lake (Wing Commander John Higginson: Cat. No.774).

*c.*1787–8 Mountain landscape with sheep (Birmingham City Art Gallery: Cat. No.772).

*c.*1787–8 Mountain landscape with lake (Tate Gallery: Cat. No.776).

On the assumption, which is consistent with what we know of Gainsborough's practice,[3] that these drawings, if not normally direct preparatory studies,[4] were soon translated into paint and are therefore to be placed within the same date bracket as the paintings, it is possible to work out almost as fully coherent a stylistic development for the landscape drawings as for the portraits.[5] The argument that follows is based entirely on the drawings listed above and on portrait drawings datable from the evidence of costume; drawings that can be linked with these on stylistic grounds and may serve to amplify this account of Gainsborough's development will be found in the Catalogue and by reference to the plates.

Gainsborough's earliest documented drawings are very tight in character. The pair of portraits in Dublin of 1743–4 (Pls.1 and 2), which are in the tradition of the seventeenth century 'plumbago' miniature and hint at a phase of Gainsborough's career of which we have little knowledge, are modelled with the utmost care and neatness; and the drawings for Boydell's engravings of 1747 were evidently exceedingly elaborate and contrived, full of incidental detail, and built up on a succession of receding planes alternately light and dark| in tone (Pls.10, 240 and 243). It is clear, however, from the Paris (Pl.7) and Morgan Library drawings (Pl.374), that in his sketches he was already capable of an effective looseness of touch, especially in delineating trees and foliage, though the same weaknesses in suggesting depth are as fully apparent: in the Paris drawing, for example, the *mise en scène* of the beautifully observed and portrayed courting couple is carefully restricted to two planes, and the modelling of the undulating foreground is hesitant.

It was to master these problems of composition and recession that Gainsborough turned to studying the Dutch masters, and in his large chalk drawing after Ruisdael of about 1747 (Pl.248) depth is more subtly suggested by means of the winding sunlit path and river and the carefully overlapping trees, while the latter are also composed into a gracefully rhythmical silhouette. His technique in this drawing is characterized by a use of zig-zag strokes in addition to hatching and a tendency to rather brittle, angular line.

[3] See p.33.

[4] Mary Woodall, in her review of the exhibition of *Gainsborough Landscapes* at Nottingham University in 1962, rightly pointed out that the landscape drawings, though usually in the event only modified slightly in the course of painting, are really 'ideas' rather than direct studies (see *The Burlington Magazine*, December 1962, p.562).

[5] Mary Woodall has stated that 'The dating of the [landscape] drawings depends almost entirely on their correspondence both in subject matter and pencilling, with the paintings and portrait backgrounds' (op. cit., p.562). Since she has examined these correspondences at length in her own book on the drawings (1939), it has seemed more sensible to adopt a different approach here. Moreover, Gainsborough was apt to repeat his subject-matter, and it is not always easy, except in a general way, to equate drawing techniques with those employed in painting. Reference only to drawings that can be associated compositionally with particular paintings provides an equally valid method of dating, and perhaps a more precise one (Mary Woodall in fact used it herself to great advantage in her book).

By the mid-1750's, when he executed the Washington drawing (Pl.41), another equally finished work, both his style and his technique in drawings of this kind were very much broader. Though the landscape in the Washington drawing is still arranged in carefully differentiated planes, the composition is dominated by the track which swings majestically across the foreground and then winds back into the middle distance; the forms are broadly massed, the foliage more generalized in treatment, and the cart load of calves silhouetted against massive clouds. In the Bulkeley Smith drawing (Pl.315), the forms are similarly broadly grouped, though the design is based on a counterpoint of diagonals rather than on Hogarth's serpentine line.

This breadth of treatment is even more marked in drawings of the later 1750's. The Witt drawing of 1759 (Pl.74) is also characterized by very free rhythmical scallops delineating the foliage, which, taken with such motifs as the dynamic, twisting tree trunks growing out of the bank on the right, gives the impression of the landscape being alive with movement. This vitality of line is nowhere more evident than in the bold and masterly study for the portrait of the *Hon. Richard Savage Nassau* (Pl.255), and were this drawing not datable, one might well be excused for supposing it to be a work of a much later period.

The increasingly broad and rhythmical style of the late 1750's is continued in the early Bath period. Though the composition of the Morris watercolour (Pl.77) relates to Claude and the *mise en scène* to the Dutch Italianates,[6] the fundamental characteristic of this elaborate drawing is a broad and pervasive lateral rhythm: the graceful line of the mountain, for instance, is carried on in the silhouette of the bushes on the right, and that of the rococo wooden bridge in the lopped branch straddling the foreground. The technique of delineating the foliage in rhythmical scallops is similar to the Witt drawing, and so also is the motif of the closely grouped intertwining trees; the dramatic qualities latent in the treatment of these tree trunks have their outlet here in the fitful stormy sky. The rhythmical qualities of the Morris drawing are developed in the watercolour of a scene near Foxley (Pl.80), executed in the following year, where the comparatively slender intertwined trees of the earlier drawing are replaced by two fine beeches and the foliage opens out into a gentle arc echoing the shape of the hillock. The dramatic elements are taken up later, in the composition study in the Ashmolean Museum (Pl.263), a drawing in which a brilliant use of lead white to heighten enhances the effect of storm-laden sky and windswept trees.

There are no documented landscape drawings from the mid-1760's (for this period, fortunately, comparison with the painted landscapes and portrait backgrounds is of particular value), but four are datable to 1770 or just previous: two of these are controlled in character (Pl.103), the others more spirited and dramatic (Pls.108 and 112), and they serve to demonstrate (if demonstration be needed) that Gainsborough's drawing style at a given moment was remarkably varied even within one type of drawing, and probably increasingly so as time went on.

There are certain characteristics in common between this group and the Ash-

[6]See p.60.

molean drawing, in particular the use of broken line to indicate rather than to outline shapes, but there are also significant differences: the extension of this broken line to the scallops outlining foliage, the replacement of that pervasive heightening in lead white which seems to have been a technique restricted to a phase in the early to mid 1760's by the white of the paper itself, and, the corollary of this, a new, much bolder use of grey wash to model forms in light and shade, most evident and assured in the rocks of the Cleveland drawing.

The two datable landscape drawings of the early 1770's are in black and white chalks on grey paper, with strongly contrasted light and shade. The upward-thrusting foliage of the Ashmolean drawing (Pl.113) is closely related to the trees on the left in the Cleveland drawing, but the scallop convention has become more mannered. The drawing formerly in the Heseltine collection (Pl.282) is fairly summary in treatment and more obviously a composition sketch.

This was also the period when Gainsborough experimented with varnished drawings in the complex and highly personal technique already described. He exhibited drawings in imitation of oil painting in 1772, and his letter to Jackson describing his method is dated 29 January 1773,[7] evidence that enables us to assign a number of drawings of this character, which have stylistic affinities with those previously discussed, to these years. According to early tradition, the Bath period was also the time when Gainsborough developed his 'mopping' technique for landscape drawing.[8] Unfortunately, there are no examples of this kind of drawing datable to the 1760's or early 1770's (most are to be associated with work of the 1780's), but this is insufficient reason to discount the near contemporary evidence on this point.

Perhaps understandably, the portrait drawings changed far less during the course of these fifteen years than the landscapes, in spite of the transformation of his portrait style; understandably because while his style of painting developed, the problems he had to resolve in his sketches remained fundamentally the same. His composition sketches, for the portraits of *Mrs Thicknesse* (Pl.327), an unknown sitter with a fan (Pl.89), and the group of musicians at a harpsichord (Pl.122), are all roughed out with the facility and brilliance of the earlier study for the *Hon. Richard Savage Nassau*, though the media are in fact different in each case, pencil, coloured chalks, and red chalk, respectively. The softening of contour lines is the most striking difference between the study of the unknown lady and the *Nassau*, which are otherwise the most closely comparable.

A soft, atmospheric quality is the distinguishing feature of the pastels which Gainsborough executed between the mid-1760's and the early 1770's; similarly, in his more finished portrait drawings, many of them studies of the fall and folds of costume in different positions, it is this quality that generally predominates. One may fairly presume also, perhaps, that a study of costume so carefully detailed as in the lady with a rose (Pl.95) dates from the first half of the 1760's, while the broad

[7] Woodall *Letters*, No.103, pp.177–9.

[8] Edward Edwards, *Anecdotes of Painters*, London, 1808, p.139; see also Henry Angelo, *Reminiscences*, Vol.I, London, 1828, pp.218–9. For a discussion of this technique, see p.24.

and sketchy study of a lady seated (Pl.98) dates from the second half, the difference in treatment being exactly comparable to that between the Whitworth landscape of 1760, detailed and gently atmospheric, and the Ashmolean landscape of the early 1770's, a drawing in black and white chalks conceived in terms of bold chiaroscuro.

During the early London period Gainsborough developed a more abbreviated style of drawing which relates most closely to the Heseltine sketch, and he seems to have worked mainly either in black and white chalks on blue or grey paper or else in grey and grey black washes. The Melbourne drawing of 1778 (Pl.145), which is in the latter technique, displays a use of line which is almost shorthand in places, while the washes, which effectively model the forms, are very rapidly swept in. The Duchess of Kent's *Cottage Door* (Pl.147) is hardly less dexterous.

The chalk drawings are similar in treatment. In the Kansas City landscape (Pl.331), the tree trunks and branches are delineated in just one or two strokes, the scallops outlining foliage have begun to degenerate into hatching, and the animals are modelled in a welter of almost random touches. This summary technique is equally apparent in the Mellon drawing (Pl.138), where the foreground reeds and log are hardly more than indicated; but most evident in Mrs Keith's drawing (Pl.423), a classical design similar to the Heseltine landscape. This is the first datable landscape drawing in which the composition is worked out in stump, or possibly more accurately, with sponge, as described by Edwards;[9] in other words, it is the earliest certain example of one of Gainsborough's 'moppings'. The masses are reinforced in places with touches of black chalk, figures and sheep are rapidly indicated, and the more brilliant lights obtained with slabs of white chalk. Brilliant and spontaneous drawings of this kind foreshadow the masterpieces of Gainsborough's highly personal later style.

Of the few portrait drawings datable to the later 1770's, the study for *Lady Clarges* (Pl.141) is executed in a brilliant but highly impressionistic technique quite unlike anything of an earlier date, and comparable, though on a larger scale, to the modelling of the animals in the Kansas City landscape. The more finished drawing of a lady seated in front of a book of music (Pl.142), on the other hand, is executed in a completely different style, softly and gently modelled in a manner close to the effect of soft-ground etching, a technique with which Gainsborough was just beginning to experiment at this date.

In about 1779–80 Gainsborough began to experiment with seascapes, and in his drawings of coastal scenes he developed a much broader use of wash. This is especially evident in the sketchy drawing in Detroit (Pl.152), while comparison of the cliffs in the Eva Andresen drawing (Pl.151) with the rocks in the Cleveland drawing of ten years earlier (Pl.112) reveals a more rapid, facile technique in which forms are suggested and softened rather than described and brought into focus. It is significant of this growing tendency that the highlights in white chalk in the Bolton coastal scene (Pl.153) are scattered about the composition more to enliven the surface than anything else, and do little actually to model or describe forms. At the same time, these techniques create a greater sense of movement and vitality; and the mastery

[9] Ibid., p.139.

of suggesting either rough or calm seas with the simplest of washes, and his highly sensitive, more carefully executed study of *Langdale Pikes* (Pl.179) and the moisture-laden atmosphere of the Lake District, at once allay any suspicion one might otherwise have had that Gainsborough was beginning to lose control.

Most of the wash drawings of country scenes of the early 1780's differ very little from the drawings of the late 1770's: foliage is indicated in abbreviated scallops, and figures and animals in quick, disconnected strokes with the minimum of internal modelling. The pair of river scenes in the Huntington Art Gallery dating from 1782 (Pls.163 and 437) are also executed much in this style, but with features that relate them to the coastal drawings: in one, the rising ground on the left is treated in a particularly facile way, while in the other, the broadly washed clouds are comparable only with the swiftly moving clouds of the seascapes, and there is that same scatter of white chalk highlights as in the Bolton drawing, in this case more palpably to suggest the sparkle of reflected light. The Witt drawing (Pl.288) of 1781 is closer throughout to the style of the coastal scenes, and the urgent sense of movement created by the rapid use of wash and the many scattered highlights is fully in keeping with the rococo compositional arrangement and the oval format; the outlines of many of the forms have been strengthened with black chalk, and this characteristic now becomes increasingly common in the wash drawings.

Gainsborough's visit to the Lakes in the late summer of 1783[10] heralded a dramatic development of his landscape style, which certainly could not be guessed at from the gentle drawing he made of *Langdale Pikes*. The key example is the mountain landscape in the Ponce Museum (Pl.181), executed in black and white chalks on brown paper. In this drawing, all the shapes are softened into undulating forms which pulsate across the composition and create an almost violent sense of lateral movement; the heightening in white chalk, still used in part to create a surface glitter and suggest reflected light, adds powerfully to this impetus not only in the sky, where it is applied in long sweeping strokes and follows the entire silhouette of the mountains, but also in the rising ground on the right, where it is touched into a loose form of hatching. In Lord Methuen's drawing (Pl.198), where the forms are 'mopped' in and reinforced with black chalk, and at the same time more generalized, the effect is perhaps less dramatic but certainly more overwhelmingly rhythmical. Gainsborough seems to have concentrated on mountain scenes of various kinds in the mid-1780's, and in all of them the sense of rhythm and movement is powerfully accented; contrasts of dramatic lighting and deep shadow are much in evidence, and in some the forms are so generalized that it is difficult to distinguish between sheep and bushes.

The few datable late drawings are scarcely less vigorous, but they tend to be richer in texture and to achieve a greater stability through a sophisticated play of movement and counter-movement. The three *Diana and Actaeon* drawings (Pls.343–5), for instance, though close to the Witt drawing of 1781 in actual handling and their generalized treatment, are considerably more complex in design. The foliage is more richly diversified and modulated, and the compositional emphasis deliber-

10 Whitley, p.209.

ately contrasted (though less so in the final solution) to heighten the drama of the subject: the effect of confusion so strikingly conveyed in the Anglesey version is enhanced by the twisting tree trunks and the now familiar scattered highlights. In the drawing for the *Peasant Smoking at a Cottage Door* (Pl.349) the foliage is equally rich and dense, thrusting upwards to the right in counterbalance to the emphatic diagonal of the long and angular dead trunk, and the peasant family is set against a background of exceptional majesty. These drawings have an air of strength and grandeur about them which is generally absent from the previous rhythmical style, vigorous, dynamic and exciting though it is.

The trees in the study for the *Peasant Smoking* are also characterized by a new atmospheric quality; and this blurring of outlines is accompanied in a number of the later landscapes by an extraordinary sensitivity in modulation, an increasing expressiveness within a very restricted range of tones, usually greys, so subtle indeed that these works are practically impossible to photograph.

Gainsborough seems to have needed the help of preliminary sketches in his portraiture far less in later years, and portrait drawings dating from the 1780's are exceedingly rare. One case in which he wanted to work out a more elaborate arrangement than usual was that of the *Duke and Duchess of Cumberland*, and two composition sketches for this survive (Pls.337 and 339). The designs are very roughly 'mopped' out, and the forms are then reinforced with black chalk and heightened with roughly applied whites comparable in effect and touch to the *Lady Clarges*.

Two of Gainsborough's fancy drawings datable to the mid-1780's, the *Housemaid* (Pl.361) and the *Girl Seated* (Pl.201), are fairly sketchily drawn in black chalk and stump, with very loose white chalk highlights, in a manner connecting most closely with the style of the mountain landscape in the Ponce Museum. But in the magnificent series of drawings of ladies in large picture hats dating from about 1785 (Pls.204–6) the technique is similar to that used for the *Duke and Duchess of Cumberland*, though in manner of execution infinitely more brilliant: the loosely handled black chalk and bravura display of white heightening not only create a feast for the eye, but effectively suggest the weight and movement of body and costume. Closely related in style to this group are the study of a woman and three children on some steps in the British Museum (Pl.202), and the three studies of woodmen dating from 1787 (Pls.231–3): here it is the energetic black chalk contours which have a brilliant life of their own.

These figure drawings of the later 1780's may stand beside the late landscapes and the *Diana and Actaeon* sketches to demonstrate the continually increasing richness and vitality of Gainsborough's work, and the infinite resourcefulness both of his imagination and his drawing technique.

5
Subject Matter and Imagery

Gainsborough's youthful and wholehearted absorption in drawing the ordinary features of the Suffolk countryside was not stamped out of him during his 'prentice years in London, as it could well have been had he trained with a recognized landscape painter brought up in the classical tradition such as Wootton or Collins. On the contrary, it was actually encouraged. Associating with those *avant-garde* rococo artists who have recently and aptly been called the St Martin's Lane set,[1] he found it not only acceptable but fashionable to take his subjects from the every-day world around him and to treat them in an unaffected informal way. In his little canvas of *The Charterhouse*, indeed,[2] he produced a work of this kind composed on Hogarthian principles which that great man must surely have envied as well as praised.

But this sort of direct transcription was quite exceptional in his *œuvre*. He was no mere topographer, like Scott or Wale; and in a much quoted letter to his patron Lord Hardwicke, he emphatically disclaimed interest in real views: 'if His Lordship wishes to have anything tollerable of the name of G. the subject altogether, as well as figures &c. must be of his own Brain; otherwise Lord Hardwicke will only pay for Encouraging a Man out of his Way.'[3] He painted the Suffolk countryside, none more delightfully, and later the West Country, but in producing his compositions, he instinctively generalized. In this, of course, he was very much a product of his age, strangely close to Reynolds's ideal student, who 'regards all Nature with a view to his profession; and combines her beauties, or corrects her defects.'[4] His materials were not only nature as it lay before him, but memories both of nature and of art, an accumulated but carefully sifted 'stock of ideas, to be combined and varied as occasion may require.'[5] What, however, *was* the substance of his work? And is it possible to derive from an analysis of his subject matter and imagery conclusions about his attitude towards landscape and the world in general?

In his very early drawings for Boydell, which were in what he would later call 'the *schoolboy* stile',[6] he crammed a great deal in; one of these compositions (Pl.10)

[1] Mark Girouard, 'English Art and the Rococo – 1', *Country Life*, 13 January 1966, p.59.

[2] Waterhouse, No.861, repr. pl.1.

[3] Gainsborough to Lord Hardwicke, n.d.: Woodall *Letters*, No.42, p.91.

[4] Sir Joshua Reynolds, *Discourses on Art*, ed. Robert R. Wark, San Marino, 1959, p.36.

[5] Ibid., p.26.

[6] Gainsborough to Bate Dudley, London, 11 March 1788: Woodall *Letters*, No.5, p.35.

has three distinct figure groups as well as an elaborate townscape and harbour scene in the background. But in the Suffolk period he settled down to a less wasteful way of working. His subjects then were chiefly woodland scenes, with pools or streams, winding tracks, knolls with sandy or chalky banks, cottages nestling among trees and church towers rising over them. Shepherd boys with flocks of sheep, drovers and cattle, plough-teams, woodgatherers, milkmaids, herdsmen resting (or sleeping) beside a path, cows silhouetted on banks, and groups of donkeys were introduced to diversify the landscape, and ploughshares and withered or pollarded trees, especially the latter, which lent themselves so readily to rococo treatment (Pls.40 or 51), were also familiar motifs.

Generally speaking, he did not regard his figures and animals as much more than accents and this was an attitude, derived largely no doubt from his study of Dutch landscape, that he maintained for the better part of his life. In a letter to Jackson, he contrasted the intellectual effort involved in history painting with 'what little dirty subjects of coal horses & Jack asses and such figures as I fill up with . . . do you really think that a regular Composition in the Landskip way should ever be fill'd with History, or any figures but such as fill a place (I won't say stop a Gap) or to create a little business for the Eye to be drawn from the Trees in order to return to them with more glee.'[7] One or two early drawings, however, do contain more prominent groups, a drover taking a cartload of calves to market being one example (Pl.41); and occasionally in the paintings there is something like a real subject, usually the courting of a milkmaid and woodcutter reminiscent of a Boucher pastoral.[8]

The imagery of the Bath period was different in character, and for the first time he indulged in classicizing compositions of a kind he would have scorned ten or fifteen years earlier.[9] In his letter to Lord Hardwicke, already quoted, he went so far as to say that 'with respect to *real Views* from Nature in this Country he has never seen any Place that affords a Subject equal to the poorest imitations of Gaspar or Claude.'[10] And this despite the hilly and romantic nature of the country round Bath, which we know he loved and that Benjamin West thought hardly to be equalled: 'Take Bath & 20 miles round it', he told Farington, '& there is not in the world anything superior to it. Rocks of the finest forms for a painter that He had ever seen, large, square forms. Quarry's worked out now most picturesque & romantic. Wyck & Hampton rocks, Chedder Cliffs, most picturesque – distances the most beautiful – roads with occasional pools & streams of water falling from the Hills & Cattle & figures such as Bergham never saw.'[11]

[7] Gainsborough to Jackson, Bath, 23 August (1767): Woodall *Letters*, No.49, p.99.

[8] Compare the pictures at Woburn and in Montreal (Waterhouse, Nos.829, repr. pl.41, and 844, repr. pl.40).

[9] Occasional classical compositions do occur, however, in the later Ipswich period: the landscapes owned by Edward Seago (Cat. No.180), Derek Melville (Cat. Nos. 182–3), and already more personal in interpretation, the landscape with figures and donkey owned by Donald Towner (Cat. No.240).

[10] See note 3.

[11] *The Farington Diary*, 10 November 1807 (from the typescript in the British Museum Print Room, p.3848). Even so theatrical a landscapist as de Loutherbourg is supposed to have declared that '*no English landscape painter needed foreign travel to collect grand prototypes for his study*' (Ephraim Hardcastle (=W. H. Pyne), *Wine and Walnuts*, London, 2nd edn., 1824, Vol.I, p.283).

In fact, of course, the particular types of subject that Gainsborough now developed were a highly personal fusion of ideas drawn from a widely varied experience: not only from Claude and Gaspard, but from other seventeenth-century masters he was now in a position to study at leisure,[12] from his forays into the Somerset countryside, and from his own former style. The landscape in the Ashmolean Museum (Pl.263) is entirely Claudean in its use of two side wings and a mountain closing the distance, but the withered, twisted tree trunks are a cross between Gaspard and the rococo and the cottage with its smoking chimney a Gainsborough motif by now familiar to us. And if we examine the mountain landscape owned by D. J. Morris (Pl.77), in which the main group of trees is placed in a relationship to a Claudean composition paralleled in countless works by that master, it is more the Bath countryside and the rhythm of the rococo that is called to mind than Claude, while the shepherd boy surrounded by his flock of sheep and the drover with his cattle are stock Gainsborough features. It is possible, incidentally, that the retention in such classicizing landscapes of his own particular brand of staffage drawn from contemporary country life may have struck a jarring note at the time, though this is not actually a point that the critics hit upon. Sandby, who, like everyone else, drew contemporary figures in contemporary dress for his topographical work, was normally careful to introduce nothing but old master figures into his landscape compositions, though there are exceptions to this rule (Pl.275); and Gainsborough's adoption of certain compromises with classical seventeenth-century procedure, drapery thrown over the shoulder or arms outstretched and pointing to the horizon, in some of the later landscape paintings, shows that he was aware of this problem.

The experience of the country round Bath was richly rewarding for Gainsborough's work. His landscapes were now more thickly wooded, with high banks and rocks and stone bridges over streams, and by about 1770 he was doing some in which luxuriant trees and dramatic rocks were the principal subject (Pl.112), an emphasis which corresponds with his remark to his friend Unwin, then in Derbyshire, in 1768: 'I suppose your Country is very woody – pray have you Rocks and Water-falls! for I am as fond of Landskip as ever.'[13] Distant villages are inserted as accents in his wooded backgrounds (Pl.77), and landscapes like the gouache in Major Ingram's collection, where a cluster of far-off buildings is framed by foreground trees on left and right (Pl.265), are a wholly English answer to Claude. He was also much more occupied with the fall of light: its effect in breaking up shapes into boldly contrasted areas of light and dark and forming pools of sunshine in a woodland glade as in the British Museum watercolour (Pl.267), or its dramatic power in throwing trees, the arches of a bridge and distant hills into strong relief and sharply highlighting tree trunks and boulders as in Mr and Mrs Fosburgh's drawing (Pl.84). The most brilliant and forceful use of light for compositional purposes at this period is found in the oil sketch owned by N. L. Hamilton-Smith (Pl.128).

During the 1760's his figures and animals remained to a large extent subordi-

[12] See pp.58–9.

[13] Gainsborough to Unwin, Bath, 25 May 1768: Woodall *Letters*, No.90, p.167.

nate, as they had been earlier, creating 'a little business for the Eye' and not much more. But in the latter part of the Bath period these scattered points of interest were more often concentrated into proper subjects. A group of cattle at a watering place (Pl.284), cows being driven home (Pl.120), or peasants travelling to and from market (Pl.119) became dominant themes, while whole villages (Pl.126) now replaced the sequestered cottage and church tower peeping over trees.

In one or two examples, notably the drawing in the Pilkington collection (Pl.121), the theme of a peasant family grouped outside a cottage door made its first appearance, in this case linked with the motifs of a passing country cart and of pigs drinking at a trough, the latter later to be the subject of one of his most celebrated fancy pictures. Sentiment is never so overt in the drawings as in the paintings, but in subjects such as this there are more than hints of that attitude towards the life of the countryside which are found to a certain extent already in Thomson's poem *The Seasons*, dating from 1726–8, and which Goldsmith expressed in 1770 in *The Deserted Village* (a work, incidentally, so immediately popular that it ran to five editions in the year of publication alone). Gainsborough's rural village scenes of the early 1770's, in which Goldsmith's 'decent church that topp'd the neighbouring hill' is occasionally portrayed (Pl.120), may fairly be regarded as the visual counterpart to the *imagery* of the poem.

On the other hand, there is no indication that Gainsborough shared Goldsmith's polemics, his almost religious belief in a sturdy independent peasantry[14] and the virtues of the simple life untouched by luxury, nor his hatred of the encroachments of gentlemen's seats and landscaped parks on village life. The parallel is by no means a complete one. Gainsborough's attitude to country life was less carefully thought out, too, and his sentiment was only one, if important, aspect of his mercurial temperament: the brilliant, almost Rembrandtesque, study of a boy whistling as he reclines in the back of a cart (Pls.104–5) reflects another equally strong impulse, the simple healthy joy in just being alive. Uvedale Price put things well in his account of his 'frequent excursions with him into the country' when he wrote that Gainsborough was a man 'of a lively and playful imagination, yet at times severe and sarcastic: but when we came to cottage or village scenes, to groups of children, or to any objects of that kind which struck his fancy, I have often remarked in his countenance an expression of particular gentleness and complacency.'[15]

Gainsborough's classicizing landscapes of the early London period were more obviously Claudean than those of the 1760's. His compositions became broader and more densely massed, and in some the middle distance opened out into a vast panorama swept by sunlight (Pl.131), while the cottages which had formerly embellished a wooded hillside were now replaced quite often by country mansions (Pl.132), or by more anonymous block-like buildings reminiscent of Gaspard Dughet (Pl.174) but based on sketches he was doing at this time of houses, mills and village streets (Pls.171 and 172).[16]

14 The feeling he expressed in his much later drawings of woodmen (see pp.52-3) is still rather different in character.

15 Uvedale Price, *Essays on the Picturesque*, London, 1810, Vol.2, p.368.

16 See also my article 'Gainsborough and the Gaspardesque' in *The Burlington Magazine*, May 1970, pp.308-11.

He was obviously concerned at this stage of his career to elevate his landscapes from the purely pastoral (which by the standards of the day was an inferior mode of composition) into something grander, but he rarely ventured farther than this in the direction of the historical style. In 1783 he wrote to Sir William Chambers that if he could 'pick pockets in the portrait way two or three years longer I intend to turn into a cot & turn a serious fellow',[17] but the only major composition which resulted from this intention was his *Diana and Actaeon* (Pl.346), for which three splendid drawings survive (Pls.343–5). An examination of these preparatory studies suggests that the subject appealed to him principally as an excuse for grouping nudes rather than his customary cattle, and also as something of an exercise in rococo composition; it is significant that he did not essay other mythological subjects in which these opportunities were unlikely to occur. In fact, he kept very much to his own kind of subject matter, and was commended for this by Reynolds.[18]

Most of his pastoral subjects of the London period were of a similar nature to his earlier, and in many of them his figures and animals continued to be just staffage. But a number of new motifs were now introduced, cattle being driven across a bridge, timber waggons, upturned carts, horses grouped together, roadside fountains, woodcutters bundling faggots; and some of these, such as his cattle ferry (Pl.213) and pack-horses being loaded at a mill (Pl.148), give an unusually strong impression of being observed freshly from the life. This applies also to much of the detail in his coastal scenes, which he began to do in about 1779: not only his ships in full sail, but rowing boats being pushed out, fishermen netting, and girls selling fish. On the other hand, sketches such as that in the British Museum where a couple of cows are introduced onto the shore just as accents (Pl.212) underline the essential artificiality of Gainsborough's style, and improbabilities of this kind could be multiplied: bridges which are quite unnecessary, cottages with streams running almost past the front door and, perhaps above all, those curious country mansions, occasionally with complex systems of terraces and steps, which suddenly start up out of the landscape (Pl.167).

Much of Gainsborough's late imagery corresponds closely with what the late eighteenth century understood as 'Picturesque', and he is known to have visited the Lakes, Glastonbury, and Tintern. His late mountain landscapes, memories of the Lakes, were as fully and consciously classical and Gaspardesque as those of an earlier date; but they also betray other affinities, as the gentle silhouette of the distant ranges, the rugged edges of foreground cliffs and hills, and the deep ravines with masses of dark bushy trees (Pl.220), are all exactly the kind of features which Gilpin picked out as the materials for picture-making in his survey of the Lake District.[19] The winding rivers and ruined castles which play so great a part in Gilpin's tours are also dominant motifs in Gainsborough's late drawings (Pls.223

[17] Gainsborough to Chambers, London, 27 April 1783: Woodall *Letters*, No.11, p.43.

[18] Reynolds, op. cit., p.255.

[19] William Gilpin, *Observations ... on ... the Mountains, and Lakes of Cumberland, and Westmoreland*, London, 1786, Vol.1, pp.82, 83 and 114.

and 234), as are other of Gilpin's picturesque images, such as flocks of sheep scattered about steep cliffs (Pl.146),[20] and every kind of irregularity or broken ground.

Certain drawings have a deliberate air of melancholy about them which is missing from Gilpin, who was entirely concerned with visual attitudes; an obvious example is the landscape with a figure sitting by a ruined building in Colonel Wright's collection (Pl.114), which is close in mood to one aspect of Wilson's imagination.[21] And it may have been this element in Gainsborough, his preoccupation with mood and sentiment, as well as his picturesque qualities, that led Barrington in his history of gardening to select him as the most fit designer for an English garden in the contemporary taste.[22] He would also surely have appealed in this capacity to his friend Uvedale Price and to Payne Knight, had he been alive still at the time they were writing their treatises.

Dramatic lighting now played an increasingly dominant role in Gainsborough's imagery, and as his sense of chiaroscuro developed, his drawing style became more summary and his forms abbreviated and shadowy. Evening light blazes across the horizon and is beautifully reflected in pools and streams (Pl.223), trees are sharply silhouetted (Pl.225), and in studies like the drawing in the Spooner collection (Pl. 168), two riders travelling in a landscape emptied of all incident are romantically described against the evening sky. Sentiment is not far away from drama in some of these drawings, notably in the sketch of figures coming back from market in Lord Eccles's collection (Pl.156); and the sentimental strand in Gainsborough's make-up is noticeable again in his drawings of lovers in a country lane (Pl.155), or of peasants waiting at a cottage door with perhaps a woodcutter seen trudging home (Pl.147).

In the last ten years or so of Gainsborough's life, the rustic figures that had animated his landscapes began to be treated in their own right. Some of his drawings of fancy figures, notably groups of children with their mother (Pl.202), were characterized by that care for individuality which marked his portraits, and others, like his shrimpers or housemaid sweeping (Pl.361), seem quite straightforward.[23] But the studies of beggar children in all sorts of attitudes (Pl.296), of shepherd boys gazing upwards with rapt expressions (Pl.298), and, above all, of woodmen, reflect his search for a grander figure style that would convey more powerful feelings. Three brilliant studies of woodmen survive (Pls.231–3), all of them done from the same model, the first of which was initially adopted for the grandest of his very late landscapes.[24] The firm expressions suggest that he was beginning to

[20] William Gilpin, *Observations on the River Wye*, London, 1782, pp.20 and 30.

[21] Compare his drawing *A Ruin* in the Victoria and Albert Museum (reproduced Brinsley Ford, *The Drawings of Richard Wilson*, London, 1951, pl.41).

[22] The Hon. Daines Barrington, 'On the Progress of Gardening', *Archaeologia*, Vol.VII., 1785, p.130 (paper read before the Society of Antiquaries, 13 June 1782). I am indebted to Mr Peter Willis for this reference. See also Anon. (=Richard Graves), *Recollections of some particulars in the life of the late William Shenstone, Esq.*, London, 1788, pp.67–8.

[23] But see under Cat. No.837.

[24] The figure appears in the preparatory drawing (Pl.349) but not in the finished work (Pl.350).

regard the woodman as the embodiment of the eternal peasant, much as Wordsworth saw him, and these studies are perhaps the clue to the true meaning of the statement he made to Reynolds in 1788 that 'he now began . . . to see what his deficiencies were; which he flattered himself in his last works were in some measure supplied.'[25]

Gainsborough sketched the entire range of English scenery, from the quiet and rustic East Anglian to the bleakness and grandeur of the Lakes, and created from his lifelong study of the countryside and of landscape tradition a range of compositions which embraced the lazily pastoral, the sentimental, the classical, the picturesque and the brilliantly dramatic. An early nineteenth-century writer said that it was Gainsborough who really created the taste for the picturesque (certainly he must share that credit with Gilpin), and who 'taught the artists and amateurs how to select' from English scenery;[26] the enormous popularity of his drawings, which has never at any point declined, is attested by the number of enthusiastic imitators and collectors of his work. These followers and admirers are the subjects of later chapters, but first we must examine to what extent Gainsborough was himself a follower and admirer.

[25] Reynolds, op. cit., p.252.

[26] The author of 'Observations on the Rise and Progress of Painting in Water Colours' in *The Repository of Arts* for 1812 and 1813: see the issue for 9 April 1813, p.219.

6

Formative Influences

When Bate-Dudley, in his obituary of Gainsborough, made his celebrated remark that 'Nature was his teacher and the woods of Suffolk his academy',[1] he was talking specifically about the painter's boyhood, but he had none the less unwittingly put into an apt phrase a view that was to become, with reservations about the early influence of the Dutch, the generally accepted notion of Gainsborough as a landscape painter for well over a century.[2]

It is, of course, readily understandable that the Victorians, for whom fidelity to natural appearances was the principal touchstone of art, should have cherished this interpretation, and we have seen that Gainsborough did spend much of his time drawing from nature and observing its effects, particularly in the earlier part of his career, but also whenever he could in later life. Nevertheless he was far from being revolutionary. His attitudes towards landscape were those of his contemporaries, Cozens, Wilson, Reynolds, Gilpin; he was deeply indebted to the history of the art; and though never in any sense a chameleon, he derived inspiration which matured and developed his style from a greater variety of sources than is usually supposed.

It was Reynolds who said that Gainsborough 'was well aware, that the language of the art, the art of imitation, must be learnt somewhere',[3] and Smirke went so far as to declare (which was not at all what Reynolds implied) that 'He thought Gainsborough was not an original genius, one who had attentively studied nature & derived from original thoughts, but that on the contrary His art was founded upon the works of others; made up from observations He had made upon the pictures of different masters, but that He had not looked beyond that source',[4] a view that is to a certain very limited extent true of Gainsborough in the last decade of his career, the period with which Smirke would have been familiar.

Gainsborough's most impressionable years, his late 'teens, were spent under Gravelot, but the paucity of evidence makes the extent of the influence which Gravelot actually exerted difficult to calculate. It is possible that many of his earlier drawings were designs for the decorative arts, and would bear little or no

[1] *The Morning Herald*, 4 August 1788.

[2] This was still the emphasis placed by Sir Walter Armstrong in his *Gainsborough and his Place in English Art*, London, 1904, pp.48–52.

[3] Sir Joshua Reynolds, *Discourses on Art*, ed. Robert R. Wark, San Marino, 1959, p.253.

[4] *The Farington Diary*, 17 June 1813 (from the typescript in the British Museum Print Room, p.6332).

relation to his work as we know it from 1746 or so onwards; and we are in fact specifically informed by the obituarist in the *Morning Chronicle* that he 'drew most of the ornaments which decorate the illustrious heads, so admirably engraved by Houbraken.'[5]

The provision of ornamental portrait frames for engraved plates was a field in which Gravelot had acquired a considerable reputation,[6] and these portraits, later issued in volume form,[7] were produced by him between 1735 and 1750, and must therefore have been in progress all the time that Gainsborough was working as his assistant. Fifteen preparatory drawings for the ornaments survive in the Sutherland collection in the Ashmolean Museum (Pl.239), four more are in the British Museum and another is in the Victoria and Albert. Over half of these are signed by Gravelot, the remainder are by other hands, demonstrably not Gainsborough's.[8] Since only a fraction of the drawings are known, more evidence is needed than is at present available in order to verify or refute the statement in *The Morning Chronicle*; but if it were possible to accept that Gainsborough executed any of the ornamental surrounds for the heads, which have recently and not unjustly been described as 'among the most exuberant examples of Rococo decoration produced in this country',[9] it would go far towards establishing the roots of his personal style. He was undoubtedly influenced by Hogarth's ideas, notably in the composition of *The Charterhouse*,[10] and, moving in the progressive art circles of the 1740's, would have accepted the serpentine line as the norm of beauty; but some such early exercise as the ornaments for the Houbraken heads seems necessary to explain the extraordinary power which curving and swirling rococo line held over his pictorial imagination throughout his career.

Certain technical devices Gainsborough probably acquired from Gravelot, in particular his practice of using specially jointed costumed dolls for modelling his figures (Pls.18 and 246),[11] and his employment of quadrilled paper (Pl.6). Neither practice, however, was unique to Gravelot; Roubiliac, for instance, also used a doll which had a large wardrobe of clothes,[12] and Hayman's figures presuppose a similar model. One of Gainsborough's dolls was later acquired by Collins,[13] and his use of this aid to drawing is most apparent in a series of early figure sketches in which the

[5] *The Morning Chronicle*, 8 August 1788.

[6] See Edwin Wolf, 'Gravelot as Designer of Engraved Portrait Frames', *Print Collectors Quarterly*, March 1950, pp.41–7.

[7] Thomas Birch, *The Heads of Illustrious Persons of Great Britain*, published by J. & P. Knapton, London, 2 vols., 1747 and 1752.

[8] See my article, 'The Ornamental Surrounds for Houbraken's Illustrious Heads', 'Notes on British Art 13', *Apollo*, January 1969, pp.1–3.

[9] H. A. Hammelmann, 'A French Master of English Illustration: Gravelot's Years in London', *Country Life*, 3 December 1959, p.1087.

[10] Which is an object-lesson in what Hogarth later propounded with regard to painting buildings (see *The Analysis of Beauty*, ed. Joseph Burke, Oxford, 1955, p.37).

[11] Gravelot's dolls, which, incidentally, were made in England, are described in the catalogue of his sale, where three were sold together with their wardrobes of clothes: Basan, 19 May 1773 (Lugt 2169), Lots 11 and 12.

[12] It is now in the London Museum.

[13] Whitley, p.231.

arm and leg positions are quite obviously unnatural (Pl.242). He evidently used dolls for a number of his portrait studies of the 1760's (Pls.78–9), and certainly used them for his picture of *The Mall* in 1783, as Jackson tells us that 'all the female figures in his Park-scene he drew from a doll of his own creation.'[14] His occasional habit of blocking out the shape of a head with simple slightly curving lines crossing at the forehead (Pl.255) is also French practice.

Gainsborough certainly absorbed something of the elegance and languor of Gravelot's figure style, as the dainty, elegant figures characteristic of his drawings for Boydell (Pl.243) are clearly derived from this source (Pl.245), and his very early figure drawings are far more accomplished than his landscape. But he seems not to have copied his figure drawings in black and white chalks, in which his fellow-pupil Grignion was assiduous, and he never imitated the rather spidery pen and wash drawings (Pl.245) which were Gravelot's most typical medium, though Hayman did (with more panache), and so did Louis Philippe Boitard. It is significant that his figure drawings of the late 1740's, in particular his courting couple in the Paris drawing (Pls.7–8) (incidentally, an early instance of his adoption of Hayman's informal portrait-in-a-landscape compositions), are much more vigorous in style; and the only two later Suffolk period portrait drawings that survive, a study for the three-quarter length of Richard Savage Nassau (Pl.255) and another for a man in an unidentified portrait group (Pl.259), are executed with an assurance, sweep, and vigorous angularity that makes Ramsay pale in comparison (Pl.257) and is to be paralleled at this date only in the work of Chardin or Parrocel (Pl.260).

But if the influence of Gravelot, of French style and techniques generally, and of Hogarth's serpentine line, was the most fundamental and pervasive, the influence of the Dutch and Flemish seventeenth-century landscape tradition was almost equally important for Gainsborough's development, while that of contemporary English landscape should not be totally ignored.

His drawings for Boydell, with their rather mechanical and stagey arrangement in clearly distinct planes and their miscellaneous scattered figure motifs (Pl.240), are close enough to Boydell's own early landscape compositions (Pl.241),[15] and in the first respect, also to Hayman.[16] Very few of Hayman's pure landscapes have survived (he may not have done many), so that his influence on Gainsborough is difficult to assess; but it is at least interesting to remark that motifs he used such as a cottage half obscured by trees were later popularized by Gainsborough, while his pencilwork, though certainly more mannered than Gainsborough's, is not dissimilar to the latter's early technique and could have provided an initial impetus (Pls.246–7).

The influence of the Dutch and Flemish is easier to trace. There is no definite instance of Gainsborough's ever having copied a drawing[17] – and in this context it

[14] William Jackson, *The Four Ages*, London, 1798, p.167.

[15] See Nos.77–88 in J. Boydell, *A Collection of Views in England and Wales*, London, 1790.

[16] Compare *The Sparrow and the Dove* for his *Fables of the Female Sex*, 1744 (the original drawings are bound into the copy of the book in the Rothschild collection at Waddesdon Manor).

[17] The sketch of a boy after Van Dyck (Cat. No.37) mentioned on p.58 is the likeliest instance of such a copy.

is interesting to note that though he later formed a collection of old masters which he used as an adjunct to his painting, he never collected drawings[18] – but he did copy a number of pictures at various dates. From about 1747 dates an exact and elaborate study in chalks of Ruisdael's landscape *La Forêt* (Pl.248),[19] and the Rev. Kirby Trimmer, who inherited the large collection of early drawings owned by Joshua Kirby, said that his first sketch in oils was 'after the manner of Waterloo, whom in his early days he much studied.'[20]

It has usually been argued that he saw and studied examples of Dutch landscapes of the naturalistic school, Ruisdael, Hobbema, Wijnants, and Waterloo, in private collections in East Anglia;[21] but without denying that this may have been so, it is now possible to demonstrate that considerable quantities of works by or attributed to exactly these masters were beginning to pour onto the London art market in the mid to later 1740's, at just the time Gainsborough was starting out on his own.[22] Their style accorded with the naturalistic leanings of Hogarth, Roubiliac, and other prominent artists, and they were obviously the *avant-garde* thing both to study and collect – the Duke of Bedford, for instance, bought a Ruisdael as early as 1742.[23] Certainly, Gainsborough studied them attentively, and together with the French rococo, they provided the essentials of his Suffolk style. So deep-rooted was his affection, indeed, that right at the end of his life he expressed nostalgic feelings for his 'first imatations of little Dutch Landskips.'[24]

From a technical point of view, it was principally the drawings of Waterloo and Teniers that were a direct influence. The pervasive zig-zag touch in modelling forms characteristic of his copy of Ruisdael (Pl.248), of his landscape with groups of donkeys (Pl.12), and of his woodland scenes in pencil or black chalk (Pl.17), was derived from a study of the techniques employed by Berchem, Waterloo (Pl.250), and Wijnants;[25] though the angular and brittle character he gave to tree trunks and branches in these drawings was inspired rather by Ruisdael. Certain of these compositions are especially Dutch in quality, and give the impression of being copies (Pl.249). Teniers seems to have been an equally important influence, as a number of different kinds of sketch (Pls.251–2) are technically very close to his

[18] The only exceptions seem to have been the books each containing fifty-four drawings of shipping by Van de Velde which were Lots 93–4 in the Gainsborough sale, Christie's, 11 May 1799 (Lugt 5917).

[19] This was first pointed out by Mary Woodall ('A Note on Gainsborough and Ruisdael', *The Burlington Magazine*, January 1935, p.45, where the Ruisdael is reproduced).

[20] See Walter Thornbury, *The Life of J. M. W. Turner, R.A.*, London, 1862, Vol.2, p.58.

[21] See, for example, Mary Woodall, *Thomas Gainsborough*, London, 1949, p.24, and Waterhouse, p.13.

[22] See my article on 'British Patrons and Landscape Painting: 2. Eighteenth-century collecting', *Apollo*, March 1966, p.190.

[23] Samuel Paris sale, 1742, 1st Day Lot 43 (Houlditch MSS. in the Victoria and Albert Museum Library).

[24] Gainsborough to Thomas Harvey, London, 22 May 1788: Woodall *Letters*, No.43, p.91.

[25] In addition to Pl.250, compare especially the Berchem drawing in the British Museum (1910-2-12-115), and such Waterloos as the signed drawing recently with Richard Hodgkin (1967 Catalogue, No.19, repr.). Gessner is of particular interest on the subject of Waterloo as inspiration: 'the more I studied this artist; the more I found, in his landscapes, the true character of nature . . . it was to him I owed at last the felicity of expressing my own ideas; but it was by borrowing his style' (Solomon Gessner, *A Letter . . . on Landscape Painting*, Edinburgh 1798, p.120).

pencil drawings (Pls.253–4). The hatching and softness of modelling in many of the early pencil drawings is also close to Dujardin;[26] while the hatching and high-lighting of certain of his figure studies of rustics (Pl.256) is not dissimilar to Berchem (Pl.258).

In addition, a large part of Gainsborough's early repertory of forms was derived from Dutch example. Though he added a number of ideas of his own, owed his rustic lovers theme to Boucher, and probably gleaned other motifs from the growing number of English landscape prints, his familiar sandy banks are characteristic of Wijnants and Wouwerman, and his winding rutted tracks, cottages on banks, church towers peeping over trees, donkeys silhouetted against banks, peasants seated or sleeping by the roadside, withered tree trunks, and prominent burdocks, plants, and reeds in his foregrounds, are all elements of Dutch picture-making which he found acceptable pictorial material.

When Gainsborough moved to Bath in 1759 he came under the influence of a far wider range of art, and was admitted to numerous important West Country collections,[27] several of whose owners sat to him for their portraits. He is known to have admired Claude and Gaspard Dughet,[28] was so enamoured of Van Dyck's portraits that he copied several of his full-lengths,[29] and, equally enduring influence, was excited by the energy and brilliance and richness of Rubens's landscapes.[30] He also widened his knowledge of Dutch landscape, and, in the early 1770's, was again much influenced by Teniers: he even copied (twice) the latter's large *Return from Shooting* in Lord Radnor's collection,[31] and is also known to have copied at least one other Flemish landscape at this period, a Bout and Boudewijns which included figures and a church spire, and was probably a village scene, that was owned by his physician, Dr Charlton.[32] An example of a case where Gainsborough seems certainly to have copied a drawing is a slight chalk sketch of a youth (Pl.269), drawn on the *verso* of a more elaborate portrait study, which is not only obviously derived from Van Dyck but suggestive of his technique (there is the same rather thin broken line characteristic of certain of his portrait drawings (Pl.270)).

Among collections of drawings he must have been familiar with the examples bought by his young friend Uvedale Price when the latter was on the Grand Tour in 1767–8,[33] and indeed a large and spirited drawing of herdsmen and animals then attributed to Van Dyck which was in Price's collection has the following inscription on the back: 'Vandyk. thought so by Mr West. It was a very favorite drawing of Gainsborough's.'[34] There is also a parallel to Gainsborough's later studies of goats

[26] Compare the drawing in the British Museum (1895–9–15–1188).

[27] Corsham, Longford Castle, Stourhead and Wilton among others.

[28] See his letter to Lord Hardwicke, n.d.: Woodall *Letters*, No.42, p.87.

[29] See Waterhouse, Nos.1015, 1016, and 1017.

[30] See my article on 'Gainsborough and Rubens', *Apollo*, August 1963, pp.89–97.

[31] Waterhouse, Nos.1029 and 1030.

[32] Both the original and the copy were in Dr Charlton's sale, Christie's, 5 March 1790 (Lugt 4541), Lots 16 and 17 respectively.

[33] The contents of the collection can be assessed from the sale at Sotheby's, 3–4 May 1854 (Lugt 21889).

[34] This drawing is now in the British Museum (1936–10–10–23), and catalogued as Anon. Flemish.

(Pl.226) in a black chalk drawing of a reclining goat by Adriaen van de Velde formerly owned by Price.[35]

In the early 1760's Gainsborough adopted an opaque lead white for heightening, both in his wash drawings and his watercolours, which he applied broadly and loosely in the sky and in rather quick, nervous touches for the highlights of tree trunks and foliage (Pl.263). This was an admirable medium for suggesting those strong effects of light, particularly of light bursting through and enlivening the trees, that he had begun to admire in Rubens; and it seems likely to have been suggested to him by the gouache drawings of Busiri (Pl.264), examples of which had been acquired in Italy by Robert Price,[36] and which he would no doubt have seen when he was at Foxley in 1760.

The broad scallops outlining foliage in such drawings of the early 1760's as that at Uppingham (Pl.261) are typical of a certain kind of Gaspard drawing (Pl.262), and his landscapes were also to some extent influenced directly by Rubens or Van Dyck at this period, as the loose handling of the foliage and the fresh, pale tone in such landscapes as the gouache in Michael Ingram's collection (Pl.265) are remarkably close to certain landscape sketches by these artists (Pl.266). The watercolour of a waggon in a woodland glade in the British Museum (Pl.267), though already more personal in treatment and related rather to the gentler landscape of contemporary watercolourists like Taverner or Skelton, is also suggestive of Van Dyck in the handling of wash and subtle interpenetration of tones in the foliage. The influence of contemporary watercolour on Gainsborough's work of this period is most obvious in the landscape with a horseman passing a stile in Toledo (Pl.271), where the conventions for touching in foliage, as well as the kind of composition and lighting effect, can be paralleled in Skelton (Pl.272).[37]

The development of a looser style of drawing in the later 1760's seems to owe much to the influence of Waterloo, as the treatment in certain landscapes of this date, in particular such technical characteristics as the rough squiggles outlining shapes and paths (Pl.273), is very close to the Waterloo in the Rijksmuseum (Pl.274), which is unusually 'Gainsboroughesque' in feeling generally. This was an influence also felt by Sandby (Pl.275).

Another tangible influence is evident in a particular type of pen and brown wash drawing he began to do towards 1770 (Pls.276 and 280). It would be difficult, however, to be precise about the source in this case. In general, they are close in character to a certain type of Claude drawing (Pl.277),[38] though the Gainsboroughs are

[35] This is now in the Witt Collection, Courtauld Institute of Art (4449).

[36] See Francis W. Hawcroft, 'The "Cabinet" at Felbrigg', *The Connoisseur*, May 1958, p.216.

[37] The native roots of Gainsborough's pastoral landscapes with figures on a path winding amongst trees can be studied also in such Taverners as the water-colour formerly with Colnaghi (*English Drawings and Watercolours*, August 1964, No.29, repr. pl.III), where the composition is more static in conception and the figures so indeterminate that they could be construed as 'classical'.

[38] Compare the drawing in the British Museum formerly in Payne Knight's collection (O.o.7–202).

[39] The loose treatment of the outlines of the foliage is close to drawings in the British Museum (O.o.9–49 and 1897–4–10–16) in which the light feathery quality and the tremendous sense of rhythm produced by the hatching are especially close to the spirit of Gainsborough's work.

much firmer in touch; but there are also parallels with Van Dyck,[39] Both and Swanevelt, among others. The rich, dense treatment of foliage and loose scallops outlining foliage have affinities with such Van Dycks as the watercolour then in Reynolds's collection (Pl.278); the rather spare tree trunks, sometimes with a zig-zag line serving for internal modelling, could well be derived from Both (Pl.279), though Gainsborough never sought to imitate his thin, crisp, angular penwork, which (like Gravelot's slightly emasculated technique) would have been uncongenial to his temperament; and the broken contours indicating clouds and foliage are also close to Swanevelt (Pl.281). It seems possible that this style of drawing, which is at any rate patently seventeenth century in character, may have been suggested to him by examples in the Price collection, then quite recently formed.

There are, of course, other instances of parallels between techniques employed by Gainsborough during the Bath period and those used by earlier draughtsmen. Obviously in many cases this could be accidental, due simply to the fact that two artists of different centuries and schools may decide to tackle a similar problem in a similar way. One might mention, however, the unusual use of red chalk for his study of musicians round a harpsichord (Pl.122), no doubt influenced by contemporary French drawings, and the equally unusual bold and sketchy penwork, especially evident in the horse, in his drawing of a boy reclining in the back of a cart (Pls.104–5), penwork which gives the impression that he may have been trying to emulate a Rembrandt drawing.

In many of his drawings of this period, particularly those intended for translation into paint, he was influenced in his choice of subject and composition by Claude, Gaspard Dughet, and the Dutch Italianates. The Morris drawing of 1759 (Pl.77) combines elements from different sources: the composition, with a group of trees framing the scene on the left, a principal tree mass to right of centre, and mountains closing the distance, is plainly Claudean, but the hilly terrain with a drop into a sunlit distance is more characteristic of Both or Berchem. The Ashmolean drawing (Pl.263) is a more simplified type of classical composition, with Gaspardesque wind-swept tree trunks on the left. And an example from a decade later is the drawing formerly in the Heseltine collection (Pl.282), where the masses are still more clearly defined, and a Claudean bridge is inserted into the middle distance to link the two halves of the composition at this point. The idea of including a small group of buildings in the distance as a highlit accent, which is found in numerous drawings (Pls.102 and 265), and the strongly lit block-like buildings characteristic of the Hamilton-Smith drawing (Pl.128), are derived from Gaspard (Pl.295). And among other subjects first developed in this period, the ubiquitous cows at a watering place (Pl.284) are obviously derived from Rubens (Pl.285), and the village scenes of the early 1770's from Teniers. Most of the latter (Pl.286) are executed in that complicated technique with which he was then experimenting, and the dull tonality and spiky treatment of the foliage in these drawings is also influenced by Teniers's style of painting (Pl.287).

During the last fifteen years of his life, the years he spent in London, Gainsborough's drawing style became increasingly artificial, but at the same time

increasingly personal and less subject to influences of a technical nature. Parallels to be detected are more likely just to be parallels than influences; though it should be remembered that he was capable of sudden enthusiasm and that he even continued to make copies of pictures by which he was excited in these last busy years.

It is conceivable that there is a connection between Gainsborough's 'mopping' technique (Pl.133) and Cozens's 'blots' (Pl.306),[40] though the latter were intended rather to *assist* invention than to carry it forward, and the main parallels in his landscape drawings are with draughtsmen he had already studied closely, Waterloo and Teniers. Quite a number of his drawings in black and white chalks on blue paper of the mid-1780's, with their rhythmical treatment of tree trunks and foliage, pronounced contours and broken highlights (Pl.292), are close to drawings in a similar medium by Waterloo (Pl.293); and many of his sketches of country lanes with cottages (Pl.290) to drawings in an identical technique by Teniers (Pl.291).

There was also a period in the late 1770's when he began to use a very soft, almost muzzy type of chalkwork in certain drawings, both landscapes and portraits (Pls142–3), which is commonly to be found in contemporary French drawings, notably by Fragonard and Hubert Robert; and the treatment of foliage in another type of chalk drawing of his later years (Pl.420) is reminiscent of Blanchet.[41] It is instructive, too, to compare other sketches in this same technique with Taverner's gentler, more static treatment of analogous compositions.[42] Connecting again with French style, there is a close parallel between the impressionistic technique used in the study for *Lady Clarges* (Pl.141), with its welter of strokes in black and white chalks sweeping in every direction, and the draughtsmanship of Claude-Michel Clodion. His figure studies of the 1780's (Pl.231), on the other hand, though mostly executed in black and white chalks on buff paper, a medium used by Gravelot for his single figures, have more affinities with the rough vigour of earlier Italian drawing than with anything French.

With regard to composition and subject-matter in the London period, Smirke was to some extent justified in saying that 'His art was founded upon the works of others; made up from observations He had made upon the pictures of different masters.'[43] Gainsborough now became a devotee of the saleroom, and began to form a collection of paintings,[44] some of which can be shown to be directly related to new departures in his own work. Margaret Gainsborough later told Farington that her father 'was passionately fond of the pictures of Berghem & Cuyp',[45] and ruined towers and castles, herdsmen driving cattle along a hillside track, and glow-

[40] See A. P. Oppé, *Alexander and John Robert Cozens*, London, 1952, p.26. It is perhaps also significant that Gainsborough used the word 'blot' in referring to his drawings in a letter to Garrick; the letter is unfortunately undated, but was written sometime in the Bath period (Woodall *Letters*, No.30, p.71).

[41] Compare the drawing in the Witt Collection, Courtauld Institute of Art (3929) or the drawing owned by Sir John Witt (repr. *France in the Eighteenth Century*, R.A., January–March 1968, fig.260).

[42] Compare the drawing exhibited by John Baskett, *Old Master and English Drawings*, May–June 1969 (II repr.).

[43] *The Farington Diary*, 17 June 1813 (p.6332).

[44] See (Tancred Borenius), 'Gainsborough's Collection of Pictures', *The Burlington Magazine*, May 1944, pp.107–10.

[45] *The Farington Diary*, 29 January 1799 (p.1455).

ing distances, are constant features of his later drawings. Specific motifs that can be paralleled in Berchem are those of watermills, shepherds or cowherds talking to a peasant girl, peasants begging from a cavalier and his lady as they ride by, and figures passing through a ruined arch.[46] Other motifs drawn from the Dutch include the fishermen netting, girls buying fish and cattle silhouetted on cliffs of his coastal scenes. There are broad affinities in some of his work to the classical pastorals of Zuccarelli, and his unusual oval composition with cattle crossing a bridge is certainly a Fragonard conception (Pls.288–9);[47] but his *Diana and Actaeon*, also suggestive of Fragonard (Pls.343–6),[48] could well have been prompted by Wheatley's *Nymphs Bathing* of 1783 (Pl.347). More important, however, was the continuing influence of Rubens, Claude, and Gaspard Dughet; and in his figure drawings, the new one of Murillo.

Hoppner, in describing Gainsborough's last manner, spoke of 'the studies he made at this period of his life, in chalks, from the works of the more learned painters of landscape, but particularly from Gasper Poussin';[49] and one study of this description, now in Melbourne (Pl.185), a mountain landscape with a shepherd on a hillside and some Italianate buildings among trees on the left, was actually noted as such at the time, being inscribed on the contemporary mount as an 'original chalk drawing by Gainsbro given by him to my Father Rich.ᵈ French after the style of Gaspar Poussin.' Gainsborough owned four Poussins, probably Gaspard rather than Nicholas,[50] and his lake scene with a rowing boat in the foreground (Pl.294) and many of his late mountain drawings (Pl.184) are Gaspardesque in arrangement (Pl.295), with squat Italianate-looking buildings as prominent features. Moreover, his visit to the Lakes in the late summer of 1783 was avowedly to gather material for compositions of this type.[51]

Hoppner also noted as characteristic of Gainsborough's drawings of this date an 'agreeable flow of lines, and breadth of effect',[52] and the prevailing lateral rhythms and brilliant effects of light (Pl.307) undoubtedly had their roots in Rubens's style of landscape (Pl.308), an influence that ran deep and is most obvious in the paintings. Many of Gainsborough's later landscape drawings are also very close to the descriptions of picturesque scenery in the *Tours* of William Gilpin.[53] It is not known whether Gainsborough ever read any of Gilpin's works, though some were quite widely circulated in manuscript in the 1770's[54] and the first of them, the

[46] Compare the Berchem drawings in the British Museum 1910–2–12–115, G.g.2–270, 1895–9–15–1107, 1836–8–11–48, and 1871–12–9–6309.

[47] An oval format was much favoured by Fragonard: one instance out of many is *The New Model* (Georges Wildenstein, *The Paintings of Fragonard*, London, 1960, Cat.293 and repr. pl.50).

[48] Compare his *Women Bathing* (*ibid.*, Cat.234 and repr. fig.115).

[49] *The Quarterly Review*, February 1809, p.48.

[50] Borenius, op. cit., p.108.

[51] See his letter to William Pearce, n.d. (=summer 1783): Woodall *Letters*, No.64, p.125.

[52] *The Quarterly Review*, February 1809, p.48.

[53] See pp.18 and 51–2.

[54] See Gilpin's preface to his tour of the Lakes (*Observations . . . on . . . the Mountains, and Lakes of Cumberland, and Westmoreland*, London, 1786, Vol.1, pp.v–vi.

tour of the Wye, came out in the summer of 1783;[55] in view of his antipathy to reading he probably did not, and it is likely that the two men's work proceeded on the same lines (Pls.303–4) simply from a certain identity of outlook.[56]

In 1780 Gainsborough saw Murillo's *The Good Shepherd* (actually a copy by Grimou) in the Duke of Bridgwater's collection, and immediately afterwards made his own copy of it from memory.[57] The year after, he exhibited the first of his fancy pictures in the Murillo manner, the subject being a shepherd boy at rest (Pl.297).[58] Murillo's particular brand of sentiment suited Gainsborough's mood exactly, and a whole series of drawings of shepherd boys an dbeggar children (Pls.158 and 296), some of them gazing heavenward with a rapt expression on their faces (Pl.298), are obviously influenced by Murillo's work (Pl.299). *The Woodman*, which he seems to have regarded as his masterpiece in painting,[59] and for which there are several fine drawings in poses not adopted (Pls.231–3), was cast in the same mould, and executed in the summer of 1787 shortly after his purchase, for no less than 500 guineas, of Murillo's *St John in the Wilderness*.[60]

On this analysis, the principal formative influences on Gainsborough's style, imagery and draughtmanship were first the French rococo, the serpentine line, and the Dutch naturalists; later, Rubens, the Italianate landscape tradition, in portraiture (and pervading the whole spirit of his art) Van Dyck (Pl.268),[61] and for the development of his subject pictures, Murillo. Numerous other influences were also at work, but these played, on the whole, a limited or ephemeral role in the progress of his style. What is also significant, of course, is that Gainsborough turned only to those artists he knew could help him in what he was trying to achieve at a given moment; he always assimilated what he needed with great speed, and the drawings in which specific influences can be most clearly detected are already personal creations, Gainsboroughs of a richer kind, not mere imitations.

[55] Not 1782, as stated on the title page (see Carl Paul Barbier, *William Gilpin*, London, 1963, p.71).

[56] Though not of theory. Gilpin was inclined to the sublime or heroic style of landscape, and scornful of imagery that pertained to the pastoral or rural style (see Barbier, op. cit., pp.112–15).

[57] Waterhouse, No.1025; see also *Southill A Regency House*, London, 1951, p.49 and pl.61.

[58] On Gainsborough's new genre see Ellis K. Waterhouse, 'Gainsborough's "Fancy Pictures" ', *The Burlington Magazine*, June 1946, pp.134–41.

[59] Whitley, p.285.

[60] Whitley, p.275.

[61] There is no doubt that Gainsborough had a particular sympathy and love for Van Dyck; according to Jackson, his dying words were 'We are all going to Heaven, and Vandyke is of the party' (Jackson, op. cit., p.161).

7

Assistants, Pupils and Imitators

By far the highest proportion of drawings wrongly, but plausibly, attributed to Gainsborough are in fact by his nephew

Gainsborough Dupont (1754–97)

Dupont was the eldest surviving son of Gainsborough's sister, Sarah, and of Philip Dupont, of Sudbury, and showing some aptitude for painting decided to become his uncle's assistant. He was formally apprenticed in January 1772,[1] when he was 17, and besides his practical training in the studio received more academic tuition at the Royal Academy schools, to which Gainsborough had him admitted in 1775.[2] After he had finished his articles, he elected to stay on as studio assistant and remained at Schomberg House until Gainsborough died in 1788. His work was chiefly on the portrait side, helping with draperies and accessories, executing repetitions, and, from 1779, engraving some of the most important canvases in mezzotint. But he also did small copies of the fancy pictures, from which Earlom prepared his engravings; and may already have done landscapes, for in 1788 Thicknesse declared that if Dupont took over Schomberg House he could 'support its former credit, either as a landscape or Portrait painter'.[3] In fact, he tried both, in the brief eight years before his premature death in January 1797. As a portraitist, he enjoyed the patronage of Pitt and the Royal Family, among others, and exhibited regularly at the Academy; his most important work was the large group portrait of the *Merchant Elder Brethren* for Trinity House. But something like thirty of his landscapes are extant[4] (about a sixth of Gainsborough's known output), and Bate-Dudley, for one, regretted that so few of them appeared on the Academy walls. 'We attribute the loss of his *rustic* pencil, this year', he wrote in 1795, 'to the time he has unavoidably devoted to a great public work; but we hope he will soon resume those pastoral pursuits, to which his genius naturally inclines.'[5]

Contemporary critics differed considerably in their opinion as to Dupont's merits as an artist, but they were all agreed on one point, that his style was an

[1] The articles of apprenticeship were recently with Bennett and Marshall, Los Angeles (Catalogue No.9, Item 258), and the document is reproduced in Woodall *Letters*, pl.13.

[2] 6 March 1775 (Royal Academy Students Register: published in Sidney C. Hutchison, 'The Royal Academy Schools, 1768–1830', *The Walpole Society*, Vol.38, 1962, p.141).

[3] Thicknesse, p.46.

[4] Dupont's landscape paintings will be discussed in detail in my forthcoming Catalogue Raisonné of *Gainsborough's Landscape Paintings*.

[5] *The Morning Herald*, 8 May 1795.

exact imitation of Gainsborough's. This was perhaps inevitable. Dupont had spent over sixteen years with Gainsborough; none but the strongest personality could have overcome so magnetic an influence within the space of a few years, and Dupont was far from being a strong personality. Thicknesse speaks of his 'diffidence and modesty',[6] and Farington said that 'he was very moderate in his expressions as to his claims and hopes'[7] at the time of his third attempt to secure election as A.R.A. in 1795. The influence of Gainsborough's style, techniques, and subject-matter so evident in the paintings is no less marked in the drawings, and in the light of recent research[8] it is now possible to distinguish several types of Dupont drawing. The most personal are his studies in black lead pencil, principally landscapes but also including figure subjects. More obviously Gainsboroughesque are his landscapes in black and white chalks on blue paper, figure studies in the same medium for his portraits and the staffage of his landscapes, figure drawings for the mezzotints, and landscapes in pen and grey wash. They may conveniently be studied in this order.

Most of the larger pencil drawings are clearly studies for landscape compositions, and two, one in the Metropolitan Museum (11.66.1)[9] and one formerly in Ronald Horton's collection,[10] can be linked with known pictures; but a considerable number of small pencil drawings executed on card, of which groups are in the Huntington[11] and Yale University Art Galleries, are less certainly studies, and some at least may have been intended as records of his compositions. All, however, are drawn in a similar style, a style derived from the pencil sketches Gainsborough had done in early life, which Mrs Gainsborough had retained in her possession, and that Dupont must certainly have known well. The similarities are obvious; but there are also fundamental differences. Gainsborough's sketches are marked by flowing line, boundless vitality, and a sure feeling for organic growth and plasticity of form. Dupont's style, on the other hand, lacks flow. To be sure, there is vitality in plenty, but fascinated as he was by the rhythm and boldness of effect so characteristic of Gainsborough, he never succeeded in matching his ambitions with a corresponding technical agility. His calligraphy is fundamentally nervous and staccato, full of hesitations and niggling touches (Pls.355–6). And his modelling is unconvincing (Pl.353): contours are sometimes surrounded by a positive welter of meaningless lines, his foliage tends to be insubstantial, without plasticity, and his figures, often elongated in proportion, seem stiff and uncomfortably rooted to the ground (Pl.354).

[6] Thicknesse, p.46.

[7] *The Farington Diary*, 2 November 1795 (from the typescript in the British Museum Print Room, p.406).

[8] A reconstruction of Dupont's *œuvre* as a draughtsman, based on documentary evidence, is attempted in my article on 'The Drawings of Gainsborough Dupont', *Master Drawings*, Vol.3, No.3, 1965, pp.243–56; as it would take a disproportionate amount of space even to summarize the arguments here, the reader is referred to this publication for the (firm) evidence supporting the attributions of the drawings discussed in the pages that follow.

[9] Reproduced in Woodall, pl.98 (the painting is pl.99).

[10] Reproduced in *Master Drawings*, op. cit., pl.2 (the painting is fig.3).

[11] Some of these are reproduced in Woodall, pl.95 and *Master Drawings*, op. cit., pl.1.

Dupont's landscapes in black and white chalks on blue paper, in which the defects of his pencil drawings are equally evident, derive from some of Gainsborough's sketchier late drawings, the best example in this context being the sheet originally given to Hoppner, now in the Pennsylvania Academy of the Fine Arts (Pl.359). In Dupont's drawing of three women under a tree, with a fourth watching a camp fire, in the Victoria and Albert Museum (Pl.358), another study for a known painting, the disjointed staccato effect is produced chiefly by the highlights, thin scratchy touches in white chalk; there is little sense of form, foliage tending to float away from branches, banks being unmodelled and figures elongated, and, generally, the rhythmic unity of conception characteristic of Gainsborough is replaced by an impression of confusion and lack of co-ordination.

Most of Dupont's figure drawings in this medium known to us seem to have come from two lots in his sale at Christie's, both purchased by Sir William Young. A high percentage of the drawings are studies for the various poses in the Trinity House picture.[12] But there are also studies for other portraits, notably his full length of the *Princess of Wales* in her wedding gown;[12A] some studies after Gainsboroughs, such as the important fancy piece of a *Peasant Girl Gathering Sticks* and his late equestrian portrait (Pls.340–2); and a number of sketches for the figures in his landscapes[13] which he incorporated in his pictures for the most part unchanged (Pl.360).

Stylistically, these studies can be related to those numerous fancy drawings of woodcutters and beggar children which Gainsborough executed in the last decade of his life. But fine as some of Dupont's figure drawings undoubtedly are, they tend to lack Gainsborough's marvellous breadth of treatment and mastery of suggesting form with the utmost economy of means (Pl.361). Arms and legs are often limp, contours imprecise, highlights fussy, and the spatial setting uncertain (Pls.342 and 360).

Several drawings survive that are connected with the mezzotints of Gainsborough's portraits, which were one of Dupont's responsibilities as studio assistant. Some of these are quite sketchy, but one, the portrait of Francis Rawdon Hastings, 2nd Earl of Moira, in the Worcester Art Museum (1941.24), is more highly wrought,[14] and may serve as a useful example of Dupont's draughtsmanship in a finished drawing. His characteristic broken touch is seen in the tree on the right, and uncertainties of modelling are evident in the bank behind the sitter and in the clouds.

Dupont's pen and wash drawings may be represented by the sketch of two cows at a watering place formerly in Derek Lockett's collection (Pl.362). The poses of the two cows are in reverse from an original Gainsborough in Lord Spencer's collection (Pl.363), and the staccato contours, shapeless clouds, lack of organic relationship between the main tree and the ground, and unbalanced composition are typical of everything noted so far about Dupont's work.

[12] Several of these are reproduced in my article on 'The Trinity House Group Portrait', *The Burlington Magazine*, July 1964, figs.2, 3, 5, and 6; and another is reproduced in *Master Drawings*, op. cit., pl.4.

[12A] Reproduced in Oliver Millar, *Later Georgian Pictures in the Royal Collection*, London, 1969, Vol.I, fig.5.

[13] Some of these are reproduced in *Master Drawings*, op. cit., pls.6, 7, 8, and 10.

[14] Reproduced in *Master Drawings*, op. cit., pl.9.

Dupont emerges as a conscientious and industrious but fundamentally un-original artist, who strove to imitate and develop his uncle's style, but only succeeded in exaggerating his mannerisms without achieving his sureness and facility of execution. Now that the full range of his work can be studied and analysed, it should not prove as difficult as it has been in the past to distinguish a Dupont from a Gainsborough drawing.

Unlike so many of his contemporaries, Gainsborough never ran much of a studio, and did most of his pictures unaided, wholly so until 1772. Edwards wrote that 'It is not known, whether Mr. Gainsborough had any pupils',[15] and there is certainly no evidence to show that he employed anyone but Dupont as assistant. He never took regular pupils, as, for example, Wilson did, except perhaps in his early days: Joshua Kirby's son William (in company with an unidentified Master W——) was his student for a short time at Ipswich.[16] William Kirby however died young, and nothing of his work survives today except some drawings of architectural subjects done in Rome in 1767–8.[17]

Of those few who did have tuition of one kind or another from him, all were amateurs, and first should be noted his daughters, Mary and Margaret. In 1764 he wrote to James Unwin: 'You must know I'm upon a scheeme of learning them both to paint Landscape; and that somewhat above the common Fan-mount stile. I think them capable of it, if taken in time and with proper pains bestow'd.'[18]

Mary Gainsborough (1748–1826)

No drawings by Mary Gainsborough are known, but Thicknesse was evidently familiar with her work, as he noted at the end of his short memoir of Gainsborough that 'Mrs.G. has a great number of drawings, some of which are of Mrs.Fischer's pencil.'[19]

Margaret Gainsborough (1752–1820)

Margaret Gainsborough inherited her father's drawings after her mother's death in 1798, and though parting with a good many at various times,[20] retained a considerable number, which she bequeathed (along with portraits and other items) to her cousins.[21] It is quite possible that some of the unattributed copies of Gainsborough's drawings which exist are by Margaret, but, as in Mary's case, no authenticated examples of her work survive, and we know only what she told Farington in 1799, that her father had taken pains to send her advice when she was learning to draw

[15] Edward Edwards, *Anecdotes of Painters*, London, 1808, p.143.

[16] Fulcher, pp.40–1.

[17] Now in the Royal Library (A. P. Oppé, *English Drawings . . . at Windsor Castle*), London, 1950, p.70.

[18] Gainsborough to James Unwin, Bath, 1 March 1764: Woodall *Letters*, No.85, p.151. According to Whitley, p.352, a number of landscapes by 'Miss Gainsborough' (presumably Margaret) occur in early sale catalogues.

[19] Thicknesse, p.61.

[20] She sold Gainsborough's sketchbooks at Christie's, 10–11 May 1799 (Lugt 5917) 2nd Day, Lots 81–90; and see also *The Farington Diary*, 25 January 1799 (p.1451), 29 January 1799 (p.1454), 30 January 1799 (p.1455) and 11 April 1801 (p.1944).

[21] W. T. Whitley, 'The Gainsborough Family Portraits', *The Studio*, August 1923, p.63.

and that 'she regretted much having lost many letters which He wrote to her and Her Sister while they were at Blacklands School, containing instructions for drawing.'[22]

One long and important Gainsborough letter with instructions for drawing does chance to survive; this, however, was not directed to either of his daughters but to his intimate friend

William Jackson (1730–1803)[23]

Jackson was a musician by profession. He achieved an early success in 1755 with a set of twelve songs, but nevertheless had to earn his living by teaching music, which he did in his native city of Exeter. A passionate lover of nature, he took up landscape painting as a hobby in 1757, and became acquainted with Gainsborough in the early 1760's, through Samuel Collins, the miniature painter.[24] The two soon became fast friends, and instruction in music was exchanged for advice on painting. Gainsborough often went down to or near Exeter to stay, and there is a reference to one of these visits in a letter of July 1779: 'I hope to see you in about a fortnight, as I purpose spending a month or six weeks at Tingmouth or other places round Exeter – get your Chalks ready, for we must draw together.'[25]

At some point in the late 1760's Jackson seems to have thought seriously of giving up music in favour of painting, and Gainsborough advised him that 'there is a branch of Painting next in Profit to Portrait, and quite in your power without any more drawing than I'll answer for your having, which is Drapery & Landskip backgrounds.'[26] He sent two landscapes in to the Academy in 1771, but these were his only exhibits there. Apart from his few known oils, the best of which is dated 1763, there is only one watercolour and one wash drawing that can now be attributed to him with any conviction, both, however, strongly influenced by Gainsborough.

The watercolour with a cart travelling down a country lane in the possession of Mr and Mrs Arnold Whitridge (Pl.364) is closely related to Gainsborough's work of about 1770. The motif is not dissimilar from the drawing of a cart dated 1769 (Pl.365), while the conception in two almost separate halves with strong lighting in between and the particular type of tall spindly trees recall the varnished drawing of a herdsman and cows in Minneapolis (Pl.366). A wash drawing in the Leeds City Art Gallery (Pl.368) characterized by the same niggling contours combines two familiar Gainsborough motifs of the early 1770's in the same composition: the two figures on horseback returning from market are taken directly from the masterpiece at Royal Holloway College of close to 1773 (Pl.369), while the group of three cows recurs in several pictures of this period (Pl.367).[27]

[22] *The Farington Diary*, 29 January 1799 (p.1455).

[23] See my article on 'William Jackson of Exeter' in *The Connoisseur*, January 1970, pp.17–24, for a full account of his activities as an artist and the arguments for attributing the two drawings discussed here.

[24] 'Autobiography of William Jackson', *The Leisure Hour*, May 1882, p.276.

[25] Gainsborough to William Jackson, Bath, 8 July 1779: Woodall *Letters*, No.62, p.123.

[26] Ibid., No.58, p.119.

[27] Waterhouse, Nos.890, pl.81; 922, pl.123; and 931, pl.124.

In 1773 Gainsborough sent Jackson a long letter with detailed instructions for producing chalk drawings in imitation of oil paintings, his obsession of the moment. 'When you can make a Drawing to please your self by my direction Send it to me, & I'll tell you if they are right', he added.[28] Unfortunately, none of Jackson's experiments in this medium seems to have survived.

Apart from a close dependence on Gainsborough, and a tendency to use his ideas and motifs quite unashamedly, the hallmarks of Jackson's style are his thin and overcareful contour lines, fundamental unsureness of drawing, and inability to fuse the different elements in his compositions into a unified whole. Gainsborough was wise not to encourage him to think too highly of his talents, and it was perhaps fortunate that his appointment as organist of Exeter Cathedral in 1777 ensured him a comfortable living in his own profession.

One other friend whom there is record of Gainsborough having instructed at Bath was Philip Thicknesse's daughter

Anna Thicknesse

All that is known of her talents as a draughtsman, however, is contained in a story told by Thicknesse: 'My departed daughter, who had some claim to genius with her pencil, and now and then obtained a hint of importance from Mr. Gainsborough's, had prevailed upon him to give her a little feint tinted drawing of his to copy, from which, she made so exact a resemblance, that at a slight view, it was not readily distinguished from the original; one night, *but after supper*, at my house in town, she laid her copy before him, said nothing, but waited to hear what he would say, Gainsborough instead (of) saying any thing, took it up and instantly tore it through the middle! The truth was, inattention, good spirits, and a glass or two of wine, had so cheered him, that he thought it was his own, yet at the same time perceiving that it was not quite so perfect as a work of *his* ought to be, he demolished it.'[29]

In the 1780's Gainsborough was patronized by the Royal Family, and is supposed to have taught drawing to

<div align="center">

Queen Charlotte (1744–1818)

The Princess Royal, Charlotte Augusta Matilda (1766–1828)

Princess Augusta Sophia (1768–1840)

and Princess Elizabeth (1770–1840)

</div>

Angelo wrote that 'Her majesty took some lessons of Gainsborough, during the then fashionable rage for that artist's eccentric style, denominated Gainsborough's moppings',[30] and he was doubtless the source for Pyne's reference to Queen Charlotte as 'his kind, illustrious pupil.'[31] The Princess Royal and her sisters probably took lessons in the early and mid-1780's (Gainsborough was down at Windsor paint-

[28] Gainsborough to William Jackson, Bath, 29 January 1773 : Woodall *Letters*, No.103, pp.177–9.

[29] Thicknesse, pp.44–5.

[30] Henry Angelo, *Reminiscences*, London, Vol.1, 1828, p.194.

[31] Anon. (=W. H. Pyne), 'The Greater and Lesser Stars of Pall Mall', ch.2, *Fraser's Magazine*, November 1840, p.552.

ing the Royal Family in 1782, for instance[32]); and they apparently formed a group for drawing and painting in the winter of 1786–7.[33] Though there is not the slightest trace of Gainsborough's influence in any of the drawings by these royal amateurs in the portfolios of their work which survive in the Royal Library, it is clear that they admired Gainsborough's drawings. They visited Schomberg House together in April 1789 when the artist's pictures were put on sale after his death, Queen Charlotte buying a group of six drawings on this occasion,[34] and Bate-Dudley noted later that 'The PRINCESS ROYAL has copied those in the Queen's possession in a most successful stile; and indeed these *sketches* are the first lessons for *effect*.'[35]

One pupil of the London period whose drawings *can* be identified, with some probability, is

Miss Charlotte Warren

Charlotte Warren was one of the daughters of the distinguished physician, Richard Warren (1731–97), who may well have attended Gainsborough, though there is no evidence of such a connection. Her association with Gainsborough is known only from the inscription on the back of two wash drawings now in the Dunedin Art Gallery (Pl.371) to the effect that they were 'given by the artist to his pupil Miss Charlotte Warren and done by him in her presence'. Now, one would expect an enthusiastic pupil to copy drawings done actually in front of her eyes and afterwards given to her, and a copy of one of the Dunedin drawings, formerly in the collection of Wing Commander John Higginson, does in fact exist (Pl.370). Though it is a close copy, however, it is not entirely assured. There is none of Gainsborough's feeling for light breaking through the trees on the left, and there are notable misunderstandings of form – the cow seen in foreshortening, for example, has been wrenched round and its proportions lost in the process. The drawing is evidently an amateur's work, and it is a fair presumption that it was done by Miss Warren. A large watercolour now in the collection of Mr and Mrs Paul Mellon (LGD 94), which is imitative of Gainsborough's late mountain scenes, may be attributed to the same hand; the cows have precisely the same awkwardness, and the terrain the same rhythmical but shapeless quality.

No other artists, amateur or professional, can be documented as receiving direct instruction from Gainsborough,[36] though many who imitated his style were acquainted with him personally; and the remaining imitators to whom drawings can be attributed may be classified most conveniently as followers respectively of his

[32] *The Morning Herald*, 14 September 1782.

[33] H. Clifford Smith, *Buckingham Palace*, London, n.d. (=1931), p.91.

[34] *The Diary*, 18 April 1789.

[35] *The Morning Herald*, 1789 (only known from the volume of *Press Cuttings from English Newspapers on Matters of Artistic Interest 1686–1835*, in the V. & A. Library, Vol.2, p.472).

[36] The statement that Gainsborough taught drawing to Jane and Ann, the daughters of his patron Thomas Coke of Norfolk (Elizabeth Wheeler Manwaring, *Italian Landscape in Eighteenth Century England*, New York, 1925, p.89) is difficult to take seriously, since even the elder daughter had not reached her 'teens when Gainsborough died.

Suffolk, Bath, and London manners. Pre-eminent amongst those who imitated his early work, from the point of view of sheer quantity, was

George Frost (1745–1821)[37]

When Constable tried to discover what he could about Gainsborough's life in Suffolk in 1797, he met with little success. 'I can assure you', he wrote to his friend J. T. Smith, 'it is not for the want of asking that I have not been successful, for indeed I have talked with those who knew him. I believe in Ipswich they did not know his value till they lost him.'[38] One of the persons he is likely to have met on this visit was George Frost, who settled in Ipswich some years after Gainsborough's departure, but soon developed a lasting admiration for his landscape drawings, many of which he was able to acquire. He wrote to Constable in 1807: 'You know I am extravagantly fond of Gainsbro' perhaps foolishly so.'[39] Frost was an amateur. He worked until he was 70 as a clerk in the Blue Coach office at Ipswich, and is not known to have been instructed in drawing. But much of his leisure was spent in sketching, and for a time at any rate, probably in his later years, he seems to have been active as a drawing master.[40]

According to his friend, the Rev. James Ford: 'he studied nature with the closest attention' and 'the pleasing scenery around the town of Ipswich; its hollow and tortuous lanes with broken sand-banks; its copse-grown dells; above all, the richly-wooded and picturesque acclivities of its winding river, were his perpetual haunts.' He 'was a most ardent admirer, and a close and correct imitator, of the productions of his countryman, the celebrated Gainsborough; and in his own admirable sketches from nature decisively evinced with what a congenial ardour, and with how keen a relish, he had imbibed the genius and the spirit of his adopted master. He possessed a pleasing collection of Paintings, and many valuable drawings, of his favourite Gainsborough (which will now be sold), executed in different ways, but principally with black chalk and lead pencil, in the neat style of his earlier manner.'[41]

Some of Frost's Gainsborough drawings (perhaps most or all of them) were acquired by that voracious collector, William Esdaile; and the sale of Esdaile's English drawings in 1838 included over 200 of Frost's own drawings, half of which were specifically entitled 'Sketches by Frost, in the manner of Gainsborough'.[42] A block of 165 Frost drawings, all bearing Esdaile's collector's mark, was recently

[37] See my article on 'The Drawings of George Frost', *Master Drawings*, Vol.4, No.2, 1966, pp.163–8, for a fuller account of Frost's activities as a draughtsman and the evidence for the authenticity of the drawings discussed here.

[38] Constable to J. T. Smith, East Bergholt, 7 May 1797 (R. B. Beckett, 'John Constable's Correspondence II', *Suffolk Records Society*, Vol.6, 1964, p.11).

[39] Frost to John Constable, Ipswich, 6 September 1807 (ibid., p.37).

[40] Constable mentions 'Smart and Frost (two drawing-masters in Ipswich)' in his letter to J. T. Smith already cited (ibid., p.12).

[41] Obituary in *The Gentleman's Magazine*, July 1821, p.90. Frost may have acquired late Gainsborough drawings in London sales, which we know he took note of from a letter to Constable, Ipswich, 11 May 1810 (ibid., p.38): 'I would willingly have been in time for Mr. Hopner's Sale but circumstances won't allow it – I wanted to see how Gainsbro's things sold.'

[42] William Esdaile sale, Christie's, 20 March 1838 (Lugt 14982), Lots 543–63.

acquired by Colnaghi's, and Frost's work can fortunately be studied in detail not only in this group, but from two scrapbooks he compiled (it was his practice to paste his sketches into a book on returning home from an expedition into the country)[43] which are now in the Ipswich Museum (1912–28 and 1917–23), and a third once in the possession of the Rev. James Ford but now broken up.[44] Instances of his 'close and correct' imitation of Gainsborough are much in evidence both in these well-documented series, and in other drawings that can be attributed to him; as early as 1848, in fact, Frost's work could pass as Gainsborough even in the families of his friends.[45]

Two pencil drawings bought by the British Museum in 1878 as Frost may be noted first. One of these (1878–7–13–1259) is an exact copy of an early Gainsborough pencil sketch now in the Yale University Library, but lacking the freedom and vigour of the original.[46] The other (Pl.372) is probably also a copy, again very carefully executed, with over precise-contours, and certain weaknesses in drawing, for example, in the forelegs of the horse drinking. Another pencil drawing in the British Museum (Pl.373), showing some woodcutters in a clearing, is imitative of a more loosely handled type of early Gainsborough sketch, such as the drawing in the Morgan Library also showing figures resting (Pl.374): the girl is actually so close in pose to the central figure in this drawing as to suggest that Frost knew it. The badly drawn figures are typical of Frost's work, while the nervous, brittle delineation of some of the branches and fuzzy modelling of the foliage can be paralleled in the woodland scene in Ipswich (Pl.375), an exercise in the manner of yet another type of early Gainsborough sketch.[47]

Linking very closely technically with the Ipswich woodland sketch is a large group of pencil sketches in various collections (Pl.376), the main series being in the Norwich Museum, all usually attributed (but without foundation of any sort) to Crome.[48] One of these is watermarked 1799.[49] Typical subjects in this group, studies of a path running through a wood, with perhaps a cottage half-hidden by trees, or a cow on a bank, are very Gainsboroughesque. The rhythmical treatment of the foliage is equally clearly based on Gainsborough, while the nervous staccato touch, and use of zig-zag strokes to model banks seem plainly to derive from such early Gainsborough sketches as the drawing in the Witt Collection (Pl.9), though

[43] Frank Brown, *Frost's Drawings of Ipswich and Sketches in Suffolk*, Ipswich, 1895, p.15.

[44] This was formerly in the possession of the Crisp family, and until recently owned by Major T. C. Binny, Little Wenham Hall, Colchester.

[45] See the drawing by Frost in the Whitworth Art Gallery (1453), which was presented by the son of Thomas Green to Hugh Reveley in 1848 as an 'Original Sketch by Gainsborough'.

[46] Both original and copy are reproduced in *Master Drawings*, op. cit., pl.25.

[47] Ibid., pl.27.

[48] The series in the Norwich Museum was formerly in the collection of Arthur, 1st Baron Mancroft (1872–1942), one time Lord Mayor of Norwich, who also owned a number of Crome oils, and the attribution was disseminated by the publication of one of these drawings as Crome in H. M. Cundall, 'The Norwich School', *The Studio*, 1920, pl.xxxii. The attribution to Frost was suggested to me by Dr Miklos Rajnai, Deputy Director of the Norwich Museum, who has also pointed out that the type of cottages depicted are more Suffolk in character than Norfolk. I am much indebted to Dr Rajnai for several enlightening conversations on East Anglian drawings of this period.

[49] A drawing in the Norwich series (14.59.935).

the quality of the draughtsmanship is much less spirited and vital.

There are two other cases of direct copies of early Gainsborough, both formerly in the Ford scrapbook and in Frost's more usual medium of black chalk: the study of woodland scenery done from a drawing now in the Witt Collection,[50] and the sketch of a country track with high sandy banks on either side, which was taken from the drawing in T. R. C. Blofeld's collection.[51] Both the originals bear Esdaile's collector's mark and were presumably then in Frost's possession. One or two pencil drawings clearly imitative of early Gainsborough have lines carefully ruled round the composition, and seem likely to be copies; and a pencil drawing in the Victoria and Albert Museum (E4034–1919) is a variant of a Gainsborough composition,[52] again possibly actually a copy. The country scene with stile from the Colnaghi group (Pl.382) is a more vigorous type of pastiche, in which the hatching technique and loosely outlined trees in the distance are also based on Gainsborough's very late Ipswich style (Pl.68).

Frost's personal style is characterized by heavily applied chalk work, firm but often clumsy description of shapes (figures and animals in particular usually being blocked out rather than delineated), broad massing and chiaroscuro, for the most part unsubtle gradations of tone, and a rather fuzzy definition of landscape. Though one must be prepared for a considerable variation in point of quality, it is a very idiosyncratic style, and once studied at all, quite easily recognized. To a large extent it was based on the series of soft-ground etchings after Gainsborough drawings published by Laporte and Wells between 1802 and 1805. A drawing formerly in the Ford scrapbook is a close copy of one of these prints,[53] and another in Ipswich (Pl.378) embodies the features on the left of the same composition; the rhythmical conception of this second drawing, the strongly marked chiaroscuro, fuzziness of definition, and in detail, the scallop convention used for outlining the foliage, can be paralleled exactly in Laporte and Wells's prints (Pl.379). There is one instance of Frost's copying a late Gainsborough drawing, the mountain landscape in W. A. Brandt's collection (Pl.380), which is derived from the drawing in the Ponce Museum (Pl.181); the chalk work, especially the heightening in white chalk, and the use of stump are also influenced by Gainsborough's technique of this date.

Frost was thus very deeply influenced by Gainsborough's drawings, in particular those of the Suffolk period and as disseminated by Laporte and Wells. He also absorbed Gainsborough's type of subject matter. In some cases, such as a drawing in Ipswich (Pl.381), where the motifs of the country cart, the drover's arm outstretched, and the dog drinking in the foreground, are all to be found in the same Gainsborough landscape (Pls.334 and 336), he evidently took over material in much the same spirit as he copied certain drawings. But for the most part the similarities are less specific, and though some of his subjects, carts disappearing round bends, waggons passing over hillocks, and so on, are strikingly reminiscent of

[50] Woodall, p.90.

[51] The Frost is reproduced in Woodall, pl.115.

[52] Waterhouse, No.837.

[53] The Frost is reproduced in Woodall, pl.117.

Gainsborough, other resemblances may be due simply to the fact that he was sketching in a countryside where little could have changed since Gainsborough's time.

Though none of his drawings is dated, or watermarked, before 1799, when he was already in his 50's, he was certainly active before this,[54] and seems to have been a prolific draughtsman. Examples of his work, usually attributed, more or less hesitantly, to Gainsborough, can be found in most print rooms. Frost was not an artist of any great merit, but he has a significant place in the Gainsborough tradition, and is of importance also for his association with the other great Suffolk painter

John Constable (1776–1837)

Constable was admitted to the Academy schools in February 1799. That summer he went sketching in Suffolk, and wrote to J. T. Smith from Ipswich: 'It is a most delightful country for a painter. I fancy I see Gainsborough in every hedge and hollow tree.'[55] There is obviously a close affinity between the two great painters in their love for the English countryside, particularly in its humbler, less spectacular aspects; and Constable had the most profound admiration for Gainsborough, which only strengthened as he grew older, though it is true that as a youth he dismissed the later works as 'so wide of nature',[56] and the Gainsborough drawings in black and white chalks which hung in his parlour in later years he appreciated (erroneously) as examples of Gainsborough's reference to nature, studies done at a particular time of day, when sundown had reduced the landscape to nothing more than skeletons and masses.[57]

Constable's early development as a draughtsman is still insufficiently known, and a really precise chronology has never been attempted. At some point, however, he was certainly influenced by Gainsborough's drawings. Sir Charles Holmes claimed that his watercolours done between 1800 and 1807 were almost invariably based upon Girtin, and that his black and white sketches of the same period were 'based with no less consistency upon the style of Gainsborough, sometimes aping it so nearly as to make immediate discrimination between the two far from easy.'[58] But the majority of the drawings with which Holmes illustrated his thesis have in fact little to do with Gainsborough, and much to do with Frost.[59] They are studies in black chalk and stump on large sheets of white paper, exactly in Frost's technique, and in some cases almost indistinguishable from him. Constable was 'on intimate terms of friendship' with Frost,[60] and the two men are known to have gone sketch-

[54] He was active as a drawing master by 1797 (see note 40).

[55] Constable to J. T. Smith, Ipswich, 18 August 1799 (Beckett, Vol.6, op. cit., p.16).

[56] *The Farington Diary*, 25 February 1799 (p.1474).

[57] Leslie, op. cit., p.270.

[58] Sir Charles Holmes, *Constable Gainsborough and Lucas*, privately printed, 1921, p.11.

[59] The same is true of the early landscape study in the Beckett collection which the owner describes as 'a palpable imitation' of Gainsborough (R. B. Beckett, 'Constable's Early Drawings', *The Art Quarterly*, Vol.XVII, No.4, Winter 1954, p.376 and fig.4).

[60] Brown, op. cit., p.16.

ing together, as Constable refers in a letter to an occasion they were both at Stoke Mills;[61] twenty-seven of Frost's black chalk drawings 'in imitation of Gainsborough' were in Constable's possession at the time of his death.[62] The period when Constable was most influenced by Frost's work seems to have been about 1802, as there is a drawing of a windmill in the Victoria and Albert Museum dated October 1802 which is particularly close both in style and technique.

One drawing illustrated by Holmes, which he calls 'the nearest to Gainsborough',[63] is certainly rather different from the others, and exhibits on the right that pervasive parallel hatching in diagonal strokes that is so characteristic of Gainsborough's early sketches. In other respects, however, it is still closest to Frost, and the real evidence for Gainsborough's influence on the young Constable is to be found not in this series at all, but in a group of drawings in the Huntington Art Gallery, generally unknown until they were exhibited there in 1961.[64]

One drawing in this group (Pl.383), executed in black chalk and stump, a large and carefully composed study of a wooded landscape with a milkmaid and cows seen beyond a gate, is comparable in several respects with Frost's freer imitations of early Gainsborough; the touch in the bushes on the right, and the modelling of the middle ground banks, are remarkably close to Frost's wooded scene with stile (Pl. 382). But these similarities may be due to their common source. Broadly, it is based on (perhaps even copied from one of) Gainsborough's finished drawings of the late 1750's, the kind he sent up to the London print shops for sale or intended for engraving; the parallel hatching in the sky, the modelling of the tree trunks, the wispish treatment of some of the foliage, the feeling for light in the water, and the degree of finish, may all be compared with such drawings as those owned by Eric Sexton (Pl.68) or in the Witt Collection (Pl.74). There is also some evidence here to suggest that Constable was equally aware of a rather later type of Gainsborough; the way in which the atmospheric quality of the trees has been enhanced by blurring and moistening the chalk, and the handling of the foreground and of the trees generally, are strikingly reminiscent of the drawing in the late Lord Wharton's collection, datable to the early 1760's (Pl.384).

The pencil drawing of a path leading into a wood (Pl.385) is indeed not only influenced by Gainsborough but closer to the essentials of his style than any other drawing by any artist one can think of, with the exception only of Dupont. The diagonal hatching, the sharp touches delineating branches, and the boldly drawn scallops outlining foliage, are all strikingly reminiscent of such splendid early Gainsboroughs as the study of trees owned by Charles Monteith (Pl.386). In

[61] Constable to John Dunthorne, 22 February 1814 (Beckett, op. cit., p.101).

[62] John Constable sale, Foster's ,10 May 1838 ff., 2nd Day, Lots 294-5.

[63] Holmes, op. cit., No.5 and p.21.

[64] *John Constable Drawings & Sketches*, Huntington Art Gallery, November–December 1961; the references that follow are to the numbers in the Catalogue of this exhibition, compiled by Robert R. Wark. Study of these drawings in 1964 led me to modify the view I held previously, that Constable seemed not to have been influenced by Gainsborough's actual technique, a view for which I have rightly been taken to task by Charles Rhyne ('Fresh Light on John Constable', *Apollo*, March 1968, p.230).

another pencil drawing of a similar subject (Pl.387) the hatching is considerably more vigorous and all pervasive, as in other Gainsborough sketches, but the detailed influence is less obvious and Constable's technique more personal, freer in all respects than in the previous drawing. It is sketches of this kind that prefigure fine rhythmical compositions such as the study of a herdsman and cows at the edge of a wood in the Victoria and Albert Museum, dated June 1803 (Pl.389), in which Gainsborough's influence, though still recognizable enough in a general way, has been thoroughly absorbed.

There remains to consider whether Constable was influenced by Gainsborough before or after he was influenced by Frost. The development discernible from drawings closely based on Gainsborough towards a freer, broader style suggests that Frost's breadth of technique and massing helped to serve as a liberating influence on Constable, and to bring him closer to the underlying structure of landscape; and Constable's enthusiasm for Gainsborough can be documented to 1799, while his association with Frost was around 1802. The unity of conception, sense of grandeur in the principal trees, and feeling for movement and rhythmical flow, in the study of trees in the Huntington Art Gallery (Pl.388), executed in Frost's technique, are anticipated in the drawings influenced by Gainsborough but more fully apparent in the less derivative Victoria and Albert Museum drawing. And it was this latter type of drawing that was to serve as the stylistic starting-point for those brilliant watercolours of the Lakes, done in 1806, that herald the mature Constable.

At roughly the same time as Frost and Constable were learning from Gainsborough, another artist working in East Anglia was imitating Gainsborough's early style; this was

John Crome (1768–1821)

Crome started his career in 1783 as an apprentice to a coach, house and sign painter in Norwich. In about 1790, however, he had the good fortune to meet Thomas Harvey, the banker, an art lover and former friend of Gainsborough, who encouraged him to come and copy the landscapes in his collection at Catton House. He is recorded as having copied Gainsborough's *Cottage Door*,[65] which Harvey had bought in 1786,[66] possibly as a replacement when it was sold in 1807;[67] and Dawson Turner claimed that one of Crome's early canvases, the *Cottage at Hunstanton* (now in the Clifford collection),[68] owed everything to this picture 'in tone, and color, and handling, and surface.'[69] Another of his canvases was apparently often mistaken for Gainsborough, even by Henry Walton, the painter and connoisseur.[70] Crome owned a number of prints after Gainsborough, and two of his

[65] Dawson Turner, *Etchings of Views in Norfolk by the late John Crome . . . together with a Biographical Memoir*, Norwich, 1838, p.6.

[66] Waterhouse, No.941, pl.203.

[67] Derek and Timothy Clifford, *John Crome*, London, 1968, p.52.

[68] Ibid., pp.190–1, Cat. No.P23x.

[69] Dawson Turner, *Outlines in Lithography*, Yarmouth, 1840, p.23.

[70] Ibid., p.21.

black chalk drawings;[71] and in 1806 he exhibited a sketch in the style of Gainsborough at the Norwich Society of Artists.[72]

Hardly any drawings can be attributed to Crome with certainty, so that the relationship of his drawing style to Gainsborough is almost impossible to establish. But three drawings always ascribed to Crome may be noted here. One, a crisp pencil drawing in Edward Seago's collection, is an imitation of an early Gainsborough drawing owned at that time by Richard Payne Knight,[73] in whose house it could well have been studied; and the pencil drawing of a herdsman and cows near a gate in the British Museum (Pl.390) is close to Gainsborough sketches of the kind represented by the woodland scene at Raveningham (Pl.391). The third, a grey wash drawing in the Spooner Bequest to the Courtauld Institute (Pl.392), is related, in its semi-abstract use of washes, to Gainsborough's late wash drawings (Pl.393); and has obvious affinities with the style of Cotman.

One would certainly expect to find other draughtsmen of the Norwich School imitating Gainsborough, but the only case documented so far is a comparatively minor figure

Joseph Geldart (1808–82)

A volume of Geldart's drawings in the Norwich Public Library contains a sketch which is inscribed underneath: *After a drawing by Gainsborough.*[74] In fact, it is based in style on Wells and Laporte's soft-ground etchings of Gainsborough's drawings (though the colour is more subdued) and the composition is a variant on one of these prints.

For some reason, the drawings and watercolours done by Gainsborough at Bath were not so much imitated by professional artists, though Pyne talks of the 'polite idlers' there who sought to emulate the style of his 'moppings' and noted in 1823 that 'there are yet some antique beaux and belles of *haut ton*, who recollect their many friends, who, with themselves, were stricken with this sketching phrenzy'.[75] Ozias Humphrey, who often accompanied Gainsborough on his sketching expeditions into the country in the early 1760's,[76] has left us nothing to suggest that he was ever influenced by him, though one suspects that he must have been; and apart from Jackson, whom we have discussed already, the only imitator we can identify was

[71] Crome sale, Noverre's, Yarmouth, 23–5 September 1812 (Lugt 8238) 1st Day Lots 14 and 91, 2nd Day Lot 205; Crome sale, Athow's, Norwich, 25 September 1821 ff. (Lugt 10113) 1st Day Lots 1, 36, and 105, 2nd Day Lots 13, 25, and 32, and 4th Day Lot 60.

[72] No.221: 'Sketch, from nature, in the style of Gainsborough'. Unfortunately, the catalogue does not make it clear whether this was a drawing or a sketch in oils.

[73] The two drawings are reproduced in Woodall, pls.112 and 16. The Cliffords (op. cit., p.109) rightly relate the Seago drawing (D2 in their Catalogue) to the *Landscape at Hethersett* (D1), and both drawings are undoubtedly by the same hand, but it should be pointed out that the latter forms part of a volume of drawings by David Hodgson presented to the Norwich Museum by the artist's widow.

[74] This drawing was kindly brought to my attention by Dr Rajnai.

[75] 'The Rise and Progress of Water-Colour Painting in England', No.VII, *The Somerset House Gazette*, 20 December 1823, p.162.

[76] 'Biographical Memoir' in Vol.I of the *Original Correspondence of Ozias Humphry, R.A.* (Royal Academy Library).

Thomas Barker (1769–1847)

Barker came to Bath from Wales with his parents in 1782, and shortly afterwards made the acquaintance of Charles Spackman, a wealthy coach painter, who evidently seeing signs of artistic promise in the young lad, took him into his house. 'The first four years he was with Mr. SPACKMAN, he most diligently applied himself to drawing, and copying the works of the principal landscape-painters of the Italian and Flemish schools.'[77] A considerable number of copies and imitations of Gainsborough landscapes of the early 1760's, which were presumably in collections in and around Bath, also date from this period; among these are the signed gouache with Manning Gallery and a watercolour formerly in the Cave collection[78], the tonality and handling of the trees and distance deriving from gouache drawings such as the wooded landscape now in Michael Ingram's collection (Pl.265).

The amount of work he did seems to have been prodigious, and 'his astonishing *facility*'[79] was matter for comment. So, too, were his imitations, as Bate-Dudley wrote in June 1789 that 'an execrable *Impostor* at the brush, who resides at *Bath*, has been labouring for some months past to impose on the taste of the public, by pictures and drawings in this Master's (Gainsborough's) stile.'[80] In 1790 Spackman sent Barker to Italy, where he remained until 1793;[81] he then returned to Bath, and began a highly successful career there. West told Farington in 1807 that he 'lives upon the reputation of *His Woodman* but His Portfolio is stored with subjects of Peasantry &c. landscape admirably drawn with Chalk on stained paper, for truth of expression excellency unrivalled.'[82]

The majority of his surviving drawings are in fact pen drawings, in a broadly Guercinesque style, and probably date from the middle and later years of his career. He published a series of figure drawings of this kind in 1813, following up this volume in 1814 with a series of landscape subjects.[83] None of these drawings is in any way influenced by Gainsborough. But there is one group of drawings, attributable to Barker, all of which have formerly been ascribed to Gainsborough, that do derive from the latter, and were done probably either in the very late 1780's or in the 1790's.

The key drawing in this group is the large watercolour with figures outside a cottage door and children playing oranges and lemons now in the Mellon collection (Pl.395), in which the handling of the foliage, the slightly brittle treatment of the

[77] Anon. (=Sir Edward Harington), *A Schizzo on the Genius of Man*, Bath, 1793, p.126. See also on Barker generally my introduction to the catalogue of the *Barker of Bath* exhibition, Victoria Art Gallery, Bath, June 1962.

[78] S. A. Cave sale, Christie's, 26 May 1961, Lot 47.

[79] Harington, op. cit., p.132, note.

[80] *The Morning Herald*, 11 June 1789.

[81] Introduction to the *Barker of Bath* catalogue, op. cit., p.2.

[82] *The Farington Diary*, 10 November 1807 (p.3848).

[83] *Forty Lithographic Impressions from Drawings by Thomas Barker, selected from his studies of Rustic Figures after Nature*, Bath, December 1813; and *Thirty Two Lithographic Impressions from Pen Drawings of Landscape Scenery, by Thomas Barker*, Bath, 1814.

branches, and the tendency to angularity in the description of form, all link closely with such Barkers as the Italian period watercolours, for instance, the landscape near Sant' Agata in the National Museum of Wales (Pl.394). The other drawings in the group, which are in chalk and wash, but identical in the idiosyncratic treatment of foliage and figures, are the large upright scene of figures in a woodland clearing at Bedford, the landscape with horse and cart and figures at Newport and the smaller landscape with figures and donkeys in Belfast (Pl.396),[84] all of which demonstrate Barker's extraordinary facility and rapidity of execution. The Mellon watercolour derives from Gainsborough's cottage door subjects of the late 1770's (Pl.147), and the Belfast drawing from his late impressionistic sketches of the type now in Rotterdam (Pl.397).

A large chalk drawing in Cleveland (Pl.398) which would appear, at first sight, to have little connection with this group, in fact displays certain technical characteristics in common, in particular the way of modelling the foliage in a loose, long, zig-zag touch, and the rather facile treatment of contours and of the foreground. The brilliant but rather uncontrolled application of the highlights is also entirely typical of Barker, and based on Gainsboroughs like the mountain landscape in the Huntington Art Gallery (Pl.399). The Cleveland drawing is an unashamed pastiche, combining three separate Gainsborough motifs, a sequestered cottage, a woman carrying a pitcher on her head, and horses drinking, the latter an almost exact transposition (including the dog) from the *Horses Watering at a Fountain* which was in Lord Robert Spencer's sale in 1799.[85]

Two other drawings that have appeared with attributions to Barker are copies of Gainsborough, one a small copy again of the *Horses Watering at a Fountain*,[86] the other[87] a replica of the upright drawing with milkmaid and cows in the Witt Collection (Cat. No.500).

Barker's oils in imitation of Gainsborough were principally of landscapes painted during the 1760's, but in his drawings he was clearly influenced by Gainsborough's London style and subject-matter as much as by his Bath, and must be considered as among the more important imitators of the late drawings. Numerous artists imitated Gainsborough's later drawings, but the chief were Hoppner and Dr Thomas Monro.

John Hoppner (1758–1810)

Hoppner was admitted to the Royal Academy schools in 1775, the same year as Dupont (by a coincidence, actually on the same day),[88] and it may thus have been through Dupont that he became acquainted with Gainsborough. As well as being a lover of landscape he was a man of some accomplishment, a wit and a brilliant talker, which would obviously have endeared him to the artist; and there is record of one occasion when the two went on an expedition together in the shape of the

[84] A large drawing of figures and a market cart identical in technique with these was in *Parsons Catalogue*, No.49 (301 repr.)

[85] Waterhouse, No.944; the composition is reproduced on pl.201.

[86] Exhibition of *English Drawings and Watercolours*, Colnaghi's, July–August 1965, No.65.

[87] Exhibition of *18th and 19th Century English Watercolours*, Appleby's, June–July 1965, No.91.

[88] 6 March 1775 (Royal Academy Students Register: published in Hutchison, op. cit., p.141).

black chalk drawing on blue paper by Gainsborough in Philadelphia (Pl.359), which is inscribed as being a study from nature done in Hoppner's presence and afterwards given to him.

Hoppner in fact possessed several of Gainsborough's drawings, as eleven appeared in his sale in 1810, and he also owned a copy of Wells and Laporte.[89] It is of interest to note that he had hardly any drawings other than the Gainsboroughs, and also that many of his own landscape and topographical drawings, including one described as being on blue paper, figured in the sale. A quantity of Hoppner's landscape drawings, including four specified as being after Gainsborough and three in his manner, were later in the possession of Dr Monro.[90]

Hoppner continued to do landscapes at intervals throughout his career. Danloux visited his studio in 1792 and noted that 'il m'a montré des dessins pris sur nature, et me semble vouloir imiter un certain Gainsborough, qui est mort, laissant une grande réputation',[91] and it was in 1803, when he had long been one of London's leading fashionable portraitists, that Farington noted that 'Hoppner shewed me several sketches of Landscape made with Black Chalk on White Paper in the manner of Gainsborough, with whose drawings He is passionately enamoured.'[92] By 1828, apparently, there was already confusion between Hoppner's work and Gainsborough's, as two landscapes in black chalk which were in the second Hoppner sale as Gainsborough 'very fine' were noted by the auctioneer's clerk as *not by him/ . . . by Hopp/ after*.[93]

A large group of Hoppner's landscape studies survives in the British Museum (1875–7–10–863/70), most of them executed in black and white chalks on blue paper (Pls.400–1), but some done in black chalk with a good deal of stump work on white paper, the subjects chiefly woodland scenes, but also including studies of individual trees. These provide the basis for our knowledge of Hoppner's style. In freedom of handling, the loose outlining of foliage, and the rough broken touch in the highlighting in white chalks, especially at the horizon, some of these sketches are remarkably close to the Philadelphia Gainsborough. They also recapture much of Gainsborough's rhythmical flowing movement, though the touch lacks his effortless brilliance.

The method of outlining the foliage, the broad stump work, the rough hatching in places, and the peculiar way of indicating tracks in semicircular strokes in these drawings, enables us to attribute two other drawings in the British Museum (1946–4–13–183 and Pl.404), traditionally by Gainsborough, firmly to Hoppner. These are clearly derived from Gainsborough's sketches in black chalk and stump of the mid-1780's (Pl.405), and give the impression of being copies, though no originals of these subjects are in fact known. One drawing in a similar technique, but with

[89] John Hoppner sale, Christie's, 19 May 1810 (Lugt 7782), Lots 16 (the Wells and Laporte volume), 57, 72–4, and 90–2.

[90] Thomas Monro sale, Christie's, 26 June 1833 ff. (Lugt 13354), 2nd Day, Lots 122–48 and 4th Day, Lot 164.

[91] Diary for 24 December 1792 (Le Baron Roger Portalis, *Henry-Pierre Danloux Peintre de Portraits et Son Journal durant l'Emigration*, Paris, 1910, p.94).

[92] *The Farington Diary*, 21 October 1803 (p.2404).

[93] John Hoppner sale, Sotheby's, 22 May 1828 ff. (Lugt 11759), 3rd Day Lot 357.

highlights in bodycolour, is, however, a direct copy of the engraving of Gainsborough's lost landscape with figures at a stile and sleeping pigs.[94]

Also closely related to the group of studies in the British Museum, but considerably more finished in style, is a fine woodland landscape on blue paper in the Lockett collection (Pl.402), which is nearer to Gainsboroughs like the landscape with a shepherd and flock of sheep in the Ashmolean Museum (Pl.403).

Dr Thomas Monro (1759–1833)

W. H. Pyne wrote in 1824 that 'this gentleman, perhaps, excepting the late Mr. Hoppner, of all the imitators of Gainsborough's style of sketching, was the nearest to his prototype. We have seen many of these pasticci, indeed, which would puzzle the cognoscenti to detect from originals.'[95]

Monro, who was physician to the Bethlehem Hospital and an early specialist in mental disease (he was among those who treated George III), inherited a passionate interest in the arts from his father. He was taught drawing by Laporte, and became an amateur of far more than usual distinction. According to Pyne, again, he was 'for years the very intimate friend of Gainsborough',[96] and is said also to have accompanied him on sketching expeditions.[97] He acquired a large collection of Gainsborough's drawings, about eighty of which he purchased *en bloc* from Margaret Gainsborough in 1801,[98] and these were among the drawings he allowed students to copy at his celebrated 'academy'.

This drawing school was started in the house he bought in the Adelphi in the spring of 1794, in a room especially equipped for the use of students, who came regularly on winter evenings and were paid for what they did.[99] Many copies of Gainsborough's drawings must have been made on these occasions, some no doubt by Girtin and Turner, who were employed for three years at Dr Monro's. Among later students were Linnell and W. H. Hunt, who were set to make copies of Girtin and Turner, as well as of 'studies by Gainsborough and Constable (in charcoal)'; Linnell, rightly or wrongly, 'was of opinion that the doctor used to sell their copies for originals.'[100] And copies were evidently done by Monro himself, as there is an example extant now in the British Museum (Pl.406), inscribed underneath *by Dr T Monro 1817 after Gainsborough*, which is a very close but rather hesitant copy of the

[94] Waterhouse, No.888a.

[95] Ed. Ephraim Hardcastle (=W. H. Pyne), *The Somerset House Gazette*, Vol.2, London, 1824, p.8. Monros were beginning to be distinguished from Gainsboroughs by 1880, as in the catalogue of the Benoni White sale (Christie's, 30 January 1880: Lugt 39819) there is a note in pencil in the auctioneer's copy 'Some by Monro' against Lot 204, a group of eight drawings sold as Gainsborough.

[96] *Fraser's Magazine*, November 1840, p.553. There is no support for this statement in the Monro family papers (information kindly supplied by Dr F. J. G. Jefferiss).

[97] W. Foxley Norris, 'Dr. Monro', *The Old Water-Colour Society's Club*, Vol.2, 1925, p.2. See also Arthur K. Sabin, 'Notes on Dr. Monro and his Circle', *The Connoisseur*, November 1917, p.124. Again, documentary support is lacking.

[98] *The Farington Diary*, 11 April 1801 (p.1944).

[99] J. L. Roget, *A History of the 'Old Water-Colour' Society*, London, 1891, Vol.1, pp.78–9.

[100] Alfred T. Story, *The Life of John Linnell*, London, 1892, Vol.1, p.41. 'A parcel of copies, by Hunt' was among the copies from Gainsborough in the Monro sale (loc. cit., 5th Day, Lot 14).

black chalk drawing now in the Witt Collection (Pl.407), so hesitant in fact that, were it not for the inscription and provenance from the family, one would find it hard to accept as Monro.

For though his style as we know it was evidently strongly influenced by Gainsborough's drawings, it displayed nevertheless a vigour and personal quality altogether exceptional among Gainsborough imitators. The lovely landscape with a girl on horseback in the Ashmolean Museum (Pl.408) derives broadly from such Gainsborough drawings as the landscape with shepherd and sheep in the same collection, also done in black chalk on blue paper (Pl.403), though the brilliant handling of the effects in the clouds and at the horizon, while reminiscent of Gainsborough's sketches of the early 1760's, is technically much closer to Sandby's gouaches.

His landscape with a cow standing in a pool in the British Museum (Pl.409) is more clearly derivative, from the more vigorous of Gainsborough's late black chalk drawings or oil sketches (Pl.410); and it was this kind of sketch that pre-figured the boldness of his personal style (Pl.411) which, with its rapid, broken chalk work usually on absorbent paper, in a sense caricatured Gainsborough's technique in much the same way as Rowlandson's etchings after Gainsborough did. The mountain landscape in the Huntington Art Gallery (Pl.412), formerly attributed to Hoppner, is a splendid example of Monro's sensitivity to atmosphere and light, and of his flowing Gainsboroughesque rhythm. Many of his drawings are also Gainsboroughesque in subject matter, incorporating cottage scenes or ruined castles (Pl. 411) as well as purely pastoral motifs.

Other members of the Monro family also imitated Gainsborough, notably two of the doctor's sons.

Henry Monro (1791–1814)

Henry was Thomas's second son, and trained to be a painter, being admitted to the Academy schools in 1806. There are apparently two references in his diary to copying Gainsborough's drawings, and one such copy (of Cat. No.621) was formerly in the collection of his descendant, Dr Foxley Norris.[101]

John Monro (1801–80)

A small pencil drawing of a lake scene in the British Museum by John Monro (Pl.413) is clearly influenced by certain of Gainsborough's early pencil sketches (Pl.414); and two small drawings on card, also in the British Museum (1961–5–13– 13 and 15), are related to his later style both in subject matter – a figure at a cottage door is featured in one – and in the treatment of the foliage. A larger drawing in the British Museum (1963–11–9–2) is a copy of one of Gainsborough's soft-ground etchings; and a particularly attractive large drawing in pencil on greenish paper owned by Dr F. J. G. Jefferiss, which is close in character to certain of Wells and Laporte's prints, is inscribed as being copied from a Gainsborough drawing in 1832.

[101] Woodall, p.84. The references were presumably contained in the extracts which are now missing from the manuscript.

Thomas Hearne (1744–1817)

Hearne, a prolific topographical draughtsman, was a close friend and favourite artist of Dr Monro, and exceptionally well represented in his collection. Four drawings in imitation of Gainsborough were in his sale in 1817,[102] and may have been done from examples owned by his friend; one exact copy of an early Gainsborough pencil drawing (Cat. No.92) formerly in Esdaile's collection is in the British Museum (1966-10-8-7). But his usual style, though gently rhythmical, was precise and tight, and quite unlike Gainsborough's (Pl.415).

Amelia Long, Lady Farnborough (1762–1837)

Lady Farnborough was an amateur of considerable talent, and reputed to have been Girtin's favourite pupil. Though her husband greatly admired Gainsborough's landscapes and bought *The Watering Place*, now in the National Gallery, as well as examples of his drawings, there is only one case known in which she imitated his work, namely, the signed watercolour in the Huntington Art Gallery which is a direct copy, omitting the boat setting out and the heavy seas, of the seascape then in Sir John Leicester's collection.[103] The technique of this has little to do with Gainsborough, however, and most of her known drawings derive either from Girtin, Edridge or Dr Thomas Monro; the chalk drawing of cows at a watering place in the Victoria and Albert Museum (E3803-1932), for example, in which the trees on the right are Gainsboroughesque in rhythm, is in Edridge's style.

John Laporte (1761–1839)

Laporte, principally known for his elaborate gouache landscapes, clearly knew Gainsborough's drawings intimately, as in 1802–5 he collaborated with W. F. Wells on the well-known series of soft-ground etchings after Gainsborough. Some of the drawings used for this series were in his own collection, and, not unexpectedly, the most Gainsboroughesque of Laporte's own drawings (Pl.416)[104] derives from one of these, the soft feathery treatment of the foliage in the centre, and the more rapid hatching of that on the left, being particularly close to the landscape with a woodland stream and cottage (Pl.379).

In another of the few known drawings that betrays Gainsborough's influence, the pencil drawing of a woodland scene with three stags in the British Museum (1853-8-13-63), the rhythmical conception, the light breaking through from the distance, and the treatment of the foliage, are all Gainsboroughesque without imitating any specific type of Gainsborough. A quite different type of drawing, which appeared in the sale-room in 1952 as Laporte,[105] an unusual attribution if no evidence for it ever existed, was an exact copy of a Gainsborough of which another imitation is at Yale (see p.88).

[102] Thomas Hearne sale, Christie's, 12 June 1817 (Lugt 9160), Lots 68 and 70.

[103] Waterhouse, No.954, repr. pl.224.

[104] *Twenty-Eighth Exhibition of Watercolours and Drawings*, The Manning Gallery, November 1967, No.53.

[105] Anon. sale, Sotheby's, 14 April 1965, Lot 41.

Thomas Rowlandson (1756 or 1757–1827)

Rowlandson also etched some of Gainsborough's drawings, four for Thane in 1789, but others in the artist's lifetime, five of which he included in his *Imitations of Modern Drawings* compiled about 1788. It is highly probable that he was a friend of Gainsborough's. His warm-heartedness and irrepressible love of life would undoubtedly have endeared him to the painter, and there are scraps of evidence that hint at a personal relationship: the circumstance that, like Hoppner, he was a contemporary of Dupont as a student at the Academy schools, his watercolour inscribed *M.ᴿ GAINSBOROUGH'S COTTAGE in ESSEX*,[106] and the fact that his great friend Wigstead owned many of the master's drawings.[107]

His style, as it developed away from the influence of Mortimer, seems to owe much to Gainsborough. At least, his extraordinary sense of rhythm, and the loose notation he adopted for drawing foliage, are features very much in common; and the obvious sympathy he had for Gainsborough's work is amply displayed in his soft-ground etchings of certain of his drawings, brilliant, forceful, personal interpretations though they are. One Rowlandson drawing, in the Boston Public Library (Pl.417), dated 1805, is unusually Gainsboroughesque. Not only does it depict a peasant family at a cottage door, but it includes other Gainsborough motifs: a faggot-gatherer, and a waggon winding along a narrow track. The undulating line and rhythmical treatment of the foliage are also close to Gainsborough, but the gnarled and twisted rococo tree trunks are entirely personal to Rowlandson.[108]

Joseph Farington (1747–1821)

Farington possessed a quantity of Gainsborough drawings, and although the majority of his own drawings are in quite a different style, there are some which have close affinities with Gainsborough. Sketches done on the ground, such as his view of Matlock from the Derwent (Pl.419), are very close, especially in the treatment of foliage, to Gainsborough's late sketches (Pl.420); and landscape compositions like the pen and wash drawing in the Huntington Art Gallery (Pl.421) are Gainsboroughesque in subject and rhythmic conception, though the penwork is much firmer, and closer in this respect to Rowlandson.

Sir George Howland Beaumont (1753–1827)

Sir George Beaumont owned several of Gainsborough's pictures, notably the great *Peasant Smoking at a Cottage Door* now in Los Angeles, which he bought in 1799; and he acquired half the contents of one of Gainsborough's sketch-books (he divided it with Hibbert),[109] and probably possessed other drawings. Beaumont was a very prolific but uneven amateur draughtsman, who was influenced chiefly by Wilson,

[106] Which appeared in the Hay sale, Sotheby's, 18 November 1953, Lot 31.

[107] *The Morning Post*, 5 September 1788.

[108] The drawing in the British Museum (1863–1–10–248) which Binyon catalogued as 'Landscape in the manner of Gainsborough' (*Catalogue of Drawings by British Artists*, Vol.3, 1902, p.252) is also Gainsboroughesque in subject, with its winding track and cottage surrounded by trees, but not very close technically.

[109] *The Farington Diary*, 11 May 1799 (p.1558).

J. R. Cozens, Girtin, Farington and Hearne, but imitated a variety of artists, including Gainsborough. A drawing still in the family possession[110] is in the manner of Gainsborough's rhythmical late landscapes in black and white chalks on coloured paper (Pl.191), though rather more schematic in design; certain of his pencil drawings also owe something to Gainsborough,[111] and others include Gainsborough motifs, such as a woodcutter carrying faggots.[112]

Alexander Cozens (c.1717–86)

The tradition that Cozens settled in Bath in 1765 and there developed his technique of 'blotting' has little support in fact,[113] and there is no evidence that he actually knew Gainsborough either in Bath or in London. But he seems to have been familiar with Gainsborough's work of the early London period, if Oppé's attribution is to be accepted of the unusual varnished wash drawing in his own collection (Pl.422), which is based on the study for the landscape at Petworth in Mrs Keith's collection (Pl.423), but drawn in a style closer to Chatelain than Gainsborough.

George Morland (1763–1804)

Many late eighteenth-century artists, notably Wheatley, adopted Gainsborough's gently sentimental rustic subject matter, but of these none save Morland (who took up the themes but not the sentiment) really owed much to his style of drawing. The soft rhythmical foliage in Morland's drawing of rustics resting in the shade of some trees (Pl.424) is entirely Gainsboroughesque (Pl.403), though denser and more sun-drenched; while his drawing in the British Museum signed and dated 1791 (Pl.425), with its Gainsboroughesque tree arching over the composition, thatched cottage and cart passing by, has a more powerful rhythmical quality which is also close to Gainsborough, though the chalkwork is more angular in touch, and relates technically to Gainsborough's Suffolk sketches (Pl.426) rather than to anything in his later work (compare, too, the treatment of light playing over the foliage). This angular technique is also characteristic of his drawing of a boy with faggots, formerly in the Northwick collection, which had always borne an attribution to Gainsborough.[114] Among his more obvious borrowed subjects is one of his soft-ground etchings, an adaptation of Gainsborough's own soft-ground of cattle passing over a bridge.

Richard Westall (1765–1836)

Westall was a subject and historical painter who profited from the popularity of Gainsborough's fancy pictures. No certain drawings of his are derived from Gainsborough, but one he exhibited at the Academy in 1793 was described in the press as 'a very charming imitation of the late Gainsborough in design, effect, and

[110] Reproduced in the catalogue of the exhibition *Sir George Beaumont artist and patron*, London and other centres, February–November 1969, No.56.

[111] Iolo A. Williams, *Early English Watercolours*, London, 1952, p.237.

[112] Compare the pencil drawing at Belgrave Hall, Leicester (61 A 38).

[113] The evidence is summarized in A. P. Oppé, *Alexander & John Robert Cozens*, London, 1952, pp.25–6.

[114] This appeared at Christie's, 16 July 1968, Lot 19.

the manner in which the whole is produced',[115] and a Gainsboroughesque pen and wash drawing of cows drinking at a pool in the Dunedin Art Gallery is sufficiently close technically (compare the conventions for drawing foliage and the hatching in the shadows) to his landscape in the Victoria and Albert Museum (Dyce 923) to suggest an attribution to him.

William Hamilton (1751–1801)

The 'Hamilton' whose 'Pair of Landscapes, after Gainsborough, black and white chalk, *fine*' was in Esdaile's collection[116] is presumably to be identified with William Hamilton, who specialized in sentimental genre in the style of Wheatley. There is no extant example of his copies of Gainsborough.

Charles Grignion the Younger (1754–1804)

Grignion's father, who incidentally outlived him by six years, had known Gainsborough in those early days when they were both students of Gravelot,[117] and no doubt introduced his son to him in the 1770's. Grignion became a portrait and subject painter, and his portrait drawings, of which examples are his *Joseph Nollekens* in the Huntington Art Gallery, *Richard Yeo* in the British Museum (Pl.427) and *Joseph Wilton* in the National Portrait Gallery (4314), were executed in a technique similar to Gainsborough's late figure sketches (Pl.429), black chalk and stump with white chalk to heighten either on coarse buff or on blue paper, but are very much tighter in handling.

Philippe Jacques de Loutherbourg (1740–1812)

Though de Loutherbourg was a friend of Gainsborough's and shared with him a predilection for dramatic effects (he was the inventor of the celebrated *Eidophusikon*), their drawings generally have little in common. The pen and wash drawing of heifers in a cart in an open landscape with coastal background in the Huntington Art Gallery, signed and dated 1775, is similar in subject matter to the drawing in Washington (and in *mise en scène* to Gainsborough drawings of a slightly later date), but the technique is quite dissimilar and related rather to the Gravelot tradition. His studies of animals in black and white chalks on blue paper, however (Pl.428), are close to Gainsborough's (Pl.325), though rather tighter and more mannered.

Julius Caesar Ibbetson (1759–1817)

Farington informs us that in his early days Ibbetson 'was much employed by Picture dealers in copying the works of Loutherburgh &c, which were frequently sold as originals',[118] and certain copies of Gainsborough's landscape paintings can be identified as his work. No copies of Gainsborough's drawings are yet identifiable, but it is known that he coloured some of his landscape drawings for the dealer

[115] William T. Whitley, *Artists and their Friends in England 1700–1799*, London, 1928, Vol.2, p.178.

[116] Anon. (=William Esdaile) sale, George Jones, 2 March 1819 (Lugt 9525) Lot 193. I owe this reference to Mr Edward Croft-Murray.

[117] Anthony Pasquin (=John Williams), *Memoirs of the Royal Academicians*, London, 1796, p.102, note.

[118] *The Farington Diary*: 'Notebooks on artists' (p.2).

Panton Betew, as four such appeared at Christie's in 1821.[119] His rustic subject matter, like Wheatley's, had much in common with Gainsborough.

John Linnell (1792–1882) and
William Henry Hunt (1790–1864)

are the only artists actually documented as having been put to copying Gainsborough's black chalk drawings in Dr Monro's establishment,[120] and one (unusual) later example of Linnell's draughtsmanship, a pencil and wash drawing of cows at a watering place owned by R. Byng, is fully Gainsboroughesque both in subject and treatment.

Student copies must have been common in the early nineteenth century, and

William Edward Frost (1810–77)

the follower of Etty, copied Gainsborough's pencil drawings when he was a student at Sass's Academy in the late 1820's; these are supposed to have come onto the market as originals after the artist's death.[121]

Unidentified Imitators

Imitations intended to deceive were perpetrated from very shortly after Gainsborough's death, and Bate-Dudley wrote in October 1788 of 'Attempts having been made by the *Fabricators* in the polite arts, to pass off some very *miserable imitations* of Mr. GAINSBOROUGH's beautiful stile of drawing.'[122] If it were possible to reconstruct the collections of Gainsborough drawings made in the nineteenth century a generation or more after the people who had known the artist well had died, one would certainly find that any clear understanding of the characteristics of his style had become blurred. Among the drawings collected by the Rev. Alexander Dyce, for example, whose collection survives intact in the Victoria and Albert Museum, there are not only Duponts and several Frosts, but a number of unconvincing imitations of several different sorts. A large quantity of drawings, good, bad, and indifferent, which may have been done either as *bona fide* imitations or with less honest intentions, and that are difficult to attribute to known copyists, still surround Gainsborough's *œuvre*. The more deceptive of these should be discussed briefly, starting with two or three hands of considerable character.

A draughtsman who imitated Gainsborough of the 1760's, and whom it has been tempting to identify with William Jackson, produced drawings in pencil and grey wash of the quality of the landscape with milkmaid owned by the Rev. L. W. Sholl (Pl.430) and the market cart at Leeds (Pl.432). The former relates to Gainsborough

[119] Andrew Johnson sale (of pictures formerly collected by Panton Betew), Christie's, 5 December 1821 (Lugt 10141), Lot 37.

[120] Story, op. cit., Vol.1, p.41. 'A parcel of copies, by Hunt' was in the Monro sale, Christie's, 26 June 1833 ff. (Lugt 13354), 5th Day, Lot 14.

[121] Lord Ronald Sutherland Gower, *Thomas Gainsborough*, London, 1903, p.101.

[122] *The Morning Herald*, 10 October 1788. A contrary point of view on this question of imitations was adopted by another critic, who wrote that since 'The slightest sketch from the pencil of the late GAINSBOROUGH is now held in great value . . . The diffusion of such models cannot be too wide, as the art itself must derive improvement and advantage from multiplying proofs of so chaste and elegant a fancy' (*The Morning Post*, 30 August 1788).

drawings in a similar technique like that at Yale (Pl.431), though the scallops out-lining foliage are larger and looser; and the latter is a copy of the drawing at Birmingham (Pl.433) which dates from the end of the 1760's, but again executed in a personal and vigorous style.

A skilful copyist close to Rowlandson, and more particularly Farington (compare Pl.421), but just lacking in their vitality of penwork and sense of definition, imi-tated Gainsborough's late style, probably as represented by the aquatint of a group of riders in a wooded landscape which formed one of Boydell's set (Pl.435), since he made a copy of this print (see below). The drawing with herdsman and cows at Yale (Pl.434) is exactly in this style; the pronounced contours, rough relationship of wash to outlines, and types of trees are among obvious similarities. But the draughts-manship lacks the tension and vitality of the Gainsborough. The tree trunks are slacker, the cows immobile and rooted to the ground, and the rocks fussily modelled and somewhat sponge-like instead of being blocked out boldly in light and shade. A ruled brown line surrounds the whole composition, and some brown washes have been swept across the bottom of the drawing just inside this border; a signature stamped in gold appears lower left and two further border lines enclosing a gold-tooled pattern have been added. These features are difficult to explain unless the artist was intending to pass off his work as Gainsborough's; it is possible, however, that they were already present, and that the drawing as we know it is a reworking of a faint original. It is certainly likely that the drawing is imitative of a Gains-borough composition, as another version, by Laporte, is also extant (see p.83).

Another drawing with the same technical characteristics, of almost the same size and in the same medium, and also bearing a signature stamped in gold, appeared recently in the saleroom:[123] the composition in this case is clearly derived from one of Gainsborough's late mountain landscapes. The other two drawings by this hand are both in the Spooner collection. One is an almost exact copy of the Gainsborough aquatint of a group of riders, and the other is a rather Gaspardesque mountain scene (Pl.436) in which the squiggles and dashes outlining forms characteristic of the Yale drawing have become the most dominant feature of the calligraphy. Were it not for this idiosyncratic calligraphy and the harshness of lighting, this drawing would be deceptively close to such rapid Gainsborough wash drawings as the land-scape with a country house in the Huntington Art Gallery (Pl.437). None of these four drawings, it may be noted, is on laid paper.

A vigorous draughtsman who also imitated Gainsborough's late style may be represented by a black and white chalk drawing which appeared in the saleroom a few years ago (Pl.438). The firm, thick contours are less fluent than in comparable Gainsboroughs (Pl.439), the figure and animals more static, and the foliage less organic in places.

Another unidentified copyist was responsible for the black chalk drawing of a river scene in the Morgan Library (Pl.440), which is characterized by rather emphatic and insensitive hatching and a somewhat woolly definition of form, and evidently influenced by certain of Gainsborough's drawings of the late 1770's (Pl.441). A

[123] Anon. sale, Christie's, 11 June 1968, Lot 44A.

drawing in the Mellon collection (62/12/6/259), which displays exactly the same characteristics and is clearly by the same hand, is a copy of the Gainsborough drawing of this date owned by George Goyder (Pl.135).

Two other copyists of some character may be noted briefly. One is well represented by a faithful transcription formerly in the Horne collection.[124] The second, whose technique is characterized by a rather feathery touch in the foliage and a broken use of wash, made copies of the drawing in the National Gallery of Ireland (Pls.442–3) and one of Gainsborough's soft-ground etchings with aquatint[125] (Pl.444).

A group of classicizing drawings in which the component parts are much like stage props, executed in a very generalized style, with unusually broad scallops outlining the foliage (a technique probably derived from a certain type of drawing by Gaspard Dughet), should also be mentioned. One example is in the Witt Collection (3938), and another is at Sheffield, both of these being attributed to Gainsborough. A third, in the Baltimore Museum, bears a false signature and date: *R Wilson 1776*, which gives a better clue to the artist, as the hand is clearly in the ambience of Wilson rather than of Gainsborough.

Two small pencil drawings executed on card in the Huntington Art Gallery (Pl.445) derive technically from certain of Gainsborough's early pencil sketches. The motif of the country waggon travelling along a winding track past a pollarded tree is very Gainsboroughesque, but the convention of indicating grass in a mass of disconnected dots and dashes has nothing to do with Gainsborough and is entirely personal to this copyist.

A small watercolour in the British Museum (Pl.446) is inscribed on the back by the owner who presented it, the Rev. C. M. Cracherode, 'Given me by Mr. Samuel Collins, miniature painter, who had it off Mr. Gainsborough.' Collins was working in Bath until 1763, and there is no doubt that this drawing represents Gainsborough's early Bath style: the handling is close to his study of trees at Foxley dated 1760 (Pl.80), while the idea of leading the eye into the composition through a track winding uphill from the foreground is found in Mr and Mrs Fosburgh's drawing (Pl.84). But equally, the touch is too coarse for Gainsborough himself, the outlining of the bough on the right of the tree stump, in particular, being quite uncharacteristic. One possibility is that the drawing is a copy or imitation by Collins,[126] but there are no other landscape drawings by this artist extant to serve as criteria; another is that it is by Jackson, with whose style there are certain affinities.[127]

Another drawing in the British Museum which cannot be associated with a known hand (Pl.447) is an almost exact copy of a Gainsborough of the 1760's in the Alan D. Pilkington collection (Cat. No.300), and is characterized by niggling, broken contours, and a very unsure use of wash, especially noticeable in the sky. A clever imitation of Gainsborough's drawings on blue paper of the 1770's is also in the

[124] Reproduced in Mrs Bell, f.p.20, and Armstrong 1898, f.p.160.

[125] Not listed in Woodall: the only impression known is in the Minneapolis Institute of Arts.

[126] See Woodall, pp.58–9.

[127] See my article in *The Connoisseur*, op. cit., January 1970, p.21.

British Museum (Pl.448); comparison with drawings like the landscape with a shepherd and flock of sheep in the Ashmolean Museum (Pl.403), however, reveals the trees as lacking in vigour, the highlights as not brilliantly enough touched in, and the distance as a little too particularized, the treatment in fact being pedestrian rather than evocative.

Most imitations are of the late style. A drawing in the Fogg Museum (Pl.449) is a poor attempt at a copy of the drawing in Dr Hemphill's collection (Pl.450), in which the imitator has tried to follow Gainsborough's every stroke. A drawing in Birmingham (Pl.451) is an equally flagrant copy of an original now in Bristol (Pl.452), in which the handling is completely flat and all Gainsborough's subtleties of modulation are lost. Two, one in the Glasgow University collection and the other in the Norfolk Museum, Virginia, are summary copies of the same original now in the Tate Gallery (Pl.222). And one in Chicago (Pl.453) is a copy of the superb mountain landscape in an English private collection (Pl.454)[128], executed in the style of drawings such as that in the British Museum (1910–2–12–258), but displaying a certain woolliness of modelling and outline and lacking the vigour and crispness of touch of Gainsborough.

It was not of course only landscapes that were imitated, but portrait, figure, and animal subjects as well. Copies of Gainsborough's portraits are legion, most of them direct transcripts of either the whole or the head and shoulders, but sometimes amalgamating features from different compositions (a favourite trick of the forger). A drawing of a shepherd boy with his dog in Philadelphia (Pl.455) executed on pink paper, is a somewhat clumsy imitation of Gainsborough's very rapid sketching technique in his fancy subjects (Pl.201), with background hardly indicated. The drawing of a puppy in the Huntington Art Gallery (Pl.456), on the other hand, is a rather laboured attempt to reproduce Gainsborough's spontaneous chalkwork: the hatching is regular and uninspired, the features too hard, and the lines suggesting the form of the left ear and outlining the back fail to model successfully (compare Pl.458).

Copies of engraved subjects are, as one might expect, especially common. A black chalk drawing in the Torbock collection which is a copy of one of Gainsborough's soft-ground etchings would be particularly deceptive were the paper not watermarked 1804. Another imitator, possibly a late nineteenth-century hand of the type described below, used an original soft-ground as a foundation for a drawing in black and white chalks in which the composition was amplified. Among numerous copies of Wells and Laporte (Pl.379) are examples in Bradford (Pl.457) and the Oppé collection (2510).

A good many imitations are adorned with false signatures and dates, usually very improbable dates. A drawing in Princeton (Pl.459) which is distantly related to Gainsborough's late style is inscribed *T.G. 1747*, and another, in Dunedin, which is a copy of *The Market Cart*, and probably done from an engraving, is hopefully dated 1767 (the original being executed twenty years later). The imitator who inscribed the landscape in Chicago *Gainsborough 1769* was perhaps a little nearer the mark.

[128] A variant of a mountain scene in Birmingham (Pl.221) also the subject of an exact copy.

In some cases, signatures have been added to genuine drawings by other artists: an example of this is a Monro landscape in Berlin (119–1925). There are also instances of false signatures being added to genuine drawings by Gainsborough.

Towards the end of the nineteenth century it seems to have been a practice to retouch or elaborate genuine drawings,[129] and drawings such as the landscape in Rotterdam (Pl.460), in which the stumpwork has been reinforced by black chalk outlines and modelling, and a shepherd and sheep added, by a later hand, are probably examples of this.

A number of drawings wrongly attributed to Gainsborough are not imitations at all, but independent works by other artists. Among figure drawings there are examples by the elder Grignion, Lady Diana Beauclerk, and Angelica Kaufmann; and among landscapes drawings by Hearne, Monro, and (more surprisingly) Boucher.

In conclusion, a good many late-eighteenth and nineteenth-century artists who were naturally responsive to the pastoral beauties of the English countryside produced works that might well be considered in the broadest sense Gainsborough-esque, though without being in any way imitative. Even so abstract an artist as Francis Towne can come close to Gainsborough, and his technique of delineating foliage is sometimes similar; while Turner's otherwise Girtinesque *Fonthill Abbey from the Lake* in the British Museum (Turner Bequest XLVII–46),[130] done about 1799, with its horses drawing a cart silhouetted against the distant trees and gently rhythmical composition, is an early and important example of this enduring tradition of Gainsboroughesque landscape.

[129] Gower, op. cit., p.102.

[130] Reproduced in Michael Kitson, *J. M. W. Turner*, London, 1964, p.21.

8

Owners and Collectors

The earliest owners of Gainsborough's drawings were his Ipswich friends, Thicknesse, Kirby and Kilderbee.

Thicknesse claimed to have owned his maiden drawing, 'a group of trees', which was given to him together with 'a great many sketches of Trees, Rocks, Shepherds, Plough-men, and pastoral scenes, drawn on slips of paper, or old dirty letters, which he called *his riding School*, and which have all been given, borrowed, or *taken away* from me, except his *first wonderful Sketch*, which would have been gone also, but that I had pasted it in a M.S. bound book of music, composed and written by my affectionate and departed brother';[1] this volume has never been traced. Thicknesse also mentions drawings given to him at a later date,[2] when both Gainsborough and he were living at Bath.

Our knowledge of Kirby's collection is much fuller, and derives from the catalogue of the sale held in 1860, and some reminiscences with which the Rev. Kirby Trimmer supplied Thornbury a year or so later. Like Thicknesse, Trimmer also claimed that Gainsborough 'gave him [Kirby] his first drawing (now in my possession)', as well as 'above a hundred drawings in pencil and chalk, most of which I still have', including a full-length self-portrait reclining on a bank and a sketch on a small piece of paper of the artist and his wife before they were married.[3] Of the fifteen drawings sold in 1860,[4] several were portraits, notably 'A landscape, with a courtship – portraits of Jos. Kirby and his wife', while three were acquired later than the 1750's, two of these being varnished drawings and the third a study of trees purchased at the Kilderbee sale.

Kilderbee was a life-long intimate of Gainsborough, and the executor of his will, and the drawings he owned dated from all periods (Pl.121). He also possessed an important group of Dupont drawings. But about ten landscape drawings which were in black-lead pencil, and another 'in the manner of Wynants', all evidently early works, are likely to have been given to him at Ipswich.[5]

Of his Suffolk clients, the Rev. Mr Hingeston is known to have possessed some drawings;[6] and a descendant of the Edgar family was in 1856 'in the possession of

[1] Thicknesse, p.7.

[2] Ibid., p.29.

[3] Thornbury, Vol.2, pp.58–9.

[4] Rev. Henry Scott Trimmer sale, Christie's, 17 March 1860 (Lugt 25368), Lots 1–14.

[5] Samuel Kilderbee sale, Christie's, 30 May 1829 (Lugt 12074), Lots 35–54.

[6] Fulcher, p.49.

several admirable water-color drawings executed by Gainsborough at this period (the 1750's), and given by him to one of her ancestors.'[7]

Though Gainsborough is known to have sent up drawings as well as paintings to the London dealers in his impecunious Suffolk days,[8] and sold some of his 'original DRAWINGS in the Landskip way' at the time he left Ipswich,[9] it is clear that a proportion at least were given away. For the period after 1760 we have it on the authority of Jackson that 'he never sold, but always gave away his drawings; commonly to persons who were perfectly ignorant of their value.'[10] Bate-Dudley confirmed and amplified Jackson's statement when he stated in connection with the forgeries current shortly after Gainsborough's death that he had 'authority to say, that there cannot possibly be a DRAWING (of his) . . . in the hand of any dealer whatever; that the few he parted with during life were either *gifts* to very particular friends, or select persons of fashion; and that he could never be prevailed upon to receive money for those effusions of his genius.'[11]

The people who owned Gainsborough drawings in the eighteenth century were thus for the most part either the artist's friends, or those sitters and patrons who became his friends. Among the latter were Lord Camden, who is supposed to have encouraged him when he first arrived in Bath (Pl.182);[12] Lord Hardwicke, whose fine group of drawings passed to Baroness Lucas (Pls.81 and 235); and Lord Bateman, who was given seven in September 1770 (Pls.103, 108, and 112).

As Gainsborough was a constant and far from unwilling victim to the enchantments of the fair sex, it is more than likely that many of his lady friends and female sitters were among these early owners. Jackson tells us that he once 'presented twenty drawings to a lady, who pasted them to the wainscot of her dressing-room'[13] (it was then a fashion to paste prints onto walls),[14] adding that 'sometime after she left the house: the drawings, of course, became the temporary property of every tenant.' No doubt she was one of the featherbrained whom Jackson had in mind as being ignorant of their merit. Another feminine owner of eight or ten of his drawings was the beautiful Caroline, 4th Duchess of Marlborough, who had sat to him as a young bride in the 1760's;[15] and Lady Beaumont was presented with at least one.

There is a good deal of evidence as to which of his friends owned drawings, and in some cases it is known exactly which drawings. Fourteen were presented to (almost

[7] Ibid., p.39, note.

[8] John Thomas Smith, *Nollekens and his Times*, ed. G. W. Stonier, London, 1949, p.92.

[9] *The Ipswich Journal*, 20 October 1759.

[10] Jackson, p.159.

[11] *The Morning Herald*, 10 October 1788. In a note listing some of the owners of Gainsborough's drawings, published nine months later, he commented that 'as Mr. GAINSBOROUGH, in his life-time, never could be prevailed on to part with a Drawing for money, it is not a subject of wonder, that so few are to be found in the cabinets of the curious' (*The Morning Herald*, 27 June 1789 (V. & A. Press Cuttings, Vol.2, p.462)).

[12] *The Morning Herald*, 4 August 1788.

[13] Jackson, p.159, note.

[14] Mrs Papendiek, *Court and Private Life in the Time of Queen Charlotte*, ed. Mrs V. D. Broughton, London, 1887, Vol.1, p.49.

[15] See my article on 'Gainsborough and the Bedfords', *The Connoisseur*, April 1968, pp.222–4.

certainly) Goodenough Earle,[16] his host at Barton Grange, a house in Somerset where he seems often to have stayed. Though these were sold in 1913, most have now been traced, and have turned out to be drawings of remarkably high quality (Pls.94 and 273), perhaps the finest being the magnificent late oil sketch owned by G. D. Widener (Pl.214). There is a reference in a letter to his having given a 'Chalk scratch' to Garrick,[17] and two landscape drawings were in the latter's sale.[18] Jackson must certainly have owned some; in one letter, Gainsborough, who was anxious to obtain some indigo from him, wrote: 'so look sharp for some more (& I'll send you a drawing)',[19] and in another, dated 1777, he spoke of 'a Parcell made up of two Drawings and a Box of Pencils.'[20]

Abel possessed an unusually fine collection, and was evidently a real enthusiast for anything his friend did. He gave Gainsborough a viol da gamba 'in *return* for two valuable landscapes, and several beautiful drawings',[21] and is supposed to have had 'the walls of his apartment covered with them, slightly pinned to the paper-hangings', though gradually, apparently, '*Signora Grassi*, for whom he took a house in Frith-street, wheedled him out of these treasures of art, and bestowing handsome frames upon them, they were made the decorations of the Signora's drawing-room.'[22] Enough remained, however, for as many as thirty-two drawings to appear in Abel's sale in 1789;[23] four were etched by Rowlandson at this time, and one of these is now in the British Museum.

Bate-Dudley had a small collection; a present of drawings is mentioned in a letter of 1788,[24] and the group presented to the National Gallery by his nephew in 1878 was presumably once his (Pls.222–3). Another recipient was William Pearce, of the Admiralty, who married one of Bate-Dudley's sisters; he owned one of the finest of Gainsborough's figure drawings (Pl.204), and this, together with others (Pl.140), he in turn gave away to friends. John Thomas Smith records a visit to the master's studio in company with Nollekens when Gainsborough 'gave him (Nollekens) a book of sketches to choose two from, which he had promised him.'[25] Several belonged to Colonel Hamilton, the gentleman pugilist, whose playing of the violin had so enchanted Gainsborough on the occasion of Smith's visit. Rowlandson's friend Wigstead owned 'some of GAINSBOROUGH's most charming efforts' and increased his collection after Gainsborough's death.[26] Twelve drawings were owned, and prized, by Sheridan; in spite of his perpetual financial difficulties, they were

[16] See my article 'The Gainsborough drawings from Barton Grange', *The Connoisseur*, February 1966, pp.86–7.

[17] Gainsborough to David Garrick, n.d. :Woodall *Letters*, No.33, p.75.

[18] David Garrick sale, Christie's, 5 May 1825 (Lugt 10887), Lot 134.

[19] Gainsborough to Jackson, n.d.: Woodall *Letters*, No.53, p.107.

[20] Gainsborough to Jackson, Pall Mall, 25 January 1777: Woodall *Letters*, No.60, p.121.

[21] *The Morning Herald*, 25 August 1788.

[22] Henry Angelo, *Reminiscences*, London, Vol.1, 1828, p.190.

[23] C. F. Abel sale, Christie's, 13 December 1787 (Lugt 4232), Lots 8–13 and 26–34.

[24] See *The Morning Herald*, 1789 (V. & A. Press Cuttings, Vol.2, p.503).

[25] Smith, op. cit., p.172; these were presumably Lot 106 in the Joseph Nollekens sale, Christie's, 4 July 1823 (Lugt 10492).

[26] *The Morning Post*, 5 September 1788.

still to be seen hanging in his wife's dressing-room in 1806.[27] Jonathan Buttall, Gainsborough's 'Blue Boy' of 1770, had a group, which was sold in 1796.[28] Finally, Charles Wray, chief accountant at Hoare's Bank, where Gainsborough had an account 1762–85, was given some, as he bequeathed to his nephew Charles Wilkins in 1789 'the Six Drawings by Gainsborough given me by himself (Gainsboro).'[29]

Many drawings, of course, remained in the artist's possession, or that of his careful spouse. Thicknesse remarked in 1788 that 'Mrs. G. has a great number of drawings . . . which she *hoarded* up, observing *justly*, that they would fetch a *deal* of money when *Tom was dead*.'[30] Gainsborough's drawings, after his death, were indeed 'in the highest request, and sought with the utmost avidity',[31] and though Mrs. Gainsborough declined to sell for the time being,[32] she was able to offer no fewer than 153 in the private sale which opened at Schomberg House on 30 March 1789. Among the purchasers were the Queen, Lords Carlisle, Duncannon, Ossory and Warwick, George Gostling, George Hibbert, Charles Long, and William Pearce.[33] Queen Charlotte's purchase was a group of six drawings in coloured chalks, part of a series of twelve of which Gainsborough had presented her with four through Lord Mulgrave some years earlier;[34] all told she owned twenty-two drawings, but these she was obliged to sell in 1819,[35] so that, sadly, none remains in the present royal collection.[36] A second sale was held at Christie's in June 1792,[37] prior to Mrs Gainsborough and Gainsborough Dupont removing from Schomberg House. Sixty-two drawings were offered for sale, including seven varnished drawings, and though the prices and buyers' names on this occasion are unfortunately unknown, Bate-Dudley reported that 'Gainsborough's collection of beautiful Drawings sold at prices adequate to their merit.'[38]

When Mrs Gainsborough herself died in December 1798, she bequeathed all the drawings in gilt frames and the two varnished drawings in oval gilt frames to her elder daughter Margaret, but directed that all those pictures and drawings not specified should be sold and the proceeds invested.[39] This direction Margaret

[27] *The Morning Herald*, 27 June 1789 (V. & A. Press Cuttings, Vol.2, p.462); see also Whitley, p.320.

[28] Not 1799, as stated in Lugt (5997): see *The Farington Diary*, 15 December 1796 (from the typescript in the British Museum Print Room, p.859). No copy of the catalogue has been traced, although it is included in the typewritten list compiled by Hofstede de Groot and now in the Rijksbureau.

[29] Will, proved 7 February 1791 (Somerset House Registry). I am indebted to Captain T. Barnard for this reference.

[30] Thicknesse, p.61.

[31] *The Morning Post*, 5 September 1788.

[32] *The Morning Herald*, 24 September 1788.

[33] See the list of buyers' names, taken from Dupont's own annotated copy of the catalogue, printed in Ellis Waterhouse, 'The Sale at Schomberg House, 1789', *The Burlington Magazine*, March 1945, pp.77–8.

[34] Whitley, p.320.

[35] Anon. (=Queen Charlotte) sale, Christie's, 24 May 1819 ff. (Lugt 9604), 1st Day, Lots 133–7 and 3rd Day, Lots 117–21; two more drawings were sold in An Illustrious Personage (=Queen Charlotte) sale, Christie's, 13 July 1819 ff. (Lugt 9631), 3rd Day, Lots 390–1.

[36] A. P. Oppé, *English Drawings . . . at Windsor Castle*, London, 1950, p.52.

[37] Gainsborough sale, Christie's, 2 June 1792 (Lugt 4926).

[38] *The Morning Herald*, 9 June 1792.

[39] Will, proved 10 January 1799 (Somerset House Registry).

Gainsborough immediately carried into effect, as shortly afterwards, on 29 January 1799, we hear of Farington paying her a visit with Sir Francis Bourgeois and buying 'many sketches by her late Father';[40] Farington called again the following day '& bought some more sketches.'[41] What happened to Farington's collection of Gainsborough drawings is unknown, but there is a possible clue in a later entry in his diary: 'Dr. Monro called & looked over part of my sketches by Gainsborough and expressed a desire to purchase some of them.'[42] Some might well have passed to Constable when he moved into Farington's house in Charlotte Street after the latter's death in 1821, as he is known to have purchased the Wilsons.[43]

Though Margaret Gainsborough tried to sell many of her father's pictures by private treaty she was not very successful in her attempts, as she priced them too high, and in May 1799 she resorted to auction sale. Farington noted that 'Walton bought the Welsh view for 31 guineas, for which Miss Gainsborough asked 100',[44] but allowed that Gainsborough's sketch-books 'went for prices beyond my expectations. The eight books sold for 140–3–6. – Mr. Hibbert bought two, & He & Sir George Beaumont bought one to divide. Mr. Payne Knight bought one. Mr. Pugh bought one.'[45] In actual fact, ten books were offered for sale,[46] of which Hibbert bought three, Pugh bought three, and Payne Knight and Colnaghi's one each; two, including the book containing 'imitations from antique vases and sculpture', were bought in. The later history of some of these drawings is known: Payne Knight bequeathed the sketch-book he acquired to the British Museum in 1824, and a large proportion of the sketches which Hibbert bought (he possessed well over 100, perhaps nearer 140) were in the Holland-Hibbert sale in 1913[47] (Pls.175, 176, and 420). What happened to Sir George Beaumont's, however, is unclear.

But Margaret Gainsborough had by no means exhausted the supply of her father's drawings with the sale at Christie's. Farington dined with Dr Monro in April 1801, and noted that 'After tea we looked at a Portfolio of drawings by Gainsborough purchased lately by Dr. Monro from Mrs. (Miss) Gainsborough. He gave her a draft for 160 guineas, & afterwards added 20 guineas on her complaining of it being too little. – There are I suppose about 80 in number. – Some of them very fine.'[48] She also kept a number 'as favourite studies of her Father',[49] some of which were bequeathed to her executrix, Sophia Lane,[50] who was the daughter of

[40] *The Farington Diary*, 29 January 1799 (p.1454).

[41] Ibid., 30 January 1799 (p.1455).

[42] Ibid., 14 June 1820 (p.7797).

[43] See Constable's letter to John Fisher, April 1822: 'They mean to part with some things – not by auction. They will sell the *Wilsons*' (R. B. Beckett, *John Constable and the Fishers*, London, 1952, p.97).

[44] Ibid., 10 May 1799 (p.1558).

[45] Ibid., 11 May 1799 (p.1558). George Hibbert (1757–1837), a West Indian merchant, was a prominent book and print collector. Mr. Pugh was probably one of the artists of that name active at this period.

[46] Gainsborough sale, Christie's, 11 May 1799 (Lugt 5917), Lots 81–90.

[47] Hon. A. H. Holland-Hibbert sale, Christie's, 30 June 1913.

[48] *The Farington Diary*, 11 April 1801 (p.1944).

[49] See above Lot 95 in Anon. (=Lane and Briggs) sale, Christie's, 25 February 1831 (Lugt 12572).

[50] Will, proved 5 January 1821 (Somerset House Registry).

Gainsborough's sister Susannah, and these descended to her son, Richard Lane. The greater part, however, she gave to her friend and neighbour in Acton, Henry Briggs.

A large proportion of these groups, seventeen figure drawings and sixteen landscapes in all, were dispersed at Christie's in 1831;[51] the portrait and fancy drawings, many of which had been lithographed by Richard Lane and were among those published in volume form in 1825, must rank among Gainsborough's most outstanding drawings (Pls.98, 201, and 205).

Other groups of drawings were bequeathed to Sophia Lane's two sisters, Susan Gardiner and Elizabeth Green.[52] The first of these was inherited by the Rev. Edward Gardiner and eventually appeared in the saleroom in 1923,[53] and the other passed through the possession of Miss Thorne to Mrs Kenneth Potter, the present owner (Pl.199).

Among the early collectors pride of place must certainly go to Dr Thomas Monro (1759–1833), who is said to have known Gainsborough and was possibly therefore a recipient of gifts of drawings. Monro was well known as the patron of Girtin, Turner, Hearne, and other contemporary watercolourists, and Farington noted in 1795 that 'Dr. Monro's collection of drawings by modern artists is larger than any I have before seen.'[54] His collection of Gainsborough drawings alone numbered over 130 examples,[55] and, apart from Hibbert's, was the largest ever to be formed by any private person. The emphasis was entirely on landscapes, and a proportion consisted of sketches and early works (Pl.28). Eighty, as noted above, were purchased *en bloc* from Margaret Gainsborough early in 1801, and of Monro's drawings traceable now, all are of considerable quality: the landscape with shepherd and sheep in the Ashmolean Museum (Pl.403) or the landscape with cottage and market cart in Melbourne (Pl.145) may be cited as examples. We know something also of how Monro kept his drawings, as his granddaughter described 'the manner in which he would cover the walls of his room at Bushey with sketches by Gainsborough, Turner, Girtin, and others. These sketches he pasted on to the wall side by side, neither mounted nor framed, and he would nail up strips of gilt beading to divide the one from the other, and give the appearance of frames.'[56]

George Baker (1747–1811), lace merchant of St Paul's Churchyard, an ardent bibliophile and print collector who owned matchless series of prints by Hogarth and Woollett, possessed over sixty Gainsborough drawings (Pl.228),[57] including a sketchbook containing thirty-three drawings of landscapes and animals, presumably

[51] Anon. (=Lane and Briggs) sale, Christie's, 25 February 1831 (Lugt 12572), Lots 95–117.

[52] Will, proved 5 January 1821 (Somerset House Registry).

[53] Mrs Harward sale, Christie's, 11 May 1923, Lots 95–100.

[54] *The Farington Diary*, 1 December 1795 (p.438).

[55] Dr Monro sale, Christie's, 26 June 1833 ff. (Lugt 13354), 2nd Day, Lots 149–76, 3rd Day, Lots 64–76, 4th Day, Lots 147–51, and 5th Day, Lot 3 and Lots 165–79.

[56] W. Foxley Norris, 'Dr. Monro', *The Old Water-Colour Society's Club*, Vol.2, 1925, p.3. The strips of gilt beading may have been intended to imitate the tooled gold borders which Gainsborough himself used for many of his late drawings.

[57] George Baker sale, Sotheby's, 16 June 1825 ff. (Lugt 10923), 3rd Day, Lots 351–62 and 10th Day, Lot 1007.

Lot 83 from the 1799 sale. George Nassau (1756–1823), another bibliophile, who came from a prominent county family in Suffolk, and whose father had sat to Gainsborough in the 1750's, was noted by Reveley in 1820 as among those with the most considerable collections of Gainsborough drawings,[58] and owned twenty-eight examples,[59] including the two brilliant late sketches in brown wash in Rotterdam (Pl.393) and the fine set of landscapes with deer in one frame which was bought by Lord Gower and is still in the family's possession. George Frost, the Ipswich amateur who imitated Gainsborough, possessed a large collection principally of his early sketches (Pl.9).[60] And one formerly unknown enthusiast whose collection was dispersed as early as 1802 was a Peterborough merchant named Sprignall Brown, who owned forty-seven landscape drawings, twenty-seven 'masterly studies of Ruins' and thirteen studies of figures;[61] whether all these were genuine, of course, it is impossible to say, as no extant drawing has a provenance going back to Brown.

The only Gainsborough collector to rival Monro, however, was the banker William Esdaile (1759–1837), who brought together the finest and most comprehensive print collection of his day, and later, in the 1820's, turned to drawings. He bought blocks by Rembrandt, Claude, and Titian at Sir Thomas Lawrence's sale, and among English draughtsmen specialized in Wilson and Gainsborough, eventually owning about a hundred examples of the latter's work, almost exclusively landscapes.[62] When J. T. Smith visited Esdaile at his home on Clapham Common, he was particularly excited by the Gainsboroughs, though he 'had seen many of them before, in the possession of the artist, Colonel Hamilton, Mr. Nassau, and Mr. Lambert.'[63] We are better informed about the contents of Esdaile's collection than almost any other of the period, as he not only employed a mark (unlike Monro) but annotated his drawings on the back with the details of their provenance. He bought a large number of drawings privately from the widow of George Frost, and acquired choice examples from the collections of Baker, Nassau, Lawrence, and Monro when these came up for auction. The pearls of the collection were the two magnificent oil sketches now in Williamstown, which he purchased from Richard Ford in 1823 (Pl.215).

Several artists of the generation following Gainsborough collected his drawings. There were twenty-six among Lawrence's vast collection of drawings of all schools, chiefly late landscapes, but also including a couple which Gainsborough had given him at Bath (Pl.282).[64] Constable, as might be expected, owned a group, twelve in all, three of which were fine early drawings; two later black chalk drawings, des-

[58] Henry Reveley, *Notices Illustrative of the Drawings and Sketches of Some of the most Distinguished Masters in all the Principal Schools of Design*, London, 1820, p.266.

[59] George Nassau sale, Evans, 25 March 1824 ff. (Lugt 10627), 2nd Day, Lots 243–7 and 3rd Day, Lots 339–51.

[60] *The Gentleman's Magazine*, July 1821, p.90.

[61] Sprignall Brown sale, Phillips, 2 June 1802 ff. (Lugt 6457), 2nd Day, Lot 261, 3rd Day, Lots 389–90 and 399 and 4th Day, Lots 407, 445–7, 450, 453–5, 460, 474–7, and 494.

[62] William Esdaile sale, Christie's, 15 March 1838 ff. (Lugt 14982), 5th Day, Lots 649–82 and 685 and 6th Day, Lots 790–824, 846, 853, 858, 863, and 870.

[63] John Thomas Smith, *A Book for a Rainy Day*, London, 1845, pp.262–3.

[64] Sir Thomas Lawrence sale, Christie's, 20 May 1830 ff. (Lugt 12380), 1st Day, Lots 126–30 and 2nd Day, Lots 238–45; and 17 June 1830 ff. (Lugt 12414), 1st Day, Lots 93–7 and 137.

cribed in his sale as *'very fine'*,[65] were presumably among those which Leslie referred to as hanging in his parlour.[66] William Alexander had sixty examples in his collection, mainly sketches.[67] Hoppner had upwards of a dozen landscape drawings (Pl.359), and one of his studies of a woodman.[68]

The most important early Victorian collector was John Heywood Hawkins (1803–1877)[69] of Bignor Park, Sussex, a Radical politician who retired from Parliament in 1841 after the fall of Melbourne, and devoted himself to cultural pursuits. Like Esdaile, he was an amateur who brought together the finest collection of prints of his period; and he owned about seventy Gainsborough landscape drawings,[70] those identifiable being of uniformly high quality and including the study for the *Repose* in Kansas City (Pl.331) and the oil sketch of three horsemen in an open landscape in the Ashmolean Museum. George Guy, 4th Earl of Warwick (1818–1893), a prominent collector of old master drawings who had also inherited a superb collection from his uncle Sir Charles Greville (1763–1832), owned nineteen Gainsboroughs (Pl.236), including some of his most outstanding figure drawings (Pl.206).[71]

The Rev. Dr Henry Wellesley (1791–1866), Principal of New Inn Hall, Oxford, who also possessed an important collection of old master drawings (especially notable for its fine Claudes), and achieved a European reputation as a collector, owned eleven Gainsborough drawings,[72] including the study for *The Harvest Waggon* (Pl.329), and was among the purchasers at the Esdaile sale. Another notable collector buying at this period was the Rev. Alexander Dyce (1798–1869), the Shakespearean scholar, who formed a collection of drawings of all schools, the English being the best, which he bequeathed to the South Kensington (now the Victoria and Albert) Museum.[73] Twenty-seven of his drawings were ascribed to Gainsborough, not all correctly, however, though the group included the superb seated housemaid (Pl.201) and the Van Gogh-like landscape with a country cart (Pl.195).

The finest collections of Gainsborough drawings formed in the latter part of the nineteenth and the beginning of the present century were those of Charles Fairfax Murray (1849–1919), Henry Joseph Pfungst (1844–1917), and Guy Bellingham Smith (1865–1945).

[65] John Constable sale, Foster's, 10 May 1838 ff. (Lugt 15066), 2nd Day, Lots 289–93 and 3rd Day, Lots 523–4.

[66] C. R. Leslie, *Memoirs of the Life of John Constable*, ed. Jonathan Mayne, London, 1951, p.270, note.

[67] William Alexander sale, Sotheby's, 27 February 1817 ff. (Lugt 9050), 7th Day, Lots 835–55 and 10th Day, Lot 1218.

[68] John Hoppner sale, Christie's, 19 May 1810 (Lugt 7782), Lots 57, 72–4, and 90–2; and Sotheby's, 22 May 1828 ff. (Lugt 11759), 1st Day, Lot 1, 2nd Day, Lot 162, and 3rd Day, Lots 357–8.

[69] About whom little is known; there is a short obituary notice in *The Times*, 6 July 1877.

[70] A Distinguished Amateur (=Hawkins) sale, Sotheby's, 29 April 1850 ff. (Lugt 19833), 9th Day, Lots 41–50 and 125–6; C. H. T. Hawkins sale, Christie's, 29 March 1904, Lots 175–98; and Mrs J. E. Hawkins sale, Christie's, 30 October 1936, Lot 103.

[71] Earl of Warwick sale, Christie's, 20 May 1896 (Lugt 54472), Lots 133–42, and Sotheby's, 17 June 1936, Lot 167.

[72] Rev. Dr Wellesley sale, Sotheby's, 25 June 1866 ff. (Lugt 29221), 4th Day, Lots 692–701.

[73] *Catalogue of the Dyce Collection*, London, 1874, Nos.670–96.

Fairfax Murray, an artist who studied under Burne-Jones, and worked for Ruskin in Italy as a copyist of works of art in the 1870's, later turned with extraordinary singleness of purpose to connoisseurship and collecting, becoming a quasi-dealer in order to finance his acquisitions.[74] He built up by this method one of the most outstanding collections of old master drawings of the period, which was bought *en bloc* in 1910 by Pierpont Morgan, and forms the nucleus of the present Morgan Library collection. The Gainsborough drawings, about twenty-five in number, were of high quality (Pls.40 and 410), and included the superb figure study once owned by Constable (Pl.79).

Pfungst was a wine merchant who made fine collections of Italian and Japanese bronzes and Italian and Persian faience before turning to old master drawings and specializing in Gainsborough's drawings and prints. He owned nearly eighty Gainsborough drawings,[75] of which two-thirds were landscapes, notably the two fine oil sketches now in Williamstown (Pl.215) and the California Palace of the Legion of Honor and important examples from the Warwick and Hawkins collections. The twenty-one portrait drawings included the study for the double portrait of Gainsborough's daughters now at Worcester (Pl.90), and the eight figure subjects one of Gainsborough's finest studies of a woodman (Pl.231) and his two faggot-gatherers (Pl.203). His collection of Gainsborough's prints, which he presented to the Berlin Kupferstichkabinett in 1913, included many early states and was the most important ever made.[76]

Bellingham Smith was a surgeon who made specialized collections of English glass, Chinese porcelain, and Japanese sword-hilts, but also collected pictures, prints, and drawings.[77] His group of Gainsboroughs comprised only twenty drawings,[78] and was confined to landscapes, but the quality was extremely high, the superb late black chalk and wash drawing of horsemen beside a pool in Mrs Williamson's collection (Pl.216) and the Gaspardesque mountain landscape now in Melbourne (Pl.185) being among the best examples.

The only other large collection formed at this time was that of Sir J. C. Robinson (1824–1913), art historian and Surveyor of The Queen's Pictures, who specialized in drawings of all schools, but disposed of his holdings every now and then in order to start again.[79] The Gainsboroughs consisted of about sixty items,[80] including the

[74] He told Benson, 'I have always gone on the principle of buying, let us say, twenty things at a sale, and paying for them by selling one, and keeping nineteen' (A. C. Benson, *Memories and Friends*, London 1924, p.215). I am indebted to Miss Felice Stampfle, Curator of Drawings at the Morgan Library, for this reference and other information about Fairfax Murray.

[75] Henry J. Pfungst sale, Christie's, 15 June 1917, Lots 1–74. Pfungst's typewritten catalogue of the collection, profusely illustrated with photographs, is now in the Mellon collection. From this it was possible to deduce that a high proportion of his drawings were genuine.

[76] These will be discussed in my forthcoming study of Gainsborough's prints.

[77] See D'Arcy Power and W. R. Le Fanu, *Lives of the Fellows of the Royal College of Surgeons 1930–51*, London 1953, p.721 (I am indebted for this information to the Library of the Royal Society of Medicine).

[78] It would appear that most of the collection was sold privately to Colnaghi's, but one drawing was in the Bellingham-Smith sale, Muller, Amsterdam, 5 July 1927, Lot 37.

[79] Frits Lugt, *Les Marques de Collections de Dessins & d'Estampes*, The Hague, 1956, p.259.

[80] Sir J. C. Robinson sale, Christie's, 21 April 1902, Lots 34–8 and 105–35.

fine late Suffolk pencil drawing now in Sir John Witt's collection (Pl.70), and were sold in 1902.

Two other collections of note were formed partially in the last decades of the nineteenth century but chiefly in the first quarter of the present century, one by Arthur Kay (died 1939) and the other by Sir George Donaldson (1845–1925), a dealer who was also a patron of music and the arts, a Director of the Royal Academy of Music and the founder of the Donaldson Museum of musical instruments.

Kay was a businessman of Yorkshire descent who lived in Edinburgh. He had developed a passion for the old masters during a period of study abroad after leaving Glasgow University, and spent a lifetime collecting. Dutch pictures and Constable sketches were among his particular interests, but he also bought contemporary Scottish work, and was Chairman of the Scottish Modern Arts Association.[81] In the field of drawings, he specialized in Gainsborough, and owned sixty examples[82] which were hung in the hall of his Edinburgh home.[83] Although sixteen of the figure drawings have now been shown to be Dupont's work, a number being studies for his large group portrait at Trinity House,[84] most of the remainder were of fine quality and included important drawings such as the study for Lord Jersey's picture now in the Ashmolean Museum (Pl.113) and the sheet of shrimpers at Detroit (Pl.228).

Kay's interests were wide, but Donaldson's were even more catholic, as he furnished a house at Hove with fine sculpture, tapestries, furniture, and silver, more or less as a private museum.[85] He seems to have owned about twenty-five Gainsborough drawings, principally portrait and figure drawings, many of which he bought at the Pfungst sale, and they included such splendid examples as the pastel of Lord Rivers in the Victoria and Albert Museum, the study of a lady seen from behind in the Ashmolean Museum (Pl.97) and the woodman owned by Mrs Keith (Pl.231). Twenty-one of these drawings were purchased from him, probably not long before his death, by an American collector, Henry J. Schniewind, Jr. These were all exhibited at Cincinnati in 1931,[86] and dispersed at Sotheby's in 1938.[87]

Without any doubt the most important collection started between the wars was that of J. Leslie Wright, who concentrated on fine English drawings and watercolours, built a special gallery to house them, at his home, Haseley House, Warwick, and finally bequeathed the whole collection to the Birmingham City Art Gallery, his son and two daughters, however, retaining a life-interest in some of the

[81] See Arthur Kay, *Treasure Trove in Art*, Edinburgh, 1939, pp.vii–x, and *The Times*, 2 January 1939.

[82] Arthur Kay sale, Christie's, 23 May 1930, Lots 1–58. Kay retired to Sussex, and the drawings were sold at this time.

[83] Kay, op. cit., p.x.

[84] See my articles on 'The Drawings of Gainsborough Dupont', *Master Drawings*, Vol.3, No.3, 1965, pp.250–1 and 'The Trinity House Group Portrait', *The Burlington Magazine*, July 1964, pp.311–2.

[85] The contents were sold by Puttick and Simpson, 6 July 1925 ff.; four Gainsborough drawings were 2nd Day, Lots 213–6. See also *The Times*, 20 March 1925.

[86] *Exhibition of Paintings and Drawings by Thomas Gainsborough, R.A.*, Cincinnati Art Museum, May 1931, Nos.51–60, 62–6, 68, and 70–4.

[87] Anon. (=Schniewind) sale, Sotheby's, 25 May 1938, Lots 136–54.

finest.[88] Though the collection also contained large groups of Rowlandson and Sandby, Gainsborough was the artist for whom Wright had the deepest affection, and he was represented by some thirty-five examples mostly of very high quality, about a quarter of which were once in the Bellingham Smith collection. They included the poetic landscape with ruins by a river (Pl.114) and the superb oil sketches of cattle in a stream (Pl.284), a cattle ferry (Pl.213) and a woodland cottage (the last-named being among those etched by Rowlandson).

A later enthusiast was Howard Bliss, the brother of the composer, who was attracted by the lyrical style in landscape, and began collecting in the middle years of the war. Though principally interested in contemporaries such as Ivon Hitchens, he owned twenty Gainsborough landscape drawings, including the superb oil sketch of cows being driven home in the Hamilton-Smith collection (Pl.128) and the Gaspardesque mountain landscape now in Melbourne (Pl.185). This collection was sold at the Leicester Galleries in 1950.[89]

Other collections built up between the wars which included a dozen or more Gainsborough drawings were those of Ernest C. Innes,[90] Paul Oppé (1878–1957), Sir Robert Witt (1872–1952),[91] and Henry S. Reitlinger (1882–1950).[92] Several living connoisseurs of English drawings have a particular affection for Gainsborough, notably Lord Eccles, Mrs W. W. Spooner and Alan D. Pilkington; but the only present-day collector on any scale is Mr Paul Mellon, who now owns more than fifteen examples, chiefly landscapes, including the brilliant late mountain scene with a ruined castle (Pl.234) and the study for the *Peasant Smoking at a Cottage Door* (Pl.349).

In conclusion, it is worth asking how prices have fluctuated over the years, disregarding, as far as possible, the special conditions of war and slump. Drawings were priced at from 2 to 16 guineas each at the Gainsborough sale, but though it was reported that 'upwards of one third' were sold within three days,[93] in fact only a quarter were sold during the entire period,[94] so that the top range of prices was probably excessive: Charles Long described himself as 'fool enough yesterday to give thirty Guineas for three little Sketches in chalk.'[95] Prices soon settled down, and in 1794 Farington reported Monro as saying that 'the pictures of Gainsborough are decreasing in value. The raging fashion of collecting them subsiding fast.'[96]

In fact, from the 1790's until the early Victorian period, prices remained remark-

[88] A large part of the collection was exhibited at the Royal Academy under the title *Masters of British Water-Colour*, November–December 1949. A short article on the collection by Kenneth Garlick (reproducing a photograph of Leslie Wright) was published in *Apollo*, April 1968, pp.282–3.

[89] *From Gainsborough to Hitchens*, The Leicester Galleries, January 1950, Nos.1–3, 5–8, and 12–25.

[90] Ernest C. Innes sale, Christie's, 13 December 1935, Lots 26–35.

[91] Sir Robert Witt sold a few of his Gainsborough drawings at different times (e.g. Cat. No.473), but the remainder is now in the Witt Collection at the Courtauld Institute.

[92] H. S. Reitlinger sale, Sotheby's, 27 January 1954, Lots 141–8.

[93] *The Diary*, 2 April 1789.

[94] See Waterhouse, op. cit., *The Burlington Magazine*, March 1945, pp.77–8.

[95] Long to George Cumberland, London, 10 April (1789) (B.M. Add. MSS.36,496).

[96] *The Farington Diary*, 15 July 1794 (p.196).

ably constant, a few shillings for sketches, up to 4 or 5 pounds for fine examples; though occasionally higher prices are met, such as the 26 guineas for the three landscapes in one frame in the Nassau sale in 1824. Farington summed up the situation in his note on Buttall's sale in 1796: 'Several of his drawings were sold in pairs some went so high as 8 guineas & half the pair. I bought a pair for 5 guineas and half. Dr. Monro, Wodehouse, Baker &c. &c. were there. A pair of highly finished *handled* tinted drawings sold the cheapest, only 3 guineas, they had not the effect of those in black and white.'[97] Very similar prices still obtained at the Esdaile sale in 1838, and it was again those in black and white or those 'with capital effect' that reached prices of 3 pounds or more. A sympathetic attitude towards drawings of this sort, as opposed to finished works where 'the elaboration of a thought tends to evaporate its spirit', is also traceable in print;[98] while critics of this period who cavilled at draughtsmen who substituted 'incoherence and scrawling, for correctness of drawing; and blotting and sponging, for precision of touch' were prepared to accept that Gainsborough's drawings stood in a class of their own.[99] To underline the fact that this was the great age of British landscape, portrait and fancy drawings fetched no more than landscape, the top price at the Lane–Briggs sale in 1831 being 3½ guineas for *The Housemaid* now in the Tate Gallery (Pl.361).

In the second half of the nineteenth century, prices for good examples of the landscapes rose only very slowly from an exceptional 10 pounds for a fine varnished drawing at the Trimmer sale in 1860 to up to 15 pounds in the 1880's or 1890's. At the same time, in the latter part of this period, with the rising prices of Gainsborough's portraits and the competition of the American market, prices of portrait drawings rose to between 40 and 50 pounds.

A steeper rise in landscape prices may be noted by 1910 or so, remaining fairly constant thereafter until around 1950.[100] Really fine oil sketches and other important drawings such as the study for the *Repose* in Kansas City (Pl.331) could make up to 200 pounds, important landscapes in other media generally between 70 and 100 pounds, and other examples perhaps 30 to 50 pounds, with sketches up to about 7 pounds. Portrait drawings would still fetch more than good landscapes, the lovely Ashmolean drawing (Pl.97) selling for 120 pounds in 1937;[101] a really important example like the Warwick drawing made 310 pounds in 1936,[102] and a large drawing of a subject such as Mrs Siddons could command four figures in 1917.[103] Fancy drawings generally fetched no more than modest landscapes.

If the declining value of the pound is taken into account, one may conclude from this survey that it was not until the second decade of the present century that any

[97] Ibid., 15 December 1796 (p.859).

[98] William Hone, *The Every-Day Book*, Vol.2, London, 1830, p.1067.

[99] Anon., 'The Rise and Progress of Water-Colour Painting in England', *The Somerset House Gazette*, 13 December 1823, p.145 and 20 December 1823, p.162.

[100] The late Mr D. C. T. Baskett, of Colnaghi's, once remarked to the present writer that the prices of Gainsborough drawings had remained more or less constant throughout his career, only rising in the mid-1950's.

[101] Anon. sale, Christie's, 11 June 1937, Lot 49.

[102] Earl of Warwick sale, Sotheby's, 17 June 1936, Lot 167.

[103] Henry J. Pfungst sale, Christie's, 15 June 1917, Lot 30.

marked change in prices occurred. Then real prices multiplied by something like eight times. From the early 1950's, the situation has altered even more drastically, the prices of Gainsborough drawings rising sharply *pari passu* with the prices of other drawings, and with ever growing scarcity. A drawing that would fetch 200 pounds in the 1930's and up to 1950, might fetch over 500 pounds in 1960, and 1,500 or more today. In this increasingly unreal situation, one stabilizing factor remains: that the collectors who buy them tend, on the whole, to treasure their Gainsborough acquisitions as lovingly as did Leslie Wright, or Hawkins, or Monro, before them.

Catalogue Raisonné

William Jackson, writing ten years after the artist's death, said that of Gainsborough 'perhaps, there are more drawings existing than of any other artist, ancient or modern. I must have seen at least a thousand, not one of which but possesses merit, and some in a transcendent degree.' Fewer than a thousand can be recorded today; but a considerable quantity must certainly have been lost or destroyed. Of the 500 or so studies contained in the ten sketch-books sold in 1799, for example, only a fraction survives; and since the same applies to the engraved works, where the ratio is about two in five, it is reasonable to guess that only a small proportion of the drawings actually produced by Gainsborough *does* survive. The whereabouts of something like 730 drawings have now been traced; these are scattered the world over (several are as remote as New Zealand, and many are on the west coast of the United States), and distributed fairly evenly between private and public collections, though the balance is now beginning to incline towards the latter.

The most important collection is still, as it should be, that in the British Museum, which contains about 115 examples, fully representative of each phase of Gainsborough's development and most types of drawing. Smaller groups of importance are in the other London public collections, nineteen being in the Victoria and Albert Museum and nineteen in the Witt Collection at the Courtauld Institute. The three outstanding collections outside London are those in the Berlin Kupferstichkabinett (these drawings being to a large extent quite unknown), the Morgan Library in New York, and Birmingham City Art Gallery (mostly part of the J. Leslie Wright bequest); there are also groups of about fifteen drawings in the Ashmolean Museum, Oxford, and the Huntington Art Gallery, San Marino. Among those in private ownership there are upwards of fourteen examples in the Oppé collection and the collection of Mr and Mrs Paul Mellon, but for the most part the groups are much smaller; there are no present day collectors who specialize in Gainsborough in the way that Henry Pfungst did, or Howard Bliss, and the growing scarcity of fine examples and rapidly increasing prices make it unlikely that this would ever be possible again.

Needless to say, it has proved impossible to see every known drawing, even in the space of ten years, though fortunately I have been able to see most; even good photographs are deceptive, and more often than not unexpected effects or subtleties and technical characteristics have been revealed through confrontation with the originals. The three criteria for inclusion in the Catalogue are personal autopsy, the existence of an early print (e.g. Wells and Laporte), or the existence of a reproduction

105

of sufficient quality to confirm attribution. Where drawings are catalogued on the basis of prints or photographs, I have noted this fact against the description of the subject-matter.

There is no insuperable difficulty in establishing Gainsborough's *œuvre* as a draughtsman, since a sufficient nucleus of drawings either signed with initials or otherwise documented survives upon which attributions can be based. I am completely satisfied as to the authenticity of the vast majority of drawings included in the Catalogue that ensues, but inevitably there are certain borderline cases. Where no positive reason exists to exclude a drawing about which I have reservations (but not of course serious doubts), it has seemed to me preferable, indeed, more honest, to include it in the Catalogue rather than to reject it: it will be easier, in later years, to remove a drawing from the canon than to re-establish it. On the other hand, a considerable number of drawings customarily regarded as Gainsborough, some of which appeared in Mary Woodall's catalogue, have been excluded on the positive grounds that they can be attributed to someone else, and I have been at some pains to identify the work of the many draughtsmen surrounding Gainsborough (see Chapter VII). A list of drawings in public collections attributed to Gainsborough follows the Catalogue. What I would regard as an absolute canon for Gainsborough's various styles and types of drawing is provided by the selection of Plates.

The Catalogue comprises drawings, watercolours and works in other media executed on *paper*, with the exception of portraits and large landscapes done entirely in oil, and lists all those drawings known to the author by the end of June 1970; the record of ownership is as far as possible correct up to that date. Inevitably, more drawings will be brought to light as a result of the publication of this book, and these, together with such errors of omission or commission as may have crept in inadvertently, will be published in a future issue of *The Burlington Magazine*. Drawings are listed according to subject, Portrait, Landscape and so on, and in a broadly chronological order within these categories; an index of owners is provided at the end, preceding the concordance with Mary Woodall's catalogue. In the case of the landscape drawings, it is only possible to establish a detailed chronology by using stylistic criteria: this accounts for the somewhat tedious comparisons which I have felt it important to make in order to give each drawing firm chronological roots. The terms 'identical with', 'closely related to' and 'related to' indicate varying degrees of similarity. These comparisons will also assist the reader to see how the attributions have been controlled. A small number of drawings are catalogued without appreciable comment. This implies no disrespect for these drawings but means simply that I have not had an opportunity to re-examine the originals or consult a photograph at the last stages of cataloguing, and thus been unable to relate them with complete precision. It should also be noted that certain groups of later drawings could easily be dated rather differently by making different, and probably equally valid, stylistic comparisons: I have done my best to establish a sensible chronology, but inevitably fresh eyes will wish to make certain adjustments.

I have endeavoured to be as accurate as possible in the description of techniques,

but in the case of a draughtsman as experimental as Gainsborough, it would be foolish to pretend that one's guesses are always right; in any case, it is hoped that a proper technical analysis of the drawings will be attempted by experts skilled in this field of scientific research in the near future. Thus I have not attempted to distinguish between, for example, such similar media as black chalk with stump and charcoal, or to describe evidence of deterioration, such as oxidization, unless it affects the attribution. Neither have I noted the presence of watermarks. For obvious practical reasons, it has been impossible to examine all drawings for these; moreover, none that I have seen has borne a date, and the evidence of the marks themselves is unlikely to be of material value in this connection. Finally, I have not attempted to note the various hieroglyphics (prices, dealers' codes, etc.) on the backs of drawings or on old mounts. Measurements are in inches, with millimetres in brackets, height preceding width.

Details of provenance, exhibitions and bibliography have all been checked from the original sources. Though I have tried to make these as full as possible, there will inevitably be omissions, many of them unavoidable, either from lack of information or from the difficulty of connecting information with particular drawings. The following abbreviations have been employed:

Aldeburgh 1949	*Drawings by Thomas Gainsborough*, The Aldeburgh Festival, June 1949.
Armstrong 1894	Walter Armstrong, *Thomas Gainsborough*, London, 1894.
Armstrong 1898	Sir Walter Armstrong, *Gainsborough & his Place in English Art*, London, 1898.
Armstrong 1904	Sir Walter Armstrong, *Gainsborough and his Place in English Art*, London, 1904.
Armstrong 1906	Sir Walter Armstrong, *Thomas Gainsborough*, London, 1906.
Arts Council 1949	*Thomas Gainsborough*, Arts Council (Bath, Ipswich, Worcester, York, Bolton and Darlington), May–October 1949.
Arts Council 1960–1	*Gainsborough Drawings*, Arts Council (York, Bristol, Liverpool, Edinburgh and Cardiff), November 1960–April 1961.
Bath 1951	*Paintings and Drawings by Thomas Gainsborough*, Victoria Art Gallery, Bath, May–June 1951.
Mrs Bell	Mrs Arthur Bell, *Thomas Gainsborough: A Record of his Life and Works*, London, 1897.
Binyon	Laurence Binyon, *Catalogue of Drawings by British Artists . . . in the British Museum*, London, Vol.II, 1900 (Gainsborough).
Boulton	William B. Boulton, *Thomas Gainsborough His Life, Work, Friends, and Sitters*, London, 1905.
Chamberlain	Arthur B. Chamberlain, *Thomas Gainsborough*, London, n.d. (=1903).
Cincinnati 1931	*Paintings and Drawings by Thomas Gainsborough, R.A.*, Cincinnati Art Museum, May 1931.
Colnaghi's 1906	*A Selection of Studies & Drawings Thomas Gainsborough, R.A.*, P. & D. Colnaghi & Co., May 1906.
Fulcher	George Williams Fulcher, *Life of Thomas Gainsborough, R.A.*, London, 1856 (2nd edn., revised, also 1856).
Gower	Lord Ronald Sutherland Gower, *Thomas Gainsborough*, London, 1903.
Gower *Drawings*	Lord Ronald Sutherland Gower, *Drawings of Gainsborough*, London, n.d. (=1906).
Huntington 1967–8	*Gainsborough and the Gainsboroughesque*, Henry E. Huntington Library and Art Gallery, November 1967–February 1968.

Ipswich 1927	*Bicentenary Memorial Exhibition of Thomas Gainsborough, R.A.*, Ipswich Museum, October–November 1927.
Knoedler's 1914	*Drawings by Thomas Gainsborough*, M. Knoedler & Co., New York, January 1914.
Knoedler's 1923	*Pictures by Gainsborough*, M. Knoedler & Co., New York, December 1923.
Lane	Richard Lane, *Studies of Figures by Gainsborough*, London, 1 January 1825 (lithographic printing by Hullmandel).
Menpes and Greig	Mortimer Menpes and James Greig, *Gainsborough*, London, 1909.
Millar	Oliver Millar, *Thomas Gainsborough*, London, 1949.
Nottingham 1962	*Landscapes by Thomas Gainsborough*, Nottingham University Art Gallery, November 1962.
Oxford 1935	*Drawings by Thomas Gainsborough*, Oxford Arts Club, June–July 1935.
R.A.	Royal Academy of Arts.
Sassoon 1936	*Gainsborough*, 45 Park Lane, February–March 1936.
Thicknesse	Philip Thicknesse, *A Sketch of the Life and Paintings of Thomas Gainsborough, Esq.*, London, 1788.
Waterhouse	Ellis Waterhouse, *Gainsborough*, London, 1958.
Wells and Laporte (or Laporte and Wells)	W. F. Wells and J. Laporte, *A Collection of Prints, illustrative of English Scenery: from the Drawings and Sketches of Gainsborough: In the various Collections of the Right Honorable Baroness Lucas; Viscount Palmerston; George Hibbert, Esq. Dr. Monro, and several other Gentlemen*, London, n.d. (=1802–5).
Whitley	William T. Whitley, *Thomas Gainsborough*, London, 1915.
Woodall	Mary Woodall, *Gainsborough's Landscape Drawings*, London, 1939.
Woodall 1949	Mary Woodall, *Thomas Gainsborough: His Life and Work*, London, 1949.
Woodall *Letters*	ed. Mary Woodall, *The Letters of Thomas Gainsborough*, London, 2nd edn. revised, 1963.

Portrait Drawings

Portraiture was always Gainsborough's main occupation as a painter, and it is as a portraitist that he will be most widely remembered. But though he must have painted well over a thousand portraits – some 800 are known today – comparatively few preparatory drawings survive. There are a handful of studies for the early portraits, notably the portrait-in-a-landscape compositions, a good many costume studies dating from his first years at Bath, when he began to paint full lengths as regular routine, and a number of composition sketches for certain of his more ambitious and important portraits of this period and later. Generally speaking, he probably felt it unnecessary to produce drawings, and worked out his designs directly upon the canvas. There are also a few independent sketches, like his study of a child asleep, and a group of pastel portraits executed chiefly in the late 1760's and early 1770's. Gainsborough made extensive use of costumed dolls, and attention should be drawn to the difficulty (in certain cases) of determining whether he was sketching from the life or from a doll. Most of the portrait drawings can be dated on the evidence of costume, where other documentation is lacking, but care has been taken to propose only fairly wide brackets. Not only is dress often much more varied and idiosyncratic than some costume historians would suppose, but it depends also upon the age of the sitter or the remoteness from the centre of fashion (which latter factor affects Gainsborough's Suffolk portraits); in the last analysis, the only really safe evidence is the date when a particular garment or fashion was first introduced.

Mid to Later 1740's

1 Portrait of an Unknown Gentleman
Plate 1
National Gallery of Ireland, Dublin

Pencil. $4\frac{15}{16} \times 4\frac{1}{16}$ (125 × 103).
Signed and dated bottom left: *Tho: Gainsborough/fecit 1743–4.*
Half-length facing half-right, with his head turned towards the spectator; plain background.
PROVENANCE: Purchased in Carlow, Eire, 1894.
BIBLIOGRAPHY: Armstrong 1894, pp.13 and 75, repr. p.12; Armstrong 1898, pp.59 and 72, repr. p.1; Armstrong 1904, pp.77–8 and 95, repr. f.p.8; Armstrong 1906, pp.32 and 185, repr. f.p.28; Menpes and Greig, pp.26 and 36; John Hayes, 'The Ornamental Surrounds for Houbraken's "Illustrious Heads",' Notes on British Art 13, *Apollo*, January 1969, p.2.

This portrait and its companion (Cat. No.2) are Gainsborough's earliest recorded drawings.

Since they are dated 1743–4, they were presumably executed between 1 January and 25 March 1744 (the Julian calendar, in which the year commenced on 25 March, was operative until 1752). Except for the fact that they are on paper not vellum, they are wholly in the tradition of the 'plumbago' miniature, long since outmoded, and executed in a meticulous technique only encountered elsewhere in the landscape with figures on a country road in the British Museum (Cat. No.67). The poses are a little stiff, but the heads are lively and the modelling assured and sensitive. There is no evidence to support the theory advanced by Menpes and Greig (*op. cit.*) that the portraits represent William Horobine and his wife Susanna (née Gainsborough), with whom they suggest Gainsborough may have lived during his 'prentice years in London. Also mentioned on pp.38 and 41.

2 Portrait of an Unknown Lady Plate 2
National Gallery of Ireland, Dublin

Pencil. 4 15/16 × 4 (125 × 102).
Signed and dated bottom left: *Tho· Gainsborough/fecit 1743-4.*
Half-length facing slightly to left; plain background.
PROVENANCE: Purchased in Carlow, Eire, 1894.
BIBLIOGRAPHY: Armstrong 1894, pp.13 and 75, repr.
p.13; Armstrong 1898, pp.59 and 72, repr. p.1;
Armstrong 1904, pp.77–8 and 95, repr. f.p.8;
Armstrong 1906, pp.32 and 185, repr. f.p.32;
Menpes and Greig, pp.26 and 36; John Hayes, 'The
Ornamental Surrounds for Houbraken's "Illustrious
Heads",' Notes on British Art 13, *Apollo*, January
1969, p.2.

See the previous entry (Cat. No.1). Also mentioned on pp.38 and 41.

**3 Portraits of an Unknown Lady and
Gentleman, possibly the Artist and his
Wife** Plates 7 and 8
Private Collection, Paris

Pencil. 7 15/16 × 10 9/16 (202 × 268).
Whole-lengths of a lady and gentleman standing in
the foreground left, the man in a tricorne hat facing
half-right with his head turned downwards and seen
in profile talking to the lady who is wearing a hooped
dress and holding her bergère hat on her head with
her left hand; part of a bench in the middle distance
left; a cow behind a bank in the foreground right;
wooded background.
Inscribed bottom left in pencil in a later hand:
Mr P Sandby and his Wife.
PROVENANCE: Archdeacon Burney.
BIBLIOGRAPHY: John Hayes, 'English Painting and
the Rococo', *Apollo*, August 1969, p.120.

This early drawing of a courting couple clearly
does not represent Paul Sandby and his wife, as
they were not married until 1757. Identification
with the couple depicted in the double portrait
in the Louvre (Waterhouse 752, pl.17), a more
sophisticated interpretation of the same theme,
is entirely plausible, and there is an early tradi-
tion, dating from 1825, that this painting repre-
sents Gainsborough himself with his wife.
Gainsborough was married in 1746, which is
about the date of the picture, and there is
nothing in the early self-portraits, or portraits of
his wife, to preclude the identification. The
costume, notably the bergère hat, criss-cross
lacing, single ruffles to the sleeves and pannier
hoops of the girl's dress, indicates a date of about
1745–50; and the awkwardness of the landscape
setting a date in the earlier part of this bracket.

Gainsborough did a drawing of a similar descrip-
tion of Mr and Mrs Kirby, which was last in the
Trimmer sale (Christie's, 17 March 1860, Lot 4)
and there described as *A landscape, with a court-
ship – portraits of Jos. Kirby and his wife*. The sub-
ject of a courting couple is also found in
Laroon's work of the 1740's, and was included
in a series of six small paintings of stages in
married life, attributed to Paul Sandby, which
was with Bernard in 1954. A tracing of the
drawing was made by William Sandby when it
was in the possession of Archdeacon Burney (this
was kindly drawn to my attention by Mr
William Drummond). Also mentioned on pp.35,
41 and 56.

4 A Youth seated
Pierpont Morgan Library, New York (III, 59a)

Pencil. 6 1/8 × 5 1/8 (156 × 130).
Whole-length of a youth seated cross-legged facing
half-right but with his head turned towards the
spectator, his hands held in front of him, and his hat
tucked under his right arm; no background.
PROVENANCE: Charles Fairfax Murray, from whom
it was purchased by J. Pierpont Morgan 1910.
EXHIBITED: *The Art of Eighteenth Century England*,
Smith College Museum of Art, January 1947 (29).
BIBLIOGRAPHY: *J. Pierpont Morgan Collection of
Drawings by the Old Masters formed by C. Fairfax
Murray*, Vol.III, London, 1912, No.59a (repr.).

Drawn from an articulated doll, and a study for
one of Gainsborough's early portraits in a land-
scape: the pose is identical with that of Joshua
Kirby in the portrait with his wife in the
National Portrait Gallery (Waterhouse 420,
pl.16), but the figure does not represent Kirby.
The crisp pencilwork is close to the drawing of a
courting couple formerly owned by Archdeacon
Burney (Cat. No.3).

**5 Study for the Portrait of an
Unidentified Lady, possibly Miss Lloyd**
Plate 309
Pierpont Morgan Library, New York (III, 46c)

Pencil. 7 3/8 × 5 7/8 (187 × 149).
Whole-length of a lady seated in front of a tree and a
plinth surmounted by an urn, facing to the right but
with her head turned towards the spectator; the
plinth is on the left of the composition.
Inscribed in pen and brown ink bottom right: *TG.*
PROVENANCE: Charles Fairfax Murray, from whom
it was purchased by J. Pierpont Morgan, 1910.
EXHIBITED: *The Art of Eighteenth Century England*,

Smith College Museum of Art, January 1947 (24).
BIBLIOGRAPHY: *J. Pierpont Morgan Collection of Drawings by the Old Masters formed by C. Fairfax Murray*, Vol.III, London, 1912, No.46c.

The first idea for the portrait of an unidentified lady, traditionally called Miss Lloyd, in a landscape setting, owned by the Kimbell Art Foundation, Fort Worth (Waterhouse 455) (Plate 313), painted in the late 1740's. In this design, the sitter is seated in front of a tree with an urn supported on a high plinth half-hidden behind it. The figure is barely more than outlined, and the right half of the composition is left blank. Also mentioned on p.35.

6 Study for the Portrait of an Unidentified Lady, possibly Miss Lloyd
Plate 310
Pierpont Morgan Library, New York (III, 46a)

Pencil. 7⅜ × 5⅞ (187 × 149).
Whole-length of a lady seated in front of a tree and a plinth surmounted by an urn, facing to the right but with her head turned towards the spectator; the plinth is in the centre of the composition.
Inscribed in pen and brown ink bottom right: *TG*.
PROVENANCE: Charles Fairfax Murray, from whom it was purchased by J. Pierpont Morgan, 1910.
EXHIBITED: *The Art of Eighteenth Century England*, Smith College Museum of Art, January 1947 (24).
BIBLIOGRAPHY: *J. Pierpont Morgan Collection of Drawings by the Old Masters formed by C. Fairfax Murray*, Vol.III, London, 1912, No.46a (repr.); 'The Gainsborough Exhibition in Cincinnati,' *The Burlington Magazine*, August 1931, p.91 and repr. pl.1A f.p.86; Woodall 462, pp.35–6 and 39 and repr. pl.24; Geoffrey Grigson, *English Drawing*, London, 1955, p.174 and repr. pl.44.

The second design for the Kimbell Art Foundation portrait (Waterhouse 455) (Plate 313) has the urn and plinth moved to the centre of the picture, a jet of water playing into a basin from an aperture in the plinth to create incident on the right, a branch filling the top part of the composition on the right, and a second tree echoing the figure spiralling diagonally up to the left. The figure is filled in slightly more, and the feet are shown as finally painted. This conception, with the background dominated by a large urn on a plinth set among trees, can be paralleled in Hayman's contemporary double portrait of George and Margaret Rogers (?) in the Mellon collection. Also mentioned on p.35.

7 Study for the Portrait of an Unidentified Lady, possibly Miss Lloyd
Plate 311
Pierpont Morgan Library, New York (III, 46b)

Pencil. 7⅜ × 5⅝ (187 × 143)
Whole-length of a lady seated in front of a tree and a plinth surmounted by an urn, facing to the right but with her head turned towards the spectator; the plinth is in the centre of the composition and serves also as a fountain.
Inscribed in pen and brown ink bottom right: *TG*.
PROVENANCE: Charles Fairfax Murray, from whom it was purchased by J. Pierpont Morgan, 1910.
EXHIBITED: *The Art of Eighteenth Century England*, Smith College Museum of Art, January 1947 (24).
BIBLIOGRAPHY: *J. Pierpont Morgan Collection of Drawings by the Old Masters formed by C. Fairfax Murray*, Vol.III, London, 1912, No.46b (repr.); 'The Gainsborough Exhibition in Cincinnati', *The Burlington Magazine*, August 1931, p.91; Woodall 463, pp.35–6 and 39 and repr. pl.25.

The final design for the Kimbell Art Foundation portrait (Waterhouse 455) (Plate 313) shows the branch on the right arching over the urn as in the finished picture, and the spiralling tree replaced by upright trees on either side of the main trunk, again as in the finished picture. In the painting, the branch above the sitter is raised and the urn made larger to fill the centre of the composition towards the top, three slender trees are introduced on the right, and the basin and jet of water are replaced by a grassy bank. The costume, with the round-eared cap, pannier hoops, winged cuffs, single ruffles to the sleeves, and massive heels of the shoes, indicates a date of about 1745–50. The pencilwork and treatment of the foliage are closely related to the portrait drawing formerly owned by Archdeacon Burney (Cat. No.3) and the landscape with figures in the Morgan Library (Cat. No.72). Also mentioned on p.35.

8 A Sepulchral Urn Plate 312
British Museum, London (O.0.2 – 31)

Pencil. 2½ × 3 (63 × 76)
PROVENANCE: Presumably from the sketch-book in the Gainsborough sale, Christie's, 11 May 1799, Lot 90 'A ditto (= book), with imitations from antique vases and sculpture' bt. in; Richard Payne Knight, who bequeathed it 1824.
BIBLIOGRAPHY: Binyon 24b.

The only surviving example of a number of drawings Gainsborough made from antique vases, urns and sculpture. The "books of vases"

which were Lot 135 in the Gainsborough sale at Christie's, 11 May 1799, may have been the sources for some of these studies, which were presumably made for use in the backgrounds of the more artificial of his portrait-in-a-landscape compositions, such as the picture owned by the Kimbell Art Foundation (Waterhouse 455) (see Cat. Nos.5, 6 and 7). The soft pencilwork is related to the boy with a book and a spade in the Morgan Library (Cat. No.813). Also mentioned on p.31.

Early to Mid 1750's

9 A Young Man reclining on a Bank beneath a Tree
Dr and Mrs F. W. Geib, Rochester, N.Y.

Pencil. $5\frac{3}{4} \times 7\frac{1}{4}$ (146×184).
Whole-length of a young man reclining on a bank, facing left with his right leg outstretched, his head turned slightly towards the spectator, wearing a sword and a tricorne hat; a tree behind him on the right, and two more trees in the middle distance left (from a photograph).
PROVENANCE: With P. M. Turner.
EXHIBITED: Ipswich 1927 (119); Oxford 1935 (39); Aldeburgh 1949 (22).
BIBLIOGRAPHY: Woodall 314, p.36 and repr. pl.28.
ALSO REPRODUCED: *The Illustrated London News*, 1 July 1929, p.34.

The figure is drawn from one of Gainsborough's articulated dolls, but the head is certainly a portrait, and the drawing was presumably a study for one of his informal portraits in a landscape. A more sophisticated variant of this kind of design is represented by the *John Plampin* in the National Gallery (Waterhouse 546, pl.13). The treatment of the foliage is characteristic of Gainsborough's drawings of the early 1750's, such as the landscape with a couple sketching in the British Museum (Cat. No.95).

10 Study of a Man sketching holding a Glass
British Museum, London (O.0.2 – 27)

Pencil. $7\frac{1}{4} \times 5\frac{7}{16}$ (184×138).
Whole-length of a man wearing a tricorne hat seated on a bank beneath a tree facing right, with a sketchbook open in his lap and holding a glass in front of him with his left hand; wooded background right.
PROVENANCE: From the sketch-book purchased by

Richard Payne Knight at the Gainsborough sale, Christie's, 11 May 1799, Lot 85; bequeathed 1824.
BIBLIOGRAPHY: Fulcher, 1st edn., p.234 (2nd edn., p.241); Armstrong 1894, repr. p.49; Binyon 10; Armstrong 1906, repr. f.p.128; Gower *Drawings*, p.12 and repr. pl.XI; Woodall 157a.

A study from life. There is no reason to believe that this is a self-portrait, as stated by Gower (*op. cit.*). Darkened mirrors with a slight convexity, usually known as 'Claude glasses' and often small enough to go in the pocket, were commonly used as aids to sketching in the eighteenth century, serving the functions of composing a landscape, reducing the detail and lowering the tone of the scenery reflected (see also *The Art of Claude Lorrain*, Arts Council, 1969, pp.55–6). The pencilwork is closely related to the drawing of woodgatherers owned by Lady Joan Zuckerman (Cat. No.120). A copy attributed to Thomas Barker was recently with Manning Gallery (*Twenty-Ninth Exhibition of Watercolours and Drawings*, June 1968, No.52); another copy, slightly varied in pose, is in the Morgan Library (III, 1), and a further copy is in the possession of John Bryson.

11 Portrait of Captain van Gieront Plate 49
National Gallery of Scotland, Edinburgh (4926)

Black, white and coloured chalks on grey prepared paper.
$12\frac{1}{2} \times 10\frac{1}{8}$ (317×257).
Three-quarter-length seated, facing the spectator, with his right hand placed inside his waistcoat and his left on his hip, and wearing a tricorne hat; no background.
Inscribed top in a later hand: *Van Gieront* (?)/*Captain of a sailing Vessel at Amsterdam*.
PROVENANCE: William Meyrick; Henry J. Pfungst; Pfungst sale, Christie's, 15 June 1917, Lot 10 bt. Sir George Donaldson; Henry Schniewind, Jr.; Schniewind sale, Sotheby's, 25 May 1938, Lot 140 bt. Adams; with Colnaghi, from whom it was purchased 1968.
EXHIBITED: Colnaghi's 1906 (40); Cincinnati 1931 (57 and repr. pl.66).
BIBLIOGRAPHY: Gower *Drawings*, p.13 and repr. pl.XXXIII; Menpes and Greig, p.172; E. S. Siple, 'Gainsborough Drawings: The Schniewind Collection', *The Connoisseur*, June 1934, p.355.
ALSO REPRODUCED: Heinrich Leporini, *Handzeichnungen Grosser Meister: Gainsborough*, Vienna and Leipzig, n.d. (=1925), pl.3.

The degree of finish in the head and the use of coloured chalks indicate that this is not a preparatory drawing for an oil but a portrait in its own right. The pose, with left hand on hip and

the right tucked inside the waistcoat (etiquette of the period), and the broad direct treatment of the head are typical of Gainsborough's portraits of the early to mid 1750's. Also mentioned on p.9.

12 Portrait of a Young Lady Plate 47
British Museum, London (O.o.2 – 39)

Pencil. $7\frac{9}{16} \times 5\frac{7}{8}$ (192 × 149)
Profile, facing right, the head only completed; no background.
PROVENANCE: From the sketch-book purchased by Richard Payne Knight at the Gainsborough sale, Christie's, 11 May 1799, Lot 85; bequeathed 1824.
BIBLIOGRAPHY: Binyon 8a.

The pencilwork is closely related to the study of a young girl with a basket on her arm also in the British Museum (Cat. No.820).

Later 1750's

13 Study for the Portrait of the Hon. Richard Savage Nassau (1723-80)
Plates 255 and 320
Ehemals Staatliche Museen, Berlin-Dahlem (4433)

Black chalk. $11\frac{1}{8} \times 8\frac{3}{16}$ (282 × 208).
Half-length seated, facing half-right, with his right arm in his lap and his left over the back of the chair.
PROVENANCE: Presented by an unknown donor 1910.
BIBLIOGRAPHY: John Hayes, 'Some Unknown Early Gainsborough Portraits', *The Burlington Magazine*, February 1965, pp.70 and 74, repr. fig.17.

A study from life for the arrangement of the coat in the portrait of the Hon. Richard Savage Nassau at Brodick Castle (catalogued in *The Burlington Magazine*, op. cit., p.74, fig.18) (Plate 322), painted in the later 1750's, and used practically without alteration. The head is only blocked out. This informal type of portrait derives from contemporary French painting or from Ramsay, but the relaxed pose with the arm placed comfortably over the top of the chair is closer to the easy naturalism of Hogarth. The bold and vigorous chalkwork is paralleled in the drawings of Chardin or Parrocel. Also mentioned on pp.23, 35, 42–3 and 56.

14 Study of a Man for an Unidentified Portrait Group Plate 259
Ehemals Staatliche Museen, Berlin-Dahlem (4436: verso)

Black chalk on buff paper. $12\frac{7}{16} \times 9\frac{5}{8}$ (316 × 244).
Three-quarter-length facing left, the head cut above the mouth.
Recto: study of a bull-terrier seated (Cat. No. 872).
PROVENANCE: Source of acquisition unknown.
BIBLIOGRAPHY: John Hayes, 'Some Unknown Early Gainsborough Portraits', *The Burlington Magazine*, February 1965, pp.70 and 74, repr. fig.22.

A study from life for the pose in an unidentified portrait group. The costume is difficult to date as the type of cuff, known as a boot cuff, was characteristic of the 1730's but persisted for a considerable time afterwards. The vigorous drawing style is, however, closely related to the study for the Hon. R. S. Nassau at Brodick Castle (Cat. No.13). The bold, staccato character of the line is paralleled in the drawings of Chardin or Parrocel. Also mentioned on pp.35 and 56.

15 Self-portrait sketching
Ownership unknown

Pencil (apparently). Size unknown. Upright.
Whole-length seated cross-legged on a bank, facing right, wearing a tricorne hat, holding a sheet of paper on a board in his left hand and a pencil in his right; landscape background (from the print).
ENGRAVED: Richard Lane, published 1 January 1825.
PROVENANCE: Among the drawings left by the artist to his wife, which descended through Margaret Gainsborough either to Henry Briggs or via Sophia Lane to Richard Lane.

There is nothing in the early self-portraits to preclude the identification of the figure as Gainsborough himself. The conception is similar to the portrait of a man sketching holding a glass in the British Museum (Cat. No.10). The rhythmical treatment of the foliage is characteristic of the later 1750's. A puzzling drawing owned by Walter Heil is in reverse from the print and could be the original from which it was made: in this the figure (who is drawing with the left hand) is cut out and laid down on another sheet of paper with a landscape background executed by another hand in the style of Gainsborough's drawings of the late 1750's. It is conceivable that this is identifiable with *A gentleman sketching, the landscape by Jos. Kirby* which was Lot 6 in the Henry Scott Trimmer sale, Christie's, 17 March 1860.

Early 1760's

16 Study for the Portrait of Mrs Philip Thicknesse (1732–1824) Plate 327
British Museum, London (1894–6–12–11)

Pencil and watercolour. 13$\frac{3}{16}$ × 10$\frac{1}{8}$ (335 × 257) (trimmed at all four corners).
Whole-length seated facing right, with her head turned towards the left and resting on her left arm, and her right hand holding a guitar on her lap; a cat in the foreground left; suggestions of an interior setting, with a woodland view seen through the window in the background left.
PROVENANCE: H. H. Gilchrist, from whom it was purchased 1894.
BIBLIOGRAPHY: Binyon 3; Gower *Drawings*, p.12 and repr. pl.x; 'The Gainsborough Exhibition in Cincinnati', *The Burlington Magazine*, August 1931, p.91 and repr. pl.IIA f.p.91; Woodall 1949, p.52; Geoffrey Grigson, *English Drawing*, London, 1955, p.174 and repr. pl.39; Woodall *Letters*, repr. pl.23.

A composition study for the portrait of Mrs Philip Thicknesse in Cincinnati (Waterhouse 660, pl.62) (Plate 328), painted in 1760. In the finished picture, the pose is given a more pronounced spiralling movement, the left arm is supported on a table covered with books and sheets of music, the cat is omitted, and a viol da gamba standing upright against the wall replaces the landscape background on the left. Both William Hoare (British Museum 1894–4–17–12) and Gainsborough's friend Cipriani (Ashmolean Museum) also did studies of Mrs Thicknesse holding a musical instrument. Also mentioned on pp.23, 36, 38 and 43.

17 Study for the Portrait of an Unidentified Lady with two Children
Ehemals Staatliche Museen, Berlin-Dahlem (6850)

Pencil. 14$\frac{15}{16}$ × 9$\frac{5}{8}$ (379 × 244) (trimmed at all four corners).
Whole-length of a lady standing facing half-left, with her head turned slightly towards the spectator; a young girl on the left holding the lady's right hand; another young girl on the right, facing half-left and holding the lady's left hand; landscape background.
ENGRAVED: Richard Lane, published 1 January 1825.
PROVENANCE: Among the drawings left by the artist to his wife, which descended through Margaret Gainsborough either to Henry Briggs or via Sophia Lane to Richard Lane; probably Lane sale,

Christie's, 25 February 1831, part of Lot 96 or 98; William Benoni White; possibly White sale, Christie's, 24 May 1879, Lot 201 (with two others) bt. Thibaudeau; J. P. Heseltine; presented by an unknown donor 1913.
EXHIBITED: *Gainsborough, Constable, and Old Suffolk Artists*, Art Gallery, Ipswich, October 1887 (168); Colnaghi's 1906 (68).
BIBLIOGRAPHY: *Original Drawings by British Painters in the Collection of J. P. H(eseltine)*, London, 1902, 8 (repr.).

A composition study for an unidentified portrait group: there is no reason for connecting this study with the portrait of Mrs Moodey and her children at Dulwich (Waterhouse 498), painted in the late 1770's, as stated by Heseltine (*op. cit.*). The costume, notably the stomacher with échelles, and the hair style indicate a date of about 1755–65. The rapid, sketchy pencilwork and hatching are closely related to the study for the portrait of Mrs Thicknesse in the British Museum (Cat. No.16).

18 A Woman seated in a Landscape
Plate 78 Frick Collection, New York

Pencil and black chalk. 13$\frac{7}{8}$ × 10 (352 × 254) (trimmed at all four corners).
Whole-length of a woman seated in a landscape facing half-right, with her head turned towards the spectator and supported by her left arm.
ENGRAVED: Richard Lane, published 1 January 1825.
PROVENANCE: Among the drawings left by the artist to his wife, which descended through Margaret Gainsborough either to Henry Briggs or via Sophia Lane to Richard Lane; probably Lane sale, Christie's, 25 February 1831, part of Lot 96 or 98; J. P. Heseltine; with Knoedler's, from whom it was purchased by H. C. Frick 1913.
EXHIBITED: Colnaghi's 1906 (6); Knoedler's 1914 (15).
BIBLIOGRAPHY: Armstrong 1898, repr. f.p.148 (colour); *Original Drawings in the Collection of J. P. H(eseltine)*, London, 1902, 17 (repr.); Armstrong 1904, repr. f.p.228; Harry D. M. Grier and Edgar Munhall, *Masterpieces of the Frick Collection*, New York, 1970, p.52 (repr.).

A costume and composition study, probably drawn from an articulated doll; the motif of the hand supporting the head is very common in Gainsborough's portraits. The costume, notably the stomacher with échelles, and the hair style, indicate a date of about 1755–65. Though the figure is rather less sketchily drawn, the rapid pencilwork and hatching are identical with the study for the portrait of Mrs Thicknesse in the

British Museum (Cat. No.16). There is no evidence, however, internal or otherwise, to support the view that it is a preliminary study for that portrait. Also mentioned on pp.35 and 56.

19 A Woman seated in a Landscape
Frick Collection, New York

Black chalk and stump. 15⅜×9⅞ (391×251) (trimmed at all four corners).
Whole-length of a woman seated in a landscape facing the spectator, with her head turned half-left and supported by her left arm, which is resting on a bank, an open book in her lap.
PROVENANCE: William Benoni White; probably White sale, Christie's, 24 May 1879, Lot 200 or part of Lot 201 both bt. Thibaudeau; J. P. Heseltine; with Knoedler's, from whom it was purchased by H. C. Frick 1913.
EXHIBITED: Colnaghi's 1906 (8); Knoedler's 1914 (9).
BIBLIOGRAPHY: *Original Drawings by British Painters in the Collection of J. P. H(eseltine)*, London, 1902, 14 (repr.); Harry D. M. Grier and Edgar Munhall, *Masterpieces of the Frick Collection*, New York, 1970, p.52.

A costume and composition study, probably drawn from an articulated doll: the costume itself is identical with that in the other study in the Frick Collection (Cat. No.18), though minus the shawl or cape, and it is possible that this was part of the wardrobe of one of Gainsborough's dolls. The costume, notably the stomacher with échelles, and the hair style indicate a date of about 1755–65. The sketchy technique and zig-zag shading in the dress are very close to the portrait study in Berlin (Cat. No.17).

20 A Woman seated
British Museum, London (1895–7–25–2)

Pencil. 13¹⁵⁄₁₆×8⁷⁄₁₆ (354×214) (trimmed at all four corners).
Whole-length of a woman seated facing half-left, with her head turned towards the spectator and her hands clasped in front of her; no background.
PROVENANCE: Miss L. Stephanoff, from whom it was purchased 1895.
BIBLIOGRAPHY: Binyon 5; Gower *Drawings*, p.13 and repr. pl.XXVI.

A costume study, probably drawn from an articulated doll. This is clearly not a portrait of one of Gainsborough's daughters, as suggested by Gower (*op. cit.*), since the head is only blocked out. The costume and hair style indicate a date

of about 1755–65. The sketchy pencilwork is close to the portrait study in Berlin (Cat. No.17).

21 A Woman holding a Fan
British Museum, London (1895–7–25–3)

Pencil, with traces of grey wash. 14⅛×8⅝ (359×219) (trimmed at all four corners).
Whole-length of a woman facing right, with her head turned towards the spectator and holding a closed fan in her hands; landscape background, with the knob of a balustrade visible right.
PROVENANCE: Miss L. Stephanoff, from whom it was purchased 1895.
BIBLIOGRAPHY: Binyon 4; Gower *Drawings*, p.11 and repr. pl.IV; Roger Fry, *Reflections on British Painting*, London, 1934, p.62 and repr. fig.27.

A costume and composition study, probably drawn from an articulated doll: there are traces of blocking out in the head, and the features are disposed on the two axes. There is no reason to believe that this is a portrait of one of the artist's daughters, as conjectured by Gower (*op. cit.*). The costume and hair style indicate a date of about 1755–65. The scallops outlining the foliage, and the hatching and pencilwork generally, are closely related to the study of a woman seated in the Frick Collection (Cat. No.18).

22 A Woman in an Interior
Victoria and Albert Museum, London (E 5648–1910)

Pencil, with traces of grey wash. 14½×9⅝ (368×244) (trimmed at all four corners).
Whole-length of a woman standing in an interior, facing the spectator and with her hands held in front of her; a cat and part of a looking glass are sketched in on the right, and there are suggestions of a curtain on the left.
ENGRAVED: Richard Lane, published 1 January 1825 (not in reverse).
PROVENANCE: Among the drawings left by the artist to his wife, which descended through Margaret Gainsborough either to Henry Briggs or via Sophia Lane to Richard Lane; probably Lane sale, Christie's, 25 February 1831, part of Lot 96 or 98; acquired from an unknown source 1910.
EXHIBITED: Arts Council 1960–1 (64, p.8 and repr. pl.I); *English Drawings and Water Colors from British Collections*, National Gallery of Art and the Metropolitan Museum of Art, February–June 1962 (43 and repr. frontispiece).
BIBLIOGRAPHY: *Victoria and Albert Museum Catalogue of Water Colour Paintings by British Artists*, London, 1927, p.219.

A costume and composition study, probably drawn from an articulated doll. The costume, notably the stomacher with échelles, and the hair style indicate a date of about 1755–65. The pencilwork is close to the study of a lady with a fan in the British Museum (Cat. No.21), and there are similar indications of blocking out in the head.

23 A Woman in a Landscape
Ownership unknown

Pencil, with some grey wash. 8½ × 13¼ (216 × 337).
A lady standing facing half-left, her head turned slightly to the right; landscape background (from the print).
ENGRAVED: Richard Lane, published 1 January 1825 (not in reverse).
PROVENANCE: Among the drawings which the artist left to his wife, which descended through Margaret Gainsborough either to Henry Briggs or via Sophia Lane to Richard Lane; probably Lane sale, Christie's, 25 February 1831, part of Lot 96 or 98; George Guy, 4th Earl of Warwick; Warwick sale, Christie's, 20 May 1896 Lot 135 bt. Colnaghi, from whom it was purchased by J. P. Heseltine.
EXHIBITED: *Winter Exhibition of Drawings by the Old Masters*, The Grosvenor Gallery, 1878–9 (779).
BIBLIOGRAPHY: *Original Drawings by British Painters in the Collection of J. P. H*(eseltine), London, 1902, 13 (repr.).

A costume study, probably drawn from an articulated doll. The costume and hair style indicate a date of about 1755–65, and the pose has affinities with the portrait of Lady Clanwilliam formerly with Duveen (Waterhouse 148), dated 1765. The pencilwork seems to be close to the study in the Victoria and Albert Museum (Cat. No.22).

24 A Woman holding a Shawl Plate 79
Pierpont Morgan Library, New York (III, 57)

Black chalk and stump. 16⅛ × 9 (410 × 229) (trimmed at all four corners).
Whole-length of a lady standing facing the spectator, her head turned half-right, and clutching the folds of her shawl or cape in her right hand; no background. Inscribed on the verso in pencil bottom right, in the hand of John Constable: *Given to me by/Rᵈ Lane – A.E. R.A.* Annotated by a later hand on the verso: *by Gainsborough* (top right) and *The above is the writing of John Constable R.A.* (underneath the first inscription).
ENGRAVED: Richard Lane, published 1 January 1825 (with Cat. No.56 on the same plate).

PROVENANCE: Among the drawings left by the artist to his wife, which descended through Margaret Gainsborough and Sophia Lane to Richard Lane; presented by Richard Lane to John Constable; possibly Constable sale, Foster's, 10 May 1838 ff., 2nd Day, Lot 289 (with four others) bt. White; if this is correct, William Benoni White and probably White sale, Christie's, 24 May 1879, Lot 200 or part of Lot 201 both bt. Thibaudeau; James; Charles Fairfax Murray, from whom it was purchased by J. Pierpont Morgan, 1910.
EXHIBITED: *The Art of Eighteenth Century England*, Smith College Museum of Art, January 1947 (27); *The Eighteenth Century Art of France and England*, Montreal Museum of Fine Arts, April–May 1950 (51); *Age of Elegance: The Rococo and its Effect*, Baltimore Museum of Art, April–June 1959 (355).
BIBLIOGRAPHY: Chamberlain, p.169, repr. p.93; *J. Pierpont Morgan Collection of Drawings by the Old Masters formed by C. Fairfax Murray*, Vol.III, London, 1912, No.57 (repr.); Geoffrey Grigson, *English Drawing*, London, 1955, p.174 and repr. pl.47.

A costume study, probably drawn from an articulated doll: the costume itself is identical with that in the study in the Frick Collection (Cat. No.18) and it is possible that this was part of the wardrobe of one of Gainsborough's dolls. The costume and hair style indicate a date of about 1755–65. The hatching and chalkwork are close to the study in the Victoria and Albert Museum (Cat. No.22). The fact that this drawing was lithographed by Lane on the same plate as another drawing, although unusual, does not imply that the two drawings were once on the same sheet, as both the size and colour of the paper are different. Also mentioned on pp.35, 56 and 100.

25 Study for a Portrait of the Artist's Daughters Plate 90
Private Collection, London

Black and white chalks on blue paper. 10¾ × 8 9/16 (273 × 217).
Three-quarter-length of both figures facing left; Mary is shown standing behind Margaret, with her head in profile, a drawing in her right hand, and her left arm resting on a table; Margaret is shown seated, with her head turned half left; a bronze statuette on a pedestal left; suggestions of a curtain in the background left.
ENGRAVED: Richard Lane, published 1 January 1825.
PROVENANCE: Among the drawings left by the artist to his wife, which descended through Margaret Gainsborough either to Henry Briggs or via Sophia Lane to Richard Lane; Henry J. Pfungst; Pfungst sale, Christie's, 15 June 1917, Lot 32 bt. Sir George

Donaldson; Henry Schniewind, Jr.; Schniewind sale, Sotheby's, 25 May 1938, Lot 137 bt. Adams; C. R. Rudolf; with Spink, from whom it was purchased by J. A. Dewar; thence by descent.

EXHIBITED: Cincinnati 1931 (54 and repr. pl.59).

BIBLIOGRAPHY: Menpes and Greig, p.173; 'The Gainsborough Exhibition in Cincinnati', *The Burlington Magazine*, August 1931, p.86; E. S. Siple, 'Gainsborough Drawings: The Schniewind Collection', *The Connoisseur*, June 1934, pp.357–8.

A composition study for the portrait of the artist's daughters in the Worcester Art Museum, Mass. (Waterhouse 287, repr. pl.90), painted in about 1763–4. In the finished picture, Margaret is seen looking slightly downwards, and Mary is holding a portfolio of drawings in her lap and a pencil in her right hand. Also mentioned on p.100.

Mid to Later 1760's

26 Study of a Woman seated holding a Fan Plate 89
British Museum, London (1907-5-15-25)

Black and coloured chalks on blue paper. $11\frac{1}{4} \times 7\frac{7}{8}$ (286 × 200).

Three-quarter-length of a woman with a fan in her hands seated in a chair, facing left but with her head turned to the spectator; no background.

PROVENANCE: With Frank T. Sabin, from whom it was purchased 1907.

A study from life for an unidentified portrait. The costume, notably the stomacher and ruffles, and the absence of piled up hair indicate a date of about 1755–65. The bold chalkwork is characteristic of Gainsborough's portrait studies, and may be compared with the drawing of the artist's daughters formerly owned by Mrs J. A. Dewar (Cat. No.25). Also mentioned on p.43.

27 Study for the Portrait of Carl Friedrich Abel (1725–87) playing a Viol da Gamba
Ownership unknown

Black chalk and stump and white chalk on green paper (apparently). Size unknown. Upright.

Three-quarter-length seated facing the spectator, his head turned half-right, with his viol da gamba between his knees, holding the strings with his left hand and the bow with his right; interior setting, with a window on the left (from the print).

ENGRAVED: Richard Lane, published 1 January 1825.

PROVENANCE: Among the drawings left by the artist to his wife, which descended through Margaret Gainsborough to Henry Briggs; Briggs sale, Christie's, 25 February 1831, Lot 106 (as a portrait of Abel) bt. Crompton.

BIBLIOGRAPHY: Fulcher, 1st edn., p.216 (2nd edn., p.220).

A composition study, probably for a lost portrait: the painting formerly owned by Carl P. Dannett (Waterhouse 3), in which the pose is identical though the costume and background are different, is not certainly a portrait of Abel. The costume, notably the deep cuffs, and hair style indicate a date of about 1755–65; and the type of design, with the figure seated beside a window and the legs cut below the knees, is most commonly found in Gainsborough's portraits of the early 1760's. This evidence is supported by the age of the sitter, who is manifestly much younger than in the portrait of him in the Huntington Art Gallery (Waterhouse 1, pl.171), exhibited R.A. 1777. The strong diagonal hatching in the shadows is paralleled in the study of a woman seated in the Springell collection (Cat. No.32).

28 A Woman holding a Vase
Ownership unknown

Black chalk and stump and white chalk on blue paper. $7\frac{7}{8} \times 12\frac{5}{8}$ (200 × 320).

Whole-length of a woman walking to the right with her head turned towards the spectator and holding a vase in her left hand; no background.

Collector's mark of the Earl of Warwick bottom right.

ENGRAVED: Richard Lane, published 1 January 1825 (not in reverse).

PROVENANCE: Among the drawings left by the artist to his wife, which descended through Margaret Gainsborough either to Henry Briggs or via Sophia Lane to Richard Lane; probably Lane sale, Christie's, 25 February 1831, part of Lot 97 or 99 (the latter bt. Sir Charles Greville); George Guy, 4th Earl of Warwick; Warwick sale, Christie's, 20 May 1896 Lot 136 bt. Colnaghi; Anon. sale, Charpentier, 24 May 1955, Lot 127 (repr. pl.1).

EXHIBITED: *Winter Exhibition of Drawings by the Old Masters*, The Grosvenor Gallery, 1877–8 (1090).

A costume study, probably drawn from an articulated doll. The costume and hair style indicate a date of about 1755–65, and the pose is similar to the portrait of Lady Egremont at Petworth (Waterhouse 236), painted in the mid to late 1760's.

29 A Woman with a Rose
Plate 95
British Museum, London (1855–7–14–70)

Black chalk and stump and white chalk on grey-green paper. 18¼ × 13 (464 × 330).
Whole-length of a woman wearing a hat, facing left with her head in profile, looking downwards, her left arm on her hip and her right hand holding a rose; suggestions of grass and plants.
PROVENANCE: With Tiffin, from whom it was purchased 1855.
BIBLIOGRAPHY: Armstrong 1894, repr. p.42; Armstrong 1898, repr. f.p.184 (colour); Binyon 8; Chamberlain, p.169, repr. p.97; Armstrong 1904, repr. f.p.252; Armstrong 1906, repr. f.p.108; Gower *Drawings*, p.13 and repr. pl.xxvIII; Geoffrey Grigson, *English Drawing*, London, 1955, p.174 and repr. pl.43.
ALSO REPRODUCED: Heinrich Leporini, *Handzeichnungen Grosser Meister: Gainsborough*, Vienna and Leipzig, n.d. (=1925), pl.5.

A costume study, probably from an articulated doll. The costume, notably the open robe with apron over the petticoat and the pronounced tilt of the milkmaid hat, and the hair style (not yet very high) indicate a date of about 1765–70. Also mentioned on pp.35 and 43.

30 Study of a Woman seen from behind
Plate 97
Ashmolean Museum, Oxford

Black chalk and stump and white chalk on grey-green paper. 19¼ × 11 15⁄18 (489 × 303).
Whole-length of a woman in a mushroom-shaped hat facing half-left, with her left arm behind her back, walking away from the spectator; no background.
ENGRAVED: Richard Lane, published 1 January 1825.
PROVENANCE: Among the drawings left by the artist to his wife, which descended through Margaret Gainsborough either to Henry Briggs or via Sophia Lane to Richard Lane; probably Lane sale, Christie's, 25 February 1831, part of Lot 97 or 99; Sir George Donaldson; Donaldson sale, Puttick and Simpson, 6 July 1925 ff., 2nd Day, Lot 216 (repr.); E. Buchanan; Buchanan sale, Puttick and Simpson, 23 July 1936, Lot 49 (repr.); Anon. (=F. Lesser) sale, Christie's, 11 June 1937, Lot 49 bt. E. A. Mott; Mrs A. J. Mott, who bequeathed it 1959.
EXHIBITED: *British Painting from Hogarth to Turner*, British Council (Hamburg, Oslo, Stockholm and Copenhagen), 1949–50 (52); *Europäisches Rokoko*, Residenz, Munich, June–September 1958 (277).
BIBLIOGRAPHY: *Apollo*, June 1925, p.374 repr.; *Ashmolean Museum Report 1959*, pp.41–2 and repr. pl.xi.

ALSO REPRODUCED: *The Connoisseur*, September 1936, p.184.

The unusual nature of the pose, in which the sitter is shown hitching up her skirts as though to avoid a puddle, suggests a study from life rather than a drawing from an articulated doll, as proposed in the Ashmolean report (*op. cit.*). The costume, notably the mushroom hat and high heels, indicates a date of about 1760–70. The chalkwork is related to the study of a woman with a rose in the British Museum (Cat. No.29). Also mentioned on pp.101 and 103.

31 A Woman seated
With Fine Art Society, London

Black and white chalks on blue paper. 12¾ × 8¾ (324 × 222) (trimmed at all four corners).
Whole-length of a woman seated in a chair facing half-right, her head turned towards the spectator, with her arms clasped together in her lap; no background (from the print).
Collector's mark of C. R. Rudolf on the mount bottom right.
ENGRAVED: Richard Lane, published 1 January 1825.
PROVENANCE: Among the drawings left by the artist to his wife, which descended through Margaret Gainsborough either to Henry Briggs or via Sophia Lane to Richard Lane; either this, the study of a woman seated in the Springell collection (Cat. No.32) or the study of a woman seated in Berlin (Cat. No.56) was probably Lane sale, Christie's, 25 February 1831, Lot 100 bt. Crompton; Victor Koch; C. R. Rudolf; with Spink; Anon. sale, Christie's, 20 October 1970, Lot 71 (repr.) bt. Fine Art Society.

A costume and composition study, probably drawn from an articulated doll. The costume and hair style indicate a date of about 1755–65. The chalkwork is closely related to the study of a woman seated in the Springell collection (Cat. No. 32), with which the pose also has affinities.

32 Study of a Woman seated Plate 98
Dr Francis Springell, Portinscale

Black chalk and stump and white chalk on blue paper. 12⅜ × 9 5⁄16 (314 × 237).
Whole-length of a woman seated in a chair facing the spectator, with her arms folded in her lap and wearing a hat; no background.
Verso: whole-length of a small girl seated on a bank (Cat. No.33).
ENGRAVED: Richard Lane, published 1 January 1825 (not in reverse).
PROVENANCE: Among the drawings left by the artist

to his wife, which descended through Margaret Gainsborough and Sophia Lane to Richard Lane; either this, the study of a woman seated formerly in the Koch collection (Cat. No.31), or the study of a woman seated in Berlin (Cat. No.56), was probably Lane sale, Christie's, 25 February 1831, Lot 100 bt. Crompton; with Spiller, from whom it was purchased 1943.

EXHIBITED: *Drawings by Old Masters*, R.A., August–October 1953 (448 and repr. in the Souvenir pl.59); *Drawings by Old Masters from the Collection of Dr and Mrs Francis Springell*, Colnaghi's, October–November 1959 (61 and repr. pl.XXVII); *Springell Collection*, Hatton Gallery, Newcastle upon Tyne, November–December 1959 (61); Arts Council, 1960–1 (65, p.8 and repr. cover); *Old Master Drawings from the collection of Dr and Mrs Francis Springell*, National Gallery of Scotland, Edinburgh, July–September 1965 (85); *The French Taste in English Painting*, Iveagh Bequest, Kenwood, Summer 1968 (76).

A study from life for the pose in an unidentified portrait. This type of design, with the sitter seated in a chair in a frontal pose, is very rare in Gainsborough, but is paralleled in the portrait of the Hon. Mrs Charles Hamilton (Waterhouse 341), painted about the mid 1760's. The costume, notably the milkmaid hat worn completely flat (as in the portrait of Lady Howe (Waterhouse 387, pl.88), painted about the mid-1760's), indicates a date of about 1760–70. Also mentioned on pp.43–4 and 97.

33 Study of a Girl seated Plate 100
Dr Francis Springell, Portinscale

Black chalk on blue paper. $12\frac{3}{8} \times 9\frac{5}{16}$ (314×237).
Whole-length of a small girl seated on a bank facing left, with her head turned towards the spectator; no background.
Recto: whole length of a woman seated in a chair (Cat. No.32).
PROVENANCE: Among the drawings left by the artist to his wife, which descended through Margaret Gainsborough and Sophia Lane to Richard Lane; perhaps Lane sale, Christie's, 25 February 1831, Lot 100 bt. Crompton (see under Cat. No.32); with Spiller, from whom it was purchased 1943.

A study from life for the pose in an unidentified portrait. The figure and head are no more than outlined, but the characterization is complete. This type of pose was used by Gainsborough in several of his portraits of children, notably the double portrait of Robert and Susannah Charlton in the Virginia Museum of Fine Arts (Waterhouse 137, pl.149), painted about the early 1770's.

34 A Woman seated playing a Harp
Plate 101
British Museum, London (1890–10–13–2)

Black chalk and stump and white chalk on buff paper. $14\frac{1}{2} \times 10\frac{5}{8}$ (368×270).
Whole-length of a woman seated playing a harp facing left; suggestions of an interior setting.
PROVENANCE: Charles Fairfax Murray, from whom it was purchased 1890.
BIBLIOGRAPHY: Armstrong 1898, repr. f.p.178 (colour); Binyon 2; Gower *Drawings*, p.14 and repr. pl.XLIII; Menpes and Grieg, p.166.

A composition study for an unidentified portrait. There is no reason to connect it with the portrait either of Lady Clarges (for which see Cat. No.50), or Lady Lincoln, as has been suggested by Gower (*op. cit.*); both these portraits of ladies playing a harp were executed in the late 1770's (the latter in any case now being attributed to William Hoare) and the costume and hair style in the drawing indicate a date of about 1755–65. The delicacy of the chalkwork and the evocative quality of this drawing foreshadow Whistler; in simplicity of characterization it is comparable with the study of a girl seated in the Springell collection (Cat. No.33).

35 Study of Mary Gainsborough
(**1748–1826**) Plate 96
British Museum, London (1960–11–10–1)

Black chalk and stump and white chalk on grey-green paper. $17\frac{3}{8} \times 13\frac{1}{8}$ (441×333).
Whole-length of a woman in a hat facing the spectator, with her head turned towards the left and her arms folded in front of her; no background.
Inscribed in pencil on the old mount bottom centre: *MARY*.
PROVENANCE: With Agnew; Esmond, 2nd Viscount Rothermere; Miss Judith Ellen Wilson, who bequeathed it 1960.
BIBLIOGRAPHY: Menpes and Grieg, p.175.

The sitter's name is noted as being Mary, and comparison with portraits of Mary Gainsborough, such as that in the National Gallery (Waterhouse 289, pl.175) painted some years later, suggests that the drawing represents Gainsborough's daughter. The costume, notably the open robe with an apron over the petticoat, and the hair style (not yet very high) indicate a date of about 1765–70. The hatching in the background is close in character to the study in the Ashmolean Museum (Cat. No.30), and the chalkwork generally is similar to the companion

119

drawing in the British Museum (Cat. No.36). The motif of the arms crossed in this way was used by Gainsborough in his portrait of Lady Margaret Fordyce in Lord Crawford's collection (Waterhouse 266, pl.136), exhibited R.A. 1772.

36 Study of a Woman in a Chip Hat
British Museum, London (1960–11–10–2: recto)

Black chalk and stump and white chalk on grey-green paper. 17¹¹⁄₁₆ × 13⅝ (454 × 346).
Whole-length of a woman in a hat facing left, with her head turned towards the spectator and her hands clasped in front of her; suggestions of a landscape setting.
Inscribed in pencil on the old mount bottom centre: *CATHERINE*.
Verso: three-quarter-length of a youth after Van Dyck (Cat. No.37).
PROVENANCE: With Agnew; Esmond, 2nd Viscount Rothermere; Miss Judith Ellen Wilson, who bequeathed it 1960.
BIBLIOGRAPHY: Menpes and Greig, p.175.

A study from life of an unidentified sitter named Catherine. The costume, notably the chip hat, indicates a date of about 1765–70. The cross-hatching in the background is similar in character to the study of a woman with a rose also in the British Museum (Cat. No.29).

37 A Youth (after Van Dyck) Plate 269
British Museum, London (1960–11–10–2: verso)

Black chalk on grey-green paper. 17¹¹⁄₁₆ × 13⅝ (454 × 346).
Three-quarter-length of a youth facing left.
Recto: whole length of a woman in a chip hat (Cat. No.36).
PROVENANCE: With Agnew; Esmond, 2nd Viscount Rothermere; Miss Judith Ellen Wilson, by whom it was bequeathed in 1960.

A study after Van Dyck. Mr Oliver Millar has kindly informed me that there is no Van Dyck portrait known to him with which this drawing corresponds exactly, but that (though the features are dissimilar) the pose is close to the boy on the right in the Kenelm Digby family group (see Oliver Millar, *The Tudor Stuart and Early Georgian Pictures in the Collection of Her Majesty The Queen*, London, 1963, Vol.I, pl.36). As the study is a brilliant rendering of Van Dyck's own drawing style, there is a strong possibility that it is actually a copy of a lost Van

Dyck drawing rather than of a picture. Probably executed in the same period as the study on the recto, about 1765–70. Also mentioned on pp.31, 56 and 58.

38 A Boy's Head (after Van Dyck)
Ownership unknown

Black and white chalks on brown paper.
14⁹⁄₁₆ × 10³⁄₁₆ (370 × 259).
Head and shoulders of a boy facing slightly to the right (from a photograph).
PROVENANCE: Henry J. Pfungst; Pfungst sale, Christie's, 15 June 1917, Lot 33 bt. Sir George Donaldson; Henry J. Schniewind, Jr.
EXHIBITED: Cincinnati 1931 (72 and repr. pl.62) (as Master Linley).

There is no foundation for the view that this drawing represents any of the Linley family, and it is in fact a direct study of the head of George Villiers, 2nd Duke of Buckingham, either from the original Van Dyck double portrait of the Villiers children at Windsor (then at Buckingham House) or from one of the many copies of it. Being a copy, it is difficult to establish the date with any precision, but the comparatively tight handling seems to suggest a date in the 1760's rather than later, and Gainsborough is known to have made several copies in oil after Van Dyck portraits at this period.

39 A Woman seated beside a Plinth
Plate 110
Pierpont Morgan Library, New York (III, 58)

Black chalk and stump and white chalk on grey-green paper. 17½ × 14 (444 × 356).
Whole-length of a lady seated facing right, supporting her head on her left arm, which is resting on a plinth.
PROVENANCE: Dr John Percy; Sir J. C. Robinson; Robinson sale, Christie's, 21 April 1902, Lot 105 bt. Charles Fairfax Murray, from whom it was purchased by J. Pierpont Morgan 1910.
EXHIBITED: *The Eighteenth Century Art of France and England*, Montreal Museum of Fine Arts, April–May 1950 (52).
BIBLIOGRAPHY: Chamberlain, p.169, repr. p.89; *J. Pierpont Morgan Collection of Drawings by the Old Masters formed by C. Fairfax Murray*, Vol.III, London, 1912, No.58 (repr.); Geoffrey Grigson, *English Drawing*, London, 1955, p.174 and repr. pl.46.
ALSO REPRODUCED: T. Martin Wood, 'English Drawing', *The Studio*, November 1906, f.p.124.

A composition study for an unidentified portrait. The costume, notably the milkmaid hat, and the

hair style indicate a date of about 1760–70. The loose rapid chalkwork and broad hatching on the right are close to the study of a woman seated in the Springell collection (Cat. No.32), but rather looser in handling. This type of pose, with the figure seated beside a plinth and the left elbow resting on its parapet, was used by Gainsborough in his portrait of Lady Chesterfield owned by Sir John Leigh (Waterhouse 141) exhibited R.A. 1778.

40 Portrait of Caroline, 4th Duchess of Marlborough (1743–1811) Plate 115
Private Collection, England

Pastel on grey paper. 12$\frac{9}{16}$ × 9$\frac{9}{16}$ (319 × 243).
Half-length seated facing the spectator, with her head turned half-right and downwards, her arms folded, and an open book in her lap; a pinkish-grey curtain in the background left.
PROVENANCE: Jane, 6th Duchess of Marlborough; given after her death in 1844 (by the Duke) to her daughter Louisa, who married Colonel Robert C. H. Spencer; Blanche Louisa Spencer, who married Captain H. G. Fane; thence by descent.
LITERATURE: John Hayes, 'Gainsborough and the Bedfords', The Connoisseur, April 1968, pp.217 and 222–3, repr. fig.10.

The sitter is wearing a blue and white dress with a black lace shawl. The hair style indicates a date of about 1767–72. The Duchess looks more demure and slightly younger if anything than in the Gainsborough portrait of her at Woburn (Waterhouse 467), painted in the later 1760's. Also mentioned on pp.9 and 36.

41 Portrait of George, 1st Duke of Montagu (1712–90) Plate 116
British Museum, London (1951-1-29-1)

Pastel. 10$\frac{11}{16}$ × 8$\frac{15}{16}$ (271 × 227) (oval).
Half-length in a feigned oval facing left and with his head turned to the spectator, wearing a red suit and the star and ribbon of the Order of the Garter.
PROVENANCE: Anon. sale, Dowell's, Edinburgh, 11 March 1950, Lot 23 (as unknown sitter); with Colnaghi, from whom it was purchased by the National Art-Collections Fund and presented 1950.
EXHIBITED: British Portraits, R.A., November 1956–March 1957 (594).
BIBLIOGRAPHY: National Art-Collections Fund Annual Report 1950, London, 1951, p.29 (repr. f.); E. K. Waterhouse, 'Preliminary Check List of Portraits by Thomas Gainsborough', The Walpole Society, Vol.33, Oxford, 1953, pp.76 and 126; Waterhouse, p.81.

Montagu was created K.G. in 1762, but there is nothing else about the costume to help in dating (the type of wig, for example, remained fashionable until about 1780). The sitter does not look older than in the portrait of him in the Buccleuch collection (Waterhouse 490, pl.101), which Gainsborough painted in 1768, and the pastel probably dates from about this time. Also mentioned on pp.9 and 36.

42 Portrait of George, 1st Baron Rivers (1721–1803)
Victoria and Albert Museum, London (P25-1938)

Pastel on grey paper. 11$\frac{1}{8}$ × 9$\frac{3}{16}$ (283 × 233) (oval).
Head and shoulders in a feigned oval, facing half-left wearing a silver-grey coat with a pink collar, and holding a tricorne hat under his left arm.
Inscribed on the verso: Bridget Bowaters/Picture/The Right Honble/Lord Rivers one of/his Majestys Lords of the/Bed Chamber.
PROVENANCE: Bridget Bowater; by descent to Lady Knightley of Fawsley; Henry J. Pfungst; Pfungst sale, Christie's, 15 June 1917, Lot 12 bt. Sir George Donaldson; Henry Schniewind, Jr.; Anon. (=Schniewind) sale, Sotheby's, 25 May 1938, Lot 154 bt. Bier; Mrs Martha Oppenheimer, from whom it was purchased.
EXHIBITED: Cincinnati 1931 (73 and repr. pl.60).
BIBLIOGRAPHY: 'The Gainsborough Exhibition in Cincinnati', The Burlington Magazine, August 1931, p.85; E. S. Siple, 'Gainsborough Drawings: The Schniewind Collection', The Connoisseur, June 1934, pp.355–6.

There is nothing in the costume to help in dating (the type of wig, for example, remained fashionable until about 1780), but the sitter does not look older than in the Gainsborough portrait of him owned by G. H. Lane-Fox-Pitt-Rivers (Waterhouse 577, pl.110), exhibited R.A. 1769, and the pastel probably dates from about this time. Also mentioned on p.101.

43 Portrait of Elizabeth, 3rd Duchess of Buccleuch (1743–1827) Plate 124
G. D. Lockett, Clonterbrook House

Pastel on blue paper. 10$\frac{1}{8}$ × 7$\frac{3}{4}$ (257 × 197) (oval).
Head and shoulders facing the spectator, her head turned half-left; plain background.
PROVENANCE: Victor Koch; Mrs Flora Koch Charitable Settlement sale, Christie's, 19 March 1968, Lot 104 (repr.) bt. Baskett, from whom it was purchased.

ALSO REPRODUCED: *Christie's Review of the Year 1967–1968*, London, 1968, p.52.

The sitter is identifiable from the Gainsborough portrait of her in the Buccleuch collection (Waterhouse 89), where she looks some years older. She is wearing a blue and white dress and hat, with a black shawl. The hair style indicates a date of about 1767–72. Also mentioned on p.36.

44 Portrait of Gertrude Leveson-Gower, 4th Duchess of Bedford (d.1794)
Private Collection, England

Pastel on grey paper. $10\frac{5}{16} \times 8\frac{13}{16}$ (262 × 224) (oval). Head and shoulders in a feigned oval, facing the spectator.
PROVENANCE: Jane, 6th Duchess of Marlborough; given after her death in 1844 (by the Duke) to her daughter Louisa, who married Colonel Robert C. H. Spencer; Blanche Louisa Spencer, who married Captain H. G. Fane; thence by descent.
LITERATURE: John Hayes, 'Gainsborough and the Bedfords', *The Connoisseur*, April 1968, pp.217 and 222–3, repr. fig.9.

The sitter is wearing a blue dress and hat, with a blue and white bow and a black and brown shawl. The hair style indicates a date of about 1767–72. The Duchess looks some years older than in the portrait of her at Woburn (Waterhouse 58) painted by Gainsborough in 1764. The sketchy technique is closely related to the pastel of the Duchess of Buccleuch in the Lockett collection (Cat. No.43).

Early 1770's

45 Portrait of Frances Catherine, 2nd Countess of Dartmouth (*c*.1733–1805)
Private Collection, England

Pastel on grey paper. $12\frac{1}{16} \times 9\frac{3}{8}$ (306 × 238) (oval). Head and shoulders in a feigned oval, facing the spectator, her head turned slightly to left.
PROVENANCE: William, 2nd Earl of Dartmouth; thence by descent.
EXHIBITED: *British Portraits*, R.A., November 1956–March 1957 (589).
BIBLIOGRAPHY: E. K. Waterhouse, 'Preliminary Check List of Portraits by Thomas Gainsborough,' *The Walpole Society*, Vol.33, Oxford, 1953, p.27; Waterhouse, p.62.

The hair style indicates a date of about 1767–72. The sitter looks about the same age as in the portrait of her (Waterhouse 187, pl.142) which Gainsborough painted in 1771, and the pastel probably dates from about this time.

46 Portrait of William, 2nd Earl of Dartmouth (1731–1801)
Private Collection, England

Pastel on grey paper. $12\frac{1}{16} \times 9\frac{3}{8}$ (306 × 238) (oval). Head and shoulders in a feigned oval, facing half-left, wearing a red coat and holding a tricorne hat under his left arm.
PROVENANCE: William, 2nd Earl of Dartmouth; thence by descent.
EXHIBITED: *British Portraits*, R.A., November 1956–March 1957 (591).
BIBLIOGRAPHY: E. K. Waterhouse, 'Preliminary Check List of Portraits by Thomas Gainsborough', *The Walpole Society*, Vol.33, Oxford, 1953, p.27; Waterhouse, p.62.

There is nothing in the costume to help in dating (the type of wig, for example, remained fashion.able until about 1780), but the pastel was presumably executed at the same time as the companion portrait of Lady Dartmouth (Cat. No.45).

47 Study of a Music Party Plate 122
British Museum, London (1889–7–24–371)

Red chalk and stump. $9\frac{1}{2} \times 12\frac{3}{4}$ (241 × 324) (trimmed at all four corners).
Four musicians facing right: from left to right, a female singer, a male violinist, a female pianist seated at the keyboard, and a male singer; a dog underneath the harpsichord; suggestions of an interior setting.
PROVENANCE: W. Ward, from whom it was purchased 1889.
BIBLIOGRAPHY: Binyon 1; Gower *Drawings*, p.13 and repr. pl.XXXII; Geoffrey Grigson, *English Drawing*, London, 1955, p.174 and repr. pl.41; Woodall *Letters*, repr. pl.1.

One of Gainsborough's most brilliant and effective sketches from life: the use of red chalk is unusual, and probably influenced by French usage. The musicians have never been identified, but it is tempting to suppose that the scene is the Linleys' house in Bath, where Gainsborough was a constant and welcome visitor; the lady seated at the harpsichord is difficult to identify (conceivably she is Mrs Linley), but

comparison with portraits does not preclude the possibility that the other sitters are Elizabeth Linley (1754–92), Felice de Giardini (1716–96), and Thomas Linley, Sr. (1733–95). If this hypothesis could be supported, the drawing would have to date from about the early 1770's, when Elizabeth was in her late 'teens. The hair style of the girl on the left indicates a date of about 1767–72. Also mentioned on pp.10, 43 and 60.

48 Study of Arms and Drapery, possibly for the Portrait of Robert and Susannah Charlton Plate 123
Ehemals Staatliche Museen, Berlin-Dahlem (4550)

Black chalk and stump and white chalk on blue paper. $9\frac{3}{8} \times 7\frac{11}{16}$ (238 × 195).
Lower half only of a woman seated facing half-left, with her left arm held across her lap; separate study of an arm top right; no background.
PROVENANCE: Presented by an unknown donor 1911.

A study from life for the pose and arrangement of the arms, possibly for the double portrait of Robert and Susannah Charlton in the Virginia Museum of Fine Arts (Waterhouse 137, pl.149), painted in the early 1770's. The arm at the top of the drawing is very similar in pose and the arrangement of the fingers to Robert's outstretched right arm in the picture, but the only similarity to Susannah is that the drawing which occupies the rest of the sheet also represents a girl in a plain decolleté dress seated facing half-left. The vigorous chalkwork and broad highlighting are similar in character to the study of a woman holding a fan in the British Museum (Cat. No.26). Also mentioned on p.35.

49 Portrait of Gainsborough Dupont (1754–97) Plate 125
Victoria and Albert Museum, London (P.80–1962)

Black chalk and stump, coloured chalks and watercolour, varnished. $6\frac{1}{2} \times 5\frac{9}{16}$ (165 × 141).
Head and shoulders facing half-left.
Inscribed bottom in a later hand: *T Gainsb*^h *ft.* and *Gainsborough Dupont, Painter*.
Inscribed on the verso, in Gainsborough Dupont's hand: *Portrait of/Gainsborough Dupont/drawn in chalks by/Gainsborough/Bath about the/Year 1775*.
PROVENANCE: Gainsborough Dupont; W. H. Alexander; Anon. (=Alexander) sale, Christie's,

15 July 1958 (with thirteen others), Lot 220 bt. Colnaghi, from whom it was purchased by Claude D. Rotch; bequeathed 1962.
EXHIBITED: Arts Council 1960–1 (68, and p.4).
BIBLIOGRAPHY: *Victoria and Albert Museum, Department of Prints and Drawings and Department of Paintings, Accessions 1962*, pp.v and 66; Frank Davis, 'A Review of the Claude Rotch Bequest', *The Illustrated London News*, 22 December 1962, p.1020.

Dupont is not likely to have remembered incorrectly in stating that this portrait was done at Bath, but the year is wrong, since Gainsborough left Bath in 1774. Presumably executed between 1772 (when Dupont was apprenticed to Gainsborough) and 1774. Also mentioned on p.36.

Mid to Later 1770's

50 Study for the Portrait of Louisa, Lady Clarges (1760–1809) Plate 141
British Museum, London (1895-7-25-4)

Black chalk and stump and white chalk.
$12\frac{1}{2} \times 10\frac{1}{4}$ (317 × 260)
Three-quarter-length facing left playing a harp; a dog behind the harp left.
PROVENANCE: Miss L. Stephanoff, from whom it was purchased 1895.
BIBLIOGRAPHY: Armstrong 1898, repr. f.p.176 (colour); Binyon 7; Armstrong 1904, repr. f.p.246; Boulton, p.22; Gower *Drawings*, p.14 and repr. pl.xxxvii; Menpes and Greig, p.165; M. T. Ritchie, *English Drawings*, London, 1935, repr. pl.22; E. K. Waterhouse, 'Preliminary Check List of Portraits by Thomas Gainsborough', *The Walpole Society*, Vol.33, Oxford, 1953, p.22.

A composition study for the portrait of Lady Clarges owned by Mrs Stella Hotblack (Waterhouse 149), painted in the late 1770's but never finished. There is a pentimento in the placing of the left forearm. In the painting, the conception is far less intimate and informal: the dog is replaced by a formal background of column and curtain, and the top and left side of the harp are shown, thus reducing the immediacy of the original design; the pose of the figure was unaltered, and the upper of the two positions of the left forearm used. Also mentioned on pp.44, 46 and 61.

51 Study of a Woman seated Plate 142
British Museum, London (1895–7–25–1)

Black and white chalks. $12\frac{5}{16} \times 9\frac{3}{16}$ (313×233) (trimmed at all four corners).
Half-length of a woman seated at a table studying a book of music facing right, with her head turned towards the spectator.
PROVENANCE: Miss L. Stephanoff, from whom it was purchased 1895.
BIBLIOGRAPHY: Binyon 6; Boulton, p.22 and repr. f.; Gower *Drawings*, p.13 and repr. pl.xxv.
ALSO REPRODUCED: Heinrich Leporini, *Handzeichnungen Grosser Meister: Gainsborough*, Vienna and Leipzig, n.d. (=1925), pl.8.

A study from life. The high-piled hair indicates a date of about 1775–80. The soft chalkwork and rhythmical hatching are characteristic of Gainsborough's style of the late 1770's, and can be paralleled in the landscape with a horse and cart at Manchester (Cat. No.407). Also mentioned on pp.44 and 61.

52 Study of a Woman seated
British Museum, London (1901–4–17–12)

Pencil. $17\frac{9}{16} \times 9\frac{7}{8}$ (446×251).
Whole-length of a woman seated, facing half-right and with her chin resting on her right hand; no background.
PROVENANCE: With Colnaghi, from whom it was purchased 1901.
BIBLIOGRAPHY: Gower *Drawings*, p.13 and repr. pl.xxx.

A study from life for an unidentified portrait. The high-piled hair indicates a date of about 1775–80. Gainsborough rarely used pencil at this period and, were it not for the fashion, the drawing might well be dated to the early 1760's.

1780's

53 Study of a Child asleep Plate 159
B. C. G. Whitaker, London

Black chalk and stump and white chalk on blue paper. $5\frac{3}{4} \times 7\frac{9}{16}$ (146×192).
A child reclining, facing upwards and half-left, with its left arm behind its head and its right arm stretched upwards; no background.
PROVENANCE: John F. Keane; Keane sale, Sotheby's, 3 December 1947, Lot 79 bt. Spink, from whom it was purchased.
EXHIBITED: Arts Council 1960–1 (69, and p.4).

A rapid and brilliant sketch from life. The stumpwork is close in character to the study of a beggar boy in the Spooner collection (Cat. No.834). Also mentioned on pp.10, 22 and 36.

54 Study of a Woman in a Mob Cap
Plate 429
Mr and Mrs Paul Mellon, Oak Spring, Virginia

Black and white chalks on buff paper.
$7\frac{5}{8} \times 5\frac{5}{16}$ (194×135).
Head and shoulders of a woman facing half-right, with her head in profile; no background.
Collector's mark of T. E. Lowinsky bottom left.
PROVENANCE: Sir George Donaldson; Henry Schniewind, Jr.; Anon. (=Schniewind) sale, Sotheby's, 25 May 1938, Lot 139 bt. Wheeler; T. E. Lowinsky; by descent to Justin Lowinsky, from whom it was purchased.
EXHIBITED: Cincinnati 1931 (59 and repr. pl.73); Arts Council 1960–1 (66).
BIBLIOGRAPHY: E. S. Siple, 'Gainsborough Drawings: The Schniewind Collection', *The Connoisseur*, June 1934, p.355.

A sketch from life. The loose 'romantic' hair style indicates a date in the 1780's. The white hatching in the modelling of the head and the broken white highlights in the costume and hair are technically very close to the chalkwork in landscape drawings such as the mountain scene in the Ponce Museum (Cat. No.590), executed in 1783. Also mentioned on p.86.

55 Portrait of the Rev. Richard Graves (1715–1804)
Pierpont Morgan Library, New York (1957.12)

Black, white and coloured chalks on brown paper. $5\frac{1}{4} \times 4\frac{1}{8}$ (133×105) (oval).
Head and shoulders facing left, the head turned slightly towards the spectator, and wearing clerical dress.
Inscribed by the sitter on the back of the original frame: *Hanc/Patris sui Effigiem/Quem/ad vivum delineavit/ Egregius Pictor T. Gainsbo/rough/Lucillae Annae Mariae/ Filiae suae dilectissimae / Dedit Richardus Graves/Ecclesiae Clavertoniae/in agno Somerset/Rector/8th Aug. 1786.*
ENGRAVED: Gainsborough Dupont, n.d. (=1790); J. Basire, 1812; J. Scott.
PROVENANCE: Rev. Richard Graves, who gave it to his daughter Lucy Anne Mary 1786; C. Ford 1856; A. D. Skrine of Warleigh Manor (a descendant of one of the sitter's pupils); by descent to Miss Dorothea Skrine; with Colnaghi, from whom it was purchased on behalf of Mrs Junius S. Morgan and presented 1957.

EXHIBITED: *Art Treasures of the West Country*, Royal West of England Academy Galleries, Bristol, May–June 1937 (132); Arts Council 1949 (35); *Old Master Drawings*, Colnaghi's, May–June 1957 (41 and repr. pl.x).
BIBLIOGRAPHY: Fulcher, 1st edn., p.214 (2nd edn., p.218); Boulton, p.177; E. K. Waterhouse, 'Preliminary Check List of Portraits by Thomas Gainsborough', *The Walpole Society*, Vol.33, Oxford, 1953, p.50.

The loose 'romantic' hair style indicates a date in the 1780's, which accords with the age of the sitter, who appears to be at any rate in his sixties; a *terminus ante quem* is provided by the date at which the portrait was given by Graves to his daughter, August 1786. Richard Graves, writer and poet, was presented to the rectory of Claverton, Somerest, by William Skrine, 1748, and came to know Gainsborough at Bath.

56 A Woman seated Plate 200
Ehemals Staatliche Museen, Berlin-Dahlem (4432)

Black chalk and stump and white chalk on blue paper. $11 \times 7\frac{5}{16}$ (279×186).
Whole-length of a woman seated facing right, with her head turned slightly downwards, and her right arm resting on the plinth of a column; a curtain behind.
ENGRAVED: Richard Lane, published 1 January 1825 (with Cat. No.21 on the same plate).
PROVENANCE: Among the drawings left by the artist to his wife, which descended through Margaret Gainsborough either to Henry Briggs or via Sophia Lane to Richard Lane; either this, the study of a woman seated formerly in the Koch collection (Cat. No.31) or the study of a woman seated in the Springell collection (Cat. No.32), was probably Lane sale, Christie's, 25 February 1831, Lot 100 bt. Crompton; presented by an unknown donor 1910.

A composition study for an unidentified portrait: the motif of the arm resting on a plinth is very common in Gainsborough's later portraits. The costume is difficult to distinguish exactly, but the sitter appears to be wearing a closed robe and flowing pelisse (compare the latter with the study of a lady in the Morgan Library: Cat. No.61) characteristic of the 1780's with the casual kind of turban also worn at this date. The loose rapid chalkwork is close to the study of a girl seated at a doorway in the Victoria and Albert Museum (Cat. No.838). The fact that this drawing was lithographed by Lane on the same plate as another drawing, although un-usual, does not imply that the two drawings

were once on the same sheet, as both the size and colour of the paper are different.

57 Study for the Portrait of Henry Frederick, Duke of Cumberland (1745–90), and Anne, Duchess of Cumberland (1743–1808), with Lady Elizabeth Luttrell (d.1799) Plate 337
H.M. The Queen, Windsor Castle

Black chalk and stump and white chalk on buff paper. $9\frac{7}{8} \times 12\frac{1}{2}$ (251×317).
Whole-lengths of the Duke and Duchess of Cumberland, accompanied by a dog, walking towards the left, their heads turned to the spectator, in the foreground centre; Lady Elizabeth Luttrell seated on a garden seat in the middle distance right; background of trees sketched in.
Inscribed in pencil bottom left: *20* and *Gainsborough*.
PROVENANCE: Edward Basil Jupp; Thomas William Waller; Elizabeth Stauffer Moore; thence by descent to Elizabeth Richardson Simmons; Simmons sale, Christie's, 12 November 1968, Lot 62 (repr.) bt. Colnaghi.
EXHIBITED: *Gainsborough*, The Queen's Gallery, Buckingham Palace, 1970 (21).
BIBLIOGRAPHY: *A Descriptive List of Original Drawings, Engravings, Autograph Letters, and Portraits illustrating the Catalogues of the Society of Artists of Great Britain . . . in the possession of Edward Basil Jupp, F.S.A.*, 1871, p.8; Oliver Millar, *The Later Georgian Pictures in the Collection of Her Majesty The Queen*, London, 1969, Vol.I, p.40 and repr. fig.6.

The first design for the picture in the royal collection (Waterhouse 178) (Plate 338) painted in the mid-1780's. This is conceived in the tradition of the conversation piece. The back-ground, totally different from the finished work, is no more than blocked out, the hats of the Duke and Duchess have a more rakish tilt, and Lady Elizabeth Luttrell is seated farther away and in a more relaxed posture. The broad stumpwork is close to the study for an equestrian portrait owned by Lord Hartwell (Cat. No.65). The drawing has been badly stained. Also mentioned on pp.36 and 46.

58 Study for the Portrait of Henry Frederick, Duke of Cumberland (1745–90), and Anne, Duchess of Cumberland (1743–1808), with Lady Elizabeth Luttrell (d.1799) Plate 339
British Museum, London (1902–6–17–6)

Black chalk and stump and white chalk on buff paper. $16\frac{7}{8} \times 12\frac{7}{16}$ (429×316).

Whole-lengths of the Duke and Duchess of Cumberland, accompanied by a dog, walking towards the left, their heads turned to the spectator, in the foreground centre; Lady Elizabeth Luttrell seated in the foreground right; wooded background.

PROVENANCE: W. F. Mercer; Anon. (=Mercer) sale, Christie's, 19 April 1869, Lot 209 bt. Hogarth; Sir J. C. Robinson; Robinson sale, Christie's, 21 April 1902, Lot 106 bt. Colnaghi, from whom it was purchased 1902.

BIBLIOGRAPHY: Gower *Drawings*, p.12 and repr. pl.XVII; Woodall 158; Oliver Millar, *The Later Georgian Pictures in the Collection of Her Majesty The Queen*, London, 1969, Vol.I, pp.39–40 and repr. fig.7.

ALSO REPRODUCED: R. H. Wilenski, *English Painting*, London, 1933, pl.52.

The final design for the picture in the royal collection (Waterhouse 178) (Plate 338), painted in the mid-1780's. The format is now vertical instead of horizontal, the poses of the figures have almost been finalized and the arrangement of the background broadly determined. In the finished picture the pose of the Duke's outstretched right arm has been abandoned in favour of the posture adopted in the first design, the trees have been varied slightly, and a plinth surmounted by an urn has been introduced; the rectangular format of the composition has also been abandoned in favour of an oval design. The costume, notably the elaborate polonese dress and the ladies' hats tilted forwards, indicates a date of about 1783–5 (Gainsborough included costume and hats of the same type in his painting of *The Mall* in the Frick Collection (Waterhouse 987, pl.243), finished in December 1783). The sketchy handling of the background trees and the rich broken highlighting in the drawing is very close to Gainsborough's drawings for his *Richmond Water-walk* (Cat. Nos.59–63). A copy, derived from the painting and omitting Lady Elizabeth Luttrell, was in an Anon. sale, Christie's, 16 July 1963, Lot 96A, bt. Maison. Also mentioned on pp.36 and 46.

59 Study of a Lady for *The Richmond Water-walk* Plate 204
British Museum, London (1910–2–12–250)

Black chalk and stump on buff paper, heightened with white. $19\frac{5}{16} \times 12\frac{1}{4}$ (491 × 311).

Whole-length of a lady in a large hat facing half-right and walking away from the spectator, her head turned back and seen in profile, holding a rose in her left hand; wooded background.

The label formerly on the back of the frame is inscribed: *This drawing was given by Gainsborough/to M^r Pearce Chief Clerk of the Admiralty,/& by him to me. He had left it to me/in his will, but in the year 1834 chose rather/to give it to me & he accompanied it with/the following written account of the drawing/"Gainsbro' once told me that King/George III having expressed a wish to have/a picture representing that part of S^t. James's/Park which is overlooked by the garden/of the Palace – the assemblage being there,/for five or six seasons, as high dressed &/fashionable as Ranelagh – employed/him to paint it. 'His Majesty' said Gains/bro' 'very sensibly remarked that he did/not desire the high finish of Watteau, but,/a sketchy picture.' & such was the/picture produced by Gainsbro'. While/sketching one morning in the Park for this/picture, he was much struck with what/he called 'the fascinating leer' of the Lady/who is the subject of the drawing. He never/knew her name, but she was that evening/in company with Lady N . . . field, & ob/serving that he was sketching she walk=/ed to & fro' two or three times, evidently/to allow him to make a likeness. Sir/Thomas Lawrence when he lodged in Jer=/myn Street came to my house in Pall Mall,/for several successive days, when Lord Derby/employed him to paint Miss Farren to/study this drawing" – William Pearce/1^st. Feb. 1834"/ JW Croker 1842.*

PROVENANCE: Presented by the artist to William Pearce, who gave it to John Wilson Croker 1834; Lord Leighton; Leighton sale, Christie's, 14 July 1896, Lot 256 bt. Agnew for George Salting, who bequeathed it 1910.

EXHIBITED: Colnaghi's 1906 (16); *Romantic Art in Britain*, Detroit Institute of Arts and Philadelphia Museum of Art, January–April 1968 (21 repr.); *Bicentenary Exhibition*, R. A., December 1968–March 1969 (662).

BIBLIOGRAPHY: Armstrong 1898, p.170 and repr. f.p.164 (colour); 'The Truth about "The Stolen Duchess"', *The Candid Friend*, 1 May 1901, p.20; W. Roberts, 'Mr. J. Pierpont Morgan's Pictures: The Early English School II', *The Connoisseur*, November 1906, p.136 and repr. p.135; W. Roberts, *Pictures in the Collection of J. Pierpont Morgan*, London, 1907 (under the entry for Gainsborough's Duchess of Devonshire) (repr. in the folio edn.); Gower, pp.67–8; Armstrong 1904, repr. f.p.240; Menpes and Greig, pp.125 and 165; Whitley, p.394; M. T. Ritchie, *English Drawings*, London, 1935, p.ii and repr. pl.20; Woodall 87; John Hayes, 'Gainsborough's "Richmond Water-walk"', *The Burlington Magazine*, January 1969, pp.28 and 31 and repr. fig.48.

According to Pearce (see above), a study from life taken in St James's Park and a preparatory drawing for a subject picture commissioned by George III. This picture cannot be identified with *The Mall* in the Frick Collection, painted in 1783, which Pearce seems to suggest, as the fashion depicted, notably the large picture hat, and the hair style, with the hair in loose ringlets

and flowing down over the shoulder, are those of about 1785–90; and the drawing must be related to the canvas noted by Bate-Dudley as intended for the King, and as a companion to *The Mall*, the setting to be 'Richmond water-walk, or Windsor – the figures all portraits' (*The Morning Herald*, 20 October 1785). Four other drawings of figures in similar costume, in the same media and technique and about the same size (Cat. Nos.60–63), are probably also to be associated with this picture. There is no foundation for the traditional view (see Roberts, *op. cit.*) that this or any other of these drawings, except possibly that in the British Museum (Cat. No.62), represent the Duchess of Devonshire: the three drawings which include portrait heads in any case portray different people. For a fuller account, see my article in *The Burlington Magazine*, *op. cit.* Also mentioned on pp.19, 46 and 94.

60 Study of a Lady for *The Richmond Water-walk*
Private Collection, New York

Black chalk and stump heightened with white on pale buff paper. 19¼ × 12⅜ (489 × 314).
Whole-length of a lady in a large hat, carrying a muff, facing half-right and walking away from the spectator; wooded background, with water on the right.
ENGRAVED: Richard Lane, published 1 January 1825.
PROVENANCE: Among the drawings left by the artist to his wife, which descended through Margaret Gainsborough and Mrs Lane to Richard Lane; probably Lane sale, Christie's, 25 February 1831, Lot 99 (with another) bt. Sir Charles Greville; inherited by George Guy, 4th Earl of Warwick; Warwick sale, Sotheby's, 17 June 1936, Lot 167 (repr.) bt. Spink; Lord Doverdale; Doverdale sale, Sotheby's, 8 November 1950, Lot 86 (repr.) bt. J. R. Huntington; Huntington sale, Sotheby's, 4 April 1968, Lot 85 (repr.) bt. Robins.
BIBLIOGRAPHY: Woodall 300; John Hayes, 'Gainsborough's "Richmond Water-walk" ', *The Burlington Magazine*, January 1969, pp.31 and repr. fig.49.

Almost certainly a preparatory drawing for a companion picture to *The Mall* in the Frick Collection, never executed (see Cat. No.59); the conception is similar to that of the principal figure in the left foreground of *The Mall*. The suggestion of water and a far bank on the right is corroborative of Bate-Dudley's statement that the setting was to be 'Richmond water-walk' (*The Morning Herald*, 20 October, 1785). The

costume, notably the large picture hat, and the hair style, with the hair flowing down over the shoulder, indicate a date of about 1785–90. Also mentioned on p.103.

61 Study of a Lady, probably for *The Richmond Water-walk* Plate 205
Pierpont Morgan Library, New York (III, 63b)

Black chalk and stump and white chalk on buff prepared paper. 19⅜ × 12¼ (492 × 311).
Whole-length of a lady in a large hat facing half-right and walking towards the spectator, her head turned half-left and her left arm held across her body; wooded background.
ENGRAVED: Richard Lane, published 1 January 1825.
PROVENANCE: Among the drawings left by the artist to his wife, which descended through Margaret Gainsborough either to Henry Briggs or via Sophia Lane to Richard Lane; possibly Briggs sale, Christie's, 25 February 1831, Lot 115 (as the Duchess of Devonshire); C. F. Huth; J. Pierpont Morgan, from whose estate it was purchased 1943.
EXHIBITED: *The Art of Eighteenth Century England*, Smith College Museum of Art, January 1947 (34); *Treasures from the Pierpont Morgan Library*, Pierpont Morgan Library, 1957 (104 and repr. pl.68); *18th Century Prints and Drawings*, Baltimore Museum of Art, December 1963–February 1964.
BIBLIOGRAPHY: W. Roberts, 'Mr. J. Pierpont Morgan's Pictures: The Early English School II', *The Connoisseur*, November 1906, p.136 and repr. p.135; W. Roberts, *Pictures in the Collection of J. Pierpont Morgan*, London, 1907 (under the entry for Gainsborough's Duchess of Devonshire) (repr. in the folio edn.); Menpes and Greig, pp.125 and 165; *J. Pierpont Morgan Collection of Drawings by the Old Masters formed by C. Fairfax Murray*, Vol.III, London, 1912, No.636 (repr.); John Hayes, 'Gainsborough's "Richmond Water-walk" ', *The Burlington Magazine*, January 1969, pp.28 and 31 and repr. fig.45.

Although not executed on dark coloured paper, the overall effect is dark, and the drawing may possibly therefore have been the 'splendid drawing in black and white chalks on dark coloured paper' which was Lot 115 in the Briggs sale and there catalogued as the Duchess of Devonshire. Though the head is clearly a portrait, however, it is not a likeness of the Duchess of Devonshire. Probably a preparatory drawing for a companion picture to *The Mall* in the Frick Collection, never executed (see Cat. No.59). The pose is identical with that used for the portrait of Lady Sheffield at Waddesdon (Waterhouse 609), begun in the spring of 1785, but the likeness is of a different sitter. The costume, notably the large

picture hat, and the hair style, with the hair loosely dressed in ringlets and flowing down on either side, indicate a date of about 1785–90. Also mentioned on pp.19, 46 and 97.

62 Study of a Lady, probably for *The Richmond Water-walk* Plate 206
British Museum, London (1897-4-10-20)

Black chalk and stump on buff paper, heightened with white. 19 1/16 × 12 1/4 (484 × 311) (trimmed at all four corners).
Whole-length of a lady in a large hat walking towards the left, her head turned to the spectator and her arms folded in front of her, holding a rose in her hands; wooded background.
Collector's mark of the Earl of Warwick bottom right.
ENGRAVED: Richard Lane, published 1 January 1825 (not in reverse).
PROVENANCE: Among the drawings left by the artist to his wife, which descended through Margaret Gainsborough and Mrs Lane to Richard Lane; probably Lane sale, Christie's, 25 February 1831, Lot 99 (with another) bt. Sir Charles Greville; inherited by George Guy, 4th Earl of Warwick; Warwick sale, Christie's, 20 May 1896, Lot 134 bt. Colnaghi, from whom it was purchased 1897.
EXHIBITED: *Winter Exhibition of Drawings by the Old Masters*, The Grosvenor Gallery, 1877–8 (1091).
BIBLIOGRAPHY: Armstrong 1898, p.170 and repr. f.p.168 (colour); Binyon 9; 'The Truth about "The Stolen Duchess"', *The Candid Friend*, 1 May 1901, p.20 and repr. p.19; Gower, pp.9 and 67–8; Armstrong 1904, p.229; Gower *Drawings*, pp.7 and 11 and repr. frontispiece (misleadingly on blue paper); W. Roberts, 'Mr. J. Pierpont Morgan's Pictures: The Early English School II', *The Connoisseur*, November 1906, p.136 repr.; W. Roberts, *Pictures in the Collection of J. Pierpont Morgan*, London, 1907 (under the entry for Gainsborough's Duchess of Devonshire) (repr. in the folio edn.); Menpes and Greig, pp.125 and 165; Woodall 86; Geoffrey Grigson, *English Drawing*, London, 1955, p.174 and repr. pl.45; John Hayes, 'Gainsborough's "Richmond Water-walk"', *The Burlington Magazine*, January 1969, pp.28 and 31 and repr. fig.47.

Probably a preparatory drawing for a companion picture to *The Mall* in the Frick Collection, never executed (see Cat. No.59): the scale of the trees in relation to the figure suggests that it was not intended for an individual portrait. The head is only blocked out. The pose was later used in reverse for the portrait of the Duchess of Devonshire owned by Mrs Mabel S. Ingalls (Waterhouse 195), painted in the late 1780's.

The costume, notably the large picture hat, and the hair style, with the hair loosely dressed in ringlets and flowing down over the shoulder, indicate a date of about 1785–90. A free copy, reduced in size, was with Manning Gallery 1967. Also mentioned on pp.19, 46 and 99.

63 Study of a Lady with a small Child, probably for *The Richmond Water-walk*
Ownership unknown

Black chalk and stump on buff paper, heightened with white. Size unknown.
Whole-length of a lady in a large hat walking towards the left, her head turned half-right and slightly downwards, holding a small girl in her right hand; wooded background (from a photograph).
PROVENANCE: M. Hodgkins.
BIBLIOGRAPHY: Menpes and Greig, pp.125, 165 and 172; Heinrich Leporini, *Die Stilentwicklung des Handzeichnungens*, Vienna, 1925, 300 and repr. pl.300; John Hayes, 'Gainsborough's "Richmond Water-walk"', *The Burlington Magazine*, January 1969, p.31 and repr. fig.50.
ALSO REPRODUCED: Heinrich Leporini, *Handzeichnungen Grosser Meister: Gainsborough*, Vienna and Leipzig, n.d. (= 1925), pl.6.

Probably a preparatory drawing for a companion picture to *The Mall* in the Frick Collection, never executed (see Cat. No. 59). The head of the woman is clearly a portrait. The costume, notably the large picture hat, and the hair style, with the hair dressed in loose ringlets and flowing down over the shoulder, indicate a date of about 1785–90.

64 Study for the Portrait of Mrs Sarah Siddons (1775–1831)
Dr W. Katz, London

Black chalk and stump and white chalk. 17 15/16 × 13 5/8 (455 × 346).
Half-length seated facing left, wearing a hat and holding a muff in her lap with her left hand.
PROVENANCE: R. P. Roupell; Roupell sale, Christie's, 14 July 1887, Lot 1331 bt. Thibaudeau; Henry J. Pfungst; Pfungst sale, Christie's, 15 June 1917, Lot 30 (repr.) bt. Connell; Andrew T. Reid; with Oscar and Peter Johnson.
EXHIBITED: Colnaghi's 1906 (50).
BIBLIOGRAPHY: Sir James L. Caw, *The Collection of Pictures formed by Andrew T. Reid of Auchterarder*, Glasgow, 1933, p.v and p.5 (repr.).

Study for the portrait in the National Gallery (Waterhouse 617, repr. pl.250), painted in 1785.

No alterations were made in the final picture. The broad and sketchy modelling in stump may be compared with the study for a figure group in the Morgan Library (Cat. No.845) and the study for an equestrian portrait, probably the Prince of Wales, owned by Lord Hartwell (Cat. No.65). The black chalkwork, notably the rather finicky touches in the hair, is not integral to the drawing, and seems likely to be by a later hand, very possibly Dupont, whose practice this seems to have been with certain of his uncle's drawings which were useful in his own work or study (see Cat. No.66). Also mentioned on pp.39 and 103.

65 Study for an Unidentified Portrait, probably George, Prince of Wales, later George IV (1762–1830) Plate 340
Lord Hartwell, London

Black chalk and stump and white chalk.
$13\frac{15}{18} \times 10\frac{7}{18}$ (354×265).
Whole-length on horseback facing right and wearing a cocked hat, his head (and that of his mount) turned back and facing slightly to left of the spectator; landscape background.
PROVENANCE: Sir George Donaldson; Henry Schniewind, Jr.; Anon. (=Schniewind) sale, Sotheby's, 25 May 1938, Lot 143 bt. Langton; with Spink, from whom it was purchased.
EXHIBITED: Cincinnati 1931 (58 and repr. pl.58) (as representing General Honywood); Arts Council 1960–1 (67, and p.7).
BIBLIOGRAPHY: Woodall Letters, p.155.

This drawing has been assumed hitherto to be a study for the portrait of General Honywood (Waterhouse 375, repr. pl.83), exhibited at the Society of Artists 1765. Beyond the fact that it is a study for an equestrian portrait, however, there is no connection of any sort with *General Honywood*, while the drawing style is manifestly of some twenty years later. Gainsborough is not known to have completed any other equestrian portrait, but in 1785–7 he was engaged on a portrait of George, Prince of Wales, on horseback, intended for T. W. Coke, of Holkham, and as a companion to the latter's Van Dyck equestrian portrait of the Duc d'Arenberg in armour (see *The Morning Herald*, 24 January 1785, 11 April 1786 and 13 June 1787). The Prince sat once for this portrait in 1785 or 6, and it was announced in June 1787 that he was to sit again for its completion: at this date, the costume was to be 'either in armour; or else slight martial attire, with the mantle of a

Knight of the *Garter* over it.' It seems probable that the drawing is a study for this portrait: there is no mantle, but the costume does fit the description 'slight martial attire', and the likeness is not inconsistent with the appearance of the Prince at the age of twenty-five. This theory is supported by the existence of a drawing (Cat. No.66), in which the composition and pose of the horse are similar, but the sitter is in armour: this may well be a drawing showing the Prince in alternative dress. The broad modelling in stump is closely related to Gainsborough's late drawings of woodmen (e.g. Cat. No.852), but the traces of strengthening in black chalk (much of which has been removed since 1931: see the illustration cited above) are uncharacteristic, and may have been added later (see also Cat. No.66). There is a major pentimento in the drawing of the left foreleg. Also mentioned on p.66.

66 Study for an Unidentified Portrait, probably George, Prince of Wales, later George IV (1762–1830) Plate 341
With Colnaghi's, London

Black chalk and stump and white chalk, with pencil strengthening. $6\frac{13}{18} \times 5\frac{1}{4}$ (173×133).
Whole-length on horseback facing right and wearing armour, his head (and that of his mount) turned back and facing the spectator; landscape background.
PROVENANCE: Mrs Russell Emily Jacks; Jacks sale, Christie's, 17 June 1969, Lot 139 bt. in; Anon. sale, Christie's, 16 June 1970, Lot 129 bt. Colnaghi.

The composition and pose of the horse are similar to the previous drawing (Cat. No.65), but the sitter is in armour. See the previous entry for the argument in favour of these drawings being connected with a projected equestrian portrait of George, Prince of Wales. However, though the proportions and liveliness of the conception, and the relationship of horse and rider to the background, are entirely convincing, especially in comparison with the copy noted below, there are certain puzzling features. In particular, the chalkwork lacks the breadth characteristic of Gainsborough's late drawings, and both this and the even more uncharacteristic pencil strengthening were probably added by a later hand, almost certainly Dupont, who made a copy of this drawing, formerly in the Kay collection (Pl.342), in which the pose of the horse's head is derived from the alternative design (Cat. No.65).

Landscape Drawings

Though Gainsborough was able to devote only a small part of his energies to landscape painting, it is clear enough that landscape was his chief love, and the hundreds upon hundreds of sketches of landscape scenery he poured out at all periods of his life (more than three-quarters of his output as a draughtsman) are ample testimony to this fact. Most of his early sketches are studies direct from nature, either of details for inclusion in his landscapes, or else containing ideas for compositions; and all those drawings which appear to be studies from nature are noted as such in the entries, though, as in the case of the portrait drawings, there are a number of cases in which it is difficult to be certain whether a drawing is really a sketch done in front of the motif or a jotting for a possible composition roughed out in the studio. Gainsborough's more finished drawings of this period are very close in character to his paintings. In the 1760's he executed a number of watercolours, probably worked up from sketches done on the spot, and in the early 1770's developed an elaborate technique for varnished drawings which would approximate in force and effect to oil paintings. The drawings of his later years are in a great variety of media, but the majority of them are rapid sketches of imaginary compositions done for the most part as a recreational activity or for the pleasure of his friends: his style became increasingly more sketchy, brilliant and forceful, and his very late drawings are a part of the rich heritage of English romanticism.

Mid to Later 1740's

67 Study of a Branch and of a Wooded Road with Figures Plate 3
British Museum, London (O.0.2 – 3): verso

Pencil. 6 × 6¹⁵⁄₁₆ (152 × 176)
A branch top left; a country road bottom right, running from the foreground right into the middle distance centre, where there are two figures.
Recto: study of trees (Cat. No.68).
PROVENANCE: From the sketch-book purchased by Richard Payne Knight at the Gainsborough sale, Christie's, 11 May 1799, Lot 85; bequeathed 1824.
BIBLIOGRAPHY: Binyon 31 (7a); Woodall 128 and 476.

The study of a branch is a rough sketch drawn in the loose manner characteristic of certain areas of the study of trees on the recto, especially lower right, and the upper part of the landscape with a cow on a bank in the Witt Collection (Cat. No.70). The study of a woodland road, however, is drawn in a very precise way, some-what lacking in spontaneity, the two little figures especially being carefully delineated rather than suggested in the manner that one would expect in a Gainsborough sketch: it was presumably this part of the sheet that led Mary Woodall (476) to reject the whole drawing. However, the modelling is very close in character to certain passages of the study on the recto and also to the study of trees in the Witt Collection (Cat. No.77), and the tightness of this little drawing may be accounted for by the fact that it was executed very early indeed in Gainsborough's career. This view is supported by a certain similarity between the hatching in this drawing and in the sleeve of the portrait of an unknown lady in Dublin (Cat. No.2), executed early in 1744.

68 Study of Trees in a Wood Plate 4
British Museum, London (O.o.2 – 3: recto)

Pencil. $6 \times 6\frac{15}{16}$ (152 × 176)
Trees in a wood.
Verso: study of a branch (top left) and of a country
road with figures (bottom right) (Cat. No.67).
PROVENANCE: From the sketch-book purchased by
Richard Payne Knight at the Gainsborough sale,
Christie's, 11 May 1799, Lot 85; bequeathed 1824.
BIBLIOGRAPHY: Binyon 31 (7a); Woodall 128 and 476
and p.35; John Hayes, 'The Drawings of George
Frost', *Master Drawings*, Vol.4, No.2, 1966, p.164
and repr. pl.27b.

A study from nature. The crisp delineation of
the tree trunks and branches and angular treat-
ment of the foliage are closely related to the
study of trees in the Witt Collection (Cat. No.77),
but rather looser in style. This drawing also
appears in Woodall (476) as not by Gains-
borough, but there is nothing uncharacteristic
about it and the provenance is too good to reject
it without very strong reasons.

69 Study of Trees in a Wood
D. L. T. Oppé, London (2511b)

Pencil. $7\frac{1}{2} \times 6\frac{1}{16}$ (190 × 154).
A path rising up a slope from the foreground right
into the middle distance right; trees stretching across
the foreground.
PROVENANCE: Sir J. C. Robinson; Robinson sale,
Christie's, 21 April 1902; E. Horsman Coles;
bequeathed to A. Paul Oppé 1954.

A study from nature. One of Gainsborough's
earlier drawings. The crisp delineation of the
tree trunks and branches and the angular treat-
ment of the scallops outlining the foliage are
closely related to the woodland study in the
British Museum (Cat. No.68), while the broad
handling of the left side of the drawing is
identical with the study of a branch on the verso
of the British Museum sketch (Cat. No.67).

**70 Wooded Landscape with Cow on a
Bank** Plate 5
Courtauld Institute of Art, Witt Collection,
London (4158)

Pencil. $6\frac{3}{8} \times 8\frac{1}{4}$ (162 × 210).
A cow on a bank in the foreground left; a country
lane in the foreground right.
Collector's mark of Sir Robert Witt on the back of
the mount bottom left.
PROVENANCE: Anon. sale, Sotheby's, 14 July 1948,

Lot 170 (with three others) bt. Colnaghi, from whom
it was purchased by Sir Robert Witt; bequeathed
1952.
EXHIBITED: Arts Council 1960–1 (1); Nottingham
1962 (30).
BIBLIOGRAPHY: *Hand-List of Drawings in the Witt
Collection*, London, 1956, p.22.

One of Gainsborough's earlier drawings, in
which the modelling is rather uncertain. The
angular treatment of the cow and the loose
touch in the foliage are comparable with the
portrait group formerly owned by Archdeacon
Burney (Cat. No.3).

71 Wooded Landscape with Donkey
Plate 391
Sir Edmund Bacon, Raveningham

Black chalk. $8 \times 12\frac{1}{8}$ (203 × 308).
A donkey on a bank in the foreground right.
Verso: a greyhound asleep (Cat. No.854).
PROVENANCE: Rev. Dr Wellesley (?); Sir Hickman
Bacon.

The conception in two distinct planes, and the
treatment of the tree trunks, branches and
foliage, are closely related to the landscape in
the portrait group formerly owned by Arch-
deacon Burney (Cat. No.3). Also mentioned on
p.77.

**72 Wooded Landscape with Group of
Figures** Plate 374
Pierpont Morgan Library, New York (III, 52)

Pencil. $7\frac{3}{8} \times 5\frac{3}{4}$ (187 × 146).
A peasant with a stick in his right hand talking to two
girls seated against a bank in the foreground right.
PROVENANCE: Sir J. C. Robinson; Robinson sale,
Christie's, 21 April 1902, Lot 131 (with another) bt.
Charles Fairfax Murray; purchased from Fairfax
Murray by J. Pierpont Morgan 1910.
BIBLIOGRAPHY: *J. Pierpont Morgan Collection of
Drawings by the Old Masters formed by C. Fairfax
Murray*, Vol.III, London, 1912, No.52 (repr.);
Woodall 452.

Study for the small landscape with figures now
in the Mellon collection (Waterhouse 872),
painted about 1744–6. In the finished picture
the composition was converted into an oblong
shape through the addition of a panorama with
distant hills on the left, but otherwise the
arrangement was hardly changed even in detail.
The treatment of the tree trunks, the hatching
and the loose touch in the foliage, as well as the

conception in clearly distinct planes and un-
certainties in suggesting depth, are closely
related to the landscape with a portrait group
formerly owned by Archdeacon Burney (Cat.
No.3). Also mentioned on pp.39, 41 and 72.

73 Wooded Landscape with Huntsmen, Figures and distant Seaport Plate 10
Ownership unknown

Pencil (presumably). Size unknown.
A woman accompanied by a child talking to a woman
seated on a log in the foreground right, with a man
carrying a pitchfork behind them; two huntsmen
accompanied by two hounds, and followed by another
figure, in the middle distance left; three figures, one
of them seated, in the middle distance right; a walled
town with shipping in the harbour in the distance
left; two ships at sea in the distance centre (from the
print).
ENGRAVED: John Boydell, published 1747 as No.1 in
a series (republished in J. Boydell, *A Collection of Views
in England and Wales*, London, 1790, pl.89).
BIBLIOGRAPHY: Menpes and Greig, pp.41 and 49;
Woodall, pp.9–11; Woodall 1949, p.16; John
Hayes, 'The Ornamental Surrounds for Houbraken's
"Illustrious Heads" ', Notes on British Art 13, *Apollo*,
January 1969, p.2.

This and its companion drawings (Cat. Nos.74,
75 and 76) are very contrived compositions,
organized in clearly distinct planes and full of
miscellaneous incident. Also mentioned on pp.2,
39, 41 and 47–8.

74 Wooded Landscape with Figures and Packhorses
Ownership unknown

Pencil (presumably). Size unknown.
Seven figures, one of them seated, accompanied by
a dog, in the foreground centre; two packhorses in the
foreground right; buildings in the distance left and
right (from the print).
ENGRAVED: John Boydell, published 1747 as No.2 in
a series (republished in J. Boydell, *A Collection of Views
in England and Wales*, London, 1790, pl.90).
BIBLIOGRAPHY: Menpes and Greig, pp.41 and 49;
Woodall, pp.9–11; Woodall 1949, p.16; John
Hayes, 'The Ornamental Surrounds for Houbraken's
"Illustrious Heads" ', Notes on British Art 13, *Apollo*,
January 1969, p.2.

See under Cat. No.73. Also mentioned on pp.2
and 39.

75 Wooded Landscape with a Picnic Party Plate 240
Ownership unknown

Pencil (presumably). Size unknown.
Three figures, two of them seated and the third
standing, drinking from a pitcher, picnicking in the
foreground left; two women in the middle distance
centre; pools in the foreground right and middle
distance centre; a church in the distance left and
other buildings in the distance right (from the print).
ENGRAVED: John Boydell, published 1747 as No.3
in a series (republished in J. Boydell, *A Collection of
Views in England and Wales*, London, 1790, pl.91).
BIBLIOGRAPHY: Menpes and Greig, pp.41 and 49;
Woodall, pp.9–11, Woodall 1949, p.16; John Hayes,
'The Ornamental Surrounds for Houbraken's
"Illustrious Heads" ', Notes on British Art 13,
Apollo, January 1969, p.2.

See under Cat. No.73. Also mentioned on pp.2,
39, 41 and 56.

76 Wooded Landscape with Fisherman Plate 243
Ownership unknown

Pencil (presumably). Size unknown.
A fisherman, with a man, a woman and a dog, in the
foreground centre; another man and woman on a
bank in the middle distance left; a pool stretching
across the foreground and middle distance (from the
print).
ENGRAVED: John Boydell, published 1747 as No.4 in
a series (republished in J. Boydell, *A Collection of Views
in England and Wales*, London, 1790, pl.92).
BIBLIOGRAPHY: Menpes and Greig, pp.41 and 49;
Woodall, pp.9–11; Woodall 1949, p.16; John Hayes,
'The Ornamental Surrounds for Houbraken's
"Illustrious Heads" ', Notes on British Art 13,
Apollo, January 1969, p.2 and repr. fig.6.

This is the least laboured and most successful of
the four drawings for Boydell. The figures are
influenced by Gravelot. Also mentioned pp.2, 39,
41 and 56.

77 Study of a Wooded Landscape with Figures Plate 9
Courtauld Institute of Art, Witt Collection,
London (1165)

Pencil. $4\frac{5}{8} \times 7\frac{1}{4}$ (117 × 184).
Elm trees at the edge of a wood, with two figures in
the middle distance right.
Inscribed on the verso in ink bottom left and centre:
1822 WE – G – Frost's coll – N103 and *Gainsbrough*.
Collector's mark of William Esdaile bottom right.

Collector's mark of Sir Robert Witt on the verso bottom right.
PROVENANCE: George Frost; William Esdaile; Esdaile sale, Christie's, 20–1 March 1838; William Roscoe (?); Sir Robert Witt; bequeathed 1952.
EXHIBITED: Arts Council 1960–1 (2).
BIBLIOGRAPHY: Woodall 367 and p.90; *Hand-List of the Drawings in the Witt Collection*, London, 1956, p.21.

A study from nature. The zig-zag modelling, derived from Waterloo, is identical with the drawing in the Morgan Library (Cat. No. 81), but the treatment of the trees is less mannered, and closely related to one of Boydell's engravings after Gainsborough (Cat. No.76): this is in fact the only drawing which betrays any stylistic connections with this series, for which the original drawings must have been made either in 1746 or 1747. According to Mary Woodall (*op. cit.*, p.90) a copy by Frost was in a scrapbook then owned by Miss Crisp (and later by Major T. C. Binny) but now sold. Also mentioned on pp.72–3 and 98.

78 Wooded Landscape
Royal Academy of Arts, London (Jupp extra-illustrated R.A. Catalogues, Vol.1, f.57: recto)

Pencil. $4\frac{3}{8} \times 7\frac{3}{16}$ (111 × 183).
A path winding from the foreground centre into the middle distance centre.
Collector's mark of William Esdaile bottom right.
Verso: a female head (Cat. No.817).
Inscribed in ink by William Esdaile bottom left: *Gainsboro/1822 WE G Frost's coll N* (number illegible).
PROVENANCE: George Frost; William Esdaile; Esdaile sale, Christie's, 20–1 March 1838; Rev. Dr Wellesley; Wellesley sale, Sotheby's, 28 June 1866, Lot 692 (with another) bt. James; Edward Basil Jupp, who bequeathed it.
BIBLIOGRAPHY: Paul Hulton, 'A Little-known Cache of English Drawings', *Apollo*, January 1969, p.54.

The zig-zag touch and feeling for light in the foliage are closely related to the wooded landscape with figures in the Witt Collection (Cat. No.77), but the handling is a little looser.

79 Wooded Landscape
Royal Academy of Arts, London (Jupp extra-illustrated R.A. Catalogues, Vol.1, f.59)

Pencil. $4\frac{7}{16} \times 6\frac{15}{16}$ (113 × 176).
A path winding over rising ground between trees in the foreground right.
Collector's mark of William Esdaile bottom left.
Inscribed on the verso in ink by William Esdaile

bottom left: (date illegible) *WE G Frost's Co*n (number illegible) *Gainsborough*.
PROVENANCE: George Frost; William Esdaile; Esdaile sale, Christie's, 20–1 March 1838; Rev. Dr Wellesley; Wellesley sale, Sotheby's, 28 June 1866, Lot 692 (with another) bt. James; Edward Basil Jupp, who bequeathed it.
BIBLIOGRAPHY: Paul Hulton, 'A Little-known Cache of English Drawings', *Apollo*, January 1969, p.54.

The zig-zag touch and feeling for light in the foliage are closely related to the wooded landscape with figures in the Witt Collection (Cat. No.77), but, as in the companion drawing (Cat. No.78), the handling is a little looser.

80 Wooded Landscape with River, Cattle and Figures (after Ruisdael) Plate 248
Whitworth Art Gallery, Manchester (D.2.1935) (1641)

Black and white chalks on buff paper.
$16\frac{1}{16} \times 16\frac{5}{8}$ (408 × 422).
Two peasants with a cow in the foreground centre; a peasant resting in the foreground left; a peasant accompanied by a dog walking along a track through the woods in the middle distance left; cows drinking in the middle distance centre.
PROVENANCE: Rev. Gainsborough Gardiner; by descent to Edward Netherton Harward; Harward sale, Christie's, 11 May 1923, Lot 95 bt. Colnaghi.
EXHIBITED: Aldeburgh 1949 (13); Arts Council 1960–1 (3, and p.5); Nottingham 1962 (31); *English Drawings from the Whitworth Art Gallery*, Colnaghi's, 1967 (7).
BIBLIOGRAPHY: Fulcher 1st edn., p.234 (2nd edn., p.241); Mary Woodall, 'A Note on Gainsborough and Ruisdael', *The Burlington Magazine*, January 1935, pp.40 and 45 and repr. pl.B f.p.40; Woodall 227, pp.11–4 and 33–5 and repr. pl.3; Waterhouse, pp.39 and 107; Woodall 1949, p.24; John Hayes, 'The Gainsborough Drawings from Barton Grange', *The Connoisseur*, February 1966, p.88.

Fulcher described this drawing as 'an excellent copy, in chalks, of one of Ruysdaal's pictures', but Mary Woodall was the first to point out the exact source, Jacob Ruisdael's large canvas entitled *La Forêt*, now in the Louvre, of which it is a very close copy. It is not known whether the original was familiar to Gainsborough, or whether he knew the composition only from a copy: pictures by Ruisdael made an increasingly common appearance in the salesroom during the late 1740's, when Gainsborough had his studio in London, and his influence on Gainsborough's oil painting is evident in the landscape in

Philadelphia (Waterhouse 831, repr. pl.23), signed and dated 1747. Gainsborough used Ruisdael's design as the basis for the landscape now in São Paulo (Waterhouse 826, repr. pl.46) also painted at this period. Also mentioned on pp.31, 39, 41 and 57.

81 Wooded Landscape with Herdsman, Cow and Cottage Plate 11
Pierpont Morgan Library, New York (III, 51)

Pencil. $5\frac{3}{8} \times 7\frac{5}{8}$ (137 × 194).
A herdsman resting by the side of a country track at the edge of a wood in the middle distance right, with a cow a little beyond; a cottage half-hidden by trees in the foreground left; a stile in the foreground centre.
PROVENANCE: Charles Fairfax Murray, from whom it was purchased by J. Pierpont Morgan 1910.
BIBLIOGRAPHY: *J. Pierpont Morgan Collection of Drawings by the Old Masters formed by C. Fairfax Murray*, Vol.III, London, 1912, No.51 (repr.); Woodall 455, p.35 and repr. pl.19.

The zig-zag modelling employed throughout derives from Waterloo, and the brittle angular treatment of the tree trunks from Jacob Ruisdael. Slightly looser in handling than the wooded landscape in the Witt Collection (Cat. No.77), to which it is otherwise closely related in technique. Also mentioned on p.18.

82 Wooded Landscape with Donkeys
Plate 12
T. R. C. Blofeld, Hoveton

Black chalk and stump, grey stump and white chalk on buff paper. $14\frac{9}{16} \times 20\frac{5}{16}$ (370 × 516).
Five donkeys in two groups in the foreground centre; two pigs in the foreground right; a cow in the middle distance right; a country track winding from the foreground left into a wood in the distance centre.
PROVENANCE: Given by the artist probably to Goodenough Earle, of Barton Grange, Somerset; by descent to Francis Wheat Newton; sold to Agnew's 1913, who immediately resold it to Knoedler's, from whom it was purchased by P. M. Turner 1935; with the Fine Art Society, from whom it was purchased 1944.
EXHIBITED: Knoedler's 1914 (12); Knoedler's 1923 (16); Cincinnati 1931 (67 and repr. pl.51); Nottingham 1962 (32).
BIBLIOGRAPHY: Fulcher, 2nd end., p.241; Woodall 334, pp.34–5 and repr. pl.20; John Hayes, 'The Gainsborough Drawings from Barton Grange', *The Connoisseur*, February 1966, pp.88 and 93, repr. fig.3.

The zig-zag modelling and brittle angular treatment of the tree trunks, influenced by Waterloo and Ruisdael, are related to the landscape with a cottage in the Morgan Library (Cat. No.81), while the conception in carefully differentiated planes and treatment of the foliage relate to the woodland scene in the British Museum (Cat. No.84); but the technique is closest to the copy of Ruisdael's *La Forêt* at Manchester (Cat. No.80). In Gainsborough's work in oils, a treatment of the trees similarly influenced strongly by Ruisdael can be found in the landscape with peasants and donkeys in the Kunsthistorisches Museum (Waterhouse 859), painted about 1747–8. Also mentioned on pp.22 and 57.

83 Study of a Wooded Lane Plate 13
British Museum, London (1910–2–12–257: verso)

Pencil on grey-green paper. $5\frac{1}{2} \times 7\frac{7}{16}$ (140 × 189).
Recto: a study of trees (Cat. No.85).
Collector's mark of John Lowndes bottom right.
PROVENANCE: John Lowndes; Sir J. C. Robinson; Robinson sale, Christie's, 21 April 1902, Lot 130 (with another) bt. George Salting; bequeathed 1910.
BIBLIOGRAPHY: Woodall 172.

A study from nature. The treatment of the tree trunk on the left and the use of a zig-zag contour are related to the early study of a cow on a bank in the Witt Collection (Cat. No.70), but otherwise the rather brittle and angular treatment of the trees and foliage and the zig-zag modelling of the undergrowth, influenced by Ruisdael and Waterloo, are exactly like the landscape with a cottage in the Morgan Library (Cat. No. 81). Also mentioned on p.22.

84 Wooded Landscape with Path
Plate 249
British Museum, London (1910–2–12–255)

Black chalk. $5\frac{3}{4} \times 7\frac{1}{2}$ (146 × 190).
Interior of a wood with a path running from the foreground right into the middle distance centre.
The drawing appears to have been cut at the bottom as the top parts of two initials in brown ink appear right and seem likely to be the remnants of the collector's mark of John Lowndes.
PROVENANCE: Probably John Lowndes; Sir J. C. Robinson; Robinson sale, Christie's, 21 April 1902, Lot 127 (with another) bt. George Salting; bequeathed 1910.
BIBLIOGRAPHY: Woodall 169, p.35 and repr. pl.18.

The lighting effects and the zig-zag treatment throughout are closely modelled on Waterloo, and the drawing gives the impression of being an imitation of one of his compositions. The handling of the foliage and the hatching are closely related to the study of trees also in the British Museum (Cat. No.83). Also mentioned on pp.15, 31 and 57.

85 Study of Trees Plate 14
British Museum, London (1910-2-12-257: recto)

Black chalk and stump on grey-green paper. $5\frac{1}{2} \times 7\frac{7}{16}$ (140 × 189).
Verso: a wooded lane (Cat. No.83).
PROVENANCE: John Lowndes; Sir J. C. Robinson; Robinson sale, Christie's, 21 April 1902, Lot 130 (with another) bt. George Salting; bequeathed 1910.
BIBLIOGRAPHY: Woodall 171.

A study from nature. Though broader in handling, the treatment of the foliage and zig-zag modelling of the undergrowth are related to the study on the verso (Cat. No.83) and to the woodland scene also in the British Museum (Cat. No.84). Also mentioned on p.22.

86 Study of Burdock Leaves Plate 19
British Museum, London (1910-2-12-256: recto)

Black chalk on grey-green paper. $5\frac{7}{16} \times 7\frac{5}{16}$ (138 × 186).
Burdock leaves, with the foot of a tree above left.
Verso: study of a male figure in a tricorne hat (Cat. No.818).
PROVENANCE: Sir J. C. Robinson; Robinson sale, Christie's, 21 April 1902, Lot 130 (with another) bt. George Salting; bequeathed 1910.
Inscribed in pencil bottom left: 59.
BIBLIOGRAPHY: Woodall 170 and pp.39-40; Millar, p.6 and repr. pl.11; Drawings by Wilson, Gainsborough and Constable, Leeds Art Calendar, Autumn 1956, pp.10-1.

A study from nature. The hatching and modelling of the tufts of grass are similar in character to the study of trees also in the British Museum (Cat. No.85). Also mentioned on p.27.

87 A Path through a Wood Plate 17
Donald Towner, London

Black chalk. $6\frac{1}{16} \times 7\frac{13}{16}$ (154 × 198).
A path winding through a wood from the foreground

centre into the middle distance centre.
PROVENANCE: Presented by the artist to Joshua Kirby; thence by descent to F. E. Trimmer; Trimmer sale, Sotheby's, 22 December 1883, Lot 357 (with four others) bt. Edward Bell; thence by descent to Mildred Glanville, who gave it to the present owner 1963.

The chalkwork is very close to the woodland scene in the British Museum (Cat. No.84), but the composition is freer and more rhythmical. Also mentioned on p.57.

88 Study of Alders Plate 16
British Museum, London (O.0.2-30)

Pencil. $5\frac{13}{16} \times 7\frac{5}{8}$ (148 × 194).
Alders, with a pig in the foreground left and a stile in the foreground right.
PROVENANCE: From the sketch-book purchased by Richard Payne Knight at the Gainsborough sale, Christie's, 11 May 1799, Lot 85; bequeathed 1824.
BIBLIOGRAPHY: Binyon 31 (22b); Gower Drawings, p.14 and repr. pl.xxxvi; Woodall 157.

A study from nature. The treatment of the foliage, in particular the zig-zag convention employed, is closely related to the wooded landscape owned by Donald Towner (Cat. No.87).

89 Study of Footbridges over a Stream
British Museum, London (O.0.2 – 45)

Pencil. $6\frac{1}{16} \times 6\frac{1}{8}$ (154 × 156).
A stream with footbridges in the foreground left and the middle distance centre.
PROVENANCE: From the sketch-book purchased by Richard Payne Knight at the Gainsborough sale, Christie's, 11 May 1799, Lot 85; bequeathed 1824.
BIBLIOGRAPHY: Binyon 31 (21a); Woodall 154 and 477.

A study from nature. The treatment of the bridges and the zig-zag modelling of the foliage are closely related to the study of alders also in the British Museum (Cat. No.88). Mary Woodall lists this drawing as not by Gainsborough (477) and it is certainly not one of the artist's more sensitive sketches, but the provenance is too good for it to be rejected without very strong reasons.

90 Study of a Sandy Bank Plate 20
National Gallery of Scotland, Edinburgh (4679)

Pencil. $5\frac{9}{16} \times 8\frac{5}{16}$ (141 × 211).
PROVENANCE: Sir J. C. Robinson; Robinson sale,

Christie's, 21 April 1902; Herbert Horne, from whom it was purchased by Sir Edward Marsh, 1904; bequeathed (through the National Art-Collections Fund) 1953.
BIBLIOGRAPHY: *National Art-Collections Fund Fiftieth Annual Report 1953*, London, 1954, p.36.

A study from nature. The somewhat staccato treatment of the grass and shrubs is characteristic of many of Gainsborough's early drawings, such as the wooded scene owned by Colin Clark (Cat. No.114), while the pencilwork is similar to the landscape owned by Donald Towner (Cat. No.87). Studies of this kind, with richly modelled banks alternately highlit and cast in shadow but linked by a common rhythmical silhouette, were no doubt used during the composition of very early painted landscapes like the picture in Dublin (Waterhouse 870).

91 Study of Sand Dunes
Nicholas Barker, London

Pencil. $4\frac{1}{4} \times 7\frac{1}{16}$ (108×179).
Sand dunes stretching across the foreground.
PROVENANCE: Sir J. C. Robinson; Herbert Horne, from whom it was purchased by Sir Edward Marsh, 1904; H. C. Green; Green sale, Sotheby's, 18 October 1961, Lot 64 bt. Barker.
EXHIBITED: Ipswich 1927 (125).
BIBLIOGRAPHY: Woodall 232, and p.15.

A very softly-drawn study from nature. The handling of the tufts of grass is close to the study of a sandy bank in Edinburgh (Cat. No. 90).

Early to Mid 1750's

92 River Scene with a Family in a Rowing Boat Plate 246
Gerald Bronfman, Montreal

Pencil. $7\frac{1}{2} \times 5\frac{7}{8}$ (190×149).
A rowing boat in the foreground left and centre, with a woman holding a baby seated in the prow, a small boy and a man propelling the boat out from the bank with an oar; a river winding from the foreground into the distance right; a church tower in the middle distance centre.
Collector's mark of William Esdaile bottom right.
PROVENANCE: William Esdaile; Esdaile sale, Christie's, 20–1 March 1838; Anon. sale, Sotheby's, 30 November 1955, Lot 11 bt. Colnaghi, from whom it was purchased.
EXHIBITED: *Old Master Drawings*, Colnaghi's, May–June 1956 (60).

The tall spare trees and church tower seen in the distance are characteristic features of Gainsborough's early Suffolk style. The figures were probably drawn from an articulated doll. A copy by Hearne is in the British Museum (1966–10–8–7), and a drawing of a very similar type, probably by George Frost, was in the L. G. Duke sale, Sotheby's, 5 March 1970, Lot 80 (repr.). Also mentioned on pp.32, 55, 56 and 83.

93 Wooded Landscape with Buildings, Sheep and Distant River Plate 21
Yale University Library, New Haven (Denham Album, f.67)

Pencil. $5\frac{15}{16} \times 7\frac{1}{2}$ (151×190).
Three sheep in the foreground left; a building on a hill in the middle distance left; another building in the middle distance right; a tower in the distance centre, with a river beyond.
PROVENANCE: Mr and Mrs John Charles Denham, Norwich; thence by descent to Louisa Jane Copeman; Frank Tetley; with James Miles, Leeds; Sir Harold Mackintosh; Edwin J. Beinecke, who presented it 1953.
BIBLIOGRAPHY: John Hayes, 'The Drawings of George Frost', *Master Drawings*, Vol.4, No.2, 1966, pp.164 and 168 and repr. pl.25b.

The tall spare trees, the treatment of the foliage and the pencilwork generally, are similar to the river scene owned by Gerald Bronfman (Cat. No.92). There are copies of this drawing by Frost in the Victoria and Albert Museum (Dyce 685: Woodall 196) and the British Museum (1878–7–13–1259: repr. Hayes, *op. cit.*, pl.25a). Also mentioned on pp.26 and 72.

94 Wooded Landscape with Church Tower
Ownership unknown

Pencil (apparently). Size unknown.
A pool in the foreground centre; a church tower in the distance right (from the print).
ENGRAVED: J. Laporte, published by Laporte and Wells, 1 September 1803 (as in the collection of Dr Thomas Monro).
PROVENANCE: Dr Thomas Monro; Monro sale, Christie's, 26 June 1833 ff.

The treatment of the foliage seems to be closely related to the wooded panoramic landscape in Yale University Library (Cat. No.93).

95 Landscape with a Couple sketching on a River Bank Plate 22
British Museum, London (1868–3–28–315)

Pencil. $7\frac{1}{2} \times 6$ (190 × 152).
A man and a woman seated sketching on a bank in the foreground left; a winding river flowing into the middle distance right, with meadows beyond.
PROVENANCE: With Colnaghi, from whom it was purchased.
BIBLIOGRAPHY: Binyon 21; Woodall 97, p.36 and repr. pl.27.

The coulisse arrangement of the composition, the tall trees and the treatment of the foliage and foreground detail are identical with the river scene owned by Gerald Bronfman (Cat. No.92). Also mentioned on p.26.

96 Wooded Landscape with Distant Church Tower Plate 23
With Sabin Galleries, London

Pencil. $6 \times 7\frac{5}{8}$ (152 × 194).
A pool in the foreground centre; a church tower between trees in the distance right.
PROVENANCE: J. Heywood Hawkins; Anon. (=Hawkins) sale, Sotheby's, 9 May 1850, Lot 44 bt. Oliver.
EXHIBITED: *The Cunning Hand: Drawings by English and Anglicized Artists*, Sabin Galleries, October–November 1969 (6 repr.).
BIBLIOGRAPHY: *The Burlington Magazine*, October 1969, p.627, repr. fig.61.

The treatment of the trees and foreground plants is closely related to the river scene with figures sketching in the British Museum (Cat. No.95). The composition has affinities with the picture in the Fitzwilliam Museum (Waterhouse 860), painted in the early 1750's.

97 Wooded Landscape with Track
British Museum, London (O.0.2 – 4)

Pencil. $7\frac{1}{16} \times 6$ (179 × 152).
A track running from the foreground centre into the distance left.
PROVENANCE: From the sketch-book purchased by Richard Payne Knight at the Gainsborough sale, Christie's, 11 May 1799, Lot 85; bequeathed 1824.
BIBLIOGRAPHY: Binyon 31 (15b); Gower *Drawings*, p.13 and repr. pl.XXXIV; Woodall 143, pp.32–4, and 38, 88 and repr. pl.16.

A highly-wrought drawing, in which the treatment of the foliage is close in character to the wooded landscape with Sabin Galleries (Cat. No.96), but much tighter in handling. Studies of the kind also in the British Museum (Cat. No.86) were probably used for the prominent burdock leaves in the foreground. A copy ascribed to Crome is in Edward Seago's collection. Also mentioned on p.77.

98 Wooded Landscape with Herdsman and Cattle
Edward Seago, Ludham

Pencil. $7\frac{1}{4} \times 5\frac{11}{16}$ (184 × 144).
A herdsman on horseback, with three cows and a goat, in the foreground left; a track winding from the foreground left into the middle distance right.
PROVENANCE: Sir Edward Marsh; Anon. sale, Sotheby's, 9 December 1964, Lot 38 bt. Patch; with Lowndes Lodge Gallery; with John Baskett, from whom it was purchased 1968.
EXHIBITED: Ipswich 1927 (122).

The tall thin trees and the treatment of the foliage and foreground detail are identical with the wooded landscape with Sabin Galleries (Cat. No.96). The soft modelling and hatching are suggestive of Dujardin.

99 Wooded Landscape with Rustic Lovers
The Master of Kinnaird, Rossie Priory

Pencil. $7\frac{7}{16} \times 5\frac{16}{16}$ (189 × 151).
A couple of lovers seated in the foreground right, the boy with his left arm round the girl's waist; a country track winding from the foreground left into the middle distance left.
PROVENANCE: Sir Edward Marsh; with P. M. Turner; Anon. sale, Sotheby's, 14 January 1959, Lot 2 (with a parcel) bt. Colnaghi, from whom it was purchased.
EXHIBITED: Ipswich 1927 (118); Oxford 1935 (29).
BIBLIOGRAPHY: Woodall 339.

The soft bushy sun-drenched trees, the treatment of the foliage and the shading are closely related to the landscape with herdsman and cattle in Edward Seago's collection (Cat. No.98) and the crisp handling of the branches and the broken touches outlining the track to the landscape with faggot-gatherers in the Horne Foundation (Cat. No.118). The treatment of the girl is similar to the landscape with figures in the Morgan Library (Cat. No.72).

100 Wooded Landscape with Figures, Donkey and Cow

Ownership unknown

Pencil. 7½ × 6 (190 × 152).
A boy feeding a donkey, while a man harnesses it, in the foreground centre; a cow reclining in the foreground right; a house in the distance right (from a photograph).
PROVENANCE: Sir Edward Marsh.
EXHIBITED: Ipswich 1927 (114).
BIBLIOGRAPHY: Woodall 232a, pp.36–7 and repr. pl.29.

The tall trees, hatching and treatment of the foliage are closely related to the landscape with herdsman and cattle in Edward Seago's collection (Cat. No.98).

101 Wooded Landscape with Fence

Sir Edmund Bacon, Raveningham

Pencil. 7⅝ × 6⅛ (194 × 156).
A path leading from the foreground centre into the middle distance centre; a fence in the middle distance left and centre.
PROVENANCE: Sir Hickman Bacon.

The shading and treatment of the foliage are closely related to the wooded landscape with church tower with Sabin Galleries (Cat. No.96).

102 Open Landscape with Figures and Distant Village

British Museum, London (1910-2-12-254)

Pencil. 5¾ × 7½ (146 × 190).
Two figures, one of them seated, accompanied by a dog, in the foreground right; a track winding from the foreground centre into the middle distance centre; a village in the distance centre.
PROVENANCE: Sir J. C. Robinson; Robinson sale, Christie's, 21 April 1902, Lot 127 (with another) bt. George Salting; bequeathed 1910.
BIBLIOGRAPHY: Woodall 168.

A sketch in which the treatment of the foliage is closely related to the wooded landscape with church tower with Sabin Galleries (Cat. No.96).

103 Open Landscape with Alders and Pool

R. E. G. Evers, Malvern

Black chalk and stump and white chalk on buff paper. 11⁷⁄₁₆ × 15½ (291 × 394).
A clump of alders in the foreground left; a pool in the foreground and middleground centre; a tower in the distance centre.
PROVENANCE: Sir George Clausen; Clausen sale, Sotheby's, 2 June 1943, Lot 71 (unattributed, with three others) bt. Agnew, who sold it to J. C. Butterwick; with Agnew, who sold it to Commander M. Daintry; with Agnew, from whom it was purchased.
EXHIBITED: *71st Annual Exhibition of Water-Colour Drawings*, Agnew's, February–March 1944 (68); *75th Annual Exhibition of Water-Colour Drawings*, Agnew's, January–March 1948 (53); *Works of Art belonging to the Friends of the Art Gallery*, City of Birmingham Museum and Art Gallery, February–March 1962 (59).

The chalkwork and treatment of the distance are related to the landscape with donkeys owned by T. R. C. Blofeld (Cat. No.82), but the handling of the foliage is closer to the wooded landscape at Raveningham (Cat. No.101).

104 Study of Trees and Plants Plate 27

D. L. T. Oppé, London (2512b)

Black chalk. 6¹¹⁄₁₆ × 7½ (170 × 190).
A bank in the foreground left and centre, with plants and the lower parts of some tree trunks.
PROVENANCE: Dr Thomas Monro; Monro sale, Christie's 26 June 1833ff.; John Laporte; E. Horsman Coles; bequeathed to A. Paul Oppé 1954.

A study from nature. The handling of the tree trunks and plants and the soft rounded scallops outlining the foliage are closely related to the landscape with alders and pool owned by R. E. G. Evers (Cat. No.103).

105 Study of Trees near a Bank

D. L. T. Oppé, London (2512a)

Black chalk. 5¾ × 7½ (146 × 190).
A bank in the foreground centre and right, with the lower parts of six tree trunks; a river in the middle distance centre and right.
PROVENANCE: Dr Thomas Monro; Monro sale, Christie's, 26 June 1833ff.; John Laporte; E. Horsman Coles; bequeathed to A. Paul Oppé 1954.

A study from nature. The soft pencilwork and treatment of the tree trunks are identical with the study of trees and plants also in the Oppé collection (Cat. No.104).

106 Study of Trees by a River
Henry E. Huntington Library and Art Gallery,
San Marino (59.55.563)

Black chalk. $7\frac{7}{16} \times 5\frac{7}{8}$ (189 × 149).
Four or five trees on a bank in the foreground right;
a river winding from the foreground left and centre
into the distance left.
PROVENANCE: Alfred, 1st Baron Melchett, who
bequeathed it to Violet, Lady Melchett; Gilbert
Davis, from whom it was purchased 1959.
EXHIBITED: *Winter Exhibition*, Burlington Fine Arts
Club, 1923–4 (142 with Cat. No.107).
BIBLIOGRAPHY: John Hayes, 'The Drawings of
George Frost', *Master Drawings*, Vol.4, No.2, 1966,
p.167.

A rough study from nature. Though much less
sensitive in character, the modelling of the tree
trunks, the heavy black shadows between the
trunks, the nervously delineated branches, the
scallops outlining the foliage, and the hatching,
are identical with the study of trees and plants
in the Oppé collection (Cat. No.104). The
attribution to Frost suggested in my article on
that artist (*op. cit.*) should not be allowed to
stand, and the documented Frost reproduced
there as Pl.32 is evidently derivative from this
type of early Gainsborough drawing.

107 Study of Trees by a Pool
Mrs F. Gillham, East Molesey

Black chalk. $7\frac{6}{16} \times 5\frac{11}{16}$ (186 × 144).
Four or five trees in the middle distance centre
beside a pool stretching from the foreground left
and centre into the distance left; part of a fence in
the foreground right.
PROVENANCE: Alfred, 1st Baron Melchett; F. Gillham.
EXHIBITED: *Winter Exhibition*, Burlington Fine Arts
Club, 1923–4 (142 with Cat. No.106).

A study from nature. The treatment of the tree
trunks and foliage, and the heavy black chalk-
work in the shadows, are identical with the study
of trees in the Huntington Art Gallery (Cat.
No.106).

108 Wooded Landscape with River and Church
P. J. B. Clive, Nunnington

Black chalk. $5\frac{1}{4} \times 6\frac{7}{8}$ (133 × 175).
A river winding from the foreground left into the
middle distance; a boat in the middle distance left,
and a church with a tower behind.
PROVENANCE: Charles Fairfax Murray; H. S.

Reitlinger; Reitlinger sale, Sotheby's, 27 January
1954, Lot 144 (with another) bt. L. G. Duke;
with Spink, from whom it was purchased.

The chalkwork is identical with the study of
trees in the Huntington Art Gallery (Cat.
No.106).

109 Study of Trees on a Bank
With Manning Gallery, London

Black chalk. $5\frac{7}{16} \times 6\frac{13}{16}$ (138 × 173).
A bank in the foreground centre, with a pool in the
foreground left and centre.
PROVENANCE: Unknown.
EXHIBITED: *Twenty-sixth Exhibition of Watercolours and
Drawings*, Manning Gallery, November 1966 (81).

A study from nature. The hatching and chalk-
work are related to the study of trees by a river
in the Huntington Art Gallery (Cat. No.106),
though the drawing is a little unusual in
character.

110 Study of a Tree
D. L. T. Oppé, London (2511a)

Black chalk. $7\frac{1}{2} \times 5\frac{15}{16}$ (190 × 151).
The upper part of a tree in the foreground centre;
no background.
PROVENANCE: Sir J. C. Robinson; Robinson sale,
Christie's, 21 April 1902; E. Horsman Coles;
bequeathed to A. Paul Oppé 1954.

A study from nature. The soft touch and hand-
ling of the foliage are closely related to the
woodland study in the British Museum (Cat.
No.84), and the chalkwork and treatment of the
tree trunk to the study also in the Oppé collec-
tion (Cat. No.105). Similar studies of trees were
made by Sandby.

111 Wooded Landscape with Donkeys
Plate 24
Pierpont Morgan Library, New York (III, 50)

Pencil. $11\frac{1}{8} \times 8$ (283 × 203).
Two donkeys in the foreground left; beside a track
winding between tall trees from the foreground left
into the distance left; a wooden fence on a bank in
the foreground right.
Signed in pencil bottom left: *TG*.
The composition is surrounded by a ruled line in
pencil.
ENGRAVED: John Browne.
PROVENANCE: Sir J. C. Robinson; Robinson sale,
Christie's, 21 April 1902, Lot 115 bt. Charles Fairfax

Murray, from whom it was purchased by J. Pierpont Morgan 1910.
BIBLIOGRAPHY: *J. Pierpont Morgan Collection of Drawings by the Old Masters formed by C. Fairfax Murray*, Vol.III, London, 1912, No.50 (repr.); Woodall 453.
ALSO REPRODUCED: Alfred East, 'Pencil-Drawing from Nature', *The Studio*, October 1906, p.24.

The treatment of the foliage is related to the wooded landscape with fence owned by Sir Edmund Bacon (Cat. No.101).

112 Wooded Landscape with Cottage
Ownership unknown

Pencil (apparently). Size unknown.
A pool in the foreground left and centre; a cottage in the middle distance right (from the print).
ENGRAVED: John Browne, 1798.

The tall trees, treatment of the foliage, and schematic arrangement of the composition appear to be related to the wooded landscape with donkeys in the Morgan Library (Cat. No.111), an upright drawing also engraved by Browne.

113 Study of Willows and Burdocks
Plate 25
Henry E. Huntington Library and Art Gallery, San Marino (59.55.567)

Pencil. $7\frac{7}{16} \times 6\frac{1}{8}$ (189 × 156).
Two willows and some burdocks by some fencing in the foreground centre and right; a cottage half-hidden by trees in the middle distance left.
Collector's mark of Gilbert Davis on the verso bottom left.
PROVENANCE: Sir J. C. Robinson; Robinson sale, Christie's, 21 April 1902; Gilbert Davis, from whom it was purchased 1959.
EXHIBITED: Huntington 1967–8 (1).

A study from nature. The shading and treatment of the foliage and foreground grass are closely related to the wooded landscape with donkeys in the Morgan Library (Cat. No.111).

114 Wooded Landscape with Building
Plate 357
Colin Clark, London

Pencil. $5\frac{7}{8} \times 7\frac{5}{8}$ (149 × 194).
A pool in the foreground right, with a wood behind; a country track winding from the foreground into the distance left, where a building is visible.

Inscribed on the verso: *Gainsborough delt.*
PROVENANCE: Henry S. Reitlinger; Reitlinger sale, Sotheby's, 27 January 1954, Lot 146 (with another) bt. Agnew, from whom it was purchased 1957.
EXHIBITED: Arts Council 1960–1 (6).
BIBLIOGRAPHY: Woodall 270 and p.33.

The pencilwork is similar to the panoramic landscape at Yale (Cat. No.93), but the foliage is more rounded and less angular in treatment and closer in character to the wooded landscape with donkeys in the Morgan Library (Cat. No.111). A copy by Frost is in the Victoria and Albert Museum (Dyce 694).

115 Wooded Landscape with Church Tower
Ownership unknown

Pencil (apparently). Size unknown.
A track which winds from the foreground centre towards a church tower in the distance centre (from the print).
ENGRAVED: J. Laporte, published by Laporte and Wells, 1 September 1803 (as in the collection of Dr Thomas Monro).
PROVENANCE: Dr Thomas Monro; Monro sale, Christie's, 26 June 1833 ff.

The treatment of the foliage seems to be closely related to the wooded landscape owned by Colin Clark (Cat. No.114).

116 Wooded Landscape with Country Cart
Ownership unknown

Pencil (apparently). Upright. Size unknown.
A figure accompanied by a dog seated beside a track in the foreground left; a cart drawn by four horses in the foreground centre on a track which winds into the middle distance centre (from the print).
ENGRAVED: J. Laporte, published by Laporte and Wells, 1 September 1803 (as in the collection of Dr Thomas Monro).
PROVENANCE: Dr Thomas Monro; Monro sale, Christie's, 26 June 1833 ff.

The treatment of the foliage seems to be closely related to the wooded landscape owned by Colin Clark (Cat. No.114).

117 Wooded Landscape with Figures and Church Tower
Ownership unknown

Pencil (apparently). Size unknown.
A man and woman, accompanied by a child and dog, walking along a winding track in the foreground right; a church tower on a bank in the middle distance left; two buildings beside a winding stream in the middle distance right; low hills in the distance right (from the print).
ENGRAVED: J. Laporte, published by Laporte and Wells, 1 March 1802 (as in the collection of J. Laporte).
PROVENANCE: J. Laporte.

The treatment of the foliage seems to be related to the wooded landscape owned by Colin Clark (Cat. No.114).

118 Wooded Landscape with Women gathering Faggots
Horne Foundation, Florence (5975) (deposited in the Uffizi)

Pencil. $7\frac{9}{16} \times 5\frac{15}{16}$ (192 × 151).
Two women gathering faggots, one of them seated, accompanied by a dog, in the foreground centre; three cows on a bank in the middle distance left; a path winding from the foreground left into the middle distance centre.
PROVENANCE: Anon. sale, Sotheby's, 28 March 1904 ff., 3rd Day, Lot 364 (with nine other miscellaneous drawings) bt. Herbert Horne.
BIBLIOGRAPHY: Licia Ragghianti Collobi, *Disegni Inglesi della Fondazione Horne*, Pisa, 1966, Cat.11, p.10 and repr. pl.12.

The treatment of the branches and foliage is close to the similar subject owned by Lady Joan Zuckerman (Cat. No.120), while the outlining of the track on the left is identical in technique with the wooded landscape owned by Colin Clark (Cat. No.114).

119 Wooded Landscape with Church Tower
Ownership unknown

Pencil (apparently). Size unknown. Upright.
A winding path leading from the foreground right past banks to a church tower in the distance centre (from the print).
ENGRAVED: J. Laporte, published by Laporte and Wells, 1 March 1802 (as in the collection of William Alexander).
PROVENANCE: William Alexander; Alexander sale, Sotheby's, 11 March 1817.

The treatment of the foliage and the track, and the tall trees, seem to be closely related to the landscape with faggot gatherers in the Horne Foundation (Cat. No.118).

120 Wooded Landscape with Faggot Gatherers Plate 28
Lady Joan Zuckerman, London

Pencil. $7\frac{7}{16} \times 6\frac{1}{16}$ (189 × 154).
Three woodgatherers, one picking up sticks, one with a basket, and one seated, at the foot of a tree in the foreground centre; a country lane winding into the distance left.
Collector's mark of Dr John Percy bottom left.
ENGRAVED: J. Laporte, published 1 May 1802 (as in the collection of Dr Thomas Monro).
PROVENANCE: Dr Thomas Monro; Monro sale, Christie's, 26 June 1833 ff.; Dr John Percy; Violet, Lady Melchett.
EXHIBITED: Aldeburgh 1949 (39); Arts Council 1960–1 (7).
BIBLIOGRAPHY: Woodall 235, p.36 and repr. pl.26; Woodall 1949, p.22 and repr. p.19.

A more assured treatment of a type of subject of which the drawing in the Morgan Library (Cat. No.72) is an earlier variant. The handling of the branches and foliage is identical with the wooded landscape owned by Colin Clark (Cat. No.114). Also mentioned on p.97.

121 Wooded Landscape with Faggot Gatherers
Ownership unknown

Pencil (apparently). Size unknown. Upright.
A woman talking to a small girl with a bundle of faggots under her arm, and a man picking up a bundle of faggots, in the foreground centre; a gate in the middle distance centre (from the print).
ENGRAVED: J. Laporte, published by Laporte and Wells, 1 May 1802 (as in the collection of Dr Thomas Monro).
PROVENANCE: Dr Thomas Monro; Monro sale, Christie's, 26 June 1833 ff.

The treatment of the foliage seems to be closely related to the landscape of a similar subject owned by Lady Joan Zuckerman (Cat. No.120).

122 Wooded Landscape with Cottage
British Museum, London (O.o.2 – 7)

Pencil. $5\frac{13}{16} \times 7\frac{5}{8}$ (148 × 194).
A track winding from the foreground left near an

oak tree close to a bank, past a cottage in the middle distance centre, into the distance right.
PROVENANCE: From the sketch-book purchased by Richard Payne Knight at the Gainsborough sale, Christie's, 11 May 1799, Lot 85; bequeathed 1824.
BIBLIOGRAPHY: Binyon 25b; Gower *Drawings*, p.12 and repr. pl.XIV; Woodall 107.

A sketch in which the hatching and treatment of the foliage is identical with the landscape with faggot gatherers owned by Lady Joan Zuckerman (Cat. No.120).

123 Wooded Landscape with Figures, Animals and Distant House
Pierpont Morgan Library, New York (III, 49)

Pencil. $5\frac{7}{8} \times 7\frac{11}{16}$ (149 × 195).
Two figures walking along a winding track in the middle distance centre; a cow and a donkey beneath a tree in the foreground left; a pond in the middle distance right, with a large house beyond; some logs in the foreground right.
Collector's mark of John Lowndes bottom left.
PROVENANCE: John Lowndes; Charles Fairfax Murray, from whom it was purchased by J. Pierpont Morgan 1910.
BIBLIOGRAPHY: *J. Pierpont Morgan Collection of Drawings by the Old Masters formed by C. Fairfax Murray*, Vol.III, London, 1912, No.49 (repr.).

The treatment of the tree trunks and branches, the logs, the winding track, the foliage and the clouds is identical with the wooded landscape owned by Colin Clark (Cat. No.114).

124 Wooded Landscape with Plough-team and Cottage Plate 29
G. D. Lockett, Clonterbrook House

Pencil. $6 \times 7\frac{5}{16}$ (152 × 186).
A plough-team in the foreground centre and right; a cottage half-hidden by trees in the middle distance left.
ENGRAVED: J. Laporte, published by Wells and Laporte, 1 November 1802 (as in the collection of J. Laporte).
PROVENANCE: J. Laporte; Henry S. Reitlinger; Reitlinger sale, Sotheby's, 27 January 1954, Lot 148 (with another) bt. Squire Gallery; Norman Baker; with Edward Levine, from whom it was purchased 1963.
EXHIBITED: Arts Council 1960–1 (8).
BIBLIOGRAPHY: Woodall 267, pp.32–3, 36, 38–9 and repr. pl.17.

The pencilwork and treatment of the foliage and branches are closely related to the wooded land-

scape owned by Colin Clark (Cat. No.114) and the landscape with wood gatherers owned by Lady Joan Zuckerman (Cat. No.120). The use of a row of foreground plants as a repoussoir is related to the panoramic landscape at Yale (Cat. No.93). A plough-team is the principal subject of two of Gainsborough's landscape paintings of the early to mid 1750's (Waterhouse 865 and 866). The plough itself is extremely generalized, as may be seen by comparing it with those in the drawings owned by Christopher Norris (Cat. No.178) and Bulkeley Smith (Cat. No.158). A copy by Frost is in the National Gallery of Scotland (497), and another copy is in the National Museum of Wales. Also mentioned on p.17.

125 Study of Trees at the Edge of a Wood
British Museum, London (O.0.2 – 28)

Pencil. $5\frac{7}{8} \times 7\frac{1}{2}$ (149 × 190).
Edge of a wood, in the middle distance centre and right, with a fence in the foreground left.
PROVENANCE: From the sketch-book purchased by Richard Payne Knight at the Gainsborough sale, Christie's, 11 May 1799, Lot 85; bequeathed 1824.
BIBLIOGRAPHY: Binyon 24b; Gower *Drawings*, p.12 and repr. pl.XIX; Woodall 105.

A study from nature. The handling of the foliage and branches is closely related to the background in the drawing of a plough-team in the Lockett collection (Cat. No.124).

126 Study of Trees with a Gate
Ownership unknown

Pencil. $6\frac{1}{8} \times 7\frac{3}{4}$ (155 × 195).
A gate in the foreground left; a pool in the foreground right (from a photograph).
PROVENANCE: With R. Ederheimer.

A study from nature. The bushy trees and loose looped scallops in the foliage are closely related to the study of trees at the edge of a wood in the British Museum (Cat. No.125).

127 Study of Trees
British Museum, London (O.0.2 – 6)

Pencil. $5\frac{13}{16} \times 7\frac{9}{16}$ (148 × 192).
A pond in the foreground centre; a fence in the foreground left and right.
PROVENANCE: From the sketch-book purchased by

Richard Payne Knight at the Gainsborough sale, Christie's, 11 May 1799, Lot 85; bequeathed 1824.
BIBLIOGRAPHY: Binyon 23b; Gower *Drawings*, p.14 and repr. pl.XL; Woodall 103.

A study from nature. The pencilwork is identical with the study of trees also in the British Museum (Cat. No.125).

128 Wooded Landscape with Herdsman, Cattle and Farm Buildings Plate 26
Pierpont Morgan Library, New York (III, 53)

Pencil. 8½ × 11⅜ (216 × 289).
A herdsman driving two cows and a sheep along a winding track in the foreground left; a cowshed behind a fence with a gate in the foreground right; two cottages or cowsheds in the middle distance left.
ENGRAVED: J. Laporte, published by Laporte and Wells, 1 December 1802 (as in the collection of J. Laporte).
PROVENANCE: J. Laporte; Stanley; Sir J. C. Robinson; Robinson sale, Christie's, 21 April 1902, Lot 122 bt Charles Fairfax Murray; purchased from Fairfax Murray by J. Pierpont Morgan 1910.
BIBLIOGRAPHY: *J. Pierpont Morgan Collection of Drawings by the Old Masters formed by C. Fairfax Murray*, Vol.III, London, 1912, No.53 (repr.); Woodall 456.

A study from nature. The pencilwork and treatment of the foliage and branches are closely related to the wooded landscape owned by Colin Clark (Cat. No.114) and the landscape with wood gatherers owned by Lady Joan Zuckerman (Cat. No.120). The conventions for indicating branches have now become very mannered and rococo.

129 Wooded Landscape with Lake
Ownership unknown

Grey wash on buff paper (apparently). Size unknown.
A lake stretching from the foreground left into the middle distance centre (from the print).
ENGRAVED: J. Laporte, published by Laporte and Wells, 1 July 1802 (as in the collection of William Alexander).
PROVENANCE: William Alexander; Alexander sale, Sotheby's, 11 March 1817.

The treatment of the foliage seems to be closely related to the landscape with herdsman and cows in the Morgan Library (Cat. No.128).

130 Wooded Landscape with Distant Church
Ownership unknown

Pencil (apparently). Size unknown.
A fence in the foreground centre and right; open country on the left, with a track winding towards a church in the distance left (from the print).
ENGRAVED: J. Laporte, published by Laporte and Wells, 1 March 1802 (as in the collection of J. Laporte).
PROVENANCE: J. Laporte.

The treatment of the foliage seems to be related to the landscape with herdsman and cows in the Morgan Library (Cat. No.128).

131 Wooded Landscape with Figures, Donkeys and Cottage Plate 377
Courtauld Institute of Art, Witt Collection, London (2369)

Pencil. 8⅜ × 11⅛ (213 × 283).
Two donkeys on a bank in the foreground left; a cottage amongst trees in the middle distance right; a horseman and another figure in the distance centre travelling along a lane which winds from the foreground centre.
Collector's mark of Sir Robert Witt on the back of the mount bottom left.
PROVENANCE: Frank Gibson; T. P. Greig; Anon. (=Greig) sale, Christie's, 11 May 1928, Lot 6 bt. Sir Robert Witt; bequeathed 1952.
EXHIBITED: Ipswich 1927 (120); *Two Hundred Years of British Painting*, Public Library and Art Gallery, Huddersfield, May–July 1946 (160); *Some British Drawings from the Collection of Sir Robert Witt*, Arts Council, 1948 (27); Aldeburgh 1949 (31); *Old Master Drawings from the Witt Collection*, Auckland City Art Gallery, 1960 (11); Arts Council 1960–1 (4); Nottingham 1962 (33); *English Landscape Drawings from the Witt Collection*, Courtauld Institute Galleries, January–May 1965 (7).
BIBLIOGRAPHY: Woodall 371 and p.33; *Hand-List of the Drawings in the Witt Collection*, London, 1956, p.22.

The pencilwork, the looped conventions for the foliage and the rather stylish rococo branches of the trees, are closely related to the landscape with herdsman and cows in the Morgan Library (Cat. No.128).

132 Wooded Landscape with Country Cart, Figures and Cottage Plate 32
Mrs M. G. Turner, Gerrards Cross

Pencil. 8¼ × 10⅞ (210 × 276).
A country cart drawn by two donkeys and accompanied by a drover in the foreground right, travelling along a track which winds from the foreground left into the middle distance right; a woman drawing water from a well in the foreground centre; a cottage on top of a sandy bank in the middle distance centre; a figure in the middle distance right.
PROVENANCE: Given by the artist probably to Goodenough Earle, of Barton Grange, Somerset; by descent to Francis Wheat Newton; sold to Agnew's 1913, who immediately resold it to Knoedler's, from whom it was purchased by P. M. Turner 1926.
EXHIBITED: Knoedler's 1914 (21); Knoedler's 1923 (13); Ipswich 1927 (116); Oxford 1935 (57); Arts Council 1960–1 (9, and pp.5 and 7).
BIBLIOGRAPHY: Fulcher, 2nd edn., p.241; Woodall 333, pp.37–8 and repr. pl.32; John Hayes, 'The Gainsborough Drawings from Barton Grange', *The Connoisseur*, February 1966, p.90 and repr. fig.9.

A highly-wrought drawing characterized by very soft and sensitive modelling. The bushy treatment of the foliage is related to the watercolour formerly in the Randall Davies collection (Cat. No.149), while the elaborately modelled and strongly-lit sandy bank is a common feature in Gainsborough's painted landscapes of the early to mid 1750's, for instance, the river scene with a horse drinking in St Louis (Waterhouse 834, repr. pl.47). The woman drawing water is in the same pose as one of the wood gatherers in the landscape owned by Lady Joan Zuckerman (Cat. No.120), but she is treated in a more rounded and less angular way. Also mentioned on p.22.

133 Wooded Landscape with Figure and Dog
T. R. C. Blofeld, Hoveton

Pencil. 7¼ × 9 (184 × 229).
A figure accompanied by a dog in the middle distance centre walking along a track which winds from the foreground centre into the distance centre; a high sandy bank in the foreground left.
Collector's mark of William Esdaile bottom right.
PROVENANCE: William Esdaile; Esdaile sale, Christie's, 20–1 March 1838.
EXHIBITED: Nottingham 1962 (34).
BIBLIOGRAPHY: John Hayes, 'The Drawings of George Frost', *Master Drawings*, Vol.4, No.2, 1966, pp.164 and 168.

The treatment of the sandy bank, the soft bushy trees, and the hatching in the sky are all closely related to the landscape with donkeys and country cart owned by Mrs M. G. Turner (Cat. No.132). There are two copies of this composition by Frost: one in the scrapbook formerly owned by Major T. C. Binny and now sold (repr. Woodall, pl.115), and another recently with Colnaghi. Also mentioned on p.73.

134 Study of a Mossy Bank Plate 31
British Museum, London (O.0.2 – 2)

Pencil. 5¹³⁄₁₆ × 7⅝ (148 × 194).
A mossy bank, with bushes above centre and right.
PROVENANCE: From the sketch-book purchased by Richard Payne Knight at the Gainsborough sale, Christie's, 11 May 1799, Lot 85; bequeathed 1824.
BIBLIOGRAPHY: Binyon 31 (11b); Gower *Drawings*, p.11 and repr. pl.VI; Woodall 135 and p.15.

A study from nature. The sensitive modelling of the bank and the careful hatching are close in character to the landscape with donkeys and a country cart owned by Mrs M. G. Turner (Cat. No.132), and studies of this description may have served as models for the bank in this drawing. Also mentioned on p.27.

135 Study of a Thistle and Bank
Plate 30
British Museum, London (O.0.2 – 1)

Pencil. 5⅜ × 6⅛ (137 × 156).
A thistle top left; a bank with plants above right.
PROVENANCE: From the sketch-book purchased by Richard Payne Knight at the Gainsborough sale, Christie's, 11 May 1799, Lot 85; bequeathed 1824.
BIBLIOGRAPHY: Binyon 31 (15a); Woodall 142, pp.39–40 and 69 and repr. pl.39.

A study from nature. The pencilwork is close to the study of a mossy bank also in the British Museum (Cat. No.134).

136 Study of Banks
Robert McDougall Art Gallery, Christchurch, N.Z.

Pencil. 5¾ × 6¾ (146 × 171).
Banks in the foreground left and right (from a photograph).
PROVENANCE: With John Manning, from whom it was purchased 1956.
EXHIBITED: *Spring Exhibition English and Continental Drawings*, John Manning, 1956 (1).

A study from nature. The hatching and crisp treatment of the tufts of grass are closely related to the study of a thistle and bank in the British Museum (Cat. No.135). The sketchy handling of the unfinished background is similar to the passages on the right of the study of tress owned by Charles Monteith (Cat. No.168).

137 Study of Trees in a Wood
D. L. T. Oppé, London (251 1c)

Pencil. $7\frac{1}{2} \times 5\frac{15}{16}$ (190 × 151).
Trees stretching across the foreground.
PROVENANCE: Sir J. C. Robinson; Robinson sale, Christie's, 21 April 1902; E. Horsman Coles; bequeathed to A. Paul Oppé 1954.

A study from nature. The broad slightly angular scallops outlining the foliage, the hatching, and the use of the paper to produce effects of sunlight, are closely related to the study of a thistle and bank in the British Museum (Cat. No.135).

138 Study of Willows Plate 38
British Museum, London (O.o.2 – 9)

Pencil. $6 \times 7\frac{1}{4}$ (152 × 184).
Willows, with a dead willow and a gate in the foreground right.
PROVENANCE: From the sketch-book purchased by Richard Payne Knight at the Gainsborough sale, Christie's, 11 May 1799, Lot 85; bequeathed 1824.
BIBLIOGRAPHY: Binyon 23a; Gower *Drawings*, p.13 and repr. pl.XXII; Woodall 102.

A study from nature. The bushy treatment of the foliage is close in character to the drawings owned by Bulkeley Smith (Cat. No.158) and Mrs M. G. Turner (Cat. No.132).

139 Study of a Mossy Bank Plate 34
British Museum, London (O.o.2 – 25)

Pencil. $5\frac{13}{16} \times 7\frac{3}{4}$ (148 × 197).
A mossy bank, with tree trunks (possibly planes).
PROVENANCE: From the sketch-book purchased by Richard Payne Knight at the Gainsborough sale, Christie's, 11 May 1799, Lot 85; bequeathed 1824.
BIBLIOGRAPHY: Binyon 31 (6b); Woodall 127.

A study from nature. The pencilwork is similar in character to the study of a mossy bank also in the British Museum (Cat. No.134).

140 Study of Cottages Plate 33
British Museum, London (O.o.2 – 57)

Pencil. $6 \times 7\frac{1}{8}$ (152 × 181).
Two cottages amongst trees near a bank in the foreground left; a track running from the foreground centre into the middle distance right.
PROVENANCE: From the sketch-book purchased by Richard Payne Knight at the Gainsborough sale, Christie's, 11 May 1799, Lot 85; bequeathed 1824.
BIBLIOGRAPHY: Binyon 31 (1a); Woodall 117.

A study from nature. The pencilwork is close to the study of a bank also in the British Museum (Cat. No.139). Also mentioned on p.27.

141 Study of Trees
British Museum, London (O.o.2 – 58)

Pencil. $6 \times 7\frac{3}{8}$ (152 × 187).
Trees at the edge of a wood.
PROVENANCE: From the sketch-book purchased by Richard Payne Knight at the Gainsborough sale, Christie's, 11 May 1799, Lot 85; bequeathed 1824.
BIBLIOGRAPHY: Binyon 31 (1b); Woodall 155.

A study from nature. The pencilwork throughout is identical with the study of cottages also in the British Museum (Cat. No.140).

142 Study of Meadows with a Bridge over a River
British Museum, London (O.o.2 – 40)

Pencil. $5\frac{7}{16} \times 7\frac{1}{2}$ (138 × 190).
Meadows, with a bridge over a river in the middle distance left and a man on horseback about to cross over centre.
PROVENANCE: From the sketch-book purchased by Richard Payne Knight at the Gainsborough sale, Christie's, 11 May 1799, Lot 85; bequeathed 1824.
BIBLIOGRAPHY: Binyon 31 (13a); Woodall 138.

A study from nature. The treatment of the foliage is related to the study of cottages also in the British Museum (Cat. No.140).

143 River Scene with House and Sheep
British Museum, London (O.o.2 – 43)

Pencil. $5\frac{1}{2} \times 7\frac{7}{16}$ (140 × 189).
Open landscape with a winding river right; a house in the middle distance left; scattered sheep in the middle distance centre.
PROVENANCE: From the sketch-book purchased by Richard Payne Knight at the Gainsborough sale, Christie's, 11 May 1799, Lot 85; bequeathed 1824.
BIBLIOGRAPHY: Binyon 17a; Woodall 146.

The treatment of the foliage and the pencilwork generally is closely related to the study of meadows near a river also in the British Museum (Cat. No.142).

144 Study of Cottages Plate 37
British Museum, London (O.o.2 – 51: recto)

Pencil. $5\frac{1}{2} \times 7\frac{11}{16}$ (140 × 189).
A row of cottages, with a hill behind.
Verso: study of a hut (Cat. No.145).
PROVENANCE: From the sketch-book purchased by Richard Payne Knight at the Gainsborough sale, Christie's, 11 May 1799, Lot 85; bequeathed 1824.
BIBLIOGRAPHY: Binyon 31 (2b); Woodall 119.

A study from nature. The pencilwork is similar to the study of cottages also in the British Museum (Cat. No.140).

145 Study of a Hut
British Museum, London (O.o.2 – 51: verso)

Pencil. $5\frac{1}{2} \times 7\frac{11}{16}$ (140 × 189).
A hut in the foreground left and centre.
Recto: a row of cottages (Cat. No.144).
PROVENANCE: From the sketch-book purchased by Richard Payne Knight at the Gainsborough sale, Christie's, 11 May 1799, Lot 85; bequeathed 1824.
BIBLIOGRAPHY: Binyon 31 (2b); Woodall 119.

A study from nature. The pencilwork is identical with the study of cottages on the recto (Cat. No.144).

146 Study of a Cottage
British Museum, London (O.o.2 – 61)

Pencil. $5\frac{3}{8} \times 7\frac{15}{16}$ (137 × 186).
A cottage with a figure outside in the foreground centre.
PROVENANCE: From the sketch-book purchased by Richard Payne Knight at the Gainsborough sale, Christie's, 11 May 1799, Lot 85; bequeathed 1824.
BIBLIOGRAPHY: Binyon 31 (2a); Woodall 118.

A study from nature. The pencilwork is close to the study of cottages also in the British Museum (Cat. No.144).

147 Study of a Bridge
British Museum, London (O.o.2 – 47)

Pencil. $5\frac{1}{2} \times 7\frac{3}{8}$ (140 × 187).
A stone bridge or entrance to a tunnel.
PROVENANCE: From the sketch-book purchased by

Richard Payne Knight at the Gainsborough sale, Christie's, 11 May 1799, Lot 85; bequeathed 1824.
BIBLIOGRAPHY: Binyon 31 (13b); Woodall 139.

A study from nature. The pencilwork is closely related to the study of a cottage also in the British Museum (Cat. No.146).

148 Study of an Evergreen Tree
British Museum, London (O.o.2 – 13)

Pencil. $7\frac{7}{16} \times 5\frac{13}{16}$ (189 × 148).
A dying conifer or a young pine.
PROVENANCE: From the sketch-book purchased by Richard Payne Knight at the Gainsborough sale, Christie's, 11 May 1799, Lot 85; bequeathed 1824.
BIBLIOGRAPHY: Binyon 31 (20a); Woodall 152.

A study from nature. The pencilwork is similar to the study of cottages also in the British Museum (Cat. No.144).

149 Wooded Landscape with Herdsman and Cattle, Rustic Lovers and Church Tower Plate 39
Ownership unknown

Pencil and watercolour. Size unknown.
A herdsman driving three cows along a road, and four sheep, in the foreground right; a girl talking to a seated shepherd by the side of the road in the foreground centre; a high bank in the foreground left; a cottage on a bank half-hidden by trees in the middle distance right (from a photograph).
PROVENANCE: Randall Davies.

An elaborate but only partially finished early watercolour: the trees on the right have been taken almost to their final state, but the remainder of the sheet is in different stages of completion, the bank on the left and the figures in the foreground being no more than outlined. This method of carrying the composition forward in parts is characteristic also of Gainsborough's painting during the early part of his career, as may be seen from the *Gipsies under a Tree* in the Tate Gallery (Waterhouse 864), which dates from the early 1750's. The treatment of the foliage, the church tower seen between trees with a large cloud behind it, and the lighting, are all comparable with Gainsborough's painted landscapes of the early to mid 1750's. Also mentioned on pp.22 and 32.

150 Wooded Landscape with Plough-team and Cottage Plate 40
Pierpont Morgan Library, New York (III, 47)

Pencil. $11\frac{1}{4} \times 13\frac{1}{2}$ (286 × 343).
A ploughman with a ploughshare drawn by two horses in a field in the middle distance right; a cottage with a milkmaid milking a cow in the middle distance left; two cows, one of them reclining, and a herdsman leaning against a tree, in the middle distance centre; a pool and a withered tree stump in the foreground centre.
ENGRAVED: W. F. Wells, published by Wells and Laporte, 1 January 1805 (as in the collection of Baroness Lucas).
PROVENANCE: Philip, 2nd Earl of Hardwicke; by descent to Amabel, Baroness Lucas; Charles Fairfax Murray, from whom it was purchased by J. Pierpont Morgan 1910.
EXHIBITED: *The Eighteenth Century Art of France and England*, Montreal Museum of Fine Arts, April–May 1950 (46); *Landscape Drawings and Water-Colors, Bruegel to Cézanne*, Pierpont Morgan Library, January–April 1953 (83).
BIBLIOGRAPHY: Chamberlain, pp.165–6, repr. p.67; *J. Pierpont Morgan Collection of Drawings by the Old Masters formed by C. Fairfax Murray*, Vol.III, London, 1912, No.47 (repr.); Woodall 454, pp.37—8 and repr. pl.31.

The rococo treatment of the branches on the left, the bushy modelling of the foliage, and the zig-zag touch in the foreground are all related to the landscape with peasant, cows and sheep owned by Mrs Eckley Markle (Cat. No.163). The diagonal placing of the withered tree stump is similar to the drawing owned by Bulkeley Smith (Cat. No.158). A companion to this drawing, now missing, was in the Lucas sale, Sotheby's, 29 June 1926, Lot 33 bt. Oliver. Also mentioned on pp.32, 34, 48 and 100.

151 Wooded Landscape with Donkeys
George F. Benson, London

Pencil. $11\frac{3}{16} \times 13\frac{7}{8}$ (284 × 352).
Two donkeys, one of them reclining, in the foreground and middle distance right; a tree trunk with its branches lopped, and a ploughshare, in the foreground centre; a path leading from the foreground left into the middle distance centre.
PROVENANCE: William Gilpin; thence by descent.
BIBLIOGRAPHY: Carl Paul Barbier, *William Gilpin*, Oxford, 1963, p.24.

The treatment of the foliage, the foreground detail and the track is identical with the landscape with plough-team in the Morgan Library (Cat. No.150). The soft quality of the drawing, which appears uncharacteristic at first sight, is due to it having been rubbed slightly.

152 Open Landscape with Drover and Calves in a Country Cart Plate 41
National Gallery of Art, Washington, D.C.

Pencil and grey wash. $9\frac{7}{16} \times 11\frac{7}{16}$ (240 × 291).
A cart drawn by two horses, with drover and dog, and carrying three calves, in the foreground centre and right, travelling along a track which winds from the foreground left into the middle distance right; a pond in the foreground centre.
PROVENANCE: Given by the artist probably to Goodenough Earle, of Barton Grange, Somerset; by descent to Francis Wheat Newton; sold to Agnew's 1913, who immediately resold it to Knoedler's, from whom it was purchased by C. R. Williams 1914; Howard Sturges, who presented it.
EXHIBITED: Knoedler's 1914 (18).
BIBLIOGRAPHY: Fulcher, 2nd edn., p.241; John Hayes, 'The Gainsborough Drawings from Barton Grange', *The Connoisseur*, February 1966, p.90 and repr. fig.8.

A highly-wrought drawing in which the treatment of the foreground detail and the soft bushy foliage is closely related to the landscape with plough-team in the Morgan Library (Cat. No.150). The motif of a country cart with calves was also used in the landscape painting formerly in the McCormack collection (Waterhouse 862), painted about 1754–6, and in the picture entitled *The Broken Egg*, now known only from a copy (Waterhouse 832), probably painted at about the same period. The motif of the large white cloud setting off the main feature of the composition is characteristic of Gainsborough's work in the early and mid 1750's. Also mentioned on pp.34, 39, 42, 48 and 86.

153 Wooded Landscape with River, Footbridge, Figure and Buildings
Plate 42
Victoria and Albert Museum, London (Dyce 676)

Pencil and watercolour, with some bodycolour. $11\frac{3}{4} \times 14\frac{1}{4}$ (298 × 362).
A stream across the foreground which joins a river running into the middle distance right; a cottage amongst trees on a bank in the middle distance left; a figure crossing a wooden footbridge in the middle

distance right; a church in the distance centre, and houses in the distance right.

The composition is surrounded by a double ruled line in brown ink.

Collector's mark of William Esdaile bottom right. Inscribed on the verso in pen by Esdaile bottom left: *G – Frost's coll ͬ N50+*.

PROVENANCE: George Frost; William Esdaile; Esdaile sale, Christie's 20–1 March 1838; Rev. Alexander Dyce, who bequeathed it to the South Kensington Museum 1869.

BIBLIOGRAPHY: *Dyce Collection Catalogue*, London, 1874, p.99; *Victoria and Albert Museum Catalogue of Water Colour Paintings by British Artists*, London, 1927, p.220 and repr. fig. 65; Woodall 190, pp.37–8 and repr. pl.33.

A highly-wrought composition in which the treatment of the foreground detail and soft bushy foliage is closely related to the landscape with country cart in Washington (Cat. No.152), and the handling of the foliage on the right, in particular the elongated scallops, is similar to the landscape with church tower in the Huntington Art Gallery (Cat. No.187). Hardly any drawings in watercolour from the Suffolk period have survived, and this is executed in the very pale tones characteristic of Skelton, Taverner and Lambert. Also mentioned on p.34.

154 Wooded Landscape with Peasant Asleep Plate 43
Ownership unknown.

Pencil (presumably). Size unknown.
A herdsman asleep beside a track in the foreground centre; a cottage in the middle distance left; groups of buildings and a church in the distance centre and right; a track winding from the foreground centre into the distance centre (from the print).
ENGRAVED: William Elliot.
PROVENANCE: Unknown.

The treatment of the foreground detail and the soft bushy trees, as well as the prominent withered tree stump, the large bright clouds used to emphasize the composition and the motif of the peasant sleeping, suggest that this was executed in the mid-1750's.

155 Wooded Landscape with Herdsman and Cattle
Ownership unknown

Pencil (presumably). Size unknown.
A herdsman crossing a wooden footbridge in the foreground left; three cows in the foreground centre; a cottage in the middle distance left; a church and houses in the distance centre; a pool in the foreground centre and right (from the print).
ENGRAVED: William Elliot.
PROVENANCE: Unknown.

The treatment of this drawing appears to be very similar to the landscape with peasant asleep also engraved by Elliott (Cat. No.154), so that it was probably executed at about the same period. A late eighteenth-century soft-ground etching oddly entitled 'The last Production by GEORGE GAINSBOROUGH', though including a dog and differing very slightly in detail, is presumably also taken from this drawing and not from a variant.

156 Study of Branches
L. G. Duke, London

Black chalk and stump. $5\frac{3}{4} \times 6\frac{11}{16}$ (146×170).
Study of some branches; no background.
Verso: study of the upper part of a tree (Cat. No.157).
PROVENANCE: Rev. J. Round; with Shemilt, from whom it was purchased 1951.

A study from nature. Executed in the early 1750's.

157 Study of Part of a Tree
L. G. Duke, London

Black chalk and stump. $5\frac{3}{4} \times 6\frac{11}{16}$ (146×170).
Study of the upper part of a tree; no background.
Recto: study of some branches (Cat. No.156).
PROVENANCE: Rev. J. Round; with Shemilt, from whom it was purchased 1951.

A study from nature. Executed in the early 1750's.

Later 1750's

158 Wooded Landscape with Herdsman, Cows and Buildings Plate 315
F. Bulkeley Smith, Hamden, Conn.

Pencil, varnished. $11\frac{1}{8} \times 14\frac{1}{2}$ (283×368).
A peasant boy with three cows, one reclining, under a tree in the foreground centre; a wheel plough in the foreground left; a stile in the foreground right, farm buildings and a church tower half-hidden by trees in the middle distance right.
PROVENANCE: Given by the artist probably to Goodenough Earle, of Barton Grange, Somerset; by descent to Francis Wheat Newton; sold to Agnew's 1913, who immediately resold it to

Knoedler's, from whom it was purchased by
F. B. Smith 1914.
EXHIBITED: Knoedler's 1914 (23).
BIBLIOGRAPHY: Fulcher, 2nd edn., p.241; John
Hayes, 'The Gainsborough Drawings from Barton
Grange', *The Connoisseur*, February 1966, pp.88–90
and repr. fig.4.

A very detailed and highly-wrought work for
which there are a number of studies or related
drawings (Cat. Nos.860, 855, 824 and 159). The
composition was used in reverse, with minor
variations and the addition of another cow and a
milkmaid climbing over the stile, for the left
side of the landscape owned by Earl Howe
(Waterhouse 845) (Plate 318), painted about
1755–7. The motif of the dead tree trunk acting
as a fulcrum to the design is familiar from other
pictures of the mid-1750's such as the landscapes
with rustic lovers at Woburn (Waterhouse 829,
repr. pl.41) and Montreal (Waterhouse 844,
repr. pl.40). The Suffolk type wheel plough seen
on the left is clearly based on a sketch made
from an actual implement, but it is interesting
to notice that in an elaborate drawing of this
description Gainsborough has taken less care
over the detail: the board between the wheels
is unusually high, the beam given an exaggera-
ted curvature, and (most telling point) the
mould board and coulter are blended together
(information kindly supplied by Mrs L. A. West
of the Science Museum). Also mentioned on
pp.28, 32, 40 and 42.

159 Study of Church Towers Plate 314
British Museum, London (O.o.2 – 18)

Pencil. $3\frac{13}{16} \times 7\frac{1}{8}$ (97 × 181).
Study of three towers, those on the left and right
certainly being church towers, screened in front by
trees; a windmill roughly sketched top right.
PROVENANCE: From the sketch-book purchased by
Richard Payne Knight at the Gainsborough sale,
Christie's, 11 May 1799, Lot 85; bequeathed 1824.
BIBLIOGRAPHY: Woodall 144.

A study of different types of tower, half-hidden
by trees, for inclusion in one of his landscape
compositions, such as the drawing owned by
F. Bulkeley Smith (Cat. No.158). None of the
towers is identifiable, and the detail is general-
ized, so that it is probable that they were drawn
from memory: the tower on the left is very
simple and similar to those on many Suffolk
churches; the tower on the right has angle
buttresses (not very clearly understood) and a

wind vane, both of which are features of a
number of Suffolk churches, including St
Margaret's, Ipswich. The pencilwork is similar
in character to the Bulkeley Smith drawing.
Also mentioned on p.28.

160 Study of a Rough Slope
British Museum, London (O.o.2 – 49)

Pencil. $6\frac{1}{16} \times 6\frac{7}{16}$ (154 × 164).
Rough slope, with trees above left and centre.
PROVENANCE: From the sketch-book purchased by
Richard Payne Knight at the Gainsborough sale,
Christie's, 11 May 1799, Lot 85; bequeathed 1824.
BIBLIOGRAPHY: Binyon 31 (11a); Gower *Drawings*,
p.13 and repr. pl.XXXI; Woodall 134.

A study from nature. The modelling of the
ground is close in character to the study of a
mossy bank also in the British Museum (Cat.
No.134), but the crisp curving strokes in the
bushes are more closely related to the back-
ground in the study of a cow in the Oppé collec-
tion (Cat. No.861).

161 Wooded Landscape with Drover and
Horse carrying Lambs Plate 53
Victoria and Albert Museum, London
(F.A.594)

Black chalk. $7\frac{1}{8} \times 8\frac{15}{16}$ (181 × 227).
A drover holding a stick in his left hand and leading
a horse carrying two lambs by the reins with his
right in the foreground centre and right; a cottage
with an open window in the middle distance left.
Inscribed in pencil on the back of the card upon
which the drawing is laid: *Capital Drawing of
Gainsborough./Mr. DelaMotte/1800.*
ENGRAVED: John Ogborne.
PROVENANCE: William Delamotte; acquired 1863.
BIBLIOGRAPHY: *Victoria and Albert Museum Catalogue of
Water Colour Paintings by British Artists*, London, 1927,
p.219; Woodall 203.

The treatment of the branches and foreground
and the modelling of the horse and cottage are
closely related to the landscape with shepherd
and sheep owned by Mrs Eckley Markle (Cat.
No. 163).

162 Wooded Landscape with Horses
Ownership unknown

Pencil. Size unknown.
A horse standing behind a bank centre on a track
which winds from the foreground left into the

distance right; another horse standing behind a gate in the middle distance left; the roof of a cottage in the distance left; a church in the distance right; a pool in the foreground right (from a photograph).
PROVENANCE: With Parsons 1927.

The pencilwork is closely related to the landscape with a horse carrying lambs in the Victoria and Albert Museum (Cat. No.161).

163 Peasant Boy with Cows and Sheep outside a Cottage at the Edge of a Wood Plate 51
Mrs Eckley B. Markle, Fort Lauderdale, Fla.

Pencil. Size unknown.
A peasant with two cows, one reclining, and four sheep, in the foreground left and centre; a cottage amidst trees in the middle distance left; a track winding into the distance right (from a photograph). Signed with initials *TG* bottom left.
PROVENANCE: Given by the artist probably to Goodenough Earle, of Barton Grange, Somerset; by descent to Francis Wheat Newton; sold to Agnew's 1913, who immediately resold it to Knoedler's, from whom it was purchased by Mrs John Markle 1914; thence by descent.
EXHIBITED: Knoedler's 1914 (3).
BIBLIOGRAPHY: Fulcher, 2nd edn., p.241; John Hayes, 'The Gainsborough Drawings from Barton Grange', *The Connoisseur*, February 1966, p.90 and repr. fig.7.

The rococo treatment of the branches on the right, the modelling of the bushy foliage, the handling of the foreground detail, and the cross-hatching in the sky are all similar to the landscape with peasant boy and cows owned by Bulkeley Smith (Cat. No.158). Also mentioned on p.48.

164 Study of an Old Hurdle Plate 50
Courtauld Institute of Art, Witt Collection, London (3884)

Pencil. $5\frac{7}{8} \times 7\frac{1}{4}$ (149 × 184).
Collector's mark of Sir Robert Witt on the verso bottom left.
PROVENANCE: Violet, Lady Melchett; with Squire Gallery, from whom it was purchased by Sir Robert Witt; bequeathed 1952.
EXHIBITED: Arts Council 1960–1 (5).
BIBLIOGRAPHY: *Hand-List of Drawings in the Witt Collection*, London, 1956, p.22.

A study from nature. The spiralling treatment of the foliage is close in character to the drawings owned by Mrs Eckley Markle (Cat. No.163) and

in the Morgan Library (Cat. No.150). Also mentioned on p.27.

165 Wooded Landscape with a Woodcutter on a Hillock Plate 52
Courtauld Institute of Art, Witt Collection, London (554)

Pencil. $5\frac{5}{8} \times 7\frac{5}{8}$ (143 × 194).
A woodcutter carrying some sticks over his shoulder on a hillock in the foreground centre; some sheep and a log in the foreground left; a pool in the foreground right; a cottage in the middle distance right.
Collector's mark of Sir Robert Witt on the back of the mount bottom left.
ENGRAVED: W. F. Wells, published by Wells and Laporte, 1 May 1803 (as in the collection of George Hibbert).
PROVENANCE: From one of the sketch-books purchased by George Hibbert at the Gainsborough sale, Christie's, 11 May 1799, Lot 82, 84 or 88; by descent to the Hon. A. H. Holland-Hibbert; Holland-Hibbert sale, Christie's, 30 June 1913, Lot 17 bt. Leggatt; Sir Robert Witt; bequeathed 1952.
EXHIBITED: Arts Council 1960–1 (12).
BIBLIOGRAPHY: Woodall 83; *Hand-List of the Drawings in the Witt Collection*, London, 1956, p.21.

The pencilwork is similar to the study of trees owned by Alexander Lowenthal (Cat. No.172), while the treatment of the log on the left is closely related to the study of logs in the British Museum (Cat. No.214).

166 Landscape with Shepherd and Sheep on a Hillock
Courtauld Institute of Art, Witt Collection, London (3950)

Pencil. $5\frac{5}{8} \times 7\frac{3}{8}$ (143 × 187).
A shepherd with scattered sheep on a hillock in the middle distance centre; a log and pool in the foreground centre and right.
Collector's mark of Sir Robert Witt on the verso bottom left.
ENGRAVED: W. F. Wells, published 1 January 1802 (as in the collection of George Hibbert).
PROVENANCE: From one of the sketch-books purchased by George Hibbert at the Gainsborough sale, Christie's, 11 May 1799, Lot 82, 84 or 88; by descent to the Hon. A. H. Holland-Hibbert; Holland-Hibbert sale, Christie's, 30 June 1913, Lot 37 (with another) bt. Agnew; with P. M. Turner; Sir Robert Witt, who bequeathed it 1952.
BIBLIOGRAPHY: Woodall 342; *Hand-List of Drawings in the Witt Collection*, London, 1956, p.22.

A very rough sketch in which the handling is similar to the landscape with woodcutter also in the Witt Collection (Cat. No.165). In the engraving by Wells, the composition has been extended on the right (the left side of the drawing) to include a panoramic distance.

167 Wooded Landscape with Cottages and Sheep
Mrs M. Schwartz, London

Pencil. $6\frac{1}{8} \times 7\frac{1}{2}$ (156 × 190).
A cottage half-hidden by trees, a gate in front, in the foreground left; some sheep on a bank in the foreground centre; a cottage in the middle distance right.
ENGRAVED: W. F. Wells, published by Laporte and Wells, 1 November 1802 (as in the collection of George Hibbert).
PROVENANCE: From one of the sketch-books purchased by George Hibbert at the Gainsborough sale, Christie's, 11 May 1799, Lot 82, 84 or 88; by descent to the Hon. A. H. Holland-Hibbert; Holland-Hibbert sale, Christie's, 30 June 1913; Caroll Carstairs; by descent to Mrs M. Schwartz; Anon. (=Schwartz) sale, Christie's, 19 March 1968, Lot 44 bt. in.

The treatment of the foliage and clouds is closely related to the landscape with a woodcutter on a hillock in the Witt Collection (Cat. No.165).

168 Study of Trees Plate 386
Charles Monteith, London

Pencil. $5\frac{1}{2} \times 7\frac{1}{2}$ (140 × 190).
Trees, possibly elms.
PROVENANCE: From one of the sketch-books purchased by George Hibbert at the Gainsborough sale, Christie's, 11 May 1799, Lot 82, 84 or 88; by descent to the Hon. A. H. Holland-Hibbert; Holland-Hibbert sale, Christie's 30 June 1913; H. W. Underdown (?); Henry S. Reitlinger; Reitlinger sale, Sotheby's, 27 January 1954, Lot 147 (with another) bt. Squire Gallery, from whom it was purchased.
EXHIBITED: Nottingham 1962 (35).
BIBLIOGRAPHY: Woodall 272.

A study from nature, characterized by a crisp treatment of the tree trunks and branches and very broad scallops in parts of the foliage. The scallops outlining the foliage and the rapid hatching modelling the trees are closely related to the landscape with a woodcutter on a hillock in the Witt Collection (Cat. No.165). Also mentioned on p.75.

169 Study of Trees with a Hill behind
Plate 54
British Museum, London (O.o.2 – 5)

Pencil. $5\frac{9}{16} \times 7\frac{1}{2}$ (141 × 190).
Trees at the edge of a wood, with a stile in the foreground left; a hill in the middle distance right.
PROVENANCE: From the sketch-book purchased by Richard Payne Knight at the Gainsborough sale, Christie's, 11 May 1799, Lot 85; bequeathed 1824.
BIBLIOGRAPHY: Binyon 31 (7b); Woodall 129.

A study from nature. The treatment of the foliage, in particular the loose scallops, is closely related to the study of trees owned by Charles Monteith (Cat. No.168).

170 Study of Trees
Mrs I. A. Williams, London

Pencil. $5\frac{11}{16} \times 7\frac{7}{8}$ (144 × 200).
Trees stretching across the foreground; a hill behind in the distance centre.
PROVENANCE: From one of the sketch-books purchased by George Hibbert at the Gainsborough sale, Christie's 11 May 1799, Lot 82, 84 or 88; by descent to the Hon. A. H. Holland-Hibbert; Holland-Hibbert sale, Christie's, 30 June 1913, Lot 47 (with another) bt. Mrs Cropper; purchased by Iolo A. Williams in Kendal 1931.
BIBLIOGRAPHY: Woodall 353.

A study from nature. The pencilwork and outlining of the foliage are identical with such studies as that in the British Museum (Cat. No.169).

171 Study of Trees
Ownership unknown

Pencil. $7\frac{1}{2} \times 5\frac{1}{2}$ (190 × 140).
A tall tree in the foreground centre, with other trees on either side (from a photograph).
PROVENANCE: Henry S. Reitlinger; Reitlinger sale, Sotheby's, 27 January 1954, Lot 146 (with another) bt. Agnew; Anon. sale, Phillips Son and Neale, February 1955.
BIBLIOGRAPHY: Woodall 273.

A study from nature. The treatment of the foliage in the principal tree is closely related to the study of trees owned by Mr and Mrs Alexander Lowenthal (Cat. No.172), and the handling of the foliage on the right to the study of trees in the British Museum (Cat. No.169).

172 Study of Oaks Plate 56
Mr and Mrs Alexander Lowenthal,
Pittsburgh, Pa.

Pencil. 6⅛ × 4⅝ (156 × 117).
Tall oaks in the foreground left and centre (from a
photograph).
PROVENANCE: From one of the sketch-books
purchased by George Hibbert at the Gainsborough
sale, Christie's, 11 May 1799, Lot 82, 84 or 88;
by descent to the Hon. A. H. Holland-Hibbert;
Holland-Hibbert sale, Christie's, 30 June 1913,
Lot 30 (with another) bt. Leggatt; Anon. sale,
American Art Association, Anderson Galleries, 21
January 1937, Lot 227 bt. Lowenthal.

A study from nature. The treatment of the
foliage is related to the study of trees owned by
Charles Monteith (Cat. No.168). Also men-
tioned on p.28.

173 Study of Trees
A. C. Greg, Acton Bridge

Pencil. 7½ × 5⅝ (190 × 143).
Tall trees across the foreground with suggestions of
a track in front.
PROVENANCE: From one of the sketch-books
purchased by George Hibbert at the Gainsborough
sale, Christie's, 11 May 1799, Lot 82, 84 or 88;
by descent to the Hon. A. H. Holland-Hibbert;
Holland-Hibbert sale, Christie's, 30 June 1913;
H. W. Underdown; with John Manning (as
Constable), from whom it was purchased.

The pencilwork throughout is identical with the
study of trees owned by Mr and Mrs Alexander
Lowenthal (Cat. No.172).

174 Wooded Landscape with Hill
Ehemals Staatliche Museen, Berlin-Dahlem
(4702)

Pencil, with traces of grey wash. 5⅝ × 7⅜ (143 × 187).
A winding track centre leading up to a hill in the
distance.
PROVENANCE: From one of the sketch-books
purchased by George Hibbert at the Gainsborough
sale, Christie's, 11 May 1799, Lot 82, 84 or 88;
by descent to the Hon. A. H. Holland-Hibbert;
Holland-Hibbert sale, Christie's, 30 June 1913,
Lot 45 (with another) bt. Hofer; presented by an
unknown donor 1913.
BIBLIOGRAPHY: Woodall 414.

The scallops outlining the foliage, the pencil-
work and the hatching are closely related to such
studies as that in the British Museum (Cat.
No.169), and the treatment of the foreground

trees, in particular the hatched modelling on the
right, is very close to passages in the study of
oaks owned by Mr and Mrs Alexander Lowen-
thal (Cat. No.172).

175 Wooded Landscape with Rooftop
Ehemals Staatliche Museen, Berlin-Dahlem
(4700)

Pencil and grey wash. 5⅝ × 7¼ (143 × 184).
Thickly-wooded scenery with a rooftop visible over
the trees in the distance right.
PROVENANCE: From one of the sketch-books
purchased by George Hibbert at the Gainsborough
sale, Christie's, 11 May 1799, Lot 82, 84 or 88;
by descent to the Hon. A. H. Holland-Hibbert;
Holland-Hibbert sale, Christie's, 30 June 1913,
Lot 39 (with another) bt. Hofer; presented by an
unknown donor 1913.
BIBLIOGRAPHY: Woodall 413.

The scallops outlining the foliage and the pencil-
work throughout are identical with the wooded
landscape with hill also in Berlin (Cat. No.174).

176 Study of Trees Plate 252
The Hon. Christopher Lennox-Boyd, London

Pencil and grey wash. 6⅛ × 7⅝ (156 × 194).
Trees at the edge of a wood.
PROVENANCE: From one of the sketch-books
purchased by George Hibbert at the Gainsborough
sale, Christie's, 11 May 1799, Lot 82, 84 or 88;
by descent to the Hon. A. H. Holland-Hibbert;
Holland-Hibbert sale, Christie's, 30 June 1913;
Caroll Carstairs; by descent to Mrs M. Schwartz;
Anon. (=Schwartz) sale, Christie's, 19 March 1968,
Lot 46 bt. Sanders.

A study from nature. The treatment of the
foliage, in particular the loose scallops, and the
broad hatching, are closely related to the study
of trees owned by Charles Monteith (Cat.
No.168). The vigorous pencilwork is close in
character to Teniers. Also mentioned on p.57.

177 Study of Mallows Plate 57
H. C. Torbock, Crossrigg Hall

Pencil. 7½ × 6⅛ (190 × 156).
Mallows, with bushes above top left.
Collector's mark of Henry Reitlinger on the verso
bottom right.
PROVENANCE: Charles Fairfax Murray; Henry S.
Reitlinger; Reitlinger sale, Sotheby's, 27 January
1954, Lot 147 (with another) bt. Squire Gallery,

from whom it was purchased.
EXHIBITED: Nottingham 1962 (36).
BIBLIOGRAPHY: Woodall 274 and p.40.

A detailed and sensitive study from nature. The hatching in the background and the crisp slightly curving touches in the bushes are closely related to the background in the study of a cow in the Oppé collection (Cat. No.861). Similar studies of plants were made by Wilson (compare the drawing in the Ford collection reproduced in Brinsley Ford, *The Drawings of Richard Wilson*, London, 1951, pl.12), but it is doubtful if either artist was acquainted with the other's work during most of the 1750's. Also mentioned on p.27.

178 Wooded Landscape with Figure, Ploughs and Cottage Plate 58
Christopher Norris, Polesden Lacey

Pencil. $6\frac{1}{16} \times 7\frac{3}{8}$ (154×187).
A ploughman bending down in the foreground centre; a swing plough beside a sweet chestnut tree in the foreground left; a wheel plough in the foreground right; a cottage half-hidden by trees in the middle distance centre; a church tower in the distance right.
ENGRAVED: W. F. Wells, published by Wells and Laporte, 1 March 1803 (as in the collection of George Hibbert).
PROVENANCE: From one of the sketch-books purchased by George Hibbert at the Gainsborough sale, Christie's, 11 May 1799, Lot 82, 84 or 88; by descent to the Hon. A. H. Holland-Hibbert; Holland-Hibbert sale, Christie's, 30 June 1913.

The two ploughs in the foreground are rather over-obvious set pieces, out of scale with the figure behind, and are clearly derived from sketches made from actual implements. Mrs L. A. West, of the Science Museum, has kindly informed me that they are reasonably accurate representations of Suffolk type swing and wheel ploughs respectively, but that the linkage of the wheel plough is of an unexpected sort. The tree on the left is identifiable as a sweet chestnut. The pencilwork is identical with the background in the study of a cow in the Oppé collection (Cat. No.861).

179 Study of a Withered Tree
Mr and Mrs Robert W. Bloch, New York

Pencil. $6\frac{13}{16} \times 4\frac{9}{16}$ (173×116).
A forked tree on a sandy or mossy bank in the foreground right.

PROVENANCE: Sir J. C. Robinson; with Squire Gallery, from whom it was purchased by Ralph Edwards; with John Baskett, from whom it was purchased.
EXHIBITED: *Old Master and English Drawings*, John Baskett, May–June 1969 (25 repr.).

A study from nature. The hatching and crisp delineation of the branches are closely related to the landscape with ploughs owned by Christopher Norris (Cat. No.178).

180 Wooded Landscape with Herdsman, Cows and Church Tower
Edward Seago, Ludham

Pencil. $6\frac{1}{16} \times 7\frac{7}{8}$ (154×200).
A herdsman seated beneath a withered tree trunk, and two cows, in the foreground left; a pool in the middle distance centre; a church tower half-hidden by trees in the distance right.
PROVENANCE: Anon. sale, Sotheby's, 14 January 1959, Lot 2 (part of a parcel) bt. Colnaghi, from whom it was purchased 1959.

An unusually classical composition for Gainsborough of the mid–1750's. The treatment of the tree trunks, foliage and foreground, and even the cross-hatching in the sky, are all exactly in the manner of the Bulkeley Smith drawing (Cat. No.158). Also mentioned on p.48.

181 Wooded Landscape with Herdsman, Cattle and Church Tower
Panton Corbett, London

Pencil. $6\frac{1}{8} \times 7\frac{7}{8}$ (156×200).
A herdsman driving two cows past a knoll in the foreground left and centre along a track which winds into the middle distance centre; a church tower in the distance centre.
PROVENANCE: John Hale; Hale sale, Sotheby's, 13 March 1969, Lot 119 bt. R. P. Corbett.

The crisp, nervous treatment of the branches of the tree on the right, the handling of the foliage, the hatching in the sky and the pencilwork generally are identical with the landscape with herdsman and cattle in Edward Seago's collection (Cat. No.180).

182 Wooded Landscape with Herdsman, Cows, River and Church Tower
Derek Melville, Yoxford

Pencil. $6\frac{3}{16} \times 7\frac{3}{4}$ (157×197).
A herdsman driving five or six cows in the foreground

left; a church tower half-hidden by trees in the middle distance left; a river winding into the distance centre, with a bridge in the middle distance centre.
PROVENANCE: Guy Bellingham Smith; Lady Eason; Anon. sale, Sotheby's, 11 November 1964, Lot 74 (with another) bt. Bossuet; with Savage.
BIBLIOGRAPHY: Woodall 43.

A classical type of composition in which the pencilwork throughout is identical with the drawing in Edward Seago's collection (Cat. No.180). Also mentioned on p.48.

183 Wooded Landscape with Figures, Donkey and Buildings
Derek Melville, Yoxford

Pencil. $6\frac{3}{16} \times 7\frac{3}{4}$ (157 × 197).
Three figures at the top of a hilly road, and a donkey under a tree, in the foreground right; a group of buildings in the middle distance right.
PROVENANCE: Guy Bellingham Smith; Lady Eason; Anon. sale, Sotheby's, 11 November 1964, Lot 74 (with another) bt. Bossuet; with Savage.
BIBLIOGRAPHY: Woodall 44.

A classical type of composition in which the pencilwork throughout is identical with the drawing in Edward Seago's collection (Cat. No.180). Also mentioned on p.48.

184 Wooded Landscape with Figures and Cows
British Museum, London (O.0.2 – 10)

Pencil and brownish-black bodycolour, varnished (the latter elements added later).
$7\frac{3}{8} \times 6\frac{1}{16}$ (187 × 154).
A figure travelling along a winding track in the foreground left; a herdsman driving two cows in the foreground right.
PROVENANCE: From the sketch-book purchased by Richard Payne Knight at the Gainsborough sale, Christie's, 11 May 1799, Lot 85; bequeathed 1824.
BIBLIOGRAPHY: Binyon 26b; Gower *Drawings*, p.12 and repr. pl.IX; Woodall 109.

The treatment of the foliage and foreground is related to the landscape with church tower in Edward Seago's collection (Cat. No.180).

185 Wooded Landscape with Bridge
British Museum, London (O.0.2 – 19)

Pencil. $5\frac{15}{16} \times 7\frac{5}{8}$ (151 × 194) (trimmed at the upper corners).

A track winding from the foreground left past an elm tree into the middle distance left; a horse on a bank in the middle distance left; a bridge in the distance right.
PROVENANCE: From the sketch-book purchased by Richard Payne Knight at the Gainsborough sale, Christie's, 11 May 1799, Lot 85; bequeathed 1824.
BIBLIOGRAPHY: Binyon 25a; Gower *Drawings*, p.14 and repr. pl.XXXVIII; Woodall 106.

Possibly a study from nature. The pencilwork and treatment of the foliage are closely related to the landscape with a church tower in Edward Seago's collection (Cat. No.180).

186 Study of Rough Ground with Stream
Mrs M. C. Mortimer, London

Pencil. $5\frac{1}{2} \times 7\frac{1}{2}$ (140 × 190).
A track leading from the foreground right into the middle distance centre; a stream at a lower level running from the foreground right into the middle distance centre.
PROVENANCE: By descent.

A study from nature. The treatment of the trees and the modelling of the undulating ground are closely related to the landscape with figures owned by Derek Melville (Cat. No.183).

187 Wooded Landscape with Figure, Stream and Church Tower Plate 60
Henry E. Huntington Library and Art Gallery, San Marino (65.16A)

Pencil. $5\frac{7}{8} \times 7\frac{3}{8}$ (149 × 187).
A figure in the middle distance centre, on a path which winds into the foreground right; a stream running from the foreground left into the middle distance centre, where there is a bridge; a church tower half-hidden by trees in the distance left.
PROVENANCE: Anon. sale, Sotheby's, 28 July 1965, Lot 100 bt. Spink, from whom it was purchased 1965.
EXHIBITED: Huntington 1967–8 (2 and repr. f.p.5).

The pencilwork and rhythmical treatment of the foliage are closely related to the Bulkeley Smith drawing (Cat. No.158). The short curving strokes used to build up form are very characteristic of Gainsborough's technique in the mid-1750's, and analogous to his touch in the tightly painted wigs of the portraits of this period (compare especially Waterhouse 118a, repr. pl.43).

188 Wooded Landscape with Figures and Buildings
Private Collection, London

Pencil. $6\frac{1}{8} \times 7\frac{9}{16}$ (156×192).
Two figures descending a slope in the foreground right; a gate in the foreground left; the roof of a house half-hidden by trees in the middle distance left; a church tower half-hidden by trees in the distance right.
PROVENANCE: Anon. sale, Sotheby's, 28 July 1965, Lot 99 bt. Duits.

The pencilwork and treatment of the foliage is identical with the landscape with church tower in the Huntington Art Gallery (Cat. No.187) and the landscape with a plough owned by Douglas Everett (Cat. No.201).

189 Country Churchyard with Two Donkeys Plate 59
D. L. T. Oppé, London (1429)

Pencil. $6\frac{3}{16} \times 7\frac{3}{4}$ (157×197).
Two donkeys, one with its head over the other's back, standing in the foreground left beside two graves in the foreground centre; a partly-ruined church behind in the middle distance centre and right; hills in the distance left.
Stamped *TG* in monogram in gold bottom left.
PROVENANCE: T. H. Parker; Anon. (=Parker) sale, Puttick and Simpson, 20 January 1922, Lot 11 (with ten other miscellaneous drawings) bt. A. Paul Oppé.
BIBLIOGRAPHY: Woodall 247.

The hatching, the long curving strokes in the foliage and the treatment of the foreground plants are all identical with the landscape with church tower in the Huntington Art Gallery (Cat. No.187). The motif of the two donkeys, one with its head over the other's back, was used again by Gainsborough in the early 1760's (see Cat. No.271). The theme of the country churchyard was also taken up later, in 1780, when he produced a soft-ground etching of this subject in which the church is again ruined and a donkey appears in the foreground (Plate 300). Also mentioned on p.25.

190 Wooded Landscape with Herdsman and Cattle
Ownership unknown

Pencil (apparently). Size unknown.
A herdsman with three cows on the crest of a hill

in the middle distance right; a pool in the foreground left (from the print).
ENGRAVED: W. F. Wells, published 1 January 1802 (as in the collection of George Hibbert).
PROVENANCE: From one of the sketch-books purchased by George Hibbert at the Gainsborough sale, Christie's, 11 May 1799, Lot 82, 84 or 88; by descent to the Hon. A. H. Holland-Hibbert; Holland-Hibbert sale, Christie's, 30 June 1913.

The treatment of the foliage seems to be closely related to the landscape with distant church tower in the Huntington Art Gallery (Cat. No.187).

191 Wooded Landscape with Herdsman and Cattle
Ownership unknown

Pencil (apparently). Size unknown. Upright.
A herdsman driving two cows over the crest of a hill in the foreground centre; a tree stump in the foreground right (from the print).
ENGRAVED: W. F. Wells, published by Wells and Laporte, 1 December 1802 (as in the collection of George Hibbert).
PROVENANCE: From one of the sketch-books purchased by George Hibbert at the Gainsborough sale, Christie's, 11 May 1799, Lot 82, 84 or 88; by descent to the Hon. A. H. Holland-Hibbert; Holland-Hibbert sale, Christie's, 30 June 1913.

The treatment of the foliage seems to be closely related to the landscape with distant church tower in the Huntington Art Gallery (Cat. No.187).

192 Wooded Landscape with Figures
Ownership unknown

Pencil. (apparently). Size unknown. Upright.
A man with a stick and a small boy walking in the foreground centre; low hills in the distance centre and right (from the print).
ENGRAVED: W. F. Wells, published by Wells and Laporte, 1 December 1803 (as in the collection of George Hibbert).
PROVENANCE: From one of the sketch-books purchased by George Hibbert at the Gainsborough sale, Christie's, 11 May 1799, Lot 82, 84 or 88; by descent to the Hon. A. H. Holland-Hibbert; Holland-Hibbert sale, Christie's, 30 June 1913.

The treatment seems to be closely related to the wooded landscape with distant church tower in the Huntington Art Gallery (Cat. No.187).

193 Open Landscape with Herdsman driving Cattle over a Bridge
Ownership unknown

Pencil (apparently). Size unknown.
A herdsman driving four cows over a stone bridge in the foreground centre; two figures in the middle distance centre walking along a track which winds from the bridge into the middle distance right; a farm and two outbuildings in the foreground right; a river running across the foreground; the roofs of three cottages visible in the distance left and centre; low hills in the distance centre (from the print).
ENGRAVED: W. F. Wells, published by Wells and Laporte, 1 September 1803 (as in the collection of George Hibbert).
PROVENANCE: From one of the sketch-books purchased by George Hibbert at the Gainsborough sale, Christie's, 11 May 1799, Lot 82, 84 or 88; by descent to the Hon. A. H. Holland-Hibbert; Holland-Hibbert sale, Christie's, 30 June 1913, Lot 27 (with another) bt. Agnew.

The treatment of the foliage seems to be closely related to the landscape with distant church tower in the Huntington Art Gallery (Cat. No.187).

194 Wooded Landscape with Cottages and Figures
Ownership unknown

Pencil (apparently). Size unknown.
Two figures travelling along a road in the middle distance left; two cottages in the middle distance centre; a fence on a bank in the foreground right; low hills in the distance (from the print).
ENGRAVED: W. F. Wells, published 1 January 1802 (as in the collection of George Hibbert).
PROVENANCE: From one of the sketch-books purchased by George Hibbert at the Gainsborough sale, 11 May 1799, Lot 82, 84 or 88; by descent to the Hon. A. H. Holland-Hibbert; Holland-Hibbert sale, Christie's, 30 June 1913, Lot 7 bt. Agnew.

The treatment of the foliage seems to be related to the landscape with distant church tower in the Huntington Art Gallery (Cat. No.187).

195 Wooded Landscape with Figure
Ownership unknown

Pencil (apparently). Size unknown.
A figure in the foreground centre; rising ground in the foreground left; a path winding from the foreground into the middle distance right (from the print).

ENGRAVED: W. F. Wells, published 1 January 1802 (as in the collection of George Hibbert); republished in a *Drawing Book, being Studies of Landscape*, published by E. and C. M'Lean, London, 1823, No.4; L. Francia, 1810.
PROVENANCE: From one of the sketch-books purchased by George Hibbert at the Gainsborough sale, Christie's, 11 May 1799, Lot 82, 84 or 88; by descent to the Hon. A. H. Holland-Hibbert; Holland-Hibbert sale, Christie's, 30 June 1913.

The treatment of the foliage seems to be related to the landscape with distant church tower in the Huntington Art Gallery (Cat. No.187).

196 Study of Trees
British Museum, London (O.o.2 – 22)

Pencil. $5\frac{9}{16} \times 7\frac{1}{4}$ (141 × 184).
Bushy trees at the edge of a wood.
PROVENANCE: From the sketch-book purchased by Richard Payne Knight at the Gainsborough sale, Christie's, 11 May 1799, Lot 85; bequeathed 1824.
BIBLIOGRAPHY: Binyon 31 (5b); Woodall 125.

A study from nature. The treatment of the foliage is identical with the trees on the far bank in the landscape with church tower in the Huntington Art Gallery (Cat. No.187).

197 Study of Foliage
British Museum, London (O.o.2 – 12)

Pencil. $5\frac{13}{16} \times 7\frac{5}{8}$ (148 × 194).
Foliage centre.
PROVENANCE: From the sketch-book purchased by Richard Payne Knight at the Gainsborough sale, Christie's, 11 May 1799, Lot 85; bequeathed 1824.
BIBLIOGRAPHY: Binyon 31 (5a); Woodall 124 and p.38.

A study from nature. The soft rhythmical treatment of the foliage, with elongated strokes and scallops, is related to the study of trees also in the British Museum (Cat. No.196), but rather less mannered.

198 Study probably of an Ash Tree
Plate 63
British Museum, London (O.o.2 – 11)

Pencil. $7\frac{1}{2} \times 5\frac{7}{8}$ (190 × 149).
Inscribed bottom left: *Ash*.
A tree, probably an ash, but perhaps an alder.
PROVENANCE: From the sketch-book purchased by Richard Payne Knight at the Gainsborough sale,

Christie's, 11 May 1799, Lot 85; bequeathed 1824.
BIBLIOGRAPHY: Binyon 31 (20b); Woodall 153.

A study from nature. The pencilwork is similar to the study of trees also in the British Museum (Cat. No.196). Also mentioned on p.27.

199 Study of a Tree Trunk and Foliage
Plate 62
British Museum, London (O.o.2 – 53)

Pencil. $6\frac{3}{16} \times 5\frac{3}{4}$ (157 × 146).
A tree trunk.
PROVENANCE: From the sketch-book purchased by Richard Payne Knight at the Gainsborough sale, Christie's, 11 May 1799, Lot 85; bequeathed 1824.
BIBLIOGRAPHY: Binyon 26a; Woodall 108.

A study from nature. The highly rhythmical treatment of the foliage and the pervasive diagonal hatching are closely related to the landscape with a church tower in the Huntington Art Gallery (Cat. No.187). Gainsborough later used trees of this kind as the principal compositional stresses in portraits such as the General Johnston in Dublin (Waterhouse 403, repr. pl.96), painted in the mid–1760's, and Viscount Kilmorey in the Tate Gallery (Waterhouse 411, repr. pl.116), painted about 1768.

200 Study of Trees Plate 426
The Hon. Douglas Everett, Ottawa

Pencil. $6 \times 7\frac{1}{2}$ (152 × 190).
Trees in a wood, with a path running from the foreground centre into the middle distance left.
PROVENANCE: From one of the sketch-books purchased by George Hibbert at the Gainsborough sale, Christie's, 11 May 1799, Lot 82, 84 or 88; by descent to the Hon. A. H. Holland-Hibbert; Holland-Hibbert sale, Christie's, 30 June 1913; Caroll Carstairs; by descent to Mrs M. Schwartz; Anon. (=Schwartz) sale, Christie's, 19 March 1968, Lot 45 bt. Everett.

A study from nature. The pencilwork is identical with the landscape with church tower in the Huntington Art Gallery (Cat. No.187). The conception of the trees in sunlight in the centre is similar to the study in the British Museum (Cat. No.196), though rather sketchier in treatment. Also mentioned on p.85.

201 Wooded Landscape with Church Tower and Farmhouse Plate 61
The Hon. Douglas Everett, Ottawa

Pencil. $6 \times 7\frac{3}{4}$ (152 × 197).
A figure seated in front of a farmhouse with some sheep and a church tower half-hidden by trees in the middle distance centre; a wheel plough in the foreground right.
ENGRAVED: W. F. Wells, published 1 January 1802 (as in the collection of George Hibbert).
PROVENANCE: From one of the sketch-books purchased by George Hibbert at the Gainsborough sale, Christie's, 11 May 1799, Lot 82, 84 or 88; by descent to the Hon. A. H. Holland-Hibbert; Holland-Hibbert sale, Christie's, 30 June 1913; Caroll Carstairs; by descent to Mrs M. Schwartz; Anon. (=Schwartz) sale, Christie's, 19 March 1968, Lot 43 bt. Everett.

The church tower seems a little high in relation to the ground, and the plough on the right is very generalized, as may be seen by comparing it with those in the drawings owned by Christopher Norris (Cat. No.178) and Bulkeley Smith (Cat. No.158). The pencilwork is identical with the drawing owned by Christopher Norris, and the rhythmical treatment of the foliage is close to the drawing owned by Bulkeley Smith, though rather sketchier; the treatment of the foliage is also close to, but more mannered than, such studies from nature as that in the British Museum (Cat. No.204). Also mentioned on pp.10 and 32.

202 Study of a Tree
H. C. Torbock, Crossrigg Hall

Pencil. $7\frac{3}{16} \times 5\frac{11}{16}$ (198 × 144).
A tree placed centrally; no background.
PROVENANCE: With John Manning, from whom it was purchased 1957.
EXHIBITED: *Eighth Exhibition of Watercolours and Drawings*, John Manning, November 1957 (23).

The treatment of the foliage is closely related to the landscape with a plough owned by Douglas Everett (Cat. No.201).

203 Wooded Landscape with Plough Team
Ownership unknown

Black chalk and stump and brown and white chalks on buff paper (apparently). Size unknown.
A ploughman ploughing with two horses on rising ground in the foreground left; a horse beside a gate

in the foreground right; a pool in the foreground centre; a cottage half-hidden by trees in the middle distance right; a hill in the distance right (from the print).
ENGRAVED: J. Laporte, published by Wells and Laporte, 1 November 1802 (as in the collection of Dr Thomas Monro); L. Francia, 1810.
PROVENANCE: Dr Thomas Monro; Monro sale, Christie's, 26 June 1833 ff.

The treatment of the foliage seems to be related to the landscape with a plough owned by Douglas Everett (Cat. No.201). The motif of the plough-team in a field above a bank is similar to the landscape with plough-team in the Morgan Library (Cat. No.150).

204 Study of Fields
British Museum, London (O.0.2 – 20)

Pencil. $6\frac{3}{16} \times 7\frac{1}{2}$ (157 × 190).
Fields in undulating country.
PROVENANCE: From the sketch-book purchased by Richard Payne Knight at the Gainsborough sale, Christie's, 11 May 1799, Lot 85; bequeathed 1824.
BIBLIOGRAPHY: Binyon 31 (21b).

A study from nature. The broad scallops of the foliage are closely related to the study of a mossy bank also in the British Museum (Cat. No.139) and the landscape with a plough owned by Douglas Everett (Cat. No.201).

205 Study of a Woodland Path Plate 64
British Museum, London (O.0.2 – 48)

Pencil. $5\frac{13}{16} \times 7\frac{1}{2}$ (148 × 190).
A path winding between trees from the foreground left into the middle distance centre.
PROVENANCE: From the sketch-book purchased by Richard Payne Knight at the Gainsborough sale, Christie's, 11 May 1799, Lot 85; bequeathed 1824.
BIBLIOGRAPHY: Binyon 31 (6a); Woodall 126.

A study from nature. The diagonal hatching and sketchy treatment of the foliage are identical with the study also in the British Museum (Cat. No.207).

206 Study of a Gate with Flooded Path and Fields
D. L. T. Oppé, London (1875)

Pencil. $6\frac{5}{16} \times 7\frac{11}{16}$ (160 × 195).
A gate in the foreground centre; a flooded path leading towards the gate in the foreground centre, with flooded fields beyond; a hill in the middle distance centre.
PROVENANCE: From one of the sketch-books purchased by George Hibbert at the Gainsborough sale, Christie's, 11 May 1799, Lot 82, 84 or 88; by descent to the Hon. A. H. Holland-Hibbert; Holland-Hibbert sale, Christie's, 30 June 1913; H. W. Underdown.
BIBLIOGRAPHY: Woodall 251.

A study from nature. The very sketchy pencil-work is closely related to passages in the study of a woodland path in the British Museum (Cat. No.205).

207 Study of Trees
British Museum, London (O.0.2 – 29)

Pencil. $5\frac{7}{8} \times 7\frac{1}{8}$ (149 × 181).
A sweet chestnut in the foreground left; a figure on a track in the foreground centre.
PROVENANCE: From the sketch-book purchased by Richard Payne Knight at the Gainsborough sale, Christie's, 11 May 1799, Lot 85; bequeathed 1824.
BIBLIOGRAPHY: Binyon 24a; Woodall 104.

A study from nature. The broad hatching and sketchy treatment of the foliage are closely related to the study of a woodland path also in the British Museum (Cat. No.205).

208 Study of a Milkmaid and Cows
British Museum, London (O.0.2 – 17)

Pencil. $5\frac{13}{16} \times 7\frac{11}{16}$ (148 × 195) (trimmed at the upper corners).
A milkmaid seated milking a cow, with another cow behind her; a third cow lying down in the middle distance left.
PROVENANCE: From the sketch-book purchased by Richard Payne Knight at the Gainsborough sale, Christie's, 11 May 1799, Lot 85; bequeathed 1824.
BIBLIOGRAPHY: Binyon 31 (22a); Woodall 156.

A study from nature. The broad hatching is closely related to the study of a woodland path also in the British Museum (Cat. No.205).

209 Study of Trees Plate 65
British Museum, London (O.0.2 – 8)

Pencil. $6 \times 7\frac{1}{4}$ (152 × 194).
An oak or elm on the left.
PROVENANCE: From the sketch-book purchased by Richard Payne Knight at the Gainsborough sale, Christie's, 11 May 1799, Lot 85; bequeathed 1824.
BIBLIOGRAPHY: Binyon 31 (16b); Woodall 145.

A study from nature. The treatment of the branches top left, the loose scallops of the foliage and the diagonal hatching are similar to the study of trees owned by Charles Monteith (Cat. No.168). The diagonal hatching and sketchy delineation of the foliage are also close to the study of a woodland path in the British Museum (Cat. No.205). Also mentioned on p.27.

210 Study of a Hillside Path
Mrs I. A. Williams, London

Pencil. 5⅝ × 7½ (143 × 190).
A path winding up a hillside from the foreground left into the middle distance centre; trees lining the hill in the middle distance.
PROVENANCE: From one of the sketch-books purchased by George Hibbert at the Gainsborough sale, Christie's, 11 May 1799, Lot 82, 84 or 88; by descent to the Hon. A. H. Holland-Hibbert; Holland-Hibbert sale, Christie's, 30 June 1913, Lot 47 (with another) bt. Mrs Cropper; purchased by Iolo A. Williams in Kendal 1931.
BIBLIOGRAPHY: Woodall 352.

A study from nature. The broad diagonal hatching of the foliage is close in technique to certain studies in the British Museum (Cat. Nos.207 and 209).

211 Wooded Landscape with Church
British Museum, London (O.0.2 – 62)

Pencil. 5⅞ × 7 11/16 (149 × 195).
A church amongst trees on a hillside in the middle distance left; a path winding from the foreground left into the middle distance left.
PROVENANCE: From the sketch-book purchased by Richard Payne Knight at the Gainsborough sale, Christie's, 11 May 1799, Lot 85; bequeathed 1824.
BIBLIOGRAPHY: Binyon 31 (4b); Woodall 123, pp.21, 53 and 65, and repr. pl.55.

A rough sketch, in which the pencilwork is closely related to the study of a woodland path also in the British Museum (Cat. No.205).

212 Study of Farm Buildings near a Pond
Plate 319
British Museum, London (O.0.2 – 52)

Pencil. 5 13/16 × 7⅝ (148 × 194).
Farmyard with a plough against a wall in the middle distance left; a pond in the middle distance centre; part of a gate in the foreground right.
PROVENANCE: From the sketch-book purchased by

Richard Payne Knight at the Gainsborough sale, Christie's, 11 May 1799, Lot 85; bequeathed 1824.
BIBLIOGRAPHY: Binyon 31 (12a); Woodall 136.

Probably a study from nature, and used as the framework for the landscape with farm buildings, figures and cows in the Mellon collection (not recorded in Waterhouse) (Plate 321), painted about 1754–6. The pencilwork is similar to the landscape with a church also in the British Museum (Cat. No.211). Also mentioned on pp. 28 and 39.

213 Study of a Cottage and Horseman
Plate 251
British Museum, London (O.0.2 – 60: recto)

Pencil. 5 13/16 × 7½ (148 × 190).
A cottage and outbuilding in the middle distance centre; a figure on horseback in the middle distance right; a track leading from the foreground centre into the middle distance right.
Verso: study of logs (Cat. No.214).
PROVENANCE: From the sketch-book purchased by Richard Payne Knight at the Gainsborough sale, Christie's, 11 May 1799, Lot 85; bequeathed 1824.
BIBLIOGRAPHY: Binyon 31 (12b); Woodall 137.

A rough sketch from nature. The pencilwork, which is close in character to Teniers, is closely related to the sketch of a landscape with a church also in the British Museum (Cat. No.211). Also mentioned on p.57.

214 Study of Logs
British Museum, London (O.0.2 – 60: verso)

Pencil. 5 13/16 × 7½ (148 × 190).
Two logs, with trees behind on the left.
Recto: study of a cottage, with a man on horseback (Cat. No.213).
PROVENANCE: From the sketch-book purchased by Richard Payne Knight at the Gainsborough sale, Christie's, 11 May 1799, Lot 85; bequeathed 1824.
BIBLIOGRAPHY: Binyon 31 (12b); Woodall 137.

A rough sketch from nature, in which the handling is similar to the drawing of a cottage on the recto (Cat. No.213).

215 Study of a Woodland Pool Plate 414
British Museum, London (O.0.2 – 55)

Pencil. 5¾ × 7 11/16 (146 × 195).
A leaning tree in the centre; a figure in the foreground left; a pond in the foreground right.
PROVENANCE: From the sketch-book purchased by

Richard Payne Knight at the Gainsborough sale, Christie's, 11 May 1799, Lot 85; bequeathed 1824.
BIBLIOGRAPHY: Binyon 31(3b); Woodall 121.

A study from nature. The soft broad hatching is closely related to other studies in the British Museum (Cat. Nos.213 and 220). Also mentioned on p.82.

216 Wooded Landscape with Church
Plate 67
British Museum, London (O.o.2 – 54)

Pencil. $5\frac{13}{16} \times 7\frac{5}{8}$ (148×194).
A church amongst trees in the middle distance left; a path leading through a gate from the foreground right into the middle distance right.
PROVENANCE: From the sketch-book purchased by Richard Payne Knight at the Gainsborough sale, Christie's, 11 May 1799, Lot 85; bequeathed 1824.
BIBLIOGRAPHY: Binyon 31 (18b); Woodall 149, pp.21, 53 and 65 and repr. pl.56.

A rough sketch, in which the pencilwork is similar to the landscape with a church also in the British Museum (Cat. No.211).

217 Study of Cottages in Undulating Country
Borough Council, Sudbury

Pencil. $6\frac{1}{8} \times 7\frac{1}{16}$ (156×179).
A country track in the foreground centre leading downhill past two cottages in the foreground right; hills in the distance.
PROVENANCE: John Rimmer, who presented it.

A study from nature. The modelling of the unfinished bank on the left in loose squiggles is similar to the wooded landscape with a church in the British Museum (Cat. No.216), and the broad hatching in the hills to the treatment of the sky in the landscape with a ruined castle owned by Mr and Mrs Eric Sexton (Cat. No.227).

218 Study of Cows watering Plate 66
British Museum, London (O.o.2 – 59)

Pencil. $5\frac{7}{8} \times 6\frac{13}{16}$ (149×173).
Two cows watering at a pool in the foreground right, accompanied by a herdsman centre.
PROVENANCE: From the sketch-book purchased by Richard Payne Knight at the Gainsborough sale, Christie's, 11 May 1799, Lot 85; bequeathed 1824.
BIBLIOGRAPHY: Binyon 31 (19a); Woodall 150.

Probably a study from nature. The pencilwork is closely related to the landscape with a church also in the British Museum (Cat. No.211). Also mentioned on p.27.

219 Wooded Landscape with Track
British Museum, London (O.o.2 – 41)

Pencil. $5\frac{13}{16} \times 7\frac{11}{16}$ (148×195).
A track winding from the foreground left into the distance left.
PROVENANCE: From the sketch-book purchased by Richard Payne Knight at the Gainsborough sale, Christie's, 11 May 1799, Lot 85; bequeathed 1824.
BIBLIOGRAPHY: Binyon 31 (9b); Woodall 131.

A rough sketch, in which the pencilwork and treatment of the foliage are identical with the study of cows watering also in the British Museum (Cat. No.218).

220 Wooded Landscape with Trees on a Hillside
British Museum, London (O.o.2 – 42)

Pencil. $5\frac{3}{4} \times 7\frac{5}{8}$ (146×194).
A track winding from the foreground right into the middle distance left; another winding from the foreground centre up a hillside into the middle distance centre.
PROVENANCE: From the sketch-book purchased by Richard Payne Knight at the Gainsborough sale, Christie's, 11 May 1799, Lot 85; bequeathed 1824.
BIBLIOGRAPHY: Binyon 31 (9a); Woodall 130.

A rough sketch, in which the pencilwork and treatment of the foliage are identical with the study of cows watering also in the British Museum (Cat. No.218).

221 Study of a Cottage near a Pond
British Museum, London (O.o.2 – 44)

Pencil. $5\frac{3}{4} \times 5\frac{1}{8}$ (146×130).
A cottage amongst trees in the middle distance right; a bank in the middle distance centre, and a pond stretching across the foreground.
PROVENANCE: From the sketch-book purchased by Richard Payne Knight at the Gainsborough sale, Christie's, 11 May 1799, Lot 85; bequeathed 1824.
BIBLIOGRAPHY: Binyon 31 (18a); Woodall 148.

A study from nature. The pencilwork and treatment of the foliage are identical with the wooded landscape also in the British Museum (Cat. No.220).

222 Study of Trees on a Bank
Borough Council, Sudbury

Pencil. 6⅛ × 7⅜ (156 × 187).
A country track in the foreground centre winding to the left round a bank in the middle distance centre and right.
PROVENANCE: John Rimmer, who presented it.

A study from nature. The elongated scallops outlining the foliage, the shading, and the heavy pencilwork on the right are closely related to the study of a cottage in the British Museum (Cat. No.221).

223 Wooded Landscape with Buildings
D. L. T. Oppé, London (2514)

Pencil. 6⁵⁄₁₆ × 7¾ (160 × 197).
A cottage in the foreground left; a group of buildings half-hidden by trees on a hillside in the middle distance left and centre; a track winding from the foreground left into the middle distance right.
PROVENANCE: From one of the sketch-books purchased by George Hibbert at the Gainsborough sale, Christie's, 11 May 1799, Lot 82, 84 or 88; by descent to the Hon. A. H. Holland-Hibbert; Holland-Hibbert sale, Christie's, 30 June 1913; E. Horsman Coles; bequeathed to A. Paul Oppé 1954.

The rapid pencilwork is closely related to the study of a cottage in the British Museum (Cat. No.221).

224 Study of a Footbridge across a Stream
British Museum, London (O.o.2 – 50)

Pencil. 5¹³⁄₁₆ × 7⁹⁄₁₆ (148 × 192).
A stream running from the foreground right into the middle distance left; a footbridge with a figure approaching it in the foreground centre.
PROVENANCE: From the sketch-book purchased by Richard Payne Knight at the Gainsborough sale, Christie's, 11 May 1799, Lot 85; bequeathed 1824.
BIBLIOGRAPHY: Binyon 31 (3a); Woodall 120.

Probably a study from nature. The pencilwork is closely related to the study of cows watering also in the British Museum (Cat. No.218).

225 Study of Trees on a Slope
British Museum, London (O.o.2 – 63)

Pencil. 5¹³⁄₁₆ × 6⅝ (148 × 168).
Trees on sloping ground.

PROVENANCE: From the sketch-book purchased by Richard Payne Knight at the Gainsborough sale, Christie's, 11 May 1799, Lot 85; bequeathed 1824.
BIBLIOGRAPHY: Binyon 31 (4a); Woodall 122.

Probably a study from nature. The pencilwork is similar to the study of cows watering also in the British Museum (Cat. No.218).

226 Wooded Landscape with Tree Stump, Figure and Plough
British Museum, London (O.o.2 – 56)

Pencil. 5¹¹⁄₁₆ × 7¾ (144 × 197).
A withered tree in the foreground centre, with a figure seated beside it on the left and a wheel plough beside it on the right; an animal on a bank near a tree in the middle distance left.
PROVENANCE: From the sketch-book purchased by Richard Payne Knight at the Gainsborough sale, Christie's, 11 May 1799, Lot 85; bequeathed 1824.
BIBLIOGRAPHY: Binyon 31 (17b); Woodall 147.

A rough sketch, in which the scratchy pencilwork and elongated scallops of the foliage are identical with the study of trees on a slope also in the British Museum (Cat. No.225). The motif of a wheel plough beside a withered tree was used by Gainsborough in a more finished drawing in the woodland scene owned by George F. Benson (Cat. No.151).

227 Wooded Landscape with Herdsman, Cows and Ruined Castle Plate 68
Mr and Mrs Eric H. L. Sexton, Camden, Maine

Pencil. 10³⁄₁₆ × 14⅛ (259 × 359).
A herdsman seated on a bank against a brick wall, and accompanied by a dog, in the middle distance centre; two cows on a bank in the middle distance left; part of a ruined castle half-hidden by trees in the middle distance right; a pool in the foreground centre and right; low hills in the distance left.
PROVENANCE: Guy Bellingham Smith; with Colnaghi, from whom it was purchased 1937.
BIBLIOGRAPHY: Woodall 289.

The pencilwork throughout is closely related to the landscape with peasants and donkey dated 1759 in the Witt Collection (Cat. No.238). It is also similar in size to this drawing, and may have formed part of a series intended for engraving. Also mentioned on pp.34, 73 and 75.

228 Wooded Landscape with Milkmaid, Cottage and Cows
Ownership unknown

Pencil. Size unknown.
A milkmaid with a yoke and two pails walking down a winding path in the foreground right; a cow beyond a gate in the foreground left; two cows reclining on a hillside in the middle distance left; a figure disappearing over the hill and a cottage half-hidden by trees in the middle distance right; a stream running from the foreground left into the middle distance centre (from a photograph).
PROVENANCE: With Arnold, Dresden, in 1912.

The treatment of the foliage, the cows and the foreground detail, and the pencilwork in the sky are closely related to the landscape with a ruined castle owned by Mr and Mrs Eric Sexton (Cat. No.227), while the treatment of the foliage and the gnarled tree trunk on the right are also close to the landscape with peasants and donkeys dated 1759 in the Witt Collection (Cat. No.238). The complex rococo composition is one of the most sophisticated Gainsborough produced in the Suffolk period, and anticipates the mountain landscape owned by Desmond Morris (Cat. No.243), which is also dated 1759 but must belong to the beginning of the Bath period.

229 Wooded Landscape with Figures and Ruined Building
Ownership unknown

Pencil (apparently). Size unknown.
A figure reclining on a bank in the foreground right; three figures beside some trees in the middle distance centre; a large half-ruined building in the distance left; a pool in the foreground right (from the print).
ENGRAVED: J. Laporte, published by Laporte and Wells, 2 May 1803 (as in the collection of Dr Thomas Monro).
PROVENANCE: Dr Thomas Monro; Monro sale, Christie's, 26 June 1833 ff.

The treatment seems to be related to the landscape with a ruined castle owned by Mr and Mrs Eric Sexton (Cat. No.227).

230 Wooded Landscape with Lake
Ownership unknown

Pencil (apparently). Size unknown.
A high bank in the foreground left; a lake stretching from the foreground centre to the foreground right (from the print).

ENGRAVED: W. F. Wells, published by Wells and Laporte 1 December 1802 (as in the collection of George Hibbert).
PROVENANCE: From one of the sketch-books purchased by George Hibbert at the Gainsborough sale, Christie's, 11 May 1799, Lot 82, 84 or 88; by descent to the Hon. A. H. Holland-Hibbert; Holland-Hibbert sale, Christie's, 30 June 1913.

The treatment throughout seems to be closely related to the landscape with a ruined castle owned by Mr and Mrs Eric Sexton (Cat. No.227) or the study of trees in the British Museum (Cat. No.239).

231 Coastal Scene with Figures, Shipping and Cottage
Victoria and Albert Museum, London (Dyce 687)

Pencil. $6\frac{1}{16} \times 8\frac{13}{16}$ (154×224).
A shepherd with a crook seated by a monument in the foreground centre, a goat close by; a cottage under a high cliff in the foreground left; two figures in a rowing boat by the shore in the foreground right; a sailing boat at sea in the middle distance centre; more sailing boats and a promontory in the distance right.
ENGRAVED: J. Laporte, published by Laporte and Wells 1 March 1803 (as in the collection of Dr Thomas Monro).
PROVENANCE: Dr Thomas Monro; Monro sale, Christie's, 26 June 1833 ff.; Rev. Alexander Dyce, who bequeathed it to the South Kensington Museum 1869.
BIBLIOGRAPHY: *Dyce Collection Catalogue*, London, 1874, p.100; Woodall 199.

Though rather looser in character, the hatching and treatment of the foreground are related to the landscape with a ruined castle owned by Mr and Mrs Eric Sexton (Cat. No.227). Gainsborough painted several estuary scenes in the late 1750's (e.g. Waterhouse 843, repr. pl.38) and there is a sketchier drawing of a similar subject in the British Museum (Cat. No.242). The monument on the shore has not been identified.

232 Coastal Scene with Boats and Figures
Ownership unknown

Pencil (apparently). Size unknown.
A sailing boat with two figures aboard, one of them seated, on the shore in the foreground right; two figures on a bank in the foreground centre; two figures in a rowing boat in the middle distance left; a sailing boat in the middle distance right; several

sailing boats outside a harbour in the distance left; four more sailing boats beyond a headland in the distance centre (from the print).
ENGRAVED: J. Laporte, published by Laporte and Wells 1 July 1802 (as in the collection of Dr Thomas Monro).
PROVENANCE: Dr Thomas Monro; Monro sale, Christie's, 26 June 1833 ff.

The treatment throughout seems to be closely related to the coastal scene in the Victoria and Albert Museum (Cat. No.231).

233 Wooded Landscape with Herdsman and Cow Plate 70
Sir John and Lady Witt, London

Pencil. $11 \times 15\frac{1}{8}$ (279×383).
A herdsman, with a dog and a cow, resting on a hillock in the middle distance right; a stile in the middle distance left; a country track winding from the foreground right into the distance right, where hills and a tower are visible.
Collector's mark of Sir John Witt on the back of the mount bottom left.
PROVENANCE: Sir J. C. Robinson; Robinson sale, Christie's, 21 April 1902, Lot 125 bt. Leggatt.
EXHIBITED: Arts Council 1960–1 (10); Nottingham 1962 (37 repr.); *The John Witt Collection (Part II: English School)*, Courtauld Institute Galleries, April–June 1963 (23).
BIBLIOGRAPHY: Woodall 355.

One of the most effective of Gainsborough's more highly-wrought late Ipswich compositions. The strongly rhythmical handling of the foliage, the treatment of the foreground and distance, and the cross hatching in the sky are all closely related to the landscape with peasants and donkey dated 1759 in the Witt Collection (Cat. No.238). It is also similar in size to this drawing and may have formed part of a series intended for engraving. The treatment of the foliage and the sky and the technique generally are also identical with the large framed pencil drawing which hangs on the wall behind the sitter in Gainsborough's portrait of Uvedale Tomkyns Price (Waterhouse 556, repr. pl.60) painted about 1760. This drawing may well have been a prized original in Price's collection. It is interesting also to notice how Gainsborough framed his elaborate drawings of this description. Also mentioned on pp.32 and 101.

234 Wooded Landscape with Cows
Ownership unknown

Pencil (apparently). Size unknown.
Two cows passing over the crest of a hill in the foreground centre; low hills in the distance right (from the print).
ENGRAVED: W. F. Wells, published by Wells and Laporte 1 January 1803 (as in the collection of George Hibbert).
PROVENANCE: From one of the sketch-books purchased by George Hibbert at the Gainsborough sale, Christie's, 11 May 1799, Lot 82, 84 or 88; by descent to the Hon. A. H. Holland-Hibbert; Holland-Hibbert sale, Christie's, 30 June 1913.

The treatment of the foliage seems to be related to the wooded landscape with a cow on a bank in Sir John Witt's collection (Cat. No.233).

235 Wooded Landscape
Ownership unknown

Pencil (apparently). Size unknown.
A track winding through trees from the foreground right into the distance right (from the print).
ENGRAVED: W. F. Wells, published by Wells and Laporte 1 November 1804 (as in the collection of George Hibbert).
PROVENANCE: From one of the sketch-books purchased by George Hibbert at the Gainsborough sale, Christie's, 11 May 1799, Lot 82, 84 or 88; thence by descent to the Hon. A. H. Holland-Hibbert; Holland-Hibbert sale, Christie's, 30 June 1913.

The treatment throughout seems to be closely related to the landscape with a cow on a bank owned by Sir John Witt (Cat. No.233).

236 Wooded Landscape with Rustic Lovers, Horseman and Plough-team
Plate 69
Private Collection, England

Pencil, black chalk and stump and white chalk on buff paper. $13\frac{1}{2} \times 18\frac{3}{4}$ (343×476).
A horseman descending a slope in the foreground centre; two rustic figures resting beside a tree in the foreground right; a ploughman with a pair of oxen drawing the plough in the foreground left; a pool in the foreground right; a mountain in the distance left.
PROVENANCE: Probably given by the artist to his physician, Dr Abel Moysey; thence by descent.
EXHIBITED: Arts Council 1960–1 (11, p.7 and repr. pl.II).
BIBLIOGRAPHY: John Hayes, 'The Drawings of

George Frost', *Master Drawings*, Vol.4, No.2, 1966, p.168.

Although more summary in treatment, the rhythmical handling of the foliage, the treatment of the foreground detail, the cross-hatching in the sky, and the conception in clearly distinct planes are related to the landscape with peasants and donkey dated 1759 in the Witt Collection (Cat. No.238). The generalized treatment and such characteristics as the cross-hatching in the bank and clear delineation of the clouds indicate that the drawing was intended for engraving; it is also by far the largest of Gainsborough's Suffolk drawings. The plough-team and withered tree stump acting as a fulcrum for the composition are characteristic features of Gainsborough's work in the Ipswich period (see Cat. Nos.150 and 158). Also mentioned on p.34.

237 Wooded Landscape with Figure and Donkey
Ownership unknown

Watercolour (apparently). Size unknown.
A man and donkey in the foreground left travelling past a sandy bank; hills in the distance right (from the print).
ENGRAVED: W. F. Wells, published by Wells and Laporte 1 September 1803 (as in the collection of George Hibbert).
PROVENANCE: George Hibbert; by descent to the Hon. A. H. Holland-Hibbert; Holland-Hibbert sale, Christie's, 30 June 1913.

The treatment seems to be related to the landscape with horseman and plough-team originally owned by Dr Moysey (Cat. No.236).

238 Wooded Landscape with Peasants, Donkey and Cottage Plate 74
Courtauld Institute of Art, Witt Collection, London (1.61)

Pencil. $11\frac{1}{16} \times 15\frac{1}{4}$ (281 × 387).
Two peasants reclining beneath a high bank in the foreground centre, a donkey close by; a cottage with a smoking chimney half-hidden by trees in the middle distance left; hills and a tower in the distance centre.
Inscribed beneath in pencil bottom left: *Gainsborough fec: 1759* and bottom right: *1*.
PROVENANCE: Sir J. C. Robinson; probably Robinson sale, Christie's, 21 April 1902, Lot 116 bt. Parsons; with John Mitchell; John S. Newberry, who presented it 1961.

EXHIBITED: *Old Master Drawings*, Newark Museum, March–May 1960 (56); *Newly Acquired Drawings for the Witt Collection*, Courtauld Institute Galleries, October 1965–March 1966 (53).

The clarity of detail as well as the inscription and numbering beneath indicates that this drawing was intended for engraving. Also mentioned on pp.34, 38, 42 and 75.

239 Study of Trees Plate 72
British Museum, London (O.o.2 – 24)

Pencil. $6\frac{1}{8} \times 7\frac{3}{4}$ (156 × 197).
Trees.
PROVENANCE: From the sketch-book purchased by Richard Payne Knight at the Gainsborough sale, Christie's, 11 May 1799, Lot 85; bequeathed 1824.
BIBLIOGRAPHY: Binyon 31 (14b); Woodall 141; John Hayes, 'The Drawings of Gainsborough Dupont', *Master Drawings*, Vol.3, No.3, 1965, pp.250 and 256 and repr. pl.3.

A study from nature. The zig-zag touch in the left foreground, the crisp delineation of the branches and the strongly rhythmical treatment of the foliage are all identical with the landscape with a figure on a donkey owned by Donald Towner (Cat. No.240).

240 Wooded Landscape with Donkey and Figures Plate 73
Donald Towner, London

Pencil. $6\frac{5}{16} \times 8\frac{1}{8}$ (160 × 206).
A figure on a donkey and another figure holding a stick in the foreground centre, travelling along a track which winds past a bank into the foreground right; a seated figure in the middle distance left; a church tower in the distance left, with a hill behind.
PROVENANCE: Presented by the artist to Joshua Kirby; thence by descent to F. E. Trimmer; Trimmer sale, Sotheby's, 22 December 1883, Lot 357 (with four others) bt. Edward Bell; thence by descent to Mildred Glanville, who gave it to the present owner 1963.

Although much sketchier in treatment, the crisp delineation of the branches, the handling of the foreground, the strongly rhythmical and elongated scallops of the foliage, and the cross-hatching in the sky are all closely related to the landscape with peasants and donkey dated 1759 in the Witt Collection (Cat. No.238). This personal type of classical composition anticipates work of the early Bath period. Also mentioned on p.48.

241 Wooded Landscape with Buildings on a Hillside
British Museum, London (O.o.2 – 23)

Pencil. $6 \times 7\frac{11}{16}$ (152 × 195).
A figure and donkey in the foreground left; a cottage in a valley in the middle distance left, from which a track winds up a hillside towards a group of buildings in the distance left.
PROVENANCE: From the sketch-book purchased by Richard Payne Knight at the Gainsborough sale, Christie's, 11 May 1799, Lot 85; bequeathed 1824.
BIBLIOGRAPHY: Binyon 31 (14a); Woodall 140.

A sketch in which the crisp treatment of the branches and the broad scallops in parts of the foliage are related to the study of trees also in the British Museum (Cat. No.239).

242 Wooded Landscape with Ships on an Estuary
British Museum, London (O.o.2 – 64)

Pencil. $5\frac{13}{16} \times 7\frac{1}{2}$ (148 × 190).
An estuary with shipping in the middle ground left; a figure resting on the bank and a figure on horseback in the foreground centre.
PROVENANCE: From the sketch-book purchased by Richard Payne Knight at the Gainsborough sale, Christie's, 11 May 1799, Lot 85; bequeathed 1824.
BIBLIOGRAPHY: Binyon 31 (19b); Woodall 151.

A sketch in which the pencilwork is related to the wooded scene with buildings on a hillside also in the British Museum (Cat. No.241).

243 Wooded Mountain Landscape with Herdsman and Cows crossing a Bridge over a Stream Plate 77
Desmond Morris, Attard, Malta

Pen and ink and watercolour. $16\frac{5}{8} \times 18\frac{5}{8}$ (421 × 473).
A herdsman accompanied by a dog driving two cows over a stream in the foreground left; a shepherd with six or seven sheep on a high bank in the middle distance centre; a church tower and some houses half-hidden by trees in the distance left; a stream running from the foreground left into the middle distance left; high mountains in the distance left and centre.
Inscribed underneath: *Thomas Gainsborough inv. et delineavit 1759*.
PROVENANCE: Purchased in a sale at Marlborough, Wiltshire about 1947–8.
BIBLIOGRAPHY: Waterhouse, p.18.

An unusually grand composition in which Gainsborough has fused his developing rococo style with the classical tradition of Claude and the Dutch Italianates. The drawing is dated 1759, and the nature of the countryside depicted suggests that it was executed after his move to Bath. The inscription beneath indicates that it was intended for engraving. Also mentioned on pp.34, 38, 42, 49 and 60.

244 Mountain Landscape with a Town on a Hill Plate 75
British Museum, London (O.o.2 – 26)

Pencil. $5\frac{7}{8} \times 7\frac{3}{16}$ (149 × 183).
A waggon travelling up a road on the side of a hill in the foreground centre; a town on a hill in the middle distance left; a mountain in the distance centre.
PROVENANCE: From the sketch-book purchased by Richard Payne Knight at the Gainsborough sale, Christie's, 11 May 1799, Lot 85; bequeathed 1824.
BIBLIOGRAPHY: Binyon 31 (10a); Woodall 132.

The composition is related in character to the distant part of the mountain landscape owned by Desmond Morris (Cat. No.243), and the drawing may have been a preparatory sketch either for this or a similar work. The treatment of the foliage is similar to the sketch also in the British Museum (Cat. No.239).

245 Study of a Quarry Plate 76
British Museum, London (O.o.2 – 46)

Pencil. $6\frac{1}{16} \times 7\frac{13}{16}$ (154 × 198).
A quarry in the middle distance centre; a track left winding from the foreground centre into the middle distance; a figure on a bank in the foreground right.
PROVENANCE: From the sketch-book purchased by Richard Payne Knight at the Gainsborough sale, Christie's, 11 May 1799, Lot 85; bequeathed 1824.
BIBLIOGRAPHY: Binyon 31 (10b); Woodall 133.

A study from nature. The loose scallops of the foliage and the pencilwork generally are identical with the sketch also in the British Museum (Cat. No.244).

246 Study of Trees
Ownership unknown

Pencil. $7\frac{1}{4} \times 5\frac{7}{8}$ (184 × 149).
Five trees clumped together on the slope of a bank in the foreground centre.
PROVENANCE: With Squire Gallery, from whom it was purchased by Norman Baker; later sold by him.

EXHIBITED: *A Selection of Pictures from Private Collections*, Moot Hall, Colchester, July 1951 (41).

Executed in the late 1750's.

247 Wooded Landscape with Buildings
A. C. Greg, Acton Bridge

Pencil. $5\frac{7}{8} \times 7\frac{7}{16}$ (149 × 189).
Some buildings half-hidden by trees on rising ground in the middle distance left; a gate in the foreground left.
PROVENANCE: With Squire Gallery, from whom it was purchased.

Executed in the late 1750's.

Early to Mid 1760's

248 Beech Trees in the Woods at Foxley, with Yazor Church in the Distance
Plate 80
Whitworth Art Gallery, Manchester (D.1.1896) (318)

Brown chalk, watercolour and bodycolour over pencil. $11\frac{5}{16} \times 15\frac{3}{16}$ (287 × 389).
Two beech trees on a mound in the foreground centre; part of a fence in the foreground right; a track winding from the foreground left into the middle distance left; a church tower among trees in the distance left, with hills beyond.
The composition is surrounded by a ruled line in pencil.
Signed and dated *Tho: Gainsborough/del 1760* on a fragment of paper now pasted on the back of the frame.
An old label pasted on the back of the frame is inscribed: *A study from nature, by/Gainsborough when on a visit/to Foxley – the seat of the late/Sir Robt. Price Bart – /From the coll* . . . This is elaborated in another label on the back of the frame written in a nineteenth century hand: *From Lord Bateman's Collection of Pictures/at Shobdon Court./A water colour Landscape by Thomas Gainsborough R.A./while on a visit at Foxley,/A study from nature of some famous beech/trees in the woods at Foxley,/with a view of Yazor Church in the distance/ signed, "Thomas Gainsborough 1760."/Originally in the collection of the late Sir Robert/Price, Bart., M.P. of Foxley, Herefordshire.*
PROVENANCE: Sir Robert Price, of Foxley (probably a gift from the artist); John, 2nd Viscount Bateman; Bateman sale, Christie's, 11 April 1896, Lot 20 bt. Agnew; with Walker's Galleries; A. E. Anderson, who presented it 1931.
EXHIBITED: *Two Hundred Years of British Painting*, Public Library and Art Gallery, Huddersfield,

May–July 1946 (125); Aldeburgh 1949 (12); Bath 1951 (54); Arts Council 1960–1 (13, and p.6); Nottingham 1962 (38).
BIBLIOGRAPHY: *Manchester Whitworth Institute Catalogue of Water-Colour Drawings*, Manchester, 1905, p.19, No.126; Woodall 485, pp.58–9 and repr. pl.68; Mary Woodall, 'Gainsborough Landscapes at Nottingham University', *The Burlington Magazine*, December 1962, p.562; John Hayes, 'The Gainsborough Drawings from Barton Grange', *The Connoisseur*, February 1966, p.91.

A highly-wrought watercolour probably based on sketches (done at Foxley, if the inscriptions are to be relied upon) rather than actually executed on the spot. Sir Robert Price, who owned Foxley, and his son Uvedale, were friends of Gainsborough's in the 1760's. The rhythmical treatment of the foliage and the church among trees in the middle distance are characteristic of such Gainsborough landscapes of the early 1760's as the picture in Lord Crawford's collection (Waterhouse 910, repr. pl.80). This drawing was originally rejected by Mary Woodall (485), but is now accepted by her. Also mentioned on pp.30, 38, 42, 44 and 89.

249 Study of Trees Plate 82
City Museum and Art Gallery, Birmingham (192'53)

Watercolour and bodycolour over pencil. $7\frac{5}{8} \times 9\frac{3}{4}$ (194 × 248).
Trees left and right, with a sunlit glade between.
PROVENANCE: Victor Rienaecker; J. Leslie Wright, who bequeathed it 1953.
EXHIBITED: Ipswich 1927 (131); Oxford 1935 (50); Aldeburgh 1949 (38); *Masters of British Water-Colour: The J. Leslie Wright Collection*, R.A., October–November 1949 (68); Arts Council 1960–1 (15); *English Drawings and Water Colors from British Collections*, National Gallery of Art and the Metropolitan Museum of Art, February–June 1962 (42); *De Engelse Aquarel uit de 18de Eeuw van Cozens tot Turner*, Rijksmuseum, April–May 1965 and Albertina, June–July 1965 (50 and repr. p.98); *Peintures et Aquerelles Anglaises 1700–1900 du Musée de Birmingham*, Musée des Beaux Arts, Lyons 1966 (51, and p.7); *Dvě století britského malířství od Hogartha k Turnerovi*, National Gallery, Prague and Bratislava 1969 (62).
BIBLIOGRAPHY: H. M. Cundall, 'The Victor Rienaecker Collection', *The Studio*, September 1922, p.119; Woodall 388.

Possibly a study from nature. The treatment of the foreground and the light handling of the foliage are identical with the rocky landscape

also at Birmingham (Cat. No.255), and closely related to the landscape with a peasant asleep in a cart in the Ashmolean Museum (Cat. No.266).

250 Study of Trees
Ehemals Staatliche Museen, Berlin-Dahlem
(4703: recto)

Black and white chalks and grey wash on grey-green paper. $6\frac{1}{8} \times 8\frac{1}{4}$ (156 × 210).
A track flanked by trees running from the foreground centre into the middle distance right.
Verso: sketch of a house (Cat. No.251).
PROVENANCE: From one of the sketch-books purchased by George Hibbert at the Gainsborough sale, Christie's, 11 May 1799, Lot 82, 84 or 88; by descent to the Hon. A. H. Holland-Hibbert; Holland-Hibbert sale, Christie's, 30 June 1913, Lot 48 (with another) bt. Hofer; presented by an unknown donor 1913.
ENGRAVED: W. F. Wells, published 1 March 1803 (as in the collection of George Hibbert).
BIBLIOGRAPHY: Woodall 415.

A study from nature. The treatment of the foliage is closely related to the study of trees in Birmingham (Cat. No.249), though the provenance from the Hibbert sketch-book would suggest a much later dating.

251 Study of a House
Ehemals Staatliche Museen, Berlin-Dahlem
(4703: verso)

Black chalk on grey-green paper. $6\frac{1}{8} \times 8\frac{1}{4}$ (156 × 210).
A house on the right; no background.
Inscribed in ink centre left: *N.º 12*.
Recto: a track flanked by trees (Cat. No.250).
PROVENANCE: From one of the sketch-books purchased by George Hibbert at the Gainsborough sale, Christie's, 11 May 1799, Lot 82, 84 or 88; by descent to the Hon. A. H. Holland-Hibbert; Holland-Hibbert sale, Christie's, 30 June 1913, Lot 48 (with another) bt. Hofer; presented by an unknown donor 1913.
BIBLIOGRAPHY: Woodall 415.

A study from nature, but scarcely more than started.

252 Study of an Oak Branch
Ehemals Staatliche Museen, Berlin-Dahlem
(4704)

Black and white chalks and grey wash on grey-green paper. $8 \times 6\frac{1}{8}$ (203 × 156).

An oak branch filling the whole sheet; no background.
PROVENANCE: From one of the sketch-books purchased by George Hibbert at the Gainsborough sale, Christie's, 11 May 1799, Lot 82, 84 or 88; by descent to the Hon. A. H. Holland-Hibbert; Holland-Hibbert sale, Christie's, 30 June 1913, Lot 48 (with another) bt. Hofer; presented by an unknown donor 1913.
BIBLIOGRAPHY: Woodall 416.

A study from nature. The treatment of the foliage is identical with the study of trees also in Berlin (Cat. No.250). The tightness of the drawing is against the much later dating suggested by the provenance from the Hibbert sketch-book.

253 Study of a Tree
British Museum, London (1899–5–16–10: verso)

Black chalk and watercolour. $9\frac{5}{16} \times 12\frac{1}{2}$ (237 × 317).
A tree in the middle distance right, with suggestions of a hilly background washed in behind.
Recto: waggon and figures in a woodland glade (Cat. No.282).
PROVENANCE: W. T. Green, from whom it was purchased 1899.
BIBLIOGRAPHY: Gower *Drawings*, p.14 and repr. pl.XLI; Woodall 162.

A study from nature. The treatment of the foliage, with its very tight scallops, is related to passages in the study of trees in Birmingham (Cat. No.249).

254 Wooded Landscape with Figures and Cottages
British Museum, London (1885–5–9–1640)

Watercolour over pencil. $7\frac{15}{16} \times 9\frac{3}{4}$ (186 × 248).
A man leaning on a staff conversing with a girl seated on a bundle of faggots at the edge of a wood in the foreground right; two cottages in the middle distance left.
PROVENANCE: Edward Cheney; Cheney sale, Sotheby's, 29 April 1885 ff., 2nd Day, Lot 324 bt. Colnaghi on behalf of the British Museum.
BIBLIOGRAPHY: Armstrong 1894, repr. p.25; Armstrong 1906, repr. f.p.50; Gower *Drawings*, p.14 and repr. pl.XXXIX; Woodall 96.

The fairly tight treatment of the foliage is closely related to the study of a tree also in the British Museum (Cat. No.253), and to certain passages in the landscape with a horseman in the Fogg Museum (Cat. No.259). Both the

technique and the pale tone are close to Taverner.

255 Rocky Wooded Landscape
City Museum and Art Gallery, Birmingham
(204′53)

Watercolour over pencil. $7\frac{9}{16} \times 9\frac{11}{16}$ (192 × 246).
A track winding from the foreground centre into the distance left; rocks in the foreground and middle distance right.
PROVENANCE: Sir George Donaldson; Henry Schniewind, Jr.; Schniewind sale, Sotheby's, 25 May 1938, Lot 147 (inaccurately described as a landscape with a church in coloured chalks) bt. Colnaghi, from whom it was purchased by J. Leslie Wright; bequeathed 1953.
EXHIBITED: Cincinnati 1931 (62 and repr. pl.54); *Masters of British Water-Colour: The J. Leslie Wright Collection*, R.A., October–November 1949 (82); *Panorama of European Painting Rembrandt to Picasso*, Opening Exhibition, Rhodes National Gallery, Salisbury, Rhodesia, July–September 1957 (230); *De Engelse Aquarel uit de 18de Eeuw van Cozens tot Turner*, Rijksmuseum, April–May 1965 and Albertina, June–July 1965 (49).
BIBLIOGRAPHY: E. S. Siple, 'Gainsborough Drawings: The Schniewind Collection', *The Connoisseur*, June 1934, p.355 and repr. p.357; Woodall 383.

The treatment of the foliage and the foreground detail are identical with the study of trees also in Birmingham (Cat. No.249).

256 Wooded Landscape with Peasant on Horseback and Horse drinking Plate 81
Ownership unknown

Black and white chalks and grey wash on grey paper. $11\frac{1}{2} \times 14\frac{1}{2}$ (292 × 368).
A peasant seated side-saddle, and a horse drinking, in the middle distance left; a pool stretching from the foreground right into the middle distance centre; a track leading from the foreground centre into the middle distance left (from a photograph).
Stamped *TG* in monogram bottom left.
ENGRAVED: W. F. Wells, published by Wells and Laporte 1 January 1805 (as in the collection of Baroness Lucas).
PROVENANCE: Philip, 2nd Earl of Hardwicke; by descent to Amabel, Baroness Lucas; Lady Lucas sale, Sotheby's, 29 June 1926, Lot 31 bt. Colnaghi; Martin sale, Parke-Bernet, 18–19 October 1946, Lot 306 (repr.).
BIBLIOGRAPHY: Woodall 35.

The detailed treatment of the track and the foreground grasses and reeds, the handling of the

tree trunks and passages in the foliage, the firm delineation of the horses and the carefully controlled space are all closely related to the rocky landscape in Birmingham (Cat. No.255) and the landscape with horseman in the Fogg Museum (Cat. No.259). Also mentioned on p.93.

257 Wooded Landscape with Figures and Cattle in a Stream Plate 384
The Executors of the late Lord Wharton, London

Black chalk and stump and white chalk on buff paper. $10\frac{11}{16} \times 15$ (271 × 381).
A herdsman talking to a seated female figure in the foreground left; three cows in a stream in the middle distance centre; a church tower in the distance centre; a stream winding from the foreground right into the middle distance right; a track winding from the middle distance centre behind trees into the distance left.
PROVENANCE: With Colnaghi; from whom it was purchased by Lord Wharton about 1939–40.

The treatment of the tree trunks and foliage and the carefully controlled space are closely related to the wooded landscape with horseman and packhorses formerly in the Lucas collection (Cat. No.256). The composition anticipates the river scene in the Philadelphia Museum of Art (Waterhouse 945, repr. pl.122), painted about 1768–71. Also mentioned on p.75.

258 Wooded Landscape with Herdsman, Cows and Goats
Raymond Smith, Caracas

Black chalk and stump and white chalk. Size unknown.
A herdsman on horseback driving seven cows and two goats through a dell in the foreground centre and right; a pool in the foreground left; high rocks in the foreground right (from a photograph).
PROVENANCE: McPeake; Anon. (=McPeake) sale, Puttick and Simpson, 3 June 1943, Lot 56 bt. Yakaloff; with Agnew, from whom it was purchased by Francis F. Madan 1944; returned to Agnew, from whom it was purchased by Roger Makins (now Lord Sherfield) 1944; with Agnew, from whom it was purchased.
EXHIBITED: *71st Annual Exhibition of Water-Colour Drawings*, Agnew's, February–March, 1944 (71).

The treatment of the foliage and foreground detail, the hatching in the sky and the outlining of the clouds, are closely related to the landscape with cows formerly in the Wharton collec-

tion (Cat. No.257). The theme and composition anticipate the wooded landscape with herdsman and cattle owned by Lord Faringdon (Waterhouse 926), executed about 1771–2. A copy in oils by Barker, which varies only in the inclusion of a herdsman and dog and the omission of the birds, was in an Anon. sale, Christie's, 17 April 1964, Lot 43.

259 Wooded Landscape with Horseman
Plate 83
Fogg Museum of Art, Cambridge, Mass.
(1943.472)

Watercolour and bodycolour over pencil and black chalk. $9\frac{15}{16} \times 13\frac{3}{4}$ (252 × 349).
A horseman travelling along a winding track in the middle distance centre; pools in the foreground left and right.
Stamped *TG* in monogram in gold bottom left.
PROVENANCE: With Scott and Fowles; Grenville L. Winthrop, who bequeathed it 1943.

The treatment of the foliage and the foreground detail is closely related to the study of trees at Birmingham (Cat. No.249). The free use of lead white is characteristic of Gainsborough's work of the early 1760's, but it is applied in a more schematic way than, for example, the landscape with a distant mountain in the Ashmolean Museum (Cat. No.265). Also mentioned on p.22.

260 Wooded Landscape with Figure, Horse and Cart
Metropolitan Museum of Art, New York
(17.120.235)

Watercolour and bodycolour over black chalk. $9\frac{1}{2} \times 12\frac{5}{8}$ (241 × 321).
A peasant preparing to harness a horse to a cart in the clearing of a wood in the middle distance centre; a log in the foreground left; a pool in the foreground right.
Stamped *TG* in monogram in gold bottom left.
PROVENANCE: Given by the artist probably to Goodenough Earle, of Barton Grange, Somerset; thence by descent to Francis Wheat Newton; sold to Agnew's 1913, who immediately resold it to Knoedler's, from whom it was purchased by Isaac D. Fletcher 1914; bequeathed 1917.
EXHIBITED: Knoedler's 1914 (19).
BIBLIOGRAPHY: Fulcher, 2nd edn., p.241; Woodall 467 and p.57; John Hayes, 'The Gainsborough Drawings from Barton Grange', *The Connoisseur*, p.91 and repr. fig.10.

The treatment of the foliage and the use of lead white are closely related to the landscape with a horseman in the Fogg Museum (Cat. No.259). There is a pentimento of a figure and horse to the left of and beneath the present figure.

261 Wooded Landscape with Horseman
With Marshall Spink, London

Black chalk and stump and white chalk, with some bodycolour, on dark brown paper. $18\frac{5}{8} \times 22\frac{1}{4}$ (473 × 565).
A horseman travelling down a slope in the foreground centre; a church tower in the distance centre with a hill behind.
PROVENANCE: Anon. sale, Sotheby's, 9 December 1964, Lot 40 bt. Leger.

The composition has elements in common, notably the dominating withered tree trunk on the right, the mountainous distance and the very strong effect, with such pictures as the landscape with carthorses drinking in the Tate Gallery (Waterhouse 897, repr. pl.65), painted in the early 1760's. The unusual character of the drawing, its strength and boldness, and its exceptionally large size all suggest that it was intended as a model for engraving; and the generalized treatment of the foliage and handling of the foreground detail down to such features as the cross-hatching in the bank are related to the landscape with horseman and plough-team drawn in the late 1750's (Cat. No.236), which was also intended for engraving. A copy of almost the same size, in which the horseman is lacking his stick, was formerly in the C. R. Rudolf collection; and a smaller copy is in the National Gallery of Victoria, Melbourne (2329/4).

262 Hilly Wooded Landscape with Weir
R. E. D. Rawlins, Ballakilpheric, Isle of Man

Pencil. $2\frac{3}{16} \times 3$ (56 × 76).
A weir and hill in the middle distance centre.
Drawn on part of a letter dated Bath 28 July 1763: addressee unknown.
PROVENANCE: Unknown.
BIBLIOGRAPHY: Woodall *Letters*, p.173 and repr. p.26 (left).

Rough sketch for a landscape composition. The rapid, broken contours have affinities with the wooded landscape with horseman with Marshall Spink (Cat. No.261), though the latter drawing

is of course on a very much larger scale. Also mentioned on p.38.

263 Hilly Wooded Landscape with Weir
R. E. D. Rawlins, Ballakilpheric, Isle of Man

Pencil. $2\frac{3}{16} \times 2\frac{15}{16}$ (56×59).
A weir in the middle distance centre, with a mountain in the distance beyond; a hill in the middle distance left.
Drawn on part of a letter dated Bath 28 July 1763: addressee unknown.
PROVENANCE: Unknown.
BIBLIOGRAPHY: Woodall *Letters* p.173 and repr. pl.26 (right).

Rough sketch for a landscape composition, alternative to the idea sketched on the same letter (Cat. No.262). The broad hatching has affinities with the wooded landscape with horseman with Marshall Spink (Cat. No.261). Also mentioned on p.38.

264 Wooded Landscape with Horseman and Bridge Plate 84
Mr and Mrs James Fosburgh, New York

Watercolour and bodycolour. $10\frac{13}{16} \times 14\frac{7}{8}$ (275×378).
A horseman, peasant and dog, travelling along a country track in the foreground left; a stone bridge over a stream in the foreground right; a mountain in the distance right.
PROVENANCE: Dr Rice Charlton; with Durlacher, from whom it was purchased.
EXHIBITED: *Old Master Drawings*, Durlacher, New York, December 1950; *Paintings, Drawings and Sculpture collected by Yale Alumni*, Yale University Art Gallery, May–June 1960 (172 repr.).
BIBLIOGRAPHY: *Art News*, December 1950, p.48 (repr.).

A highly rhythmical composition in which the treatment of the foliage is closely related to the watercolour of beech trees at Foxley (Cat. No.248). The dramatic use of lead white to enhance the sense of movement and to highlight forms derives from the practice of Marco Ricci or Busiri; and the broken lights in the sky can be paralleled in Gainsborough's painting of the early 1760's, notably the background of the group portrait of the Byam Family at Marlborough College (Waterhouse 108, repr. pl.82), painted about 1764. Also mentioned on pp.49 and 89.

265 Wooded Landscape with Figures and Distant Mountain Plate 263
Ashmolean Museum, Oxford

Watercolour and bodycolour, with traces of pencil, on brown paper. $11 \times 14\frac{3}{4}$ (279×375).
A figure with a child and dog walking along a winding track centre; a house in the middle distance centre, with a mountain beyond.
PROVENANCE: Mrs W. F. R. Weldon, who presented it 1934.
EXHIBITED: Nottingham 1962 (40).
BIBLIOGRAPHY: Woodall 491; Mary Woodall, 'Gainsborough Landscapes at Nottingham University', *The Burlington Magazine*, December 1962, p.562 and repr. fig.46; John Hayes, 'Gainsborough and the Gaspardesque', *The Burlington Magazine*, May 1970, p.308.

Study for the landscape in the possession of W. J. Mullens (not recorded in Waterhouse: exhibited Nottingham 1962 (15)), painted in the early 1760's. In the finished picture, there are two donkeys in the foreground, a log and fence on the right, only one figure on the track, a bridge in the middle distance and a church tower at the foot of the mountain. The treatment of the foliage and the foreground detail, and the lively use of bodycolour, influenced by Marco Ricci or Busiri, are closely related to the landscape with a boy asleep in a cart also in the Ashmolean Museum (Cat. No.266). Also mentioned on pp.40, 42, 49, 59 and 60.

266 Wooded Landscape with a Peasant asleep in a Cart Plate 86
Ashmolean Museum, Oxford

Watercolour and bodycolour, with traces of pencil, on brown paper. $11\frac{1}{16} \times 14\frac{15}{16}$ (281×380).
A cart drawn by two horses, with a sleeping peasant in the back, travelling along a track which winds from the foreground centre into the middle distance left; high rocks in the middle distance centre; part of a fence in the foreground right, with a log in front.
PROVENANCE: Mrs W. F. R. Weldon, who presented it 1934.
EXHIBITED: Nottingham 1962 (41).
BIBLIOGRAPHY: Woodall 490.

The rhythmical treatment of the foliage, the dramatic use of lead white, and the handling of the foreground detail, are identical with the landscape with a horseman approaching a bridge owned by Mr and Mrs Fosburgh (Cat. No.264). This drawing was originally rejected by Mary Woodall (490), but is now accepted by

her. Another version was in the possession of the late Lord Wharton (Cat. No.267).

267 Wooded Landscape with a Peasant asleep in a Cart
The Executors of the late Lord Wharton, London

Watercolour and bodycolour over pencil on buff paper. $11\frac{1}{4} \times 14\frac{15}{16}$ (286 × 379).
A cart drawn by two horses, with a sleeping peasant in the back, travelling along a track which winds from the foreground centre into the middle distance left; high rocks in the middle distance centre; part of a fence in the foreground right, with a log in front.
PROVENANCE: L. F. Outram; Anon. (=Outram) sale, Christie's, 12 May 1939, Lot 39 bt. Agnew, from whom it was purchased 1940.
EXHIBITED: *Sixty-seventh Annual Exhibition of Water-Colour and Pencil Drawings*, Agnew's, February–March 1940 (123).

Version of the drawing with a peasant asleep in the back of a cart in the Ashmolean Museum (Cat. No.266). The technique is a little more generalized in places, such as the clouds, but otherwise the treatment is identical.

268 Hilly Wooded Landscape with Oxen, Cottage and Distant Mountain Plate 85
Ashmolean Museum, Oxford

Grey and brown washes over pencil. $11\frac{1}{4} \times 15$ (286 × 381).
Two oxen drawing what appears to be a cartload of hay in the middle distance left; a cottage in the middle distance centre with a pond in front centre and right; a large mound in the foreground left and centre; suggestions of a ruined tower in the middle distance right, with a mountain beyond centre.
PROVENANCE: Anon. sale, Sotheby's, 15 April 1953, Lot 18 bt. Colnaghi, from whom it was purchased 1953.
BIBLIOGRAPHY: *Ashmolean Report 1953*, p.63.

An elaborate composition sketch with a number of pentimenti, notably the ruined tower. The loose treatment of the foliage is related to the landscape with a peasant asleep in a cart also in the Ashmolean Museum (Cat. No.266). The handling of the tree trunks on the right, the log on the left, and passages in the foliage, are related to a certain type of drawing attributed to Gaspard Dughet.

269 Wooded Landscape with Figures and Pool
National Gallery of Canada, Ottawa (2887)

Grey and brown washes, gone over in places with pencil. $11\frac{3}{8} \times 14\frac{1}{2}$ (289 × 368).
A man on a donkey, accompanied by a woman holding a baby, travelling along a track which disappears behind a bank in the middle distance left; a pool in the foreground left and centre, with some sheep on a slope behind, in the middle distance centre; hills in the distance left.
PROVENANCE: With Parsons, from whom it was purchased 1922.

The motif of the figure group seen behind is related to the landscape with figures and donkey owned by Donald Towner (Cat. No.240); but the rhythmical treatment of the foliage, the handling of wash, and the use of pencil, are all related to the mountain landscape with oxen in the Ashmolean Museum (Cat. No.268). Compositionally, the strong emphasis on vertical elements links it with the slightly earlier style of the landscape with horseman in the Fogg Museum (Cat. No.259).

270 Wooded Landscape with a Clump of Trees Plate 261
Uppingham School, Uppingham

Pencil and grey and brown washes.
$10\frac{1}{16} \times 13\frac{7}{8}$ (256 × 352).
A clump of trees on a knoll in the middle distance centre and right; the roof of a house sketched in the foreground left; hills in the distance left.
PROVENANCE: A. de Pass, who presented it 1920.
BIBLIOGRAPHY: *Uppingham School Magazine*, December 1920.

The treatment of the foliage, the use of wash and the combination of media are similar to the landscapes in the Ashmolean Museum (Cat. No.268) and in Ottawa (Cat. No.269); but the highly rhythmical nature of the composition is related more to the landscape with a horseman approaching a bridge owned by Mr and Mrs James Fosburgh (Cat. No.264); and the treatment of the foreground detail and the scallops outlining the foliage are close in character to the mountain landscape dated 1759 owned by Desmond Morris (Cat. No.222). The handling of the foliage is related to a certain kind of drawing attributed to Gaspard Dughet (see pl.262). Also mentioned on p.59.

271 Wooded Landscape with Peasant and Donkeys Plate 431
Yale University Art Gallery, New Haven (54.57.2)

Pencil and grey and brown washes.
11 × 15⅛ (279 × 384).
A rustic figure travelling along a road in the foreground left; two donkeys on a bank in the foreground centre; a house half-hidden by trees in the middle distance left.
Inscribed on the verso in brown ink in a nineteenth-century hand: *A Gift from Mᵣ Gainsborough/To Mᵣ E–E–*.
PROVENANCE: Given by the artist to E.E. (perhaps Edward Edwards); with Parsons; Wilmarth S. Lewis, who presented it.
BIBLIOGRAPHY: *Parsons Catalogue* 1929 (453 repr.); *Bulletin of the Associates in Fine Arts at Yale University*, Vol.21, No.2, 1955, pp.7 and 12.

The stiffly drawn figure and precisely delineated cottage are uncharacteristic, but there is no reason to discount the attribution, as the scallops outlining the foliage, the treatment of the foreground detail and the use of wash are closely related to the landscape with a clump of trees at Uppingham (Cat. No.270). The motif of the two donkeys, one with its neck over the other's back, was used in two landscape paintings of this period, *The Woodman's Return* in the Houston Museum of Fine Arts (Waterhouse 899), and the picture in the possession of W. J. Mullens (not recorded in Waterhouse: exhibited Nottingham 1962 (15)). Also mentioned on p.88.

272 Wooded Landscape with Shepherds, Sheep and Cottages
Mrs Clifford Duits, London

Pencil, watercolour and bodycolour on pink toned paper. 8⅜ × 11 (213 × 279).
Two shepherds seated, one of them on a log, in the foreground centre; a flock of sheep in the foreground left; two cottages amidst trees in the middle distance right.
PROVENANCE: Henry Temple, 2nd Viscount Palmerston; thence by descent to Countess Mountbatten of Burma, from whom it was acquired.
EXHIBITED: *Drawings by Old Masters*, R.A., August–October 1953 (463); Arts Council 1960–1 (17, and p.6).

The treatment of the foliage and the foreground detail, the sense of light breaking through the trees, and the rhythmical silhouette are closely related to the landscape with a peasant asleep in the back of a cart in the Ashmolean Museum (Cat. No.266).

273 Wooded Landscape with Herdsman and Cattle Plate 265
Major Michael Ingram, Driffield

Pencil, watercolour and bodycolour on pinkish paper. 8⁷⁄₁₆ × 11⅛ (214 × 283).
A herdsman on horseback driving three cows down a slope in the middle distance centre; a village amidst trees in the distance centre.
PROVENANCE: With Colnaghi, from whom it was purchased by Sir Bruce Ingram; bequeathed 1962.
EXHIBITED: *Watercolour Drawings of Three Centuries from the collection of Sir Bruce and Lady Ingram*, Colnaghi's, February–March 1956 (19 repr.); Arts Council 1960–1 (16, and p.6); Nottingham 1962 (42); *English Drawings and Watercolours in memory of the late D. C. T. Baskett*, Colnaghi's, July–August 1963 (27).

The handling of the foliage and the foreground detail, the use of gouache and the broken lights in the sky, are identical with the landscape with shepherds and sheep owned by Mrs Clifford Duits (Cat. No.272). The treatment and tonality are strongly influenced by Van Dyck's landscape sketches. Also mentioned on pp.49, 59, 60 and 78.

274 Wooded Landscape with Boy and Packhorse Plate 87
Private Collection, London

Pencil, grey wash and bodycolour on pale buff paper prepared with brown. 10 × 7¹¹⁄₁₆ (254 × 195).
A boy with a stick in his right hand leading a packhorse down a track in the foreground right; a pool in the foreground left, with part of a fence behind.
PROVENANCE: With Manning Gallery, from whom it was purchased.
EXHIBITED: *Twenty-Ninth Exhibition of Watercolours and Drawings*, Manning Gallery, June 1968 (79 repr.).

The treatment of the foliage and foreground detail is closely related to the landscape with horseman owned by Mr and Mrs Fosburgh (Cat. No.264), and the use of bodycolour and pale tonality to the landscape with herdsman and cattle in Major Ingram's collection (Cat. No.273).

275 Open Landscape with Farm Boy and Horses
Viscount Hawarden, Wingham Court

Grey wash and bodycolour on brown prepared paper. 8⁷⁄₁₆ × 7¹³⁄₁₆ (214 × 198).

A farm boy leaning against a tree in the foreground left; two horses, one of them reclining, in the foreground centre and right.
Stamped *TG* in monogram in gold top right.
PROVENANCE: The Hon. Mrs M. Maude, who gave it to Alice (Emily Maude?) 1871; thence by descent.

The handling and tonality are closely related to the wooded landscape with boy and packhorse formerly with Manning Gallery (Cat. No.274).

276 Wooded Landscape with Gypsy Encampment Plate 88
Mr and Mrs Paul Mellon, Oak Spring, Virginia (62/5/22/14)

Watercolour and bodycolour over pencil on pale brown prepared paper. $11\frac{1}{4} \times 9\frac{3}{16}$ (286 × 233).
Four men, a woman and a child beside a roadside in the foreground left, all of them seated except one of the men; a woman lifting two children out of a pannier being carried by a donkey in the foreground centre, another child in a second pannier; a church tower in the distance centre.
PROVENANCE: Miss Florence Osborne; Miss Treacher; with Colnaghi, from whom it was purchased 1962.
EXHIBITED: *English Drawings and Water Colors from the collection of Mr and Mrs Paul Mellon*, National Gallery of Art, February–April 1962 (36); *Painting in England 1700–1850: Collection of Mr and Mrs Paul Mellon*, Virginia Museum of Fine Arts, Richmond, 1963 (61); *English Drawings and Watercolours from the collection of Mr and Mrs Paul Mellon*, Colnaghi's, December 1964–January 1965 (13 and repr. pl.VIII).

The handling of the foliage, the figures, the foreground detail and the distant vista, the sense of light breaking through the trees, the use of bodycolour and the tonality are identical with the landscape with herdsman and cattle in Major Ingram's collection (Cat. No.273). The treatment of the foliage and the lighting are related to Gainsborough's painting of the mid-1760's, for instance, the left background of the portrait of General Honywood in Sarasota (Waterhouse 375, repr. pl.83), exhibited S.A. 1765.

277 Wooded Landscape with Horseman, Figure leaning over Stile, and Cottage Plate 271
Toledo Museum of Art, Toledo, Ohio (53.99)

Watercolour and bodycolour over pencil. $9\frac{7}{16} \times 12\frac{1}{8}$ (240 × 308).
A horseman travelling along a country road in the foreground centre; a peasant leaning over a stile in the foreground left; a cottage half-hidden by trees in the middle distance centre.
Stamped *TG* in monogram in gold bottom left.
PROVENANCE: George Richmond; Richmond sale, Christie's, 29 April 1897, Lot 164 bt. Walter Richmond; with Colnaghi, from whom it was purchased 1953.

The treatment of the foliage, the foreground detail and the patch of sunlight is closely related to, though rather tighter than, the landscape with a waggon in a glade in the British Museum (Cat. No.282). The broad conception of this drawing, with its dense and dominating trees, has affinities with the picture of a milkmaid and drover formerly in the possession of Mrs L'Estrange Malone (Waterhouse 900, repr. pl.92), exhibited S.A. 1766. This watercolour is particularly close in character and technique to the work of Skelton. Also mentioned on p.59.

278 Wooded Landscape with Drover and Packhorses
Alexander G. Dunlop, Manly, N.S.W.

Watercolour and bodycolour over pencil. $11\frac{1}{2} \times 14$ (292 × 356).
A drover with a stick, and two packhorses drinking, in the foreground left; a stream running across the foreground; a path winding from the foreground left into the middle distance right (from a photograph).
Stamped *TG* in monogram in gold bottom left.
PROVENANCE: The Hon. Mrs Thomas Graham (apparently), who is supposed to have given it to Mrs William Archer of Gleneagles; thence by descent.

The treatment of the foliage appears to be related to the landscape with a figure at a stile in Toledo (Cat. No.277).

279 Rocky Landscape with Figures, Horses and Cottage Plate 92
Sir Edmund Bacon, Raveningham

Black and white chalks, and grey and brown washes, on buff paper. $17\frac{7}{8} \times 13\frac{3}{4}$ (454 × 349).
A rider on a donkey, accompanied by a dog, in the middle distance left; a man with two horses, one of which he is holding, talking to a woman seated in the foreground centre in front of a grassy mound; a woman seated at the top of a flight of steps outside a cottage in the middle distance right; a log in the foreground left.
Unknown collector's mark (a shell) on the verso bottom right, with *W* inscribed in ink.

Inscribed in pencil on the verso: *by Gainsborough/ bought of his daughter of J⁰ D* and *Hark of/John Tetlow of/Manchester.*
PROVENANCE: John Downman; sold by his daughter to an unknown purchaser; John Tetlow of Manchester, from whom it was acquired by a Mr Hark; Sir Hickman Bacon.
EXHIBITED: *English Watercolours from the Hickman Bacon Collection*, Arts Council, 1948–9 (70).

The loose treatment of the foliage and the way in which the clouds are outlined are very similar to the landscape with herdsman and cattle in Major Ingram's collection (Cat. No.273).

280 Wooded Landscape with Country Cart, Figures and House Plate 93
Holburne of Menstrie Museum, Bath

Black chalk and watercolour. $9\frac{1}{8} \times 12$ (232×305).
Two figures on horseback, a country cart drawn by a single horse with a figure inside, a figure and a dog, and another figure, travelling along a country road in the foreground left; a figure travelling in the opposite direction in the foreground right; a house half-hidden by trees in the middle distance left.
Inscribed bottom left in a later hand: *Gainsborough.*
PROVENANCE: Sir Thomas William Holburne, by whom it was bequeathed 1882.
BIBLIOGRAPHY: W. Chaffers, *Catalogue of the Holburne of Menstrie Art Museum*, Bath, 1887, No.1606; Woodall 11.

The treatment of the foliage is closely related to the landscape with figures and horses at Raveningham (Cat. No.279) and the landscape with a waggon in a glade in the British Museum (Cat. No.282), while the static conception is characteristic of the mid-1760's.

281 Study of Foliage Plate 91
Courtauld Institute of Art, Witt Collection, London (552)

Pencil with grey and blue washes. $5\frac{5}{8} \times 7\frac{5}{8}$ (143×194).
Foliage.
Collector's mark of Sir Robert Witt on the mount bottom left.
PROVENANCE: From one of the sketch-books purchased by George Hibbert at the Gainsborough sale, Christie's, 11 May 1799, Lot 82, 84 or 88; by descent to the Hon. A. H. Holland-Hibbert; Holland-Hibbert sale, Christie's, 30 June 1913, Lot 30 (with another) bt. Leggatt; Sir Robert Witt; bequeathed 1952.
EXHIBITED: Aldeburgh 1949 (32); Bath 1951 (56); Arts Council 1960–1 (14); Nottingham 1962 (39).
BIBLIOGRAPHY: Woodall 359; *Hand-List of the Drawings in the Witt Collection*, London, 1956, p.21.

A study from nature. The treatment of the foliage is closely related to the landscape with a waggon in a glade in the British Museum (Cat. No.282). Also mentioned on p.29.

282 Wooded Landscape with Waggon in a Glade Plate 267
British Museum, London (1899–5—16–10: recto)

Black chalk and watercolour, heightened with white. $9\frac{5}{16} \times 12\frac{1}{2}$ (237×317).
A waggon drawn by four horses accompanied by a man with a pitchfork over his left shoulder on a track at the edge of a wood in the middle distance centre; a man on horseback in the middle distance right.
Stamped *TG* in monogram in gold bottom left.
Verso: an unfinished composition with a tree in the middle distance right and suggestions of a hilly background washed in behind (Cat. No.253).
PROVENANCE: W. T. Green, from whom it was purchased 1899.
BIBLIOGRAPHY: Gower *Drawings*, p.13 and repr. pl.XXIX; Woodall 161, pp.18 and 57–8 and repr. pl.65; Millar, p.10 and repr. pl.26; Woodall 1949, pp.92–3; Iolo A. Williams, *Early English Watercolours*, London, 1952, p.71 and repr. fig.128; Martin Hardie, *Water-colour Painting in Britain 1. The Eighteenth Century*, London, 1966, p.75 and repr. pl.47.

The loose treatment of the foliage is related to the landscape with herdsman and cows in Major Ingram's collection (Cat. No.257). Also mentioned on pp.30, 49 and 59.

283 Wooded Landscape with Horseman Plate 94
Mr and Mrs Donald S. Stralem, New York

Black chalk, watercolour and bodycolour. $9 \times 11\frac{1}{4}$ (229×286).
A horseman, accompanied by another figure, travelling along a winding lane into the depths of a wood in the middle distance centre; bundles of faggots in the foreground left.
Stamped *TG* in monogram in gold bottom left.
PROVENANCE: Given by the artist probably to Goodenough Earle, of Barton Grange, Somerset; by descent to Francis Wheat Newton; sold to Agnew's 1913, who immediately resold it to Knoedler's, from whom it was purchased by C. I. Stralem 1929.
EXHIBITED: Knoedler's 1914 (22); Knoedler's 1923 (9).
BIBLIOGRAPHY: Fulcher, 2nd edn., p.241; Woodall 65, p.57 and repr. pl.66; John Hayes, 'The

Gainsborough Drawings from Barton Grange',
The Connoisseur, p.91 and repr. fig.11.

The loose treatment of the foliage and fore-
ground detail, the sharp highlighting of certain
of the trees in lead white, and the feeling for
sunlight flooding the scene, are closely related to
the landscape with a waggon in a glade in the
British Museum (Cat. No.282). The subject-
matter, a woodland track winding through trees
in full foliage with light breaking through from
behind, is related to the picture of figures re-
turning from market in Toledo (Waterhouse
906, repr. pl.98), painted about 1766–7. Also
mentioned on pp.26, 34 and 94.

Later 1760's

284 Study of a Harvest Waggon
Viscount Knutsford, Munden

Black and white chalks on grey-green paper.
$5\frac{3}{4} \times 7\frac{15}{16}$ (146 × 202).
A four-wheeled harvest waggon; no background.
PROVENANCE: From one of the sketch-books
purchased by George Hibbert at the Gainsborough
sale, Christie's, 11 May 1799, Lot 82, 84 or 88;
thence by descent.

A study from nature. The waggon is related
closely in type and in the viewpoint chosen to
that in *The Harvest Waggon* in the Barber Insti-
tute (Waterhouse 907, repr. pl.99), almost
certainly the landscape exhibited Society of
Artists 1767, and is probably a study for that
picture. A study for the figure grouping is in the
possession of Mrs Mark Hodson (Cat. No.825).
The same waggon in the same position was used
again by Gainsborough for his *Harvest Waggon*
in Toronto (Waterhouse 993, repr. pl.270),
painted in the winter of 1784–5. Also mentioned
on p.38

285 Study of a Horse and Cart
Ownership unknown

Black and white chalks on grey paper.
$5\frac{1}{2} \times 7\frac{7}{16}$ (140 × 189).
A two-wheeled cart with a horse between the shafts;
a tree and stream in the background right (from a
photograph).
PROVENANCE: From one of the sketch-books
purchased by George Hibbert at the Gainsborough
sale, Christie's, 11 May 1799, Lot 82, 84 or 88;
by descent to the Hon. A. H. Holland-Hibbert;
Holland-Hibbert sale, Christie's, 20 June 1913,

Lot 36 (with another) bt. Parsons; Sir George
Donaldson; Henry Schniewind, Jr.; Anon.
(=Schniewind) sale, Sotheby's, 25 May 1938,
Lot 148 bt. Adams.
EXHIBITED: Cincinnati 1931 (66 and repr. pl.61).

A study from nature. This drawing is close in
character to the study of a harvest waggon
owned by Lord Knutsford (Cat. No.284).

286 Wooded Upland Landscape with Figures, Cattle and Buildings Plate 102
Ehemals Staatliche Museen, Berlin-Dahlem
(4705)

Watercolour over black chalk. $9\frac{1}{2} \times 12\frac{1}{2}$ (241 × 317).
Three cows standing in the foreground left; what
appear to be two figures (partially erased) in the
foreground right; two cows and the roofs of two
cottages in the middle distance centre and right;
farm buildings on rising ground in the distance
right.
PROVENANCE: Presented by an unknown donor 1913.
BIBLIOGRAPHY: Woodall 407.

The treatment of the foliage, the foreground de-
tail and the animals, and the squiggles and
washes outlining clouds, are identical with the
landscape with a waggon in a glade in the British
Museum (Cat. No.282), but the composition is
conceived in terms of lateral movement instead
of static serenity. Also mentioned on p.60.

287 Wooded Landscape with Figure and Packhorse
Viscount Knutsford, Munden

Pen and brown ink, black and coloured chalks,
varnished. $4\frac{15}{16} \times 6\frac{9}{16}$ (125 × 167).
A figure and a packhorse in the foreground right;
hills in the distance left.
PROVENANCE: George Hibbert; thence by descent.

The treatment is closely related to the landscape
with cows in Berlin (Cat. No.286).

288 Wooded Landscape with Figures and Sheep Plate 280
C. L. Loyd, Lockinge

Brown and grey washes over traces of black chalk.
$7\frac{1}{2} \times 10\frac{1}{8}$ (190 × 257).
Two figures, one of them seated, in the foreground
right; scattered sheep in the foreground centre and
right.
PROVENANCE: Henry Oppenheimer; Oppenheimer
sale, Christie's, 14 July 1936, Lot 453 bt. Agnew,

from whom it was purchased by A. T. Loyd 1938.
EXHIBITED: *The Sixty-Fifth Annual Exhibition of
Water-Colour and Pencil Drawings*, Agnew's, February–
April 1938 (95).
BIBLIOGRAPHY: Woodall 2 and p.56; Anon. (=Leslie
Parris), *The Loyd Collection*, London, 1967, 101 (repr.).

The bushy trees, the conventions for outlining
foliage, the treatment of the figures and the
summary suggestion of the distance are identical
with the landscape with reclining figure owned
by R. M. Barrington Ward (Cat. No.298). Also
mentioned on pp.59–60.

289 Wooded Landscape with Distant Mountains
Louvre, Paris (29.903)

Brown and grey washes over an offset outline.
$7\frac{11}{16} \times 10\frac{5}{16}$ (195 × 262).
A path winding from the foreground centre past
some trees into the middle distance right; mountains
in the distance left and right.
Stamped *T. Gainsborough* bottom left (a similar stamp
erased bottom right) between a ruled line in brown
ink which surrounds the composition and a brown
wash border between two further ruled lines.
ENGRAVED: J. Laporte, published by Laporte and
Wells, 1 September 1803 (as in the collection of
Dr Thomas Monro).
PROVENANCE: Dr Thomas Monro; Monro sale,
Christie's, 26 June 1833 ff.; with Colnaghi; with
P. M. Turner; acquired from the latter's heirs 1951.
EXHIBITED: Oxford 1935 (54); *Choix de pièces des
donations et acquisitions du Cabinet des Dessins du Louvre*,
Louvre (11).
BIBLIOGRAPHY: Woodall 341, pp.18 and 55–6 and
repr. pl.61.

The treatment of the foliage with fairly tight
scallops is identical with the landscape with
figures and sheep at Lockinge (Cat. No.288).

290 Wooded Upland Landscape with Horseman and Stream
Lord Sherfield, Sherfield Court

Grey and brown washes over an offset outline.
$7\frac{9}{16} \times 10\frac{5}{16}$ (192 × 262).
A horseman travelling up a hilly track and passing
out of sight over the crest of the hill in the middle
distance right; a stream winding from the foreground
centre into the foreground left and behind a group
of six tall trees; low hills in the distance left.
The composition is surrounded by a ruled line in
brown ink.
PROVENANCE: Lady Stuart Williams; with Agnew,
from whom it was purchased 1959.

The treatment of the foliage is closely related to
the landscape with figures and sheep at Lockinge
(Cat. No.288).

291 Wooded Landscape with Shepherd and Sheep
Milton W. McGreevy, Kansas City

Brown wash over an offset outline.
$7\frac{5}{16} \times 10\frac{1}{8}$ (186 × 257).
A shepherd with a staff in his hand, accompanied by
a dog, on a knoll in the foreground centre; scattered
sheep in the middle distance centre and foreground
right; hills in the distance centre.
PROVENANCE: Lady Stuart Williams; with Agnew,
from whom it was purchased 1959.

The treatment of the foliage and the wiry tree
trunks which spring out of the ground are
closely related to the landscape with figures and
sheep at Lockinge (Cat. No.288).

292 Wooded Landscape with Figures and Cottage
Victoria and Albert Museum, London (Dyce 670)

Pen and brown ink, and grey and brown washes,
over pencil. $9\frac{7}{8} \times 12\frac{15}{16}$ (251 × 328).
Four figures, accompanied by a dog and a cat, in
conversation in a lane in the foreground right; a
cottage almost hidden behind banks in the middle
distance left; two or three stumps of tree in the
foreground left.
PROVENANCE: Rev. Alexander Dyce, who bequeathed
it to the South Kensington Museum 1869.
BIBLIOGRAPHY: *Dyce Collection Catalogue*, London,
1874, pp.21 and 99; Woodall 188.

The scallops outlining the foliage and the treat-
ment of the tree trunks are similar in character
to, but very much broader than, the drawing in
the Loyd collection (Cat. No.288), and the
group of figures in conversation anticipates
Gainsborough's village scenes of the early
1770's.

293 Wooded Landscape with Figures and High Rocks
Ownership unknown

Brown wash (apparently). Size unknown.
Two figures, one of them seated, in the foreground
centre; a pool in the foreground left; high rocks in the
middle distance left and centre; hills in the distance
right (from the print).

ENGRAVED: J. Laporte, published by Laporte and Wells 1 September 1803 (as in the collection of Dr Thomas Monro).
PROVENANCE: Dr Thomas Monro; Monro sale, Christie's, 26 June 1833 ff.

The type of composition and the bushy treatment of the foliage seem to be closely related to the landscape with figures and sheep at Lockinge (Cat. No.288).

294 Upland Landscape with Sheep
Private Collection, London

Black chalk, pen and brown ink, and grey and brown washes. 8⅞ × 10½ (225 × 267).
Scattered sheep in the foreground right beside a country road which winds from the foreground left into the middle distance centre; hills in the distance centre.
Stamped bottom left: *T. Gainsborough* between two ruled lines outside which there is a gold tooled arabesque border.
Collector's mark of William Esdaile bottom right.
Collector's mark of Gilbert Davis top right.
PROVENANCE: Dr Thomas Monro; Monro sale, Christie's, 26 June 1833 ff.; William Esdaile; Esdaile sale, Christie's, 20–1 March 1838; Gilbert Davis; with Colnaghi, from whom it was purchased.

The fairly tight scallops outlining the foliage is closely related to the wooded landscape in the Louvre (Cat. No.289), and the handling of wash to the landscape with reclining figure owned by R. M. Barrington Ward (Cat. No.298).

295 Wooded Landscape with Rocks
Ownership unknown

Black chalk and stump (apparently). Size unknown.
Rocks in the foreground centre (from the print).
ENGRAVED: J. Laporte, published by Laporte and Wells, 1 March 1803 (as in the collection of Dr Thomas Monro).
PROVENANCE: Dr Thomas Monro; Monro sale, Christie's, 26 June 1833 ff.

The treatment of the foliage seems to be closely related to the wooded landscape in the Louvre (Cat. No.289).

296 Wooded Landscape with Figures, Donkeys and Cottage
Mr and Mrs Paul Mellon, Oak Spring, Virginia (66/9/13/19)

Pen and brown ink with grey wash.
7¼ × 9⅝ (184 × 244).
Two figures on donkeys and another figure, accompanied by a dog, outside a cottage among trees in the middle distance centre.
PROVENANCE: Herbert Horne, from whom it was purchased by Sir Edward Marsh 1904; with Colnaghi, from whom it was purchased 1966.
EXHIBITED: *The Herbert Horne Collection of Drawings*, Burlington Fine Arts Club, 1916 (53); *English Drawings and Watercolours*, Colnaghi's, July–August 1966 (19).

The treatment of foliage and the handling of wash are closely related to the landscape with farm cart owned by Mrs Owen (Cat. No.302).

297 Rocky Wooded Landscape with Figures
Pierpont Morgan Library, New York (III, 56)

Brown and grey washes. 8¹¹⁄₁₆ × 12³⁄₁₆ (221 × 309).
Two figures, one seated, in the foreground centre; high rocks in the foreground right; hills in the distance left.
Stamped *TG* in monogram in gold bottom left.
PROVENANCE: Charles Fairfax Murray, from whom it was purchased by J. Pierpont Morgan 1910.
EXHIBITED: *The Eighteenth Century Art of France and England*, Montreal Museum of Fine Arts, April–May 1950 (49).
BIBLIOGRAPHY: *J. Pierpont Morgan Collection of Drawings by the Old Masters formed by C. Fairfax Murray*, Vol.III, London, 1912, No.56 (repr.); Woodall 461.

The treatment of the figures, the foliage and the tree trunks are identical with the landscape with figures and sheep at Lockinge (Cat. No.288).

298 Wooded Landscape with Shepherd reclining on a Rock
R. M. Barrington Ward, London

Brown wash over an offset outline.
7¾ × 10¼ (197 × 260).
A shepherd reclining, and a sheep, on a rock in the foreground right; a high rock in the foreground centre; hills in the distance right (from a photograph).
PROVENANCE: With Colnaghi, from whom it was purchased about 1946.

The use of wash, and the treatment of the foreground detail and foliage, are similar to the

landscape with a waggon in a glade in the British Museum (Cat. No.282), except that Gainsborough has evolved a tighter convention for outlining foliage under the influence of seventeenth-century drawing technique. The summary treatment of the distance is related to the background vista seen on the left of the landscape with cows in Berlin (Cat. No.286).

299 Wooded Landscape with Figures and Distant Village Plate 103
Mrs Edmund Wood, London

Pen and grey wash, on brown-toned paper, varnished. 7 × 9¾ (178 × 238).
Two figures on a country track in the middle distance right; a village in the distance right.
Pasted on the back of the frame is an old label inscribed in ink: *Presented to John Viscount Bateman, in September 1770, by Mʳ Gainsborough.*
PROVENANCE: Presented by the artist to John, 2nd Viscount Bateman; Bateman sale, Christie's, 11 April 1896, Lot 19 bt. Wass; Edmund W. H. Wood.
EXHIBITED: Arts Council 1960–1 (18, and p.7).
BIBLIOGRAPHY: Woodall 375, pp.18, 54–5, 71 and 79 and repr. pl.59; Woodall 1949, p.93; John Hayes, 'William Jackson of Exeter', *The Connoisseur*, January 1970, p.20 and repr. fig.10.

Executed before September 1770, the date when it was given to Lord Bateman. The bushy trees, the conventions for outlining foliage and the use of wash are identical with the landscape with reclining figure owned by R. M. Barrington Ward (Cat. No.298). Also mentioned on pp.38–9, 42 and 93.

300 Rocky Wooded Landscape with Figure
Alan D. Pilkington, Eton College

Pen and grey wash, varnished. 8½ × 11½ (216 × 292).
A figure descending a slope in the middle distance left; rocks in the middle distance centre; a log in the foreground left.
PROVENANCE: W. B. Paterson; Anon. (=Paterson) sale, Christie's, 9 July 1926, Lot 48 bt. in; Anon. sale, Sotheby's, 24 January 1951, Lot 116 (with 8 others) bt. Colnaghi, from whom it was purchased.

The broken scallops in the foliage and penwork generally are closely related to the rocky landscape owned by Mrs Wood (Cat. No.299). A copy omitting the figure is in the British Museum (O.0.5 – 35). Also mentioned on p.89.

301 Wooded Landscape with Covered Cart and Figure Plate 365
W. A. Brandt, Ashdon

Pen and brown ink, with grey and brown washes, on paper laid down on board, varnished.
7⅛ × 9¾ (181 × 248).
A covered cart drawn by a single horse, accompanied by a man with a bundle on the end of a stick over his right shoulder, travelling along a winding track in the foreground centre.
Inscribed in ink on paper laid down on the back of the board, apparently the original backing paper: *Jan: 23ᵈ 1769/* and lower down: *A present from Mʳ Gainsborough to/his friend Col Sᵗ Paul/much valued.*
PROVENANCE: Given by the artist to Colonel St Paul; with Gerald Norman 1965; Anon sale, Sotheby's, 23 November 1966, Lot 250 bt. Fielding and Morley-Fletcher, from whom it was purchased.
EXHIBITED: *English Water-colours of the Great Period from a Private Collection*, Ickworth, May–June 1968 (31).
BIBLIOGRAPHY: John Hayes, 'William Jackson of Exeter', *The Connoisseur*, January 1970, p.20.

Executed before January 1769, the date inscribed on the back, which is probably to be interpreted as the date when it was given to Colonel St Paul. The drawing has become badly discoloured by the penetration of the fixative and by heavy varnish, but it can still be seen to be a characteristic example of Gainsborough's pen and wash drawings of the late 1760's. The treatment of the foliage and the foreground detail is related to the landscape with shepherds and sheep at Lockinge (Cat. No.288). Also mentioned on pp.38–9 and 68.

302 Wooded Landscape with Farm Cart
Mrs Charles Owen, London

Pen with grey and brown ink, and grey and pinkish-red washes. 6⅝ × 8¹⁵⁄₁₆ (168 × 227).
A cart drawn by a single horse, with a seated figure inside, travelling along a winding track in the foreground centre; a cottage half-hidden by trees in the foreground left; a pool in the foreground right; hills in the distance centre.
ENGRAVED: J. Laporte, published by Wells and Laporte, 2 May 1803 (as in the collection of Dr Thomas Monro).
PROVENANCE: Dr Thomas Monro; Monro sale, Christie's, 26 June 1833 ff.; Anon. sale, Christie's, 19 March 1968, Lot 148 bt. Fry, from whom it was purchased 1968.

The treatment of the horse and cart is similar to the landscape with cart in the W. A. Brandt collection (Cat. No.301), while the handling of

the foliage and tree trunks and summary suggestion of the distance are closely related to the wooded landscape owned by Mrs Wood (Cat. No.299).

303 Wooded Landscape with Shepherd and Sheep Plate 276
Mr and Mrs Paul Mellon, Oak Spring, Virginia (62/11/1/26)

Pen and brown ink, with grey wash, varnished. $6\frac{15}{16} \times 9\frac{3}{16}$ (176×233).
A shepherd driving a flock of sheep along a country track in the foreground right.
Collector's mark of John Deffett Francis bottom left.
PROVENANCE: John Deffett Francis; P. O'Byrne; O'Byrne sale, Christie's, 3 April 1962, Lot 70 bt. Colnaghi, from whom it was purchased 1962.
EXHIBITED: *Painting in England 1700–1850: Collection of Mr and Mrs Paul Mellon*, Virginia Museum of Fine Arts, Richmond, 1963 (62).

The modelling of the tree trunks, the scallops outlining the foliage, and the penwork generally, are closely related to the wooded landscape owned by Mrs Wood (Cat. No.299), and influenced by seventeenth-century drawing technique. The treatment of the foliage and the foreground detail is also similar to the landscape with a country cart in the W. A. Brandt collection (Cat. No.301). Also mentioned on pp.59–60.

304 Wooded Landscape with Cows
Courtauld Institute of Art, Witt Collection, London (2867)

Pen and brown ink with brown and grey washes. $7\frac{1}{16} \times 9\frac{5}{16}$ (179×237).
Three cows, one reclining, grouped in front of a clump of trees in the foreground centre.
PROVENANCE: Edward Cheney; Cheney sale, Sotheby's, 29 April 1885 ff., 2nd Day, Lot 321; Starkey; Lord Weirdale; Mrs Frances Evans; with Colnaghi, from whom it was purchased by Sir Robert Witt 1937; bequeathed 1952.
EXHIBITED: *Some British Drawings from the Collection of Sir Robert Witt*, Arts Council, 1948 (26 and repr. pl.1); Aldeburgh 1949 (30); *Some British Drawings from the collection of Sir Robert Witt*, National Gallery of Canada, Ottawa, 1949 and American Federation of Arts 1951 (24 and repr. pl.1).
BIBLIOGRAPHY: Woodall 374, pp.18, 57–8 and 100 and repr. pl.63; *Hand-List of the Drawings in the Witt Collection*, London, 1956, p.22.

The treatment of the foliage and tree trunks is

identical with the wooded landscape with shepherd and sheep in the Mellon collection (Cat. No.303). A copy was formerly in the Rienaecker collection (Woodall repr. pl.64).

305 Open Landscape with Country Cart and Cottage
Viscount Knutsford, Munden

Pen and brown ink and watercolour over pencil, varnished. $7\frac{1}{8} \times 9\frac{5}{16}$ (181×237).
A cart drawn by a single horse, with a woman seated inside, beside some trees in the foreground centre; a thatched cottage half-hidden by trees in the foreground left.
PROVENANCE: George Hibbert; thence by descent.

The treatment is closely related to the wooded landscape with shepherd and sheep in the Mellon collection (Cat. No.303).

306 Wooded Landscape with Stream
Viscount Knutsford, Munden

Pen and brown ink, grey and brown washes, varnished. $7\frac{1}{8} \times 9\frac{5}{16}$ (181×237).
A large rock in the foreground centre; a track winding through a wood from the foreground right to the middle distance right; a stream running from the foreground left to the middle distance left; a hill in the distance left.
PROVENANCE: George Hibbert; thence by descent.

The treatment is closely related to the wooded landscape with shepherd and sheep in the Mellon collection (Cat. No.303).

307 Wooded Landscape with Boy reclining in a Cart Plates 104–5
British Museum, London (1896–5–11–2)

Pen and brown ink, with grey and brown washes. $6\frac{15}{16} \times 8\frac{11}{16}$ (176×221).
A cart drawn by two horses, with a boy reclining in the back and dangling his right leg, travelling along a track at the edge of a wood in the foreground centre; a church in the distance right.
PROVENANCE: J. E. Preston, from whom it was purchased 1896.
BIBLIOGRAPHY: Binyon 11; Gower *Drawings*, p.11 and repr. pl.11; M. T. Ritchie, *English Drawings*, London, 1935, repr. pl.23; Woodall 88, pp.18–9 and 56 and pl.62; Woodall 1949, p.92 and repr. p.88.

The treatment of the foliage and the horse and cart is similar to the landscape with a cart owned by Mrs Charles Owen (Cat. No.302),

but the more vigorous handling and the rapid squiggles outlining the track are closer in character to the landscape with a farmhouse owned by Boies Penrose (Cat. No.309). Also mentioned on pp.29–30, 50 and 60.

308 Wooded Landscape with Figures and Country Cart Plate 273
Boies Penrose, Devon, Pa.

Watercolour and bodycolour over black chalk and pencil. $9\frac{1}{4} \times 12\frac{1}{4}$ (235 × 311).
A country cart drawn by two horses and accompanied by a drover, travelling down a country lane in the foreground left; a peasant carrying a bundle of faggots over his left shoulder passing in the opposite direction in the foreground centre; a pool in the foreground right.
Stamped *TG* in monogram in gold bottom left.
PROVENANCE: Given by the artist probably to Goodenough Earle, of Barton Grange, Somerset; thence by descent to Francis Wheat Newton; sold to Agnew's 1913, who immediately resold it to Knoedler's, from whom it was purchased by Wadsworth R. Lewis, 1923; Lewis sale, Parke-Bernet, 2 April 1943, Lot 407 (repr.) bt. Penrose.
EXHIBITED: Knoedler's 1914 (8); Knoedler's 1923 (7).
BIBLIOGRAPHY: Fulcher, 2nd edn., p.241; John Hayes, 'The Gainsborough Drawings from Barton Grange', *The Connoisseur*, February 1966, p.91 and repr. fig.12.

The treatment of the foliage and foreground detail is related to, but rather looser than, the landscape with horseman owned by Donald S. Stralem (Cat. No.283). The scallops outlining the foliage are related to passages in the landscape with shepherd and sheep in the Mellon collection (Cat. No.303). Also mentioned on pp.59 and 94.

309 Wooded Landscape with Figures and Farmhouse Plate 106
Boies Penrose, Devon, Pa.

Black chalk, watercolour and bodycolour.
$9\frac{5}{8} \times 12\frac{1}{4}$ (244 × 311).
Two figures behind a pool of water in the foreground right; a farmhouse in the middle distance centre.
Stamped *TG* in monogram in gold bottom right.
PROVENANCE: Dr Thomas Monro; Monro sale, Christie's, 26 June 1833 ff.; with Parsons, from whom it was purchased in the 1930's.
EXHIBITED: *Art Treasures of the West Country*, Royal West of England Academy Galleries, Bristol, May–June 1937 (554).
BIBLIOGRAPHY: *Parsons Catalogue* No.50 (63); Woodall 264.

The treatment of the foliage and the squiggles outlining foreground detail and clouds are similar to the landscape with a cart also owned by Boies Penrose (Cat. No.308), but looser and more rapid in execution, and the handling is more closely related to the landscape with rocks in Cleveland (Cat. No.325).

310 Wooded Landscape with Figures, Cart and Cottage Plate 433
City Museum and Art Gallery, Birmingham (195'53)

Black chalk and watercolour. $9\frac{5}{8} \times 12\frac{1}{4}$ (244 × 311).
A cart with a drover standing on the shafts drawn by two horses, passing a woman carrying a load of faggots over her left shoulder, in the foreground right; a cottage half-hidden by trees in the middle distance left; a track running from the middle distance left into the foreground right.
PROVENANCE: With Walker's Galleries, from whom it was purchased by J. Leslie Wright; bequeathed 1953.
EXHIBITED: *30th Annual Exhibition of Early English Water-Colours*, Walker's Galleries, June–Autumn 1934 (39); *Early English Water-Colours from the Collections of J. Leslie Wright and Walter Turner*, Birmingham Art Gallery, April 1938 (84); Aldeburgh 1949 (33); *Masters of British Water-Colour: The J. Leslie Wright Collection*, R.A., October–November 1949 (71); *L'Aquarelle Anglaise 1750–1850*, Musée Rath, Geneva, October 1955–January 1956 and L'Ecole Polytechnique Fédérale, Berne, January–March 1956 (58); *De Engelse Aquarel uit de 18ᵈᵉ Eeuw van Cozens tot Turner*, Rijksmuseum, April–May 1965 and Albertina, June–July 1965 (44 and repr. p.96).
BIBLIOGRAPHY: Woodall 381 and p.57; Mary Woodall, 'Gainsborough's use of models', *Antiques*, October 1956, p.363 and repr. p.364.

The treatment of the foliage is identical with the wooded landscape with farmhouse owned by Boies Penrose (Cat. No.309), and the handling of the foliage, the use of wash and the sense of movement are also closely related to the landscape with cows in Berlin (Cat. No.286). The awkward figure strikes a slightly jarring note. A vigorous copy is in the Leeds City Art Gallery (13.110/53) (Plate 432). Also mentioned on p.88.

311 Study of Rocks and Plants Plate 107
Mr and Mrs Paul Mellon, Oak Spring, Virginia (62/5/26/33)

Black chalk and watercolour, heightened with white, varnished. $9 \times 11\frac{3}{16}$ (229 × 284).
A rock in a woodland pool in the foreground centre;

a branch in the foreground right; burdock leaves in the middle distance right.

PROVENANCE: David Rolt (a descendant of Dr Thomas Monro); with Colnaghi, from whom it was purchased 1962.

EXHIBITED: *Painting in England 1700–1850: Collection of Mr and Mrs Paul Mellon*, Virginia Museum of Fine Arts, Richmond, 1963 (58 repr.); *English Drawings and Watercolours from the collection of Mr and Mrs Paul Mellon*, Colnaghi's, December 1964–January 1965 (12).

A study from nature. The rapid handling of the foreground detail is closely related to the landscape with a boy reclining in a cart in the British Museum (Cat. No.307), and the treatment of the foliage to the landscape with a farmhouse owned by Boies Penrose (Cat. No.309). Also mentioned on p.29.

312 Hilly Wooded Landscape with Herdsman and Cattle Plate 108
Mrs J. Peyton-Jones, London

Pencil and watercolour on brown-toned paper, varnished. $7\frac{11}{16} \times 9\frac{11}{16}$ (195 × 246).
A herdsman driving five cows down a slope in the foreground centre and right; a pool in the foreground left; a rocky mound in the middle distance centre. Pasted on the back of the frame is an old label inscribed in ink: *Presented to John, Viscount Bateman/in September 1770, by M.ʳ Gainsborough.*
PROVENANCE: Presented by the artist to John, 2nd Viscount Bateman; Bateman sale, Christie's, 11 April 1896, Lot 13 bt. Wass; Sir John Wood; thence by descent.
EXHIBITED: Arts Council 1960–1 (20, and p.7).
BIBLIOGRAPHY: Woodall 376, pp.54–5 and 79; Woodall 1949, p.93.

The treatment of the foliage, the tree trunks and the foreground detail, and the use of wash are closely related to the wooded landscape with rocks in Cleveland (Cat. No.325). Gainsborough took up the subject of this drawing in his landscape painting of a herdsman driving cows downhill at Bowood (Waterhouse 953, repr. pl.125), painted about 1771–4. A version of this composition is in the Huntington Art Gallery (Cat. No.313). Also mentioned on pp.38–9, 42 and 93.

313 Hilly Wooded Landscape with Herdsman and Cattle
Henry E. Huntington Library and Art Gallery, San Marino (63.52.87)

Brown, grey and grey-black washes, varnished on both sides. $7\frac{11}{16} \times 9\frac{7}{8}$ (195 × 251).
A herdsman driving five cows down a slope in the foreground centre and right; a pool in the foreground left; a mountain in the middle distance centre. Collector's mark of Sir Bruce Ingram on the verso bottom left.
PROVENANCE: Sir Bruce Ingram; with Colnaghi, from whom it was purchased 1963.
EXHIBITED: Huntington 1967–8 (3).

Version of the landscape with drover and cows owned by Mrs Peyton-Jones (Cat. No.312). The composition is substantially identical except that the group of cows is placed more centrally, the principal tree is also in the centre and stretches out to the top left in a diagonal, and the trees, hill and foreground bank differ very slightly in detail. This drawing is an example of Gainsborough's practice of varnishing on both sides, to which he refers in his letter to Jackson, dated 29 January 1773 (Woodall *Letters*, No.103, p.179).

314 Open Landscape with Herdsman driving Cows down a Hillside
Ashmolean Museum, Oxford

Watercolour, varnished. $7\frac{5}{8} \times 9\frac{3}{4}$ (194 × 248).
A cowherd accompanied by a dog driving cows down a hill; a pond in the foreground left; mountainous distance.
PROVENANCE: The Earls of Home; Home sale, Christie's, 20 June 1919, Lot 108 (with another) bt. F. T. Sabin; Mrs W. F. R. Weldon, who presented it 1934.
BIBLIOGRAPHY: *Ashmolean Museum Report 1934*, p.22; Woodall 252.

Executed in the later 1760's. The subject is related to the landscape painting with herdsman driving cows downhill at Bowood (Waterhouse 953, repr. pl.125), painted about 1771–4. The theme as well as the treatment of the cows and the foreground detail are closely related to the landscape with cows being driven down a slope owned by Mrs Peyton-Jones (Cat. No.312). The latter drawing is also the same size and treated with a similar varnish.

315 Open Landscape with Cows
Ashmolean Museum, Oxford

Grey wash, varnished. 7¾ × 9¾ (197 × 248).
Three cows left, one standing in a pond, the others outside, standing and reclining respectively; what appears to be a haystack behind trees in the middle distance left.
PROVENANCE: The Earls of Home; Home sale, Christie's, 20 June 1919, Lot 108 (with another) bt. F. T. Sabin; Mrs W. F. R. Weldon, who presented it 1934.
BIBLIOGRAPHY: *Ashmolean Museum Report 1934*, p.22; Woodall 253.

The modelling of the tree trunks and the handling of the foreground detail are closely related to the landscape with cows being driven down a slope owned by Mrs Peyton-Jones (Cat. No.312). The latter drawing is also the same size and treated with a similar varnish. There is a pentimento of a cottage in the middle distance right.

316 Wooded Landscape with Figures on Horseback returning from market
Mrs J. Peyton-Jones, London

Pencil and watercolour on brown-toned paper, varnished. 7¾ × 9¾ (197 × 248).
Two figures on horseback travelling along a country track at the edge of a wood in the foreground centre; three more figures on horseback in the middle distance right, followed by three figures on foot; a village in the distance right.
Pasted on the back of the frame is an old label inscribed in ink: *Presented to John Viscount Bateman,/in September 1770, by Mr Gainsborough.*
PROVENANCE: Presented by the artist to John, 2nd Viscount Bateman; Bateman sale, Christie's, 11 April 1896, Lot 17 bt. Wass; Sir John Wood; thence by descent.
EXHIBITED: Arts Council 1960–1 (19, and p.7).
BIBLIOGRAPHY: Woodall 377, pp.54–5 and p.79; Woodall 1949, p.93 and repr. p.94.

Executed before September 1770, the date when it was given to Lord Bateman. The types of tree trunk, the use of wash and the rhythmical treatment of the terrain are closely related to the wooded landscape owned by Mrs Wood (Cat. No.299), but the scallops outlining the foliage are looser. Also mentioned on pp.38–9 and 42.

317 Wooded Landscape with Country Cart and Faggot Gatherers
Major J. R. O'B. Warde, Squerryes Court

Pen and brown ink and watercolour on brown prepared paper, heightened with white.
8⅜ × 11¹³⁄₁₆ (213 × 300).
A cart drawn by a single horse, with two peasants inside, one with his left leg dangling, is travelling in open country in the middle distance left; a building in the middle distance left; three faggot gatherers in the foreground centre; low hills in the distance centre.
PROVENANCE: By descent.
BIBLIOGRAPHY: M. T. Ritchie, *English Drawings*, London, 1935, repr. pl.25; Woodall 344.

The treatment is close in character to the landscape with peasants returning from market owned by Mrs Peyton-Jones (Cat. No.316).

318 Village Scene with Horsemen and Figures Plate 111
Edward Seago, Ludham

Black chalk, watercolour and bodycolour.
9¼ × 12⅞ (235 × 327).
A man on horseback, accompanied by a second horseman and a dog, talking to a man in the foreground centre; two men and a woman seated near a cottage in the middle distance left; a church and group of houses in the middle distance centre and right, with a figure seated outside one of the houses; a road winding through the village centre.
Collector's mark of the Earl of Warwick bottom right.
PROVENANCE: George Guy, 4th Earl of Warwick; Warwick sale, Christie's, 20 May 1896, Lot 137 (with another) bt. H. Quilter; by descent to Miss Rosalind Denny; Denny sale, Sotheby's, 10 March 1965, Lot 46 (repr.) bt. Colnaghi, from whom it was purchased.

Village scene in the tradition of Teniers. The treatment of the foliage is closely related to the landscape with herdsman and cows owned by Mrs Peyton-Jones (Cat. No.312), and the summary outlining of the figures to the landscape with farmhouse owned by Boies Penrose (Cat. No.309). Churches with spires are fairly numerous in Gloucestershire and Somerset, but even allowing for Gainsborough's summary treatment of topographical features the spire seen here bears very little resemblance to types visible in the West Country and for more to those the artist might have seen in pictures by Teniers (compare, for example, the Teniers in the Beit collection exhibited *Flemish Art*, R.A., 1953–4 (410)). Gainsborough is known to have made

a copy of a "little dutch spire" by Bout and Boudewijns as he refers to it in a letter to its owner, Dr Charlton, in 1779 (Woodall *Letters*, No.12, p.45; the copy was Lot 17 and the original Lot 16 in the Charlton sale, Christie's, 5 March 1790).

319 Wooded Landscape with Figures and Buildings
Ownership unknown

Brown wash. 9¾ × 14⅝ (248 × 371).
Two figures in the middle distance centre on a track which winds from the foreground centre into the distance centre; buildings behind a bank among trees in the middle distance left; three or four houses among trees in the middle distance right (from a photograph).
PROVENANCE: With Parsons.
BIBLIOGRAPHY: *Parsons Catalogue No.44* (352 repr.).

The treatment of the figures, foliage and buildings seem to be closely related to the village scene owned by Edward Seago (Cat. No.318).

320 Wooded Landscape with Herdsman and Cows at a Watering Place
James Christie, Framingham Pigot

Grey, brown and blue washes, varnished.
7⅞ × 10 (200 × 254) (slightly irregular at the top).
A herdsman with a staff in his left hand and four cows at a watering place in the foreground centre (one cow is standing in the pool, and the three others are leaving the water and climbing up a track which winds into the middle distance right); a house half-hidden by a bank in the middle distance right.
Inscribed on the old paper upon which the drawing (badly torn in places, especially on the right) is mounted, in ink bottom left in William Esdaile's hand: *1833 WE 20+Dr Monro's sale.*
Inscribed on a second piece of backing paper, in ink bottom centre in William Esdaile's hand: *Gainsborough* and in brown ink middle centre: *No.7.*
PROVENANCE: Dr Thomas Monro; Monro sale, Christie's, 26 June 1833 ff.; William Esdaile; Esdaile sale, Christie's, 20–1 March 1838.

The treatment of the foliage and the foreground detail is related to passages in the landscape with rocks in Cleveland (Cat. No.325). The drawing is now badly damaged in places.

321 Wooded Landscape with Drovers and Horses Plate 109
Mrs U. Stuttard, London

Grey and brown washes over pencil outline.
7¾ × 9¾ (197 × 248).
Two drovers, one of them a boy, accompanied by a dog, in the foreground left, driving four horses in the foreground centre up a sloping track which winds from the foreground left into the distance centre; a shepherd seated and six or seven sheep on a bank beside the track in the middle distance right.
PROVENANCE: With Squire Gallery; with Maas Gallery, from whom it was purchased 1966.
REPRODUCED: Derek Clifford, *Collecting English Watercolours*, London, 1970, pl. 82.

The treatment of the foliage and the tree trunks is closely related to the landscape with herdsman and cows owned by Mrs Peyton-Jones (Cat. No.312).

322 Open Landscape with Herdsman, Horses and Cows
Ownership unknown

Grey wash. Size unknown.
A herdsman seated under a tree in the foreground right, with two horses behind; three cows beyond a pool in the foreground left; a high rock in the middle distance right (from a photograph).
PROVENANCE: With Colnaghi in 1936.

The treatment of the foliage and the tree trunk and the modelling of the animals are closely related to the landscape with drover and horses owned by Mrs Stuttard (Cat. No.321).

323 Rocky Wooded Landscape with Pool
Rudolf J. Heinemann, New York

Pen and grey ink, with grey and brown washes, over pencil, varnished. 7⅝ × 9 9/16 (194 × 243).
A pool in the foreground centre; a track winding from the middle distance left into the distance left.
PROVENANCE: Miss E. M. M. Brenton; Brenton sale, Christie's, 24 February 1956, Lot 3 (with another) bt. Agnew, from whom it was purchased 1956.

Related to the landscape with herdsman and cattle owned by Mrs Peyton-Jones (Cat. No.312).

324 Wooded Landscape with Rocks and Tree Stump
Denys Wells, London

Black chalk, grey and brown washes, heightened with white. 7¾ × 10 (197 × 254).

A tree stump in the foreground right, with rocks behind.

Stamped *TG* in monogram in gold bottom right. The composition is surrounded by a ruled line in brown ink.

Collector's mark of William Esdaile bottom left, and annotated by him bottom left in ink: *Gainsborough* and on a piece of paper now stuck onto the verso bottom right: *WE 13+D^r Monro's sale.*

PROVENANCE: Dr Thomas Monro; Monro sale, Christie's, 26 June 1833 ff.; William Esdaile; Esdaile sale, Christie's, 20–1 March 1838; Viennese private collection sale, Boerner and Graupe, Berlin, 10–11 May 1930, Lot 74.

EXHIBITED: *Early English Water-Colours and Drawings by European Masters from the Denys Wells Collection*, Art Exhibitions Bureau, n.d. (18).

Related to the landscape with herdsman and cattle owned by Mrs Peyton-Jones (Cat. No.312).

Early 1770's

325 Wooded Landscape with Country Track Plate 112
Cleveland Museum of Art, Cleveland (29.547)

Pen and brown ink and brown and grey washes over pencil on grey paper, varnished. $7\frac{7}{8} \times 9\frac{7}{8}$ (200 × 251).
A country track in the foreground left winding through a wood right; rocks in the middle distance centre.
Pasted on the back of the frame is an old label bearing the inscription: *Presented to John Viscount Bateman/in September 1770, by M^r Gainsborough.*
PROVENANCE: Presented by the artist to John, 2nd Viscount Bateman; Bateman sale, Christie's, 11 April 1896, Lot 18 bt. Agnew; with Colnaghi, from whom it was purchased 1929.
BIBLIOGRAPHY: Leona E. Prasse, 'A Drawing by Thomas Gainsborough', *The Bulletin of the Cleveland Museum of Art*, December 1933, p.162 and repr. f.p.166; Woodall 444, pp.18, 54, 71 and 79 and repr. pl.60; Woodall 1949, p.93.

Executed before September 1770, the date when it was given to Lord Bateman. The use of wash and the scallops outlining the foliage are similar to the landscape with peasants returning from market owned by Mrs Peyton-Jones (Cat. No.316), but the handling is much more rapid and vigorous and is more closely related in character to the landscape with a farmhouse owned by Boies Penrose (Cat. No.309). Also mentioned on pp.33, 38–9, 43–4, 49 and 93.

326 Open Landscape with Cows
British Museum, London (G.g.3 – 390)

Watercolour, varnished. $7\frac{5}{16} \times 9\frac{1}{4}$ (186 × 235).
Three cows, two standing and one reclining, in the foreground centre and right; hills in the distance left; a pond in the foreground centre.
Collector's mark of the Rev. C. M. Cracherode bottom right.
PROVENANCE: Rev. C. M. Cracherode; bequeathed 1799.
ENGRAVED: Thomas Gainsborough; Thomas Rowlandson (included in his *Imitations of Modern Drawings*, c.1788).
BIBLIOGRAPHY: Binyon 14; Gower *Drawings*, p.12 and repr. pl.XVIII; Woodall 91.

Study for the etching with aquatint of which an impression is in the British Museum (1872–6–8–283). The treatment of the foreground detail is closely related to the wooded landscape with rocks in Cleveland (Cat. No.325), and the modelling of the tree trunk on the right to the landscape with drover and horses owned by Mrs Stuttard (Cat. No.321). The motif of three cows grouped together reappears in a number of Gainsborough's compositions of the early 1770's, such as the landscape with milkmaid and cows in the Ashmolean Museum (Cat. No.328) and the landscape with rustic lovers and cows formerly in the Heseltine collection (Cat. No.366).

327 Open Landscape with Cows
Ownership unknown

Pencil and grey wash. $7\frac{1}{2} \times 9\frac{1}{2}$ (190 × 241).
Two cows on a bank in the middle distance right, and a third reclining in the middle distance centre; a pool in the foreground left and centre (from a photograph).
PROVENANCE: William Lambshead; Anon. sale, Sotheby's, 20 April 1955, Lot 45 bt. Spink.

The treatment of the foliage, tree trunk and cows appears to be closely related to the landscape with cows in the British Museum (Cat. No.326).

328 Open Landscape with Figures, Dog and Cows Plate 113
Ashmolean Museum, Oxford

Black chalk and stump on buff paper prepared with grey, heightened with white. $13\frac{5}{16} \times 15\frac{3}{4}$ (338 × 400).
A milkmaid seated and three cows in the foreground left; a cowherd reclining and gazing at the milkmaid, accompanied by a dog, in the foreground centre; a shadowy figure in the middle distance right; a pool

and prominent tree stump in the foreground right.

PROVENANCE: Arthur Kay; Kay sale, Christie's, 23 May 1930, Lot 13 bt. Colnaghi; Francis F. Madan, who bequeathed it 1961.

EXHIBITED: Ipswich 1927 (132); Sassoon 1936 (41); Arts Council 1960–1 (26 and p.7); *Paintings and Drawings from the Collection of Francis Falconer Madan*, Colnaghi's, February–March 1962 (41); *Drawings and Watercolours in memory of the late D. C. T. Baskett*, Colnaghi's, July–August 1963 (20).

BIBLIOGRAPHY: Gower, repr. f.p.8; Woodall 220, pp.50, 55 and 71 and repr. pl.47; Woodall 1949, p.91 and repr. p.122; *Ashmolean Report 1962*, p.48.

Study for the landscape with figures and cows in the collection of the Earl of Jersey (Waterhouse 931, repr. pl.124) (Plate 367), painted about 1771–4. No changes were made in the finished picture. The hatching treatment in the foliage and the loose scallops outlining the leaves are closely related to the wooded landscape with rocks in Cleveland (Cat. No.325). Also mentioned on pp.40, 44 and 101.

329 Wooded Landscape with Figure and Ruined Castle Plate 114
Colonel P. L. M. Wright, Roundhill

Black chalk and stump and white chalk on grey-blue paper. $9\frac{11}{16} \times 12\frac{1}{8}$ (246 × 308).

A figure seated in front of a ruined castle on a bank in the middle distance left; a river in the middle distance right.

PROVENANCE: J. Leslie Wright, who bequeathed it to Birmingham City Art Gallery (with a life-interest to his son) 1953.

EXHIBITED: Oxford 1935 (59); *Masters of British Water-Colour: The J. Leslie Wright Collection*, R.A., October–November 1949 (81); Arts Council 1960–1 (27).

BIBLIOGRAPHY: Woodall 393.

The scallops outlining the foliage and the treatment of the foreground are closely related to the landscape with milkmaid and cows in the Ashmolean Museum (Cat. No.328). Also mentioned on pp.18, 52 and 102.

330 Wooded Landscape with Church and Figures
Henry E. Huntington Library and Art Gallery, San Marino (65.9)

Black chalk, pen and brown ink, and grey and brown washes on brown prepared paper, heightened with white, and varnished. $9\frac{1}{2} \times 13\frac{1}{8}$ (241 × 333).

A woodcutter with a bundle of faggots over his right shoulder, accompanied by a child, in the foreground right, walking along a country road which winds from the foreground centre into the middle distance right; a church between trees in the middle distance left.

Collector's mark of the Earl of Warwick bottom right.

PROVENANCE: George Guy, 4th Earl of Warwick; Warwick sale, Christie's, 20 May 1896, Lot 137 (with another) bt. H. Quilter; by descent to Miss Rosalind Denny; Denny sale, Sotheby's, 10 March 1965, Lot 47 bt. Agnew, from whom it was purchased.

EXHIBITED: Huntington 1967–8 (5 and repr. f.p.3).

BIBLIOGRAPHY: *Henry E. Huntington Library and Art Gallery Annual Report 1964–5*, p.5 and repr. f.p.28.

The tight but loosely connected scallops outlining the foliage are similar to the wooded landscape owned by Mrs Wood (Cat. No.299), but otherwise the treatment of the foliage is closely related to the landscape with herdsman and cows owned by Mrs Peyton-Jones (Cat. No.312). On the subject of Gainsborough's church towers, see under Cat. No.318.

331 Wooded Landscape with Horseman and Packhorse Plate 117
Minneapolis Institute of Arts, Minneapolis

Black chalk and watercolour, heightened with white, varnished. $8\frac{1}{4} \times 12$ (210 × 305).

A horseman and packhorse travelling along a country track in the foreground centre.

Inscribed on the back of the old backing paper in pencil: *Genuine Gainsboroughs/Presented by Mrs Jay/to J D McCabe*.

PROVENANCE: Mrs John Jay, Richmond, Va., who gave it to the Rev. James Debney McCabe; thence by descent to Mrs Darragh Aldrich, who presented it 1964.

BIBLIOGRAPHY: *Bulletin of the Minneapolis Institute of Arts*, Vol.LIII, No.4, December 1964, p.5 (repr.).

The bushy treatment of the foliage and tight scallops outlining the foliage have affinities with the wooded landscape with figures and sheep at Lockinge (Cat. No.288), but the technique is now more personal and less seventeenth century in character, and the handling of the foliage, the spindly tree trunks and the distance is closely related to the landscape with distant church in the Huntington Art Gallery (Cat. No.330).

332 Wooded Landscape with Herdsman driving Cattle Plate 366
Minneapolis Institute of Arts, Minneapolis

Black chalk and watercolour, heightened with white, varnished. $8\frac{1}{2} \times 11\frac{15}{16}$ (216 × 303).

A herdsman driving three cows along a wooded track in the foreground right.
PROVENANCE: Mrs John Jay, Richmond, Va., who gave it to the Rev. James Debney McCabe; thence by descent to Mrs Darragh Aldrich, who presented it 1964.
BIBLIOGRAPHY: *Bulletin of the Minneapolis Institute of Arts*, Vol.LIII, No.4, December 1964, p.5 (repr.); John Hayes, 'William Jackson of Exeter', *The Connoisseur*, January 1970, p.21 and repr. fig.11.

This drawing has always been a companion to the landscape with horseman and packhorse also in Minneapolis (Cat. No.331), and the treatment of the foliage and tree trunks, as well as the type of composition, is closely related. The handling of the foliage is also similar to the landscape with milkmaid and cows in the Ashmolean Museum (Cat. No.328). Also mentioned on p.68.

333 Wooded Landscape with Figure on Horseback and Packhorses
City Museum and Art Gallery, Birmingham (211'53)

Black chalk, watercolour and bodycolour on reddish-brown toned paper, varnished. $8\frac{5}{16} \times 11\frac{16}{16}$ (211 × 303).
A figure on horseback with two packhorses travelling along a track at the edge of a wood in the foreground right; a cottage in the foreground right; a church tower in the distance right.
Stamped *TG* in monogram bottom right.
PROVENANCE: With Palser Gallery, from whom it was purchased by J. Leslie Wright; bequeathed 1953.
EXHIBITED: Oxford 1935 (48); Sassoon 1936 (34); *Twee Eeuwen Engelsche Kunst*, Stedelijk Museum, Amsterdam, July–October 1936 (217); *La Peinture Anglaise*, Louvre, 1938 (203); *Masters of British Water-Colour: The J. Leslie Wright Collection*, R.A., October–November 1949 (89); *Peintures et Aquarelles Anglaises 1700–1900 du Musée de Birmingham*, Musée des Beaux Arts, Lyons, 1966 (53, and p.7); *Dvě století britského malířství od Hogartha k Turnerovi*, National Gallery, Prague and Bratislava 1969 (61).
BIBLIOGRAPHY: Woodall 386.

The treatment of the trees and the outlining of the animals are identical with the landscape with cows in Minneapolis (Cat. No.332).

334 Wooded Landscape with Horsemen, Figures, Cows and Buildings
Graves Art Gallery, Sheffield (819)

Black chalk, watercolour and bodycolour, varnished. $8\frac{5}{16} \times 11\frac{11}{16}$ (211 × 297).

A herdsman driving two cows along a winding track in the foreground centre; two figures on horseback followed by a figure on foot just ahead in the foreground right; a group of buildings in the middle distance right.
PROVENANCE: Henry J. Pfungst; Pfungst sale, Christie's, 15 June 1917, Lot 4 bt. Colnaghi, who sold it to Knoedler; with Colnaghi; Dr Leonard Gow; Gow sale, Sotheby's, 5 May 1943 bt. Agnew, from whom it was purchased 1943.
EXHIBITED: Knoedler's 1923 (11); Ipswich 1927 (145); *Watercolours from the Graves Art Gallery*, Arts Council 1948 (3); *Festival of Britain Art Exhibition*, Graves Art Gallery, Sheffield, May–October 1951 (193).

The treatment of the foliage and the spindly tree trunks are closely related to the landscape with distant church in the Huntington Art Gallery (Cat. No.330).

335 Wooded Landscape with Cottage, Cows and Sheep
Walter C. Baker, New York

Black chalk, pen and ink, blue and brown washes, heightened with white, varnished and laid down on canvas. $8\frac{7}{8} \times 12\frac{5}{8}$ (225 × 321).
Two cows and scattered sheep in the middle distance centre; a cottage in the middle distance right; a pool in the foreground left and centre; mountains in the distance left.
Stamped *TG* in monogram in gold bottom right.
PROVENANCE: Martin H. Colnaghi; with Barbizon House; Anon. sale, Sotheby's, 18 July 1962, Lot 35 bt. Colnaghi, from whom it was purchased 1963.
EXHIBITED: *French and English Painters of the Eighteenth Century*, Guildhall Art Gallery, 1902 (65); *Old Master Drawings*, Colnaghi's, July 1963 (20 and repr. pl.VII).
ALSO REPRODUCED: *The Illustrated London News*, 13 July 1963, p.57.

The handling of the foliage and the clouds is closely related to the landscape with horsemen, herdsman and cows in Sheffield (Cat. No.334), and the thin contours to the treatment of the cows in the landscape with cows in Minneapolis (Cat. No.332).

336 Wooded Landscape with Herdsman, Cows and Cottage
Dr Francis Springell, Portinscale

Black chalk, watercolour and oil on brown prepared paper, varnished. $8\frac{1}{2} \times 12$ (216 × 305).
A herdsman with a stick over his right shoulder in the middle distance left; two cows in the foreground

centre; part of a cottage in the foreground right.

PROVENANCE: Victor Koch.

EXHIBITED: Sassoon 1936 (71); *Drawings by Old Masters from the Collection of Dr and Mrs Francis Springell*, Colnaghi's, October–November 1959 (67 and repr. pl.xxviii); *Springell Collection*, Hatton Gallery, Newcastle upon Tyne, November–December 1959 (67); *Old Master Drawings from the Collection of Dr and Mrs Francis Springell*, National Gallery of Scotland, Edinburgh, July–September 1965 (86).

BIBLIOGRAPHY: Woodall 75.

ALSO REPRODUCED: *The Illustrated London News*, 29 February 1936, p.380.

The spindly tree trunks, the handling of the foliage, the use of wash and the treatment of the highlights are closely related to the landscape with horsemen, herdsman and cows at Sheffield (Cat. No.334).

337 Wooded Landscape with Herdsman, Cows and Church
Philip Hofer, Cambridge, Mass.

Black chalk, watercolour and oil on brown prepared paper. $8\frac{11}{16} \times 12\frac{3}{16}$ (221 × 310).

A herdsman driving three cows in the foreground left and centre towards a river which runs across the middle distance; a church beyond the river in the distance right.

Stamped *TG* in monogram bottom right.

PROVENANCE: Guy Bellingham Smith; with Colnaghi, from whom it was purchased 1930.

EXHIBITED: *Master Drawings*, Albright Art Gallery, Buffalo, January 1935 (76 repr.); *The Art of Eighteenth Century England*, Smith College Museum of Art, January 1947 (36).

BIBLIOGRAPHY: Woodall 448.

ALSO REPRODUCED: *Pantheon*, December 1935, p.417.

The tall spindly trees, the treatment of the foliage, the handling of wash and the rough highlighting in oil are closely related to the landscape with cows in the Springell collection (Cat. No.336).

338 Wooded Landscape with Figures, Cattle and Water
Edgar Blaiberg, London

Black chalk, watercolour and oil, varnished. $8\frac{3}{8} \times 12\frac{1}{16}$ (213 × 306).

Two figures leading three cows to a watering place in the foreground centre and right; a shepherd and sheep in the middle distance left; high rocks in the distance centre; water stretching from the foreground right to the middle distance centre and right.

PROVENANCE: With Colnaghi, from whom it was purchased.

EXHIBITED: Oxford 1935 (52).

BIBLIOGRAPHY: Woodall 18.

The handling is closely related to the landscape with cows in the Springell collection (Cat. No.336).

339 Open Mountain Landscape with Figures, Cattle and Houses
City Art Gallery, Leeds (13.111/53)

Black chalk, grey wash (some brown wash on one of the cows) and oil on brown prepared paper, varnished. $8\frac{1}{4} \times 11\frac{7}{16}$ (210 × 291).

A herdsman with a staff, accompanied by a dog, in the foreground centre at a pool stretching into the foreground right; a milkmaid milking a white cow on a knoll in the foreground centre, with three other cows nearby in the foreground left; two figures followed by two or three packhorses, the last with a rider, travelling along a winding track in the middle distance right; a group of three buildings in the middle distance centre; hills in the distance right.

PROVENANCE: With Colnaghi; Norman Lupton; bequeathed 1953.

BIBLIOGRAPHY: Woodall 217; *Drawings by Wilson, Gainsborough and Constable*, Leeds Art Calendar, Autumn 1956, pp.18 and 25.

The handling is closely related to the landscape with cows in the Springell collection (Cat. No.336).

340 Wooded Landscape with Cottage
Fitzwilliam Museum, Cambridge (PD17 – 1961)

Black and white chalk, grey wash and oil on brown prepared paper, varnished. $8\frac{5}{8} \times 12\frac{7}{16}$ (219 × 316).

Stamped *TG* in monogram bottom left.

A cottage in the middle distance right; a pool in the foreground right.

PROVENANCE: With Colnaghi, from whom it was purchased 1961.

BIBLIOGRAPHY: *Fitzwilliam Museum Report 1961*, p.8.

Perhaps due to the action of a fixative, the brown preparation of the paper has now absorbed the upper layers of wash, so that the tonality has become brown throughout, thus completely distorting the original values. The tight scallops outlining the foliage, the thin contours to the tree trunks and the soft treatment of the clouds, are closely related to the landscape with cottage in Walter Baker's collection (Cat. No.335).

341 Rocky Wooded Landscape with Figure and Cottage Plate 118
Private Collection, England

Watercolour and oil, varnished. 8$\frac{3}{16}$ × 12 (208 × 305).
A figure accompanied by a dog climbing up a slope between large rocks in the middle distance centre towards a cottage half hidden by trees in the middle distance right; a stream stretching across the foreground.
PROVENANCE: Francis, 1st Baron Northbrook; thence by descent.

The tight but loosely connected scallops outlining the foliage, and the treatment of the tree trunks, the rocks and the foreground detail are closely related to the landscapes in Minneapolis (Cat. Nos.331 and 332), though the rich highlighting in oil gives the drawing a completely different character. The highlighting in this and the succeeding drawings is very close in character to Gainsborough's landscape paintings of the early 1770's, such as the village scene owned by Miss Lloyd-Baker (Waterhouse 924, repr. pl.134) or the wooded landscape with figures and cows formerly in the Palmer-Morewood collection (Waterhouse 925, repr. pl.135), and it is significant that Gainsborough exhibited at the R.A. in 1772 'Two landscapes, drawings, in imitation of oil painting.' A number of landscape paintings of this period are executed not on canvas, but on several pieces of paper joined together: a notable example is the wooded landscape with cattle owned by Lord Faringdon (Waterhouse 926).

342 Wooded Landscape with Horseman, Figures and Cottage
Ownership unknown

Black chalk, watercolour and oil. Size unknown.
A horseman accompanied by two figures travelling down a track winding past a rocky bank in the foreground centre; a cottage half-hidden by trees in the middle distance right (from a photograph).
PROVENANCE: With J. R. Saunders 1933.

The treatment of the tree trunks and the rough highlighting in oil are closely related to the landscape with a figure travelling up an incline formerly in the Northbrook collection (Cat. No.341). See also under that entry.

343 Wooded Landscape with Herdsman driving Cattle and Buildings
Ownership unknown

Black chalk, grey wash and oil, varnished.
9 × 13 (229 × 330).
A herdsman driving three cows and two goats along a track between two banks in the foreground centre; two houses on a bank in the middle distance right; rocks in the foreground left (from a photograph).
PROVENANCE: Queen Charlotte; possibly Anon. (=Queen Charlotte) sale, Christie's, 24 May 1819 ff., 3rd Day, Lot 120 (with another) bt. Peacock; with Hodgkins Galleries; Edward H. Roselle; with Newhouse Galleries; Mr and Mrs Robert W. Lyons, Washington; Lyons sale, Parke-Bernet, 4 January 1945, Lot 13 (repr.) bt. Somers.

This is the only drawing at present known which claims to have a provenance deriving from Queen Charlotte; the Queen is recorded as having possessed a series of Gainsborough's drawings in 'coloured chalks' (Whitley, p.320), and a number of drawings in chalks, some noted as tinted, appeared in her sale at Christie's in 1819, but their subsequent history is unknown. The scallops outlining the foliage, the treatment of the tree trunks and the rich highlighting in oil are closely related to the wooded landscape with a figure climbing up an incline formerly in the Northbrook collection (Cat. No.341). See also under that entry.

344 Wooded Landscape with Cows
City Museum and Art Gallery, Birmingham (P19'48)

Pen, black chalk, watercolour and oil on brown-toned paper, varnished. 8$\frac{1}{2}$ × 12 (216 × 305).
Five cows grouped in the foreground centre; a pond in the foreground right.
PROVENANCE: Otto Gutekunst; purchased by the Association of Friends of the Art Gallery and presented 1948.
EXHIBITED: *Dvě století britského malířství od Hogartha k Turnerovi*, National Gallery, Prague and Bratislava 1969 (59).
BIBLIOGRAPHY: *Supplement No.111 to the Catalogue*, City of Birmingham Museum and Art Gallery, 1951, p.24.
REPRODUCED: *One Hundred Water Colours in the permanent collection*, City of Birmingham Museum and Art Gallery, n.d., p.20.

The elongated scallops outlining the foliage in black chalk and the thin contours and hatching in the cows are similar to the landscape with herdsman and cows in Minneapolis (Cat.

No.332), but the broad handling of the foliage, the treatment of the tree trunks and the rough highlighting in oil are more closely related to the similar wooded landscape with cows at a watering place in Colonel Wright's collection (Cat. No.345). See also under Cat. No.341.

345 Wooded Landscape with Cattle at a Watering Place Plate 284
Colonel P. L. M. Wright, London

Black chalk, watercolour and oil on pinkish-toned paper, varnished. $8\frac{5}{16} \times 12\frac{3}{8}$ (211 × 314).
Four cows at a wooded watering place in the foreground centre.
PROVENANCE: Miss G. L. Young; Anon. (=R. H. Young) sale, Christie's, 11 June 1937, Lot 52 bt. Colnaghi, from whom it was purchased by J. Leslie Wright; bequeathed to Birmingham City Art Gallery (with a life-interest to his son) 1953.
EXHIBITED: *Early English Water-Colours from the Collections of J. Leslie Wright and Walter Turner*, Birmingham Art Gallery, April 1938 (92); Aldeburgh 1949 (35); *Masters of British Water-Colour: The J. Leslie Wright Collection*, R.A., October–November 1949 (91 repr. pl.II); *European Masters of the Eighteenth Century*, R.A., November 1954–February 1955 (540); Arts Council 1960–1 (21).
BIBLIOGRAPHY: Woodall 403.

The treatment of the foliage, the tree trunks, and the rough highlighting in oil, are closely related to the rocky landscape with a figure travelling up an incline formerly in the Northbrook collection (Cat. No.341). See also under that entry. Also mentioned on pp.23, 50, 60 and 102.

346 Wooded Landscape with Herdsman driving Cattle downhill Plate 120
Colonel P. L. M. Wright, London

Black chalk, grey wash and oil on brown-toned paper, varnished. $8\frac{5}{8} \times 12\frac{7}{16}$ (219 × 316).
A herdsman driving three cows down a winding hillside track in the foreground right; three figures, a church and a cottage, at the top of the hill in the middle distance centre.
PROVENANCE: Miss G. L. Young; Anon. (=R. H. Young) sale, Christie's, 11 June 1937, Lot 53 bt. Colnaghi, from whom it was purchased by J. Leslie Wright; bequeathed to Birmingham City Art Gallery (with a life interest to his son) 1953.
EXHIBITED: *Early English Water-Colours from the Collections of J. Leslie Wright and Walter Turner*, Birmingham Art Gallery, April 1938 (95); *Masters of British Water-Colour: The J. Leslie Wright Collection*, R.A., October–November 1949 (64); *European*

Masters of the Eighteenth Century, R.A., November 1954–February 1955 (542); Nottingham 1962 (44 repr.).
BIBLIOGRAPHY: Woodall 391.

The treatment of the foliage and the tree trunks, and the rich encrusted highlights in oil, are closely related to the wooded landscape with a figure climbing up an incline formerly in the Northbrook collection (Cat. No.341). See also under that entry. On the subject of Gainsborough's church towers, see under Cat. No.318. Also mentioned on pp.24 and 50.

347 Wooded Landscape with Village Scene Plate 286
Mrs D. A. Williamson, London

Watercolour and oil on reddish-brown toned paper, varnished and mounted on canvas. $16\frac{3}{8} \times 21\frac{1}{8}$ (416 × 537).
A figure on horseback accompanied by two other figures travelling along a country road in the middle distance centre; two figures, one seated, and a dog, in the foreground left; a cottage with figures and pigs outside in the middle distance left; a church with a tall spire in the distance centre; a pool in the foreground centre.
PROVENANCE: Sir Michael Sadler; with Fine Art Society, from whom it was purchased by J. Leslie Wright 1948; bequeathed to Birmingham City Art Gallery (with a life-interest to his daughter) 1953.
EXHIBITED: *Masters of British Water-Colour: The J. Leslie Wright Collection*, R.A., October–November 1949 (79); *The Romantic Movement*, Arts Council (Tate Gallery), July–September 1959 (698); Arts Council, 1960–1 (24 and repr. pl.IV).
BIBLIOGRAPHY: Woodall 282.

Village scene in the tradition of Teniers: the tonality and handling of the foliage are also close to his technique. The treatment of the foliage and the rough highlighting in oil are closely related to the landscape with herdsman and cattle in Colonel Wright's collection (Cat. No.346). See also under Cat. No.341. A version in oil, of approximately the same size, and executed in the technique noted under Cat. No.341, was with Maas Gallery 1963 (not recorded in Waterhouse), and painted about 1771–2. On the subject of Gainsborough's church towers, see under Cat. No.318. Also mentioned on pp.23 and 60.

348 Wooded Landscape with Figures and Pigs outside Cottage and Country Cart
Plate 121
Alan D. Pilkington, Eton College

Black chalk, watercolour and oil on brown-toned paper, varnished. $8\frac{7}{16} \times 12\frac{5}{16}$ (214×313).
A large peasant family outside a cottage, and four pigs eating at troughs, in the foreground left; a country cart, with two figures inside, travelling down a wooded lane in the foreground right.
PROVENANCE: Samuel Kilderbee; Kilderbee sale, Christie's, 30 May 1829, Lot 50 (with another) bt. Cooper; Sir John Neeld, Grittleton House; L. W. Neeld sale, Christie's, 13 July 1945, Lot 104 bt. Fine Art Society, from whom it was purchased 1948.
EXHIBITED: *Works by the Old Bath Artists*, Victoria Art Gallery, Bath, Spring 1903 (176); Arts Council 1960–1 (25); Nottingham 1962 (46).

The treatment of the foliage and the rough highlighting in oil are closely related to the village scene owned by Mrs Williamson (Cat. No.347). The cottage with pigs outside in the latter drawing have now become a more prominent motif. The rhythmical cadences of the foliage may be compared with the landscape backgrounds of portraits of the early 1770's such as the Linley sisters at Dulwich (Waterhouse 450, repr. pl.145), exhibited R.A. 1772. Also mentioned on pp.50 and 92.

349 Rocky Wooded Landscape with Cows
Private Collection, England

Black chalk, watercolour and oil, varnished. $8\frac{3}{16} \times 12$ (208×305).
Four cows, one of them reclining, in the foreground left and centre; rocks in the middle distance centre and right; some sheep in the distance left.
PROVENANCE: Francis, 1st Baron Northbrook; thence by descent.

The broad treatment of the foliage, the contours to the animals, and the rough highlighting in oil are closely related to the landscape with cottage and cart in the Pilkington collection (Cat. No.348). See also under Cat. No.341.

350 Farm Scene with Figures and Packhorses
The National Trust for Scotland, Brodick Castle, Isle of Arran (105)

Black chalk, watercolour and oil. $8\frac{3}{8} \times 12\frac{3}{8}$ (213×314)
A farm hand with a pitchfork in the foreground left; a woman seated, with a dog, in the foreground centre; four packhorses in the foreground centre and right; a farmhouse and barn in the foreground right; no distance.
PROVENANCE: The Dukes of Hamilton; by descent to Mary, 6th Duchess of Montrose; accepted (as part of the contents of Brodick Castle) in lieu of death duties 1958.
EXHIBITED: *Gainsborough, Constable, and Old Suffolk Artists*, Art Gallery, Ipswich, October 1887 (137).

The black chalk contours, the handling of wash and the rough highlighting in oil are related to the landscape with cottage and figures formerly in the Northbrook collection (Cat. No.358).

351 Open Landscape with Cottage, Herdsman and Cows and Rabbit-catcher
The National Trust for Scotland, Brodick Castle, Isle of Arran (106)

Watercolour and oil. $8\frac{7}{16} \times 12\frac{3}{8}$ (214×314).
A herdsman reclining, with five cows, the cow on the far left reclining, in the foreground left to right; a man with a rabbit on a stick over his right shoulder in the foreground right; a white house with a man at the door-way in the middle distance left.
PROVENANCE: The Dukes of Hamilton; by descent to Mary, 6th Duchess of Montrose; accepted (as part of the contents of Brodick Castle) in lieu of death duties 1958.
EXHIBITED: *Gainsborough, Constable, and Old Suffolk Artists*, Art Gallery, Ipswich, October 1887 (137).

The handling of wash and the rough highlighting in oil are closely related to the landscape with farm scene also at Brodick (Cat. No.350), and the treatment of the cows is related to the landscape with cows formerly in the Northbrook collection (Cat. No.349).

352 Village Scene with Figures Plate 126
Private Collection, England

Grey and brown washes, traces of black chalk, bodycolour and oil, varnished. $8\frac{3}{16} \times 12$ (208×305).
Two figures seated beside a track in the foreground left; two more figures seated in the foreground right; two figures standing, and one seated, in the middle distance centre; three figures, one of them a mother and child, standing, and three seated, in front of a cottage in the middle distance right; a track winding from the foreground right into the middle distance left; a church in the middle distance left, from which three or four cottages stretch into the foreground right.
PROVENANCE: Francis, 1st Baron Northbrook; thence by descent.

190

The broad treatment of the foliage, the thin contours to the figures, and the rough highlighting in oil, are closely related to the wooded landscape with cottage and cart in the Pilkington collection (Cat. No.348). This type of village scene is very similar to the landscape painting owned by Miss Lloyd-Baker (Waterhouse 924, repr. pl.134), painted about 1771–2. See also under Cat. No.341. A replica is in the Tate Gallery (Cat. No.353). Also mentioned on p.50.

353 Village Scene with Figures
Tate Gallery, London

Pen with grey and brown ink, grey and red washes, and bodycolour, on brown paper, varnished.
$8\frac{5}{8} \times 12\frac{3}{8}$ (219 × 314).
Two figures seated beside a winding track in the foreground left; two seated figures in the foreground right; three figures in the middle distance centre; three or four figures standing, and three seated, outside a cottage in the middle distance right; three cottages and a smaller building stretching from the foreground right into the middle distance centre; a church in the distance centre.
PROVENANCE: Herbert Powell, who bequeathed it to the National Art-Collections Fund 1929; presented (with a large part of the Powell collection) 1968.
EXHIBITED: Constantly in the provinces.
BIBLIOGRAPHY: *Catalogue of the Herbert Powell Collection*, National Art-Collections Fund, 1931, 59 (repr. p.42); Woodall 240; *National Art-Collections Fund 65th Report 1968*, London, 1969, p.32; *The Collections of the Tate Gallery*, London, 1969, p.33.

An almost exact replica of the village scene formerly in the Northbrook collection (Cat. No.352), though the handling is much tighter and less spontaneous. See also under Cat. No.341.

354 Wooded Landscape with Buildings and Figures
Peter Dangar, Armidale, N.S.W.

Black chalk, watercolour and oil.
$8\frac{3}{8} \times 12\frac{5}{16}$ (213 × 313).
A figure seated in the foreground centre beneath a bank upon which is a large building of an indeterminate character with two figures outside; another figure talking to a seated figure in the foreground right; a track winding from the foreground centre towards a church in the distance right, with a hill beyond (from a photograph).
PROVENANCE: With J. R. Saunders; with Walker's Galleries, from whom it was purchased.

The broad treatment of the foliage and the rough highlighting in oil are closely related to the village scene formerly in the Northbrook collection (Cat. No.352). The buildings in Gainsborough's landscapes are often strangely indeterminate, a fact which underlines their predominantly compositional rôle, and the building on the left in this drawing, with porch and windows suggestive of a church, but no logical connection between the parts, is an unusually striking example. See also under Cat. No.341.

355 Wooded Landscape with Ruined Buildings and Figures Crossing a Bridge
John Nicholas Brown, Providence, R.I.

Black chalk, watercolour and oil, on prepared paper, varnished. $8\frac{5}{16} \times 11\frac{13}{16}$ (211 × 300).
Two figures crossing, and one leaning over, a stone bridge in the foreground centre; a ruined abbey in the foreground right; another ruined building on a slope in the middle distance left.
PROVENANCE: Henry J. Pfungst; Pfungst sale, Christie's, 15 June 1917, Lot 3 bt. Colnaghi; with Knoedler; with Colnaghi, from whom it was purchased.
EXHIBITED: Knoedler's 1923 (4).
BIBLIOGRAPHY: Woodall 441.

The broad handling of the foliage, the treatment of the buildings with the use of thin broken contours, and the rough highlighting in oil, are closely related to the village scene formerly in the Northbrook collection (Cat. No.352) and the landscape with building owned by Peter Dangar (Cat. No.354). As in the case of the latter drawing, the ruined abbey has little architectural logic.

356 Open Landscape with Country Cart, Figures and Ruined Building
Pierpont Morgan Library, New York (III, 55)

Black chalk, watercolour and oil, varnished.
$8\frac{3}{4} \times 12\frac{1}{4}$ (222 × 311).
A country cart with a peasant inside and drawn by a single horse in the foreground left, followed by two figures on foot; two figures resting in the foreground right; a ruined building in the middle distance right; hills in the distance left.
PROVENANCE: Charles Fairfax Murray, from whom it was purchased by J. Pierpont Morgan 1910.
EXHIBITED: *The Art of Eighteenth Century England*, Smith College Museum of Art, January 1947 (26); *Landscape Drawings and Water-Colors, Bruegel to Cézanne*, Pierpont Morgan Library, January–April 1953

(85 and repr. pl.XIII); *The Pierpont Morgan Treasures*, Wadsworth Atheneum, Hartford, November–December 1960 (84).
BIBLIOGRAPHY: *J. Pierpont Morgan Collection of Drawings by the Old Masters formed by C. Fairfax Murray*, Vol.III, London, 1912, No.55 (repr); Woodall 458.

The drawing is dominated by the ruined building on the right, which is rather out of key with the pastoral theme. The very thick highlights in oil and the treatment of the foliage without black chalk contours are close to the landscape with ruined buildings in the collection of John Nicholas Brown (Cat. No.355) and the landscape with a herdsman and cattle passing down a lane with buildings beyond owned by N. L. Hamilton-Smith (Cat. No.363).

357 Open Landscape with Shepherd, Sheep and Church Tower
The Earl of Perth, London

Watercolour and oil, varnished. $8\frac{5}{8} \times 12\frac{1}{8}$ (219 × 308).
A shepherd and dog on a mound in the foreground centre; two figures in a rowing boat fishing in the foreground right; a herdsman with five cows behind some water in the middle distance right; a church tower and churchyard in the middle distance right; a flock of sheep in the distance left.
PROVENANCE: Skrine; with Colnaghi, from whom it was purchased by Sam Sayer 1957; Anon. sale, Sotheby's, 30 November 1960, Lot 12A bt. Colnaghi, from whom it was purchased.

The treatment of the church tower and the rich highlights in oil are closely related to the landscape with country cart and ruined building in the Morgan Library (Cat. No.356), and the handling of the figure and foliage are related to the landscape with cattle at Brodick (Cat. No. 351). The motif of the shepherd on a hillock is found also in the landscape with shepherd, sheep and cows at Bradford (Cat. No.366).

358 Wooded Landscape with Cattle and Buildings
Philadelphia Museum of Art, Philadelphia (John G. Johnson Collection 835)

Black chalk, watercolour and oil on dark-brown-toned paper, varnished, and mounted on canvas. $16\frac{5}{8} \times 21\frac{1}{2}$ (422 × 546).
Five cows standing in the foreground centre; some outbuildings in the foreground left; a church tower visible above the trees in the distance centre.

PROVENANCE: John G. Johnson; bequeathed 1917.

The broad handling of the foliage, the treatment of the tree trunks and the rough highlighting in oil are related to the landscape with buildings owned by Peter Dangar (Cat. No.354). This is the same unusually large size as the village scene owned by Mrs Williamson (Cat. No.347), and similarly mounted on canvas. See also under Cat. No.341.

359 Wooded Landscape with Cottage and Figures Plate 127
Private Collection, England

Black chalk, watercolour and oil, varnished. $8\frac{3}{16} \times 12$ (208 × 305).
Three figures, one carrying a small child, in the foreground left beside a pool which stretches across the foreground centre to right; a cottage half-hidden by trees in the middle distance centre.
PROVENANCE: Francis, 1st Baron Northbrook; thence by descent.

The black chalk scallops outlining the foliage are similar in character to the wooded landscape with cows at a watering place in Birmingham (Cat. No.344), but the breadth of treatment, the loose handling of wash and the rough highlighting in oil are more closely related to the village scene also formerly in the Northbrook collection (Cat. No.352).

360 Wooded Upland Landscape with Horseman and Cottage
Fogg Museum of Art, Cambridge, Mass. (1965.177)

Black chalk and watercolour, heightened with white, and varnished. $8\frac{5}{16} \times 10\frac{1}{2}$ (211 × 267).
A peasant and woman and child on horseback, with a third horse unmounted, travelling along an upland track in the foreground left; part of a cottage in the middle distance right; mountains in the distance left.
PROVENANCE: Paul J. Sachs, by whom it was bequeathed 1965.
EXHIBITED: Cincinnati 1931 (61 and repr. pl.69).
BIBLIOGRAPHY: Woodall 470; *Fogg Art Museum Acquisitions 1965*, Cambridge, Mass., 1966, p.30.

The broad scallops outlining the foliage, the treatment of the figures and the handling of wash are closely related to the landscape with a cottage formerly in the Northbrook collection (Cat. No.359). A poor copy, omitting one of the riders, was in the McDonald and Nicholson sale, Christie's, 21 July 1933 Lot 16.

361 Wooded Landscape with Horseman, Figures and Ruined Building
Dr Paul Toller, London

Black chalk, touches of red chalk, grey wash and oil, varnished. 7¾ × 11 7/16 (197 × 291).
A horseman accompanied by two figures in the foreground right; a ruined building behind a hillock in the middle distance left.
PROVENANCE: H. W. Underdown; Underdown sale, Sotheby's, 15 December 1926, Lot 118 bt. Colnaghi; Dr Leonard Gow; Gow sale, Sotheby's, 5 May 1943, Lot 77 bt. Tooth; Howard Bliss; with Leicester Galleries, who sold it to Spink, from whom it was purchased.
EXHIBITED: *From Gainsborough to Hitchens*, The Leicester Galleries, January 1950 (16).
BIBLIOGRAPHY: Woodall 33.
REPRODUCED: *The Illustrated London News*, 14 January 1950, p.73.

The types of tree, the loose outlines of the foliage in black chalk, the contours of the figures and horse, the broad handling of wash and the rough, broken highlights in oil, are closely related to the landscape with a family on horseback in the Fogg Museum (Cat. No.360).

362 Hilly Wooded Landscape with Cows and Building
Private Collection, London

Black chalk, grey and brown washes and oil, varnished. 8⅜ × 12⅛ (213 × 308).
Three cows in the foreground right beside a hillock flanked by trees in the foreground left and centre; a building in the middle distance right with wooded hills behind.
PROVENANCE: By descent to R. Erskine; with Agnew, from whom it was purchased 1970.
EXHIBITED: *97th Annual Exhibition of Water-Colours and Drawings*, Agnew's, January–February 1970 (33).

The loose treatment of the tree trunks and foliage and the rough broken highlights are clearly related to the landscape with ruined building owned by Dr Paul Toller (Cat. No. 361).

363 Wooded Landscape with Herdsman, Cattle and Buildings Plate 128
N. L. Hamilton-Smith, Windlesham

Oil on brown-toned paper, varnished. 8 7/16 × 12 1/16 (214 × 306).
A peasant on horseback driving a herd of cows and some sheep down a wooded lane in the foreground right; a church and other buildings in the middle distance left and right.
PROVENANCE: Henry J. Pfungst; Pfungst sale, Christie's, 15 June 1917, Lot 2 bt. Colnaghi; Victor Koch; Howard Bliss; with Leicester Galleries, who sold it to Spink, from whom it was purchased.
EXHIBITED: Sassoon 1936 (72); *From Gainsborough to Hitchens*, The Leicester Galleries, January 1950 (17 repr.); Arts Council 1960–1 (23); Nottingham 1962 (45).
BIBLIOGRAPHY: Roger Fry, *Reflections on British Painting*, London, 1934, pp.76–7 and repr. fig.31; Woodall 72; John Hayes, 'Gainsborough and the Gaspardesque', *The Burlington Magazine*, May 1970, p.311.
ALSO REPRODUCED: *The Illustrated London News*, 14 January 1950, p.73.

The broad treatment of the foliage and the rough highlighting (in the sky as well as the landscape) are closely related to the wooded landscape with cows at a watering place in Colonel Wright's collection (Cat. No.345). The effect, with brilliant streaks of light breaking through the trees, can be paralleled at this period in the background of the portrait of Jonathan Buttall ('The Blue Boy') in the Huntington Art Gallery (Waterhouse 106, repr. pl.127), exhibited R.A. 1770. Also mentioned on pp.49, 60 and 102.

364 Wooded Landscape with Drover and Horses
Ownership unknown

Black chalk, watercolour and oil. 8¼ × 11¾ (210 × 298).
A drover driving three horses between wooded banks in the foreground centre (from a photograph).
Stamped *TG* in monogram bottom right.
PROVENANCE: Arthur Morrison; Morrison sale, Sotheby's, 19 March 1946, Lot 58 (repr.) bt. Fine Art Society, from whom it was purchased by W. B. Simpson.

The broad treatment of the foliage and the rough highlighting in oil are related to the wooded landscape with cows at a watering place in Colonel Wright's collection (Cat. No.345).

365 Wooded Mountain Landscape with Buildings and Cattle at a Pool
Whitworth Art Gallery, Manchester (D.24.1925) (1054)

Black chalk, touches of blue chalk, and watercolour on pink prepared paper, heightened with white. 8½ × 12 (216 × 305).

Two cows drinking at a pool, in the foreground centre; two buildings in the middle distance centre; high rocks in the foreground right; a mountain in the distance centre.

PROVENANCE: With Agnew; A. E. Anderson, who presented it 1925.

EXHIBITED: Ipswich 1927 (150); *Watercolour Drawings from the Whitworth Art Gallery Manchester*, Agnew's, February–March 1954 (113); *Drawings and Water-Colours from the Whitworth Art Gallery*, Arts Council, 1960 (31).

BIBLIOGRAPHY: *Whitworth Art Gallery Report 1925*, p.7 and repr. p.17; Woodall 226.

The broad handling of the trees and the rough highlighting in oil are close in character to the landscape with drover and packhorses formerly in the Morrison collection (Cat. No.364).

366 Open Landscape with Shepherd, Sheep and Cows
City Art Gallery, Bradford
(19–12)

Black chalk, grey and some brown washes on grey-blue paper, heightened with white.
$8\frac{1}{2} \times 12\frac{3}{16}$ (216 × 313).
Two cows, and a shepherd with sheep on a hillock, in the foreground left; a farmhouse among trees in the distance right.
Stamped *TG* in monogram bottom left.
PROVENANCE: William Rothenstein, from whom it was purchased 1912.
EXHIBITED: *English Art*, Cartwright Hall, Bradford, 1904 (365 or 366); Ipswich 1927 (173).
BIBLIOGRAPHY: Woodall 21.

The broad treatment of wash is related to the landscape with drover and horses formerly in the Morrison collection (Cat. No.364).

367 Wooded Landscape with Figures and Cattle
City Art Gallery, Wakefield (574)

Watercolour and oil on two pieces of paper joined together, varnished, and laid down on canvas.
$17\frac{3}{16} \times 22$ (440 × 559).
A herdsman on horseback with three cows in the foreground left; a peasant accompanied by a dog in the foreground centre; another figure in the middle distance centre.
PROVENANCE: Sir Cuthbert Quilter; Quilter sale, Christie's, 26 June 1936, Lot 27 bt. Gooden and Fox; Ernest E. Cook, by whom it was bequeathed (through the National Art-Collections Fund) 1955.
BIBLIOGRAPHY: Woodall 52; John Hayes, 'William Jackson of Exeter', *The Connoisseur*, January 1970, p.19, and fig.7.

The broad washy treatment of the foliage and the rough highlighting in oil are related to the landscape with drover and horses formerly in the Morrison collection (Cat. No.364). This is the same unusually large size as the drawings owned by Mrs Williamson (Cat. No.347) and in the Johnson collection (Cat. No.358), and similarly mounted on canvas.

368 Wooded Landscape with Herdsman and Cattle, and Rustic Lovers Plate 282
Ownership unknown

Black chalk and stump and white chalk on grey-green paper. $10\frac{1}{2} \times 12\frac{3}{4}$ (267 × 324).
A herdsman crossing a stream, which winds into the middle distance centre, in the foreground centre; three cows and a goat, and two rustic lovers, in the foreground right; two cows in the middle distance left; another cow on a bank in the middle distance centre; a shepherd and sheep and a stone bridge in the middle distance centre beyond; a half-ruined building on a hill in the middle distance left; a mountain in the distance centre (from a photograph). According to the Lawrence sale catalogue (see below), inscribed beneath: *Given me by himself (Gainsborough) at Bath.*
PROVENANCE: Presented by the artist to Sir Thomas Lawrence; Lawrence sale, Christie's, 17 June 1830, Lot 93 bt. Kennedy; J. P. Heseltine.
EXHIBITED: Colnaghi's 1906 (83).
BIBLIOGRAPHY: Fulcher, 1st edn., p.234 (2nd edn., p.241); Armstrong 1898, repr. f.p.152 (colour); *Original Drawings by British Painters in the Collection of J. P. H(eseltine)*, London, 1902, 12 repr.; Armstrong 1904, repr. f.p.234; Woodall 54, pp.22, 50–2 and 71 and repr. pl.52; Woodall 1949, p.91.

Study for the landscape with figures and cattle in the Mellon collection (Waterhouse 890, repr. pl.81), painted about 1771–4. In the finished picture there are only very slight alterations: in the disposition of the cows and the figures on the right. The broad scallops outlining the foliage are similar to the landscape with figures and cottage formerly in the Northbrook collection (Cat. No.359). Also mentioned on pp.40, 43–4, 60 and 98.

369 Wooded Upland Landscape with Herdsman and Cattle Plate 129
Private Collection, England

Watercolour and oil on brown prepared paper, mounted on canvas, and varnished.
$15\frac{1}{2} \times 20\frac{7}{8}$ (394 × 530).

A herdsman accompanied by a dog, and five cows, on rising ground in the foreground centre and right; two farm buildings in the foreground left; a pool in the foreground centre and right (from a photograph).
PROVENANCE: Mrs Trimmer (?); G. A. F. Cavendish Bentinck; Bentinck sale, Christie's, 13 July 1891, Lot 692 bt. McLean; with Agnew, from whom it was purchased by Lord Blackford; with Agnew; with Leggatt.

The broad washy treatment of the foliage and the landscape and the rough highlighting in oil are related to the landscape with herdsman and cows in Wakefield (Cat. No.367); the handling of the cow on the right and the mound beneath are very close to the landscape with shepherd, sheep and cows in Bradford (Cat. No.366). The drawing is mounted on canvas and similar in size to the drawings owned by Mrs Williamson (Cat. No.347) and in the Johnson collection (Cat. No.358).

Mid to Later 1770's

370 Open Landscape with Horseman, Figures, Bridge and Buildings Plate 130
Ashmolean Museum, Oxford

Black chalk, watercolour and oil, on grey-blue paper, heightened with white, varnished.
$8\frac{1}{2} \times 11\frac{7}{8}$ (216 × 302).
A horseman accompanied by a herdsman and a dog in the foreground centre; a seated figure in the foreground left; a group of buildings in the middle distance left; a winding stream in the middle distance, with a bridge upon which are two figures, in the centre; mountains in the distance centre.
Inscribed on the verso: *This Drawing was purchased at the/Sale of the effects of the late Miss L. Loscombe/ of the Bull Ring, Worcester, and was given/by Thomas Gainsborough to her father/an amateur and antiquarian.*
PROVENANCE: Given by the artist to a Mr Loscombe; Miss Loscombe sale, Worcester; Arthur Kay; Kay sale, Christie's, 23 May 1930, Lot 41 bt. Colnaghi; Francis F. Madan, who bequeathed it.
EXHIBITED: *English Art*, Cartwright Hall, Bradford, 1904 (364); Ipswich 1927 (148); Sassoon 1936 (74); Arts Council 1960–1 (50); *Paintings and Drawings from the Collection of Francis Falconer Madan*, Colnaghi's, February–March 1962 (66 and repr. pl.VII).
BIBLIOGRAPHY: Woodall 222; *Ashmolean Report 1962*, p.48.

The broad treatment of wash, the sketchy outlining of the foliage in black chalk, and the contouring of horse and herdsman are similar to the landscape with horsemen in the Fogg Museum (Cat. No.360).

371 Wooded Landscape with Horsemen and distant Village
The National Trust for Scotland, Brodick Castle, Isle of Arran (104)

Black chalk, watercolour and bodycolour.
$8\frac{7}{16} \times 12\frac{3}{16}$ (214 × 313).
Two horsemen followed by a man on foot passing on the far side of a knoll in the foreground centre; a village, with a tall church spire, in the distance right.
PROVENANCE: The Dukes of Hamilton; by descent to Mary, 6th Duchess of Montrose; accepted (as part of the contents of Brodick Castle) in lieu of death duties 1958.
EXHIBITED: *Gainsborough, Constable, and Old Suffolk Artists*, Art Gallery, Ipswich, October 1887 (137).

The treatment of the foliage, the outlining of the animals in black chalk, the rough handling of the foreground detail, and the treatment of the shadows over the landscape are all identical with the landscape with horseman and bridge in the Ashmolean Museum (Cat. No.370).

372 Wooded Landscape with Herdsman and Cows, Figures in a Boat, and Buildings
Mrs P. J. G. Gray, Ashby St Mary

Black chalk and watercolour on grey-blue paper, heightened with white, and varnished.
$7\frac{7}{8} \times 11\frac{5}{16}$ (200 × 287).
Two figures, one standing and the other seated, in a rowing boat in the foreground left; a herdsman with a stick in his right hand driving two cows along a track in the foreground right; a large pool in the foreground and middle distance left and centre; a house half-hidden by trees in the middle distance left; a building in the distance centre.
PROVENANCE: Guy Bellingham Smith; Mrs Frances Evans; Viscount Eccles; with Colnaghi, from whom it was purchased by H. L. Bradfer-Lawrence 1952; thence by descent.
EXHIBITED: *Leeds Art Collections Fund Members Exhibition*, Temple Newsam, 1952; *Watercolours and Drawings from the Bradfer-Lawrence Collection*, Arts Council, 1953 (23).
BIBLIOGRAPHY: Woodall 49; *Leeds Art Calendar*, Summer and Autumn 1952, p.23.

The treatment of the figures and animals and of the tree trunks and foliage and the handling of wash and chalkwork throughout are closely related to the landscape with horseman and bridge in the Ashmolean Museum (Cat. No.370).

The chalkwork and handling of wash are related to the wooded landscape with mansion owned by L. H. Gilbert (Cat. No.374). The cows are carefully outlined as in many drawings of the early 1770's.

373 Wooded Landscape with Herdsman and Cows
Edward Speelman, London

Watercolour over black chalk, heightened with white, varnished. $8\frac{13}{16} \times 12\frac{5}{16}$ (224 × 313).
A herdsman with a staff over his left shoulder, and four cows at a watering place, in the foreground centre; the pool stretches right across the foreground.
PROVENANCE: Michael Harvard.

The treatment and colouring are closely related to the landscape with horseman and bridge in the Ashmolean Museum (Cat. No.370).

374 Wooded Landscape with House and Figure
L. H. Gilbert, Lisbon

Black chalk and grey and grey-black washes, varnished. $8\frac{5}{8} \times 11\frac{1}{4}$ (219 × 286).
A figure walking along a winding track in the foreground centre; a house among trees in the middle distance centre.
PROVENANCE: Otto Gutekunst; Howard Bliss; with Leicester Galleries, from whom it was purchased by Viscount Radcliffe; with Agnew, from whom it was purchased by H. M. Langton 1953; with Agnew, from whom it was purchased 1959.
EXHIBITED: From Gainsborough to Hitchens, The Leicester Galleries, January 1950 (20).
REPRODUCED: The Illustrated London News, 14 January 1950, p.73.

The rough treatment of wash and the loose outlining of the foliage in black chalk are closely related to the landscape with horseman and distant village at Brodick (Cat. No.371).

375 Wooded Landscape with Cows
Colonel P. L. M. Wright, Roundhill

Black and white chalks and grey wash, with touches of red wash, on brown paper. $8\frac{9}{16} \times 12\frac{1}{16}$ (217 × 306).
Five cows in the foreground right; a church between trees in the distance centre.
PROVENANCE: With Colnaghi, from whom it was purchased 1960.

376 Wooded Landscape with Figures and Flock of Sheep
Mrs W. W. Spooner, Bath

Black chalk, touches of blue chalk, watercolour and bodycolour, varnished. $8\frac{13}{16} \times 12\frac{1}{8}$ (224 × 308).
A shepherd with a stick, accompanied by a dog, talking to a woman seated on a log in the foreground left; a flock of sheep in the middle distance right; a pool in the foreground centre and right.
PROVENANCE: H. B. Milling.
EXHIBITED: Early English Water Colours, Leeds City Art Gallery, October–November 1958 (38).

The rough treatment of wash, the loose outlining of the foliage in black chalk, and the contouring of figures and animals are closely related to the landscape with horseman and bridge in the Ashmolean Museum (Cat. No.370).

377 Wooded Upland Landscape with Herdsman, Cows and Buildings
City Art Gallery, Leeds (17.1/35)

Black chalk, watercolour and bodycolour. $8\frac{5}{16} \times 11\frac{16}{16}$ (211 × 303).
A herdsman driving two cows along a track on the far side of a knoll in the foreground centre; buildings in the middle distance left and right; a pool in the foreground right; mountains in the distance left and right.
PROVENANCE: With Palser Gallery, from whom it was purchased by A. E. Anderson and presented 1935.
EXHIBITED: English Water Colour Drawings of the 18th and 19th Centuries, Palser Gallery, Summer 1935 (37 repr.); Sassoon 1936 (51).
BIBLIOGRAPHY: Woodall 79; Drawings by Wilson, Gainsborough and Constable, Leeds Art Calendar, Autumn 1956, pp.18 and 25, repr. p.17.
ALSO REPRODUCED: William Wells, 'Temple Newsam House', The Studio, January 1950, p.9.

The loose treatment of wash and the outlining of the foliage are closely related to the landscape with sheep owned by Mrs Spooner (Cat. No. 376).

378 Upland Landscape with Figures and Sheep Plate 423
Mrs Cecil Keith, Rusper

Black chalk and stump and white chalk with some brown chalk, on grey-blue paper. $8\frac{7}{8} \times 12\frac{7}{16}$ (225×316).
Two figures seated in the foreground centre; a pool in the foreground left; a shepherd with a flock of sheep in the middle distance left; a cow on a bank in the middle distance centre; rocks in the middle distance left and right; a building in the distance left, with hills beyond centre.
PROVENANCE: John Edward Taylor; Taylor sale, Christie's, 8 July 1912, Lot 191 bt. Agnew; Ernest C. Innes; Innes sale, Christie's, 13 December 1935, Lot 32 bt. Colnaghi, from whom it was purchased by J. Leslie Wright; bequeathed to Birmingham City Art Gallery (with a life interest to his daughter) 1953.
EXHIBITED: Sassoon 1936 (60); *Early English Water-Colours from the Collections of J. Leslie Wright and Walter Turner*, Birmingham Art Gallery, April 1938 (85); *Masters of British Water-Colour: The J. Leslie Wright Collection*, R.A., October–November 1949 (77); Nottingham, 1962 (49); *English Watercolour Drawings from the collection of Mrs Cecil Keith*, Worthing Art Gallery, March 1963 (7).
BIBLIOGRAPHY: Woodall 400.

Study for the landscape with figures and cows at Petworth (Waterhouse 952, repr. pl.179), painted about 1774–80. In the finished picture the sheep were omitted (they appear in the painting of the same subject at Burghley: Waterhouse 951), the figures altered in pose and three cows positioned on the bank in place of one. The loose treatment of the foliage is related to the mountain landscape at Leeds (Cat. No. 377). A copy by Alexander Cozens, in which the rocks on the right are replaced by a country mansion, is in the Oppé collection (1148) (Plate 422). Also mentioned on pp.40, 44 and 85.

379 Wooded Landscape with Herdsman, Cows and Buildings
Miss Margaret Crawford, London

Black chalk and stump and white chalk on grey-blue paper. $10\frac{1}{2} \times 12\frac{7}{8}$ (267×327).
A herdsman driving two cows along a winding track in the foreground centre; a figure outside a house set among trees in the middle distance left; some buildings half hidden by trees on a high bank in the middle distance right; hills in the distance centre.
Inscribed in pen on the old backboard: *This sketch in crayons by Gainsborough, its companion, and*
the two tinted sketches by/the same painter, were given to me, Nov. 1865, by Mr Andrews, apothecary of Crawford St Marylebone/in the 83d year of his age. He had them from Dr Thompson who died 15 years ago, in Osnaburgh St, at the age of 93, and had informed Mr Andrews that he obtained the sketches from a member/of Gainsboroughs family –/Alex Shaw.
PROVENANCE: Given by a member of Gainsborough's family to Dr William Thompson; William Richard Andrews, who gave it to Alexander Shaw 1865; by descent to Captain Norman Shaw; Anon. = (Shaw) sale, Christie's, 6 November 1953, Lot 63 bt. Fine Art Society, from whom it was purchased 1954.
EXHIBITED: *Spring Exhibition Early English Water-Colours and Drawings*, 2nd edn., Fine Art Society 1954 (27).

The loose treatment of the foliage, the atmospheric quality, and the stumpwork generally are identical with the mountain scene in Mrs Keith's collection (Cat. No.378).

380 Wooded Landscape with Cottage, Figures and Cows
Mrs J. Hamilton Coulter, Huntington, N.Y.

Black chalk and stump and white chalk.
$9\frac{7}{16} \times 12\frac{5}{8}$ (251×321).
Four figures, three of them seated, outside the door of a cottage at the top of a few steps in the foreground right; two cows in the foreground centre.
PROVENANCE: With Leggatt; Anon. (=Leggatt) sale, Christie's, 28 March 1952, bt. Colnaghi, from whom it was purchased 1952.
EXHIBITED: *Old Master Drawings*, Colnaghi's, April–May 1952 (63 and repr. pl.v).

One of Gainsborough's earlier cottage door drawings. The cows seem unrelated to this theme. The loose treatment of the foliage and the stumpwork are related to the landscape with buildings owned by Miss Margaret Crawford (Cat. No.379).

381 Landscape with Hill Plate 133
Art Gallery, Aberdeen (54.24: verso)

Black chalk and stump and white chalk on grey-blue paper. $10\frac{3}{8} \times 12\frac{13}{16}$ (264×325).
A hill in the middle distance centre.
Recto: wooded landscape with herdsman, cows and building (Cat. No.382).
PROVENANCE: Given by a member of Gainsborough's family to Dr William Thompson; William Richard Andrews, who gave it to Alexander Shaw 1865; by descent to Captain Norman Shaw; Anon.

(=Shaw) sale, Christie's, 6 November 1953, Lot 62
bt. Colnaghi, from whom it was purchased 1954.

An unfinished sketch in which Gainsborough
has hardly more than formulated a composition.
The rapid stumpwork is similar to the landscape
with buildings owned by Miss Crawford (Cat.
No.379). Also mentioned on pp.13–14 and 61.

382 Wooded Landscape with Herdsman driving Cows Plate 132
Art Gallery, Aberdeen (54.24: recto)

Black chalk and stump and white chalk on
grey-blue paper. 10⅜ × 12¹⁸⁄₁₆ (264 × 325).
A herdsman driving two cows along a winding
track in the foreground centre; a figure seated by
the side of the track in the middle distance centre;
a mansion in the distance centre.
Verso: an unfinished drawing with a hill
(Cat. No.381).
PROVENANCE: Given by a member of Gainsborough's
family to Dr William Thompson; William Richard
Andrews, who gave it to Alexander Shaw 1865;
by descent to Captain Norman Shaw; Anon.
(=Shaw) sale, Christie's, 6 November 1953, Lot 62
bt. Colnaghi, from whom it was purchased 1954.
EXHIBITED: Old Master Drawings, Colnaghi's,
June 1954 (52); Arts Council 1960–1 (29).
BIBLIOGRAPHY: Permanent Collection Catalogue,
Aberdeen, 1968, p.49 and repr. pl. x.
The loose treatment of the foliage, the atmos-
pheric quality and the stumpwork generally are
identical with the landscape with buildings
owned by Miss Crawford (Cat. No.379). Also
mentioned on pp.13 and 50.

383 Wooded Mountain Landscape with Figures and Buildings
City Art Gallery, Bradford (20–12)

Black chalk and stump on grey-blue paper,
heightened with white. 10¼ × 12¾ (260 × 324).
Two figures in the foreground centre; buildings in
the middle distance centre and right; mountains
in the distance left and centre.
PROVENANCE: William Rothenstein, from whom it
was purchased 1912.
EXHIBITED: English Art, Cartwright Hall, Bradford,
1904 (365 or 366); Ipswich 1927 (156).
BIBLIOGRAPHY: Woodall 20.

An unfinished sketch in which the masses have
been worked out but the detail has not been
filled in. The stumpwork is close in character to
the unfinished sketch in Aberdeen (Cat. No.
381).

384 Open Landscape with Figures, Animals and Church
Victoria and Albert Museum, London
(Dyce 678)

Black chalk, watercolour and oil, varnished.
8¼ × 10¼ (210 × 260).
A shepherd holding a crook and three sheep in the
foreground left; a figure and animal under a bank
in the foreground centre; another figure in the
foreground right; a church tower in the distance
centre.
PROVENANCE: Rev. Alexander Dyce, who
bequeathed it to the South Kensington Museum 1869.
BIBLIOGRAPHY: Dyce Collection Catalogue, London,
1874, pp.21 and 100; Victoria and Albert Museum
Catalogue of Water Colour Paintings by British Artists,
London, 1927, p.220; Woodall 192; Martin Hardie,
Water-colour Painting in Britain 1. The Eighteenth
Century, London, 1966, p.76.

The rapid sketchy treatment and, in particular,
the handling of the foliage and of the tree to the
right are similar to the unfinished landscape
at Bradford (Cat. No.383).

385 Wooded Upland Landscape with Herdsman and Cattle
Seattle Art Museum, Seattle

Black chalk and stump and white chalk on blue
paper. 9⅛ × 12¹⁸⁄₁₆ (232 × 325).
A herdsman leading three cows towards a pool in
the foreground left; a church tower half-hidden
by trees on rising ground in the middle distance
right; hills in the distance centre.
PROVENANCE: J. P. Heseltine; Henry Oppenheimer;
Le Roy M. Backus, by whom it was bequeathed.
BIBLIOGRAPHY: S.E.L., The Le Roy M. Backus
Memorial Collection, Seattle Art Museum, 1952,
Cat. No.20 (repr.)

The treatment of the foliage and the church
tower and the chalk and stumpwork through-
out are closely related to the landscape with
herdsman and cattle in Aberdeen (Cat. No.382).

386 Wooded Upland Landscape with Herdsman and Cattle
Barber Institute of Fine Arts, Birmingham

Black chalk and stump and white chalk on blue
paper. 10⅝ × 13⅛ (270 × 333).
A herdsman leading three cows towards a pool in
the foreground left; a church tower half-hidden
by trees in the middle distance right; hills in the
distance centre.
PROVENANCE: Rev. Stopford A. Brooke; Brooke

sale, Sotheby's, 24 February 1937, Lot 14 bt. Bodkin.
BIBLIOGRAPHY: Woodall 15; *Handbook of the Barber Institute of Fine Arts*, Birmingham, 1949, p.20; Millar, p.13 and repr. pl.36; *Catalogue of the Paintings . . . in the Barber Institute of Fine Arts*, Cambridge, 1952, p.142 and repr. p.143.

A slightly larger version of the drawing in Seattle (Cat. No.385).

387 Wooded Landscape with Shepherd and Sheep
City Museum and Art Gallery, Birmingham (1975'3)

Black chalk and stump on grey paper, heightened with white. $8\frac{7}{8} \times 12\frac{9}{16}$ (225×319).
A shepherd and sheep in the middle distance left; a figure resting by the side of a pond in the foreground centre; a mountain in the distance centre; buildings behind trees in the middle distance right.
PROVENANCE: Guy Bellingham Smith, who sold it to Colnaghi, from whom it was purchased by J. Leslie Wright 1936; bequeathed 1953.
EXHIBITED: Oxford 1935 (31); *Masters of British Water-Colour: The J. Leslie Wright Collection*, R.A., October–November 1949 (73).
BIBLIOGRAPHY: Woodall 380.
REPRODUCED: Kenneth Garlick, *The J. Leslie Wright Collection of English Water-colours*, Apollo, April 1968, p.282.

The handling of the figures, the foliage, the distant mountain and the sky, the atmospheric treatment of the landscape, and the use of very heavy black chalk in places are closely related to the landscape with herdsman and cattle in Seattle (Cat. No.385).

388 Open Landscape with Herdsman and Cattle Plate 131
Lord Clark, Saltwood Castle

Black chalk and stump and white chalk on grey paper. $8\frac{15}{16} \times 12\frac{1}{2}$ (227×317).
A herdsman driving cows along a winding track in the foreground right; buildings in the middle distance right; hills in the distance centre.
PROVENANCE: Rev. Stopford A. Brooke; Brooke sale, Sotheby's, 24 February 1937, Lot 15 bt. Squire Gallery; J. Leslie Wright; Howard Bliss; with Leicester Galleries, from whom it was purchased 1950.
EXHIBITED: *From Gainsborough to Hitchens*, The Leicester Galleries, January 1950 (23); *Three*

Centuries of British Water-Colours and Drawings, Arts Council, 1951 (70); *Le Paysage Anglais de Gainsborough à Turner*, Orangerie, February–April 1953 (49); *European Masters of the Eighteenth Century*, R.A., November 1954–February 1955 (539); Arts Council 1960–1 (28, and repr. pl.III).
BIBLIOGRAPHY: Woodall 399.
ALSO REPRODUCED: *The Illustrated London News*, 14 January 1950, p.73.

The treatment of the foliage and the herdsman and cattle, the atmospheric quality, and the chalk and stumpwork generally are closely related to the landscapes in Aberdeen and Seattle (Cat. Nos.382 and 385). Also mentioned on p.50.

389 Wooded Landscape with Herdsman and Cattle Plate 139
Earl Spencer, Althorp

Black chalk and grey and grey-black washes on buff paper, heightened with white. $10\frac{13}{16} \times 14\frac{1}{8}$ (275×359).
A herdsman driving two cows down a wooded lane in the foreground left; some sheep in the foreground right.
Collector's mark of Earl Spencer bottom right.
PROVENANCE: By descent.
EXHIBITED: Oxford 1935 (18); Sassoon 1936 (69).
BIBLIOGRAPHY: Woodall 292.

The loose but dense treatment of the foliage is related to the landscape with herdsman and cattle at Aberdeen (Cat. No.382).

390 Wooded Landscape with Shepherd, Sheep and Cottage
Earl Spencer, Althorp

Grey wash, heightened with white. $10\frac{3}{4} \times 14$ (273×356).
A shepherd with a flock of sheep in the foreground centre, beyond a stream which winds from the foreground right to the middle distance left; a cottage with a smoking chimney on rising ground in the middle distance left.
Collector's mark of Earl Spencer bottom right.
PROVENANCE: By descent.
EXHIBITED: Oxford 1935 (6); Sassoon 1936 (64).
BIBLIOGRAPHY: Woodall 295.

The treatment of the foliage is related to the landscape with herdsman and cattle also at Althorp (Cat. No.389).

199

O

391 Wooded Landscape with Shepherd and Sheep
H. F. Oppenheimer, London

Grey wash and white chalk. $10\frac{3}{4} \times 13\frac{5}{8}$ (273×346).
A shepherd and dog in the foreground left, with a flock of sheep in the foreground centre; a rock in the middle distance centre.
PROVENANCE: Guy Bellingham Smith; Howard Bliss; with Leicester Galleries, who sold it to Spink, from whom it was purchased.
EXHIBITED: *From Gainsborough to Hitchens*, The Leicester Galleries, January 1950 (24).

The treatment of the foliage and the handling of wash are identical with the wooded landscape with shepherd and sheep at Althorp (Cat. No.390).

392 Wooded Landscape with Shepherd and Sheep
Ownership unknown

Grey and grey-black washes. $10\frac{3}{4} \times 13\frac{5}{8}$ (273×346).
A shepherd accompanied by a dog, with a flock of sheep, in the foreground left and centre; a rocky bank in the middle distance centre (from a photograph).
PROVENANCE: Guy Bellingham Smith; with Meatyard; with Spink.
BIBLIOGRAPHY: *Meatyard Catalogue No.24*, 1941 (436 repr.)

The treatment of the foliage is closely related to the landscape with shepherd and sheep at Althorp (Cat. No.390).

393 Coastal Scene with Figures, Shipping and Ruined Castle
Earl Spencer, Althorp

Grey wash, heightened with white. $10\frac{5}{8} \times 13\frac{13}{16}$ (270×351).
Two figures on the shore in the middle distance centre; two figures near a ruined castle on a bank in the middle distance left; a shepherd seated, with scattered sheep, on rising ground in the middle distance right; a sailing boat at sea in the distance centre.
Collector's mark of Earl Spencer bottom right.
PROVENANCE: By descent.
EXHIBITED: Oxford 1935 (17); Sassoon 1936 (65); *L'Aquarelle Anglaise 1750–1850*, Musée Rath, Geneva October 1955–January 1956 and L'Ecole Polytechnique Fédérale, January–March 1956 (60).
BIBLIOGRAPHY: Woodall 298.

The treatment of the foliage, the rapid broken

contours, and the handling of wash are closely related to the wooded landscape with shepherd and sheep also at Althorp (Cat. No.390).

394 Wooded Mountain Landscape with Figures and distant Village
The Earl of Harrowby, Sandon Hall

Black chalk and stump and white chalk on grey paper. $10\frac{3}{8} \times 12\frac{15}{16}$ (264×329).
A figure in the foreground left walking towards a bridge over a stream in the foreground centre; a figure resting by the side of a track in the middle distance right; craggy rocks in the middle distance left and right; a village beyond a wooded valley in the distance centre, and hills at the horizon.
PROVENANCE: By descent.

The chalkwork and atmospheric quality are related to the landscape with pool at Seattle (Cat. No.385).

395 Wooded Upland Landscape with Shepherd, Sheep and Church Tower
The Earl of Harrowby, Sandon Hall

Black chalk and stump and white chalk on grey paper. $10\frac{7}{16} \times 13$ (265×330).
A shepherd with his dog and a flock of sheep travelling down a road beneath an overhanging rock in the foreground left; two figures on a winding hilly road in the middle distance right; a church tower half-hidden by trees in the middle distance right; hills in the distance centre.
PROVENANCE: By descent.

Companion to the previous drawing (Cat. No. 392). The loose treatment of the foliage on the left is related to the landscape with herdsman and cattle at Althorp (Cat. No.389).

396 Rocky Wooded Landscape with Figure driving Sheep
British Museum, London (1910–2–12–260)

Black chalk and stump, with some brown chalk, on grey-blue paper, heightened with white. $11\frac{13}{16} \times 16\frac{1}{2}$ (300×419).
A figure is driving a flock of sheep up a hill in the foreground centre; a village in the distance left; a mountain in the distance right.
PROVENANCE: George Salting; bequeathed 1910.
BIBLIOGRAPHY: M. T. Ritchie, *English Drawings*, London, 1935, repr. pl.26; Woodall 175, pp.22 and 52 and repr. pl.53.

The treatment of the foliage and the middle distance, the atmospheric quality and the heavy use of black chalk are closely related to the landscapes owned by Lord Harrowby (Cat. Nos.394 and 395).

397 Mountain Landscape with Figures and Buildings
Metropolitan Museum of Art, New York (07.283.6)

Black chalk and stump on grey-blue paper, heightened with white. $10\frac{3}{8} \times 15\frac{15}{16}$ (264×403).
A figure in the foreground left; a figure crossing a bridge in the middle distance right; buildings on a hillside in the middle distance left; a building behind on a high mountainous rock in the middle distance centre; a building in the middle distance right; mountains in the distance centre.
PROVENANCE: Purchased 1907.
BIBLIOGRAPHY: *Bulletin of the Metropolitan Museum of Art*, December 1907, p.201 and repr. p.200; Woodall 466 and p.52.

The chalkwork and rapidity of handling are closely related to the rocky landscape in the British Museum (Cat. No.396).

398 Wooded Landscape with Packhorses
Mrs W. W. Spooner, Bath

Black chalk and stump and white chalk on grey-blue paper. $10\frac{11}{16} \times 13$ (271×330).
A team of four or five mounted packhorses travelling up a hilly path in the foreground right; a shepherd with a stick in the middle distance centre; a pool in the foreground left; hills in the distance left.
PROVENANCE: H. B. Milling.

The treatment of the foliage and the heavy use of black and white chalk are closely related to the rocky landscape in the British Museum (Cat. No.396).

399 Wooded Landscape with Herdsman and Cattle
Ownership unknown

Black chalk and stump. $7\frac{1}{2} \times 10\frac{3}{4}$ (190×273).
A herdsman driving two cows in the foreground left; a pool stretching across the foreground; a mountain in the distance left (from a photograph).
PROVENANCE: With Knoedler.
EXHIBITED: Knoedler's 1923 (2).
BIBLIOGRAPHY: Woodall 69 and 319.

The treatment of the foliage and the cattle and

the stumpwork are closely related to the wooded landscape with packhorses in the Spooner collection (Cat. No.398).

400 Wooded Landscape with Figures
Ownership unknown

Black chalk and grey wash. $8\frac{1}{2} \times 12\frac{1}{4}$ (216×311).
Four figures in the foreground left; two figures seated in the foreground centre; a mountain in the distance centre (from a photograph).
PROVENANCE: Otto Gutekunst; Anon (=Gutekunst) sale, Christie's, 16 April 1926, Lot 49 bt. Parsons.
BIBLIOGRAPHY: Woodall 80.

The treatment of the tree trunks and foliage is closely related to the wooded landscape with packhorses in the Spooner collection (Cat. No.398), but the foliage seems a little inorganic in places, while the subject and the use of wash rather than stump with black chalk are unusual, so that, from a photograph, this drawing has puzzling features.

401 Wooded Landscape with Figures, Carts and House
Lieutenant-Colonel H. M. C. Jones-Mortimer, Hartsheath

Black chalk and stump and white chalk on blue paper. $9\frac{1}{2} \times 12\frac{1}{2}$ (241×317).
Two figures on horseback accompanied by a dog in the foreground centre; two figures in the oreground left; two carts, travelling in opposite directions, in the middle distance right; a house half-hidden by trees on top of a hill in the middle distance centre; a hill in the distance right.
PROVENANCE: Arthur Kay; Kay sale, Christie's, 23 May 1930, Lot 32 bt. Agnew, from whom it was purchased 1938.
EXHIBITED: Ipswich 1927 (142).
BIBLIOGRAPHY: Woodall 3.

The treatment of the branches and foliage is related to the wooded landscape with packhorses in the Spooner collection (Cat. No.398).

402 Open Landscape with Herdsmen, Cows and Horses Plate 331
William Rockhill Nelson Gallery of Art, Kansas City

Black chalk with some stump, and white and coloured chalks, on blue paper. $11 \times 12\frac{9}{16}$ (279×319).
A herdsman sleeping with a dog beside him in the

foreground left; three cows, one of them reclining, and two horses in the foreground centre and right; a herdsman seated and leaning against a log in the foreground right; a cottage and church tower in the middle distance left.
PROVENANCE: J. Heywood Hawkins; probably C. H. T. Hawkins sale, Christie's, 29 March 1904, Lot 194 (with another) bt. Colnaghi; Arthur Kay; Kay sale, Christie's, 23 May 1930, Lot 29 bt. Agnew, by whom it was presented.
EXHIBITED: Ipswich 1927 (143); *Great Master Drawings of Seven Centuries*, Knoedler's, October–November 1959 (58 and repr. pl.XLVII).
ENGRAVED: Thomas Gainsborough (?) (unpublished).
BIBLIOGRAPHY: *Handbook of the Collections*, Kansas City, 1959, p.130 (repr.)

Study for the landscape with horses and cows at the edge of a wood also in Kansas City (Waterhouse 908, repr. pl.112) (Plate 332), painted about 1774–80. The herdsman was originally conceived as standing upright, as can be seen from the pentimento. No changes were made in the finished picture except for the character of the tree on the right and the omission of the buildings on the left. Also apparently a study for the etching (presumably soft-ground) known only from the description in *The Illustrated London News*, 25 July 1846, p.55: in this, the herdsman stretched on the grass was not introduced (conceivably, however, he was represented standing, as in the original state of the drawing). The treatment of the tree trunks and foliage and the heavy white chalkwork at the horizon are closely related to the wooded landscape with packhorses in the Spooner collection (Cat. No.398). Also mentioned on pp.40, 44, 99, and 103.

403 Wooded Landscape with Peasant asleep and Horses outside a Shed Plate 134
Tate Gallery, London (2227)

Pastel on grey paper. $9\frac{7}{8} \times 11\frac{7}{8}$ (251 × 302).
Five horses grouped outside a shed set between trees in the foreground centre and right (pentimenti in the legs of the horse on the right); a peasant asleep in the foreground right; a ploughshare in the foreground left; a plough in the middle distance left; a church tower in the distance left.
PROVENANCE: Probably given by the artist to Sir Henry Bate-Dudley; by descent to Thomas Birch Wolfe, who presented it to the National Gallery 1878; transferred 1919.
ENGRAVED: Thomas Gainsborough (unpublished).
EXHIBITED: *Two Centuries of British Drawings from the Tate Gallery*, C.E.M.A., 1944 (27); Aldeburgh 1949 (18).

BIBLIOGRAPHY: Whitley, p.299; Woodall 184 and pp.95 and 98; Mary Chamot, *The Tate Gallery British School: A Concise Catalogue*, London, 1953, p.74; *The Collections of The Tate Gallery*, London 1969, p.33.

Study for the soft-ground etching, the only known impression of which is in the Witt Collection, Courtauld Institute of Art (2430). The plough and ploughshare were omitted in the finished print. The treatment of the foliage and the horses and the heavy use of white chalk are closely related to the landscape with cows and horses in Kansas City (Cat. No.402).

404 Wooded Landscape with Milkmaid and Cows
Ashmolean Museum, Oxford

Black chalk and stump on pink prepared paper, heightened with white. $9 \times 12\frac{3}{8}$ (229 × 314).
A milkmaid with a pail in her left hand and her back to the spectator in the foreground centre; two cows, the one on the left reclining, in the foreground.
PROVENANCE: J. Heywood Hawkins; probably C. H. T. Hawkins sale, Christie's, 29 March 1904, Lot 198 (with another) bt. Colnaghi; Arthur Kay; Kay sale, Christie's, 23 May 1930, Lot 39 bt. Colnaghi; Mrs Metscher, who presented it to the Chicago Art Institute; returned to Colnaghi on an exchange basis; Francis F. Madan, who bequeathed it.
EXHIBITED: Colnaghi's 1906 (67); *Fifth Loan Exhibition*, Toronto Art Museum, 1912 (68); Ipswich 1927 (151); *Peinture Anglaise*, Musée Moderne, Brussels, October–December 1929 (71); Sassoon 1936 (57); *Paintings and Drawings from the Collection of Francis Falconer Madan*, Colnaghi's, February–March 1962 (54).
BIBLIOGRAPHY: *The Vasari Society*, Second Series, Part 1, Oxford, 1920, p.11 and repr. No.14; Heinrich Leporini, *Die Stilentwicklung der Handzeichnungen*, Vienna, 1925, 301 and repr. pl.301; Heinrich Leporini, *Handzeichnungen Grosser Meister: Gainsborough*, Vienna and Leipzig, n.d. (=1925), repr. pl.7; Woodall 223; *Ashmolean Report 1962*, pp.48–9.

Treatment of cows on this scale in a landscape composition is very unusual in Gainsborough's *œuvre*, though a similar subject occurs in his painting in the picture in the Duke of Sutherland's collection (Waterhouse 983), painted about 1786. The broad treatment of the tree trunks, branches and foliage is closely related to the landscape with horses outside a shed in the Tate Gallery (Cat. No.403).

405 Wooded Landscape with Figures
Plate 135
George Goyder, Rotherfield Greys

Black, white and coloured chalks on grey-blue
paper. $9\frac{7}{16} \times 11\frac{7}{8}$ (240 × 302).
Two figures near a sandy bank in the foreground
centre; logs in the foreground left; buildings and
a hill in the distance right.
PROVENANCE: Sir Henry Oppenheimer; with
Schaeffer Galleries; Mrs Robert Opton; with
Vose Galleries, who sold it to Agnew, from whom
it was purchased 1960.
EXHIBITED: *Master Drawings 15th to the 19th Century*,
Schaeffer Galleries, March–April 1941 (58); Arts
Council 1960–1 (32).

The broad treatment of the foliage and the use
of coloured chalks are similar to the landscape
with horses outside a shed in the Tate Gallery
(Cat. No.403). A copy is in the Mellon collection.
Also mentioned on p.89.

**406 Wooded Landscape with Horses
drinking** Plate 136
John Nicholas Brown, Providence, R.I.

Black, white and coloured chalks on grey-blue
paper. $9\frac{1}{8} \times 11\frac{1}{2}$ (232 × 292).
Three horses, two of them with riders, drinking
at a pool in the foreground centre; a horseman,
accompanied by a figure on foot, travelling up a
slope in the middle distance left; hills in the
distance left.
PROVENANCE: Herbert Horne, who sold it to (Sir)
Edward Marsh 1904; with Colnaghi, from whom
it was purchased.
EXHIBITED: *The Herbert Horne Collection of
Drawings*, Burlington Fine Arts Club, 1916 (55);
Ipswich 1927 (152).
BIBLIOGRAPHY: Armstrong 1898, repr. f.p.172
(colour); Woodall 439.

The soft treatment of the foliage and the use of
coloured chalks are identical with the wooded
landscape with figures owned by George Goyder
(Cat. No.405).

**407 Wooded Landscape with Country
Cart and Figures** Plate 143
Whitworth Art Gallery, University of
Manchester (D.4.1931) (1508)

Black and coloured chalks on grey prepared paper,
heightened with white. $9\frac{13}{16} \times 13\frac{1}{8}$ (249 × 333).
A country cart drawn by a single horse by the side
of a bank in the middle distance centre, with a
figure bending down inside; two figures, one of

them seated and the other standing with a stick
in his right hand and his left arm outstretched, at
the foot of the bank in the foreground left; a
shepherd with a stick over his right shoulder and
scattered sheep in the middle distance centre and
right; a pool in the foreground left.
PROVENANCE: With Walker's Galleries, from whom
it was purchased by A. E. Anderson and presented
1931.
ENGRAVED: Thomas Gainsborough; published by
J. & J. Boydell, 1 August 1797 (not in reverse).
EXHIBITED: *Annual Exhibition of Early English
Water-Colours*, Walker's Galleries, June–Autumn
1930 (54 repr.); *Drawings & Water-Colours from
the Whitworth Art Gallery*, Arts Council, 1960 (30).
BIBLIOGRAPHY: *Whitworth Art Gallery Report 1931*,
p.5; Woodall 229 and pp.95 and 97.

Study for the soft-ground etching with aquatint
(Boydell 9). Minor alterations were made in
the finished print, chiefly in the tree on the
right and the disposition of the sheep. The soft
treatment of the foliage and foreground grasses
is closely related to the landscape with horses
drinking owned by John Nicholas Brown (Cat.
No.406), and the soft chalkwork and hatching
are paralleled in certain of Gainsborough's
portrait studies of this period (compare Cat.
No. 51). The drawing of this subject in the
Torbock collection watermarked 1804 is an
exact copy of the soft-ground etching. Also
mentioned on p.61.

**408 Wooded Landscape with Horseman
and Building**
Christopher Lever, Windsor

Black and coloured chalks, with touches of brown
wash, heightened with white, varnished.
$9\frac{1}{8} \times 11\frac{1}{2}$ (232 × 292).
A figure on horseback travelling down a winding
track in the foreground centre; a figure seated
on a bank in the foreground right; a mansion on
a hill in the middle distance left.
PROVENANCE: With the Ruskin Gallery, Birmingham
from whom it was purchased by Alistair Horton;
by descent to John Wright; Anon. sale, Sotheby's,
23 November 1967, Lot 39 (repr.) bt. Winkfield.
EXHIBITED: *Works of Art belonging to the Friends of
the Art Gallery*, City of Birmingham Museum and
Art Gallery, February–March 1962 (60);
Nottingham 1962 (47 repr.)

The treatment of the foliage and the horseman
and the broken white highlights are closely
related to the landscape with horses drinking
owned by John Nicholas Brown (Cat. No.406).
The feeling for light breaking through the trees

on the right is close to the effects with which Gainsborough was experimenting in his painting at this period, under the influence of Rubens.

409 Wooded Landscape with Horsemen travelling along a Country Track
Tate Gallery, London (2225)

Pastel on grey paper. $9\frac{7}{8} \times 12\frac{1}{4}$ (251 × 311).
Three horsemen accompanied by a dog travelling along a country track in the foreground left; a pool in the foreground centre and right; houses in the middle distance left; sheep in the middle distance right.
PROVENANCE: Probably given by the artist to Sir Henry Bate-Dudley; by descent to Thomas Birch Wolfe, who presented it to the National Gallery 1878; transferred 1919.
EXHIBITED: Aldeburgh 1949 (17).
BIBLIOGRAPHY: Whitley, p.299; Woodall 183; Mary Chamot, *The Tate Gallery British School: A Concise Catalogue*, London, 1953, p.74; *The Collections of the Tate Gallery*, London, 1969, p.33.

The type of composition, the treatment of the foliage and horsemen, and the scattered white highlights are closely related to the landscape with horseman and mansion owned by Christopher Lever (Cat. No.408).

410 Wooded Landscape with Horseman
George D. Widener, Philadelphia

Black chalk and stump, watercolour and oil on reddish-brown prepared paper, varnished. $8\frac{3}{8} \times 11\frac{7}{8}$ (213 × 302).
A horseman and packhorse travelling along a country track in the foreground right; a peasant seated, with a dog, behind a pool in the foreground centre; two houses in the middle distance right; low hills in the distance right.
PROVENANCE: Given by the artist probably to Goodenough Earle, of Barton Grange, Somerset; thence by descent to Francis Wheat Newton; sold to Agnew's 1913, who immediately resold it to Knoedler's, from whom it was purchased by G. D. Widener 1914.
EXHIBITED: Knoedler's 1914 (16).
BIBLIOGRAPHY: Fulcher, 2nd edn., p.241; John Hayes, 'The Gainsborough Drawings from Barton Grange', *The Connoisseur*, February 1966, p.92 and repr. fig.13.

The treatment of the foliage, foreground detail and horseman and the loose squiggles in black chalk outlining the clouds are closely related to the landscape with horsemen in the Tate Gallery (Cat. No.409).

411 Wooded Landscape with High Rocks, Figures, Horses and Sheep
Philadelphia Museum of Art, Philadelphia (30-39-66)

Black chalk and stump on buff paper, heightened with white. $10\frac{7}{8} \times 13\frac{5}{16}$ (276 × 338).
A horseman, accompanied by a packhorse, with some sheep, travelling along a winding path in the foreground left; a shepherd seated and some sheep beneath high rocks in the middle distance centre.
PROVENANCE: Otto Gutekunst; Anon. (= Gutekunst) sale, Christie's, 16 April 1926, Lot 56 bt. Parsons; Boies Penrose, who presented it 1939.
BIBLIOGRAPHY: *Parsons Catalogue* 1929 (455 repr.)

The treatment of the foliage, horseman and animals is related to the landscape with horseman owned by George D. Widener (Cat. No. 410). The drawing is in poor condition, largely owing to oxidization.

412 Wooded Landscape with Country Cart
Ownership unknown

Black chalk and stump and white chalk on blue paper (apparently). Size unknown.
A cart, with a figure seated inside, drawn by three horses, in the foreground left and centre travelling along a track which winds into the middle distance centre (from the print).
ENGRAVED: W. F. Wells, published by Wells and Laporte 1 November 1804 (as in the collection of William Alexander).
PROVENANCE: William Alexander; Alexander sale, Sotheby's, 11 March 1817.

The treatment of the foliage and clouds seems to be closely related to the wooded landscape with horsemen owned by George D. Widener (Cat. No.410).

413 Wooded Landscape with Mountainous Distance
British Museum, London (1910-2-12-253)

Black and white chalks on blue paper. $7\frac{1}{8} \times 8\frac{11}{16}$ (181 × 221).
Part of a house in the middle distance right; mountains in the distance left.
PROVENANCE: Sir J. C. Robinson; Robinson sale, Christie's, 21 April 1902, Lot 124 bt. George Salting; bequeathed 1910.
BIBLIOGRAPHY: Woodall 167.

The treatment of the foliage and the scattered white highlights are closely related to the land-

scape with horsemen in the Tate Gallery (Cat. No.409)

414 Wooded Landscape with Cottage
British Museum, London (1910–2–12–252)

Black chalk and stump and white chalk on grey-blue paper. 6$\frac{15}{16}$×8$\frac{9}{16}$ (176×217).
A cottage and stile in the middle distance right; a pond in the foreground left.
PROVENANCE: George Salting; bequeathed 1910.
BIBLIOGRAPHY: Woodall 166.

The treatment of the foliage and the scattered white highlights are closely related to the wooded landscape also in the British Museum (Cat. No.413).

415 Wooded Landscape with Cows
British Museum, London (O.o.2–35)

Black and white chalks on blue paper. 2$\frac{7}{8}$×3$\frac{1}{8}$ (73×79).
A group of cows in the middle distance left descending a slope to a pond in the foreground right.
The composition is surrounded by a ruled line in pencil.
PROVENANCE: Richard Payne Knight; bequeathed 1824.
BIBLIOGRAPHY: Fulcher, 1st edn., p.234 (2nd edn., p.241); Binyon 27d; Gower Drawings, p.11 and repr. pl.VIIIc; Woodall 113.

A small composition study. The treatment of the foliage and the highlights in white chalk are closely related to the wooded landscape also in the British Museum. This drawing and its companions (Cat. Nos.416, 417, 418, 419 and 420) are very unusual in Gainsborough's œuvre, and the reasons for his making these small sketches are obscure. It is possible that they are not in fact studies, but records of drawings with which he had parted that for one reason or another he wished to have by him.

416 Wooded Landscape with Figure
British Museum, London (O.o.2–36)

Black and white chalks on blue paper. 2$\frac{11}{16}$×3$\frac{1}{8}$ (68×79).
A hillock in the foreground left and centre; a figure in the foreground right.
The composition is surrounded by a ruled line in pencil.
PROVENANCE: Richard Payne Knight; bequeathed 1824.

BIBLIOGRAPHY: Fulcher, 1st edn., p.234 (2nd edn., p.241); Binyon 27e; Gower Drawings, p.11 and repr. pl.VIIId; Woodall 114.

A small composition study. The treatment of the foliage and the scattered white highlights are identical with the small sketch of a landscape with cows also in the British Museum (Cat. No.415). See also under Cat. No.415.

417 Open Landscape with Figures in a Cart
British Museum, London (O.o.2–37)

Black and white chalks on blue paper. 2$\frac{3}{4}$×3$\frac{3}{16}$ (70×81).
A cart drawn by two horses, with four or five figures in or accompanying it, travelling along a track in the middle distance centre; a building in the middle distance right.
The composition is surrounded by a ruled line in pencil.
PROVENANCE: Richard Payne Knight; bequeathed 1824.
BIBLIOGRAPHY: Fulcher, 1st edn., p.234 (2nd edn., p.241); Binyon 27f; Gower Drawings, p.11 and repr. pl.VIIIa; Woodall 115.

A small composition study. The treatment of the foliage and the scattered white highlights are identical with the small sketch of a landscape with cows also in the British Museum (Cat. No.415). The figure grouping is closely related to The Harvest Waggon, painted some ten years before (see Cat. No.825). See also under Cat. No.415.

418 Open Landscape with Riders
British Museum, London (O.o.2–38)

Black and white chalks on blue paper. 2$\frac{7}{8}$×3$\frac{3}{16}$ (73×81).
Two figures on horseback and another on foot travelling along a track in the middle distance centre; a pond in the foreground left.
The composition is surrounded by a ruled line in pencil.
PROVENANCE: Richard Payne Knight; bequeathed 1824.
BIBLIOGRAPHY: Fulcher, 1st edn., p.234 (2nd edn., p.241); Binyon 27g; Gower Drawings, p.11 and repr. pl.VIIIb; Woodall 110.

A small composition study. The treatment of the tree trunk and the foreground detail and the scattered white highlights are identical with the small sketch of a landscape with cows also in the British Museum (Cat. No.415). See also under Cat. No.415.

419 Open Landscape with Shepherd and Sheep

British Museum, London (O.o.2–33)

Black and white chalks on blue paper.
2¾ × 3 (70 × 76).
A shepherd and sheep centre; a pool stretching across the foreground and into the middle distance centre.
The composition is surrounded by a ruled line in pencil.
PROVENANCE: Richard Payne Knight; bequeathed 1824.
BIBLIOGRAPHY: Fulcher, 1st edn., p.234 (2nd edn., p.241); Binyon 27b; Woodall 111.

A small composition study. The treatment of the tree trunk and the use of white chalk are closely related to the small sketch of a landscape with horsemen also in the British Museum (Cat. No.418). See also under Cat. No.415.

420 Open Landscape with Shepherd and Sheep

British Museum, London (O.o.2–34)

Black and white chalks on blue paper.
2¾ × 3 3/16 (70 × 81).
A shepherd and sheep centre; a pool stretching from the foreground centre into the middle distance right.
The composition is surrounded by a ruled line in pencil.
PROVENANCE: Richard Payne Knight; bequeathed 1824.
BIBLIOGRAPHY: Fulcher, 1st edn., p.234 (2nd edn., p.241); Binyon 27c; Woodall 112.

A small composition study. The treatment of the tree trunk and the use of white chalk are closely related to the small sketch of a shepherd and sheep also in the British Museum (Cat. No.419). See also under Cat. No.415.

421 Wooded Landscape with Timber Waggon Plate 462

City Art Gallery, Leeds (5.109/52)

Black chalk and stump, and white and coloured chalks, on grey-green paper. 11¾ × 15¾ (298 × 400).
A timber waggon drawn by a team of horses in the foreground right; some sheep on rising ground in the middle distance left; a church tower behind trees in the middle distance left; a pool in the foreground left.
PROVENANCE: With Asscher and Welker; with Palser Gallery; Norman Lupton; bequeathed 1952.
EXHIBITED: Bath 1951 (52); *Early English Water*

Colours, Leeds City Art Gallery, October–November 1958 (35); *Water Colours from Leeds*, Agnew's, October–November 1960 (13 repr.).
BIBLIOGRAPHY: Woodall 216 and p.53; E. I. Musgrave, *The Agnes Lupton Bequest*, Leeds Art Calendar, Spring 1952, p.6 and repr. p.2; *Drawings by Wilson, Gainsborough and Constable*, Leeds Art Calendar, Autumn 1956, pp.16 and 24.

The treatment of the tree trunks and foliage and the scattered white highlights are closely related to the wooded landscape in the British Museum (Cat. No.413). The use of a sheet of paper upon which a smaller piece has been pasted is accidental to this composition, and does not imply that Gainsborough first completed the smaller sheet and then extended his design on all four sides. Also mentioned on p.25.

422 Wooded Landscape with Timber Waggon Plate 461

Museum of Fine Arts, Budapest (1935–2637)

Black chalk and stump, and brown and white chalks, on blue paper. 11⅜ × 16 (289 × 406).
A timber waggon drawn by a team of horses in the foreground left; some sheep on rising ground in the middle distance right; a church behind trees in the middle distance right; a pool in the foreground right.
PROVENANCE: Dr Majovszky; acquired 1935.

An offset from the wooded landscape with timber waggon at Leeds (Cat. No.421). Gainsborough is not known to have made offsets from any other of his chalk drawings, and his purposes in making the present sheet would seem obscure. It is possible that it was an isolated experiment; more likely perhaps that it was not made by Gainsborough at all, but at a later date. Also mentioned on p.25.

423 Wooded Landscape with Timber Waggon

Ownership unknown

Black chalk (apparently). Size unknown.
A timber waggon, with two seated figures on it, drawn by two horses, travelling along a winding track in the foreground right; a hill in the distance right (from the print).
ENGRAVED: J. Laporte, published by Laporte and Wells 1 May 1802 (as in the collection of J. Laporte).
PROVENANCE: J. Laporte.

The treatment of the foliage, as well as the subject matter, seems to be related to the wooded landscape with timber waggon at Leeds (Cat. No.421).

424 Wooded Landscape with Cottage, Peasant, Cows and Sheep, and Cart travelling down a Slope Plate 333
Mrs N. Argenti, London

Black chalk and stump and white chalk on grey paper. $14\frac{15}{16} \times 12\frac{7}{16}$ (379×316).
A cottage with two figures at the doorway, one standing and one seated, in the foreground right; a peasant with two cows and a flock of sheep in front of the cottage in the foreground right; a horse and cart, with two figures inside, travelling down a slope in the foreground left; hills in the distance left.
PROVENANCE: With Alfred Scharf, from whom it was purchased by Nicholas Argenti.
EXHIBITED: Bath 1951 (48).

The treatment of the figures, animals and foreground detail, and the loose touch in the foliage, are all closely related to the landscape with horsemen in Cincinnati (Cat. No.435). The composition, notably the disposition of the trees, cows and sheep, is very closely related to the upright landscape with figures and animals at Belvoir Castle (Waterhouse 962, repr. pl.228) (Plate 335), possibly exhibited R.A. 1778, but there is no cottage or cart in the painting. Also mentioned on pp.33 and 40.

425 Wooded Landscape with Figures, Cows crossing a Bridge, and Castle
Ownership unknown

Black chalk and stump and white chalk on grey paper. $10 \times 12\frac{1}{2}$ (254×317).
Two figures, one of them seated, by the side of a bridge in the foreground left; three cows crossing the bridge in the foreground centre; two figures in a punt in the foreground centre in a stream which flows across the foreground and into the middle distance centre; a castle in the middle distance centre.
PROVENANCE: Ernest C. Innes; Innes sale, Christie's, 13 December 1935, Lot 29 bt. Squire Gallery; W. Hetherington.
EXHIBITED: Colnaghi's 1906 (38).
BIBLIOGRAPHY: Woodall 61 and p.50.

The treatment of the foliage, the foreground detail and the cows is closely related to the wooded landscape with cottage, cows and sheep

owned by Mrs Argenti (Cat. No.424). A smaller piece of paper has been pasted onto the sheet in the centre, and examination of passages at the edge of this smaller sheet (notably upper left, where the delineation of the foliage does not relate to the chalkwork on the outer sheet) suggests that Gainsborough must have been dissatisfied with the middle of his composition, stuck another piece of paper over it, and revised it. The composition was taken up and varied a few years later, and became one of Gainsborough's most important subjects of the early 1780's (see Cat. No.498).

426 Wooded Landscape with distant Town and Mountain
W. A. Brandt, Ashdon

Black chalk and stump and white chalk with touches of blue chalk, on blue paper.
$9\frac{3}{4} \times 12\frac{1}{8}$ (248×308).
A figure seated beside a track winding round a hillside in the foreground right; what appear to be two figures and some cattle travelling along the track in the middle distance centre; a town with a mountain beyond in the distance left.
PROVENANCE: With P. Polak; Anon. (= Polak) sale, Christie's, 9 November 1956, Lot 24 bt. Brandt.

The treatment of the foliage is closely related to the wooded landscape with cottage and cart owned by Mrs Argenti (Cat. No.424).

427 Wooded Landscape with River and Buildings
Ownership unknown

Black chalk and stump (apparently). Size unknown.
A river winding through tree-lined banks from the foreground right into the distance centre; a cottage half-hidden by trees in the foreground right; a larger house partly visible between trees in the distance centre (from the print).
ENGRAVED: J. Laporte, published by Wells and Laporte 1 November 1802 (as in the collection of J. Laporte).
PROVENANCE: J. Laporte.

The treatment of the foliage seems to be related to the mountain landscape in the W. A. Brandt collection (Cat. No.426).

428 Wooded Landscape with Figure, Lime Kiln and Farm Buildings
Major Michael Ingram, Driffield

Black and brown chalks and stump and white chalk on blue paper. 9¾ × 12¼ (248 × 311).
A figure working with a long stick at a smoking lime kiln in the middle distance centre; a group of farm buildings in the middle distance left; a pool in the foreground centre and right.
PROVENANCE: With Colnaghi, from whom it was purchased by Sir Bruce Ingram; bequeathed by him 1963.

The treatment of the foliage and the foreground detail is closely related to the mountain landscape in the W. A. Brandt collection (Cat. No.426). The 'industrial' subject matter is very unusual for Gainsborough.

429 Wooded Landscape with Buildings and Stream
Mrs E. M. Young, Guildford

Black, reddish-brown and white chalks on blue paper. 10 3/16 × 12 7/16 (259 × 316).
Buildings on a high bank in the middle distance left; a stream winding from the middle distance centre into the foreground right.
Stamped *T. Gainsborough* in black on the original buff mount bottom left.
PROVENANCE: Anon. sale, Christie's, 19 November 1968, Lot 27 (repr.) bt. Agnew, from whom it was purchased 1968.

The treatment of the tree trunks, foliage and foreground detail, and the use of white chalk, are closely related to the wooded landscape with lime kiln owned by Major Ingram (Cat. No. 428). The rather finicky lines outlining the bank and roof on the left are uncharacteristic, and the composition is a little stiff.

430 Wooded Landscape with Building and Pool
Christopher Lever, Windsor

Black, reddish-brown and white chalks on blue paper. 10 3/16 × 12 7/16 (259 × 316).
A building in the middle distance right; a pool in the foreground centre and right.
Stamped *T. Gainsborough* in black on the original buff mount bottom left.
PROVENANCE: Anon. sale, Christie's, 19 November 1968, Lot 26 (repr.) bt. Agnew, from whom it was purchased 1968.

The treatment of the tree trunks and foliage and

the scattered white highlights are identical with the wooded landscape with buildings on a bank owned by Mrs Young (Cat. No.429), to which the drawing is a companion. The composition is again rather stiff in character.

431 Coastal Scene with Figures and Boats Plate 140
British Museum, London (1930–6–14–1)

Black chalk and stump and white chalk over paper prepared with grey wash. 11 × 14 9/16 (279 × 370).
A figure on the shore and a small sailing boat in the foreground left; buildings in the middle distance left; a cutter in full sail in the middle distance centre; a rowing boat with figures in the foreground right; a larger sailing vessel in the distance right.
Inscribed in pencil on the verso: *This is a Gainsborough. – and belonged to/the late William Pearce Esq: of Cadogan Place/one of his intimate friends. He gave it/to Mr Marsh (?) & Mr M to me/FSH.*
PROVENANCE: William Pearce, who gave it to a Mr Marsh (?), who in turn gave it to Francis Seymour Haden; R. P. Roupell; Roupell sale, Christie's, 14 July 1887, Lot 1332 bt. Riggell; Arthur Kay; Kay sale, Christie's, 23 May 1930, Lot 20 bt. Agnew; presented by Gerland and Colin Agnew 1930.
BIBLIOGRAPHY: Gower, pp.118–19 and repr. f. p.94; C. D. (= Campbell Dodgson), *Drawings by Gainsborough*, British Museum Quarterly, Vol.v, No.2, 1930, p.66 and repr. f.; Woodall 176.

One of the earlier of Gainsborough's late coastal scenes, possibly connecting with a visit to the Devonshire coast which we know he was planning to make in the summer of 1779 (Woodall, *Letters*, No.62, p.123). The treatment of the foliage and foreground detail and the sketchy delineation of form are closely related to the wooded landscape with timber waggon at Leeds (Cat. No.421). Also mentioned on pp.29 and 94.

432 Coastal Scene with Figures, Ships and Buildings
Museum of Art, Rhode Island School of Design, Providence, R.I.

Black chalk and stump and white chalk on grey-green paper. 9 7/16 × 12 (240 × 305).
Four figures, one of them seated, in the foreground centre; a sailing ship on the beach in the foreground left; a ruined building amongst trees on a bank in the foreground right; three ships in

the distance left; several buildings and high cliffs in the distance centre.
PROVENANCE: Dr Gustav Radeke; Mrs Radeke, who bequeathed it 1921.
BIBLIOGRAPHY: *Bulletin of the Rhode Island School of Design*, October 1921, p.43; M. A. Banks, *The Radeke Collection of Drawings*, Bulletin of the Rhode Island School of Design, October 1931, p.66; Woodall 469.

The treatment of the figures and foliage is closely related to the coastal scene in the British Museum (Cat. No.431), and the parallel hatching in the sky and distance to the wooded landscape owned by Christopher Lever (Cat. No.430). The weaknesses in modulating distances on the left are presumably due to the exceptionally rapid execution.

433 Open Landscape with Riders
British Museum, London (O.o.2–32)

Black chalk and grey bodycolour. $2 \times 2\frac{5}{8}$ (51×67).
Two figures on horseback, accompanied by a dog, travelling along a track in the foreground right.
PROVENANCE: Richard Payne Knight; bequeathed 1824.
BIBLIOGRAPHY: Fulcher, 1st edn., p.234 (2nd edn., p.241); Binyon 27a; Woodall 116.

A small composition study. The treatment o the foliage, the sketchy outlining of the figures and animals, and the grey toning are related to the coastal scene also in the British Museum (Cat. No.431). The sketchy handling of the tree trunks and foliage is also closely related to the series of small sketches on blue paper also in the British Museum (Cat. Nos.415, 416, 417, 418, 419 and 420). See also under Cat. No.415.

434 Wooded Landscape with Herdsman and Cows
British Museum, London (1910-2-12-251)

Black chalk and stump and white chalk on grey-blue paper. $10 \times 12\frac{1}{2}$ (254×317).
A herdsman accompanied by a dog in the foreground left; two cows standing in a pond in the foreground right.
PROVENANCE: Sir J. C. Robinson; Robinson sale, Christie's, 21 April 1902, Lot 117 bt. George Salting; bequeathed 1910.
BIBLIOGRAPHY: Woodall 165, pp.18, 50–1 and repr. pl.48; Geoffrey Grigson, *English Drawing*, London, 1955, p.175 and repr. pl.48.

The sketchy treatment of the figure, animals and foliage and the use of white chalk are closely

related to the coastal scene in Providence (Cat No.432). This sheet, grey-blue at the edges but otherwise buff where it has been exposed to the light, is an especially striking example of the acute discoloration which has affected so many of Gainsborough's drawings on blue paper.

435 Wooded Landscape with Horsemen
Cincinnati Art Museum, Cincinnati (1954.130)

Black chalk and stump on grey-blue paper, heightened with white. $10\frac{1}{16} \times 12\frac{3}{4}$ (256×324).
Two horsemen, accompanied by a packhorse and a dog, travelling along a country track in the foreground centre and right; a pool in the foreground left; a church tower in the distance left.
PROVENANCE: H. Sutton Palmer; Palmer sale, Christie's, 11 December 1933, Lot 206 bt. Parsons: Dr Allyn C. Poole; Miss Emily Poole, who presented it 1954.
BIBLIOGRAPHY: *Parsons Catalogue*, No.50, 1934 (62 repr.); Woodall 259.

The sketchy treatment of the figures and animals, the foliage and foreground detail, and the loose highlights in white chalk are identical with the wooded landscape with cows at a pool in the British Museum (Cat. No.434). A copy was formerly in the collection of Violet, Lady Melchett (exhibited Sassoon 1936 (50)).

436 Wooded Landscape with Gypsy Encampment Plate 138
Mr and Mrs Paul Mellon, Oak Spring, Virginia (67/12/5/5)

Black chalk and stump and white chalk on blue paper. $10\frac{1}{2} \times 12\frac{7}{8}$ (267×327).
Four gypsies, two of them seated, round a pot cooking on a fire, a donkey on their left, in the foreground left; two packhorses in the foreground right; a log beside a pool in the foreground centre; a tower in the distance right.
PROVENANCE: Anon. sale, Sotheby's, 20 November 1963, Lot 8 bt. Fine Art Society, from whom it was purchased by C. F. Af Petersens; with Fine Art Society, from whom it was purchased.
EXHIBITED: Colnaghi's 1906 (3); *Forty-Fourth Exhibition Early English Water-colours and Drawings*, Fine Art Society, April 1964 (8).

Study for the landscape with gypsy encampment in the Tate Gallery (Waterhouse 936, repr. pl.132), painted about 1774–80. No changes were made in the finished picture

except for the enlargement of the figure group. The sketchy treatment of the figures and animals, the handling of the foliage and foreground detail, and the white chalk highlights breaking through the trees are identical with the wooded landscape with cows at a pool in the British Museum (Cat. No.434). Also mentioned on pp.40 and 44.

437 Wooded Landscape with Figures and Cattle at a Pool
John Tillotson, London

Black chalk and stump on brown paper, heightened with white. $9\frac{5}{16} \times 12\frac{1}{8}$ (237×308).
Two figures seated on a tree stump, and a boy with a staff under his left arm, accompanied by a dog, in the foreground right; two cows in the foreground left at a pool which stretches into the foreground right.
PROVENANCE: With Terry-Engell Gallery; with John Manning, from whom it was purchased 1958.
ENGRAVED: Thomas Gainsborough; published by J. & J. Boydell 1 August 1797.
EXHIBITED: *Tenth Exhibition: English and Continental Drawings*, John Manning, n.d. (= November 1958) (21); *The Tillotson Collection*, Hazlitt Gallery, October 1965 (30 and repr. pl.44).
ALSO REPRODUCED: *The Illustrated London News*, 8 November 1958, p.817; *The Manning Gallery 1953–1966*, London, 1966, pl.13.

Study for the soft-ground etching with aquatint (Boydell 4). No changes were made in the finished print except for the inclusion of a cottage in the middle distance right. The treatment of the tree trunks, the foliage, the cows and the foreground rushes is closely related to the landscape with cows at a pool in the British Museum (Cat. No.434).

438 Wooded Upland Landscape with Horsemen and Buildings
Ehemals Staatliche Museen, Berlin-Dahlem (4549)

Black chalk and stump and white chalk on grey prepared paper. $10\frac{15}{16} \times 15\frac{1}{16}$ (278×383).
Two horsemen and a packhorse travelling along a winding road in the middle distance centre; buildings on a hillside in the middle distance centre; a church higher up the hill in the middle distance right; hills in the distance centre.
PROVENANCE: Presented by an unknown donor 1911.
BIBLIOGRAPHY: Woodall 409.

The method of preparing the paper with grey

wash is similar to the coastal scene in the British Museum (Cat. No.431), and the treatment of the foliage and the scattered highlights in white chalk are closely related to the wooded landscape with cows at a pool also in the British Museum (Cat. No.434) and the wooded landscape with horseman, figures and cottages at Birmingham (Cat. No.445).

439 Wooded Landscape with Cows standing in a Pond
City Museum and Art Gallery, Birmingham (207'53)

Black and coloured chalks on grey-blue paper. $9\frac{9}{16} \times 12\frac{3}{8}$ (243×314).
Three cows standing in a pond in the foreground centre.
PROVENANCE: Otto Gutekunst; Guy Bellingham Smith, who sold it to Colnaghi, from whom it was purchased by J. Leslie Wright 1936; bequeathed 1953.
EXHIBITED: Colnaghi's 1906 (12); Oxford 1935 (33); Sassoon 1936 (36); *Masters of British Water-Colour: The J. Leslie Wright Collection*, R.A., October–November 1949 (85); *Paintings and Drawings by British Artists from the City of Birmingham Art Gallery*, National Library of Wales, Aberystwyth, 1956 (27).
BIBLIOGRAPHY: Woodall 395.

The rhythmical conception is similar to the landscape with horses in coloured chalks owned by John Nicholas Brown (Cat. No.406), and the chalkwork to the landscape with horses and cows in Kansas City (Cat. No.402). But the subject, the treatment of the foliage and foreground detail, and the use of white chalk bursting through the trees are most closely related to the wooded landscape with cows in a pool in the British Museum (Cat. No.434).

440 Wooded Landscape with Herdsman, Cattle and Cottage
Mr and Mrs Eric H. L. Sexton, Camden, Maine
Black chalk and stump and white chalk on buff paper. $6\frac{1}{2} \times 8\frac{3}{16}$ (165×208).
A herdsman driving cattle up a path into a wood in the foreground right; part of a cottage half-hidden by trees in the middle distance centre; a sheep by a pool in the foreground left; a sailing vessel in the distance left, with a low cliff beyond.
PROVENANCE: Rev. Stopford A. Brooke; Brooke sale, Sotheby's, 14 December 1939, Lot 159 bt. Sexton.

The handling is closely related to the wooded landscape with cows in a pool in the British Museum (Cat. No.434).

441 A Mountain seen between Trees

National Gallery of Canada, Ottawa (6304)

Black chalk and stump and white chalk on
grey-blue paper. $9\frac{1}{16} \times 12\frac{15}{16}$ (230×329).
A craggy mountain in the middle distance centre.
Inscribed in pencil on the old mount bottom centre:
Gainsborough (Nº 9 –.
PROVENANCE: Sir Michael Sadler; Anon. sale,
Sotheby's, 25 November 1953, Lot 5 bt. Colnaghi,
from whom it was purchased 1954.
EXHIBITED: *Old Master Drawings*, Colnaghi's,
June 1954 (48).
BIBLIOGRAPHY: Woodall 280.

The loose treatment of the foliage is closely
related to the landscape with horsemen in
Cincinnati (Cat. No.435).

442 Wooded Landscape with Figures on Horseback and Cattle Plate 441

British Museum, London (1901–1–4–2)

Black chalk and stump and white chalk.
$8\frac{1}{4} \times 12\frac{11}{16}$ (210×322).
Some cattle descending a slope in the foreground
left; two figures on horseback in the middle
distance left; a pond in the foreground centre;
a mountain in the distance right.
PROVENANCE: Henry Vaughan; bequeathed 1901.
BIBLIOGRAPHY: Gower *Drawings*, p.13 and repr.
pl.XXIII; Laurence Binyon, *Landscape in English
Art and Poetry*, London, 1931, p.71 and repr.
fig.13; Woodall 163.

The treatment of the foliage and the foreground
reeds is closely related to the landscape with
horsemen in Cincinnati (Cat. No.435). Also
mentioned on p.88.

443 Wooded Landscape with Horsemen, Figures and Bridge

Pierpont Morgan Library, New York (III, 61)

Black chalk and stump, heightened with white.
$8\frac{1}{2} \times 12\frac{5}{8}$ (216×321).
Three figures on horseback, accompanied by two
figures on foot, travelling by the side of a stream
in the foreground centre; a figure with a staff,
and a baby on his shoulder, accompanied by a
dog, and two seated figures, in the foreground
left; a hump-back bridge in the distance left.
PROVENANCE: Charles Fairfax Murray, from whom
it was purchased by J. Pierpont Morgan 1910.
EXHIBITED: *Six Centuries of Master Drawings*, State
University of Iowa, Iowa City, Summer 1951 (96).
BIBLIOGRAPHY: Chamberlain, pp.166–8, repr. p.75;
*J. Pierpont Morgan Collection of Drawings by the Old

Masters formed by C. Fairfax Murray*, Vol.III, London,
1912, No.61 and repr. pl.61; Woodall 459.

The treatment of the foliage and figures is
close to the landscape with horsemen in Cincin-
nati (Cat. No.435).

444 Wooded Landscape with Figures, Horses and Buildings

T. Van Norden, New York

Black chalk and stump and white chalk on grey
paper. $9\frac{1}{2} \times 12\frac{1}{4}$ (241×311).
A figure driving four horses down a track in the
foreground centre; two figures at a gateway in a
wall in the foreground left; two figures outside a
cottage in the foreground right; a house in the
middle distance left (from a photograph).
PROVENANCE: Dr Cobbold; Howard Bliss; with
Leicester Galleries, who sold it to Spink, from whom
it was purchased 1954.
EXHIBITED: *From Gainsborough to Hitchens*, The
Leicester Galleries, January 1950 (8).

From a poor reproduction, the shadowy treat-
ment of the figures and animals, the handling
of the foliage, and the scattered highlights in
white chalk seem to be related to the wooded
landscape with horsemen in Cincinnati (Cat.
No.435).

445 Wooded Landscape with Horseman, Figures and Cottages

City Museum and Art Gallery, Birmingham
(201'53)

Black chalk and stump on grey prepared paper,
heightened with white. $9\frac{7}{16} \times 13\frac{1}{4}$ (240×337).
A figure on horseback, accompanied by another
figure on one side and a cow on the other, travelling
along a track in the foreground left; two logs in
the foreground centre; two figures in the middle
distance right; cottages in the middle distance
centre and right.
PROVENANCE: With Agnew; Ernest C. Innes; Mrs
Innes sale, Christie's, 13 December 1935, Lot 30 bt.
Colnaghi, from whom it was purchased by J. Leslie
Wright; bequeathed 1953.
EXHIBITED: Sassoon 1936 (59); *Masters of British
Water-Colour: The J. Leslie Wright Collection*, R.A.,
October–November 1949 (80).
BIBLIOGRAPHY: Woodall 378.

The way in which the paper is prepared is
similar to the coastal scene in the British Mu-
seum (Cat. No.431), and the treatment of the
foliage and the scattered white highlights to the
landscape with cows at a pool also in the

British Museum (Cat. No.434) or the wooded landscape with horsemen in Cincinnati (Cat. No.435).

446 Wooded Landscape with Horseman and Buildings Plate 137
Mrs Cecil Keith, Rusper

Black chalk and stump, white and coloured chalks on blue paper. $12\frac{3}{16} \times 15\frac{7}{8}$ (313×403).
A figure on horseback leading a horse along a winding track in the foreground centre: buildings in the middle distance left and right; a church tower in the distance centre.
PROVENANCE: Arthur Kay; Kay sale, Christie's, 23 May 1930, Lot 14 bt. Agnew; Ernest C. Innes; Mrs Innes sale, 13 December 1935, Lot 28 bt. Colnaghi, from whom it was purchased by J. Leslie Wright; bequeathed to Birmingham City Art Gallery (with a life-interest to his daughter) 1953.
EXHIBITED: Ipswich 1927 (140); *British Art*, R.A., January–March 1934 (702); Sassoon 1936 (75); *Early English Water-Colours from the Collections of J. Leslie Wright and Walter Turner*, Birmingham Art Gallery, April 1938 (88); *Two Hundred Years of British Painting*, Public Library and Art Gallery, Huddersfield, May–July 1946 (29); Aldeburgh 1949 (37); *Masters of British Water-Colour: The J. Leslie Wright Collection*, R.A. October–November 1949 (87); Bath 1951 (50); Nottingham 1962 (48); *English Watercolour Drawings from the collection of Mrs Cecil Keith*, Worthing Art Gallery, March 1963 (8).
BIBLIOGRAPHY: *Commemorative Catalogue of the Exhibition of British Art 1934*, Oxford, 1935, No.607 and repr. pl.CXLVIII (b); Woodall 379, p.52 and repr. pl.58; Martin Hardie, *Water-colour Painting in Britain 1. The Eighteenth Century*, London, 1966, pp.75–6.

The treatment of the figure and horses, the banks and the foliage, and the use of scattered highlights are identical with the landscape with herdsman and cow in Birmingham (Cat. No. 445). The use of brown and orange coloured chalks is paralleled in the wooded landscape owned by George Goyder (Cat. No.405).

447 Wooded Landscape with Figures outside a Cottage Door
Public Art Gallery, Dunedin, N.Z.

Grey wash and white chalk. $10\frac{1}{2} \times 13\frac{1}{2}$ (267×343).
Nine or ten figures, most of them seated, with a dog, on a flight of steps outside the door of a thatched cottage in the foreground centre and right; a stream winding from the middle distance left into the foreground right.
PROVENANCE: Given by the artist to his pupil Miss Charlotte Warren; by descent to Mrs Warren-Codrington; Warren-Codrington sale, Christie's, 27 May 1949, Lot 2 bt. James; with Fine Art Society, from whom it was purchased.

The loose treatment of the foliage and foreground reeds is related to the landscape with horsemen in Cincinnati (Cat. No.435). The subject of the 'cottage door' was to become a recurrent theme in Gainsborough's work during the last decade of his life. Also mentioned on p.70.

448 Wooded Landscape with Figures and Cattle Plate 371
Public Art Gallery, Dunedin, N.Z.

Grey wash and white chalk. $10\frac{1}{2} \times 13\frac{1}{2}$ (267×343).
A herdsman and a milkmaid, accompanied by a dog, talking to a seated herdsman in the foreground right; three cows with a cottage behind in the middle distance right.
PROVENANCE: Given by the artist to his pupil Miss Charlotte Warren; by descent to Mrs Warren-Codrington; Warren-Codrington sale, Christie's, 27 May 1949, Lot 1 bt. James; with Fine Art Society, from whom it was purchased.

The treatment of the figures and foliage is identical with the previous drawing (Cat. No. 447), to which it is a companion. A copy by Miss Warren was formerly owned by Wing Commander John Higginson (Plate 370). Also mentioned on p.70.

449 Wooded Landscape with Figures going to Market
Sir Trenchard Cox, London

Black chalk and stump and grey wash, heightened with white. $10\frac{3}{4} \times 13\frac{7}{8}$ (273×352).
Two figures on horseback and two other figures, accompanied by a dog, travelling along a country track in the middle distance centre; a pool in the foreground centre.
PROVENANCE: With Frank T. Sabin; with Colnaghi, from whom it was purchased 1950.
EXHIBITED: *Works of Art belonging to the Friends of the Art Gallery*, City of Birmingham Museum and Art Gallery, February–March 1962 (64).

The treatment of the figures and the loose scallops outlining the foliage are closely related to the cottage door in Dunedin (Cat. No.447).

450 Wooded Landscape with a Peasant Family outside their Cottage Door
City Museum and Art Gallery, Birmingham
(203′53)

Grey wash on buff paper. $8\frac{7}{8} \times 12\frac{7}{8}$ (225×327).
A group of eight figures outside the open door of a cottage in the foreground right.
PROVENANCE: With Palser Gallery, from whom it was purchased by J. Leslie Wright; bequeathed 1953.

The summary suggestion of the figures and the treatment of wash are related to the cottage door in Dunedin (Cat. No.447).

451 Cottage with Peasant Family and Woodcutter returning home
City Museum and Art Gallery, Birmingham
(187′53)

Pen and grey-black ink, grey and grey-black washes and white chalk over a rough pencil outline. $10\frac{9}{16} \times 13\frac{11}{16}$ (268×348).
A cottage in the middle distance centre with a figure standing in the doorway, a mother seated outside holding a child, three children seated to the left, and two figures seated and another reclining to the right; a woodcutter with a bundle of faggots over his shoulder returning home in the foreground right; a pool in the middle distance centre and right.
PROVENANCE: Mrs Hibbert of Lyonshall; Anon. (= Hibbert) sale, Robinson and Fisher, 29 October 1936, Lot 172 bt. Colnaghi, from whom it was purchased by J. Leslie Wright; bequeathed 1953.
EXHIBITED: *Old Master Drawings*, Colnaghi's, November–December 1936 (7 and repr. frontispiece); *Early English Water-Colours from the Collections of J. Leslie Wright and Walter Turner*, Birmingham Art Gallery, April 1938 (94); *Masters of British Water-Colour: The J. Leslie Wright Collection*, R.A., October–November 1949 (63); *L'Aquarelle Anglaise 1750–1850*, Musée Rath, Geneva, October 1955–January 1956 and L'Ecole Polytechnique Fédérale, January–March 1956 (59); *Paintings and Drawings by British Artists from the City of Birmingham Art Gallery*, National Library of Wales, Aberystwyth, 1956 (28); Arts Council, 1960–1 (34, and pp.6 and 7); *English Drawings and Water Colors from British Collections*, National Gallery of Art and the Metropolitan Museum of Art, February–June 1962 (40); *De Engelse Aquarel uit de 18ᵈᵉ Eeuw van Cozens tot Turner*, Rijksmuseum, April–May 1965 and Albertina, June–July 1965 (46).
BIBLIOGRAPHY: Woodall 401.

The treatment of the figures, foliage and foreground detail are related to the cottage door in Dunedin (Cat. No.447).

452 Wooded Landscape with Figures outside a Cottage Door Plate 418
Mr and Mrs Paul Mellon, Oak Spring, Virginia (64/2/17/5)

Pen and ink with grey wash, heightened with white. $9\frac{1}{4} \times 13\frac{5}{8}$ (235×346).
A woman standing at the door of a cottage, with a woodcutter returning home with a bundle of faggots over his left shoulder, and three other figures seated on the steps in the foreground left; another woman, holding a baby and accompanied by a girl and a small child, outside the cottage in the foreground centre.
PROVENANCE: William Russell; Anon. sale, Sotheby's, 20 November 1963, Lot 7 (repr). bt. Colnaghi, from whom it was purchased 1964.

The loose scallops outlining the foliage and contours of the figures are closely related to the landscape with riders owned by Sir Trenchard Cox (Cat. No.449).

453 Wooded Landscape with Woodcutter and Horses
Private Collection, England

Pen and grey ink and grey wash, heightened with white. $10\frac{11}{16} \times 13\frac{11}{16}$ (271×348).
A woodcutter loading a bundle of faggots onto a horse and a second horse already laden in the foreground centre; a pool in the foreground left; a fountain and trough in the foreground right; a hill in the distance left.
PROVENANCE: Rev. Stopford A. Brooke; Brooke sale, Sotheby's, 14 December 1939, Lot 156 bt. G. D. Thomson; Anon. sale, Christie's, 3 March 1970, Lot 48 (repr.) bt. in.

The handling of the foreground grasses and the tree trunk on the right, the scallops outlining the foliage, and the broken contours modelling the woodcutter and horses are closely related to the cottage door in the Mellon collection (Cat. No.452), though the dense treatment of the foliage is closer to the cottage door in Dunedin (Cat. No.447).

454 Wooded Landscape with Cows
Pierpont Morgan Library, New York
(III, 63a)

Grey wash, with touches of black, red and white chalk. $10\frac{1}{8} \times 13\frac{5}{8}$ (257×346).
Three cows standing in a pool in the middle distance right.
ENGRAVED: Thomas Gainsborough (unpublished).
PROVENANCE: Charles Fairfax Murray, from whom

it was purchased by J. Pierpont Morgan 1910.
EXHIBITED: *Retrospective Exhibition of Landscape Painting*, Wadsworth Atheneum, Hartford, January–February 1931; *The Art of Eighteenth Century England*, Smith College Museum of Art, January 1947 (33).
BIBLIOGRAPHY: *J. Pierpont Morgan Collection of Drawings by the Old Masters formed by C. Fairfax Murray*, Vol.III, London, 1912, No.63a and repr. pl.63a.

Study for the aquatint of which an impression is in the Tate Gallery (2722). No alterations were made in the finished print. The modelling of the branches, the scallops outlining the foliage, and the broken contours of the cows are closely related to the cottage door in the Mellon collection (Cat. No.452) and the wooded landscape with woodcutter and horses formerly in the Stopford Brooke collection (Cat. No.453).

455 Wooded Upland Landscape with Shepherd, Sheep and Cottages
Mrs Dorothy Harza, Winnetica, Illinois

Pen and grey ink, traces of black chalk and stump. $8\frac{7}{16} \times 10\frac{9}{16}$ (214 × 268).
A shepherd surrounded by four or five sheep on a bank in the foreground left; a cottage on a hillside in the middle distance right; another cottage higher up in the distance right; a track winding from the foreground left into the middle distance centre.
Collector's mark of William Esdaile bottom right. Annotated on the verso bottom left in ink, by William Esdaile: *(1)833 WE 12×Dr Monro's sale. Gainsborough.*
PROVENANCE: Dr Thomas Monro; Monro sale, Christie's, 26 June 1833 ff.; William Esdaile; Esdaile sale, Christie's, 20–1 March 1838.
EXHIBITED: *The Cunning Hand: Drawings by English and Anglicized Artists*, Sabin Galleries, October–November 1969 (7 repr.)
BIBLIOGRAPHY: *The Burlington Magazine*, October 1969, p.627 and repr. fig.62.

The penwork and treatment of the foliage are closely related to the wooded landscape with cows at a pool in the Morgan Library (Cat. No. 454), but the broad stump-work and rhythmical composition look forward to Gainsborough's work of a few years later.

456 Coast Scene with Horsemen and Sailing Boat
Ownership unknown

Pen, black chalk and stump. $8\frac{3}{4} \times 10$ (222 × 254).
Three horsemen in the foreground left travelling towards the shore; rising ground in the foreground right; a sailing boat at sea in the middle distance centre (from a photograph).
PROVENANCE: Arthur Kay; Kay sale, Christie's, 23 May 1930, Lot 46 bt. P. M. Turner.
EXHIBITED: Ipswich 1927 (124).
BIBLIOGRAPHY: Woodall 317.

The loose scallops outlining the foliage and broken contours modelling the banks and horsemen are identical with the upland landscape owned by Mrs Harza (Cat. No.455).

457 Wooded Landscape with Herdsman and Cattle
Earl Spencer, Althorp

Grey wash, with traces of black chalk, heightened with white. $10\frac{3}{8} \times 13\frac{1}{2}$ (264 × 343).
A herdsman holding a staff, and accompanied by a dog, standing under a large tree in the middle distance centre; five cows in the middle distance left; a milkmaid milking a cow, and two more cows, in the middle distance right; a pool in the foreground.
Collector's mark of Earl Spencer bottom right.
PROVENANCE: By descent.
EXHIBITED: Oxford 1935 (16); Sassoon 1936 (68).
BIBLIOGRAPHY: Woodall 293.

The treatment of the foliage and foreground detail and the broken contours of the cows are closely related to the wooded landscape with cows at a pool in the Morgan Library (Cat. No. 454).

458 Wooded Landscape with Shepherd and Sheep
Ownership unknown

Grey wash. $10\frac{1}{2} \times 13\frac{1}{2}$ (267 × 343).
A shepherd and nine sheep in the foreground centre; a track which winds from the foreground right into the distance left (from a photograph).
PROVENANCE: E. A. Lewis; P. M. Turner; with Fine Art Society 1946.
EXHIBITED: Ipswich 1927 (169); Oxford 1935 (20); *Desenul şi Gravura Engleză*, Muzeul Toma Stelian, Bucharest, December 1935–March 1936 (126).
BIBLIOGRAPHY: Woodall 335.

The loose scallops outlining the foliage and the summary contours of the figure and sheep are closely related to the wooded landscape with herdsman and cows at Althorp (Cat. No.457).

459 Wooded Landscape with Figures and Cattle
Le Marquis de Chasseloup Laubat, Marennes

Grey wash, with some white chalk and traces of pencil. 10⅝ × 13½ (270 × 343).
Two figures descending a winding path in the foreground centre; three cows in a pool in the foreground right; a mountain in the distance right.
PROVENANCE: Unknown.

The loose scallops outlining the foliage and the broken contours of the figures and animals are identical with the wooded landscape with shepherd and sheep at Althorp (Cat. No.458).

460 Wooded Landscape with Cows
Plate 363
Earl Spencer, Althorp

Grey and grey-black washes, with traces of brown chalk, heightened with white. 10⅝ × 13¹³⁄₁₆ (270 × 351).
A pool in the foreground left and centre, behind which two cows are standing in the middle distance left.
Collector's mark of Earl Spencer bottom right.
PROVENANCE: By descent.
EXHIBITED: Oxford 1935 (7); Sassoon 1936 (62); *Treasures from Althorp*, Victoria and Albert Museum, March–May 1970 (M19).
BIBLIOGRAPHY: Woodall 294 and p.63.

The scallops outlining the foliage, the modelling of the cows, and the handling of wash are identical with the landscape with figures and cows owned by the Marquis de Chasseloup Laubat (Cat. No.459). Also mentioned on p.66.

461 Wooded Landscape with Church Tower
Ownership unknown

Grey wash. Size unknown.
A church tower behind trees in the middle distance left; low hills in the distance centre (from a photograph).
PROVENANCE: Formerly with Spink.

The treatment of the foliage and handling of wash are closely related to the landscape with cows at Althorp (Cat. No.460).

462 Wooded Landscape with Country Cart
Earl Spencer, Althorp

Grey wash. 10⅜ × 13¾ (264 × 349).
A cart with three figures inside, one of them reclining in the back, drawn by a single horse, in the foreground centre and travelling along a track which runs from the foreground centre into the distance right; hills in the distance right.
Collector's mark of Earl Spencer bottom right.
PROVENANCE: By descent.
EXHIBITED: Oxford 1935 (5); Sassoon 1936 (66).
BIBLIOGRAPHY: Woodall 296 and p.63.

Related in composition to, and probably a first idea for, the soft-ground etching published in 1780 (Boydell 3). The principal differences in the latter are the inclusion of a large rock among the trees on the left and the presence of a second cart. The loose scallops outlining the foliage, the contours to the figures and horse, and the treatment of wash are closely related to the wooded landscape with cows also at Althorp (Cat. No.460).

463 Wooded Landscape with Figures and Cottage
Ownership unknown

Pen and brown ink and grey wash. 9¹⁄₁₆ × 10⁷⁄₁₆ (230 × 265).
Two figures with pails, one of them seated, in the foreground right; a cottage among trees in the middle distance right (from a photograph).
PROVENANCE: Tony Straus-Negbaur; Straus-Negbaur sale, Cassirer and Helbing, Berlin, 25 November 1930, Lot 47 (repr. pl.IX).
BIBLIOGRAPHY: Woodall 427.

The very loose scallops outlining the foliage and the contours of the tree trunks and banks are identical with the landscape with country cart at Althorp (Cat. No.462).

464 Upland Landscape with Market Cart, Cottages and Figures Plate 145
National Gallery of Victoria, Melbourne (2228/4)

Grey wash, heightened with white.
10⁹⁄₁₆ × 13⅝ (268 × 346).
A market cart in the foreground right, the peasant in the cart serving a woman, accompanied by two other figures, in the foreground centre; a seated figure outside a cottage in the middle distance left; a cottage in the middle distance right; hills in the distance centre.

Inscribed on the verso in an old hand: *Drawn by Gainsborough 1778* and *1833 WE 56+ Dr Monro's sale.*
PROVENANCE: Dr Thomas Monro; Monro sale, Christie's, 27 June 1833, Lot 158 bt. Thane; William Esdaile; Esdaile sale, Christie's, 20–1 March 1838, probably 2nd Day Lot 675 bt. Rodd; with Spink, from whom it was purchased by Sir Thomas Barlow 1936; presented 1950.
BIBLIOGRAPHY: Woodall 301.

The loose scallops outlining the foliage and the broken contours of the figures and horse are closely related to the wooded landscape with horse and cart at Althorp (Cat. No.462). Also mentioned on pp.24, 38, 44 and 97.

465 Mountainous Landscape with a Boat on a Lake Plate 146
City Museum and Art Gallery, Birmingham (189'53)

Grey and grey-black washes on buff paper, heightened with white. $10\frac{3}{4} \times 14\frac{7}{16}$ (273×367).
A boat with figures on a lake in the foreground left; a craggy mountain in the distance left; a shepherd and scattered sheep amidst craggy rocks in the foreground right.
PROVENANCE: Sir George Donaldson; Henry Schniewind, Jr.; Anon. (= Schniewind) sale, Sotheby's, 25 May 1938, Lot 152 bt. Colnaghi, from whom it was purchased by J. Leslie Wright; bequeathed 1953.
EXHIBITED: Cincinnati 1931 (71 and repr. pl.72); *Masters of British Water-Colour: The J. Leslie Wright Collection*, R.A., October–November 1949 (65); *Watercolours from the Birmingham City Art Gallery*, Worthing Art Gallery, May–June 1960 (11); *De Engelse Aquarel uit de 18ᵈᵉ Eeuw van Cozens tot Turner*, Rijksmuseum, April–May 1965 and Albertina, June–July 1965 (47); *Peintures et Aquarelles Anglaises 1700–1900 du Musée de Birmingham*, Musée des Beaux Arts, Lyons, 1966 (52 and p.7); *Dvě století britského malířství od Hogartha k Turnerovi*, National Gallery, Prague and Bratislava, 1969 (64).
BIBLIOGRAPHY: Woodall 384.

The loose scallops outlining the foliage, the broken contours modelling the distant mountain, and the treatment of wash are identical with the landscape with country cart and cottage in Melbourne (Cat. No.464). Also mentioned on p.52.

466 Wooded Landscape with Figures outside a Cottage, and Donkeys
Sir O. W. Williams-Wynn, Dolben

Black chalk and grey wash, heightened with white. $10\frac{7}{16} \times 13\frac{7}{16}$ (265×341).
Two figures, one seated and the other standing, outside the door of a thatched cottage in the middle distance centre; a figure seated, with a dog, close to some steps in the foreground right; two donkeys beside a pile of faggots in the foreground left; a hill in the distance right.
PROVENANCE: By descent.

The handling is closely related to the landscape with horse and cart outside a cottage in Melbourne (Cat. No.464).

467 Wooded Landscape with Figures, Horse and Cart
Sir O. W. Williams-Wynn, Dolben

Grey wash. $10\frac{5}{16} \times 13\frac{7}{16}$ (262×341).
A man backing an unwilling horse between the shafts of a two-wheeled cart, and another placing the harness over the horse's back, in the foreground centre.
PROVENANCE: By descent.

The handling is closely related to the landscape with horse and cart at Althorp (Cat. No.462).

468 Wooded Landscape with Herdsman and Cattle
Victoria and Albert Museum, London (Dyce 681)

Grey and grey-black washes over pencil, heightened with white. $10\frac{5}{8} \times 13\frac{5}{8}$ (270×346).
A herdsman driving three cows along a country track which winds from the middle distance left in the foreground centre; a pool in the foreground left.
PROVENANCE: Rev. Alexander Dyce, who bequeathed it to the South Kensington Museum 1869.
BIBLIOGRAPHY: *Dyce Collection Catalogue*, London, 1874, p.100; Woodall 195 and p.63.

The loose scallops outlining the foliage and the treatment of the contours of the cows with the point of the brush are closely related technically to the landscape with horse and cart at Althorp (Cat. No.462).

469 Wooded Landscape with Herdsman and Cattle
Miss Maud Wethered, London

Pen and ink, traces of black chalk, grey and grey-black washes and white chalk.
10¼ × 13½ (260 × 343).
A herdsman driving five cows down a track at the edge of a wood which leads from the middle distance centre into the foreground right.
PROVENANCE: C. H. T. Hawkins; Hawkins sale, Christie's 29 March 1904, probably Lot 184 (with another) bt. Shepherd; Vernon Wethered; thence by descent.
BIBLIOGRAPHY: Woodall 349, pp.60 and 62–4 and repr. pl.72.

The modelling of the tree on the left, the abbreviated scallops outlining the foliage, and the handling of wash are closely related to the landscape with country cart at Althorp (Cat. No. 462).

470 Wooded Landscape with Milkmaid and Cows, Shepherd and Sheep
Ownership unknown

Grey and grey-black washes and white chalk.
11 × 13¾ (279 × 349).
A shepherd talking to a milkmaid milking a cow, with another cow behind, in the foreground left; nine sheep in the foreground centre; a pool stretching from the foreground right into the middle distance centre (from a photograph).
PROVENANCE: J. Heywood Hawkins; Henry J. Pfungst; Pfungst sale, Christie's, 15 June 1917, Lot 53 (repr.) bt. Blaker; F. Hayward; Hayward sale, Christie's, 15 February 1929, Lot 54 bt. in.
BIBLIOGRAPHY: Woodall 266.

The outlining and modelling of the animals and the scallops of the foliage are identical with the landscape with herdsman and cattle owned by Miss Maud Wethered (Cat. No.469).

471 Wooded Landscape with Herdsman and Cattle
Private Collection, London

Grey and grey-black washes, heightened with white. 10⅛ × 13½ (257 × 343).
A herdsman driving three cows along a track between trees in the middle distance centre.
PROVENANCE: Lord Portarlington; Portarlington sale, Dublin, about 1920–2, bt. Aubrey Toppin; Toppin sale, Sotheby's, 19 June 1969, Lot 54 (repr.) bt. in; Anon. sale, Sotheby's, 18 June 1970, Lot 104 bt. in.

BIBLIOGRAPHY: Woodall 312, pp.60–4 and repr. pl.71.

The scallops outlining the foliage, the contours of the animals, and the handling of wash are closely related to the landscape with country cart at Althorp (Cat. No.462) and the landscape with herdsman and cattle owned by Miss Maud Wethered (Cat. No.469).

472 Wooded Landscape with Figures on Horseback crossing a Bridge
Mr and Mrs Paul Mellon, Oak Spring, Virginia (M5)

Pen and grey ink with grey wash, heightened with white. 10⅜ × 13½ (264 × 343).
Two horsemen crossing a wooden bridge over a stream in the foreground centre, with two figures and a dog slightly behind them in the foreground left.
PROVENANCE: Henry Temple, 2nd Viscount Palmerston; Robert von Hirsch; Anon. sale, Sotheby's, 18 June 1952, Lot 14 bt. Colnaghi, from whom it was purchased by William Selkirk; Selkirk sale, Sotheby's, 3 May 1961, Lot 88 bt. Colnaghi, from whom it was purchased 1961.
ENGRAVED: W. F. Wells, published by Wells and Laporte 1 December 1802 (as in the collection of Viscountess Palmerston).
BIBLIOGRAPHY: Woodall 435 and p.63.

The broad scallops outlining the foliage and the handling of wash are closely related to the wooded landscape with herdsman and cows formerly owned by Aubrey Toppin (Cat. No. 471).

473 Wooded Landscape with Shepherd, Sheep, Horses and Cart
Guy Millard, London

Pen and grey ink, with grey wash, heightened with white. 10 3/16 × 13½ (259 × 343).
A shepherd with a flock of sheep in the foreground left; two horses in the middle distance centre; a shed in the middle distance left; an empty cart in the middle distance right; a pond in the foreground centre and right.
PROVENANCE: Sir Robert Witt; with Agnew, from whom it was purchased 1945.
EXHIBITED: British Art, R.A., January–March 1934 (1137); Drawings of the Old Masters from the Witt Collection, Victoria and Albert Museum, January–May 1943.
BIBLIOGRAPHY: Commemorative Catalogue of the Exhibition of British Art 1934, Oxford, 1935, No.608; M. T. Ritchie, English Drawings, London, 1935,

repr. pl.24; Woodall 366, pp.60, 62, 63–4 and repr. pl.73.

Study for the landscape with shepherd, sheep and cart-horses in the Duke of Rutland's collection (Waterhouse 963), painted about 1780–2. No changes were made in the finished picture except for the omission of the shed on the left and the inclusion of a boy sleeping on the shafts of the cart and a basket of fodder. The scallops outlining the foliage, the handling of the tree trunks, and the use of wash are closely related to the landscape with country cart at Althorp (Cat. No.462). Also mentioned on pp. 40 and 102.

474 Wooded Landscape with Farm Cart and Figures outside a Cottage Plate 150
Private Collection, London

Grey and grey-black washes and white chalk. 11 × 13⅞ (279 × 352).
A farm cart drawn by a single horse with a carter standing up inside it and a woman leaning over the back serving vegetables in the foreground centre; a woman kneeling on a bank taking the vegetables, accompanied by a woman with a child, and two figures, one of them seated, on some steps outside a cottage door, in the foreground right; a flock of sheep in the middle distance left.
PROVENANCE: Unknown.

The loose treatment of the foliage and the broken contours outlining the horse and figures are closely related to the landscape with country cart and cottage in Melbourne (Cat. No.464). Also mentioned on p.14.

475 Wooded Landscape with Herdsman and Cattle Plate 149
Private Collection, London

Grey and grey-black washes, and white chalk. 10¹³⁄₁₆ × 13¹³⁄₁₆ (275 × 351).
A drover driving five cows down a track between rocky banks in the foreground centre; two figures, one of them seated, in the foreground left; the roof of a cottage, with its chimney smoking, visible above the trees in the middle distance right.
PROVENANCE: Unknown.

The loose scallops outlining the foliage, the broken contours of the figures and animals, and the treatment of wash are identical with the previous drawing (Cat. No.474), to which it is a companion.

476 Wooded Landscape with Shepherd and Sheep
Ownership unknown

Grey and grey-black washes, heightened with white. 10¼ × 13½ (260 × 343).
A shepherd surrounded by a number of sheep on a bank in the foreground left; a cottage in the middle distance right; a hill in the distance centre.
PROVENANCE: Rev. E. Gardiner; Miss A. G. Bickham, who bequeathed it to the Manchester University Settlement; Manchester University Settlement sale, Christie's, 25 November 1927, Lot 16 bt. Agnew, from whom it was purchased by Count Sala.
BIBLIOGRAPHY: Mrs Bell, repr. f. p.13; Gower, repr. f. p.86; Woodall 1.

The broken scallops outlining the foliage and the rough treatment of the foreground are closely related to the landscape with herdsman and cattle in a London private collection (Cat. No.475).

477 Wooded Landscape with Figure unloading Packhorses outside a Mill
Plate 148
City Museum and Art Gallery, Birmingham (210′53)

Grey and grey-black washes, with some traces of black chalk, on buff paper, heightened with white. 10⅜ × 13¹⁄₁₆ (264 × 332).
A mill with a man unloading three packhorses on a bridge and two figures resting in the middle distance centre and right; two other figures in the middle distance centre; a stream in the foreground.
PROVENANCE: Philip, 2nd Earl of Hardwicke; by descent to Amabel, Baroness Lucas; Lucas sale, 29 June 1926, Lot 34 bt. Sabin; with Palser Gallery; J. Leslie Wright, by whom it was bequeathed.
EXHIBITED: *Early English Water Colours*, Palser Gallery, Summer 1937 (41), Summer 1938 (47) and April–May 1940 (55); *Masters of British Water-Colour: The J. Leslie Wright Collection*, R.A., October–November 1949 (88); *Panorama of European Painting Rembrandt to Picasso*, Opening Exhibition, Rhodes National Gallery, Salisbury, Rhodesia, July–September 1957 (231); *De Engelse Aquarel uit de 18de Eeuw van Cozens tot Turner*, Rijksmuseum April–May 1965 and Albertina June–July 1965 (45).
BIBLIOGRAPHY: Woodall 276.

The loose scallops outlining the foliage and summary contours of the figures and animals are closely related to the wooded landscape with shepherd and sheep formerly in the Gardiner collection (Cat. No.476). Also mentioned on p.51.

478 Wooded Landscape with Figures outside a Cottage Plate 147
H.R.H. The Duchess of Kent, Coppins

Grey and grey-black washes, and white chalk.
$10\frac{11}{16} \times 13\frac{5}{8}$ (271 × 346).
A woman standing at the door of a cottage, with a mother and child, a dog, and another woman seated on the steps outside, and four children and a dog playing just in front, in the foreground centre and right; a woodcutter with a bundle of faggots over his shoulder returning from work in the foreground left.
PROVENANCE: Mrs J. Egerton, from whom it was acquired by Sir William Worsley; given by him to his daughter.
EXHIBITED: Sassoon 1936 (35); *English Watercolours from Yorkshire Houses 1660–1860*, Scarborough Art Gallery, June–July 1950 (7); *Peintures Anglaises des Collections d'York et de Yorkshire*, Musée des Beaux Arts, Dijon, 1957 (51); Arts Council 1960–1 (35, and pp.6, 7 and 8).
BIBLIOGRAPHY: Mary Chamot, *Gainsborough as a Landscape Painter*, Country Life, 29 February 1936, repr. p.215; Woodall 46, p.64 and repr. pl.74; *Early English Water-Colours at Hovingham Hall*, York, 1957, Cat.17 and p.1.

Study for the landscape with figures at a cottage door in Cincinnati (Waterhouse 940, repr. pl. 192), painted about 1774–80. In the finished picture only very slight additions were made, notably the inclusion of a broom on the right, but the figure group was tightened up considerably. The scallops outlining the foliage and the handling of wash are related to the wooded landscape with shepherd and sheep formerly in the Gardiner collection (Cat. No.476). Also mentioned on pp.18, 40, 44, 52 and 79.

479 Wooded Landscape with a Peasant Family outside their Cottage Door
City Museum and Art Gallery, Birmingham (199'53)

Grey wash, heightened with white.
$10\frac{5}{16} \times 13\frac{3}{8}$ (262 × 340).
A group of seven figures outside the open door of a cottage in the middle distance right; a pond in the foreground right.
Inscribed on the old mount: *Original sketch by Thos Gainsborough from Lady Stewarts Collection*.
PROVENANCE: Lady Stewart; Guy Bellingham Smith; J. Leslie Wright, who bequeathed it 1953.
EXHIBITED: Oxford 1935 (60); *Early English Water-Colours from the Collections of J. Leslie Wright and Walter Turner*, Birmingham Art Gallery, April 1938 (93); *Masters of British Watercolour: The J.*

Leslie Wright Collection, R.A., October–November 1949 (76); *Watercolours from the Birmingham City Art Gallery*, Worthing Museum and Art Gallery, May–June 1960 (6).
BIBLIOGRAPHY: Woodall 394.

The broad treatment of wash is related to the cottage door owned by the Duchess of Kent (Cat. No.478).

Early 1780's

480 Wooded Landscape with Horseman and Horse drinking at a Trough
Ownership unknown

Brown wash heightened with white, varnished.
$9\frac{9}{16} \times 7\frac{5}{16}$ (243 × 186).
A figure on a white horse in the foreground centre, with a brown horse drinking at a trough; high rocks behind the trough in the foreground right (from a photograph).
PROVENANCE: Among the drawings left by the artist to his wife, which descended through Margaret Gainsborough and Sophia Lane to Richard Lane; Lane sale, Christie's, 25 February 1831, Lot 101 (with another) bt. Tiffin; Charles Fairfax Murray; Henry J. Pfungst; Pfungst sale, Christie's, 15 June 1917, Lot 5 bt. Sir George Donaldson; Henry Schniewind, Jr.
EXHIBITED: Colnaghi's 1906 (62); Cincinnati 1931 (70 and repr. pl.70).
BIBLIOGRAPHY: Chamberlain, p.168 and repr. p.79; E. S. Siple, 'Gainsborough Drawings: The Schniewind Collection', *The Connoisseur*, June 1934, pp.357–8 and repr. p.358; Woodall 471.

Study for the landscape with horses watering at a trough in the possession of Charles M. Williams (Waterhouse 944), exhibited R.A. 1780. A rough sketch for the central motif of this composition: in the finished picture there is a vista on the left with distant village and mountain, and a dog drinking at the trough on the right. The loose scallops outlining the foliage and the broken contours of the figure and horses are closely related to the landscape with herdsman and cattle in a London private collection (Cat. No.475). The motif of horses drinking at a trough with rocks behind was used in an imitation in the Cleveland Museum of Art, attributable to Barker (Plate 398). Also mentioned on p.38.

481 Coastal Scene with Fishermen hauling Nets and Ruined Castle
Plate 153
Museum and Art Gallery, Bolton

Grey and grey-black washes and white chalk, with traces of black chalk, on pale buff paper.
$10\frac{5}{8} \times 14\frac{1}{8}$ (270 × 359).
Two fishermen hauling in nets in the foreground centre, with a basket behind them on the shore; a rowing boat at anchor in the foreground left; a half-ruined castle in the middle distance centre; two sailing boats at sea in the middle distance left.
PROVENANCE: With Duveen; Malcolm Macdonald; with Fine Art Society, from whom it was purchased 1958.
EXHIBITED: *English Painting*, California Palace of the Legion of Honor, San Francisco, June–July 1933 (79); *Primitives to Picasso*, R.A., January–March 1962 (357).

Study for the coastal scene with fishermen dragging nets in the Fairhaven collection (Waterhouse 956, repr. pl.226), exhibited R.A. 1781. No changes were made in the finished picture except for the inclusion of a dog and a boy loading fish into the basket on the right and some slight variations in the boats in the middle distance left. The broad treatment of wash is related to the wooded landscape with shepherd and sheep formerly in the Gardiner collection (Cat. No.476). Also mentioned on pp.38, 44 and 45.

482 Wooded Landscape with Buildings, Figures and Animals
A. C. Greg, Acton Bridge

Grey wash, heightened with white.
$10\frac{3}{4} \times 14\frac{7}{16}$ (273 × 367).
Two figures on a track in the foreground right; a cow and some sheep in the foreground left; a group of buildings half-hidden by trees in the middle distance right; hills in the distance left.
PROVENANCE: Unknown.

The broad treatment of wash is related to the coastal scene at Bolton (Cat. No.481).

483 Coastal Scene with Figures and Boats
John Wright, Spondon

Black and white chalks and grey wash.
$10\frac{3}{4} \times 14$ (273 × 356).
Five men pushing out a rowing boat in the foreground centre; a fisherman with a net over his shoulder and a basket in the foreground left; two figures reclining on the shore in the foreground right; two sailing boats at sea in the middle distance centre; a church and buildings on the cliff top in the distance right.
PROVENANCE: Alistair Horton; thence by descent.
EXHIBITED: *Works of Art belonging to the Friends of the Art Gallery*, City of Birmingham Museum and Art Gallery, February–March 1962 (63).

The broad treatment of wash is closely related to the coastal scene at Bolton (Cat. No.481). A more rapidly handled version is in Rotterdam (Cat. No.484). The double ended rowing boat is of a type usually found in East Anglia (information kindly supplied by Michael Robinson).

484 Coastal Scene with Figures and Boats
Museum Boymans–Van Beuningen, Rotterdam (E4)

Grey and grey-black washes and white chalk.
$10\frac{7}{8} \times 14\frac{3}{16}$ (276 × 363).
Five men pushing out a rowing boat in the foreground centre; a fisherman with a basket in the foreground left; two figures reclining on the shore in the foreground right; two sailing boats at sea in the middle distance centre; some sheep on the cliff top in the distance right.
Collector's mark of Franz Koenigs on the verso bottom left.
PROVENANCE: J. Heywood Hawkins; Henry J. Pfungst; Pfungst sale, Christie's 15 June 1917, Lot 60 (with another) bt. Carpenter; Franz Koenigs.
EXHIBITED: *Oude Engelsche Schilderijen . . . in Nederlandsche Verzamelingen*, Museum Boymans, Rotterdam, November–December 1934 (70).
BIBLIOGRAPHY: Woodall 431.

A variant of the coastal scene owned by John Wright (Cat. No.483), in which the fisherman on the left is lacking his net and with a shepherd and sheep instead of buildings on the cliff. The bold treatment of wash is closely related to the coastal scene owned by Eva Andresen (Cat. No. 487).

485 Coastal Scene with Boats
R. L. Burnett, London

Grey and grey-black washes.
$10\frac{13}{16} \times 14\frac{1}{8}$ (275 × 359).
A man reclining on the shore beside a rowing boat in the foreground left; two sailing boats at sea in the middle distance left; cliffs in the middle distance right.

PROVENANCE: With Albany Gallery; with Spink, from whom it was purchased.
REPRODUCED: *Octagon*, Summer 1968, p.17.

Study for the coastal scene in the Westminster collection (Waterhouse 955, repr. pl.225), exhibited R.A. 1781. This is a preliminary idea without the figure group on the sea-shore: the rather awkward rock in this position appears to be a later addition, perhaps covering some figures, a possibility strengthened by the fact that the figure on the left seems also to have been absorbed into the sea-shore. A further study is in Detroit (Cat. No.486). The treatment of wash is related to the coastal scene in Bolton (Cat. No.481), though rather more hesitant in character. Also mentioned on p.38.

486 Coastal Scene with Figures and Shipping Plate 152
Detroit Institute of Arts, Detroit (34.112)

Grey and grey-black washes. $10\frac{15}{16} \times 14\frac{1}{2}$ (278×368). A girl kneeling, selling fish from a basket to two girls standing, in the middle distance centre; a man reclining on the shore beside a rowing boat in the foreground left; three sailing boats at sea in the middle distance left, and the distance left and centre; cliffs in the middle distance right.
PROVENANCE: With Parsons, from whom it was purchased 1934.

Study for the coastal scene in the Westminster collection (Waterhouse 955, repr. pl.225), exhibited R.A. 1781. No changes were made in the finished picture except for the inclusion of some sheep on the cliff. Another study, rather less boldly executed and without the figure group on the seashore, is in the possession of R. L. Burnett (Cat. No.485). The broad treatment of wash is related to the coastal scene in Bolton (Cat. No.481). Also mentioned on pp.38 and 44.

487 Coastal Scene with Figures and Boats Plate 151
Eva Andresen, Oslo

Grey and grey-black washes and white chalk. $10\frac{1}{2} \times 13\frac{3}{4}$ (267×349).
Two men hauling in nets in the foreground right; two figures and an anchor in the foreground left; three men pulling in a rowing boat in the middle distance right, with cliffs towering behind; two sailing boats at sea in the middle distance left.
PROVENANCE: J. Heywood Hawkins; possibly C. H. T. Hawkins sale, Christie's, 29 March 1904,

Lot 176 (with two others) bt. Ward; Henry J. Pfungst sale, Christie's, 15 June 1917, Lot 60 (with another) bt. Carpenter; H. S. Reitlinger; Reitlinger sale, Sotheby's, 27 January 1954, Lot 142 bt. Agnew, from whom it was purchased 1954.
BIBLIOGRAPHY: Woodall 271.

Study for the coastal scene formerly in the possession of Mrs Ailsa Mellon Bruce (Waterhouse 954, repr. pl.224), painted about 1780–2. In the finished picture the composition is reversed, an extra figure is helping to push out the boat, the two fishermen with the net are differently arranged, and the two figures with an anchor close by replaced by a rock. The bold treatment of wash is closely related to the coastal scene in Detroit (Cat. No.486). Also mentioned on pp.14, 32, 40 and 44.

488 Estuary Scene with Boats and Figures
D. L. T. Oppé, London (555)

Grey wash, traces of black chalk, and stump. $10\frac{7}{8} \times 14\frac{7}{16}$ (276×267).
A figure carrying a large bundle over his shoulder crossing a plank to a boat, on board which two men are engaged in hoisting the sail, in the foreground right; two other figures, one of them seated, on the shore in the foreground left; a sailing ship at sea in the middle distance centre, with a rowing boat, in which are two figures, alongside her; a high cliff in the middle distance right; the farther shore in the distance left and centre.
PROVENANCE: George Hibbert (?); Anon. sale, Sotheby's, 3 May 1918, Lot 21 bt. A. Paul Oppé.
EXHIBITED: *Early English Drawings and Watercolours from the Collection of Paul Oppé*, Graves Art Gallery, Sheffield, 1952 (31); *The Paul Oppé Collection*, R.A., March–June 1958 (144); *The Paul Oppé Collection*, National Gallery of Canada, Ottawa, 1961 (44).
BIBLIOGRAPHY: Woodall 245.

The breadth of handling and the sketchiness of the figures are characteristic of a number of Gainsborough's coastal scenes, such as the drawing in Rotterdam (Cat. No.484).

489 Coastal Scene with Shipping, Figures and Cows Plate 154
Earl Spencer, Althorp

Grey and grey-black washes, with traces of black chalk and stump, heightened with white. $11 \times 14\frac{1}{2}$ (279×368).
Two figures, one seated, on a cliff in the foreground left; two figures, one seated, in a rowing boat in

the foreground centre; two cows in the foreground right; three sailing boats in midstream in the middle distance centre.

Collector's mark of Earl Spencer bottom right.
PROVENANCE: By descent.
EXHIBITED: Oxford 1935 (15); Sassoon 1936 (67); Arts Council 1960–1 (39); *Treasures from Althorp*, Victoria and Albert Museum, March–May 1970 (M19).
BIBLIOGRAPHY: Woodall 299.

The broad handling of wash and the sketchy treatment of the figures are related to the coastal scene in the Oppé collection (Cat. No.488). The vessel with a mast amidships is of a type usually found on the east coast (information kindly supplied by Michael Robinson). The motif of the two cows was used in reverse by Dupont in his landscape with pool formerly in the Lockett collection (Plate 362). Also mentioned on p.66.

490 Coast Scene with Figures, Sailing Boat and Mountain
Ownership unknown

Grey wash. 11 × 14 (279 × 356).
A sailing boat with two figures aboard in the foreground left; three figures, two of them seated, on a promontory in the foreground centre; a mountain in the distance right; sea stretching from the foreground into the distance left (from a photograph).
PROVENANCE: Arthur Kay; Kay sale, Christie's, 23 May 1930, Lot 22 bt. Howard.

The bold treatment of wash is closely related to the coastal scene at Althorp (Cat. No.489).

491 Wooded Landscape with Figures in a Rowing Boat on a River
Victoria and Albert Museum, London (Dyce 679)

Grey wash and white chalk, with traces of black chalk. 10¼ × 13½ (260 × 343).
A rowing boat with three figures seated in it in the foreground right; a shepherd and sheep on a bank in the middle distance left; a river flowing from the foreground left into the middle distance right; hills in the distance centre and right.
PROVENANCE: Rev. Alexander Dyce, who bequeathed it to the South Kensington Museum 1869.
BIBLIOGRAPHY: *Dyce Collection Catalogue*, London, 1874, p.100; Woodall 193.

The broad treatment of wash and the feeling for light are related to the coastal scene at Althorp (Cat. No.489).

492 Seascape with two Sailing Boats
Ownership unknown

Black chalk (apparently). Size unknown.
A yacht with a figure seated in the stern in the foreground centre; another sailing boat in the middle distance right; coast in the distance right (from the print).
ENGRAVED: J. Laporte, published by Laporte and Wells 1 January 1802 (as in the collection of Dr Thomas Monro).
PROVENANCE: Dr Thomas Monro; Monro sale, Christie's, 26 June 1833 ff.

The treatment of the sea and ships is related to the coastal scene in Detroit (Cat. No.486) and the bold outlining of the clouds to the coastal scene at Althorp (Cat. No.489).

493 Coastal Scene with Figures and Shipping
Ehemals Staatliche Museen, Berlin-Dahlem (15336)

Black and white chalks and grey and grey-black washes on buff paper. 10⅜ × 14⅛ (264 × 359).
A group of four or five figures with a rowing boat on the shore in the foreground centre and right; two ships in full sail in the middle distance centre and right; rocks in the foreground left.
The composition is surrounded by a ruled line in grey-black ink.
PROVENANCE: With Charles de Burlet, from whom it was purchased 1935.
BIBLIOGRAPHY: Woodall 406.

The broad handling of wash and sketchy treatment of the figures are related to the coastal scene at Althorp (Cat. No.489). The vessel on the right is one of Gainsborough's more elaborate dawings of a ship in full sail, and since, from the high hull and other characteristics, it is evidently a Dutch seventeenth-century merchantman (information kindly supplied by Michael Robinson), it was probably based on Gainsborough's knowledge of Van de Velde (Gainsborough possessed two books of his shipping drawings, which were Lots 93 and 94 in the sale at Christie's, 11 May 1799). It is clear from the inclusion of seventeenth and eighteenth-century types of ship in the same drawing, as well as from his use of east coast types in other drawings of this period (see Cat. Nos.483 and 489), that Gainsborough was no more concerned than Turner about appropriateness to a particular setting. Compare also his use of church towers drawn from Teniers in his later Bath period village scenes (Cat. Nos.318 and 347).

494 Wooded Landscape with Figure and Dog Plate 160
The Earl of St Germans, Port Eliot

Grey and grey-black washes and white chalk. 10⅛ × 14⅛ (278 × 359).
A figure accompanied by a dog travelling over a hillock in the middle distance centre; a stream flowing from the middle distance left close to a large rock over a small weir into the foreground centre.
Inscribed on the original backboard in ink (the date in pencil): *AN | Original Drawing | by | GAINSBOROUGH. | 1781.*
PROVENANCE: By descent.

The broad treatment of wash, the scallops outlining the foliage, and the use of heightening in white chalk are closely related to the coastal scene in Berlin (Cat. No.493). Also mentioned on p.38.

495 Wooded Upland Landscape with Bridge and Figures
Earl Spencer, Althorp

Black and white chalk, and grey and grey-black washes. 11 1/16 × 14½ (281 × 368).
Two figures in the foreground right; a figure and packhorse crossing a bridge over a stream in the middle distance left; hills in the distance centre. Collector's mark of Earl Spencer bottom right.
PROVENANCE: By descent.
EXHIBITED: Oxford 1935 (14); Sassoon 1936 (63).
BIBLIOGRAPHY: Woodall 297.

The broad handling of wash, the modelling of the tree trunks in white chalk, and the treatment of the foliage are identical with the wooded landscape with figure at Port Eliot (Cat. No. 494).

496 Wooded Hilly Landscape with Herdsman, Cows and Cottage
Viscount Knutsford, Munden

Black chalk and grey wash, heightened with white. 11 1/16 × 13⅞ (281 × 352).
A herdsman seen between trees in the foreground centre driving three cows in the foreground right; a cottage with a smoking chimney in the foreground left; hills in the distance right.
PROVENANCE: George Hibbert; thence by descent.

The handling is related to the landscape with figures and bridge at Althorp (Cat. No.495).

497 Wooded Landscape with Shepherd and Sheep
Ownership unknown

Black chalk and stump and white chalk and grey and grey-black washes. 11 × 14¼ (279 × 362).
A shepherd seated on a bank in the foreground left; a flock of sheep in the foreground centre; low hills in the distance left and centre (from a photograph).
PROVENANCE: Marquess Camden; with P. M. Turner; with the Independent Gallery; with Fine Art Society.
EXHIBITED: Oxford 1935 (23); Sasson 1936 (37); *Early English Watercolours and Drawings*, Fine Art Society, October 1944 (37).
BIBLIOGRAPHY: Woodall 327 and p.69.
REPRODUCED: *The Daily Telegraph*, 17 February 1936.

The broad handling of wash, the treatment of the foliage, and the scattered highlights in white chalk are closely related to the wooded landscape with figure at Port Eliot (Cat. No.494).

498 Wooded Landscape with Herdsman driving Cattle over a Bridge, Rustic Lovers, and Ruined Castle Plate 288
Courtauld Institute of Art, Witt Collection, London (4181)

Black chalk and stump and white chalk, with grey and grey-black washes. 10⅞ × 13¼ (276 × 337) (oval).
A herdsman on horseback, accompanied by a dog, driving two cows and some sheep over a stone bridge in the foreground centre and left; two peasants, a man and a woman, leaning against the parapet of the bridge in the foreground left; a ruined castle amongst trees in the middle distance right; hills in the distance left.
PROVENANCE: Susannah Gardiner (Gainsborough's sister); from thence by descent to Miss R. H. Green; Anon. (= Green) sale, Christie's, 1 April 1949, Lot 34 bt. Colnaghi, from whom it was purchased by Sir Robert Witt; bequeathed 1952.
EXHIBITED: *Old Master Drawings*, Colnaghi's, April–May 1949 (52); Arts Council 1960–1 (37, and p.7); Nottingham 1962 (54); *English Landscape Drawings from the Witt Collection*, Courtauld Institute Galleries, January–May 1965 (8).
BIBLIOGRAPHY: *Hand-List of Drawings in the Witt Collection*, London, 1956, p.22.

Study for the landscape with cattle crossing a bridge in the possession of C. M. Michaelis (Waterhouse 959, repr. pl.220), exhibited R.A. 1781. No changes were made in the finished picture except of a minor sort: the second cow is shown bellowing, and the bridge has only one

arch instead of two. The drawing is also related in composition to the soft-ground etching (Boydell 1) first published 1 February 1780, but there are sufficient differences to indicate that it was executed *after* rather than before the print. A similar composition was formerly owned by W. Hetherington (Cat. No.425). The handling of wash, the treatment of the foliage, the contouring of the animals in black chalk, and the scattered highlights in white chalk are closely related to the landscape with shepherd and sheep originally owned by Lord Camden (Cat. No.497), but the execution is looser and more rapid. The theme of rustic lovers goes back to Gainsborough's Suffolk style, where it played a leading role in the imagery of his rococo pastorals. Also mentioned on pp.38, 45 and 62.

499 Wooded Landscape with Rustic Lovers and Cow Plate 155
Viscount Eccles, London

Pen and grey-black ink with grey and grey-black washes on pale buff paper, heightened with white. $13\frac{7}{8} \times 9\frac{5}{8}$ (352 × 244).
Two rustic lovers, the man with his right arm over the girl's shoulder, walking along a wooded lane in the foreground centre; a cow on a bank in the middle distance right; mountains in the distance centre.
PROVENANCE: L. G. Duke; Anon. (= Duke) sale, Christie's, 29 November 1929, Lot 1 bt. Parsons; with P. M. Turner, from whom it was purchased about 1936.
EXHIBITED: Oxford 1935 (10); *Three Centuries of British Water-Colours and Drawings*, Arts Council, 1951 (77); *Le Paysage Anglais de Gainsborough à Turner*, Orangerie, February–April 1953 (51); *European Masters of the Eighteenth Century*, R. A., November 1954–February 1955 (537); Nottingham 1962 (50 repr.); *English Drawings and Watercolours in memory of the late D. C. T. Baskett*, Colnaghi's, July–August 1963 (22 and repr. pl.v.); *Bicentenary Exhibition*, R.A., December 1968–March 1969 (517 and repr. in the Souvenir pl.42a).
BIBLIOGRAPHY: Woodall 336.
ALSO REPRODUCED: Martin Hardie, *Water-colour Painting in Britain 1. The Eighteenth Century*, London, 1966, pl.48.

The broad treatment of wash, loose handling of the foliage, and broken highlights in white chalk are related to the landscape with herdsman and cattle crossing a bridge in the Witt Collection (Cat. No.498). Also mentioned on p.52.

500 Wooded Landscape with Figures, Cattle and Cottage
Courtauld Institute of Art, Witt Collection, London (Spooner 36)

Grey and grey-black washes and white chalk on buff paper. $13\frac{7}{16} \times 10\frac{3}{8}$ (341 × 264).
A milkmaid, two cows, two goats and two sheep beside a pool in the foreground right; a large rock in the foreground centre; a cottage with two figures outside, one of them seated, in the middle distance left; a cow on a bank in the middle distance right.
PROVENANCE: Arthur Kay; Kay sale, Christie's, 23 May 1930, Lot 26 bt. P. M. Turner; Viscount Eccles; with Colnaghi, from whom it was purchased by W. W. Spooner 1956; bequeathed 1967.
EXHIBITED: *English Art*, Cartwright Hall, Bradford, 1904 (363); Colnaghi's 1906 (80); Ipswich 1927 (163); *Peinture Anglaise*, Musée Moderne, Brussels, October–December 1929 (73); Oxford 1935 (12); *Two Hundred Years of British Painting*, Public Library and Art Gallery, Huddersfield, May–July 1946 (116); *Old Master Drawings*, Colnaghi's, May–June 1956 (49 and repr. pl.IX); *English Drawings and Watercolours in memory of the late D. C. T. Baskett*, Colnaghi's, July–August 1963 (26); *The William Spooner Collection and Bequest*, Courtauld Institute Galleries, April–July 1968 (26); *Bicentenary Exhibition*, R.A., December 1968–March 1969 (518); *Masters of the water-colour: water-colours from the Spooner collection*, Holburne of Menstrie Museum, Bath, May–July 1969 (31).
BIBLIOGRAPHY: *The Vasari Society*, Second Series, Part 1, Oxford, 1920, p.11 and repr. No.16; Woodall 331.

The loose handling of the foliage, the crisp broken contours in the figures and animals, the rough highlights in white chalk, and the motif of a cow on a bank in the middle distance are identical with the wooded landscape with rustic lovers in Lord Eccles's collection (Cat. No.499). A copy by Thomas Barker was recently with Appleby (*18th and 19th Century English Watercolours*, June–July 1965 (91)). Also mentioned on p.79.

501 Wooded Landscape with Figures
Plate 187
Metropolitan Museum of Art, New York

Black and white chalk and grey and grey-black washes on buff paper. $10\frac{1}{2} \times 14\frac{1}{8}$ (267 × 359).
An old man with a stick, accompanied by a small child, climbing over a bridge or up a flight of steps in the foreground right.
PROVENANCE: Henry J. Pfungst; Pfungst sale, Christie's, 15 June 1917, Lot 67 bt. Barnard; with Craddock and Barnard, from whom it was purchased by Victor Koch; Koch sale, Anderson's, 8 February 1923, Lot 76 (repr.) bt. H. Lehman;

Robert Lehman, by whom it was bequeathed 1969.
BIBLIOGRAPHY: *Craddock and Barnard Catalogue*, No.5,
February 1918 (268 repr.)

The loose treatment of the foliage and the soft
rock forms are closely related to the landscape
with figures, cattle and cottage in the Witt
Collection (Cat. No.500).

502 Open Landscape with Peasants returning from Market Plate 156
Viscount Eccles, London

Grey, grey-black and brown washes. $7\frac{5}{8} \times 9\frac{5}{8}$
(194×244). Three figures on horseback, with a
packhorse and a dog, and two donkeys in front,
returning from market in the foreground centre
and right.
PROVENANCE: Sir Jeremiah Colman; with Walker's
Galleries; with P. M. Turner; with Colnaghi,
from whom it was purchased.
EXHIBITED: *31st Annual Exhibition of Early English
Water-Colours*, Walker's Galleries, June–Autumn
1935 (26); Aldeburgh 1949 (23); Nottingham 1962
(43); *English Drawings and Watercolours in memory
of the late D. C. T. Baskett*, Colnaghi's, July–August
1963 (30).

The loose treatment of the foliage is identical
with the wooded landscape with rustic lovers
also in Lord Eccles's collection (Cat. No.499).
The theme and composition are closely related
to the landscape with peasants going to market
at Royal Holloway College (Waterhouse 911,
repr. pl.115), painted in 1773, but the evidence
of style makes it difficult to establish a date as
early as this for the drawing and thus rules out
the possibility of it being a study for the picture.
Also mentioned on pp.18 and 52.

503 Wooded Landscape with Horseman and Cottage
National Art Gallery, Wellington, N.Z.

Grey and brown washes. $11 \times 14\frac{1}{2}$ (279×368).
A horseman in the foreground left travelling along
a track which winds into the distance centre; a
cottage half-hidden among trees in the middle
distance left; a pool filling the foreground centre
(from a photograph).
Inscribed on the verso top in ink: *A Sketch by Thos.
Gainsborough given by him to my Mother.*
PROVENANCE: Admiral Somerville; with Fine Art
Society, from whom it was purchased 1957.

The treatment of the foliage is closely related to
the landscape with peasants returning from

market in Lord Eccle's collection (Cat. No.502).
There are certain weaknesses in this drawing,
notably in the horse and the tree stumps on the
right, which seem uncharacteristic of Gains-
borough.

504 Open Landscape with Figure, Packhorses and Cottage Plate 168
Mrs W. W. Spooner, Bath

Watercolour and white chalk. $8\frac{3}{8} \times 11\frac{3}{4}$ (213×298).
A figure on a packhorse, accompanied by another
packhorse and a dog, travelling over a hillock
in the foreground right; a cottage amongst trees
in the middle distance left; a pool in the foreground
centre and right; hills in the distance left and
centre.
PROVENANCE: Fanny Marriott, who bequeathed it
to R. M. Praed; H. B. Milling.
EXHIBITED: *Early English Water Colours*, Leeds City
Art Gallery, October–November 1958 (37 and
repr. pl.1).

An unusually simple composition which fore-
shadows the imagery of romanticism. The hand-
ling of wash, the sketchy treatment of the dis-
tance, and the motif of silhouetting the rider and
packhorse against the sky are closely related to
the landscape with peasants returning from
market in Lord Eccles's collection (Cat.
No.502). Also mentioned on p.52.

505 Open Landscape with Waggon and Figures
H.M. The Queen, Windsor Castle

Watercolour and bodycolour. Unfinished.
$8\frac{1}{4} \times 11\frac{3}{8}$ (210×289).
A four-wheeled waggon, with two figures inside,
and drawn by a single horse, is travelling across
open country in the foreground left and centre;
low hills in the distance centre and right.
Inscribed on the verso in ink: *This Drawing was
given Me by | my* (some words erased); *It is | by
Gainsborough, and was purchased | at his sale, at Mr
Christie's April 10 1797 | John Thomas Smith, |
Engraver of the Antiquities | London and Its Environs | It
is drawn in a very singular manner, as will | appear
when held up to the light.*
PROVENANCE: Gainsborough Dupont sale, Christie's,
April 1797; John Thomas Smith.
BIBLIOGRAPHY: A. P. Oppé, *English Drawings . . .
at Windsor Castle*, London, 1950, No.270.

A very broadly-sketched drawing, in which the
composition is no more than adumbrated.

Executed in the 1780's. The observations made by Smith (see above) can no longer be tested, as the drawing is laid down.

506 Open Landscape with Buildings, Horses and Figures

British Museum, London (Anderdon Collection 295)

Watercolour and oil, varnished.
$8\frac{1}{4} \times 11\frac{9}{16}$ (210 × 294).
A man with a staff, accompanied by a dog, conversing with a woman and child in the middle distance centre; a cottage and larger building in the middle distance left; two saddled horses and another figure in the middle distance right.
PROVENANCE: J. H. Anderdon; formerly inserted in Anderdon's grangerized copy of Edwards' *Anecdotes of Painters*, Vol.2, p.295, presented 1867–9.
BIBLIOGRAPHY: Binyon 29; Woodall 100; Iolo A. Williams, *Early English Watercolours*, London, 1952, p.71.

The broad handling of wash and the silhouetting of figures and animals against the sky are closely related to the landscape with figure and packhorses in Mrs Spooner's collection (Cat. No.504).

507 Open Landscape with Horsemen and Covered Cart Plate 161

Mr and Mrs Paul Mellon, Oak Spring, Virginia (LGD 62/6/7/1)

Grey and grey-black washes, with traces of black and white chalk. $10\frac{11}{16} \times 14$ (271 × 356).
A covered cart with two figures inside, one standing and one seated, drawn by a single horse, in the foreground centre; two horsemen by the side of the cart in the foreground left; two figures and a dog by the other side of the cart in the foreground right; a pool stretching across the foreground; two cottages half-hidden by trees in the middle distance right; a tower in the distance left.
PROVENANCE: Ingram; Ingram sale, Foster's, 18 June 1930, Lot 19A (part of a parcel) bt. L. G. Duke; with Colnaghi, from whom it was purchased (as part of the Duke collection) 1960.
EXHIBITED: Sassoon 1936 (61); Aldeburgh 1949 (6); *English Landscape Drawing and Painting*, South London Art Gallery, May–July 1951 (45); *Three Centuries of British Water-Colours and Drawings*, Arts Council 1951 (75); *Le Paysage Anglais de Gainsborough à Turner*, Orangerie, February–April 1953 (52); *English Drawings and Water Colors from the collection of Mr. and Mrs. Paul Mellon*, National Gallery of Art, February–April 1962 (35); *Painting in England 1700–1850: Collection of Mr. & Mrs.*

Paul Mellon, Virginia Museum of Fine Arts, Richmond, 1963 (60).
BIBLIOGRAPHY: Woodall 41 and p.76.
REPRODUCED: *The Illustrated London News*, 29 February 1936, p.380.

The broad handling of wash, the treatment of the figures and animals, and the sketchy handling of the distant buildings and trees are related to the coastal scene owned by John Wright (Cat. No.483).

508 River Scene with Barge and a Party coming ashore near a Country House

Miss Helen Barlow, London

Grey wash. $10\frac{3}{4} \times 14\frac{7}{16}$ (273 × 367).
A canopied barge mooring at some steps, and the passengers going ashore, in the foreground right; two figures in a rowing-boat in the foreground left; a country house in the middle distance right; the river winding from the foreground into the distance left.
PROVENANCE: Probably Sir George Donaldson and Donaldson sale, Puttick and Simpson's, 6 July 1925 ff., 2nd Day Lot 213; with Dunthorne; with Palser Gallery, from whom it was purchased by Sir Thomas Barlow.
EXHIBITED: Nottingham 1962 (51).
BIBLIOGRAPHY: Woodall 42, p.100 and repr. pl.120 (not 121).

The crisp broken contours delineating the boat and figures are related to the wooded landscape with rustic lovers in Lord Eccles's collection (Cat. No.499).

509 River Scene with Barge and a Party coming ashore near a Country House

L. G. Duke, London

Pen and grey wash, with some white chalk.
$9\frac{11}{16} \times 13\frac{11}{16}$ (246 × 348).
A canopied barge mooring at some steps, and the passengers going ashore, in the foreground right; two figures in a rowing-boat in the foreground left; two swans in the middle distance left; a country house in the middle distance right; the river winding from the foreground into the distance left.
PROVENANCE: With Walter T. Spencer, from whom it was purchased 1933.
EXHIBITED: Sassoon 1936 (48); Aldeburgh 1949 (5); Bath 1951 (38).
BIBLIOGRAPHY: Woodall 40, p.100 and repr. pl.121 (not 120).

An almost exact replica of the river scene with a barge coming ashore owned by Miss Barlow (Cat. No.508), in which the touch is equally convincing throughout.

510 Wooded Upland Landscape with Herdsman, Cow and scattered Sheep
Mrs Kenneth Potter, North Warnborough

Grey wash. $10\frac{7}{8} \times 14\frac{1}{16}$ (276 × 357).
Three sheep scattered in the foreground left; a herdsman seated and a cow on a bank in the foreground right; hills in the distance centre and right.
PROVENANCE: Susannah Gardiner (Gainsborough's sister); thence by descent to Miss Green, who gave it to Miss A. Thorne; thence by descent.
EXHIBITED: Oxford 1935 (34).
BIBLIOGRAPHY: Woodall 309.

The treatment of the foliage and handling of wash are closely related to the river scene with a barge coming ashore owned by Miss Helen Barlow (Cat. No.508).

511 Wooded Landscape with Figures on Horseback and Cottage Plate 162
British Museum, London (G.g.3 – 392)

Grey wash and oil on brown prepared paper, varnished. $8\frac{1}{2} \times 12\frac{1}{4}$ (216 × 311).
Two figures on horseback travelling on a track in the foreground centre; a cottage half-hidden by trees in the middle distance left; a pond in the foreground centre; a figure seated by the wayside in the foreground right.
ENGRAVED: Thomas Rowlandson (included in his *Imitations of Modern Drawings*, c.1788).
PROVENANCE: Rev. C. M. Cracherode; bequeathed 1799.
BIBLIOGRAPHY: Binyon 13; Gower *Drawings*, p.12 and repr. pl.XXI; Woodall 90.

The treatment of the figures and horses and the scallops outlining the foliage are related to the landscape with covered cart in the Mellon collection (Cat. No.507).

512 Wooded Landscape with Herdsman, Cows and Sheep Plate 164
Mrs W. W. Spooner, London

Grey and grey-black washes, with traces of black chalk, on grey prepared paper heightened with white. $10\frac{3}{4} \times 13\frac{13}{16}$ (273 × 351).
A herdsman carrying a staff over his left shoulder with two cows and a flock of sheep in the middle

distance centre; a pond in the foreground; hills visible between the trees in the distance left.
PROVENANCE: Mrs Hibbert; Mrs Hibbert sale, Robinson and Fisher's, 29 October 1936, Lot 173 bt. Thompson; with Palser Gallery; Robert Strauss; with Fine Art Society, from whom it was purchased by W. W. Spooner 1961.
EXHIBITED: *Forty-First Exhibition Early English Water-colours and Drawings*, Fine Art Society, April 1961 (47); *The William Spooner Collection and Bequest*, Courtauld Institute Galleries, April–July 1968 (30); *Bicentenary Exhibition*, R.A., December 1968–March 1969 (663); *Masters of the water-colour: water-colours from the Spooner collection*, Holburne of Menstrie Museum, Bath, May–July 1969 (32).
BIBLIOGRAPHY: Woodall 256.

Study for the landscape with herdsman and cattle, shepherd, shepherdess and sheep owned by the Hon. Michael Astor (Waterhouse 930, repr. pl.133), painted about 1780–2. In the finished picture, the composition has been extended into a semicircle by the addition of a shepherd and shepherdess reclining on a bank on the left and an extra sheep and a log on the right. The summary contours of the herdsman and animals, the scallops outlining the foliage, and the treatment of the foreground detail are closely related to the landscape with figures on horseback in the British Museum (Cat. No.511). Also mentioned on p.40.

513 River Scene with Figures, Boats and Buildings Plate 163
Henry E. Huntington Library and Art Gallery, San Marino (63.52.86)

Pen and grey wash over black chalk, and white chalk. $10\frac{3}{4} \times 14\frac{3}{8}$ (273 × 365).
A figure and cow on a bank in the foreground left; a man pushing out a rowing-boat in the foreground centre; another rowing-boat, with two figures, one seated and one standing, in midstream in the middle distance centre; a house in the middle distance right; a larger building in the distance centre.
Inscribed on the verso: *Mr Gainsborough, Windsor Septr ye 17th 1782*.
Collector's mark of Sir Bruce Ingram on the verso bottom right.
PROVENANCE: Possibly John Thane and Thane sale, Christie's, 25 February 1831, Lot 64* (with another) bt. Palser; Sir Bruce Ingram; with Colnaghi, from whom it was purchased 1963.
EXHIBITED: Aldeburgh 1949 (8); Bath 1951 (44); *Old Master Drawings: A Loan Exhibition from the Collection of Sir Bruce S. Ingram*, Colnaghi's,

January–February 1952 (p.7 and 78 repr.);
L'Aquarelle Anglaise 1750–1850, Musée Rath,
Geneva, October 1955–January 1956 and L'Ecole
Polytechnique Fédérale, January–March 1956 (62);
Arts Council 1960–1 (40); Huntington 1967–8
(12 and repr. cover).
BIBLIOGRAPHY: Woodall 1949, p.78 and repr. p.79.

Evidently drawn during his visit to Windsor to
paint the entire Royal Family (see *The Morning
Herald*, 14 September 1782). The broken con-
tours of the figures and cow, the scallops out-
lining the foliage, the treatment of the fore-
ground detail, and the handling of wash are
identical with the wooded landscape with
herdsman, cows and sheep at a pool in Mrs
Spooner's collection (Cat. No.512). Also men-
tioned on pp.11–12, 39 and 45.

514 Wooded Landscape with Figure and Country Mansion Plate 437
Henry E. Huntington Library and Art
Gallery, San Marino (63.52.88)

Grey wash over pencil. $10\frac{3}{4} \times 14\frac{1}{2}$ (273×368).
A figure, accompanied by a dog, seated beside a
pool in the foreground right; a mansion on rising
ground in the middle distance centre.
Inscribed on the verso bottom left in brown ink:
Mr Gainsborough, Windsor Septr 17th 1782
Collector's mark of Sir Bruce Ingram bottom right.
PROVENANCE: Possibly John Thane and Thane
sale, Christie's, 25 February 1831, Lot 64* (with
another) bt. Palser; Sir Bruce Ingram; with
Colnaghi, from whom it was purchased 1963.
EXHIBITED: Aldeburgh 1949 (9); Bath 1951 (45);
L'Aquarelle Anglaise 1750–1850, Musée Rath,
Geneva, October 1955–January 1956 and L'Ecole
Polytechnique Fédérale, January–March 1956 (61);
Arts Council 1960–1 (41); Huntington 1967–8 (13).

Evidently drawn during his visit to Windsor to
paint the entire Royal Family (see *The Morning
Herald*, 14 September 1782). The treatment of
wash and the scallops outlining the foliage are
closely related to the previous drawing (Cat.
No.513), to which it is a companion. Also men-
tioned on pp.39, 45 and 88.

515 Wooded Upland Landscape with Houses and Sheep
The Earl of Drogheda, Englefield Green

Grey and grey-black washes. $10\frac{9}{16} \times 17\frac{1}{16}$
(268×433).
Scattered sheep in the foreground centre and right,
on either side of a track which runs from the

foreground left across a bridge over a stream in
the middle distance right and along a valley into
the distance centre; a house half-hidden by trees
in the middle distance left; two buildings on the
side of a hill in the distance right; hills in the
distance centre and right.
PROVENANCE: Arthur Kay; Kay sale, Christie's,
23 May 1930, Lot 17 bt. Maser; Sir Robert Witt;
with Agnew, from whom it was purchased 1945.
BIBLIOGRAPHY: Woodall 363.

Although much broader and more rhythmical
in handling, the treatment of wash and the
scallops outlining the foliage are closely related
to the landscape with mansion and pool in the
Huntington Art Gallery (Cat. No.514).

516 Mountain Landscape with Lake
Viscount Eccles, London

Pen and brown ink and grey wash. $10\frac{7}{16} \times 16\frac{3}{16}$
(265×414).
A lake winding from the foreground into the
middle distance centre; rocky cliffs in the middle
distance left; mountains in the distance right.
PROVENANCE: William Esdaile; Esdaile sale,
Christie's, 20–1 March 1838; Henry J. Pfungst;
Pfungst sale, Christie's, 15 June 1917, Lot 65 bt.
Colnaghi; with Knoedler; with Colnaghi; Victor
Rienaecker; with Colnaghi, from whom it was
purchased.
EXHIBITED: Knoedler's 1923 (15); Ipswich 1927
(155); *Three Centuries of British Water-Colours and
Drawings*, Arts Council, 1951 (71); *English
Drawings and Water-colours in memory of the late
D. C. T. Baskett*, Colnaghi's, July–August 1963 (19).
BIBLIOGRAPHY: Woodall 275.

The treatment of wash, the rapid broken con-
tours, and the scallops outlining the foliage are
closely related to the wooded landscape with
cottage and sheep owned by Lord Drogheda
(Cat. No.515).

517 Wooded Landscape with Herdsman, Cows and Ruined Building
Mrs M. G. Turner, Gerrards Cross

Pen and brown ink and grey wash. $8\frac{3}{8} \times 10\frac{5}{8}$
(213×270).
A ruined church or castle on a hillock in the
middle distance centre; two cows nearby in the
middle distance left; a herdsman holding a staff
in his left hand standing by a log in the
foreground left; a stream running from the
foreground left into the middle distance right.
PROVENANCE: E. A. Lewis; P. M. Turner.

EXHIBITED: Ipswich 1927 (164); Oxford 1935 (27).
BIBLIOGRAPHY: Woodall 316.

A very rapid and rather unusual sketch in which the treatment of line, the summary contours of the animals, and the scallops outlining the foliage are, however, related to the wooded landscape with cottage and sheep owned by Lord Drogheda (Cat. No.515).

518 Wooded Landscape with Country Mansion and Figures Plate 166
George Howard, Castle Howard

Grey wash. $9\frac{7}{8} \times 14\frac{1}{8}$ (251 × 359).
A mansion amidst trees in the middle distance, with a figure preceded by a dog walking out of the arched gate; a drinking fountain for cattle in the foreground left; two figures seated beneath a bank in the foreground right.
PROVENANCE: Probably Gainsborough sale, Schomberg House, March–May 1789 No.41 bt. Lord Carlisle; thence by descent.
EXHIBITED: Arts Council 1960–1 (43).

The treatment of wash and the broad scallops outlining the foliage are closely related to the landscape with mansion and pool in the Huntington Art Gallery (Cat. No.514). Gainsborough's drawings of mansions of this type, which were especially characteristic of the early and mid 1780's, were as much products of his imagination as his landscapes in general, and the tradition, based on the lines from Pope ('Oh gate, how com'st thou here? I was brought from Chelsea last year, . . .') inscribed on the back, that the gateway represents the one designed by Inigo Jones for Beaufort House, Chelsea, and now at Chiswick, is clearly unfounded.

519 Wooded Landscape with Country Mansion, Figures and Animals Plate 167
Whitworth Art Gallery, University of Manchester (D.20.1927) (1330)

Grey and grey-black washes and black and white chalks. $10\frac{1}{4} \times 14\frac{5}{8}$ (260 × 371).
A country mansion in the foreground centre and right with a figure and two children on the terrace, a child accompanied by a dog followed by two figures and another child descending a flight of steps, and a seated figure and a dog at the foot of the steps; a herdsman driving two cows along a winding track in the foreground left; four sheep scattered in the foreground left; a hill in the distance left.

PROVENANCE: Probably Henry J. Pfungst and Pfungst sale, Christie's, 15 June 1917, Lot 58 bt. Blaker; Otto Gutekunst; Anon. (=Gutekunst) sale, Christie's, 16 April 1926, Lot 47 bt. Parsons, from whom it was purchased 1927.
EXHIBITED: Colnaghi's 1906 (33); Arts Council 1960–1 (42); *English Drawings from the Whitworth Art Gallery*, Colnaghi's, 1967 (6 and repr. pl.v).
BIBLIOGRAPHY: *Whitworth Art Gallery Report 1927*, p.14 and repr. f. p.6; Woodall 228.
ALSO REPRODUCED: *The Manchester Guardian*, 14 February 1928.

The handling of wash, the treatment of the figures, and the broad scallops outlining the foliage are identical with the landscape with country mansion owned by George Howard (Cat. No.518). Gainsborough had used the motif of a country mansion with flights of steps and figures in a large landscape (Waterhouse 991) painted about 1771–2, and also in the picture of *Charity Relieving Distress* (Waterhouse 998, repr. pl.229) exhibited at Schomberg House in 1784. Also mentioned on pp.19 and 51.

520 Wooded Landscape with Country Mansion, Figures and Animals
Le Marquis de Chasseloup Laubat, Marennes

Grey and grey-black washes. $10\frac{3}{4} \times 14\frac{1}{2}$ (273 × 368).
A country mansion in the foreground centre and right with a figure and two children on the terrace, a figure by the door, two figures and two children descending a flight of steps, and a seated figure and a dog at the foot of the steps; a herdsman driving two cows along a winding track in the foreground left; four sheep scattered in the foreground left; a hill in the distance left.
PROVENANCE: Unknown.

A slightly more summary version of the landscape with country mansion in the Whitworth Art Gallery (Cat. No.519), in which there are slight changes in the disposition of some of the figures and animals. The wiry contours of the figures and animals and the scallops outlining the foliage are more closely related to the river scene with a barge coming ashore owned by Miss Barlow (Cat. No.508).

521 Wooded Landscape with Horses and Cart Plate 165
Fogg Museum of Art, Cambridge, Mass. (1943.708)

Grey wash and traces of black chalk on buff paper, heightened with white. $10\frac{1}{2} \times 13\frac{11}{16}$ (267 × 348).

Three horses in the middle distance centre standing beside an empty cart left; a pool in the foreground centre and right.
PROVENANCE: The Earls of Home; Home sale, Christie's, 20 June 1919, Lot 84 bt. Leicester Galleries; Grenville L. Winthrop, who bequeathed it 1943.

The broad scallops outlining the foliage are related to the landscape with country mansion owned by George Howard (Cat. No.518).

522 Wooded Landscape with Horseman and Figures outside a Cottage
John Nicholas Brown, Providence, R.I.

Pen and grey wash with traces of black chalk, heightened with white. $9\frac{15}{16} \times 13\frac{1}{8}$ (252 × 333).
A horseman travelling along a winding track in the foreground right; a figure standing, and four figures seated, outside a cottage with a smoking chimney in the middle distance left.
PROVENANCE: With Colnaghi, from whom it was purchased in the 1920's.
BIBLIOGRAPHY: Woodall 438.

The summary contours of the figures and horse and the broad scallops outlining the foliage are closely related to the wooded landscape with horses and upturned cart in the Fogg Museum (Cat. No.521).

523 Wooded Landscape with Herdsman and Cow drinking
Ownership unknown

Grey and grey-black washes and white chalk. $10\frac{1}{2} \times 14$ (267 × 356).
A herdsman and a cow drinking in the middle distance right; a pool stretching into the foreground left (from a photograph).
PROVENANCE: Sydney Morse; Morse sale, Christie's, 19 March 1937, Lot 93 bt. Thomson.
EXHIBITED: *English Water Colour Drawings of the 18th, 19th and 20th Centuries*, Palser Gallery, Summer 1937 (40 repr.)
BIBLIOGRAPHY: Woodall 257.

The loose treatment of the scallops outlining the foliage is closely related to the landscape with horseman and cottage in the collection of John Nicholas Brown (Cat. No.522).

524 Open Landscape with Figures, Horses and Cart
Mrs Evelyn M. Horkan, Middleburg, Virginia

Grey and grey-black washes over pencil, with some black chalk, heightened with white. $10\frac{3}{4} \times 14\frac{1}{16}$ (273 × 357).
Two peasant women seated in the foreground centre; two horses and a cart in the foreground left; a low hill in the distance centre.
Collector's mark of the Earl of Warwick bottom right.
PROVENANCE: George Guy, 4th Earl of Warwick; possibly Warwick sale, Christie's, 20 May 1896, Lot 139 (with another) bt. Shepherd; Henry J. Pfungst; Pfungst sale, Christie's, 15 June 1917, Lot 55 bt. Seligmann, from whom it was purchased by Alfred Ramage in the mid-1920's; thence by descent.
EXHIBITED: Colnaghi's 1906 (53).
BIBLIOGRAPHY: Woodall 474.

The scallops outlining the foliage are closely related to the landscape with cow drinking at a pool formerly owned by Sydney Morse (Cat. No.523).

525 Wooded Landscape with Herdsman, Cow and Sheep
Mrs Evelyn M. Horkan, Middleburg, Virginia

Grey and grey-black washes, with traces of black chalk and stump, heightened with white. $11 \times 14\frac{1}{2}$ (279 × 368).
A herdsman seated with a staff, and a cow, on a bank in the foreground centre; scattered sheep in the foreground, middle distance, and distance right.
PROVENANCE: J. Heywood Hawkins; Henry J. Pfungst; Pfungst sale, Christie's, 15 June 1917, Lot 54 (repr.) bt. Seligmann, from whom it was purchased by Alfred Ramage in the mid-1920's; thence by descent.
BIBLIOGRAPHY: Woodall 473.

The scallops outlining the foliage are closely related to the landscape with figures and horses also owned by Mrs Horkan (Cat. No.524).

526 Wooded Landscape with Figures, Horse and Shed
Mrs Isabel Ramage Maddox, Washington, D.C.

Black chalk and grey and grey-black washes, heightened with white. $10\frac{3}{4} \times 13\frac{7}{8}$ (273 × 352).
A peasant seated with a dog and a horse entering a thatched shed in the foreground right; a milkmaid carrying two pails in the middle distance centre.
Collector's mark of the Earl of Warwick bottom right.

PROVENANCE: George Guy, 4th Earl of Warwick; Henry J. Pfungst; Pfungst sale, Christie's, 15 June 1917, Lot 56 bt. Seligmann, from whom it was purchased by Alfred Ramage in the mid-1920's; thence by descent.
EXHIBITED: Colnaghi's 1906 (59).
BIBLIOGRAPHY: Woodall 472.

The scallops outlining the foliage are closely related to the landscape with a cow on a bank owned by Mrs Horkan (Cat. No.525).

527 Wooded Landscape with Shepherd, Shepherdess, Sheep and Stream
The Countess of Sutherland, London

Grey and grey-black washes and black and white chalk. $11\frac{1}{16} \times 14\frac{9}{16}$ (281×370).
A shepherd and shepherdess, accompanied by a dog which is tearing at the shepherd's leg, seated in the foreground centre; scattered sheep in the middle distance centre and right; a stream running from the middle distance left to the foreground right.
PROVENANCE: George Nassau; Nassau sale, Evans, 25 March 1824 ff., 2nd Day, Lot 351 (with two others in one frame) bt. Lord Gower; thence by descent.

The scallops outlining the foliage are closely related to the landscape with a cow on a bank owned by Mrs Horkan (Cat. No.525). The drawing was originally framed with Cat. Nos. 528 and 529. Also mentioned on p.98.

528 Wooded Landscape with Cattle and Sheep at a Watering Place, and Rustic Lovers
The Countess of Sutherland, London

Grey and grey-black washes and black and white chalk. $10\frac{5}{8} \times 14\frac{1}{16}$ (270×357).
A herdsman accompanied by a dog, with four cows, one of them reclining, and a flock of sheep, beside and drinking at a pool which stretches into the foreground centre, in the foreground left; two rustic lovers reclining on a bank in the middle distance right; low hills in the distance left and centre.
PROVENANCE: George Nassau; Nassau sale, Evans, 25 March 1824 ff., 2nd Day, Lot 351 (with two others in one frame) bt. Lord Gower; thence by descent.

The treatment of wash and the scallops outlining the foliage are identical with the previous drawing (Cat. No.527), to which it is a companion. The drawing was originally framed with Cat. Nos.527 and 529. Also mentioned on p.98.

529 Wooded Landscape with Deer
The Countess of Sutherland, London

Grey and grey-black washes and black chalk, heightened with white. $11\frac{1}{16} \times 14\frac{5}{8}$ (281×371). Two deer in the foreground right, one of them reclining; two more deer behind a mound in the middle distance left, with some palings behind them.
PROVENANCE: George Nassau; Nassau sale, Evans, 25 March 1824 ff., 2nd Day, Lot 351 (with two others in one frame) bt. Lord Gower; thence by descent.

The treatment of wash and the scallops outlining the foliage are identical with the previous two drawings (Cat. Nos.527 and 528), to which it is a companion. The drawing was originally framed with Cat. Nos.527 and 528. Also mentioned on p.98.

530 Wooded Landscape with Rocks
Henry E. Huntington Library and Art Gallery, San Marino (57.1)

Grey and grey-black washes and white chalk on pale buff paper. $10\frac{7}{8} \times 14\frac{1}{4}$ (276×362).
A track winding from the middle distance right past some rocks in the foreground centre into the recesses of a wood in the middle distance left.
PROVENANCE: Mrs Croe-Passiny; with Colnaghi, from whom it was purchased 1957.
EXHIBITED: Old Master Drawings, Colnaghi's, May–June 1957 (39 and repr. pl.VII); Huntington 1967–8 (4).

The scallops outlining the foliage are identical with the landscape with a cow on a bank owned by Mrs Horkan (Cat. No.525).

531 Wooded Landscape with Figure and Cattle
Miss Isabelle Miller, Milwaukee, Wisconsin

Black chalk and stump and white chalk with grey and grey-black washes. $12\frac{3}{8} \times 15\frac{3}{8}$ (314×390).
A figure, accompanied by a dog, seated in the foreground left; two cows travelling up a winding track in the foreground centre; a high mound in the middle distance left and centre; low hills in the distance centre and right.
PROVENANCE: J. Heywood Hawkins; Arthur Kay; Kay sale, Christie's, 23 May 1930, Lot 21 bt. Leggatt.
EXHIBITED: Fifth Loan Exhibition, Toronto Art Museum, 1912 (61); Ipswich 1927 (135 and repr. pl.X); Peinture Anglaise, Musée Moderne, Brussels, October–December 1929 (72); Wisconsin Collects, Milwaukee Art Center, September–October 1964 (124 repr.).

Q

BIBLIOGRAPHY: R. H. Wilenski, *The Gainsborough Bicentenary Exhibition*, Apollo, November 1927, p.200 and repr. p.191; Woodall 82.
ALSO REPRODUCED: R. H. Wilenski, *English Painting*, London, 1933, pl.51.

The treatment of the rocks and tree trunks and the scallops outlining the foliage are identical with the wooded landscape in the Huntington Art Gallery (Cat. No.530).

532 Wooded Landscape with Herdsman and Cows
Mr and Mrs Paul Mellon, Oak Spring, Virginia

Black chalk and grey and grey-black washes, heightened with white. 10$\frac{15}{16}$ × 14$\frac{3}{8}$ (278 × 365).
A herdsman on horseback driving two cows along a country track in the foreground right; a pool in the foreground left and centre.
Collector's marks of William Esdaile and T. E. Lowinsky bottom right.
Inscribed on the old mount in ink in Esdaile's hand: *Gainsborough* and on the verso bottom left: *1825 WE – Bakers sale N95 ×*
PROVENANCE: George Baker; Baker sale, Sotheby's, 16 June 1825 ff., probably 3rd Day, Lot 355 (with three others) bt. Thane; William Esdaile; Esdaile sale, Christie's, 20–1 March 1838; T. E. Lowinsky; by descent to Justin Lowinsky, from whom it was purchased.
BIBLIOGRAPHY: Woodall 210.

The loose scallops outlining the foliage are closely related to the wooded landscape in the Huntington Art Gallery (Cat. No.530).

533 Rocky Wooded Landscape with Shepherd and Flock
City Art Gallery, Leeds (562/24)

Grey and grey-black washes, heightened with white. 10$\frac{1}{4}$ × 13$\frac{5}{8}$ (260 × 346).
A shepherd accompanied by a dog driving a flock of sheep along a track in the foreground centre; high rocks in the foreground left; hills in the distance right.
PROVENANCE: Rev. Gainsborough Gardiner; by descent to Edward Netherton Harward; Harward sale, Christie's, 11 May 1923, Lot 98 bt. Agnew, from whom it was purchased 1924.
BIBLIOGRAPHY: Woodall 77 and p.56; 'Drawings by Wilson, Gainsborough and Constable', *Leeds Art Calendar*, Autumn 1956, pp.17 and 24, repr. cover.

The soft treatment of the rocks and the scallops outlining the foliage are closely related to the wooded landscape with cows owned by Mrs Miller (Cat. No.531).

534 Wooded Landscape with Shepherd driving a Flock of Sheep Plate 443
National Gallery of Ireland, Dublin

Grey and grey-black washes and black and white chalks. 10$\frac{1}{2}$ × 14 (267 × 356).
Two cows on a bank in the foreground left; a shepherd, accompanied by a dog, driving a flock of sheep up a country track in the foreground centre and right.
PROVENANCE: J. Heywood Hawkins.
EXHIBITED: Arts Council 1960–1 (36).
BIBLIOGRAPHY: Armstrong 1898, p.119 and repr. p.167; Armstrong 1904, pp.158–9; Woodall 434, pp.64 and 68 and repr. pl.76.

The scallops outlining the foliage and the use of white chalk heightening are closely related to the wooded landscape in the Huntington Art Gallery (Cat. No.531). A copy is in the Mellon collection (Woodall 213) (Plate 442). Also mentioned on p.89.

535 Wooded Landscape with Herdsman and Cows, Shepherdess and Sheep
Guy Millard, London

Pen and grey-black ink, and grey and grey-black washes, on buff paper, heightened with white. 10$\frac{7}{16}$ × 13$\frac{5}{8}$ (265 × 346).
A herdsman standing cross-legged talking to a seated shepherdess in the foreground left; two cows behind him; a flock of sheep in the foreground centre; a pool in the foreground right.
PROVENANCE: Sir Hugh Walpole; with Leicester Galleries, who sold it to Spink, from whom it was purchased 1945.
EXHIBITED: *The Art Collection of the late Sir Hugh Walpole*, *Part One*, The Leicester Galleries, April–May 1945 (7).

The handling is closely related to the wooded landscape with shepherd and sheep in Dublin (Cat. No.534).

536 Wooded Landscape with Herdsman and Cow Plate 170
Mrs J. Egerton, Coxwold

Black and white chalk and grey and grey-black washes on buff paper. 10$\frac{7}{16}$ × 14 (265 × 356).
A herdsman seated near a cow in the foreground centre.
PROVENANCE: Randall Davies; with Colnaghi, from whom it was purchased 1938.
EXHIBITED: *Old Master Drawings*, Colnaghi's, Autumn 1934 (10 repr.); *English Watercolours from Yorkshire Houses 1660–1860*, Scarborough Art

Gallery, June–July 1950 (8); *Leeds Art Collections Fund Members Exhibition*, Temple Newsam 1952.
BIBLIOGRAPHY: Woodall 47; *Leeds Art Calendar*, Summer and Autumn, 1952, p.23.

The treatment of the tree trunks and foliage and the use of white chalk heightening are related to the landscape with shepherd and sheep in Dublin (Cat. No.534).

537 Wooded Landscape with Figures and Stream Plate 169
Mrs J. Egerton, Coxwold

Black chalk and stump and white chalk on grey-blue paper. $10\frac{15}{16} \times 12\frac{7}{8}$ (278×327).
A girl with a bundle of faggots over her shoulder and accompanied by a dog talking to a girl seated in the foreground left; a stream running from the middle distance centre into the foreground, with a weir stretching across the composition in the foreground; high rocks in the middle distance right.
PROVENANCE: William Willes; Anon. (=Willes) sale, Christie's, 17 July 1931, Lot 30 bt. in; with Colnaghi, from whom it was purchased in the 1930's.
EXHIBITED: *English Watercolours from Yorkshire Houses 1660–1860*, Scarborough Art Gallery, June–July 1950 (9); *Leeds Art Collections Fund Members Exhibition*, Temple Newsam, 1952.
BIBLIOGRAPHY: Woodall 48; *Leeds Art Calendar*, Summer and Autumn 1952, p.23.

The loose treatment of the foliage is closely related to the wooded landscape with cow also owned by Mrs Egerton (Cat. No.536).

538 Study of a Wooded Landscape with Cottages Plate 290
Courtauld Institute of Art, Witt Collection, London (4006)

Black chalk and stump and white chalk on grey-green paper. $6\frac{1}{8} \times 8$ (156×203).
Two cottages in the foreground right; a country lane winding into the distance left.
Collector's mark of Sir Robert Witt on the back of the mount bottom left.
ENGRAVED: W. F. Wells, published by Laporte and Wells 1 May 1803 (as in the collection of George Hibbert).
PROVENANCE: From one of the sketch-books purchased by George Hibbert at the Gainsborough sale, Christie's, 11 May 1799, Lot 82, 84 or 88; by descent to the Hon. A. H. Holland-Hibbert; Holland-Hibbert sale, Christie's, 30 June 1913; with Fine Art Society, from whom it was purchased by Sir Robert Witt; bequeathed 1952.

EXHIBITED: Aldeburgh 1949 (28).
BIBLIOGRAPHY: *Hand-List of Drawings in the Witt Collection*, London, 1956, p.22.

A study from nature, one of a large number of drawings in a similar technique deriving from the Gainsborough sketch-book originally owned by George Hibbert. The loose sketchy treatment of the foliage and scattered highlights in white chalk are related to the landscape with figures near a weir owned by Mrs Egerton (Cat. No.537). Also mentioned on p.61.

539 Study of a Village Street with Trees Plate 172
Ownership unknown

Black and white chalk on grey-green paper. $6\frac{1}{2} \times 8\frac{1}{2}$ (165×216).
A tall building half-hidden by trees in the foreground left; three houses behind walls in the foreground right (from a photograph).
PROVENANCE: From one of the sketch-books purchased by George Hibbert at the Gainsborough sale, 11 May 1799, Lot 82, 84 or 88; by descent to the Hon. A. H. Holland-Hibbert; Holland-Hibbert sale, Christie's, 30 June 1913; H. W. Underdown; Underdown sale, Sotheby's, 7 July 1926, Lot 113 bt. Parsons.
BIBLIOGRAPHY: John Hayes, 'Gainsborough and the Gaspardesque', *The Burlington Magazine*, May 1970, p.308.

A study from nature. The sketchy handling of the foliage and the white chalkwork are identical with the sketch of cottages in the Witt Collection (Cat. No.538). Also mentioned on p.50.

540 Wooded Landscape with Figures, Church and Buildings Plate 173
Fitzwilliam Museum, Cambridge (976)

Black chalk and stump and white chalk on blue paper. $9\frac{15}{16} \times 12\frac{5}{8}$ (252×321).
A horseman and two or three figures on rising ground in the foreground centre; a stone bridge in the middle distance left, with a stream running into the foreground left; a church half-hidden by trees in the middle distance centre; three houses in the foreground right; a hill in the distance centre and right.
PROVENANCE: Sir Edward Poynter; presented by the Friends of the Fitzwilliam Museum 1919.
BIBLIOGRAPHY: *Fitzwilliam Museum Report 1919*, p.3; *Friends of the Fitzwilliam Museum Report 1919*, p.1; Woodall 24; John Hayes, 'Gainsborough and the Gaspardesque', *The Burlington Magazine*, May 1970, p.311.

The scallops outlining the foliage, the treatment of the buildings, the rough highlights in white chalk, and the generally sketchy handling are closely related to the sketch of a village street formerly in the Underdown collection (Cat. No.539). Compositions of this kind, in which groups of buildings play a more important part in the design than they had done since the village scenes of the early 1770's, were evidently the fruits of the studies of houses, farms, mills and village streets which Gainsborough was making at this period (compare Cat. Nos.539, 548, 550, 551, 553, 554, 555 and 561).

541 Wooded Landscape with Buildings on a Hillside Plate 174
Tate Gallery, London (2921)

Black chalk and stump and white chalk on blue paper. $9\frac{7}{8} \times 12\frac{1}{2}$ (251 × 317).
A country mansion on a hillside in the middle distance right, with other buildings left, and a track winding up the slope between; a pool in the foreground.
PROVENANCE: Sir Edward Poynter.
BIBLIOGRAPHY: Woodall 185; Mary Chamot, *The Tate Gallery British School: A Concise Catalogue*, London, 1953, p.74; *The Collections of the Tate Gallery*, London, 1969, p.33; John Hayes, 'Gainsborough and the Gaspardesque', *The Burlington Magazine*, May 1970, p.311.

The broad handling of the foliage and foreground detail, the sketchy treatment of the buildings, and the scattered highlights in white chalk closely related to the landscape with church and houses in the Fitzwilliam Museum (Cat. No.540). The composition is strongly influenced by Gaspard Dughet. Also mentioned on p.50.

542 Wooded Landscape with Buildings
Edgar Blaiberg, London

Black and white chalk on blue paper. $9\frac{5}{8} \times 12\frac{5}{16}$ (244 × 313).
A country house and other buildings half hidden by trees on rising ground in the middle distance left and centre; a church tower between trees in the middle distance right.
PROVENANCE: J. Heywood Hawkins; C. H. T. Hawkins sale, Christie's, 29 March 1904, Lot 193 (with another) bt. Colnaghi; Arthur Kay; Kay sale, Christie's, 23 May 1930, Lot 28 bt. Colnaghi, from whom it was purchased.
EXHIBITED: Ipswich 1927 (153); Oxford 1935 (21).
BIBLIOGRAPHY: Woodall 17, pp.52–3 and repr.

pl.54; John Hayes, 'Gainsborough and the Gaspardesque', *The Burlington Magazine*, May 1970, p.311 and repr. fig.47.

The treatment of the foliage, the chalkwork, and the Gaspardesque conception are closely related to the landscape with buildings on a hillside in the Tate Gallery (Cat. No.541).

543 Wooded Landscape with Mansion
Ownership unknown

Black chalk and stump and white chalk on blue paper. $12\frac{1}{2} \times 16\frac{1}{4}$ (317 × 413).
A figure climbing a flight of steps up to a mansion in the foreground and middle distance right; a weir in the foreground left; rocks or mountains in the distance left (from a photograph).
PROVENANCE: Victor Koch.
EXHIBITED: Sassoon 1936 (42).
BIBLIOGRAPHY: Woodall 74 and p.52; John Hayes, 'Gainsborough and the Gaspardesque', *The Burlington Magazine*, May 1970, p.311 and repr. fig.46.

The treatment of the foliage is closely related to the wooded landscape with buildings owned by Edgar Blaiberg (Cat. No.542).

544 Wooded Landscape with distant Mountain
Fitzwilliam Museum, Cambridge (975)

Black chalk and stump and white chalk on blue paper. $10\frac{1}{8} \times 12\frac{7}{16}$ (257 × 316).
A track winding from the foreground left into the middle distance right, past a rock in the foreground centre; a mountain in the distance right.
Collector's mark of Sir Edward Poynter bottom left.
PROVENANCE: Sir Edward Poynter; presented by the Friends of the Fitzwilliam Museum 1919.
BIBLIOGRAPHY: *Fitzwilliam Museum Report 1919*, p.3; *Friends of the Fitzwilliam Museum Report 1919*, p.1 and repr. p.3; Woodall 23 and pp.50 and 52.

The treatment of the foliage and the broad highlighting in white chalk are closely related to the wooded landscape with country mansion formerly owned by Victor Koch (Cat. No.543).

545 Study of a Wooded Landscape with Country Lane
Christopher Witt, Stock

Black and white chalks on buff paper. $5\frac{7}{8} \times 7\frac{11}{16}$ (149 × 195).

Trees in a wood, with a lane winding through the centre.
ENGRAVED: W. F. Wells, published by Wells and Laporte 1 March 1804 (as in the collection of George Hibbert).
PROVENANCE: From one of the sketch-books purchased by George Hibbert at the Gainsborough sale, Christie's, 11 May 1799, Lot 82, 84 or 88; by descent to the Hon. A. H. Holland-Hibbert; Holland-Hibbert sale, Christie's, 30 June 1913; Sir John Witt, who gave it to his son.
EXHIBITED: Arts Council 1960–1 (31, and p.7).
BIBLIOGRAPHY: Woodall 354.

A study from nature. The vigorous treatment of the foliage and the hatching in black chalk are closely related to the sketch of a village street formerly in the Underdown collection (Cat. No.539).

546 Study of a Wooded Landscape with Footbridge over a Stream
Viscount Knutsford, Munden

Black and white chalks on grey-green paper. $5\frac{3}{4} \times 7\frac{15}{16}$ (146×202).
A footbridge in the foreground centre over a stream running from the foreground left.
ENGRAVED: W. F. Wells, published 1 January 1802 (as in the collection of George Hibbert).
PROVENANCE: From one of the sketch-books purchased by George Hibbert at the Gainsborough sale, Christie's, 11 May 1799, Lot 82, 84 or 88; by descent to the Hon. A. H. Holland-Hibbert; Holland-Hibbert sale, Christie's, 30 June 1913, Lot 11 bt. in; thence by descent.

A study from nature. The vigorous treatment of the foliage and the white chalkwork are related to the sketch of a country lane owned by Christopher Witt (Cat. No.545).

547 Study of a Wooded Landscape with Stream
Ownership unknown

Black chalk and stump and white chalk on blue paper (apparently). Size unknown.
A stream running from the foreground left into the middle distance right; a gate in the middle distance right (from the print).
ENGRAVED: W. F. Wells, published 1 January 1802 (as in the collection of George Hibbert).
PROVENANCE: From one of the sketch-books purchased by George Hibbert at the Gainsborough sale, Christie's 11 May 1799, Lot 82, 84 or 88; by descent to the Hon. A. H. Holland-Hibbert; Holland-Hibbert sale, Christie's, 30 June 1913.

A study from nature. The treatment of the foliage seems to be related to the sketch of a country lane owned by Christopher Witt (Cat. No.545).

548 Study of a Village Scene with Pond
Plate 175
Henry E. Huntington Library and Art Gallery, San Marino (59.55.560)

Black and white chalks on buff paper. $6\frac{9}{16} \times 8\frac{5}{16}$ (167×211).
A group of buildings in the middle distance centre and right; a road winding from the foreground centre into the middle distance centre; a pond in the foreground right.
Collector's mark of Gilbert Davis on the mount bottom right.
PROVENANCE: From one of the sketch-books purchased by George Hibbert at the Gainsborough sale, Christie's, 11 May 1799, Lot 82, 84 or 88; by descent to the Hon. A. H. Holland-Hibbert; Holland-Hibbert sale, Christie's, 30 June 1913; H. W. Underdown; Underdown sale, Sotheby's, 7 July 1926, Lot 112 bt. Morison; Anon. sale, Sotheby's, 14 July 1948, Lot 170 (with three others) bt. Colnaghi, from whom it was purchased by Gilbert Davis; purchased from him 1959.
EXHIBITED: Huntington 1967–8 (8).
BIBLIOGRAPHY: Woodall 239.

A study from nature. The sketchy treatment of the buildings and foliage and the hatching in black chalk are closely related to the sketch of a village street formerly in the Underdown collection (Cat. No.539). Also mentioned on pp.30 and 96.

549 Study of a Wooded Landscape with Figure and Bridge
Ownership unknown

Black chalk and stump and white chalk on grey-green paper. Size unknown.
A figure crossing a wide stone bridge in the middle distance centre (from a photograph).
PROVENANCE: From one of the sketch-books purchased by George Hibbert at the Gainsborough sale, Christie's, 11 May 1799, Lot 82, 84 or 88; by descent to the Hon. A. H. Holland-Hibbert; Holland-Hibbert sale, Christie's, 30 June 1913; H. W. Underdown.

A study from nature. The sketchy handling of the foliage and the white chalkwork are identical with the sketch of cottages in the Witt Collection (Cat. No.538).

550 Study of a Water Mill Plate 171
A. C. Greg, Acton Bridge

Black chalk and stump and white chalk on
grey-green paper. 6 × 7¾ (152 × 197).
A water mill in the foreground centre and right;
a weir in the foreground left, with a stream
running across the foreground.
ENGRAVED: W. F. Wells, published 1 January 1802.
PROVENANCE: From one of the sketch-books
purchased by George Hibbert at the Gainsborough
sale, Christie's, 11 May 1799, Lot 82, 84 or 88;
by descent to the Hon. A. H. Holland-Hibbert;
Holland-Hibbert sale, Christie's, 30 June 1913,
Lot 3 bt. Agnew; H. W. Underdown; Underdown
sale, Sotheby's, 15 December 1926, Lot 114 bt.
Parsons; Anon. sale, Sotheby's, 14 November 1962,
Lot 40 bt. Spink, from whom it was purchased.
BIBLIOGRAPHY: John Hayes, 'Gainsborough and the
Gaspardesque', *The Burlington Magazine*, May 1970,
p.308.

A study from nature. The sketchy handling of
the foliage and the white chalkwork are identical
with the sketch of cottages in the Witt Collection
(Cat. No.538). Also mentioned on p.50.

551 Study of a Farmhouse
Ownership unknown

Black chalk and stump and white chalk on
grey-green paper (apparently). Size unknown.
A farmhouse in the foreground centre and right
(from the print).
ENGRAVED: W. F. Wells, published by Wells and
Laporte 1 May 1803 (as in the collection of
George Hibbert).
PROVENANCE: From one of the sketch-books
purchased by George Hibbert at the Gainsborough
sale, Christie's, 11 May 1799, Lot 82, 84 or 88;
by descent to the Hon. A. H. Holland-Hibbert;
Holland-Hibbert sale, Christie's, 30 June 1913,
Lot 13 bt. Leggatt.

A study from nature. The treatment of the build-
ings and foliage and the white chalkwork seem
to be related to the sketch of a water-mill
owned by A. C. Greg (Cat. No.550).

**552 Study of a Hilly Landscape with
Figure outside a Cottage**
Ownership unknown

Black chalk and stump and white chalk on
grey-green paper (apparently). Upright. Size
unknown.
A woman seated outside a cottage situated on
sloping ground in the foreground left and centre;

a hill in the middle distance right (from the print).
ENGRAVED: W. F. Wells, published 1 March 1802
(as in the collection of George Hibbert).
PROVENANCE: From one of the sketch-books
purchased by George Hibbert at the Gainsborough
sale, Christie's, 11 May 1799, Lot 82, 84 or 88;
by descent to the Hon. A. H. Holland-Hibbert;
Holland-Hibbert sale, Christie's, 30 June 1913.

A study from nature. The treatment of the
foliage and the white chalkwork seem to be
related to the sketch of a water-mill owned by
A. C. Greg (Cat. No.550).

**553 Study of Cottages on either side of a
Lane**
Henry E. Huntington Library and Art Gallery,
San Marino (65.168)

Black and white chalks and grey wash on buff
paper. 5⅞ × 8¼ (149 × 210).
A cottage behind a wall with a white gate in the
foreground left; a wall with a stile in the
foreground right; a lane winding from the
foreground left into the middle distance centre,
where there are two more cottages.
ENGRAVED: W. F. Wells, published by Wells and
Laporte 1 January 1803 (as in the collection of
George Hibbert).
PROVENANCE: From one of the sketch-books
purchased by George Hibbert at the Gainsborough
sale, Christie's, 11 May 1799, Lot 82, 84 or 88;
by descent to the Hon. A. H. Holland-Hibbert;
Holland-Hibbert sale, Christie's, 30 June 1913;
H. W. Underdown; Underdown sale, Sotheby's,
7 July 1926, Lot 116 bt. Parsons; with Albert
Roullier, Chicago; Anon. sale, Sotheby's, 28 July
1965, Lot 164 bt. Spink, from whom it was
purchased 1965.
EXHIBITED: Huntington 1967–8 (7).
BIBLIOGRAPHY: John Hayes, 'Gainsborough and the
Gaspardesque', *The Burlington Magazine*, May 1970,
pp.308 and 311 and repr. fig.45.

A study from nature. The sketchy treatment of
the foliage and the white chalkwork are closely
related to the sketch of a water-mill owned by
A. C. Greg (Cat. No.550).

**554 Study of a Village Street with
three Cottages**
Commander J. B. Watson, Edinburgh

Pencil and black and white chalks on grey paper.
6 × 8⁵⁄₁₆ (152 × 211).
A street running from the foreground right to the
middle distance centre; three cottages in the middle
distance left and centre.

ENGRAVED: W. F. Wells, published by Wells and Laporte 1 March 1803 (as in the collection of George Hibbert).
PROVENANCE: From one of the sketch-books purchased by George Hibbert at the Gainsborough sale, Christie's, 11 May 1799, Lot 82, 84 or 88; by descent to the Hon. A. H. Holland-Hibbert; Holland-Hibbert sale, Christie's, 30 June 1913, probably Lot 5 bt. Agnew; Anon. sale, Sotheby's, 2 December 1959, Lot 45 bt. Colnaghi, from whom it was purchased.

A study from nature. The treatment of the foliage and the white chalkwork are closely related to the sketch of a village street in the Huntington Art Gallery (Cat. No.553).

555 Study of a large House with a Flagstaff in the Garden
Ownership unknown

Black and white chalks on grey-green paper. Size unknown.
A large house and outbuildings with an arched gateway in the foreground centre and right; a flagstaff with a flag at half-mast in the foreground left (from a photograph).
PROVENANCE: From one of the sketch-books purchased by George Hibbert at the Gainsborough sale, Christie's, 11 May 1799, Lot 82, 84 or 88; by descent to the Hon. A. H. Holland-Hibbert; Holland-Hibbert sale, Christie's, 30 June 1913.

A study from nature. The sketchy handling of the foliage and the white chalkwork are identical with the sketches in the collections of A. C. Greg and Commander Watson (Cat. Nos.550 and 554).

556 Study of a Wooded Landscape with Houses
Ownership unknown

Black and white chalks on grey-green paper. Size unknown.
A large house half-hidden by trees in the middle distance right; a cottage in the middle distance centre; a track winding from the foreground right through the foreground and into the middle distance centre (from a photograph).
PROVENANCE: From one of the sketch-books purchased by George Hibbert at the Gainsborough sale, Christie's, 11 May 1799, Lot 82, 84 or 88; by descent to the Hon. A. H. Holland-Hibbert; Holland-Hibbert sale, Christie's, 30 June 1913; H. W. Underdown.

A study from nature. The handling of the foliage

and the white chalkwork in the sky are related to the sketch of a house with a flagstaff formerly in the Holland-Hibbert collection (Cat. No. 555), but the drawing is a little tighter in execution.

557 Wooded Landscape with Buildings and Sheep
Ownership unknown

Black chalk and stump and white chalk on grey-green paper (apparently). Size unknown.
Sheep scattered beside a stream which runs from the middle distance left through the foreground into the middle distance right; a cottage and a stone bridge in the middle distance left; a church tower half-hidden by trees in the middle distance centre; a cottage in the middle distance right (from the print).
ENGRAVED: W. F. Wells, published by Wells and Laporte 1 December 1803 (as in the collection of George Hibbert).
PROVENANCE: From one of the sketch-books purchased by George Hibbert at the Gainsborough sale, Christie's, 11 May 1799, Lot 82, 84 or 88; by descent to the Hon. A. H. Holland-Hibbert; Holland-Hibbert sale, Christie's, 30 June 1913.

The rhythmical composition, treatment of the foliage, and white chalkwork in the sky seem to be related to the sketch of houses beyond a hillock formerly in the Underdown collection (Cat. No.556).

558 Study of a Wooded Landscape with Cottage Plate 420
Private Collection, London

Black chalk and stump and white chalk on brown paper. $5\frac{15}{16} \times 8\frac{1}{8}$ (151 × 206).
A cottage among trees in the middle distance centre; a track leading to a gate in the foreground left.
PROVENANCE: With Gerald Norman; Anon. (= Norman) sale, Christie's, 4 July 1967, Lot 130 bt. John Manning, from whom it was purchased 1967.
EXHIBITED: *Twenty-Eighth Exhibition of Watercolours and Drawings*, The Manning Gallery, November 1967 (59).

A study from nature. The treatment of the foliage is closely related to the sketch of houses beyond a hillock formerly in the Underdown collection (Cat. No.556). Also mentioned on pp.61, 84 and 96.

559 Study of a House and Trees
Dr R. E. Hemphill, Cape Town

Pencil on grey paper. 6 15/16 × 6 15/16 (176 × 176).
Study of a house, with trees on the right.
Verso: Study of an old oak, probably by a later hand (Woodall 358).
PROVENANCE: From one of the sketch-books purchased by George Hibbert at the Gainsborough sale, Christie's, 11 May 1799, Lot 82, 84 or 88; by descent to the Hon. A. H. Holland-Hibbert; Holland-Hibbert sale, Christie's 30 June 1913, Lot 50 (with another) bt. Rimell; Sir Robert Witt.

A study from nature. The treatment of the foliage is closely related to the study of a cottage near a gate formerly with Manning Gallery (Cat. No.558). In spite of the impeccable provenance, the study of an oak tree on the verso (Woodall 358) is a little too tight and finicky in handling for Gainsborough at any stage in his career; the closeness of certain passages in the foliage to the style exemplified on the recto militates against the possibility that it might conceivably be a very early work indeed and suggests that it is a drawing by a later amateur hand influenced by Gainsborough.

560 Wooded Landscape with Country Road
D. L. T. Oppé, London (2513)

Black and white chalks on brown paper.
7⅛ × 8 1/16 (181 × 205).
A track winding through a wood from the foreground centre into the middle distance centre.
PROVENANCE: From one of the sketch-books purchased by George Hibbert at the Gainsborough sale, Christie's, 11 May 1799, Lot 82, 84 or 88; by descent to the Hon. A. H. Holland-Hibbert; Holland-Hibbert sale, Christie's, 30 June 1913; E. Horsman Coles; bequeathed to A. Paul Oppé 1954.

A study from nature. The rather tight scallops outlining the foliage are closely related to the study of a house and trees owned by Dr Hemphill (Cat. No.559).

561 Study of a River Scene with Mill
Plate 176
California Palace of the Legion of Honor, San Francisco (1961.43)

Black and white chalks on grey paper.
7⅛ × 8¼ (181 × 210).
A river winding from the foreground left into the middle distance right; a millhouse and bridge in the middle distance right.

PROVENANCE: From one of the sketch-books purchased by George Hibbert at the Gainsborough sale, Christie's, 11 May 1799, Lot 82, 84 or 88; by descent to the Hon. A. H. Holland-Hibbert; Holland-Hibbert sale, Christie's, 30 June 1913; H. W. Underdown; Underdown sale, Sotheby's ,7 July 1926, Lot 115 bt. Meatyard; (Sir) John Witt, who gave it to Thomas Carr Howe; presented 1961.
EXHIBITED: *English Painting*, California Palace of the Legion of Honour, San Francisco, June–July 1933 (76); *Old Master Drawings*, Mills College Art Gallery and Portland Museum of Art, October 1937–January 1938 (22); *Master Drawings*, Golden Gate International Exposition, San Francisco, 1940 (38 and repr. p.92).

A study from nature. The treatment of the foliage is related to the sketch of a cottage near a gate formerly with Manning Gallery (Cat. No.558). Also mentioned on pp.30 and 96.

562 Study of a Wooded Landscape with Country Road
Art Gallery and Museum, Glasgow (22–27)

Black and white chalks on grey-green paper.
6⅛ × 8 7/16 (156 × 214).
A country road edged by trees winding from the foreground right into the middle distance centre.
ENGRAVED: W. F. Wells, published 1 January 1802 (as in the collection of George Hibbert).
PROVENANCE: From one of the sketch-books purchased by George Hibbert at the Gainsborough sale, Christie's, 11 May 1799, Lot 82, 84 or 88; with Walker's Galleries, from whom it was purchased 1922.

A study from nature. The treatment of the foliage and foreground detail is related to the river scene in the California Palace of the Legion of Honor (Cat. No.561). Although much more vigorous in treatment, this type of sketch and composition is closely related to Taverner (see John Baskett, *Old Master and English Drawings*, May–June 1969, No.11 repr.)

563 Hilly Wooded Landscape with Figure and Stream
W. A. Brandt, Ashdon

Black chalk and stump and white chalk on grey paper.
8⅛ × 12 15/16 (206 × 329).
A figure with a rabbit on a stick over his right shoulder, followed by two dogs, in the foreground centre; a stream running from the foreground left into the middle distance centre; high rocks in the middle distance right; hills in the distance centre.

PROVENANCE: Sir Edward Poynter (?); Sir Michael Sadler; H. C. Green; Green sale, Sotheby's, 18 October 1961, Lot 63 bt. Spink, from whom it was purchased by G. D. Lockett; with Fine Art Society; C. F. Af Petersens; with Fine Art Society; with Feilding and Morley-Fletcher, from whom it was purchased 1967.
EXHIBITED: *English Water-colours of the Great Period from a Private Collection*, Ickworth, May–June 1968 (29).
BIBLIOGRAPHY: Woodall 281.

The treatment of the foliage and the white chalkwork are closely related to the sketch of a country road in Glasgow (Cat. No.562).

564 Mountain Landscape with Figures and Sheep Plate 183
Cecil Higgins Art Gallery, Bedford (P.71)

Black chalk and stump and white chalk on brown paper. 10⅛ × 13⅞ (257 × 352).
A shepherd and scattered sheep on a rocky slope in the foreground and middle distance left; a peasant and horse travelling along a hilly road in the middle distance right; a wooded ravine in the middle distance centre; mountains in the distance centre and right. Collector's mark of Sir George Clausen bottom right.
PROVENANCE: Rev. H. Burgess; Sir George Clausen; Clausen sale, Sotheby's, 2 June 1943, Lot 92 bt. Agnew, from whom it was purchased by Sir William Worsley 1944; returned to Agnew, and purchased by Howard Bliss 1949; with Leicester Galleries, from whom it was purchased by G. Churchill; purchased.
EXHIBITED: *71st Annual Exhibition of Water-Colour Drawings*, Agnew's, February–March 1944 (58); *From Gainsborough to Hitchens*, The Leicester Galleries, January 1950 (15); Nottingham 1962 (56).
BIBLIOGRAPHY: Sir George Clausen, *Aims and Ideals in Art*, London, 1906, repr. f. p.160; Woodall 28 and pp.67–8 and 71; Woodall 1949, p.98.

Study for the mountain landscape now in the National Gallery of Scotland (Waterhouse 966, repr. pl.257), exhibited R.A. 1783. No changes were made in the finished picture except for the inclusion of a village in the middle distance, the shepherd being shown reclining instead of standing, and some slight alterations in the disposition of the sheep. The treatment of the foliage, the scattered highlights in white chalk, and the rhythmical conception are closely related to the hilly landscape with figure and stream in the W. A. Brandt collection (Cat. No.563). A copy is in the collection of J. F. McCrindle. Also mentioned on pp.15 and 39.

565 Study of Trees
Mrs Stuart Cooper, London

Black chalk on grey paper, with touches of white chalk. 6⅜ × 7¾ (162 × 197).
A group of trees in the foreground centre; no background.
PROVENANCE: From one of the sketch-books purchased by George Hibbert at the Gainsborough sale, Christie's, 11 May 1799, Lot 82, 84 or 88; by descent to the Hon. A. H. Holland-Hibbert; Holland-Hibbert sale, Christie's, 30 June 1913; E. Horsman Coles; with John Manning, from whom it was purchased by H. W. J. Ferrand 1962; with Manning Gallery, from whom it was purchased 1967.
EXHIBITED: *Seventeenth Exhibition of Watercolours and Drawings*, John Manning, Spring 1962 (15); *Twenty-Seventh Exhibition of Watercolours and Drawings*, Manning Gallery, June 1967 (74).

A study from nature. The handling is closely related to the sketch of a country road in Glasgow (Cat. No.562).

566 Wooded Landscape with Cow and Sheep
Ownership unknown

Black chalk and stump (apparently). Size unknown.
A cow in the foreground centre; scattered sheep in the middle distance left; hills in the distance (from the print).
ENGRAVED: W. F. Wells, published by Wells and Laporte 1 December 1803 (as in the collection of George Hibbert).
PROVENANCE: From one of the sketch-books purchased by George Hibbert at the Gainsborough sale, Christie's, 11 May 1799, Lot 82, 84 or 88; by descent to the Hon. A. H. Holland-Hibbert; Holland-Hibbert sale, Christie's, 30 June 1913.

The treatment of the foliage seems to be related to the sketch of a country road in Glasgow (Cat. No.562).

567 Study of a Wooded Landscape with Stream
Ownership unknown

Black chalk and stump and white chalk on buff paper (apparently). Size unknown.
A large log in the foreground left; a stream running across the foreground; a track winding from the foreground right into the middle distance right (from the print).
ENGRAVED: W. F. Wells, published by Wells and Laporte, 1 November 1804 (as in the collection of George Hibbert).

PROVENANCE: From one of the sketch-books purchased by George Hibbert at the Gainsborough sale, Christie's, 11 May 1799, Lot 82, 84 or 88; by descent to the Hon. A. H. Holland-Hibbert; Holland-Hibbert sale, Christie's, 30 June 1913.

A study from nature. The treatment of the foliage and the foreground detail seems to be related to the sketch of a country road in Glasgow (Cat. No.562).

568 Study of a Woodland Road
Davison Art Center, Middletown, Conn.

Black chalk and stump and white chalk on grey-blue paper. $6\frac{1}{8} \times 8\frac{1}{16}$ (156 × 205).
Trees in a wood, with a lane winding through the centre.
ENGRAVED: W. F. Wells, published by Wells and Laporte, 1 January 1805 (as in the collection of George Hibbert).
PROVENANCE: From one of the sketch-books purchased by George Hibbert at the Gainsborough sale, Christie's, 11 May 1799, Lot 82, 84 or 88; by descent to the Hon. A. H. Holland-Hibbert; Holland-Hibbert sale, Christie's, 30 June 1913, probably Lot 55 bt. Agnew; George W. Davison, who presented it 1944.

A study from nature. The treatment of the foliage, the white chalkwork, and the static conception are related to the study of a country road in Glasgow (Cat. No.562).

569 Study of a Country Road
Christchurch Mansion, Ipswich (1913–45)

Black chalk and stump and white chalk on grey paper. $6\frac{11}{16} \times 8$ (170 × 203).
A country road leading through a wood from the foreground centre into the middle distance left.
ENGRAVED: W. F. Wells, published by Wells and Laporte, 1 March 1804 (as in the collection of George Hibbert).
PROVENANCE: From one of the sketch-books purchased by George Hibbert at the Gainsborough sale, Christie's, 11 May 1799, Lot 82, 84 or 88; by descent to the Hon. A. H. Holland-Hibbert; Holland-Hibbert sale, Christie's, 30 June 1913, Lot 9 bt. Gooden and Fox for the Ipswich Museum.
EXHIBITED: Aldeburgh 1949 (11).
BIBLIOGRAPHY: Woodall 63.

A study from nature. The handling is closely related to the study of a woodland road in the Davison Art Center (Cat. No.568).

570 Study of a Meadow with Sheep and distant Farm Buildings
Courtauld Institute of Art, Witt Collection, London (4110)

Pencil and black and white chalk on grey-green paper. 6 × 8 (152 × 203).
Scattered sheep beside a country track in the middle distance centre; farm buildings in the distance right. Collector's mark of Sir Robert Witt on the back of the mount bottom left.
ENGRAVED: W. F. Wells, published by Laporte and Wells, 1 January 1802 (as in the collection of George Hibbert).
PROVENANCE: From one of the sketch-books purchased by George Hibbert at the Gainsborough sale, Christie's, 11 May 1799, Lot 82, 84 or 88; by descent to the Hon. A. H. Holland-Hibbert; Holland-Hibbert sale, Christie's, 30 June 1913; Anon. sale, Sotheby's, 17 December 1947, Lot 13 bt. Agnew, from whom it was purchased by Sir Robert Witt; bequeathed 1952.
EXHIBITED: *Some British Drawings from the collection of Sir Robert Witt*, National Gallery of Canada, Ottawa, 1949 and American Federation of Arts 1951 (25).
BIBLIOGRAPHY: *Hand-List of Drawings in the Witt Collection*, London, 1956, p.22.

The treatment of the foliage is closely related to the sketch of a country road in Glasgow (Cat. No.562).

571 Study of Fields
Derek Hudson, London

Pencil, with some white chalk, on grey-green paper. $6\frac{7}{8} \times 8\frac{1}{8}$ (175 × 206).
Hedged fields and trees.
PROVENANCE: Garabed Bishirgian; purchased at a sale in Ockley, Surrey about 1941.

A study from nature. The scallops outlining the foliage and the treatment of the distant trees are identical with the sketch of a meadow with distant farm buildings in the Witt Collection (Cat. No.570).

572 Study of a Landscape with Cottage
Arnold Haskell, Bath

Pencil and black chalk. $5\frac{7}{8} \times 7\frac{13}{16}$ (149 × 198).
A cottage in the distance centre; trees in the foreground right.
ENGRAVED: W. F. Wells, published Wells and Laporte, 1 January 1803 (as in the collection of George Hibbert).
PROVENANCE: From one of the sketch-books purchased by George Hibbert at the Gainsborough sale,

Christie's, 11 May 1799, Lot 82, 84 or 88; by descent to the Hon. A. H. Holland-Hibbert; Holland-Hibbert sale, Christie's, 30 June 1913; H. W. Underdown; probably Underdown sale, Sotheby's, 7 July 1926, Lot 110 bt. Parsons; L. G. Duke.

A study from nature. The treatment of the foliage is related to the sketch of a meadow with distant farm buildings in the Witt Collection (Cat. No.570).

573 Study of Glastonbury Abbey
Plate 177
Sir John and Lady Witt, London

Black and white chalks on grey paper.
$6\frac{1}{2} \times 8\frac{5}{16}$ (165 × 211).
The ruins of the eastern piers of the crossing and the adjacent bays of the transepts stretching across the foreground, with three figures under one of the arches in the foreground left; St. Michael's Chapel on Glastonbury Tor in the distance centre.
Inscribed in a later hand in ink bottom left: *Glastonbury Abby* [sic]/(word illegible) *T Gainsborough.*
Collector's mark of A. G. B. Russell bottom right.
PROVENANCE: A. G. B. Russell; Russell sale, Sotheby's, 11 July 1928, Lot 47 (repr.) bt. Maser.
EXHIBITED: *The John Witt Collection (Part II: English School)*, Courtauld Institute Galleries, April–June 1963 (22).
BIBLIOGRAPHY: Basil S. Long, 'English Drawings in the Collection of Mr. Archibald C. B. Russell', *The Connoisseur*, July 1924, p.142 and repr. p.143; Woodall 356; John Hayes, 'Gainsborough and the Gaspardesque', *The Burlington Magazine*, May 1970, p.308.

A study from nature. The drawing is a summary sketch of the ruins which does not aim at accuracy in detail; obvious faults are the proportions of the arches, which should be heightened, and the failure to bring the piers into line. The state of the ruins seen here is not altered today, except for the removal of the bushes and other growths. Gainsborough made a tour of the West Country in the company of Gainsborough Dupont in about 1782 (see p.29), and it is possible that the drawing was made on this trip. The sketchy treatment of the buildings, the hatching in black chalk, and the scattered highlights in white chalk are closely related to the sketch of farm buildings by a pond in the Huntington Art Gallery (Cat. No.548). Also mentioned on pp.18 and 30.

574 Study of St Joseph's Chapel, Glastonbury Abbey
Mrs Charles Eade, Broadstairs

Black and white chalks on grey paper.
$6\frac{5}{16} \times 8\frac{1}{16}$ (160 × 205).
The ruins of the chapel stretching across the foreground.
Inscribed in a later hand in ink bottom right: *St Josephs Chapel /~pr* (?) *T Gainsborough.*
Collector's mark of A. G. B. Russell bottom left.
PROVENANCE: A. G. B. Russell; Russell sale, Sotheby's, 11 July 1928, Lot 48 bt. Child; J. Shirley-Fox; Red Cross sale (presented by Mrs A. R. Shirley-Fox), Christie's, 12 July 1940, Lot 775 bt. Eade.
EXHIBITED: Sassoon 1936 (54).
BIBLIOGRAPHY: Basil S. Long, 'English Drawings in the Collection of Mr. Archibald C. B. Russell', *Th Connoisseur*, July 1924, p.142 repr.; Woodall 290; John Hayes, 'Gainsborough and the Gaspardesque', *The Burlington Magazine*, May 1970, p.308.

A study from nature. A summary sketch of the ruins which does not aim at accuracy in detail, taken from the south-east. Comparison with the engraving by John Le Keux after Charles Wild, published in 1813, which was made from the same viewpoint, shows that much of the bushy growth masking the turret on the left and surmounting the arch on the right had been removed by the early 19th century. The sketchy treatment of the buildings, the hatching in black chalk, and the scattered highlights in white chalk are identical with the study of Glastonbury in Sir John Witt's collection (Cat. No.573), and the drawing was clearly made on the same occasion. Possibly executed on a tour of the West Country made in about 1782 (see Cat. No.573).

575 Study of Tintern Abbey Plate 178
D. L. T. Oppé, London (1286)

Pencil. $7\frac{5}{16} \times 9\frac{1}{16}$ (186 × 230).
The ruins of the abbey from inside the building across the foreground, with a figure standing beside a wall in the foreground left.
Inscribed in pencil top left: *Abby Tinton* [sic], *in Monmouthshire.*
Collector's mark of John Lowndes bottom right.
PROVENANCE: John Lowndes; Sir Harry Wilson (?); Anon. sale, Foster's, 8 June 1921, Lot 80 (with seven other miscellaneous drawings) bt. A. Paul Oppé.
BIBLIOGRAPHY: Woodall 248; John Hayes, 'Gainsborough and the Gaspardesque', *The Burlington Magazine*, May 1970, p.308.

The sketchy treatment of the buildings, the scallops outlining the foliage, and the hatching are closely related to the two studies of Glastonbury (Cat. Nos.573 and 574), and the sketch may well have been done on the same tour, possibly the trip made in about 1782 (see Cat. No.573). However, although the drawing has all the appearance of a sketch done on the spot, it bears little relation to any surviving part of Tintern Abbey: the windows are close in type to those at Tintern, but if the view is intended to represent the east end, as seems possible, the main window is too small, the clerestory window is missing, the arches of the crossing have been omitted, and the scale is insufficiently grand. The explanation may be that the sketch was done later, a rough jotting from memory; but it is possible also that the drawing has been incorrectly inscribed, though an alternative identification is not obvious. Also mentioned on p.18.

576 Wooded Landscape with Shipping on a River, Figures and Buildings
Ownership unkown

Pencil. 6½ × 9¼ (165 × 235).
Four sailing boats moored in a river in the foreground left and middle distance centre; two figures, one of them seated, in a rowing boat in the foreground centre; two figures and a horse crossing a stone bridge in the middle distance right; buildings in the distance left and middle distance right (from a photograph).
PROVENANCE: With Gaston von Mallmann; Mallmann sale, Lepke, Berlin, 13 June 1918, Lot 69 (repr. pl.25a).
BIBLIOGRAPHY: Woodall 425.

An unusual subject for Gainsborough. The pencilwork and treatment of the foliage are closely related to the sketch of Glastonbury owned by Mrs Charles Eade (Cat. No.574).

577 Study of Langdale Pikes Plate 179
Dr C. B. M. Warren, Felsted

Pencil and grey wash. 10⅜ × 16¼ (264 × 413).
A figure standing in a rowing boat in the foreground left; Elterwater stretching across the foreground and the middle distance left and centre; a hill in the middle distance right; Langdale Pikes in the distance centre.
PROVENANCE: Anon. sale, Sotheby's, 3 May 1918, Lot 24 bt. A. Paul Oppé; sold to Agnew 1939; Christopher Norris; with Squire Gallery; William Lambshead; Anon. sale, Sotheby's, 20 April 1955,

Lot 47 bt. Spink, from whom it was purchased.
EXHIBITED: *Sixty-Seventh Annual Exhibition of Water-Colour and Pencil Drawings*, Agnew's, February–March 1940 (125); Arts Council 1960–1 (45, and p.6).
BIBLIOGRAPHY: Woodall 246; John Hayes, 'British Patrons and Landscape Painting 3. The response to nature in the eighteenth century', *Apollo*, June 1966, fig.5; John Hayes, 'Gainsborough and the Gaspardesque', *The Burlington Magazine*, May 1970, p.308.

A study from nature. Although the silhouette of the peaks has been softened, the view is otherwise an accurate representation of Langdale Pikes as seen from Elterwater, and was presumably made by Gainsborough during his visit to the Lakes in the late summer of 1783. The treatment of the foliage is related to the study of a meadow and distant farm buildings in the Witt Collection (Cat. No.570). Also mentioned on pp.13, 18, 30, 33, 39 and 45.

578 Study of a Mountain Scene with Lake
Plate 180
J. B. Kenrick, Birmingham

Black chalk and grey wash. 11 × 17¼ (279 × 438).
A lake in the foreground and middle distance left; mountains in the distance left and centre.
PROVENANCE: Alistair Horton; by descent to John Wright; with the Ruskin Gallery, from whom it was purchased 1964.
EXHIBITED: *Works of Art belonging to the Friends of the Art Gallery*, City of Birmingham Museum and Art Gallery, February–March 1962 (58); *English Watercolours and Drawings 1750–1950*, Ruskin Gallery, Stratford, Spring 1964 (35).
BIBLIOGRAPHY: John Hayes, 'Gainsborough and the Gaspardesque', *The Burlington Magazine*, May 1970, p.308.

A study from nature. The handling of wash and the treatment of the foliage are closely related to the sketch of Langdale Pikes owned by Dr Warren (Cat. No.577): this drawing too was probably executed therefore on Gainsborough's visit to the Lakes in the late summer of 1783, but the view has not so far been identified. Also mentioned on pp.18 and 31.

579 Lake Scene with Figures and Sailing Ship
Mrs Laurence Binyon, Streatley

Grey and brown washes. 9¼ × 12½ (235 × 317).
Two figures on the shore in the foreground centre;

a sailing boat in the middle distance right, with a rowing boat astern; land across the distance.
Inscribed in pencil bottom right: *by Gainsborough / bought from his daughter by JoD.*
PROVENANCE: Among the drawings left by the artist to his wife, which descended to Margaret Gainsborough, from whom it was purchased by J. D. (possibly John Downman); L. Tatham; Laurence Binyon.
EXHIBITED: *British Art*, R.A., January–March 1934 (1145); *Desenul și Gravura Engleză*, Muzeul Toma Stelian, Bucharest, December 1935–March 1936 (123); *La Peinture Anglaise*, Louvre, 1938 (198); Nottingham 1962 (52).
BIBLIOGRAPHY: *Commemorative Catalogue of the Exhibition of British Art 1934*, Oxford, 1935, No.611 and repr. pl.CXLVII(a); Woodall 13, pp.76–7 and repr. pl.105; Iolo A. Williams, *Early English Watercolours*, London, 1952, p.71; Martin Hardie, *Water-colour Painting in Britain 1. The Eighteenth Century*, London, 1966, p.76.

A study from nature. The handling of wash and the treatment of the foliage are closely related to the lakeland scene owned by J. B. Kenrick (Cat. No.578). Possibly, like the latter, a view in the Lakes and executed during Gainsborough's visit there in the late summer of 1783. The theme, with a sailing vessel and rowing boat in a calm, is related to the coastal scene at Melbourne (Waterhouse 964, repr. pl.244), exhibited R.A. 1783.

580 Wooded Upland Landscape with Cattle at a Watering Place
L. H. Beattie, London

Pen with grey and brown washes.
$8\frac{3}{16} \times 12$ (208 × 305).
Six cows and a sheep drinking at a watering place in the foreground centre; high rocks in the middle distance left; hills in the distance right.
PROVENANCE: With Spink, from whom it was purchased.
EXHIBITED: Arts Council 1960–1 (44).

The treatment of wash and the tight scallops outlining the foliage are identical with the sketch of Langdale Pikes owned by Dr Warren (Cat. No.577). The rocks on the left are strongly suggestive of the lumps of coal which Gainsborough used in his model landscapes (see p.33), but the scene is nevertheless evocative of Lakeland scenery and was presumably based on his drawings or memories of that district.

581 Wooded Mountain Landscape with Herdsman, Cows and Stream
City Art Gallery, Bradford (11–23)

Grey wash. $10\frac{3}{4} \times 16\frac{1}{2}$ (273 × 419).
A herdsman driving five cows along a track in the middle distance left; a stream with a weir in the foreground and middle distance centre and right; high rocks in the middle distance left; a mountain in the distance centre.
Collector's mark of William Esdaile bottom right.
PROVENANCE: William Esdaile; Esdaile sale, Christie's, 20–1 March 1838; Henry J. Pfungst; Pfungst sale, Christie's, 15 June 1917, Lot 59 bt. Brown and Phillips; Asa Lingard, who presented it 1923.
EXHIBITED: Ipswich 1927 (154).
BIBLIOGRAPHY: Woodall 22.

The scallops outlining the foliage and the treatment of the foreground detail are closely related to the mountain landscape owned by L. H. Beattie (Cat. No.580).

582 Wooded Upland Landscape with Herdsman, Cow and Dog Plate 182
Mrs M. G. Turner, Gerrards Cross

Black and white chalks and grey wash on buff paper.
$10\frac{15}{16} \times 14\frac{9}{16}$ (278 × 370).
A herdsman, cow and dog descending a winding hilly road in the foreground left; rocks on rising ground in the middle distance right; hills beyond a wooded valley in the distance centre.
PROVENANCE: Marquess Camden; with Parsons, from whom it was purchased by P. M. Turner; with the Independent Gallery.
EXHIBITED: Oxford 1935 (40); Sassoon 1936 (56).
BIBLIOGRAPHY: *Parsons Catalogue*, No.48, 1932 (54 repr.); Roger Fry, *Reflections on British Painting*, London, 1934, p.78 and repr. fig.30; Woodall 326, pp.68–9 and repr. pl.88.

The scallops outlining the foliage and contours of the rocks are closely related to the mountain landscape at Bradford (Cat. No.581). Also mentioned on p.93.

583 Wooded Rocky Landscape with Shepherd and Sheep
Ownership unknown

Black chalk and stump and white chalk, and grey and grey-black washes. $11 \times 14\frac{1}{2}$ (279 × 368).
A shepherd seated with a sheep in the foreground right; several sheep in the middle distance centre; high rocks in the middle distance centre and right (from a photograph).
PROVENANCE: Marquess Camden; with P. M. Turner;

with the Independent Gallery; with Fine Art
Society.
EXHIBITED: Oxford 1935 (9); Sassoon 1936 (46);
Early English Watercolours and Drawings, Fine Art
Society, October 1944 (42).
BIBLIOGRAPHY: Woodall 328 and repr. pl.89.

The treatment of the craggy mountains and the
foliage, the white chalk highlights and the
rhythmical conception, are identical with the
mountain landscape with the same provenance
in the collection of Mrs M. G. Turner (Cat.
No.582).

**584 Upland River Landscape with
Horsemen and Packhorses crossing a
Bridge** Plate 186
Henry E. Huntington Library and Art Gallery,
San Marino (64.3)

Brown wash over an offset outline.

$7\frac{15}{16} \times 10\frac{1}{2}$ (202 × 267).
A donkey, followed by a figure leading a packhorse
and accompanied by a dog, crossing a stone bridge
in the foreground centre; two horsemen approaching
the bridge from the other side in the middle distance
right; a river running from the foreground right into
the distance centre; mountains in the middle distance
right and the distance left centre and right.
Stamped *T Gainsborough* bottom left between two
ruled lines outside which there is a gold tooled
arabesque border over brown wash.
PROVENANCE: Anon. sale, Sotheby's, 20 November
1963, Lot 20 bt. Fine Art Society, from whom it was
purchased by the Friends of the Huntington Library
1964.
EXHIBITED: Huntington 1967–8 (9).

The loose treatment of wash and the broken
contours modelling the rocks on the right are
related to the mountain landscape owned by
Mrs M. G. Turner (Cat. No.582). Robert Wark
notes (Huntington 1967–8 Catalogue, *op. cit.*)
that 'the lines and also some of the washes have
a matt appearance as if blotted or perhaps
printed by some monotype process'. On this
issue, see p.25. The type of hump-backed bridge,
which now becomes a recurrent motif in
Gainsborough's river and mountain scenes, is
characteristic of the Lake District.

**585 Hilly Landscape with Shepherd
and Sheep** Plate 188
British Museum, London (1859–8–6–428)

Brown wash over an offset outline. $7\frac{7}{8} \times 10\frac{1}{2}$
(200 × 267).

A shepherd reclining on a bank in the foreground
right; scattered sheep in the middle distance right;
a pond in the foreground right; mountainous
distance.
Signed bottom left in ink with initials: *T·G·* outside a
border consisting of two ruled lines and a gold tooled
arabesque border with a further ruled line.
PROVENANCE: With Graves, from whom it was
purchased 1859.
BIBLIOGRAPHY: Binyon 18; Gower *Drawings*, p.12
and repr. pl.XII; Woodall 94 and p.102.

The handling of wash and the treatment of the
tree trunks and foliage are identical with the
river scene in the Huntington Art Gallery (Cat.
No.584). Also mentioned on p.25.

**586 Wooded Landscape with Figures on
Horseback**
British Museum, London (1859–8–6–427)

Brown wash over an offset outline. $7\frac{7}{8} \times 10\frac{1}{2}$
(200 × 267).
Two figures on horseback, with a packhorse and
a dog, travelling along a track in the foreground
left; a pond in the foreground centre; scattered
sheep on a slope in the foreground right.
Signed bottom left in ink with initials: *T·G·*
outside a border consisting of two ruled lines and
a gold tooled arabesque border with a further
ruled line.
PROVENANCE: With Graves, from whom it was
purchased 1859.
BIBLIOGRAPHY: Binyon 17; Gower *Drawings*, p.12
and repr. pl.XX; Woodall 93 and p.102.

The loose handling of wash and the treatment
of the foliage are identical with the previous
drawing (Cat. No.585), to which it is a com-
panion.

**587 Open Landscape with Figures on
Horseback**
British Museum, London (1868–3–28–313)

Brown wash over an offset outline. $7\frac{5}{8} \times 10\frac{3}{8}$
(194 × 264).
Three figures on horseback, accompanied by a
dog, travelling along a track in the foreground
centre; a cottage in the distance left.
PROVENANCE: With Colnaghi, from whom it was
purchased 1868.
BIBLIOGRAPHY: Binyon 19; Gower *Drawings*, p.11
and repr. pl.VII; Woodall 95.

The loose handling of wash and the treatment
of the figures, animals and foliage are closely

related to the wooded landscape with riders and packhorse also in the British Museum (Cat. No. 586).

588 Wooded Landscape with Shepherd and Sheep
Ownership unknown

Brown wash over an offset outline. 8 × 10¼ (203 × 260).
A shepherd seated in the foreground right; six sheep scattered in the foreground centre and right; a rocky bank in the middle distance left and centre; a hill in the distance right (from a photograph).
PROVENANCE: Sir Robert Witt.
EXHIBITED: *Drawings of the Old Masters from the Witt Collection*, Victoria and Albert Museum, January–May 1943.

The treatment of the animals and the foliage and the handling of wash are closely related to the landscape with figures and packhorses in the British Museum (Cat. No.587).

589 Upland Landscape with Horseman and Packhorse
Lady Labouchere, London

Brown wash over an offset outline. 8 × 10¹³⁄₁₆ (203 × 275).
A horseman, accompanied by a packhorse, travelling up an incline in the foreground right. Originally stamped with the artist's name bottom left (this has been cut, but the tops of some of the letters are still visible), outside a ruled line in brown ink which surrounds the composition.
PROVENANCE: Arthur Kay; Kay sale, Christie's, 23 May 1930, Lot 52 bt. P. M. Turner; F. W. Hely-Hutchinson; Hely-Hutchinson sale, Sotheby's, 8 February 1956, Lot 31 bt. Colnaghi, from whom it was purchased by Reginald Bosanquet; with Colnaghi, from whom it was purchased 1959.
EXHIBITED: Ipswich 1927 (129); Oxford 1935 (22).

The handling is related to the landscape with figures and packhorses in the British Museum (Cat. No.587).

590 Mountain Landscape with Shepherd and Sheep Plate 181
Museum of Art (Luis A. Ferré Foundation), Ponce, Puerto Rico

Black chalk and stump and white chalk on buff paper. 9³⁄₁₆ × 14⁵⁄₁₆ (233 × 363).
A shepherd, accompanied by a dog, standing behind a pool in the foreground left; scattered sheep in the middle distance centre; mountains in the distance centre.
PROVENANCE: With Knoedler.
EXHIBITED: Knoedler 1923 (6).
BIBLIOGRAPHY: Marlene Park, 'A Preparatory Sketch for Gainsborough's "Upland Valley with Shepherd, Sheep and Cattle",' *The Art Quarterly*, Summer 1962, pp.143–6, repr. fig.2.

Study for the mountain landscape now in an American private collection (Waterhouse 992, repr. pl.259), painted in the autumn of 1783. No changes were made in the finished picture except for the addition of some cows on the bank on the left and some buildings in the distance right. The mountains are evidently memories of Langdale Pikes (see Cat. No.577). The loose handling of the foliage, the scattered highlights in white chalk, and the rhythmical treatment of the terrain are related to the mountain landscape owned by Mrs M. G. Turner (Cat. No.582), but the execution is much more rapid and vigorous throughout. A copy by Frost is in the collection of W. A. Brandt (Plate 380). Also mentioned on pp.12–13, 18, 33, 39, 45, 46 and 73.

591 Wooded Mountain Landscape with Figures, Cattle and Sheep Plate 399
Henry E. Huntington Library and Art Gallery, San Marino (59.55.561)

Black chalk and stump and white chalk on grey-blue paper. 10¼ × 14¹⁄₁₆ (260 × 357).
A shepherd seated beneath some high rocks, with three sheep, in the foreground right; a herdsman and two cows in the middle distance left; a pool in the foreground centre; hills rising in the middle distance left and right; a church tower with hills beyond in the distance left.
PROVENANCE: Otto Gutekunst; Gilbert Davis, from whom it was purchased 1959.
EXHIBITED: Aldeburgh 1949 (3); *British Water Colours and Drawings from the Gilbert Davis Collection*, Arts Council 1949 (7, and p.4); Bath 1951 (39); Huntington 1967–8 (10).

The loose handling of the foliage, the scattered highlights in white chalk, the white chalkwork in the sky, and the soft rhythmical treatment of the rocks and mountains are closely related to the mountain landscape in the Ponce Museum of Art (Cat. No.590). Also mentioned on p.79.

245

592 Mountain Landscape with Waterfall
Rev. D. H. Milling, London

Black chalk and stump and white chalk on grey
paper. $10 \times 14\frac{1}{16}$ (254×357).
A waterfall in the foreground centre with streams
running into the foreground left and right; high
rocks in the foreground left and right; mountains
in the distance left.
PROVENANCE: Vernon Wethered; Mrs W. W.
Spooner, who gave it to her son.

The loose treatment of the rocks and foliage and
the scattered highlights and contouring of the
mountains in white chalk are closely related to
the rocky landscape with cows at a pool in the
Huntington Art Gallery (Cat. No.591).

**593 Wooded Upland Landscape with
Mountain**
City Museum and Art Gallery, Birmingham
(214'53)

Black chalk and stump, with some brown chalk
and white chalk, on grey-blue paper. $9\frac{3}{8} \times 12\frac{3}{4}$
(238×324).
A mountain in the middle distance left.
PROVENANCE: J. Heywood Hawkins; Guy
Bellingham Smith, who sold it to Colnaghi, from
whom it was purchased by J. Leslie Wright 1936;
bequeathed 1953.
EXHIBITED: Oxford 1935 (4); *Masters of British
Water-Colour: The J. Leslie Wright Collection*, R.A.,
October–November 1949 (93); *Watercolours from the
Birmingham City Art Gallery*, Worthing Museum and
Art Gallery, May–June 1960 (10); *Dvě století britského
malířství od Hogartha k Turnerovi*, National Gallery,
Prague and Bratislava, 1969 (60).
BIBLIOGRAPHY: Woodall 385.

The treatment of the foliage and rocks and the
broken highlights in white chalk are identical
with the mountain landscape with waterfall
owned by the Rev. D. H. Milling (Cat. No.592).

594 Wooded Landscape with Rocks
Ownership unknown

Black chalk and stump (apparently). Size unknown.
Rocks in the foreground right (from the print).
ENGRAVED: J. Laporte, published by Laporte and
Wells 1 July 1802 (as in the collection of George
Hibbert).
PROVENANCE: From one of the sketch-books
purchased by George Hibbert at the Gainsborough
sale, Christie's, 11 May 1799, Lot 82, 84 or 88;
by descent to the Hon. A. H. Holland-Hibbert;
Holland-Hibbert sale, Christie's, 30 June 1913.

The treatment of the rocks and foliage seems to
be closely related to the mountain landscape
with waterfall owned by the Rev. D. H. Milling
(Cat. No.592).

Mid to Later 1780's

**595 Wooded Landscape with Horses,
Cart and Figures** Plate 190
City Art Gallery, Manchester (1953.1)

Black chalk and stump and white chalk on blue
paper. $7\frac{3}{16} \times 8\frac{9}{16}$ (183×217).
A cart, with a figure seated inside, drawn by two
horses, travelling along a winding track in the
foreground centre and right; a cow drinking at a
pool in the foreground left; scattered sheep in the
middle distance left.
PROVENANCE: C. Marshall Spink, from whom it
was purchased 1953.
EXHIBITED: *Filling the Gaps*, Manchester City Art
Gallery, 1956.
BIBLIOGRAPHY: *Manchester City Art Galleries Annual
Report*, 1953, pp.14 and 20, repr. pl.ix.

The composition of this drawing is not suffi-
ciently close in any respect to the landscape with
a country cart also at Manchester (Waterhouse
950) for it to be claimed as a study for that pic-
ture, as is stated in the Gallery Report (*op. cit*,
p.14). The loose rhythmical treatment of the
foliage and scattered highlights in white chalk
are closely related to the mountain landscape
in the Ponce Museum (Cat. No.590).

596 Wooded Landscape with Sheep
Ashmolean Museum, Oxford

Black chalk and stump and white chalk on blue
paper. $7\frac{1}{16} \times 8\frac{3}{4}$ (179×222).
Sheep descending a track left towards a pond in
the foreground right.
PROVENANCE: Dr Thomas Monro; Monro sale,
Christie's, 26 June 1833 ff.; Professor Goodrich;
purchased 1950.
BIBLIOGRAPHY: *Ashmolean Museum Report 1950*, p.55.

The rhythmical treatment of the foliage and the
flickering white highlights are identical with the
wooded landscape with cart at Manchester (Cat.
No.595).

597 Wooded Landscape with Herdsman and Cattle
Henry E. Huntington Library and Art Gallery San Marino (64.4)

Black chalk and stump and white chalk on blue paper. $6\frac{3}{4} \times 8\frac{1}{2}$ (171 × 216).
A herdsman with a crook over his right shoulder seated in the foreground left; two or three cows drinking at a pool in the foreground right; a horseman in the middle distance centre; a craggy rock in the distance centre.
PROVENANCE: Anon. sale, Sotheby's, 20 November 1963, Lot 9 (repr.) bt. Agnew, from whom it was purchased by the Friends of the Huntington Library 1964.
EXHIBITED: Huntington 1967–8 (6).

The loose treatment of the foliage and the scattered highlights in white chalk are closely related to the wooded landscape with cart in Manchester (Cat. No.595).

598 Wooded Landscape with Herdsman, Cow and Buildings Plate 191
Richard Cavendish, Holker Hall

Black chalk and stump and white chalk on grey-green paper. $10\frac{7}{16} \times 14\frac{3}{4}$ (265 × 375).
A herdsman with a stick in his right hand, accompanied by a dog, driving a cow down a winding wooded lane in the foreground right; a house on rising ground in the middle distance right; a pool in the foreground left; a building with a mountain beyond in the distance left.
PROVENANCE: Possibly William Esdaile sale, Christie's, 21 March 1838, Lot 824 bt. Cavendish; thence by descent.
EXHIBITED: Romantic Art in Britain, Detroit Institute of Arts and Philadelphia Museum of Art, January–April 1968 (23 repr.).

The rhythmical treatment of the foliage and the scattered highlights in white chalk are identical with the wooded landscape with cart in Manchester (Cat. No.595). Also mentioned on p.85.

599 Wooded Landscape with Figure and Church Tower
Miss Helen Barlow, London

Black chalk and stump and white chalk on grey-green paper. $6\frac{15}{16} \times 8\frac{7}{16}$ (176 × 214).
A figure seated beside a track winding between hillocks in the foreground left; a church tower half-hidden by trees in the middle distance left.
PROVENANCE: Victor Koch; with Roland, Browse and Delbanco; Howard Bliss; with Leicester Galleries, from whom it was purchased 1950.

EXHIBITED: From Gainsborough to Hitchens, The Leicester Galleries, January 1950 (13 repr.).
BIBLIOGRAPHY: Woodall 73; Michael Ayrton, British Drawings, London, 1946, repr. f. p.16 (colour).
ALSO REPRODUCED: The Illustrated London News, 14 January 1950, p.73.

The treatment of the foliage and the scattered white highlights are closely related to the landscape with herdsman driving a cow down a wooded lane at Holker Hall (Cat. No.598).

600 Wooded Landscape with Figures, Cow and Sheep
Städelsches Kunstinstitut, Frankfurt-am-Main, (13985)

Black chalk and stump and white chalk on blue paper. $9\frac{5}{16} \times 12\frac{15}{16}$ (237 × 329).
A figure in the foreground centre, partially erased; another figure in the middle distance centre; two sheep at a pool in the foreground left; a cow standing on a bank in the middle distance right (pentimento of a cow in a different position beside it); a high rock in the distance right.
PROVENANCE: With Gaston von Mallmann, from whom it was purchased 1913.
BIBLIOGRAPHY: Woodall 422.

The rhythmical treatment of the foliage and the scattered highlights in white chalk are closely related to the landscape with herdsman driving a cow down a wooded lane at Holker Hall (Cat. No.598).

601 Rocky Landscape with Herdsman and Cows
Russell-Cotes Art Gallery and Museum, Bournemouth

Brown and white chalks on buff paper (later additions in pinkish-red chalk). $9\frac{5}{16} \times 12\frac{1}{16}$ (237 × 306).
A cowherd accompanied by a dog seated in the middle distance right; two cows in the foreground centre; high rocks in the foreground and middle distance left; a pool in the foreground right.
PROVENANCE: W. J. Hedgman, who presented it 1936.
BIBLIOGRAPHY: Russell-Cotes Art Gallery & Museum Bulletin, December 1936, p.42 and repr. p.43.

The treatment of the rocks and foliage and the scattered white highlights are related to the landscape with cow and sheep in Frankfurt (Cat. No.600), but the later additions make this drawing difficult to judge.

R

602 Rocky Wooded Landscape with Shepherds and Sheep
Arnold Haskell, Bath

Black chalk and stump, and brown and white chalks, on blue paper. 6$\frac{15}{16}$ × 8$\frac{7}{16}$ (176 × 214).
Two shepherds seated on a rock in the foreground centre; scattered sheep and a drinking fountain beneath high rocks in the foreground left; high rocks in the foreground right; a mountain in the distance centre.
PROVENANCE: George Hibbert (?); Victor Koch; Howard Bliss; with Leicester Galleries, who sold it to Spink, from whom it was purchased.
EXHIBITED: *From Gainsborough to Hitchens*, The Leicester Galleries, January 1950 (21).
BIBLIOGRAPHY: Woodall 71.

Study for the mountain landscape with a flock of sheep at a spring in the Royal Academy Diploma Gallery (Waterhouse 1007), painted about 1782–4. A number of alterations were made in the finished picture, and a goat and flock of sheep were introduced beside the fountain on the left. The loose treatment of the foliage and the scattered highlights in white chalk are closely related to the landscape with herdsman driving a cow down a wooded lane at Holker Hall (Cat. No.598). Also mentioned on p.40.

603 Wooded Landscape with Shepherd driving Flock Plate 403
Ashmolean Museum, Oxford

Black chalk and stump and white chalk on blue paper. 10$\frac{1}{4}$ × 13$\frac{3}{16}$ (260 × 335).
A shepherd and boy driving a flock of sheep along a winding road left; a pond in the foreground right; a cottage and church tower in the distance left.
ENGRAVED: J. Laporte, published by Laporte and Wells 1 March 1804 (as in the collection of Dr Thomas Monro).
PROVENANCE: Dr Thomas Monro; Monro sale, Christie's, 26 June 1833 ff., possibly 2nd Day Lot 174; Anon. sale, Sotheby's, 3 May 1918, Lot 41 (repr.) bt. Agnew; Ernest C. Innes; Innes sale, Christie's, 13 December 1935, Lot 31 bt. Smith; H. C. Lawrence; purchased 1943.
BIBLIOGRAPHY: Woodall 291.

The rhythmical treatment of the foliage and the scattered highlights in white chalk are closely related to the landscape with herdsman driving a cow down a wooded lane at Holker Hall (Cat. No.598). A copy is in the possession of Milton McGreevy. Also mentioned on pp.81, 82, 85, 90 and 97.

604 Wooded Upland Landscape with Shepherd and Sheep
Vernon D. Wethered, Weybridge

Black chalk and stump and white chalk on blue paper. 10$\frac{1}{16}$ × 13 (256 × 330).
A shepherd seated on a bank in the foreground centre, minding six or seven sheep scattered in the valley below in the foreground left; sharply rising ground in the foreground right leading to a high rock in the middle distance right; hills in the distance left and centre.
ENGRAVED: L. Francia, 1810.
PROVENANCE: With Leicester Galleries, from whom it was purchased by Vernon Wethered about 1910; thence by descent.
BIBLIOGRAPHY: Woodall 350.

The subject of a shepherd seated on a bank minding sheep in the valley beneath is similar to the mountain landscape in Melbourne (Cat. No.634), and the rhythmical treatment of the design and craggy rocks to drawings of the early to mid 1780's such as the mountain landscape at Bedford (Cat. No.564). However, the hatching, the definition of distant forms and clouds in black chalk contours, the broken white chalk highlights, and the foliage conventions are closest to the landscape with shepherd and sheep in the Ashmolean Museum (Cat. No.603).

605 Wooded Landscape with Woodcutter crossing a wooden Bridge
Ownership unknown

Black chalk and stump on blue paper (apparently). Size unknown.
A woodcutter with a bundle of faggots over his left shoulder crossing a wooden bridge over a stream in the foreground right; the roof of a building visible beyond a bank in the middle distance left (from the print).
ENGRAVED: L. Francia, 1810; republished in a *Drawing Book, being Studies of Landscape*, published by E. and C. M'Lean, London, 1823, No.2.

The treatment of the tree trunks and foliage seems to be related to the landscape with shepherd and sheep in the Ashmolean Museum (Cat. No.603).

606 Wooded Landscape with Sheep and Stream Plate 192
Richard Cavendish, Holker Hall

Black and white chalks on blue paper. 9$\frac{7}{16}$ × 12$\frac{7}{16}$ (240 × 316).

Some sheep on rising ground in the middle distance left; a stream running from the foreground right into the middle distance right; a hill in the distance right.
PROVENANCE: By descent.

The loose treatment of the foliage and scattered highlights in white chalk are related to the landscape with shepherd and sheep in the Ashmolean Museum (Cat. No.603). Also mentioned on p.84.

607 Wooded Landscape with Figure and Stream
Fitzwilliam Museum, Cambridge, (PD 28–1953)

Black and white chalks on grey-blue paper. $9\frac{7}{8} \times 12\frac{11}{16}$ (251 × 322).
A figure accompanied by a dog on rising ground in the middle distance left; a stream running from the foreground right into the middle distance centre; a mountain in the distance right.
PROVENANCE: Dr Dibdin; Sir John Neeld, Grittleton House; L. W. Neeld sale, Christie's, 13 July 1945, Lot 107 (with another) bt. Agnew; Howard Bliss; with Leicester Galleries, who sold it to Spink, from whom it was purchased by Mrs E. M. Young; with Agnew, from whom it was purchased 1953.
EXHIBITED: *From Gainsborough to Hitchens*, The Leicester Galleries, January 1950 (1).
BIBLIOGRAPHY: *Fitzwilliam Museum Report 1953*, p.4 and repr. pl.IIa.

The treatment of the foliage and the broken highlights in white chalk are closely related to the very similar composition at Holker Hall (Cat. No.606).

608 Wooded Landscape
City Art Gallery, Leeds (13.109/53)

Black chalk and stump and white chalk on grey paper. $9\frac{3}{8} \times 12\frac{1}{8}$ (238 × 308).
A path running through a wood from the foreground centre into the middle distance left.
PROVENANCE: Dr Dibdin; L. W. Neeld, Grittleton House; Neeld sale, Christie's, 13 July 1945, Lot 107 (with another) bt. Agnew; Howard Bliss; with Leicester Galleries, who sold it to Spink, from whom it was purchased by Norman Lupton; bequeathed 1953.
EXHIBITED: Aldeburgh 1949 (2); *From Gainsborough to Hitchens*, The Leicester Galleries, January 1950 (6); Bath 1951 (51); *Water Colours from Leeds*, Agnew's October–November 1960 (11).
BIBLIOGRAPHY: 'Drawings by Wilson, Gainsborough and Constable', *Leeds Art Calendar*, Autumn 1956, pp.16, 18 and 23, repr. p.13.

The rhythmical composition, treatment of the foliage, and white chalkwork are closely related to the wooded landscape at Holker Hall (Cat. No.606).

609 Wooded Landscape with distant House
Montreal Museum of Fine Arts, Montreal

Black chalk and stump, with red and white chalks, on blue paper. $9\frac{1}{2} \times 12\frac{1}{8}$ (241 × 308).
A wooded lane winding between some banks in the foreground and middle distance centre; a house in the distance centre.
PROVENANCE: Samuel Woodburn; Guy Bellingham Smith; Julian G. Lousada; Anon. (=Anthony Lousada) sale, Christie's, 9 April 1954, Lot 107 bt. Agnew, from whom it was purchased 1954.
BIBLIOGRAPHY: Woodall 206.

The chalkwork and broken highlighting in white chalk are related to the wooded landscapes at Holker Hall (Cat. No.606) and in the Fitzwilliam Museum (Cat. No.607), but the foliage is rather more feathery in treatment.

610 Wooded Landscape with Figures, Sheep and Tower Plate 359
Pennsylvania Academy of the Fine Arts, Philadelphia (deposited at the Philadelphia Museum of Art)

Black chalk and stump and white chalk on grey-blue paper. $7\frac{3}{16} \times 8\frac{9}{16}$ (183 × 217).
Two figures, one of them a boy, in the foreground right; a flock of sheep watering at a pool to the right of a bank in the foreground centre and right; a tower half-hidden by trees in the middle distance left.
Signed with initials in ink: *TG* outside four ruled lines (in the same ink) on the original mount bottom left. Inscribed in ink: *Gainsborough*, on the mount top centre. There is an ink annotation on the back of the mount, which reads as follows: *Chalk drawing –/A Study from Nature by* Gainsborough *the distinguished/English painter. This drawing was made in the presence of & presented to* Hoppner *the painter/who presented it to* Hoppner Meyer *the great english engraver, whose son,* Hoppner Meyer Jr/, *also an Artist brought it to America & gave it to me, at Philada in the year 1839./* John Neagle. *Also annotated on the mount bottom, in ink and in a later hand, in abbreviation of the above: Original drawing from Nature by Gainsborough – His initials Written here by himself/From the collection*

of Hoppner the painter, who presented it to H. Meyer, artist of London. J. Neagle 1839.

PROVENANCE: Given by the artist to John Hoppner, who presented it to his nephew Henry Meyer; given by the latter's son, Henry Meyer, Jr., to John Neagle 1839.

BIBLIOGRAPHY: John Hayes, 'The Drawings of Gainsborough Dupont', *Master Drawings*, Vol.3, No.3, 1965, pp.253 and 256 and repr. fig.4.

The loose treatment of the foliage and the scattered highlights in white chalk are related to the wooded landscape at Holker Hall (Cat. No.606). The near-contemporary evidence that this drawing was done from nature is difficult to accept, but should clearly be treated with respect. Also mentioned on pp.30, 66, 80 and 99.

611 Wooded Landscape with Shepherd and Sheep

H.M. The Queen, Windsor Castle

Black chalk and stump and white chalk on grey-blue paper. $10\frac{15}{16} \times 13\frac{1}{4}$ (278×337).
A shepherd driving a flock of sheep in the foreground centre; a river in the middle distance centre and right; mountains in the distance centre and right.

PROVENANCE: By descent (possibly the Gainsborough drawing bought by the Prince of Wales from Colnaghi's in 1800).

BIBLIOGRAPHY: A. P. Oppé, *English Drawings ... at Windsor Castle*, London, 1950, No.269 and repr. pl.46.

The treatment of the foliage and the shepherd and sheep and the scattered white highlights are closely related to the landscape with shepherd and sheep in Philadelphia (Cat. No.610).

612 Wooded Landscape with Horses crossing Bridge and Rowing Boat

Ownership unknown

Black chalk and stump on blue paper (apparently). Size unknown.
A man and a woman on horseback, both riding side saddle, accompanied by a packhorse, and followed by another figure, crossing a hump-back bridge in the foreground centre; four figures, two of them seated, in a rowing boat about to go under the bridge in the foreground right; a river in the foreground right (from the print).

ENGRAVED: L. Francia, 1810.

The loose treatment of the foliage seems to be related to the landscape with shepherd and sheep in Philadelphia (Cat. No.610).

613 Wooded Landscape with Figures, Cows and Cottages Plate 292

Bruce Howe, Cambridge, Mass.

Black chalk and stump and white chalk on grey paper. $9\frac{15}{16} \times 14\frac{1}{8}$ (252×359).
Two figures outside two thatched cottages in the middle distance centre and right; two cows in the foreground right; a pool in the foreground left and centre; a tower in the middle distance left.

PROVENANCE: Mrs Granville Mathews; with Agnew; from whom it was purchased 1957.

The loose treatment of the foliage, the highlights in white chalk, and the summary contours of the cows are closely related to the landscape with shepherd and sheep in Philadelphia (Cat. No.610). Also mentioned on p.61.

614 Wooded Landscape with ruined Building

Ownership unknown

Black chalk and stump and white chalk on blue paper. Size unknown.
A track running from the foreground right into the middle distance left; a ruined building in the middle distance left (from a photograph).

PROVENANCE: Van Tokkie sale, de Vries, Amsterdam, 9–10 June 1936, Lot 313.

The handling of the foliage and the scattered white highlights are closely related to the landscapes at Manchester (Cat. No.595) and in Bruce Howe's collection (Cat. No.613).

615 Wooded Landscape with Figures at a Cottage Door and Covered Waggon

Ownership unknown

Black chalk and stump and white chalk. $13 \times 19\frac{1}{8}$ (330×485).
Five figures, three of them seated, on the steps outside the door of a cottage in the foreground right; two figures, one of them seated under a tree, the other accompanied by a dog, talking in the foreground left; a church in the middle distance left; a covered waggon and horses resting in the middle distance centre; a pool in the foreground right; a low hill in the distance centre (from a photograph).

PROVENANCE: Guy Bellingham Smith; Smith sale, Muller, Amsterdam, 5 July 1927, Lot 37 (repr. pl.3).

BIBLIOGRAPHY: *Apollo*, May 1931, p.317 and repr. p.318; Woodall 426.

The loose treatment of the foliage and the summary contours of the figures, animals and tree

trunks are closely related to the landscapes in Philadelphia (Cat. No.610) and in Bruce Howe's collection (Cat. No.613).

616 Wooded Landscape with Figures and Castle
Museum of Fine Arts, Budapest (1935–2636)

Black chalk and stump and white chalk on blue paper. $7\frac{1}{16} \times 8\frac{11}{16}$ (179 × 221).
A figure in front of some trees in the foreground left; another figure climbing up a hillside in the middle distance right; the tower of a castle half-hidden by trees in the distance right.
PROVENANCE: Dr Majovszky; acquired 1935.
BIBLIOGRAPHY: *Magyar Muveszet*, 1926, No.4, p.198 (repr.).

The loose treatment of the foliage and the white chalkwork are closely related to the landscape with shepherd and sheep in Philadelphia (Cat. No.610). The subject of a tower rising behind trees is similar in character to the drawing owned by Helen Barlow (Cat. No.599).

617 Wooded Landscape with Sheep and Church Tower
Ownership unknown

Black chalk and stump and white chalk. $7 \times 8\frac{1}{2}$ (178 × 216).
A flock of sheep in the foreground left and centre; a church tower behind a bank in the middle distance left (from a photograph).
PROVENANCE: With Duveen; Anon. (=Duveen) sale, Christie's, 9 July 1926, Lot 2 bt. Parsons; Victor Rienaecker; W. Hetherington.
EXHIBITED: Ipswich 1927 (144).
BIBLIOGRAPHY: Woodall 58.

The loose treatment of the foliage and the rough highlighting in white chalk are identical with the wooded landscape with castle in Budapest (Cat. No.616), which is also very similar in composition.

618 Wooded Landscape with Figures
Private Collection, New York

Black chalk and stump and white chalk on grey-blue paper. $9\frac{7}{8} \times 12\frac{7}{16}$ (251 × 316).
Two or three figures (apparently) grouped round a tree on a slope in the foreground left; a stream in the foreground right; a chimney rising above the trees in the middle distance left; a mountain in the distance right.

PROVENANCE: With Squire Gallery, from whom it was purchased by Norman Baker; with Lowndes Lodge Gallery, from whom it was purchased.
EXHIBITED: *A Selection of Pictures from Private Collections*, Moot Hall, Colchester, July 1951 (75).

The loose treatment of the foliage, the scattered highlights in white chalk and the motif of the castle rising behind trees are closely related to the landscape with castle in Budapest (Cat. No. 616).

619 Wooded Landscape with Sheep
Ownership unknown

Black chalk and stump and white chalk. $7 \times 8\frac{1}{2}$ (178 × 216).
Five sheep on rising ground in the foreground right; a pool in the foreground left; low hills and buildings in the distance left.
PROVENANCE: With Durlacher.

The loose treatment of the foliage and the scattered highlights in white chalk are closely related to the wooded landscape with castle formerly in Norman Baker's collection (Cat. No.618).

620 Wooded Landscape with Rustic Lovers, Packhorses and Windmill
Fogg Museum of Art, Cambridge, Mass. (1956.216)

Black chalk and stump and white chalk on blue paper. $6\frac{15}{16} \times 8\frac{7}{16}$ (176 × 214).
Two rustic lovers with two packhorses and an unloaded pack in the foreground centre; a windmill on a hill in the middle distance right; a pool in the foreground left and centre.
PROVENANCE: Henry Oppenheimer; Oppenheimer sale, Christie's, 14 July 1936, Lot 454 bt. Agnew; with Gallup; Mrs William D. Vogel, who presented it 1956.
EXHIBITED: Colnaghi's 1906 (9).
BIBLIOGRAPHY: Woodall 4.

The loose handling of the foliage, the loose white highlights in white chalk, and the summary treatment of the foreground detail and contours of the figures and cows are closely related to the wooded landscape with cottages in Bruce Howe's collection (Cat. No.613). The weaknesses in drawing and proportions in this sketch, and in others of the same type, are disquieting, but the effect is bold and the deficiencies are presumably to be explained by the rapidity of execution.

621 Wooded Landscape with Village and Figures
Ownership unknown

Black chalk and stump and white chalk on blue paper. $10 \times 12\frac{1}{4}$ (254×311).
Three figures in front of a bank in the foreground centre; a track winding from the foreground right up to a village in the middle distance centre; scattered sheep in the foreground and middle distance right (from a photograph).
PROVENANCE: With Croal Thomson.
BIBLIOGRAPHY: *Barbizon House 1921: An Illustrated Record*, No.30 (repr.); Woodall 10 and p.84.

The treatment of the foliage and the foreground detail and the loose highlights in white chalk are closely related to the wooded landscape with windmill in the Fogg Art Museum (Cat. No. 620). A copy by Henry Monro was formerly in the collection of Dr Foxley Norris; and an oval copy was with Lowndes Lodge Gallery 1965. Also mentioned on p.82.

622 Wooded Landscape with Horseman
City Art Gallery, Auckland

Black and white chalks on grey-blue paper. $9\frac{3}{4} \times 12\frac{1}{8}$ (248×308).
A horseman accompanied by another figure and a dog in the foreground centre; a pool in the foreground left.
PROVENANCE: Dr Dibdin; Sir John Neeld, Grittleton House; L. W. Neeld sale, Christie's, 13 July 1945, Lot 106 (with another) bt. Agnew; Howard Bliss; with Leicester Galleries, who sold it to Spink, from whom it was purchased.
EXHIBITED: *From Gainsborough to Hitchens*, The Leicester Galleries, January 1950 (2).
BIBLIOGRAPHY: *Auckland City Art Gallery Quarterly*, No.33, 1966, p.3 and repr. p.2.

The treatment of the tree trunks and foliage and the use of white chalk are closely related to the wooded landscape with windmill in the Fogg Art Museum (Cat. No.620).

623 Wooded Landscape with Figures
Private Collection, Glasgow

Black and white chalks on blue paper. $7\frac{1}{2} \times 8\frac{1}{2}$ (190×216).
Two figures in the foreground left.
PROVENANCE: With D. H. Farr; with Lowndes Lodge Gallery, from whom it was purchased.
BIBLIOGRAPHY: Woodall 446.

The treatment of the tree trunks and foliage and the scattered highlights in white chalk are

closely related to the wooded landscape with windmill in the Fogg Art Museum (Cat. No. 620), while the composition is very similar to the wooded landscape in Auckland (Cat. No. 622).

624 Wooded Landscape with Horseman crossing a Bridge and Ruined Building
Plate 193
Private Collection, Glasgow

Black and white chalks on blue paper. $7\frac{1}{2} \times 8\frac{1}{2}$ (190×216).
A horseman followed by another figure crossing a stone bridge over a stream in the foreground centre; a half-ruined building in the foreground right.
PROVENANCE: With D. H. Farr; with Lowndes Lodge Gallery, from whom it was purchased.
BIBLIOGRAPHY: *Barbizon House 1922: An Illustrated Record*, No.30 (repr.); Woodall 445.

The treatment of the foliage and the scattered highlights in white chalk are closely related to the previous drawing (Cat. No.623), to which it is a companion.

625 Wooded Landscape with Shepherd, Sheep and Building
Dr S. C. Lewsen, London

Black and white chalks on brown paper. $6\frac{5}{8} \times 8\frac{5}{16}$ (168×211).
A shepherd seated beneath a bank in the middle distance centre; scattered sheep in the foreground left and centre; a building amongst trees in the middle distance left.
PROVENANCE: Susannah Gardiner (Gainsborough's sister); from thence by descent to Miss R. H. Green; Anon. (= Green) sale, Christie's, 1 April 1949, Lot 36 bt. Colnaghi, from whom it was purchased by Howard Bliss; with Leicester Galleries, from whom it was purchased.
EXHIBITED: *From Gainsborough to Hitchens*, The Leicester Galleries, January 1950 (3).

The handling and forceful effect are related to the landscape with horseman crossing a bridge in a Glasgow private collection (Cat. No.624).

626 Wooded Landscape with Shepherd and Sheep
Colonel P. L. M. Wright, Roundhill

Black and white chalks and grey and grey-black washes on buff paper. $11 \times 14\frac{9}{16}$ (279×370).
A shepherd reclining on a bank in the foreground

right; scattered sheep on a mound in the middle distance centre.

PROVENANCE: Sir George Donaldson; Henry Schniewind, Jr.; Anon. (= Schniewind) sale, Sotheby's, 25 May 1938, Lot 145 bt. Colnaghi, from whom it was purchased by J. Leslie Wright; bequeathed to Birmingham City Art Gallery (with a life-interest to his son) 1953.

EXHIBITED: Cincinnati 1931 (68 and repr. pl.55); *Masters of British Water-Colour: The J. Leslie Wright Collection*, R.A., October–November 1949 (72); Nottingham 1962 (59).

BIBLIOGRAPHY: E. S. Siple, 'Gainsborough Drawings: The Schniewind Collection', *The Connoisseur*, June 1934, p.355 and repr. p.353; Woodall 382.

The modelling of the tree trunks, the loose handling of the foliage, and the rhythmical composition are related to the wooded landscape in Auckland (Cat. No.622).

627 Wooded Landscape with Buildings, Lake and Rowing Boat Plate 294
Richard Cavendish, Holker Hall

Black chalk and stump and white chalk.
$10\frac{13}{16} \times 14\frac{3}{8}$ (275 × 365).
A figure seated on the far side of a pool in the middle distance right; a rowing boat in the foreground right; a pool stretching from the foreground centre into the foreground right; a group of buildings on rising ground in the middle distance centre.

ENGRAVED: Thomas Rowlandson (included in his *Imitations of Modern Drawings, c.* 1788).

PROVENANCE: Possibly William Esdaile sale, Christie's, 21 March 1838, Lot 816 (with another) bt. Cavendish; thence by descent.

BIBLIOGRAPHY: John Hayes, 'The Holker Gainsboroughs', 'Notes on British Art 1', *Apollo*, June 1964, pp.2–3 and repr. fig.2; John Hayes, 'Gainsborough and the Gaspardesque', *The Burlington Magazine*, May 1970, p.311.

The loose scallops outlining the foliage and the hatching in the sky are related to the wooded landscape with shepherd and sheep owned by Colonel Wright (Cat. No.626). The motif of the squat, Italianate looking buildings grouped on a hillside is Gaspardesque. A copy was formerly in the collection of L. G. Duke. Also mentioned on pp.62.

628 Wooded Upland Landscape with Shepherd, Sheep and Buildings
Mr and Mrs James Burnham, Kent, Conn.

Black chalk and stump and white chalk.
$11 \times 14\frac{9}{16}$ (279 × 370).

A shepherd with two sheep in the foreground left, at a stream which runs into the middle distance left beyond a weir; some classical buildings on a high hill in the middle distance right; mountains in the distance left and centre.

Collector's mark of John Deffett Francis bottom left.

PROVENANCE: John Deffett Francis; P. O'Byrne; O'Byrne sale, Christie's, 3 April 1962, Lot 71 (repr.) bt. Lucie-Smith; with Seiferheld Gallery, from whom it was purchased.

BIBLIOGRAPHY: John Hayes, 'Gainsborough and the Gaspardesque', *The Burlington Magazine*, May 1970, p.311 and repr. fig.48.

The loose scallops outlining the foliage, the treatment of the distant buildings, and the black chalk and stumpwork generally are closely related to the wooded landscape with buildings on a hillside at Holker Hall (Cat. No.627).

629 Wooded Upland Landscape with Horseman crossing Bridge
Private Collection, England

Black chalk and stump, with traces of white chalk.
$10\frac{15}{16} \times 14\frac{5}{8}$ (278 × 371).
A figure with a stick in the middle distance left walking along a track which winds from the foreground right into the distance left; a horseman crossing a bridge in the middle distance centre; a stream running over a weir into the foreground right; a hillock in the middle distance centre; a group of buildings in the distance left, with a hill beyond.

PROVENANCE: Unknown.

The treatment of the foliage and buildings, and the black chalk and stumpwork generally are closely related to the mountain landscape owned by Mr and Mrs James Burnham (Cat. No.628).

630 Wooded Landscape with Herdsman, Cow and Buildings
Ownership unknown

Black chalk and stump (apparently). Size unknown.
A herdsman driving a cow along a winding track in the foreground right; a pool in the foreground left; a shed in the foreground right; a mansion and church tower half-hidden by trees in the middle distance centre; a building with a pedimented portico in the middle distance right (from the print).

ENGRAVED: J. Laporte, published by Laporte and Wells, 1 January 1803 (as in the collection of Dr Thomas Monro).

PROVENANCE: Dr Thomas Monro; Monro sale, Christie's, 26 June 1833 ff.

The treatment of the foliage seems to be related to the upland landscape with horseman crossing

a bridge in an English private collection (Cat. No.629). The buildings seem to be unusually elaborate and architecturally well-defined for Gainsborough, but this may not be true of the original drawing.

631 Wooded Landscape with Figure, Cattle, Bridge over a Stream, and Church Tower Plate 407
Courtauld Institute of Art, Witt Collection, London (2432)

Black chalk and stump. $11\frac{1}{8} \times 14\frac{3}{4}$ (283 × 375).
Two cows, one reclining, beside a country track in the foreground left; scattered sheep beside a stream in the foreground right; a figure and stone bridge in the middle distance right; a church tower half-hidden by trees in the distance right, with hills beyond.
Collector's mark of Sir Robert Witt on the mount bottom left.
PROVENANCE: Lord Duveen, who presented it to Sir Robert Witt; bequeathed 1952.
EXHIBITED: *Drawings of the Old Masters from the Witt Collection*, Victoria and Albert Museum, January–May 1943; *Drawings from the Witt Collection*, Arts Council, 1953 (13, repr. pl.1); Arts Council 1960–1 (53); *English Landscape Drawings from the Witt Collection*, Courtauld Institute Galleries, January–May 1965 (13).
BIBLIOGRAPHY: Woodall 364; *Hand-List of the Drawings in the Witt Collection*, London, 1956, p.22.

The handling of the foliage, the summary contours of the cows, the black chalk and stump work generally, and the rhythmical composition are related to the mountain landscape owned by Mr and Mrs James Burnham (Cat. No.628). A copy by Dr Thomas Monro is in the British Museum (1963–11–9–1) (Plate 406). Also mentioned on p.82.

632 Hilly Landscape with Figures and Cottages
Ownership unknown

Black chalk and stump (apparently). Size unknown.
Two figures walking along an undulating path in the foreground centre; two cottages beneath a high bank in the middle distance left; low hills in the distance centre and right (from the print).
ENGRAVED: J. Laporte, published by Laporte and Wells, 1 December 1802 (as in the collection of Dr Thomas Monro).
PROVENANCE: Dr Thomas Monro; Monro sale, Christie's, 26 June 1833 ff.

The treatment of the foliage, the outlines of the

clouds and hatching in the sky, and the rhythmical composition seem to be closely related to the wooded landscape with cows and sheep in the Witt Collection (Cat. No.631).

633 Wooded Landscape with Church
Ownership unknown

Pencil (apparently). Size unknown.
A path leading from the foreground right towards a church on a bank in the middle distance right (from the print).
ENGRAVED: W. F. Wells, published by Wells and Laporte 1 September 1803 (as in the collection of George Hibbert).
PROVENANCE: From one of the sketch-books purchased by George Hibbert at the Gainsborough sale, Christie's, 11 May 1799, Lot 82, 84 or 88; by descent to the Hon. A. H. Holland-Hibbert; Holland-Hibbert sale, Christie's, 30 June 1913.

The treatment of the foliage seems to be related to the wooded landscape with cows and sheep in the Witt Collection (Cat. No.631).

634 Mountain Landscape with Classical Buildings, Shepherd and Sheep Plate 185
National Gallery of Victoria, Melbourne (2356/4)

Black chalk and stump and white chalk.
$10\frac{5}{8} \times 14\frac{1}{2}$ (270 × 368).
A shepherd, accompanied by a goat, seated beside a track winding up a hillside in the foreground right; classical buildings enveloped by trees in the middle distance left; scattered sheep in the foreground and middle distance left; mountains in the distance centre.
Inscribed on the old mount: *original chalk drawing by Gainsboro given by him to my Father Rich.ᵈ French/after the style of Gaspar Poussin.*
PROVENANCE: Presented by the artist to Richard French; Guy Bellingham Smith, who sold it to Colnaghi, from whom it was purchased by J. Leslie Wright 1936; Howard Bliss; with Leicester Galleries; purchased through the Felton Bequest 1951.
EXHIBITED: Oxford 1935 (2); Sassoon 1936 (45); *From Gainsborough to Hitchens*, The Leicester Galleries, January 1950 (12).
BIBLIOGRAPHY: Woodall 390, pp.23 and 70–1 and repr. pl.92; Ursula Hoff, Note in *The Quarterly Bulletin of the National Gallery of Victoria*, Vol.5, No.4, 1951 (repr.); John Hayes, 'The Holker Gainsboroughs', 'Notes on British Art 1', *Apollo*, June 1964, p.2; John Hayes, 'Gainsborough and the Gaspardesque', *The Burlington Magazine*, May 1970, p.311.

The treatment of the foliage, the hatching in the sky, the black chalk and stump work generally, and the rhythmical composition are closely related to the wooded landscape with cows and sheep in the Witt Collection (Cat. No.631). This drawing was evidently recognized at an early date as being Gaspardesque in character. Also mentioned on pp.62, 100 and 102.

635 Wooded Upland Landscape with Castle, Shepherd and Sheep Plate 184
Richard Cavendish, Holker Hall

Black chalk and stump and white chalk.
$10\frac{13}{16} \times 15$ (275×381).
A shepherd and scattered sheep in the foreground centre; a track winding from the foreground centre into the middle distance centre; a castle half-hidden by trees on rising ground in the middle distance right; mountains in the distance centre.
The composition is surrounded by a ruled line in pencil.
PROVENANCE: Possibly William Esdaile sale, Christie's, 21 March 1838, Lot 816 (with another) bt. Cavendish; thence by descent.

The treatment of the foliage, the buildings and distant mountains, and the black chalk and stump work generally are closely related to the mountain landscape in Melbourne (Cat. No. 634). Also mentioned on p.62.

636 Mountain Landscape with Herdsman, Cows and Cottage Plate 194
Richard Cavendish, Holker Hall

Black chalk and stump. $10\frac{15}{16} \times 14\frac{3}{4}$ (278×375).
A mounted herdsman with a stick in his right hand driving five cows past a cottage along a winding track at the edge of a hill in the foreground right; a wooded valley in the middle distance left and centre; mountains in the distance left and centre.
ENGRAVED: Thomas Rowlandson.
PROVENANCE: Possibly William Esdaile sale, Christie's, 21 March 1838, Lot 822 bt. Cavendish; thence by descent.
BIBLIOGRAPHY: John Hayes, 'The Holker Gainsboroughs', 'Notes on British Art 1', *Apollo*, June 1964, pp.2-3 and repr. fig.3.

The treatment of the foliage, the hatching in the sky, and the black chalk and stump work generally are closely related to the mountain landscape in Melbourne (Cat. No.634). Also mentioned on p.34.

637 Wooded Mountain Landscape with Herdsman and Cattle
Whitworth Art Gallery, University of Manchester (D.50.1927) (1348)

Black chalk and stump and white chalk on buff paper. $10\frac{7}{8} \times 15$ (276×381).
A herdsman, accompanied by a dog, driving five cows along a winding track at the edge of a hillside in the foreground centre; a shepherd reclining and scattered sheep in the middle distance left; a wooded valley in the middle distance left and centre; mountains in the distance left and centre.
PROVENANCE: Rev. Gainsborough Gardiner; by descent to Edward Netherton Harward; Harward sale, Christie's, 11 May 1923, Lot 96 bt. Croal Thomson, from whom it was purchased by A. E. Anderson; presented (through the National Art-Collections Fund) 1927.
EXHIBITED: *National Art-Collections Fund Exhibition*, Victoria and Albert Museum, May–June 1928; *Winter Exhibition*, Royal Society of British Artists, 1948 (364); Aldeburgh 1949 (14); Bath 1951 (55); Arts Council 1960–1 (54).
BIBLIOGRAPHY: *Whitworth Art Gallery Report 1927*, p.10 and repr. f. p.5; Woodall 225.

The treatment of the foliage, the hatching in the sky, the black chalk and stump work generally, and the motif of cows being driven along a precipitous winding path are closely related to the mountain landscape at Holker Hall (Cat. No.636).

638 Wooded Mountain Landscape with Herdsman and Cows
Sir O. W. Williams-Wynn, Dolben

Black chalk and stump and white chalk.
$10\frac{5}{8} \times 14\frac{3}{16}$ (270×360).
A herdsman driving five cows along a winding path at the edge of a hill in the foreground centre; a wooded valley in the middle distance left and centre; mountains stretching across the composition in the distance.
PROVENANCE: John Hunter; Hunter sale, Christie's, 29 January 1794, Lot 18 (with another) bt. Sir Watkin Williams-Wynn; thence by descent.

Version of the mountain landscape in the Whitworth Art Gallery (Cat. No.637) but without the shepherd and sheep and the herdsman's dog. The handling is closely related to the Whitworth drawing.

639 Wooded Mountainous Landscape with Sheep
Luke Herrmann, Clipston

Black chalk and stump. $11\frac{1}{16} \times 15\frac{7}{8}$ (281×403).
Two or three sheep on a promontory overlooking a ravine in the foreground left and middle distance centre; a hill in the middle distance right; mountains in the distance centre.
Collector's mark of Sir Bruce Ingram on the back of the old mount bottom right.
PROVENANCE: The Hon. Mrs Fitzroy Newdegate; Newdegate sale, Christie's, 14 March 1952, Lot 224 bt. Colnaghi, from whom it was purchased by Sir Bruce Ingram; bequeathed by him 1963.
EXHIBITED: *Drawings from the Bruce Ingram Collection*, Arts Council, 1946–7 (40 and repr. pl.IV); *English Drawings and Watercolours in memory of the late D. C. T. Baskett*, Colnaghi's, July–August 1963 (28).
BIBLIOGRAPHY: Luke Herrmann and Michael Robinson, 'Sir Bruce Ingram as a Collector of Drawings', *The Burlington Magazine*, May 1963, repr. fig.16.

The treatment of the foliage, the banks and the distant hills are identical with the mountain landscape with herdsman and cattle in the Whitworth Art Gallery (Cat. No.637).

640 Wooded Upland Landscape with Horsemen and Sheep
Museum Boymans-Van Beuningen, Rotterdam (E5)

Black chalk and stump, heightened with a little white. $11 \times 14\frac{11}{16}$ (279×373).
Three horsemen travelling along a country road in the foreground centre and right; scattered sheep in the foreground centre; hills in the distance centre.
Collector's mark of Franz Koenigs on the verso bottom left.
PROVENANCE: Franz Koenigs.
EXHIBITED: *Oude Engelsche Schilderijen . . . in Nederlandsche Verzamelingen*, Museum Boymans, Rotterdam, November–December 1934 (71 and repr. pl.xxviii).
BIBLIOGRAPHY: Woodall 430.

The treatment of the tree trunks and foliage, the hatching in the sky, the contours of the clouds and distant hills, and the black chalk and stump work generally are closely related to the mountain landscape with herdsman and cattle in the Whitworth Art Gallery (Cat. No.637).

641 Wooded Landscape with Cattle, Sheep and Cottage
Pierpont Morgan Library, New York (III,62)

Black chalk and stump, heightened with white. $11 \times 14\frac{5}{8}$ (279×371).
Three cows travelling down a country road in the foreground left; scattered sheep in the foreground right; a cottage half-hidden by trees in the middle distance left.
PROVENANCE: Charles Fairfax Murray, from whom it was purchased by J. Pierpont Morgan 1910.
EXHIBITED: *The Art of Eighteenth Century England*, Smith College Museum of Art, January 1947 (32).
BIBLIOGRAPHY: *J. Pierpont Morgan Collection of Drawings by the Old Masters formed by C. Fairfax Murray*, Vol.III, London, 1912, No.62 and repr. pl.62; Woodall 460.

The outlining of the clouds, the hatching in the sky, the handling of the foliage and the rhythmical treatment of the foreground all relate closely to the landscape with three horsemen in Rotterdam (Cat. No.640).

642 Wooded Upland Landscape with Sheep
E. A. Mott, London

Black chalk and stump, heightened with white. $11 \times 14\frac{3}{4}$ (279×375).
Scattered sheep in the foreground and middle distance left; a track winding uphill from the foreground centre into the middle distance right.
PROVENANCE: Rev. Gainsborough Gardiner; by descent to Edward Netherton Harward; Harward sale, Christie's, 11 May 1923, Lot 97 bt. P. M. Turner; Kennedy North; E. A. Mott, who presented it to his mother; bequeathed by her 1959.
EXHIBITED: Ipswich 1927 (138); Oxford 1935 (30); *British Painting from Hogarth to Turner*, British Council (Hamburg, Oslo, Stockholm and Copenhagen), 1949–50 (53).
BIBLIOGRAPHY: Woodall 243, pp.70–1 and 100 and repr. pl.93.

The rhythmical treatment of the landscape, the handling of the foliage and the clouds, and the chalk and stump-work throughout are identical with the landscape with riders in Rotterdam (Cat. No.640). Also mentioned on p.34.

643 Wooded Upland Landscape with Sheep Plate 405
Mrs Kenneth Potter, North Warnborough

Black chalk and stump and white chalk. $11 \times 14\frac{13}{16}$ (279×376).
Scattered sheep in the foreground and middle

distance left; a track winding up an incline in the foreground right.
PROVENANCE: Susannah Gardiner (Gainsborough's sister); thence by descent to Miss Green, who gave it to Miss A. Thorne; thence by descent.
EXHIBITED: Nottingham 1962 (60).
BIBLIOGRAPHY: Woodall 304, pp.71 and 100 and repr. pl.94.

An exact replica of the upland landscape formerly owned by Kennedy North (Cat. No.642). This drawing is slightly more summary in treatment, but affords a particularly good example of Gainsborough's ability to make spirited replicas of his own compositions. It is interesting also to note that both drawings have descended from members of the Gainsborough family. Also mentioned on pp.34, and 80.

644 Wooded Landscape with Figures, Country Cart and Cottage
Smith College Museum of Art, Northampton, Mass. (1953: 28)

Black chalk and stump and grey wash.
$10\frac{3}{4} \times 14\frac{5}{8}$ (273 × 371).
A cart with two peasants seated inside and a third accompanying it on foot in the foreground centre; scattered sheep in the foreground left; a cottage on a bank in the foreground right.
PROVENANCE: Francis Wheatley (according to the Ipswich 1927 exhibition catalogue); Walter Sichel; Sichel sale, Sotheby's, 25 October 1933, Lot 300 bt. G. D. Thomson; with Palser Gallery, from whom it was purchased by Mrs Thomas W. Lamont; presented by her children 1953.
EXHIBITED: Ipswich 1927 (174); *Early English Water Colour Drawings*, Palser Gallery, January 1934 (28) and Summer 1934 (33 repr.); *Early English Water Colours by Masters of the English School*, Ruskin Gallery, Birmingham, April 1934 (63 repr.).
BIBLIOGRAPHY: *The Connoisseur*, March 1934, p.202 repr.; Woodall 450, pp.69–70 and repr. pl.90; *Smith College Museum of Art Bulletin*, No.40, 1960, p.32 (repr.).

The treatment of the foliage, the parallel hatching in the sky, and the rhythmical character of the landscape are closely related to the landscape with sheep owned by Mrs Kenneth Potter (Cat. No.643). The broad hatching is also related to the study for *The Haymaker and Sleeping Girl* in the British Museum (Cat. No.847).

645 Wooded Landscape with Riders, Sheep and Pool
Sir O. W. Williams-Wynn, Dolben

Black chalk and stump. $10\frac{11}{16} \times 14\frac{3}{8}$ (271 × 365).

Two riders travelling along a winding track in the middle distance right; scattered sheep in the foreground left; a pool in the middle distance centre.
PROVENANCE: John Hunter; Hunter sale, Christie's, 29 January 1794, Lot 18 (with another) bt. Sir Watkin Williams-Wynn; thence by descent.

The handling is closely related to the upland landscape with sheep owned by Mrs Kenneth Potter (Cat. No.643).

646 Wooded Landscape with Sheep
Ownership unknown

Black chalk and stump and watercolour.
$11 \times 14\frac{3}{4}$ (279 × 375).
A track winding past banks from the foreground centre into the distance centre; seven sheep scattered in the foreground and middle distance centre and right (from a photograph).
PROVENANCE: J. P. Heseltine; Heseltine sale, Sotheby's, 29 May 1935, Lot 411 (repr.) bt. Meatyard; Walter Turner; Turner sale, Sotheby's, 2 June 1948, Lot 126 bt. Frost and Reed.
BIBLIOGRAPHY: *Original Drawings by British Painters in the Collection of J. P. H*(eseltine), London, 1902, No. 18 (repr.); Woodall 234 and p.70.

The treatment of the foliage, the outlines of the clouds, and the chalk and stumpwork generally are closely related to the landscape with horsemen in Rotterdam (Cat. No.640).

647 Wooded Landscape with Figure and Sheep
Colonel P. L. M. Wright, Roundhill

Black chalk and stump and white chalk. $10\frac{7}{8} \times 14\frac{5}{8}$ (276 × 371).
A figure walking along a winding track in the middle distance centre; scattered sheep in the foreground right; hills in the distance right.
Collector's mark of William Esdaile bottom right.
Inscribed on the verso bottom by Esdaile: *Gainsborough*
PROVENANCE: William Esdaile; Esdaile sale, Christie's, 20–1 March 1838; Vose Galleries, from whom it was purchased by Matthiesen Galleries 1955; Anon. sale, Sotheby's, 14 March 1962, Lot 25 bt. Colnaghi, from whom it was purchased.

The treatment of the tree trunks and foliage, the hatching in the sky, the black chalk and stump work generally, and the rhythmical composition are closely related to the mountain landscape with herdsman and cattle in the Whitworth Art Gallery (Cat. No.637).

648 Wooded Landscape with Figure and Building
Alan D. Pilkington, London

Black chalk and stump and white chalk. 10⅞ × 14⅜ (276 × 365).
A figure travelling along a winding track in the middle distance centre; a building amongst trees in the middle distance right; mountains in the distance right.
PROVENANCE: The Hon. Mrs Fitzroy Newdegate; Newdegate sale, Christie's, 14 March 1952, Lot 226 bt. Colnaghi, from whom it was purchased.
EXHIBITED: *Early English Watercolours . . . from the Collection of Alan D. Pilkington*, Colnaghi's, February 1958 (15).

Executed in the mid-1780's.

649 Hilly Landscape with Figure and Mountain Stream
Ownership unknown

Black chalk and stump (apparently). Size unknown.
A woman seated in the foreground left; a stream winding from the foreground right into the middle distance centre; rising ground in the foreground left and middle distance right (from the print).
ENGRAVED: J. Laporte, published by Laporte and Wells, 1 March 1804 (as in the collection of Dr Thomas Monro).
PROVENANCE: Dr Thomas Monro; Monro sale, Christie's, 26 June 1833 ff.

The treatment of the foliage and the rhythmical composition seem to be related to the wooded landscape with figure on a winding path owned by Colonel Wright (Cat. No.647).

650 Wooded Landscape with Mansion, Figure and Packhorse
Edward Morrison, Talsarnau

Black chalk and stump and white chalk. 10⁹⁄₁₆ × 15 (268 × 381).
A figure and a packhorse travelling along a winding country road in the foreground centre; a country mansion in the middle distance centre and right; a pool in the foreground centre; hills in the distance left.
PROVENANCE: R. W. Alston; with Colnaghi, from whom it was purchased 1939.
BIBLIOGRAPHY: Woodall 32.

The treatment of the foliage, the black chalk and stump work generally, and the rhythmical quality of the terrain are closely related to the wooded landscape with figure on a winding path owned by Colonel Wright (Cat. No.647).

651 Wooded Landscape with Herdsman, Cows and Figures outside a Cottage
Miss Margaret Crawford, London

Black chalk and stump. 10³⁄₁₆ × 14¹⁄₁₆ (259 × 357).
A herdsman driving two cows along a winding track in the foreground centre; three figures, one of them seated, outside a cottage in the middle distance left; scattered sheep on a bank in the middle distance right.
PROVENANCE: With Fine Art Society, from whom it was purchased 1954.
EXHIBITED: *Spring Exhibition Early English Water-Colours and Drawings*, 2nd Edition, Fine Art Society 1954 (31).

The handling is closely related to the landscape with country mansion owned by Edward Morrison (Cat. No.650).

652 Wooded Landscape with Country House
Cecil Higgins Art Gallery, Bedford (P.228)

Black chalk and stump, heightened with a little white. 10¹⁄₁₆ × 14⁷⁄₁₆ (256 × 367).
A country house in the middle distance centre; a shepherd with a stick over his left shoulder talking to a girl, both of them seated, in the foreground right; two cows reclining in the foreground left; a track winding from the foreground right to the house in the middle distance centre.
PROVENANCE: Gilbert Davis; Anon. sale, Sotheby's, 19 March 1958, Lot 18 bt. Colnaghi, from whom it was purchased.

The wiry tree trunks, the rhythmical treatment of the foreground terrain, the outlining of the figures and animals, and the chalkwork generally are closely related to the wooded landscape with country mansion owned by Edward Morrison (Cat. No.650). A copy of this composition was recently with Albany Gallery (*Water-colours and Drawings of the English School*, November 1969 (16 repr.)).

653 Wooded Landscape with Houses, Cows and Sheep
Staatliche Kunstsammlungen, Dresden (C1899–39)

Black chalk and stump. 10⅛ × 14½ (258 × 368).
Two sheep on a bank outside a house in the foreground left; another house in the middle distance centre; two cows in the foreground right; a church tower in the distance right; a pool in the foreground left.
Inscribed in ink bottom left: *26x.*

Collector's mark of William Esdaile bottom right.
PROVENANCE: Dr Thomas Monro; Monro sale, Christie's, 26 June 1833 ff.; William Esdaile; Esdaile sale, Christie's, 20–1 March 1838; with Gutekunst, from whom it was purchased.

The treatment of the buildings, the cows and the foliage, and the use of ruled vertical lines in the architecture are closely related to the wooded landscape with country mansion at Bedford (Cat. No.652).

654 Wooded Landscape with Country Mansion
Mrs Kenneth Potter, North Warnborough

Black chalk and stump, heightened with white.
10⅞ × 14¾ (276 × 375).
A country mansion among trees in the middle distance centre, with a figure approaching the house from the right; scattered sheep in the foreground and middle distance right.
PROVENANCE: Susannah Gardiner (Gainsborough's sister); thence by descent to Miss Green, who gave it to Miss A. Thorne; thence by descent.
BIBLIOGRAPHY: Woodall 308.

The handling is related to the landscape with country mansion owned by Edward Morrison (Cat. No.650). A copy, by the same hand as the copy of the Bedford drawing of a country mansion (see Cat. No.652), was formerly in the Reitlinger collection (H. S. Reitlinger, *Old Master Drawings*, London, 1922, p.173 and repr. pl.64).

655 Hilly Landscape with Village among Trees Plate 198
Lord Methuen, Corsham Court

Black chalk and stump, and pale red wash.
11 × 15 (279 × 381).
A village with church tower amidst trees in the middle distance centre; a pool in the foreground right; hills in the distance centre and right.
PROVENANCE: By descent.
EXHIBITED: *Art Treasures of the West Country*, Royal West of England Academy Galleries, Bristol, May–June 1937 (518); *Old Masters*, Taunton School of Art, 1946; Arts Council 1960–1 (55, and p.7).
BIBLIOGRAPHY: Woodall 236 and p.70.

A study for the mountain landscape in the Metropolitan Museum (Waterhouse 969, repr. pl.191), painted about 1782–4. In the finished painting, slight alterations were made in the disposition of the trees and mountains, and staffage was added: figures, animals and a cart.

The black chalk and stumpwork are closely related to the wooded landscape with figure on a winding track owned by Colonel Wright (Cat. No.647), but the treatment of the composition is exceptionally vigorous and rhythmical. Also mentioned on pp.40 and 45.

656 Wooded Landscape with Shepherd and Sheep Plate 454
Private Collection, England

Black chalk and stump with some reddish stump.
11⅛ × 14⅞ (283 × 378).
A shepherd standing on a knoll in the foreground centre, with two sheep near him and two more at the foot of the bank; a track winding from the foreground left into the middle distance centre; mountains in the distance centre.
PROVENANCE: Unknown.

A highly rhythmical drawing in which the chalkwork, the use of reddish tones in the foreground, and use of stump to model the shapes of clouds are identical with the mountain landscape owned by Lord Methuen (Cat. No.655). The motif of the shepherd standing on a knoll with sheep is paralleled in the upland landscape in Birmingham (Cat. No.773). A copy is in the Chicago Art Institute (22.1229) (Plate 453). Also mentioned on p.90.

657 Wooded Upland Landscape with Figures, Cattle and Sheep
Ehemals Staatliche Museen, Berlin–Dahlem (12881)

Black chalk and stump and watercolour.
11 1/16 × 14 11/16 (281 × 373).
A herdsman driving two cows along a winding track in the foreground right; a shepherd reclining, with scattered sheep, in the foreground left; a cottage in the middle distance right; hills in the distance centre.
PROVENANCE: Presented by Colnaghi 1928.
BIBLIOGRAPHY: Woodall 420.

The rhythmical quality of the composition, the handling of the foliage, the contouring of the distant mountains in stump, and the black chalk and stumpwork generally are closely related to the mountain landscape with shepherd and sheep on a hillock in an English private collection (Cat. No.656), and the contours of the figures and animals to the mountain landscape with herdsman and cattle in the Whitworth Art Gallery (Cat. No.637).

658 Wooded Upland Landscape with Shepherd, Sheep and Buildings on a Hill
Ownership unknown

Black chalk and stump. $10\frac{7}{8} \times 14\frac{5}{8}$ (276×371).
A shepherd driving a flock of sheep along a winding track in the foreground centre; some buildings on a hill in the middle distance right; high banks in the foreground left; hills in the distance centre (from a photograph).
PROVENANCE: George Rushout, 3rd Baron Northwick; Northwick sale, Sotheby's, 6 July 1921, Lot 126 (repr.) bt. Sims; with P. M. Turner; Kennedy North.
EXHIBITED: Oxford 1935 (11).
BIBLIOGRAPHY: Woodall 244.

The chalk and stumpwork and the treatment of the distant hills and clouds are closely related to the mountain landscape at Corsham Court (Cat. No.655).

659 Wooded Upland Landscape with Herdsman and Cows, Shepherd and Sheep
Ownership unknown

Black chalk and stump. $11 \times 14\frac{1}{2}$ (279×368).
A herdsman driving two cows in the foreground right, along a track which winds up a hillside towards a cottage in the middle distance right; a shepherd reclining, with four sheep, in the foreground left; a hill in the middle distance left; mountains in the distance centre (from a photograph).
PROVENANCE: Henry J. Pfungst; Pfungst sale, Christie's, 15 June 1917, Lot 22 (repr.) bt. Colnaghi.
BIBLIOGRAPHY: Woodall 34.

The chalk and stumpwork and the treatment of the distant mountains are closely related to the mountain landscape at Corsham (Cat. No.655), but the treatment is rather less rhythmical.

660 Wooded Landscape with Figures and Country Waggon
Pierpont Morgan Library, New York (III,63)

Black chalk and stump. $10\frac{3}{4} \times 14\frac{5}{8}$ (273×371).
A country waggon drawn by a single horse, and accompanied by a drover, descending a winding track in the foreground left; a shepherd and scattered sheep on a bank in the middle distance left; mountains in the distance centre.
PROVENANCE: Charles Fairfax Murray, from whom it was purchased by J. Pierpont Morgan 1910.
EXHIBITED: *Master Drawings*, Albright Art Gallery, Buffalo, January 1935 (75 repr.); *Master Drawings*,

Golden Gate International Exposition, San Francisco, 1940 (37 and repr. p.92); *The Art of Eighteenth Century England*, Smith College Museum of Art, January 1947 (31); *The Eighteenth Century Art of France and England*, Montreal Museum of Fine Arts, April–May 1950 (48); *Landscape Drawings and Water-Colours, Bruegel to Cézanne*, Pierpont Morgan Library, January–April 1953 (84).
BIBLIOGRAPHY: Chamberlain p.166, repr. p.71; *J. Pierpont Morgan Collection of Drawings by the Old Masters formed by C. Fairfax Murray*, Vol.III, London, 1912, No.63 and repr. pl.63; Woodall 457.

The treatment of the foliage, the rough outlines of the clouds and distant mountains and notation adopted for suggesting the trees in the middle distance, the black chalk and stumpwork generally, and the strongly rhythmical composition are closely related to the mountain landscape with shepherd and sheep on a hillock in an English private collection (Cat. No.656).

661 Wooded Landscape with Country Cart Plate 195
Victoria and Albert Museum, London (Dyce 671)

Black chalk and stump and white chalk on buff paper. $11\frac{1}{8} \times 14\frac{15}{16}$ (283×379).
A country cart drawn by two horses, with a figure in the cart, and a dog following behind, travelling along a country road in the foreground centre; a horse reclining by the side of the road in the foreground right; a building amongst trees in the distance centre, with hills beyond.
PROVENANCE: Rev. Alexander Dyce, who bequeathed it to the South Kensington Museum 1869.
BIBLIOGRAPHY: *Dyce Collection Catalogue*, London, 1874, pp.21 and 99; Woodall 189, p.70 and repr. pl.91.

The treatment of the foliage, the black chalk and stumpwork generally, and the highly rhythmical composition are closely related to the landscape with country waggon in the Morgan Library (Cat. No.660). Also mentioned on p.99.

662 Wooded Landscape with Figure, Deer and House
Courtauld Institute of Art, Witt Collection, London (2433)

Black chalk and stump and white chalk. $11\frac{1}{8} \times 15\frac{5}{16}$ (283×389).
Three deer, one reclining, in the foreground left,

with a figure behind; a house amongst trees in the middle distance left; more deer in the middle distance centre.

Collector's mark of Sir Robert Witt on the verso bottom left.

Inscribed by a modern hand in pencil bottom right: *Gainsborough*

The composition is surrounded by three ruled lines, one in grey ink and two in brown.

PROVENANCE: Sir Robert Witt; bequeathed 1952.

EXHIBITED: *English Painting*, California Palace of the Legion of Honor, San Francisco, June–July 1933 (78); *British Country Life*, 39, Grosvenor Square, June 1937 (477A); *Drawings of the Old Masters from the Witt Collection*, Victoria and Albert Museum, January–May 1943; Bath 1951 (57).

BIBLIOGRAPHY: Woodall 368; *Hand-List of the Drawings in the Witt Collection*, London, 1956, p.22.

The treatment of the foliage, the rough outlines of the clouds in stump, and the highly rhythmical composition are related to the mountain landscape with shepherd and sheep on a hillock in an English private collection (Cat. No.656), and the upland landscape with country waggon in the Morgan Library (Cat. No.660). The introduction of deer is an unusual feature in Gainsborough's landscapes, but see also the landscape in Lady Sutherland's collection (Cat. No.529).

663 Wooded Landscape with Woodcutter and Faggot Bearers Plate 196
Tristan Catroux, Paris

Brown chalk, grey wash and oil on brown prepared paper, varnished. $8\frac{11}{16} \times 12\frac{5}{16}$ (221×313).
A woodcutter chopping wood in the foreground centre; a girl tying up a bundle of faggots, and another seated on a bundle of faggots, in the foreground right; another bundle of faggots in the foreground left.

PROVENANCE: Unknown.

The loose treatment of the tree trunks and foliage and the rhythmical composition are related to the wooded landscape with deer in the Witt Collection (Cat. No.662). Also mentioned on p.17.

664 Wooded Landscape with Figures and Wheelbarrow Plate 410
Pierpont Morgan Library, New York (III,60)

Brown chalk, grey and brown washes and oil on buff paper, varnished. $8\frac{1}{2} \times 12\frac{1}{8}$ (216×308).
A group of six figures, one of them standing and the remainder resting, beneath a bank in the

foreground left; a wheelbarrow in the foreground centre.

PROVENANCE: Charles Fairfax Murray, from whom it was purchased by J. Pierpont Morgan 1910.

EXHIBITED: *The Art of Eighteenth Century England*, Smith College Museum of Art, January 1947 (30); *The Eighteenth Century Art of France and England*, Montreal Museum of Fine Arts, April–May 1950 (47).

BIBLIOGRAPHY: *J. Pierpont Morgan Collection of Drawings by the Old Masters formed by C. Fairfax Murray*, Vol.III, London, 1912, No.60 and repr. pl.60; Woodall 451.

The loose scallops outlining the foliage, the modelling of the banks, the summary contours of the figures and the rough highlights in oil are identical with the landscape with woodcutter and faggot bearers owned by Tristan Catroux (Cat. No.663). Also mentioned on pp.82 and 100.

665 Landscape with Figures and Cows
H.R.H. The Duchess of Kent, Coppins

Brown chalk, grey wash and oil on brown prepared paper. varnished. $8\frac{3}{8} \times 11\frac{7}{8}$ (213×302).
A herdsman and three cows, the foremost of them drinking, at a pool which stretches across the foreground, in the foreground left; a man talking to a woman seated under a tree stump just behind the pool in the foreground right; a mound in the middle distance centre and right; a church tower and spire in the distance centre.

PROVENANCE: Fitzwilliams of Wiganthorpe; by descent to Miss Elsie Fitzwilliam of Slingsby; Fitzwilliam sale, 1956 bt. Sir William Worsley, who gave it to his daughter.

BIBLIOGRAPHY: *Early English Water-Colours at Hovingham Hall*, York, 1957, Cat.19 and p.1.

The handling and technique are closely related to the landscape with figures and wheelbarrow in the Morgan Library (Cat. No.664).

666 Wooded Landscape with covered Cart passing through a Ford Plate 334
Edgar Blaiberg, London

Oil on brown prepared paper, varnished. $8\frac{7}{8} \times 12\frac{5}{16}$ (225×313).
A group of figures in a covered cart drawn by a single horse passing through a ford in the foreground centre; a dog on the nearer side of the stream in the foreground centre, two figures on the farther side of the stream in the middle distance left; a stream stretching from the foreground right into the middle distance left.

PROVENANCE: Ernest C. Innes; Innes sale,
Christie's, 13 December 1935, Lot 27 bt. Blaiberg.
EXHIBITED: Burlington Fine Arts Club, 1924–5 (193).
BIBLIOGRAPHY: Woodall 16.

Study for the landscape with a cart passing
through a ford owned by Mrs Scudamore
(Waterhouse 948, repr. pl.190) (Plate 336),
painted about 1782–4. No changes were made
in the finished picture except for a slight
extension of the foreground and the inclusion
of a dog with the couple on the left. The loose
treatment of the foliage, the summary contours
of the figures and cart, and the rough highlights
in oil are closely related to the landscape with
woodcutter and faggot bearers owned by Tristan
Catroux (Cat. No.663). Also mentioned on
pp.32, 40 and 73.

667 Wooded Landscape with Cottage, Figures and a Boat on a Lake

City Museum and Art Gallery, Birmingham
(198'53)

Brown chalk and oil on brown prepared paper,
varnished. 8¼ × 11⅜ (210 × 289).
A cottage with two figures outside the door in the
foreground left; a figure in a rowing boat on a
lake in the middle distance right.
Inscribed on the verso: *Earl of Bessborough.*
ENGRAVED: Thomas Rowlandson (included in his
*Imitations of Modern Drawings, c.*1788).
PROVENANCE: Earl of Bessborough (?); Ernest C.
Innes; Innes sale, Christie's, 13 December 1935,
Lot 26 bt. Colnaghi, from whom it was purchased
by J. Leslie Wright; bequeathed 1953.
EXHIBITED: Sassoon 1936 (49); *Early English
Water-Colours from the Collections of J. Leslie Wright
and Walter Turner,* Birmingham Art Gallery, April
1938 (89); *Masters of British Water-Colour: The
J. Leslie Wright Collection,* R.A., October–November
1949 (74); Arts Council 1960–1 (51); Nottingham
1962 (63); *Peintures et Aquarelles Anglaises 1700–1900
du Musée de Birmingham,* Musée des Beaux Arts,
Lyons, 1966 (50 and p.7); *Dvě století britského
malířství od Hogartha k Turnerovi,* National Gallery,
Prague and Bratislava, 1969 (63).
BIBLIOGRAPHY: 'Gainsborough and the
Gainsborough Exhibition at 45, Park Lane', *Apollo,*
March 1936, repr. p.128; Woodall 402; John Hayes,
'The Holker Gainsboroughs', 'Notes on British Art 1',
Apollo, June 1964, p.3.

The treatment of the tree trunks, the loose scal-
lops outlining the foliage and the rough high-
lights in oil are closely related to the landscape
with cart passing through a ford owned by
Edgar Blaiberg (Cat. No.666). Also mentioned
on p.102.

668 Wooded Landscape with Houses and Figures Plate 199

Mrs Kenneth Potter, North Warnborough

Black chalk and stump and watercolour.
10¾ × 14⅞ (273 × 378).
Two figures in the foreground left seated beside a
track which winds from the foreground left into
the middle distance centre; scattered sheep on a
bank in the foreground left; houses in the middle
distance left and right, and between them two
figures.
PROVENANCE: Susannah Gardiner (Gainsborough's
sister); thence by descent to Miss Green, who gave
it to Miss A. Thorne; thence by descent.
EXHIBITED: Oxford 1935 (56); Nottingham 1962 (61).
BIBLIOGRAPHY: Woodall 306.

The handling of the foliage and the highly
rhythmical treatment of the terrain are related
to the mountain landscape with shepherd and
sheep on a hillock in an English private col-
lection (Cat. No.656), and the rough contours
of the houses in black chalk to the wooded
landscape with deer in the Witt Collection (Cat.
No.662). The use of a variety of tints, red in the
houses, yellow-brown in the track and distant
trees and blue in the sky, is unusual in this type
of drawing, though reddish tints are employed
in the foreground of the mountain landscapes
at Corsham Court (Cat. No.655) and in an
English private collection (Cat. No.656). Also
mentioned on p.97.

669 Wooded Landscape with Mansion and Figures

Victoria and Albert Museum, London
(641–1877)

Black chalk and stump, pencil and grey wash.
8⅞ × 10 5/16 (225 × 262).
A woman and child descending a long flight of
steps curving down to a gate in the foreground
right; a mansion in the middle distance right;
two deer and some sheep in the middle distance
left; a pool in the foreground left; a stump of tree
in the foreground centre.
PROVENANCE: Acquired 1877.
BIBLIOGRAPHY: *Victoria and Albert Museum Catalogue of
Water Colour Paintings by British Artists,* London, 1927,
p.219; Woodall 187.

One of Gainsborough's drawings with promi-
nent country mansions, characteristic of the
1780's. The broad stumpwork is related tech-
nically to drawings such as the landscape with
houses on either side of a country track owned
by Mrs Kenneth Potter (Cat. No.668).

262

670 Wooded Landscape with Shepherd, Sheep and Farm Buildings Plate 460
Museum Boymans-van Beuningen, Rotterdam (E9)

Black chalk and stump. $8\frac{7}{8} \times 10\frac{7}{8}$ (225 × 276).
A shepherd driving a flock of sheep along a winding track in the middle distance left; farm buildings on rising ground in the middle distance right; a pool in the foreground right; hills in the distance left.
Inscribed on the verso bottom centre: *Gainsborough.*
Collector's mark of R. P. Roupell on the verso bottom right and of Franz Koenigs on the verso bottom left.
PROVENANCE: R. P. Roupell; Roupell sale, Christie's, 14 July 1887, Lot 1336 bt. Wray; Franz Koenigs; acquired 1928.

The stumpwork is related to the landscape with houses on either side of a country track owned by Mrs Kenneth Potter (Cat. No.668), but much of the modelling, and this is particularly obvious in the contours of the shepherd and sheep and in the squiggles on the bank leading up to the house, seems to have been added by a later hand. Also mentioned on p.91.

671 Rocky Wooded Landscape with Figures on Horseback Plate 197
British Museum, London (1910-2-12-258)

Black chalk and stump and white chalk, with some brown chalk, on grey-blue paper. $9 \times 12\frac{11}{16}$ (229 × 322).
A figure leading three or four horsemen in the foreground left; rocks in the middle distance left; a village amongst trees in the distance centre, with a mountain beyond.
PROVENANCE: George Salting; bequeathed 1910.
BIBLIOGRAPHY: Woodall 173.

The treatment of the foliage is related to the landscape with houses on either side of a country track owned by Mrs Kenneth Potter (Cat. No. 668). Also mentioned on p.90.

672 Mountain Landscape with Figures and Buildings
Metropolitan Museum of Art, New York (07.283.5)

Black chalk and stump, white chalk and some brown chalk, on blue paper. $10\frac{9}{16} \times 13\frac{1}{8}$ (268 × 333).
A figure with a staff standing in a rowing boat in the foreground centre; a shepherd and some sheep in the middle distance centre; a stream in the foreground centre and right; some buildings on a bluff in the middle distance left; a high rock in

the middle distance right; a building in the distance right.
Collector's mark of William Esdaile top right.
Annotated in ink on the verso bottom by William Esdaile: *1824 WE – Nassau's sale NN57+* and *Gainsboro.*
PROVENANCE: George Nassau; Nassau sale, Evans, 25 March 1824 ff., probably 2nd Day, Lot 244 (with another) bt. Thane; William Esdaile; Esdaile sale, Christie's, 20–1 March 1838, probably 1st Day, Lot 658 bt. White; purchased 1907.
BIBLIOGRAPHY: *Bulletin of the Metropolitan Museum of Art*, December 1907, p.201; Woodall 465 and p.52; Jacob Bean, *100 European Drawings in the Metropolitan Museum of Art*, New York, n.d. (=1964), No.98 (repr.).

The handling is closely related to the rocky landscape with riders in the British Museum (Cat. No.671).

673 Wooded Landscape with Pool
Plate 439
Edgar Blaiberg, London

Black chalk and stump and white chalk on buff paper. $10\frac{7}{16} \times 12\frac{7}{8}$ (265 × 327).
A track winding between some large rocks from the foreground into the middle distance right; a pool in the foreground left and centre.
PROVENANCE: Anon. sale, Sotheby's, 15 April 1953, Lot 6 (with another) bt. Colnaghi, from whom it was purchased.

The scallops outlining the foliage, the black chalk and stumpwork generally, and the broken highlights in white chalk are closely related to the rocky landscape with horsemen in the British Museum (Cat. No.671). Also mentioned on p.88.

674 Wooded Landscape with Cottage and Figure Plate 207
Mrs Kenneth Potter, North Warnborough

Black and white chalks and grey wash. $10\frac{11}{16} \times 14\frac{3}{8}$ (271 × 365).
A cottage enveloped by trees, with a figure standing at the door, in the middle distance centre; a track winding from the foreground centre into the distance right, with hills beyond.
PROVENANCE: Susannah Gardiner (Gainsborough's sister); thence by descent to Miss Green, who gave it to Miss A. Thorne; thence by descent.
EXHIBITED: Oxford 1935 (35); Nottingham 1962 (64).
BIBLIOGRAPHY: Woodall 305.

S

The loose scallops outlining the foliage are closely related to the rocky landscape owned by Edgar Blaiberg (Cat. No.673), and the highly rhythmical treatment of the terrain to the wooded landscape with houses on either side of a track also owned by Mrs Potter (Cat. No.668). The loose treatment of the foliage is paralleled in the backgrounds of the studies for the Richmond water-walk (compare especially Cat. No. 60), dating from about 1785.

675 Wooded Upland Landscape with Shepherd and Sheep
Victoria and Albert Museum, London
(Dyce 684)

Black chalk and stump. $10\frac{15}{16} \times 14\frac{3}{4}$ (278 × 375).
A shepherd driving a flock of sheep along a track which winds from the middle distance left in the foreground left and centre; hilly ground in the middle distance centre and right.
PROVENANCE: Rev. Alexander Dyce, who bequeathed it to the South Kensington Museum 1869.
BIBLIOGRAPHY: *Dyce Collection Catalogue*, London, 1874, p.100; Woodall 197.

The very rapid chalk outlines in this highly rhythmical drawing are closely related technically to the landscape with a cottage owned by Mrs Potter (Cat. No.674), and the broad stumpwork to the rocky landscape owned by Edgar Blaiberg (Cat. No.673).

676 Wooded Landscape with Cottage and Sheep
The Mount Trust, Churchill

Black chalk and stump, and white chalk and grey wash. $10\frac{3}{8} \times 14\frac{7}{16}$ (264 × 367).
A cottage with a smoking chimney among trees in the middle distance right; scattered sheep in the foreground and middle distance right; a country road winding between banks from the foreground left into the middle distance left; hills in the distance centre.
PROVENANCE: Dr Cobbold; Howard Bliss; with Leicester Galleries, who sold it to Spink, from whom it was purchased by Captain Vivian Bulkeley-Johnson; bequeathed.
EXHIBITED: *From Gainsborough to Hitchens*, The Leicester Galleries, January 1950 (25).

The treatment of the cottage, the use of grey wash in the modelling of the trees, and the sketchy handling of the trees in the middle distance are closely related to the landscape with a cottage owned by Mrs Potter (Cat. No.674).

677 Wooded Landscape with House and Figures
Ownership unknown

Red chalk and grey wash (apparently). Size unknown.
Two figures, one of them seated, in front of a house situated on a bank in the foreground centre; low hills in the distance right (from the print).
ENGRAVED: J. Laporte, published by Laporte and Wells 1 December 1802 (as in the collection of Dr Thomas Monro).
PROVENANCE: Dr Thomas Monro; Monro sale, Christie's, 26 June 1833 ff.

The rapid handling of the foreground, the use of grey wash in the modelling of the trees, and the sketchy treatment of the trees in the middle distance and the distant mountains seem to be related to the landscape with a cottage owned by Mrs Kenneth Potter (Cat. No.674).

678 Wooded Landscape with Sheep
Plate 450
Dr R. E. Hemphill, Cape Town

Black chalk and grey wash. $10\frac{11}{16} \times 14\frac{9}{16}$ (271 × 370).
Three or four sheep scattered in the foreground and middle distance centre; a high bank in the middle distance left; a track winding uphill from the foreground right into the middle distance right.
PROVENANCE: Sir Robert Witt.
EXHIBITED: *British Art*, R.A., January–March 1934 (1150); *Drawings of the Old Masters from the Witt Collection*, Victoria and Albert Museum, January–May 1943.
BIBLIOGRAPHY: *Commemorative Catalogue of the Exhibition of British Art 1934*, Oxford, 1935, No.610; Woodall 365.

The loose scallops outlining the foliage, the use of wash in the modelling of the trees and banks, and the rhythmical treatment of the composition are closely related to the wooded landscape with a cottage owned by Mrs Potter (Cat. No. 674). A copy is in the Fogg Art Museum (1953. 91) (Plate 449). Also mentioned on p.90.

679 Wooded Landscape with Figures and Cows
British Museum, London (G.g.3–393)

Grey wash, heightened with white, over an offset outline. $9\frac{15}{16} \times 12\frac{3}{16}$ (252 × 309).
Three figures grouped beside a tree in the foreground centre; three cows in the middle

distance right; hills in the distance right.
ENGRAVED: Thomas Rowlandson, published by
J. Thane 21 May 1789 (as late in the collection of
Charles Frederick Abel).
PROVENANCE: Carl Friedrich Abel; Abel sale,
Christie's, 13 December 1787; John Thane; Rev. C.
M. Cracherode; bequeathed 1799.
BIBLIOGRAPHY: Binyon 31 (25); Gower *Drawings*,
p.14 and repr. pl.XLII; Woodall 160.

The loose scallops outlining the foliage and the
use of wash are related to the wooded landscape
with sheep owned by Dr Hemphill (Cat. No.
678).

680 Wooded Landscape with Faggot Gatherers, Cows and Sheep
Ownership unknown

Black and white chalks and grey wash (apparently).
Size unknown.
A man bundling up a pile of faggots, helped by a
woman, and accompanied by a dog, in the
foreground right; two cows and five sheep in the
foreground left and centre; a mountain in the
distance centre (from the print).
ENGRAVED: Thomas Rowlandson, published by
J. Thane 21 May 1789 (as late in the collection of
Charles Frederick Abel).
PROVENANCE: Carl Friedrich Abel; Abel sale,
Christie's, 13 December 1787; John Thane; Thane
sale, Jones, 25 March 1819, Lot 105 (with
another).

The treatment of the foliage and the clouds
seems to be related to the landscape with figures
and cows in the British Museum (Cat. No.679),
also once in the possession of C. F. Abel.

681 Wooded Landscape with Faggot Gatherer and Cows
Ownership unknown

Black chalk and grey wash (apparently). Size
unknown.
A faggot gatherer lifting a bundle of faggots onto
his shoulder in the foreground centre, with
another bundle at his feet; two cows in the
foreground left; a dog asleep in the foreground
right; a cottage and out-buildings in the middle
distance left (from the print).
ENGRAVED: Thomas Rowlandson (as late in the
collection of Charles Frederick Abel).
PROVENANCE: Carl Friedrich Abel; Abel sale,
Christie's, 13 December 1787; John Thane; Thane
sale, Jones, 25 March 1819, Lot 105 (with another).

The treatment of the foliage seems to be related

to the landscape with figures and cows in the
British Museum (Cat. No.679), also once in the
possession of C. F. Abel. The drawing owned by
Edgar Blaiberg is an exact copy of the Row-
landson print.

682 Upland Landscape with Herdsman and Cattle
Ownership unknown

Black and white chalks and grey wash (apparently).
Size unknown.
A herdsman driving two cows to a watering place
in the foreground centre; a shepherd asleep with
six sheep in the foreground right; a pool stretching
from the middle distance left into the foreground
right (from the print).
ENGRAVED: Thomas Rowlandson, published by
J. Thane 21 May 1789 (as late in the collection of
Charles Frederick Abel).
PROVENANCE: Carl Friedrich Abel; Abel sale,
Christie's, 13 December 1787; John Thane.

The treatment of the tree trunk and foliage
seems to be related to the landscape with figures
and cows in the British Museum (Cat. No.679),
also once in the possession of C. F. Abel.

683 Upland Landscape with Cows and Sheep Plate 452
City Art Gallery, Bristol

Grey wash and white chalk over an offset outline
on buff paper. $9\frac{11}{16} \times 12\frac{5}{16}$ (246×313).
Two cows under a bank in the foreground left;
scattered sheep in the foreground centre and right;
hills in the distance.
PROVENANCE: Arthur Kay; Kay sale, Christie's,
23 May 1930, Lot 38 bt. Leggatt; with P. M.
Turner; with Fine Art Society; Dr H. A. C.
Gregory; Gregory sale, Sotheby's, 20 July 1949,
Lot 15 bt. Friends of the Bristol Art Gallery.
EXHIBITED: *British Art*, Cartwright Hall, Bradford,
1904 (360); Ipswich 1927 (128); *Early English
Watercolours and Drawings*, Fine Art Society, October
1944 (40) and June 1945 (27).
BIBLIOGRAPHY: Gower, repr. f. p.8; Woodall 81.

The treatment of the cows, the foliage and the
clouds is closely related to the landscape with
figures and cows in the British Museum (Cat.
No.679). A copy is in the Birmingham City Art
Gallery (206'53) (Plate 451). Also mentioned
on p.90.

684 Wooded Landscape with Shepherd, Sheep and Cottage

Ownership unknown

Grey wash and white chalk over an offset outline. $10\frac{7}{16} \times 12\frac{5}{8}$ (264 × 322).

A shepherd and dog in the foreground centre; four sheep in the foreground left; three more sheep on a bank, with a cottage behind, in the middle distance right; a pool in the foreground left and centre (from a photograph).

PROVENANCE: Anon. Viennese private collection; sale, Boerner and Graupe, Berlin, 10–11 May 1930, Lot 75 (repr.) bt. Nebehay.

BIBLIOGRAPHY: Heinrich Leporini, *Handzeichnungen Grosser Meister: Gainsborough*, Vienna and Leipzig, n.d. (=1925), repr. pl.2.

The handling of the foliage and clouds and the modelling of the sheep are identical with the landscape with cows and sheep in Bristol (Cat. No.683).

685 Herdsman driving Cows through a Ruined Archway

City Museum and Art Gallery, Birmingham (212′53)

Grey wash and white chalk over an offset outline on buff paper. $9\frac{11}{16} \times 12\frac{3}{16}$ (246 × 309).

A herdsman on horseback driving two cows and two sheep through a ruined archway in the foreground centre.

PROVENANCE: Guy Bellingham Smith; J. Leslie Wright, who bequeathed it 1953.

EXHIBITED: *Old Master Drawings*, Colnaghi's, December 1935 (11); Sassoon 1936 (47); *Early English Water-Colours from the Collections of J. Leslie Wright and Walter Turner*, Birmingham Art Gallery, April 1938 (90); *Masters of British Water-Colour: The J. Leslie Wright Collection*, R.A., October–November 1949 (90); Arts Council 1960–1 (47).

BIBLIOGRAPHY: Woodall 396.

The treatment of the cows, the tree trunks, the foliage and the clouds is identical with the landscape with cows and sheep at Bristol (Cat. No. 683).

686 Wooded Landscape with Herdsman and Cows

City Museum and Art Gallery, Birmingham (216′53)

Grey wash and white chalk over an offset outline on buff paper. $9\frac{7}{16} \times 12\frac{1}{4}$ (240 × 311).

A herdsman with a staff and two cows in the middle distance left; a pond in the foreground left; a cottage and scattered sheep in the middle distance right.

PROVENANCE: Guy Bellingham Smith, who sold it to Colnaghi, from whom it was purchased by J. Leslie Wright 1936; beqeuathed 1953.

EXHIBITED: Oxford 1935 (8); *Early English Water-Colours from the Collections of J. Leslie Wright and Walter Turner*, Birmingham Art Gallery, April 1938 (86); *Masters of British Water-Colour: The J. Leslie Wright Collection*, R.A., October–November 1949 (95).

BIBLIOGRAPHY: Woodall 389 and p.41.

The treatment of the foliage and animals, the broad handling of wash, the broken contours in the animals, and the rough highlighting of the clouds are identical with the landscape with cows being driven through a ruined archway also in Birmingham (Cat. No.685).

687 Open Landscape with Cattle and Sheep Plate 224

Ehemals Staatliche Museen, Berlin–Dahlem (6851)

Grey and grey-black washes and white chalk over an offset outline on buff paper. $10\frac{5}{16} \times 12\frac{7}{8}$ (262 × 327).

A herdsman driving four cows and two sheep over a hillock towards the left in the foreground. Collector's mark of Benjamin West bottom left.

PROVENANCE: Benjamin West; William Esdaile; Esdaile sale, Christie's, 20–1 March 1838; William Benoni White; White sale, Christie's, 24 May 1879, Lot 202 bt. Colnaghi; J. P. Heseltine; presented by an unknown donor 1913.

BIBLIOGRAPHY: *Original Drawings by British Painters in the Collection of J. P. H(eseltine)*, London, 1902, No. 16 (repr.); Woodall 57 and 417.

Study for the landscape with herdsman, cattle and sheep in the possession of Maureen, Marchioness of Dufferin and Ava (Waterhouse 946), painted about 1786. In the finished picture there are trees and bushes on the right, and two of the cows have been replaced by a goat and an extra sheep. The broken contours of the cows, the rough highlighting of the clouds, and the loose handling of wash are closely related to the landscape with cows being driven through a ruined archway in Birmingham (Cat. No.685). Also mentioned on p.40.

688 Upland Landscape with Herdsman, Cattle and Sheep
Brinsley Ford, London

Brown wash, black chalk and stump, and brown and white chalks, on buff paper. $10\frac{1}{4} \times 12\frac{7}{8}$ (260 × 327).

A herdsman, accompanied by a dog, seated beneath a hillock in the foreground left; a withered tree stump in the foreground centre; three cows, two of them standing and one reclining, and four sheep, behind a pond in the foreground centre and right; hills in the distance right.

Inscribed in pencil on an attached piece of paper, in the hand of Richard Ford (1796–1858): *Gainsborough/given me by Lord Essex Rich Ford.*

PROVENANCE: George, 5th Earl of Essex, who gave it to Richard Ford, perhaps at the time of the latter's marriage to his daughter in 1824; thence by descent.

EXHIBITED: Ipswich 1927 (149); *Works of Art from the Ford Collection*, Royal Albert Memorial Museum, Exeter, March–April 1946 (114).

The treatment of the foliage and clouds is closely related to the landscape with cows and sheep in Bristol (Cat. No.683), and the treatment of the cows to the landscape with herdsman and cattle in Berlin (Cat. No.687). The drawing may well have been made at the time when Lord Essex was sitting to Gainsborough for his portrait, in June 1785.

689 Wooded Landscape with Cows
The Earl of Perth, London

Black chalk and stump, brown and white chalks, and grey and brown washes, over an offset outline, on buff paper. $10\frac{1}{4} \times 12\frac{5}{8}$ (260 × 321).

Two cows standing and one reclining in the middle distance centre, beside a mound to right; a pool in the foreground left; two logs in the foreground right.

PROVENANCE: John F. Keane; Keane sale, Sotheby's, 3 December 1947, Lot 77 (with another) bt. Spink; Dr H. A. C. Gregory; Gregory sale, Sotheby's, 20 July 1949, Lot 14 bt. Colnaghi, from whom it was purchased.

The modelling of the cows, the stumpwork in the clouds, and the white chalkwork are closely related to the landscape with herdsman and cattle owned by Brinsley Ford (Cat. No.688), and the modelling of the foliage in stump is closely related to the landscape with houses on either side of a country track owned by Mrs Kenneth Potter (Cat. No.668).

690 Wooded Landscape with Herdsman, Cows, Sheep and Cottage
The Executors of the late H. L. Bradfer-Lawrence, Ripon (on indefinite loan to the Castle Museum, Norwich)

Grey wash over an offset outline on buff paper, heightened with white. $9\frac{5}{8} \times 12\frac{1}{2}$ (244 × 317).

A herdsman and two cows in the middle distance left; scattered sheep on a rising bank in the middle distance right, with a cottage behind; a pool stretching across the foreground.

The labels formerly on the back of the frame are inscribed: *This Sketch by Gainsborough was given/by the Great Painter to his friend/M*ʳ *Pierce, by whom it was given,/or left by will to my Father in 1836 who was/the great grandfather of the dear Nephew/great to whom I am now with/much pleasure giving it/Your loving Aunt/Emily Marianne Selfe/1 Mountlands, Taunton/24th July 1907* and: *By Gainsborough/If M*ʳ *Deacon entirely approves of/this Genuine Drawing which M*ʳ *Pearce has/had in his possession in a Portfolio/full 25 years, he will have a frame/made for it./Cadogan Place 50/30 Jan*ʸ *1836./Received/JD/ 30 January/1836* (COPY: original in possession of *R. Sancroft/Baker/*E.S.S. Baker./*Aug: 1907.*

PROVENANCE: Given by the artist to William Pearce, who presented or bequeathed it to an unidentified friend; by descent to Emily Marianne Selfe, who gave it to her great nephew E. S. S. Baker 1907; Anon. sale, Sotheby's, 27 February 1957, Lot 46 bt. Colnaghi, from whom it was purchased by H. L. Bradfer-Lawrence.

The contouring of the animals, the handling of wash, and the rough white highlights are closely related to the landscape with herdsman and cattle owned by Brinsley Ford (Cat. No.697).

691 Open Landscape with Country Cart
Museum of Fine Arts, Boston (15.1258)

Grey and brown washes and white chalk over an offset outline on buff paper. $10\frac{1}{8} \times 12\frac{3}{4}$ (257 × 324).

A country cart with two figures seated inside, accompanied by a peasant and dog, travelling down a slope in the foreground centre; a log in the foreground right; hills in the distance left.

PROVENANCE: Purchased 1915.

BIBLIOGRAPHY: Woodall 437.

The treatment of the foliage, the foreground detail and the clouds is closely related to the landscape with cows and sheep at Bristol (Cat. No.683).

692 Open Landscape with Figures on Horseback and Packhorse
Ownership unknown

Brown chalk and grey wash, heightened with white. 10 × 12¾ (254 × 324).
A man on horseback, a woman riding side-saddle, and a packhorse, travelling up a slope in the foreground centre (from a photograph).
PROVENANCE: With Meatyard.
BIBLIOGRAPHY: *Meatyard Catalogue No.19*, 1939 (44 repr.).

The treatment of the figures and animals and the foliage is closely related to the landscape with a country cart in Boston (Cat. No.691).

693 Upland Landscape with Figures outside a Cottage
Ehemals Staatliche Museen, Berlin–Dahlem (4467)

Grey wash over an offset outline on buff paper, heightened with white. 10¼ × 12⅘ (260 × 325).
A woman standing at the door of a cottage, with four other figures seated, in the foreground right; a peasant returning home with his dog in the foreground centre; part of a cottage in the foreground left; two cows in the middle distance left; hills in the distance centre.
PROVENANCE: With Colnaghi, from whom it was purchased 1909.
BIBLIOGRAPHY: Woodall 421.

The treatment of the cows, tree trunks, foliage and clouds is closely related to the landscape with cows and sheep at Bristol (Cat. No.683).

694 Open Landscape with Herdsman, Cows and Sheep
Metropolitan Museum of Art, New York (07.282.7)

Grey wash over an offset outline on grey paper, heightened with white. 10 × 12½ (254 × 317).
A herdsman driving two cows towards a stream in the foreground centre; scattered sheep in the foreground left; a stream running from the foreground centre into the middle distance right.
Collector's mark of John Thane bottom left.
PROVENANCE: John Thane; purchased 1907.
BIBLIOGRAPHY: *Bulletin of the Metropolitan Museum of Art*, December 1907, p.201; Woodall 468.

The broad handling of wash is closely related to the landscape with cows and sheep at Bristol (Cat. No.683).

695 Wooded Landscape with Shepherdess and Sheep
The Hon. Mrs Spencer Loch, London

Grey wash over a brown offset outline on buff paper, heightened with white. 10⅛ × 12½ (257 × 317).
A shepherdess accompanied by a dog seated on a knoll in the middle distance centre; a small gate in the foreground right, and six sheep scattered in the foreground and middle distance right.
PROVENANCE: Philip, 2nd Earl of Hardwicke; thence by descent.

The handling is related to the landscape with cows and sheep at Bristol (Cat. No.683).

696 Wooded Landscape with Milkmaids and Cows
Christchurch Mansion, Ipswich (1917-12-3)

Brown and white chalks and grey wash on buff paper. 10 × 12 (254 × 305).
Two milkmaids, one standing and one seated, in front of a cow standing in profile facing right in the foreground left; a milkpail in front of a cow reclining in profile facing left in the foreground right.
PROVENANCE: Henry J. Pfungst; Pfungst sale, Christie's, 15 June 1917, Lot 50 bt. Gooden and Fox for the Ipswich Museum.
EXHIBITED: Ipswich 1927 (162).

The loose treatment of the foliage and handling of wash are related to the landscape with cattle passing through a ruined archway in Birmingham (Cat. No.685). The representation of cows on such a large scale is unusual (but compare Cat. No.404).

697 Wooded Landscape with Drover and Horse
R. W. Hompe, London

Brown wash and white chalk on grey paper. 9½ × 12 (241 × 305).
A drover and a horse, accompanied by a dog, in the foreground centre and right; a high bank in the foreground left.
Collector's mark of William Esdaile bottom right.
PROVENANCE: George Baker; Baker sale, Sotheby's, 16 June 1825 ff., 3rd Day, probably Lot 362 bt. Thane; William Esdaile; Esdaile sale, Christie's, 20–1 March 1838; Sir Robert Witt; with Fine Art Society, from whom it was purchased by H. Wolifson; Anon. sale, Sotheby's, 18 July 1962, bt. R. W. Hompe.
EXHIBITED: *Early English Watercolours and Drawings*, Fine Art Society, October 1944 (35).
BIBLIOGRAPHY: Woodall 360.

The broken contours of the figure and horse and the loose treatment of the foreground detail and background are identical with the landscape with milkmaids and cows at Ipswich (Cat. No. 696).

698 Wooded Landscape with Packhorse, Figures and Ruined Building
Ownership unknown

Brown and white chalks on buff paper.
$9\frac{15}{16} \times 11\frac{15}{16}$ (252×303).
A figure and packhorse in the foreground right; a peasant with a crook over his left shoulder seated in the foreground centre; a ruined arched building in the middle distance left.
PROVENANCE: Crabtree; with Colnaghi, from whom it was purchased on behalf of the Southampton General Hospital and presented to Dr M. K. Jardine 1957; Jardine sale, Sotheby's, 19 June 1969, Lot 172 bt. Drysdale.

The broken contours of the figures and horse, the loose treatment of the background and the scattered highlights in white chalk are closely related to the landscape with milkmaids and cows at Ipswich (Cat. No.696).

699 Wooded Landscape with Haymakers and Haycart
Horne Foundation, Florence (5980)
(deposited in the Uffizi)

Brown wash over an offset outline on buff paper.
$5\frac{13}{16} \times 7\frac{7}{16}$ (148×189).
Two haymakers, one of them standing with a pitchfork, the other seated, in the foreground left; a haycart loaded with hay, and two horses drinking from a bucket, in the foreground centre; a pail in the foreground left.
Collector's mark of Dr Edward Peart bottom left.
PROVENANCE: Dr Edward Peart; Herbert Horne.
EXHIBITED: *Disegni della Fondazione Horne*, Palazzo Strozzi, September–October 1963 (188).
BIBLIOGRAPHY: Licia Ragghianti Collobi, *Disegni Inglesi della Fondazione Horne*, Pisa, 1966, Cat.12, repr. pl.13.

The handling of the foliage, the hatching, and the fairly light treatment of the figures and animals are closely related to the landscape with figures and packhorse formerly owned by Dr M. K. Jardine (Cat. No.698).

700 Wooded Landscape with Horsemen and Cottage
With Sabin Galleries, London

Brown and white chalks on grey paper.
$9\frac{1}{4} \times 12\frac{1}{2}$ (235×317).
Four or five horsemen in the foreground left on a track which winds from the foreground right into the middle distance left; a cottage among trees in the middle distance left.
PROVENANCE: Sir J. C. Robinson; Robinson sale, Christie's, 21 April 1902; Ernest C. Innes; Innes sale, Christie's, 13 December 1935, Lot 33 bt. Meatyard; L. C. Warmington; Warmington sale, Sotheby's, 14 March 1962, Lot 107 bt. Slaughter.
BIBLIOGRAPHY: Woodall 346.

The treatment of the foliage and the scattered highlights in white chalk are closely related to the landscape with figures and packhorse formerly owned by Dr M. K. Jardine (Cat. No. 698).

701 Mountain Landscape with Shepherd, Sheep and Bridge
Alan D. Pilkington, Eton College

Brown wash and white chalk over an offset outline on grey-blue paper. $8 \times 10\frac{1}{2}$ (203×267).
A shepherd driving a flock of sheep across a stone humpback bridge over a stream in the foreground left and centre; mountains in the distance left. The composition is surrounded by a double ruled line in ink and a tooled gold arabesque border.
PROVENANCE: With Colnaghi, from whom it was purchased.

The treatment of the foliage is related to the landscape with figures and packhorse formerly owned by Dr M. K. Jardine (Cat. No.698).

702 Open Landscape with Cottage, Figures and Animals
Ownership unknown

Brown chalk and grey wash on buff paper.
$9\frac{1}{16} \times 12\frac{11}{16}$ (230×322).
A cottage with a smoking chimney behind a mound in the foreground left; two sheep in the foreground left; two cows standing near the cottage in the foreground centre; two figures accompanied by a child walking along a winding track in the middle distance right.
Collector's mark of Sir Bruce Ingram on the verso of the mount bottom right.
PROVENANCE: Sir Bruce Ingram; Ingram sale, Sotheby's, 21 October 1964, Lot 37 (erroneously listed as bt. Folio Society).

Executed in the mid-1780's.

703 Wooded Landscape with Figures, Cottage and Cattle Plate 397
Museum Boymans-van Beuningen, Rotterdam (E15)

Grey wash and white chalk over a brown offset outline on buff paper. 8⅞ × 11 15/16 (225 × 303).
A mother standing holding a child at the door of a cottage, with four other figures grouped in front of her, two of them seated and one of these smoking, in the foreground centre and right; two cows in the foreground left; a bundle of faggots in the foreground right.
Collector's mark of Franz Koenigs on the verso bottom left.
PROVENANCE: I. W. Böhler; Franz Koenigs; acquired 1929.
BIBLIOGRAPHY: Woodall 433.

The loose treatment of the foliage, the summary contours of the figures and cows, and the scattered highlights in white chalk are closely related to the wooded landscape with horsemen. With Sabin Galleries. (Cat. No.700). Also mentioned on pp.25 and 79.

704 Wooded Upland Landscape with Figure and Cattle
Ownership unknown

Brown wash over an offset outline. 6⅝ × 8 11/16 (168 × 221).
A herdsman seated in the foreground left; three cows in the foreground centre; mountains in the distance left.
PROVENANCE: J. P. sale, Ader, Hotel Drouot, 8 December 1938, Lot 49; Christopher Norris; Red Cross sale (presented by Christopher Norris), Christie's, 12 July 1940, Lot 774 bt. Mrs F. W. Bain; with Durlacher.
EXHIBITED: Durlacher, November–December 1960.
BIBLIOGRAPHY: Woodall 242a.

The loose treatment of the foliage and handling of wash, and the summary contours of the herdsman and cows are closely related to the landscape with figures outside a cottage in Rotterdam (Cat. No.703).

705 Open Landscape with Cows
Mrs P. J. G. Gray, Ashby St Mary

Brown wash over an offset outline. 7 × 8 13/16 (178 × 224).
One cow reclining and another standing in the foreground centre; rising ground on the right.
PROVENANCE: H. L. Bradfer-Lawrence; thence by descent.

The treatment of the tree trunks, the shadowy modelling and outlining of the cows, and the loose handling of wash are closely related to the landscape with herdsman and cows formerly with Durlacher (Cat. No.704).

706 Mountain Landscape
Professor E. D. H. Johnson, Princeton, N.J.

Brown wash over an offset outline. 7½ × 10 3/16 (190 × 259).
Mountains in the distance centre and right.
PROVENANCE: With Squire Gallery; Mrs W. D. Peyton; with Fine Art Society, from whom it was purchased 1965.
EXHIBITED: Forty-Fifth Exhibition Early English Water-colours and Drawings, Fine Art Society, March–April 1965 (46).

The loose and broken treatment of wash is closely related to the landscape with herdsman and cows formerly with Durlacher (Cat. No. 704).

707 Rocky Landscape with Weir
Bruce Howe, Cambridge, Mass.

Brown chalk and grey and brown washes. 7⅝ × 10 (194 × 254).
A mountain stream flowing over a weir in the foreground centre into the foreground right; high rocks in the middle distance left and foreground right; a hill in the distance centre.
PROVENANCE: With Fine Art Society, from whom it was purchased 1965.
EXHIBITED: Forty-Fifth Exhibition Early English Water-colours and Drawings, Fine Art Society, March–April 1965 (41).

The treatment of the clouds and the loose handling of wash are related to the upland landscape owned by Professor E. D. H. Johnson (Cat. No. 706).

708 Wooded Upland Landscape with Cows Plate 208
Museum Boymans-van Beuningen, Rotterdam (E10)

Brown wash over an offset outline. 7 15/16 × 10½ (202 × 267).
Three cows on a winding hilly road in the middle distance centre, with a sheep and a shepherd seated beneath the slope; a tree stump and log in the foreground centre; a stream in the foreground right.

Stamped bottom left: *T. Gainsborough* between two ruled lines surrounding the composition outside which there is a gold tooled arabesque border over brown wash and a further ruled line.
Inscribed beneath bottom left: *WE Nassau's Sale 1824. no 29* and again on the verso bottom left: *1824 WE Nassau's sale N29.*
Collector's mark of William Esdaile bottom right.
Collector's mark of Franz Koenigs on the verso bottom left.
PROVENANCE: George Nassau; Nassau sale, Evans, 25 March 1824 ff., probably 2nd Day, Lot 243 (with another) bt. Thane; William Esdaile; Esdaile sale, Christie's, 20–1 March 1838; Franz Koenigs; acquired 1929.
EXHIBITED: *Oude Engelsche Schilderijen . . . in Nederlandsche Verzamelingen*, Museum Boymans, Rotterdam, November–December 1934 (73).
BIBLIOGRAPHY: Woodall 432.

The loose treatment of the foliage and the broken handling of wash are closely related to the landscape with herdsman and cows formerly with Durlacher (Cat. No.704). Also mentioned on pp.14, 15, 26 and 98.

709 Wooded Upland Landscape with Waggon and Sheep Plate 393
Museum Boymans-van Beuningen, Rotterdam (E11)

Brown wash over an offset outline. $7\frac{7}{8} \times 10\frac{9}{16}$ (200 × 268).
A waggon containing two figures, one seated, and drawn by three horses, travelling along a track in the foreground left; scattered sheep on a hillock in the middle distance centre; a tree stump in the foreground right.
Stamped bottom left *T. Gainsborough* between two ruled lines surrounding the composition, outside which there is a gold tooled arabesque border over brown wash and a further ruled line.
Inscribed beneath bottom left: *Nassau Sale 1824. no 30* and again on the verso bottom left: *1824 Nassau's sale N30.*
Collector's mark of William Esdaile bottom right.
Collector's mark of Franz Koenig on the verso bottom left.
PROVENANCE: George Nassau; Nassau sale, Evans, 25 March 1824 ff., probably 2nd Day, Lot 243 (with another) bt. Thane; William Esdaile; Esdaile sale, Christie's, 20–1 March 1838; Franz Koenigs; acquired 1929.
EXHIBITED: *Oude Engelsche Schilderijen . . . in Nederlandsche Verzamelingen*, Museum Boymans, Rotterdam, November–December 1934 (72).
BIBLIOGRAPHY: Woodall 429.

The loose broken treatment of wash is identical with the previous drawing (Cat. No.708), to

which it is a companion. The motif of the prominent blasted tree trunk arching over the composition on the right is paralleled in the estuary scene with shepherd and sheep in the Mellon collection (Waterhouse 965, repr. pl.223), painted about 1782–4. Also mentioned on pp.15, 77 and 98.

710 Wooded Landscape with Figures
Ashmolean Museum, Oxford

Brown wash over an offset outline. $7\frac{7}{8} \times 10\frac{9}{16}$ (200 × 268).
Two figures resting beside a track in the foreground right; a cottage in the middle distance right.
Inscribed on the back of the mount: *Given to Lady Beaumont by Mr Gainsborough.*
Stamped *T. Gainsborough* in gold bottom left between two ruled lines outside which there is a gold tooled arabesque border.
PROVENANCE: Given by the artist to Lady Beaumont; Gertrude E. Baines; purchased 1948.

The handling of wash and the treatment of the tree trunk on the right are closely related to the landscape with a cart in Rotterdam (Cat. No. 709).

711 Coastal Scene with Ships, Shepherd and Sheep
City Art Gallery, Leeds (13.108/53)

Brown wash over an offset outline. $7\frac{1}{8} \times 8\frac{7}{8}$ (181 × 225).
A shepherd accompanied by a dog standing on a cliff in the foreground centre; scattered sheep in the foreground right; an anchor in the foreground left; two sailing vessels out at sea in the middle distance left and centre.
Stamped *T. Gainsborough* on the old mount bottom left, with a gold tooled arabesque border outside.
Inscribed on the verso of the old mount in ink: *H. E. Bunbury./Drawing by Gainsborough.*
PROVENANCE: Sir Henry Edward Bunbury; Henry Reveley; Reveley sale, Christie's, 11 May 1852, Lot 205 bt. in.; Norman Lupton; bequeathed 1953.
BIBLIOGRAPHY: Woodall 219; 'Drawings by Wilson, Gainsborough and Constable', *Leeds Art Calendar*, Autumn 1956, pp.18 and 25.

One of Gainsborough's sketchiest landscapes in this medium: the composition is barely more than mapped out with the simplest of washes and detail is hardly suggested. The broad treatment of wash and strong chiaroscuro are related to the landscape with a cart in Rotterdam (Cat. No.709).

712 Wooded Mountain Landscape with Herdsman and Cows
Mrs J. D. Eaton, Toronto

Brown wash over an offset outline. $7\frac{3}{8} \times 9\frac{1}{16}$ (187 × 230).
A herdsman driving five cows along a winding road in the foreground centre; mountains in the distance centre and right.
Inscribed in brown ink bottom left: *TG* between two ruled lines outside which there is a gold tooled arabesque border over brown wash and a further ruled line.
ENGRAVED: J. Laporte, published by Laporte and Wells 1 January 1803 (as in the collection of Dr Thomas Monro).
PROVENANCE: Dr Thomas Monro; Monro sale, Christie's, 26 June 1833 ff.

The loose treatment of the foliage and the loose broken handling of wash are identical with the pair of landscapes in Rotterdam (Cat. Nos.708 and 709).

713 Open Landscape with a Lady and Gentleman on Horseback and a Group of Children near a Cottage Plate 209
Mrs J. D. Eaton, Toronto

Brown wash over an offset outline. $7\frac{7}{16} \times 9\frac{1}{8}$ (189 × 232).
A lady and gentleman riding along a country track in the foreground left, the gentleman distributing largesse to a boy centre; four other children in the foreground right one playing on or near a gate which has evidently been opened for the two riders; a cottage behind the gate in the foreground right.
Stamped *T. Gainsborough* bottom left: between two ruled lines outside which there is a gold tooled arabesque border over brown wash and two further ruled lines.
PROVENANCE: Unknown.

The handling of the foliage, the broken use of wash, and the summary treatment of the figures and horses, are identical with the previous drawing (Cat. No.712), to which it is a companion. The costume of the two riders is not sufficiently detailed to help much in dating the drawing: the cocked riding hat with feathers worn by the lady is of a type fashionable from about 1777 to 1790. The theme was probably derived from Dutch landscape painting, and is found in the work of Dujardin. Also mentioned on p.26.

714 Rocky Landscape with Riders
Private Collection, England

Black chalk and brown wash. $7\frac{7}{8} \times 10\frac{1}{2}$ (200 × 267).
Three figures, one of them a woman, on horseback in the foreground centre, riding past a large rock in the foreground left; a pool in the foreground centre and right.
PROVENANCE: With Agnew, from whom it was purchased by the present owner.

The treatment of the figures and animals and the foliage and the handling of wash are identical with the landscape with herdsman and cows owned by Mrs J. D. Eaton (Cat. No.712). The theme of the three riders travelling past a rock is found also in the drawing in the British Museum (Cat. No.587), but here the composition is in reverse.

715 Hilly Landscape with Shepherd and Sheep
The Hon. Christopher Lennox-Boyd, London

Brown wash over an offset outline. $5\frac{7}{8} \times 7\frac{5}{16}$ (149 × 186) (oval).
A shepherd with a crook in his left arm seated on a bank under a tree, and playing with a dog, in the foreground centre; a sheep in the foreground right, another on a mound in the middle distance right, and three more in the middle distance left; a mountain in the distance left.
Stamped *T Gainsborough* bottom centre between two lines which are surrounded by a gold tooled arabesque border and a further line.
PROVENANCE: Anon. sale, Christie's, 11 June 1968, Lot 45 (repr.) bt. Sanders.

The handling of wash is closely related to the landscape with herdsman and cattle owned by Mrs J. D. Eaton (Cat. No.712).

716 Open Landscape with Figures, Donkey and Horses
Metropolitan Museum of Art, New York (59.23.43)

Brown wash and some grey wash over an offset outline. $9\frac{1}{8} \times 10\frac{15}{16}$ (232 × 278).
A drover seated, with a packdonkey and a dog, outside a thatched cottage half-hidden by trees in the foreground left; a figure on horseback and a packhorse in the middle distance right; a stream running from the foreground right into the middle distance centre.
PROVENANCE: Henry J. Pfungst; Pfungst sale, Christie's, 15 June 1917, Lot 48 bt. Colnaghi; with Knoedler, from whom it was purchased by

272

Charles B. Eddy 1923: with Knoedler, from whom it was purchased by Mrs Alexandrine Sinsheimer 1926; bequeathed 1959.
EXHIBITED: Knoedler 1923 (1).
BIBLIOGRAPHY: Woodall 66.

The handling of the foliage and the figures and animals and the use of wash are closely related to the landscape with children begging from a lady and gentleman on horseback owned by Mrs J. D. Eaton (Cat. No.713). The rich treatment of the foliage is paralleled in Gainsborough's landscape paintings of this period, such as the canvas of a similar subject which was in the Colonel S. J. L. Hardie sale, Sotheby's, 19 November 1969, Lot 120 (repr. colour) bt. Leger (Waterhouse 998), exhibited at Schomberg House in April 1786.

717 Wooded Landscape with Country Mansion and Figures
Courtauld Institute of Art, Witt Collection, London (4034)

Grey wash over an offset outline, with traces of black chalk and stump. $12\frac{7}{16} \times 10\frac{3}{16}$ (316 × 259).
A woman seated holding a baby, with a little girl also seated, outside an arched gateway in the foreground centre; another woman walking towards the mansion in the middle distance centre. Collector's mark of Sir Robert Witt on the verso bottom left.
PROVENANCE: Henry J. Pfungst; Pfungst sale, Christie's, 15 June 1917, Lot 66 bt. Colnaghi; Sir Robert Witt; bequeathed 1952.
BIBLIOGRAPHY: *Hand-List of Drawings in the Witt Collection*, London, 1956, p.22.

An abbreviated upright variant of the landscape with a country mansion owned by George Howard (Cat. No.518): the type of archway and the angle of the house in relation to the arch are similar in both drawings. The loose atmospheric treatment is typical of Gainsborough's late offset drawings, such as the landscape with herdsman and donkey in the Metropolitan Museum (Cat. No.716).

718 Open landscape with Figures, Cows and Cottage
Mr and Mrs Paul Mellon, Oak Spring, Virginia (62/11/1/38)

Grey wash and white chalk on buff paper over an offset outline. $10\frac{1}{4} \times 12\frac{3}{8}$ (260 × 314).
A herdsman with a crook over his left shoulder, accompanied by a dog, seated in the foreground centre; a cow in the middle distance left; a cottage with a woman and a child standing in the doorway and a pig at a trough outside in the middle distance centre; two cows, one of them reclining, in the foreground right.
PROVENANCE: Anon. sale, Christie's, 13 March 1936, Lot 29 bt. Meatyard; L. C. Warmington; Warmington sale, Sotheby's, 14 March 1962, Lot 68 bt. Colnaghi, from whom it was purchased 1962.
BIBLIOGRAPHY: Woodall 347.

The loose treatment of the foliage, figures and animals is closely related to the landscape with herdsman and donkey in the Metropolitan Museum (Cat. No.716).

719 Wooded Landscape with Figures at a Cottage Door and Cows
Ownership unknown

Black and white chalks and grey wash on brown prepared paper. $10\frac{1}{8} \times 12\frac{5}{8}$ (257 × 321).
A figure with a stick accompanied by a dog in the foreground centre; a shed in the foreground left; two cows, one of them reclining, in the middle distance left; four figures, three of them seated, at the door of a cottage in the middle distance right (from a photograph).
Annotated on the verso in Esdaile's hand: *1833. WE. Dr. Monro's sale N. 45. Gainsborough.*
PROVENANCE: Dr Thomas Monro; Monro sale, Christie's, 26 June 1833 ff.; William Esdaile; Esdaile sale, Christie's, 20–1 March 1838; with Sheepshanks; with Parsons.
BIBLIOGRAPHY: *Sheepshanks Catalogue*, 1914 (84 repr.); *Parsons Catalogue*, 1923 (456 repr.); Woodall 261.

The treatment of the figures and animals and the foliage and the handling of wash are identical with the landscape with cattle outside a cottage in the Mellon collection (Cat. No.718).

720 Wooded landscape with Figures outside a Cottage
Ownership unknown

Brown wash. $9\frac{3}{8} \times 13\frac{1}{2}$ (238 × 343).
A mother holding a baby and five or six other figures grouped outside a cottage door in the foreground right (from a photograph).
PROVENANCE: With Parsons.
BIBLIOGRAPHY: *Parsons Catalogue No.51*, 1934 (47 repr.); Woodall 260.

From a poor reproduction, the treatment of the figures outside the cottage and the loose handling of wash seem to be related to the cottage door with Parsons in 1923 (Cat. No.719).

721 Wooded Landscape with Figures outside a Cottage and Herdsman driving Cattle Plate 210
Albertina, Vienna (24459)

Oil on brown prepared paper.
8¾ × 12 (222 × 305).
A herdsman on horseback driving a herd of cows and some sheep down a country lane in the foreground left; a mother seated holding a child at the door of a cottage, and three other figures, two of them seated, on the steps outside, in the foreground right.
PROVENANCE: With Boerner, from whom it was purchased 1925.
BIBLIOGRAPHY: Heinrich Leporini, *Handzeichnungen Grosser Meister: Gainsborough*, Vienna and Leipzig, n.d. (= 1925), p.2; Woodall 428a.

The loose treatment of the figures and foliage is related to the cottage door with Parsons in 1923 (Cat. No.719). Also mentioned on p.24.

722 Wooded Landscape with Figures outside a Cottage and Cattle
Ehemals Staatliche Museen, Berlin–Dahlem (12882)

Grey and brown washes and oil over an offset outline on brown prepared paper.
8½ × 11⅞ (216 × 302).
A mother and child seated at the door of a cottage, with a peasant standing cross-legged and leaning on a pitchfork, and another peasant seated, in the foreground centre; three cows beside the cottage in the foreground left.
PROVENANCE: Henry J. Pfungst; Pfungst sale, Christie's, 15 June 1917, Lot 9 bt. Colnaghi; with Knoedler; returned to Colnaghi; presented by Colnaghi 1928.
BIBLIOGRAPHY: Woodall 67 and 408.
EXHIBITED: Knoedler's 1923 (5).

The treatment of the figures and foliage and the highlights in oil breaking through the trees are closely related to the cottage door in the Albertina (Cat. No.721).

723 Country Scene with Figures, Sheep and Cottage
The executors of the late Mrs Frances L. Evans, Woodstock

Grey wash and oil with traces of pastel on brown prepared paper, varnished. 8¼ × 11¹³⁄₁₆ (210 × 300).
A group of figures, one standing and two seated, centre, with a cottage behind them in the middle distance; some scattered sheep beneath a bank left.
PROVENANCE: With Colnaghi, from whom it was

purchased by Mrs Frances Evans.
EXHIBITED: *Drawings by Old Masters*, R.A., August–October 1953 (449).
BIBLIOGRAPHY: Woodall 51.

Executed in the mid-1780's.

724 Wooded Landscape with Horsemen and Figures
Courtauld Institute of Art, Witt Collection, London (1681)

Black and brown chalks, grey and brown washes, and oil, varnished. 8⅞ × 12 (225 × 305).
Two figures on horseback, accompanied by three other figures, the foremost with a crook in his left hand, travelling along a country road in the foreground centre and right.
PROVENANCE: With Holloway, from whom it was purchased by Sir Robert Witt; bequeathed 1952.
EXHIBITED: Ipswich 1927 (165); Sassoon 1936 (73); *Twee Eeuwen Engelsche Kunst*, Stedelijk Museum, Amsterdam, July–October 1936 (218); *British Country Life*, 39 Grosvenor Square, June 1937 (478); *La Peinture Anglaise*, Louvre, 1938 (201); *Drawings of the Old Masters from the Witt Collection*, Victoria and Albert Museum, January–May 1943; *British Painting from Hogarth to Turner*, British Council (Hamburg, Oslo, Stockholm and Copenhagen), 1949–50 (50); Bath 1951 (58); *Three Centuries of British Water-Colours and Drawings*, Arts Council 1951 (76); *Le Paysage Anglais de Gainsborough à Turner*, Orangerie, February–April 1953 (50 and repr. pl.11); *Drawings from the Witt Collection*, Arts Council, 1953 (11); *Drawings from the Witt Collection*, Courtauld Institute Galleries, 1958 (60); *Old Master Drawings from the Witt Collection*, Auckland City Art Gallery, 1960 (9); Arts Council 1960–1 (48); *Master Drawings from the Witt and Courtauld Collections*, Whitworth Art Gallery, Manchester, November–December 1962 (5); *Great Art from Private Colleges and Universities*, Marquette University, Milwaukee, February 1964; *English Landscape Drawings from the Witt Collection*, Courtauld Institute Galleries, January–May 1965 (9).
BIBLIOGRAPHY: C. H. Collins Baker, 'Some Eighteenth-Century Drawings in the Witt Collection', *The Connoisseur*, January 1926, repr. f. p.3 (colour); *ibid.*, p.45; E. S. Siple, 'Gainsborough Drawings: The Schniewind Collection', *The Connoisseur*, June 1934, repr. f. p.353 (colour); Woodall 372; *Hand-List of the Drawings in the Witt Collection*, London, 1956, p.21.

The composition is a variant of the aquatint (Boydell 12). The treatment of the tree trunks, the scallops outlining the foliage, and the rough highlights in oil are closely related to the cottage door in Berlin (Cat. No.722). A radiograph

made by the Courtauld Institute suggests that the effects in this drawing (and no doubt in many others) have been considerably reduced by chemical changes in the course of time.

725 Mountain Landscape with Figures, Sheep and Fountain
John Lowe, Liphook

Grey and grey-black washes and oil on brown prepared paper, varnished. $8\frac{3}{8} \times 11\frac{13}{16}$ (213×300).
A shepherd and a flock of sheep, the shepherd talking to a woman with a pail in her lap seated on the side of a trough, in the foreground right; a fountain, with a goat beside it, in the foreground centre; mountains in the distance left.
PROVENANCE: H. W. Underdown; Underdown sale, Sotheby's, 15 December 1926, Lot 117 bt. Colnaghi; Otto Gutekunst; with Agnew; Howard Bliss; with Leicester Galleries, from whom it was purchased by A. J. L. McDonnell; bequeathed to the present owner.
EXHIBITED: *From Gainsborough to Hitchens*, The Leicester Galleries, January 1950 (22); *Drawings by Old Masters*, R.A., August–October 1953 (445 and repr. in the Souvenir pl.57); Arts Council 1960–1 (49).

The treatment of the foliage and the rich broken highlights in oil are closely related to the landscape with riders in the Witt Collection (Cat. No.724). The subject of sheep and a goat at a trough was used by Gainsborough in his mountain landscape in the Royal Academy Diploma Gallery (Waterhouse 1007), painted about 1782–4.

726 Wooded Landscape with Horses drinking at a Trough Plate 11
Private Collection, England

Black chalk, grey wash and oil on brown prepared paper, varnished. $8\frac{13}{16} \times 11\frac{1}{2}$ (224×292).
A white horse drinking at a trough set in an arched recess, with the water spouting out of a lion's head, in the foreground left and centre; a boy bringing a black horse to drink behind in the foreground centre; a girl seated with a milkpail in the foreground left.
PROVENANCE: By descent.

The treatment of the foliage and the rich broken highlights in oil are closely related to the landscape with riders in the Witt Collection (Cat. No.724) and the mountain landscape with trough and fountain owned by John Lowe (Cat. No.725). Also mentioned on p.24.

727 Wooded Landscape with Riders, Figures and River
Whitworth Art Gallery, University of Manchester (D.17.1917) (17)

Brown chalk, grey and brown washes and oil on brown prepared paper, varnished. $8\frac{1}{2} \times 12\frac{3}{8}$ (216×314).
A figure and two riders travelling along a winding road in the middle distance left; a figure seated by the side of the road in the foreground centre; another figure walking along the road in the distance centre; a river in the foreground and middle distance right.
Inscribed bottom centre in pencil in a later hand: *Gainsborough*.
PROVENANCE: Henry J. Pfungst; Pfungst sale, Christie's, 15 June 1917, Lot 8 bt. Colnaghi for the Whitworth Art Gallery.
EXHIBITED: Ipswich 1927 (161); *Watercolour Drawings from the Whitworth Art Gallery Manchester*, Agnew's, February–March 1954 (109).
BIBLIOGRAPHY: Woodall 224.
REPRODUCED: *Twenty Early English Water-Colour Drawings in the Whitworth Art Gallery, Manchester*, n.d., pl.5.

The treatment of the tree and branches, the loose scallops outlining the foliage, and the rough highlights in oil are closely related to the wooded landscape with riders in the Witt Collection (Cat. No.724).

728 Coastal Scene with Shipping, Figures and Cows Plate 212
British Museum, London (G.g.3–391)

Grey and brown washes, and oil, varnished. $8\frac{1}{2} \times 11\frac{15}{16}$ (216×303).
Ships and figures in the middle distance left; two cows, one standing and the other reclining, in the foreground centre; a figure in the middle distance centre.
Collector's mark of the Rev. C. M. Cracherode on the verso with the date: *1788*.
ENGRAVED: Thomas Rowlandson (included in his *Imitations of Modern Drawings*, c.1788).
PROVENANCE: Rev. C. M. Cracherode; bequeathed 1799.
BIBLIOGRAPHY: Binyon 12; Gower *Drawings*, p.12 and repr. pl.XIII; Roger Fry, *Reflections on British Painting*, London, 1934, p.74 and repr. fig.28; Woodall 89.

The treatment of the foliage and the modelling of the cows in thick impasto are closely related to the cottage door in the Albertina (Cat. No. 721). The presence of the cows, which are included solely for compositional reasons, strikes a

rather incongruous note in this coastal view. The scene on the left is an admirable example of the brilliance of Gainsborough's late sketches. Also mentioned on pp.11, 24 and 51.

729 Open Landscape with Horsemen
Ashmolean Museum, Oxford

Oil on paper laid on panel, varnished. $8\frac{3}{4} \times 12\frac{1}{8}$ (222×308).
Three horsemen on a country track riding over a hillock in the foreground centre; a shepherd surrounded by a number of sheep in the foreground left; a church tower in the distance left.
ENGRAVED: Thomas Rowlandson (included in his *Imitations of Modern Drawings*, c.1788).
PROVENANCE: C. H. T. Hawkins; Mrs J. E. Hawkins sale, Christie's, 30 October 1936, Lot 103 bt. Meatyard; L. C. Warmington; E. H. W. Meyerstein, who bequeathed it 1953.
BIBLIOGRAPHY: *Meatyard Catalogue* 1936 (106 repr.); *The Connoisseur*, December 1936, p.365 repr.; Woodall 345; *Ashmolean Museum Report 1953*, p.51.

The highlights in thick chunky slabs of oil paint and the treatment of the foliage and the clouds are identical with the coastal scene with cows in the British Museum (Cat. No.728). Also mentioned on p.99.

730 A Cattle Ferry Plate 213
City Museum and Art Gallery, Birmingham (190'53)

Oil on brown prepared paper, varnished.
$8\frac{9}{16} \times 11\frac{7}{8}$ (217×302).
A herd of cattle being driven onto a ferryboat on the seashore in the foreground centre and right by a herdsman; two more herdsmen in the boat right; a promontory in the middle distance right.
PROVENANCE: Sir Michael Sadler; J. Leslie Wright, who bequeathed it 1953.
EXHIBITED: *Masters of British Water-Colour: The J. Leslie Wright Collection*, R.A., October–November 1949 (66); Arts Council 1960–1 (46); Nottingham 1962 (62).
BIBLIOGRAPHY: Woodall 283.

The treatment of the clouds and the highlighting of the cows in thick impasto are identical with the coastal scene with cows in the British Museum (Cat. No.728). Also mentioned on pp.24, 51 and 102.

731 Wooded Landscape with Herdsmen and Cows Plate 214
George D. Widener, Philadelphia

Watercolour and oil on reddish-brown prepared paper, varnished. $8\frac{3}{8} \times 12\frac{1}{16}$ (213×306).
A herdsman seated, with three cows, in the foreground centre and right; a pool stretching across the foreground; a mountain in the distance centre; low hills in the distance right.
PROVENANCE: Given by the artist probably to Goodenough Earle, of Barton Grange, Somerset; thence by descent to Francis Wheat Newton; sold to Agnew's 1913, who immediately resold it to Knoedler's, from whom it was purchased by G. D. Widener 1914.
EXHIBITED: Knoedler's 1914 (13).
BIBLIOGRAPHY: Fulcher, 2nd edn., p.241; John Hayes, *The Gainsborough Drawings from Barton Grange*, The Connoisseur, February 1966, pp.92–3 and repr. fig.14.

The treatment of the foliage, cows and clouds is closely related to the coastal scene with cows in the British Museum (Cat. No.728). Also mentioned on pp.13, 24 and 95.

732 Upland Landscape with Figures, Riders and Cattle
California Palace of the Legion of Honor, San Francisco (1952.63)

Watercolour and oil on pale brown prepared paper, varnished. $8\frac{9}{16} \times 12\frac{1}{4}$ (217×311).
Two riders, one of them riding side-saddle, followed by a figure on foot, driving two cows to a watering place in the foreground left and centre; hills in the middle distance centre and distance right.
PROVENANCE: Henry J. Pfungst; Pfungst sale, Christie's, 15 June 1917, Lot 1 (repr.) bt. Seligmann; with Knoedler; with Colnaghi; Thomas Partridge; with Colnaghi, from whom it was purchased on behalf of Mr and Mrs Sidney M. Ehrman and presented 1952.
EXHIBITED: Colnaghi's 1906 (69); Knoedler's 1923 (12); Ipswich 1927 (147).
BIBLIOGRAPHY: Woodall 68.

The treatment of the foliage and clouds and the highlighting of the animals are closely related to the mountain landscape with herdsmen and cows owned by George D. Widener (Cat. No. 731). Also mentioned on p.100.

733 Wooded Landscape with Horseman and Packhorses
Ownership unknown

Watercolour and oil, varnished. $9\frac{1}{16} \times 12\frac{3}{16}$ (230 × 313).
A horseman and two packhorses descending a slope in the foreground centre and right; a church in the distance left.
Typewritten note on the back of the frame reproducing the original inscription in pen on the old backboard (compare Cat. No.379): *This tinted sketch by Gainsborough, its companion and the two sketches in crayon, also companions, by the same painter, were given to me by Mr. Andrews, apothecary of Crawford St. Marylebone, then in the 83rd year of his age. He had them from Dr. Thompson, who died about 15 years ago, at Osnaburgh Street, at the age of 93. and had informed Mr. Andrews that he obtained them from a member of Gainsborough's family. Alex. Shaw Nov. 1865.*
PROVENANCE: Given by a member of Gainsborough's family to Dr William Thompson; William Richard Andrews, who gave it to Alexander Shaw 1865; by descent to Captain Norman Shaw; Anon. (=Shaw) sale, Christie's, 6 November 1953, Lot 61 bt. Colnaghi, from whom it was purchased by Sir Robert Abdy; with Stephen Spector.

The loose treatment of the foliage and the foreground detail and the highlighting of the horses in oil are closely related to the mountain landscape with herdsman and cows owned by George D. Widener (Cat. No.731).

734 Wooded Landscape with Cows and Sheep
Ownership unknown

Black chalk, watercolour and oil, varnished. $8\frac{9}{16} \times 11\frac{13}{16}$ (217 × 300).
Three cows, one standing and two reclining, and three sheep, on a bank in the foreground centre; two cottages in the middle distance left; a pool stretching across the foreground.
An old label pasted on the back of the frame is inscribed in ink: *by Gainsborough/Begun in Water Color/completed in Oil –.*
PROVENANCE: Unknown.

Executed in the mid-1780's. Also mentioned on p.24.

735 Upland Landscape with Cattle Crossing a Bridge
Frick Collection, New York

Watercolour and bodycolour over black chalk, varnished. $8\frac{7}{16} \times 12\frac{1}{16}$ (214 × 306).

A horseman driving three cows over a stone bridge in the middle distance centre; a stream in the foreground right; buildings on a mountain side in the distance centre.
PROVENANCE: Sir Thomas Lawrence (?); J. P. Heseltine; with Knoedler, from whom it was purchased by H. C. Frick 1913.
EXHIBITED: Colnaghi's 1906 (85); Knoedler's 1914 (14).
BIBLIOGRAPHY: *Original Drawings by British Painters in the Collection of J. P. H(eseltine)*, London, 1902, No.11 (repr.); Woodall 447; Harry D. M. Grier and Edgar Munhall, *Masterpieces of the Frick Collection*, New York, 1970, p.52.

The treatment of the foliage and animals is related to the wooded landscape with horsemen and packhorses formerly in the Shaw collection (Cat. No.733).

736 Hilly Landscape with Herdsman and Cattle Plate 215
Sterling and Francine Clark Art Institute, Williamstown

Brown chalk and stump, grey and blue washes, and oil, on pale brown prepared paper, varnished on both sides. $8\frac{3}{4} \times 12\frac{5}{16}$ (222 × 313).
A herdsman driving three cows down a country lane in the foreground left; high banks in the foreground right; a church tower and hills in the distance centre.
Annotated on the verso bottom left in ink, by William Esdaile: *1823 WE-ex. R. Ford.*
PROVENANCE: Richard Ford; William Esdaile; Esdaile sale, Christie's, 20 March 1838, probably Lot 665 bt. Graves; J. Heywood Hawkins; probably C. H. T. Hawkins sale, Christie's, 29 March 1904, Lot 195 (with another) bt. Colnaghi; Henry J. Pfungst; Pfungst sale, Christie's, 15 June 1917, Lot 6 (repr.) bt. Colnaghi, from whom it was purchased by R. S. Clark 1918.
EXHIBITED: Colnaghi's 1906 (60).
BIBLIOGRAPHY: Egbert Haverkamp-Begemann, *Drawings from the Clark Institute*, New Haven, 1964, Vol.1, p.ix and Cat.26, Vol.2, repr. pl.27 (colour); Egbert Haverkamp-Begemann, *Fifteen Master Drawings from the collection of the Sterling and Francine Clark Institute at Williamstown*, New Haven, 1965, No. 8 repr. pl.8 (colour).

The treatment of the foliage and the clouds and the rough highlights in oil are closely related to the mountain landscape with herdsman and cows owned by George D. Widener (Cat. No. 731). Also mentioned on pp.14, 24, 98 and 100.

737 Wooded Landscape with Distant Plain
Sterling and Francine Clark Art Institute, Williamstown

Watercolour and oil, varnished. $8\frac{1}{2} \times 12\frac{1}{16}$ (216×306).
A figure seated on a rocky mound in the foreground centre; a church tower in the distance right.
Annotated on the verso bottom left in ink, by William Esdaile: *1823 WE ex: R Ford* and bottom centre: *Gainsborough*
Collector's mark of John Postle Heseltine on the verso bottom left.
PROVENANCE: Richard Ford; William Esdaile; Esdaile sale, Christie's, 20 March 1838, probably Lot 664 bt. Rev. Grubb; J. P. Heseltine; with Knoedler, from whom it was purchased by R. S. Clark 1913.
BIBLIOGRAPHY: *Original Drawings by British Painters in the Collection of J. P. H(eseltine)*, London, 1902, No. 19 (repr.); Egbert Haverkamp-Begemann, *Drawings from the Clark Institute*, New Haven, 1964, Vol.1, p.ix and Cat.27, Vol.2 repr. pl.28.

The scallops outlining the foliage, the rapid treatment of the middle distance, the handling of the clouds, and the rough highlights in oil are closely related to the previous drawing (Cat. No.736), to which it is a companion. Also mentioned on p.98.

738 Wooded Landscape with Figures on Horseback
City Museum and Art Gallery, Birmingham (215'53)

Oil, varnished. $8\frac{1}{16} \times 11\frac{1}{2}$ (205×292).
Three figures on horseback, accompanied by another figure, travelling across country in the middle distance left; hills in the distance left; a pool in the foreground right.
PROVENANCE: J. Leslie Wright, who bequeathed it 1953.
EXHIBITED: *Masters of British Water-Colour: The J. Leslie Wright Collection*, R.A., October–November 1949 (94).

The treatment of the foliage and the clouds, the rapid handling of the distant panorama, and the rough highlights in oil are identical with the wooded landscape with distant plain in Williamstown (Cat. No.737).

739 Landscape with Figures and Cottage
H.R.H. The Duchess of Kent, Coppins

Grey and brown washes and oil on brown prepared paper, varnished. $8\frac{1}{2} \times 11\frac{15}{16}$ (216×303).
Three figures, two of them seated, in the foreground right; a track winding from the foreground left into the middle distance centre; a thatched cottage with a smoking chimney in the middle distance centre, with one figure at the door and two or three others outside; low hills in the distance centre.
PROVENANCE: Fitzwilliams of Wiganthorpe; by descent to Miss Elsie Fitzwilliam of Slingsby; Fitzwilliam sale, 1956 bt. Sir William Worsley, who gave it to his daughter.
BIBLIOGRAPHY: *Early English Water-Colours at Hovingham Hall*, York, 1957, Cat.18 and p.1.

The handling and rhythmical composition are closely related to the wooded landscape with horsemen in Birmingham (Cat. No.738).

740 Open Landscape with Riders and Packhorses crossing a Bridge
With Agnew's, London

Oil, mounted on canvas. $12 \times 13\frac{5}{8}$ (305×346).
Three figures on horseback and three packhorses crossing a stone bridge in the foreground centre; a track winding from the bridge into the foreground left; a stream in the foreground right; a church tower in the distance left.
PROVENANCE: Thomas Hardcastle; by descent to A. B. Hardcastle.
EXHIBITED: *Winter Exhibition of Old Masters*, R.A., January–March 1883 (273).
BIBLIOGRAPHY: Waterhouse 918.

The treatment of the tree trunk on the left, the foliage and the clouds, and the rough highlights in oil are related to the mountain landscape with herdsman and cattle in Williamstown (Cat. No.736). However, a recent opportunity to examine the original for the first time suggests the later 1760's as a more plausible dating. The fresh, light tone is more characteristic of this period, and the rich use of impasto is similar to a painting of the same size, the *Boy at a Stile* owned by Sir Ralph Anstruther (Waterhouse 889), painted about 1766–9. The motif of the figure asleep on his horse is paralleled in the *Returning from Market* in the Cincinnati Art Museum (Waterhouse 947, pl.178), painted about 1771–2.

741 Wooded Landscape with Horsemen
Ownership unknown

Oil. $8\frac{1}{8} \times 11\frac{1}{2}$ (206×292).
Three horsemen, followed by another figure, in the
foreground left; a pool in the foreground right;
a hill in the distance left (from a photograph).
PROVENANCE: Thomas Green; Henry J. Pfungst;
Pfungst sale, Christie's, 15 June 1917, Lot 7 bt.
Colnaghi; with Knoedler; with Colnaghi.
EXHIBITED: Knoedler's 1923 (8).

The treatment of the foliage and the rough
highlighting in oil are closely related to the
landscape with horsemen in the Ashmolean
Museum (Cat. No.729) and the landscape with
herdsmen and cows in Williamstown (Cat.
No.736).

**742 Wooded Landscape with Drover,
Packhorses and Building** Plate 189
Milton W. McGreevy, Kansas City

Watercolour, white chalk and some black chalk.
$8\frac{1}{2} \times 12\frac{1}{16}$ (216×306).
A horseman and two packhorses in the foreground
left; a peasant seated on a bank beside a country
lane in the foreground centre; part of a castle on
a bank in the middle distance left.
PROVENANCE: Philip Hofer; with Durlacher.
EXHIBITED: *Centennial Loan Exhibition*, Vassar College
and Wildenstein's, June–September 1961 (66 repr.).

The loose treatment of the foliage and fore-
ground detail is related to the wooded landscape
with horsemen in Birmingham (Cat. No.738).

**743 Wooded Landscape with Figures
and Buildings**
Ownership unknown

Brown wash. $9\frac{3}{4} \times 14\frac{5}{8}$ (248×371).
Two figures in the middle distance centre on a
track which winds from the foreground centre into
the distance centre; buildings among trees beyond
a rocky bank in the middle distance left; a large
mansion and two other buildings in the middle
distance right; a pool in the foreground left (from
a photograph).
PROVENANCE: With Parsons.
BIBLIOGRAPHY: *Parsons Catalogue* No.44 (352 repr.).

From a poor reproduction, the handling of wash
seems to be related to the wooded landscape
with drover and packhorses owned by Milton
McGreevy (Cat. No.742)

**744 Wooded Landscape with Herdsman,
Cattle and Buildings**
Douglas H. Gordon, Baltimore

Watercolour, with traces of brown chalk and some
red bodycolour, heightened with white, varnished.
$8\frac{9}{16} \times 12\frac{3}{16}$ (217×309).
A herdsman on horseback driving three cows down
a country lane in the foreground centre; a church
tower and other buildings in the distance centre.
PROVENANCE: Henry J. Pfungst; Pfungst sale,
Christie's, 15 June 1917, Lot 2 bt. Colnaghi, who
sold it to Knoedler, from whom it was purchased
by C. B. Eddy 1918; returned to Knoedler, from
whom it was purchased 1940.
EXHIBITED: Cincinnati 1931 (69 and repr. pl.71);
*English drawings and watercolours from the 17th
century to the present, from the Douglas H. Gordon
collection*, October–November 1947 (no catalogue).

The treatment of the animals, foliage and fore-
ground detail is closely related to the wooded
landscape with drover and packhorses owned by
Milton McGreevy (Cat. No.742).

**745 Wooded Landscape with Cottage,
Herdsman and Cattle**
Ownership unknown

Grey wash. $8\frac{1}{2} \times 12\frac{1}{2}$ (216×317).
A herdsman, accompanied by a dog, driving two
cows in the foreground left and centre; a figure at
the door of a cottage with a smoking chimney in
the foreground left; a pool in the foreground and
middle distance right (from a photograph).
PROVENANCE: H. L. Sternberg; Sternberg sale,
Christie's, 24 February 1928, Lot 18 bt. Kohnstamm.
BIBLIOGRAPHY: Woodall 64.

The loose treatment of the foliage and fore-
ground detail and the handling of wash gener-
ally are identical with the wooded landscape
with herdsman and cattle owned by Douglas H.
Gordon (Cat. No.744).

**746 Wooded Landscape with Buildings
and Figures**
A. C. Greg, Acton Bridge

Grey wash. $9\frac{7}{8} \times 13\frac{7}{8}$ (251×352).
A figure on horseback accompanied by a dog, with
another figure in front, on a track in the
foreground left; a group of buildings in the middle
distance right; a plain in the distance left with
low hills beyond.
PROVENANCE: J. Heywood Hawkins; Henry J.
Pfungst; Pfungst sale, Christie's, 15 June 1917,
Lot 64 bt. Blaker; Miss Blaker sale, Christie's,

T

20 May 1926, Lot 206 bt. H. S. Reitlinger;
Reitlinger sale, Sotheby's, 27 January 1954, Lot 143
bt. Squire Gallery, from whom it was purchased.
BIBLIOGRAPHY: Woodall 269.

The loose treatment of the foliage and the handl-
ing of wash generally are identical with the
wooded landscape with herdsman, cows and
cottage formerly in the Sternberg collection
(Cat. No.745).

747 Wooded Upland Landscape with Country Mansion
Mrs Kenneth Potter, North Warnborough

Grey wash and white chalk. $9\frac{3}{4} \times 13\frac{3}{4}$ (248×349).
A mansion half-hidden by trees in the middle
distance right; a track winding across the
foreground; hills in the distance left.
PROVENANCE: Susannah Gardiner (Gainsborough's
sister); from thence by descent to Miss Green, who
gave it to Miss A. Thorne; thence by descent.
EXHIBITED: Nottingham 1962 (58).
BIBLIOGRAPHY: Woodall 307.

The loose treatment of the foliage and the
handling of wash generally are identical with
the wooded landscape with country mansion
owned by A. C. Greg (Cat. No.746), which is
also very similar in composition.

748 Wooded Landscape with Buildings and Figures
Private Collection, London

Grey wash over pencil. $9\frac{7}{16} \times 14\frac{7}{16}$ (240×367).
Two figures on a winding track in the foreground
centre; some buildings behind a rocky bank in the
middle distance left; another group of buildings
in the middle distance right; a mountain in the
distance centre; a pool in the foreground left.
PROVENANCE: Dr H. A. C. Gregory; Gregory sale,
Sotheby's, 20 July 1949, Lot 13 bt. Agnew, from
whom it was purchased by J. A. Dewar 1949;
thence by descent.

Executed in the mid-1780's.

749 Wooded Landscape with Cows at a Watering Place
Valentine Swain, London

Pencil, grey-blue and brown washes, varnished.
$6\frac{1}{2} \times 9\frac{1}{8}$ (165×232).
Three cows in the foreground right standing in a
pool which stretches into the foreground centre;
rocks in the middle distance centre; low hills in
the distance centre and right.

PROVENANCE: With Spink, from whom it was
purchased 1959.

The loose treatment of the foliage and the
handling of wash generally are closely related
to the wooded landscape with country mansion
owned by Mrs Kenneth Potter (Cat. No.747).

750 Wooded Landscape with Cows
Wing Commander John Higginson, Ballyward,
Co. Down

Grey with some brown and blue washes, black
chalk and pencil. $8\frac{11}{16} \times 12\frac{1}{4}$ (221×311).
A herdsman reclining, with six cows, one of them
reclining, in the foreground centre and right; a
stream running from the foreground left into the
middle distance centre.
PROVENANCE: H. Sutton Palmer; Palmer sale,
Christie's, 11 December 1933, Lot 181 bt. Agnew;
with Hirschl and Adler; S. Sydney Turner; with
Agnew, from whom it was purchased 1953.
EXHIBITED: 80th Annual Exhibition of Water-Colour
Drawings, Agnew's, January–March 1953 (64);
Pictures from Ulster Houses, Belfast Museum and Art
Gallery, May–July 1961 (187).
BIBLIOGRAPHY: Woodall 6.

The loose treatment of wash and the use of blue
and brown tints are closely related to the land-
scape with cows at a watering place owned by
Valentine Swain (Cat. No.749).

751 Rocky Landscape with Shepherd and Sheep, and Cows and Goat at a Pool
Alan D. Pilkington, London

Black and white chalks and grey wash on grey
noted paper. $9\frac{3}{8} \times 12\frac{5}{8}$ (238×321).
A shepherd driving a flock of sheep round the edge
of a pool in the foreground left; high rocks behind;
two cows and a goat watering in the foreground
centre; a church tower and hills in the distance
right.
PROVENANCE: Thomas Partridge; with Colnaghi.
from whom it was purchased 1952.
EXHIBITED: English Painting, California Palace of
the Legion of Honor, San Francisco, June–July
1933 (77); Early English Watercolours . . . from the
Collection of Alan D. Pilkington, Colnaghi's, February
1958 (47); Nottingham 1962 (55); English Drawings
and Watercolours in memory of the late D. C. T.
Baskett, Colnaghi's, July–August 1963 (18).
BIBLIOGRAPHY: Woodall 362.

The treatment of the foliage is related to the
landscape with cows at a watering place owned
by Valentine Swain (Cat. No.749), and the

contours of the cows to the landscape with cows near a stream owned by Wing Commander Higginson (Cat. No.750). The rocks were probably derived from the lumps of coal which Gainsborough used in his model landscapes. The subject of cows at a watering place was a recurrent theme in Gainsborough's work.

752 Wooded Landscape with Horsemen
Horne Foundation, Florence (5983) (deposited in the Uffizi)

Grey and grey-black washes, and black and white chalks, on brown paper. $9\frac{7}{8} \times 12\frac{13}{16}$ (251 × 325). Three horsemen accompanied by another figure in the middle distance left travelling up a path which winds into the foreground left; rocks in the middle distance centre; a pool in the foreground right.
PROVENANCE: Herbert Horne.
EXHIBITED: *Disegni della Fondazione Horne*, Palazzo Strozzi, September–October 1963 (187 and repr. pl.120).
BIBLIOGRAPHY: Licia Ragghianti Collobi, *Disegni Inglesi della Fondazione Horne*, Pisa, 1966, Cat.13, repr. pl.14.

The loose treatment of the foliage and strong highlights in white chalk are closely related to the landscape with cows at a pool in the Pilkington collection (Cat. No.751), and the suggestion of the figures and horses in white chalk is similar to the mountain landscape with horsemen in the British Museum (Cat. No.671).

753 Wooded Landscape with Figures and Sheep
Ownership unknown

Black chalk and stump (apparently). Size unknown. A figure accompanied by a child and a dog on the far side of a pool in the foreground right; seven or eight sheep beneath rocks on a bank in the middle distance left; a hill in the distance right (from the print).
ENGRAVED: J. Laporte, published by Laporte and Wells 1 March 1804 (as in the collection of Dr Thomas Monro).
PROVENANCE: Dr Thomas Monro; Monro sale, Christie's, 26 June 1833 ff.

The treatment of the rocks and foliage seems to be related to the landscape with cows at a pool in the Pilkington collection (Cat. No.751).

754 Wooded Landscape with Country Cart and Figures Plate 218
Mrs W. W. Spooner, Bath

Black and white chalks and grey and grey-black washes on buff paper prepared with grey. $9\frac{9}{16} \times 12\frac{11}{16}$ (243 × 322).
A figure unloading goods from a country cart drawn by two horses in the foreground centre; two figures, one of them seated, accompanied by a dog, behind a pool in the foreground left; a figure and sheep in the middle distance centre.
ENGRAVED: Thomas Gainsborough; published by J. & J. Boydell 1 August 1797.
PROVENANCE: H. B. Milling.
EXHIBITED: Arts Council 1960–1 (38); *The William Spooner Collection and Bequest*, Courtauld Institute Galleries, April–July 1968 (28 and repr. pl.vi).

Study for the aquatint (Boydell 7). The dog and the shepherd and sheep in the middle distance were omitted in the finished print. The treatment of the foliage and the foreground detail and the white chalkwork in the clouds and foreground are related to the landscape with cows at a pool in the Pilkington collection (Cat. No.751). Also mentioned on p.34.

755 Wooded Landscape with Country Cart and Figures
Ownership unknown

Black chalk and stump (apparently). Size unknown. Two figures, one of them seated, beside a tree in the foreground left; a cart, with a family seated inside, drawn by two horses, and accompanied by a horseman, in the foreground centre and right; a cottage among trees in the foreground left; a pool in the foreground right (from the print).
ENGRAVED: J. Laporte, published by Laporte and Wells 1 March 1803 (as in the collection of Dr Thomas Monro).
PROVENANCE: Dr Thomas Monro; Monro sale, Christie's, 26 June 1833 ff.

The treatment of the foliage and the horses and cart seems to be related to the wooded landscape with country cart and figures in the Spooner collection (Cat. No.754). The copy formerly in the W. A. Brandt collection was made from the print by Wells and Laporte.

756 Wooded Landscape with Herdsman and Cows
Mrs Kenneth Potter, North Warnborough

Black chalk and grey wash, heightened with white, $10\frac{5}{8} \times 14\frac{5}{8}$ (270 × 371).

A seated herdsman and a cow in the foreground left, beside a pool; a group of cows in the middle distance right; a house in the distance right. Signed with initials on the mount bottom left in brown ink: *T.G.*
PROVENANCE: Susannah Gardiner (Gainsborough's sister); then by descent to Miss Green, who gave it to Miss A. Thorne; thence by descent.
BIBLIOGRAPHY: Woodall 310.

The scallops outlining the foliage, the thick contours of the cows, and the loose handling of wash are closely related to the landscape with cows near a stream owned by Wing Commander Higginson (Cat. No.750).

757 Upland Landscape with Horsemen and distant Buildings
Mrs Kenneth Potter, North Warnborough

Black chalk and grey wash on grey paper, heightened with white. $9\frac{5}{8} \times 12\frac{9}{16}$ (244 × 319).
Three horsemen accompanied by a dog travelling beside a stream in the foreground left; rocks in the foreground and middle distance right; buildings in the distance left.
Signed with initials outside two ruled lines on the original mount bottom left in brown ink: *T.G.*
PROVENANCE: Susannah Gardiner (Gainsborough's sister); thence by descent to Miss Green, who gave it to Miss A. Thorne; thence by descent.
EXHIBITED: Oxford 1935 (36).
BIBLIOGRAPHY: Woodall 311.

The scallops outlining the foliage, the treatment of the horses, and the loose handling of wash are identical with the wooded landscape with herdsman and cows also owned by Mrs Kenneth Potter (Cat. No.756).

758 Estuary Scene with Ships, Figures and Cattle
Ownership unknown

Grey wash, watercolour and bodycolour. $9 \times 12\frac{5}{8}$ (229 × 321).
Two sailing boats and a rowing boat in the foreground and middle distance right; two figures seated on the shore in the foreground centre; a milkmaid, another figure, and six cows on a promontory in the foreground left and centre, with a herdsman beneath the promontory in the foreground right; water stretching from the foreground right to a stretch of land in the distance right (from a photograph).
Collector's mark of William Esdaile on the verso.
Collector's mark of J. P. Heseltine on the verso.
PROVENANCE: William Esdaile; Esdaile sale,

Christie's, 20–1 March 1838; J. P. Heseltine; Madame B . . . sale, Charpentier, 12 June 1959, Lot 96 *bis* (repr. pl.xxviii).
BIBLIOGRAPHY: *Original Drawings by British Painters in the Collection of J. P. H(eseltine)*, London, 1902, No. 15 (repr.); Woodall 56.

Study for the coastal scene with cattle on a promontory owned by Mr and Mrs E. A. Leavett-Shenley (Waterhouse 957), painted about 1782–4. Only slight changes were made in the finished picture: an extra rowing boat with two figures rowing was included between the figures on the shore and the principal sailing boat, and one or two minor changes were made in the arrangement of the figures. From a poor reproduction, the treatment of the cows and the rough handling of the foreground detail seem to be related to the wooded landscape with herdsman and cows owned by Mrs Kenneth Potter (Cat. No.756). Also mentioned on p.40.

759 Wooded Landscape with Packhorses descending to a Pool Plate 217
Cecil Higgins Art Gallery, Bedford (P.314)

Black and white chalks and grey and grey-black washes. $12\frac{1}{2} \times 17\frac{3}{4}$ (317 × 451).
Two horsemen accompanying two packhorses are descending to a pool in the foreground left; craggy rocks in the middle distance left.
PROVENANCE: J. P. Heseltine; Sir Henry Oppenheimer; Mrs Robert Opton; with Vose Galleries, who sold it to Agnew, from whom it was purchased 1960.
EXHIBITED: Nottingham 1962 (65 repr.); *English Watercolours from the Cecil Higgins Art Gallery Bedford*, Reading Museum and Art Gallery, January–February 1965 (18).

The loose scallops outlining the foliage, the treatment of the horses, and the loose handling of wash are closely related to the wooded landscape with herdsman and cows owned by Mrs Kenneth Potter (Cat. No.756).

760 Wooded Landscape with Figure and Cattle
Courtauld Institute of Art, Witt Collection, London (2428)

Black and white chalks and grey wash. $10\frac{7}{8} \times 15\frac{1}{2}$ (276 × 394).
Two cows and some sheep in the foreground right; a figure, accompanied by a dog, leaning against a tree in the middle distance centre; another figure, accompanied by a dog, in the middle distance right.

Collector's mark of Sir Robert Witt on the verso bottom left.

PROVENANCE: Lord Duveen, who presented it to Sir Robert Witt; bequeathed 1952.

EXHIBITED: *British Art*, R.A., January–March 1934 (1144 and repr. in the Souvenir, p.77); Sassoon 1936 (40); *Drawings of the Old Masters from the Witt Collection*, Victoria and Albert Museum, January–May 1943; *Drawings from the Witt Collection*, Arts Council, 1953 (12); *Drawings from the Witt Collection*, Courtauld Institute Galleries, 1958 (54); *Old Master Drawings from the Witt Collection*, Auckland City Art Gallery, 1960 (10); Arts Council 1960–1 (52); *Master Drawings from the Witt and Courtauld Collections*, Whitworth Art Gallery, Manchester, November–December 1962 (6); *English Landscape Drawings from the Witt Collection*, Courtauld Institute Galleries, January–May 1965 (11).

BIBLIOGRAPHY: *Commemorative Catalogue of the Exhibition of British Art 1934*, Oxford, 1935, No.609 and repr. pl.CXLVIII (a); Sir Robert Witt, 'Some Old Master Drawings of the English School', *The Antique Collector*, December 1935, p.380 repr.; Woodall 373; *Hand-List of the Drawings in the Witt Collection*, London, 1956, p.22.

The treatment of the foliage and the loose handling of wash are identical with the landscape with horses descending to a pool at Bedford (Cat. No.759).

761 Wooded Landscape with Cows and Ruined Castle
Ashmolean Museum, Oxford

Black and white chalks and grey and blue washes. $8\frac{5}{8} \times 12\frac{7}{16}$ (219×316).
A herdsman with five cows standing beside a stream in the foreground centre and right; a small bridge in the foreground left; a ruined castle in the middle distance centre.

PROVENANCE: Henry J. Pfungst; Pfungst sale, Christie's, 15 June 1917, Lot 23 bt. Colnaghi; with Knoedler; with Colnaghi; Francis F. Madan, from whom it was purchased 1951.

EXHIBITED: Colnaghi's 1906 (35); Knoedler's 1923 (10); Sassoon 1936 (70); *La Peinture Anglaise*, Louvre, 1938 (200); *L'Aquarelle Anglaise 1750–1850*, Musée Rath, Geneva, October 1955–January 1956 and L'Ecole Polytechnique Fédérale, January–March 1956 (63).

BIBLIOGRAPHY: Woodall 221, p.76 and repr. pl.104; *Ashmolean Report 1951*, p.63.

The loose treatment of the foliage and the rough handling of wash are closely related to the landscape with cows in the Witt Collection (Cat. No.760).

762 Wooded Landscape with Figures, Packhorse and Cottage
Colonel Philip Bradfer-Lawrence, Burgh-next-Aylsham

Black chalk and grey wash, heightened with white. $10\frac{13}{16} \times 14\frac{5}{8}$ (275×371).
A horseman and a packhorse in the foreground left; a man walking down a slope in the foreground centre; a cottage, with a figure standing at the door, at the top of a rise in the middle distance right.

PROVENANCE: H. L. Bradfer-Lawrence; thence by descent.

The treatment of the foliage, the loose handling of the foreground detail, and the rough handling of wash are closely related to the wooded landscape with cows in the Witt Collection (Cat. No.760).

763 Wooded Landscape with Castle
Private Collection, London

Black and white chalks and grey wash. $8\frac{3}{16} \times 12\frac{3}{16}$ (208×309).
A castle behind trees in the middle distance left. Collector's mark of William Esdaile formerly on the old mount.

PROVENANCE: William Esdaile; Esdaile sale, Christie's, 20–1 March 1838; David Baillie, who gave it to T. Streatfeild; Sir Robert Abdy; with Agnew, from whom it was purchased 1960.

The treatment of the foliage and the loose handling of wash are closely related to the wooded landscape with cows in the Witt Collection (Cat. No.760). A copy was formerly in the Horne collection (Mrs Bell, repr. f. p.20, and Armstrong 1898, repr. f. p.160), and another is in the Norman Mackenzie Art Gallery, Regina.

764 Wooded Upland Landscape with Figure and River
Ownership unknown

Black chalk and stump (apparently). Size unknown.
A figure in the middle distance right; hilly ground in the middle distance left and centre; a river running from the middle distance right into the distance centre; a hill in the distance centre (from a photograph).

PROVENANCE: Herbert Horne.

BIBLIOGRAPHY: Mrs Bell, repr. f. p.16.

The foliage is related to the wooded landscape with castle formerly in the Baillie collection

(Cat. No.763). A copy is in the Boymans-van Beuningen Museum, Rotterdam.

765 Wooded Landscape with Shepherd and Sheep
Mr and Mrs Eric H. L. Sexton, Camden, Maine

Black chalk and stump and pencil, some orange–brown chalk, white chalk and grey wash. $9\frac{3}{16} \times 12\frac{3}{16}$ (233 × 309).
A shepherd leading a flock of sheep down a winding track to a pool in the foreground centre and right; two horsemen in the middle distance centre; hills in the distance centre.
PROVENANCE: J. Heywood Hawkins; Arthur Kay; Kay sale, Christie's, 23 May 1930, Lot 34 bt. Agnew, from whom it was purchased by Mrs Henry Goldman; Goldman sale, Parke-Bernet, 28 February 1948, Lot 94 (repr.) bt. Sexton.
EXHIBITED: Ipswich 1927 (137).
BIBLIOGRAPHY: Woodall 8.

The loose treatment of the foliage and handling of wash are closely related to the wooded landscape with castle formerly in the Baillie collection (Cat. No.763).

766 Wooded Landscape with Shepherd and Sheep
Viscount Knutsford, Munden

Pencil, black chalk and grey wash, with touches of white chalk. $11 \times 13\frac{7}{8}$ (279 × 352).
A shepherd with his sheep around him on rising ground in the foreground right.
PROVENANCE: George Hibbert; thence by descent.

The handling is related to the wooded landscape with shepherd and sheep owned by Mr and Mrs Eric Sexton (Cat. No.765).

767 Mountain Landscape with Pool
Tate Gallery, London (2224)

Black chalk and stump and white chalk on buff paper. $10\frac{1}{8} \times 14\frac{1}{4}$ (257 × 362).
The side of a hill in the foreground left; a pool in the foreground centre and right; a house in a wooded dell in the middle distance centre; another house in the middle distance right; mountains in the distance centre.
PROVENANCE: Probably given by the artist to Sir Henry Bate-Dudley; by descent to Thomas Birch Wolfe, who presented it to the National Gallery 1878; transferred 1919.
EXHIBITED: *Two Centuries of British Drawings from the Tate Gallery*, C.E.M.A., 1944 (26); Aldeburgh 1949 (19).

BIBLIOGRAPHY: Whitley, p.299; Woodall 178; Woodall 1949, p.98; Mary Chamot, *The Tate Gallery British School: A Concise Catalogue*, London, 1953, p.74; *The Collections of the Tate Gallery*, London, 1969, p.33.

The loose treatment of the foliage on the left, the rough outlining of the foreground tracks, and the soft handling of the rocks are related to the wooded landscape with castle formerly in the Baillie collection (Cat. No.763).

768 Wooded Mountain Landscape with Shepherd and Sheep Plate 351
John Wright, Spondon

Black chalk and stump and white chalk on buff paper. $9\frac{5}{8} \times 14\frac{1}{4}$ (244 × 362).
A shepherd seated in the foreground centre; a bridge in the foreground right, over a stream which runs into the middle distance left; some sheep on a bank in the middle distance centre; high rocks in the middle distance right; hills in the distance left and centre.
PROVENANCE: With the Ruskin Gallery, from it was purchased by Alistair Horton; thence by descent.
EXHIBITED: *Works of Art belonging to the Friends of the Art Gallery*, City of Birmingham Museum and Art Gallery, February–March 1962 (62).

Either this or the drawing in the Victoria and Albert Museum (Cat. No.769) was the study for the small sketchy mountain landscape with figures and horse in the National Museum of Wales (Waterhouse 982), painted about 1782–4. No changes were made in the finished picture except that the seated figure was replaced by a man leaning over a horse and a figure was introduced crossing the bridge. The treatment of the foliage, the modelling of the rocks and mountains, and the white chalkwork at the horizon are identical with the mountain landscape in the Tate Gallery (Cat. No.767). Also mentioned on pp.22 and 40.

769 Mountain Landscape with Figure, Sheep and Stream Plate 352
Victoria and Albert Museum, London (Dyce 680)

Black chalk and stump and white chalk on brown paper. $10 \times 13\frac{7}{8}$ (254 × 352).
A figure seated in the foreground centre; scattered sheep on a bank in the middle distance centre; a bridge in the foreground right over a stream which runs into the middle distance left; high rocks, with a cottage beneath, in the middle distance right; mountains in the distance left and centre.

PROVENANCE: Rev. Alexander Dyce, who bequeathed it to the South Kensington Museum 1869.

BIBLIOGRAPHY: *Dyce Collection Catalogue*, London, 1874, p.100: Woodall 194 and p.69.

A sketchier and rougher version of the mountain landscape with shepherd and sheep owned by John Wright (Cat. No. 768), in which the tone values have been drastically altered by the discoloration of the paper. The shepherd is rather awkwardly posed. The treatment of the foliage, the banks and rocks and the scattered highlights in white chalk are closely related to the Wright drawing. Also mentioned on pp.22 and 40.

770 Hilly Landscape with Figures and Sheep
Ownership unknown

Black and white chalks and blue washes (apparently). Size unknown.
A man accompanied by a woman on horseback and a dog in the foreground right; a stone bridge in the foreground left; scattered sheep in the middle distance centre; a stream winding from the foreground left into the middle distance centre; hills in the middle distance left and distance centre and right (from the print).
ENGRAVED: J. Laporte, published by Laporte and Wells 1 September 1803 (as in the collection of Dr Thomas Monro).
PROVENANCE: Dr Thomas Monro; Monro sale, Christie's, 26 June 1833 ff.

The treatment of the foliage and the type of mountain landscape, with scattered sheep, seem to be related to the mountain landscape owned by John Wright (Cat. No.768).

771 Mountain Landscape with Bridge and Gorge Plate 220
Sir William Walton, Forio

Black chalk and stump and white chalk on brown paper. $10\frac{3}{16} \times 13\frac{11}{16}$ (259 × 348).
A bridge in the foreground centre over a stream which runs into a deep gorge in the middle distance centre; two horsemen in the foreground left; a village among trees in the distance right; mountains in the distance centre and right.
PROVENANCE: Dr Dibdin; L. W. Neeld sale, Christie's, 13 July 1945, Lot 106 (with another) bt. Agnew, from whom it was purchased by Howard Bliss; with Leicester Galleries, who sold it to Spink, from whom it was purchased.
EXHIBITED: Aldeburgh 1949 (1); *From Gainsborough to Hitchens*, Leicester Galleries, January 1950 (14).

REPRODUCED: *The Illustrated London News*, 14 January 1950, p.73.

Study for the mountain landscape with cattle crossing a bridge now in the Tate Gallery (Waterhouse 984, repr. pl.269), painted about 1786. No changes were made in the finished painting except of the most minor sort, and the addition of staffage: the drover and two cows on the bridge, and flock of sheep on the left. The treatment of the foliage, the white chalkwork in the distance and sky, and the type of composition are closely related to the mountain landscape in the Tate Gallery (Cat. No.767). Also mentioned on pp.18, 40 and 51.

772 Wooded Upland Landscape with Shepherd, Sheep and Mountains
Plate 221
City Museum and Art Gallery, Birmingham (89'35)

Black chalk and stump and white chalk on brown paper. $9\frac{7}{8} \times 13\frac{7}{16}$ (251 × 341).
A shepherd and sheep on a hillock in the foreground right; scattered sheep in the foreground left and one or two more in the middle distance right; mountains in the distance left and right.
PROVENANCE: Dr Thomas Monro; Monro sale, Christie's, 26 June 1833 ff.; J. M. Geyt; Anon (=Geyt) sale, Christie's, 28 July 1933, Lot 37 bt. Thompson; with Palser Gallery, from whom it was purchased by the Association of Friends of the Gallery and A. E. Anderson and presented 1935.
EXHIBITED: *Early English Water Colour Drawings*, Palser Gallery, January 1934 (27); *Watercolours from the Birmingham City Art Gallery*, Worthing Museum and Art Gallery, May–June 1960 (8).
BIBLIOGRAPHY: *Catalogue of Drawings*, City of Birmingham Museum and Art Gallery, Derby, 1939, p.211; Woodall 14, pp.67–8 and repr. pl.86; Millar, p.13 and repr. pl.37.

Study for the mountain landscape with figures and packhorse owned by Lady Wake (Waterhouse 985), painted about 1787–8. No changes were made in the finished picture except for the inclusion of a prominent branch in the foreground right, and alterations in the staffage: the shepherd and sheep on the hillock were replaced by a mother carrying a baby and a shepherd seated, and the flock of sheep in the foreground left by a figure with a packhorse and dog and a few sheep further away. The treatment of the foliage, the mountains and the horizon and the scattered highlights in white

chalk are identical with the mountain landscape owned by Sir William Walton (Cat. No.771). A version of this drawing was formerly with Ederheimer (Cat. No.773). A copy by Dr Monro, who originally owned the drawing, was formerly in the collection of Randall Davies (Woodall 38). Also mentioned on pp.41 and 90.

773 Wooded Upland Landscape with Shepherd, Sheep and Mountains
Ownership unknown

Black and white chalks on grey-green paper. 10×14 (254×356).
A shepherd and sheep on a hillock in the foreground right; scattered sheep in the foreground left and one or two more in the middle distance right; mountains in the distance left and right.
PROVENANCE: With R. Ederheimer; Ederheimer sale, American Art Association, Anderson Galleries, 9 April 1919, Lot 173 (repr.).
BIBLIOGRAPHY: Woodall 45.

Version of the drawing in the Birmingham City Art Gallery (Cat. No.772). The treatment of the foliage, the mountains and the sky and the scattered highlights in white chalk are closely related to the latter drawing, but the handling is a little more generalized.

774 Wooded Mountain Landscape with Shepherd, Sheep and Donkey
Wing Commander John Higginson, Ballyward, Co. Down.

Black chalk and stump and white chalk on buff paper. 9$\frac{15}{16}$×14 (252×356).
A shepherd with a donkey and a dog in the foreground centre; scattered sheep in the foreground right; a lake in the middle distance centre and right; a figure on the other side of the lake in the middle distance centre; a mountain rising beyond the lake in the middle distance left; some buildings in the distance centre, with hills behind centre and right.
PROVENANCE: Major Eric Knight; Knight sale, Christie's, 1 December 1944, Lot 2 bt. Agnew, from whom it was purchased by Dr H. A. C. Gregory; with Mayor Gallery, who sold it to Agnew, from whom it was purchased 1953.
EXHIBITED: *80th Annual Exhibition of Water-Colour Drawings*, Agnew's, January–March 1953 (74); *Pictures from Ulster Houses*, Belfast Museum and Art Gallery, May–July 1961 (186).
BIBLIOGRAPHY: Woodall 1949, p.98.
Study for one of the transparencies for Gains-

borough's peep-show box (Waterhouse 972, repr. pl.263), painted about 1787–8. No changes were made in the finished painting, except that the composition was reversed. The treatment of the foliage, the scattered highlights in white chalk, and the white chalkwork in the sky are closely related to the mountain landscape owned by Sir William Walton (Cat. No.771). Also mentioned on p.41.

775 Wooded Mountain Landscape with River and Buildings
Ownership unknown

Black chalk and stump and white chalk on grey paper. 10$\frac{5}{16}$×14$\frac{1}{16}$ (262×357).
A river winding from the foreground left through the centre and under a bridge in the middle distance left; buildings in the middle distance and distance centre; cliffs in the middle distance left and right; mountains in the distance left and centre (from a photograph).
PROVENANCE: Henry Oppenheimer; Oppenheimer sale, Christie's, 14 July 1936, Lot 455 (repr. pl.106) bt. Williams.
BIBLIOGRAPHY: Sir Charles Holmes, 'Henry Oppenheimer – A Collector and his Ways', *The Studio*, September 1936, p.118 and repr. p.126; Woodall 351.

The treatment of the foliage and the buildings, the outlining of the distant mountains in white chalk, and the chalkwork throughout are identical with the river landscape owned by Wing-Commander Higginson (Cat. No.774).

776 Wooded Landscape with Shepherd and Sheep Plate 222
Tate Gallery, London (2223)

Black chalk and stump and white chalk on buff paper. 10$\frac{3}{16}$×14$\frac{5}{16}$ (259×363).
A shepherd seated accompanied by a dog in the foreground right; some sheep in the foreground centre; a pool in the middle distance left and centre; a high bluff in the middle distance centre and right; a church tower with hills beyond in the distance left.
PROVENANCE: Probably given by the artist to Sir Henry Bate-Dudley; by descent to Thomas Birch Wolfe, who presented it to the National Gallery 1878; transferred 1919.
BIBLIOGRAPHY: Whitley, p.299; Woodall 181 and pp.68 and 100; Woodall 1949, p.98; Mary Chamot, *The Tate Gallery British School: A Concise Catalogue*, London, 1953, p.74; *The Collections of the Tate Gallery*, London, 1969, p.33.

Study for one of the transparencies (Waterhouse 973, repr. pl.264), painted about 1787–8. No changes were made in the finished painting, except that the composition was reversed and a moonlight effect added. The treatment of the foliage and foreground bank and the white chalkwork throughout are closely related to the river landscape owned by Wing Commander Higginson (Cat. No.774). Copies are in the McCallum collection, University of Glasgow (Woodall 27) and the Norfolk Museum, Virginia (50.48.39). Also mentioned on pp.16, 41, 90 and 94.

777 Wooded Landscape with Horseman crossing a Bridge

Ownership unknown

Black chalk and stump and white chalk on buff paper. $10\frac{1}{8} \times 14\frac{1}{8}$ (257×359).
A figure on horseback, preceded by another figure and accompanied by a dog, crossing a stone bridge over a mountain stream in the foreground left; a shepherd with some sheep on a hillside in the middle distance centre; a cottage at the top of the hill in the middle distance right; a building in the distance centre; mountains in the distance left and centre (from a photograph).
PROVENANCE: Henry J. Pfungst, Pfungst sale, Christie's, 15 June 1917, Lot 71 bt. Colnaghi; with Knoedler.
EXHIBITED: Knoedler 1923 (6).
BIBLIOGRAPHY: Woodall 70.

The treatment of the foliage and the highlights in white chalk at the horizon are related to the upland landscape with shepherd and sheep in the Tate Gallery (Cat. No.776). The motif of a horseman and figure crossing a humpbacked bridge over a weir is paralleled in the mountain landscape in Washington (Waterhouse 1008, repr. pl.287), painted about 1782–4.

778 Wooded Landscape with Figures and Stream

Ownership unknown

Black chalk and stump (apparently). Size unknown.
Three figures, one of them bending down, in the middle distance centre beside a stream which winds from the foreground right past high banks into the middle distance centre (from the print).
ENGRAVED: J. Laporte, published by Laporte and Wells 2 May 1803 (as in the collection of Dr Thomas Monro).
PROVENANCE: Dr Thomas Monro; Monro sale, Christie's, 26 June 1833 ff.

The treatment of the foliage seems to be related to the mountain landscape with horseman crossing a bridge formerly with Knoedler (Cat. No.777).

779 Mountain Landscape with Figures crossing a Bridge

Christian Mustad, Oslo

Black chalk and stump and white chalk on buff paper. $10 \times 14\frac{1}{4}$ (254×362).
Three figures accompanied by a dog crossing a stone bridge in the foreground right; two cows in the foreground left; a river winding from the foreground right into the middle distance centre; two sheep on a bank in the middle distance centre; another sheep and a house behind in the middle distance right; a mountain in the distance centre.
PROVENANCE: Major Eric A. Knight; Knight sale, Christie's, 1 December 1944, Lot 1 bt. Agnew, from whom it was purchased by Dr H. A. C. Gregory; with Mayor Gallery, who sold it to Agnew, from whom it was purchased by C. R. N. Routh 1952; with Agnew, from whom it was purchased 1954.
EXHIBITED: *72nd Annual Exhibition of Water-Colour Drawings*, Agnew's, February–March 1945 (80).
BIBLIOGRAPHY: Woodall 1949, p.98.

Study for one of the transparencies (Waterhouse 978, repr. pl.268), painted about 1782–4. No changes were made in the finished painting except for the omission of the two cows on the left. The handling of the foliage, the scattered highlights in white chalk and the treatment of the horizon, and the rhythmical composition, are closely related to the river landscape owned by Wing Commander Higginson (Cat. No.774). Also mentioned on p.40.

780 Mountainous River Landscape with Cart and Figures

Private Collection, London

Black chalk and stump and white chalk on buff paper. $9\frac{13}{16} \times 14\frac{1}{8}$ (249×359).
A covered cart drawn by two horses with a drover behind and another figure farther back in the foreground centre, travelling along a track which winds from the foreground right into the middle distance centre; a river running from the foreground right into the middle distance centre; high rocks in the foreground right and middle distance left; mountains in the distance left and centre.
PROVENANCE: R. W. Symonds; Symonds sale,

Sotheby's, 14 March 1962, Lot 44 bt. Agnew, from whom it was purchased.

A composition inspired by memories of the Lake District. The silhouetting of the distant mountains in white chalk and the chalk and stump-work throughout are closely related to the mountainous river scene owned by Christian Mustad (Cat. No.779).

781 Wooded Landscape with Figures and Pool
Tate Gallery, London (2228)

Black chalk and stump and white chalk on buff paper. 10⅛ × 14¼ (257 × 362).
A horseman accompanied by another figure, a packhorse and a dog, travelling over a knoll in the foreground left; a figure on a stone bridge in the middle distance right; a pool in the foreground right.
PROVENANCE: Probably given by the artist to Sir Henry Bate-Dudley; by descent to Thomas Birch Wolfe, who presented it to the National Gallery 1878; transferred 1919.
BIBLIOGRAPHY: Whitley, p.299; Woodall 180; Mary Chamot, *The Tate Gallery British School: A Concise Catalogue*, London, 1953, p.74; *The Collections of the Tate Gallery*, London, 1969, p.33.

The treatment of the figures, animals and foliage, the modelling of the banks, and the rough highlights in white chalk are closely related to the river landscape with figures crossing a bridge owned by Christian Mustad (Cat. No.779). A version of this composition was formerly in the collection of Sir Robert Mond (Cat. No.782), and another is owned by the Marquis de Chasseloup Laubat (Cat. No.783).

782 Wooded Landscape with Figures and Horses
Ownership unknown

Black chalk and stump and white chalk on grey-green paper. 10⅛ × 13¾ (257 × 350).
A figure on horseback, accompanied by another figure, a packhorse and a dog, travelling past a knoll in the middle distance left; a bridge in the middle distance right; a pool in the foreground right (from a photograph).
PROVENANCE: Sir Robert Mond.
BIBLIOGRAPHY: Tancred Borenius, *Catalogue of the Collection of Drawings by the Old Masters formed by Sir Robert Mond*, London, n.d. (=1937), No.481, repr. pl.LXXXIXb; Woodall 238.

Version of the landscape in the Tate Gallery (Cat. No.781), but with the addition of a tree

on the knoll. From a poor reproduction, the handling of the foliage and the chalk and stump-work are related to the Tate drawing, but the treatment is rather more summary.

783 Wooded Landscape with Figures and Horses
Le Marquis de Chasseloup Laubat, Marennes

Black chalk and stump, heightened with white, on grey-blue paper. 10 1/16 × 14 3/16 (256 × 360).
A figure on horseback, accompanied by another figure, a packhorse and a dog, travelling past a knoll in the middle distance; a bridge in the middle distance right; a pool in the foreground right.
PROVENANCE: Unknown.

Version of the landscape formerly in the collection of Sir Robert Mond (Cat. No.782). The loose scallops outlining the foliage and the black chalk and stumpwork throughout are closely related to the Mond drawing.

784 Wooded Landscape with Figures and Donkey
Le Marquis de Chasseloup Laubat, Marennes

Black chalk and stump. 9⅛ × 13⅛ (232 × 333).
A drover with a donkey, accompanied by a dog, in the foreground centre; two other figures and a half-ruined castle gateway in the middle distance left.
PROVENANCE: Unknown.

The loose scallops outlining the foliage, the contours of the clouds, and the soft chalkwork throughout are closely related to the river scene also owned by the Marquis de Chasseloup Laubat (Cat. No.783). The hatching and soft chalkwork are paralleled in the study of a haymaker and sleeping girl in the British Museum (Cat. No.847), dating from the late 1780's.

785 Wooded Landscape with Cows and Ruined Tower
Mr and Mrs Arthur Lister, London

Black chalk and stump and white chalk on buff paper. 9 15/16 × 13 7/16 (252 × 341).
Two cows in the foreground left and centre drinking at a river which winds from the foreground centre and right into the middle distance centre; two sheep in the middle distance right; a ruined tower in the distance right.

PROVENANCE: Francis Palgrave (possibly by descent from Dawson Turner); thence by descent.
EXHIBITED: Aldeburgh 1949 (15); Bath 1951 (46).
BIBLIOGRAPHY: Woodall 84.

The chalkwork and sensitive feeling for effects of light are close in character to the river landscape owned by Wing Commander Higginson (Cat. No.774), and the soft abbreviated contours of the trees on the right are identical in technique with the wooded landscape with figure leading a donkey owned by the Marquis de Chasseloup Laubat (Cat. No.784).

786 Mountain Landscape with Figures and Houses
Albertina, Vienna (24458)

Black chalk and stump and white chalk on grey paper. $10\frac{3}{16} \times 14\frac{1}{8}$ (259 × 359).
Five or six figures grouped outside a house in the foreground centre; a waterfall in the foreground left; two houses on a rocky hillside in the middle distance left; hills in the distance centre and right.
PROVENANCE: With Boerner, from whom it was purchased 1925.
BIBLIOGRAPHY: Heinrich Leporini, *Handzeichnungen Grosser Meister: Gainsborough*, Vienna and Leipzig, n.d. (=1925), p.2 and repr. pl.4; Woodall 428.

The treatment of the foliage, the contours of the hills, the soft chalkwork, and the highlights at the horizon are closely related to the river landscape owned by Wing Commander Higginson (Cat. No.774), and the hatching in the sky and soft chalkwork to the landscape with figure leading a donkey owned by the Marquis de Chasseloup Laubat (Cat.No.784).

787 Mountain Landscape with Horseman crossing a Bridge
Dr John Bowlby, London

Black chalk and stump and white chalk on buff paper. $9\frac{7}{16} \times 13\frac{1}{2}$ (240 × 343).
A horseman preceded by another figure crossing a stone bridge in the foreground right; a village in the distance left; a river running from the foreground right into the distance left; mountains in the distance left, centre and right.
PROVENANCE: Rev. H. Burgess; Sir George Clausen; Clausen sale, Sotheby's, 2 June 1943, Lot 93 bt. Agnew, from whom it was purchased by Major John Bowlby and given to Lady Bowlby; thence by descent.
EXHIBITED: *71st Annual Exhibition of Water-Colour Drawings*, Agnew's, February–March 1944 (72).

BIBLIOGRAPHY: Woodall 26, pp.68, 71 and 100 and repr. pl.83.

The handling of the foliage, the summary treatment of the buildings in the distance, the soft chalkwork, and the highlights at the horizon are closely related to the river landscape owned by Wing Commander Higginson (Cat. No.774) and the mountain landscape with houses in the Albertina (Cat. No.786). The atmospheric quality is characteristic of many of Gainsborough's late drawings. A version is in the Tate Gallery (Cat. No.788).

788 Upland Landscape with River and Horseman crossing a Bridge Plate 223
Tate Gallery, London (2226)

Black chalk and stump and white chalk on buff paper. $10\frac{1}{4} \times 14\frac{1}{2}$ (260 × 368).
A figure and a horseman crossing a bridge in the foreground right; a river winding into depth; a village with prominent church tower in the distance left; mountains in the distance.
PROVENANCE: Probably presented by the artist to Sir Henry Bate-Dudley; by descent to Thomas Birch Wolfe, who presented it to the National Gallery 1878; transferred 1919.
EXHIBITED: Nottingham 1962 (66 repr.).
BIBLIOGRAPHY: Whitley, p.299; Woodall 182, pp.68, 71 and 100 and repr. pl.82; Woodall 1949, p.98; Mary Chamot, *The Tate Gallery British School: A Concise Catalogue*, London, 1953, p.74; *The Collections of the Tate Gallery*, London, 1969, p.33; Mary Woodall, 'Gainsborough Landscapes at Nottingham University', *The Burlington Magazine*, December 1962, p.562.

A rather bolder version of the landscape owned by Dr John Bowlby (Cat. No.787). The treatment of the foliage, the bold highlights in white chalk, and the highly rhythmical composition are closely related to the Bowlby drawing. Also mentioned on pp.16, 51, 52 and 94.

789 Wooded Landscape with Cottages
Lady Caccia, London

Black chalk and stump and white chalk on buff paper. $9\frac{7}{16} \times 13\frac{1}{2}$ (240 × 343).
Two cottages in the middle distance centre, with a woman seated outside one of them; a cow on a bank in the foreground left; two sheep in the foreground centre, on a track which runs from the middle distance left to the foreground centre; a hill in the middle distance left; a mountain in the distance centre.
PROVENANCE: Rev. H. Burgess; Sir George Clausen;

Clausen sale, Sotheby's, 2 June 1943, Lot 94 bt. Agnew, from whom it was purchased by Sir George Barstow 1944; given to his daughter.
EXHIBITED: *71st Annual Exhibition of Water-Colour Drawings*, Agnew's, February–March 1944 (63).
BIBLIOGRAPHY: Woodall 29.

The handling is closely related to the river scene with horseman crossing a bridge in the Tate Gallery (Cat. No.788).

790 Wooded River Landscape with distant Mountains
The Hon. Mrs Spencer Loch, London

Black chalk and stump and white chalk on buff paper. $9\frac{3}{4} \times 13\frac{5}{16}$ (248 × 338).
A river winding from the foreground right into the distance centre; a path beside winding from the foreground centre into the middle distance left; mountains in the distance right.
PROVENANCE: Philip, 2nd Earl of Hardwicke; thence by descent.

The handling is closely related to the river scene with horseman crossing a bridge in the Tate Gallery (Cat. No.788).

791 Wooded Upland Landscape with Cows and Cottages
Ownership unknown

Black chalk and stump and white chalk on grey-blue paper. $10\frac{1}{4} \times 14\frac{1}{8}$ (260 × 360).
Two cows in the foreground left beside a track which winds from the foreground centre into the middle distance left; a cow on a bank in the foreground left; two cottages with three or four figures outside in the middle distance left; hills in the distance left (from a photograph).
PROVENANCE: With Gaston von Mallmann; Mallmann sale, Lepke, Berlin, 13–14 June 1918, Lot 65 (repr.).

The handling of the foliage, the rough highlights in white chalk, the loose treatment of the foreground track, and the summary sketching of the figures are related to the mountain landscape with houses in Vienna (Cat. No.786).

792 Open Landscape with Herdsman and Cattle at a Watering Place Plate 219
Ehemals Staatliche Museen, Berlin-Dahlem (4409)

Black chalk and stump and white chalk on blue paper. $9\frac{3}{8} \times 12\frac{1}{2}$ (238 × 317).

A herdsman, accompanied by a dog, leaning on a stick in the foreground right; four cows, one reclining, beside a pool in the foreground centre; a tree stump in the foreground left.
PROVENANCE: With Gaston von Mallmann, from whom it was purchased 1909.
BIBLIOGRAPHY: Woodall 418.

The handling of the tree trunk and foliage, the rough highlights in white chalk, and the loose contouring of the cow on the left are closely related to the upland landscape with cows and cottages formerly with von Mallmann (Cat. No.791), and the rather finicky line in parts of the contours of the cows is similar to the cows in the river landscape with figures crossing a bridge owned by Christian Mustad (Cat. No. 779).

793 Wooded Mountainous Landscape with Figures, Church and River
Plate 307
Mrs R. Dunbar Cushing, New York

Black chalk and stump and white chalk on grey-blue paper. $10 \times 14\frac{3}{16}$ (254 × 360).
A horseman travelling along a winding track in the foreground left; a figure leaning over a stone bridge in the foreground centre; three cows in the foreground right; scattered sheep on rising ground in the middle distance left; a church amongst trees in the middle distance centre; a river winding from the foreground right into the middle distance right; high mountains in the distance centre and right.
PROVENANCE: Unknown.

The loose treatment of the tree trunks and foliage, the bold highlights in white chalk, and the summary contours of the figures and animals are closely related to the upland landscape with cows and cottages formerly with von Mallmann (Cat. No.791). A version is in the Tate Gallery (Cat. No.794). A copy is in the Mellon collection (Woodall 209 and repr. pl.85). Also mentioned on p.62.

794 Wooded Mountain Landscape with Figures, Church and River
Tate Gallery, London (2229)

Black chalk and stump and white chalk on buff paper. $10\frac{1}{8} \times 14\frac{5}{16}$ (257 × 363).
A horseman travelling along a winding track in the foreground left; a figure crossing a stone bridge in the foreground centre; a church amongst trees in the middle distance centre; a river winding from the foreground right into the middle distance

right; high mountains in the distance centre and right.

PROVENANCE: Probably given by the artist to Sir Henry Bate-Dudley; by descent to Thomas Birch Wolfe, who presented it to the National Gallery 1878; transferred 1919.

EXHIBITED: *Two Centuries of British Drawings from the Tate Gallery*, C.E.M.A., 1944 (25).

BIBLIOGRAPHY: Whitley, p.299; Woodall 179, pp.68 and 71 and repr. pl.84; Woodall 1949, p.98; Mary Chamot, *The Tate Gallery British School: A Concise Catalogue*, London, 1953, p.74; *The Collections of the Tate Gallery*, London, 1969, p.33.

A less atmospheric version of the landscape owned by Mrs Cushing (Cat. No.793), lacking the cows and sheep and the tree on the left. The treatment of the foliage, the scattered highlights in white chalk, and the black chalk and stumpwork throughout are closely related to the river scene with horseman crossing a bridge also in the Tate Gallery (Cat. No.788).

795 Wooded Mountain Landscape with Figure, Sheep and Cottage
Viscount Knutsford, Munden

Black chalk and stump on buff paper, heightened with white. $10\frac{1}{16} \times 13\frac{3}{4}$ (256×349).
A reclining figure, perhaps drinking at a stream, in the foreground right; scattered sheep in the foreground centre and right; a cottage in the middle distance right; mountains in the distance centre and right.

PROVENANCE: George Hibbert; thence by descent.

The handling is closely related to the mountain landscape owned by Mrs Cushing (Cat. No.793)

796 Wooded Landscape with Figures on Horseback Plate 216
Mrs D. A. Williamson, London

Black chalk and watercolour. $8\frac{7}{8} \times 12\frac{7}{16}$ (225×316).
Four figures on horseback travelling along a country track in the middle distance centre; a pool in the foreground left and centre; hills in the distance left.

PROVENANCE: Guy Bellingham Smith; with Colnaghi, from whom it was purchased by J. Leslie Wright; bequeathed to Birmingham City Art Gallery (with a life interest to his daughter) 1953.

EXHIBITED: Oxford 1935 (19); Sassoon 1936 (53); *La Peinture Anglaise*, Louvre, 1938 (202); *Masters of British Water-Colour: The J. Leslie Wright Collection*, R.A., October–November 1949 (75); *Drawings by Old Masters*, R.A., August–October 1953 (446); *L'Aquarelle Anglaise 1750–1850*, Musée

Rath, Geneva, October 1955–January 1956 and L'Ecole Polytechnique Fédérale, January–March 1956 (64 and repr. pl.II); *Europäisches Rokoko*, Residenz, Munich, June–September 1958 (278); Arts Council 1960–1 (56).

BIBLIOGRAPHY: Mary Chamot, 'Gainsborough as a Landscape Painter', *Country Life*, 29 February 1936, p.214; Woodall 387, p.76 and repr. pl.103; Martin Hardie, *Water-colour Painting in Britain 1. The Eighteenth Century*, London, 1966, p.76.

ALSO REPRODUCED: *The London Mercury*, April 1936, between pp.636 and 637.

The loose treatment of the tree trunks and foliage and the shadowy outlines of the riders are closely related to the mountain landscape owned by Mrs Cushing (Cat. No.793). Also mentioned on pp.14 and 100.

797 Wooded Landscape with Herdsmen and Cattle
Dr and Mrs Marvin Freilich, Beverly Hills, Calif.

Black chalk, some brown chalk, and grey wash, heightened with white. $8\frac{3}{8} \times 11\frac{7}{8}$ (213×302).
Three figures, one seated, in the foreground left; three herdsmen on horseback driving some cattle along the far side of a pool in the foreground centre.

PROVENANCE: With Fine Art Society, who sold it to Agnew, from whom it was purchased by Sir David (later Viscount) Eccles 1955; with Colnaghi, from whom it was purchased.

EXHIBITED: *Spring Exhibition Early English Water-Colours and Drawings*, Fine Art Society 1954 (31); *82nd Annual Exhibition of Water-Colour Drawings*, Agnew's, January–February 1955 (54); *Old Master Drawings*, Colnaghi's, June 1968 (61 and repr. pl.XII).

The theme, the shadowy treatment of the cavalcade beyond the pool, the chalkwork, and the handling of wash are identical with the landscape with riders owned by Mrs Williamson (Cat. No.796).

798 Cottage with Peasant Family and Woodcutter returning Home
City Museum and Art Gallery, Birmingham (193'53)

Black and white chalks and grey wash on buff paper. $9\frac{3}{4} \times 13\frac{1}{16}$ (248×332).
A cottage with a peasant family grouped outside the door in the foreground left; a woodcutter returning home with a load of faggots, and

accompanied by a dog, in the foreground right; a village in the distance right.

PROVENANCE: W. Parker; Lady Stewart; Guy Bellingham Smith; J. Leslie Wright, who bequeathed it 1953.

EXHIBITED: Oxford 1935 (1); Aldeburgh 1949 (34); *Masters of British Water-Colour: The J. Leslie Wright Collection*, R.A., October–November 1949 (69); Arts Council 1960–1 (33, and pp.6 and 7); *English Drawings and Water Colors from British Collections*, National Gallery of Art and the Metropolitan Museum of Art, February–June 1962 (41).

BIBLIOGRAPHY: Woodall 298, p.76 and repr. pl.106.

The sketchy treatment of the figures, chalkwork, and use of wash are closely related to the landscape with riders owned by Mrs Williamson (Cat. No.796). The composition is based on a reversal of the design for *The Cottage Door* in Cincinnati (Waterhouse 940, repr. pl.192), with a village scene in the distance.

799 Clump of Trees with Four Cows
Plate 305
National Gallery of Scotland, Edinburgh (4678)

Black chalk and grey wash. $7\frac{7}{16} \times 9\frac{9}{16}$ (189 × 243). A clump of trees in the foreground centre, with two cows on the left and two on the right.

PROVENANCE: Sir Edward Marsh; bequeathed (through the National Art-Collections Fund) 1953.

EXHIBITED: Nottingham 1962 (53 repr.).

BIBLIOGRAPHY: Woodall 230 and p.76; *National Art-Collections Fund Fiftieth Annual Report 1953*, London, 1954, p.36.

The handling of wash is closely related to the landscape with riders owned by Mrs Williamson (Cat. No.796). Also mentioned on p.14.

800 Open Landscape with Figures on Horseback Plate 225
British Museum, London (1930–6–14–2)

Black chalk, with grey and grey-black washes, on buff paper heightened with white. $8\frac{5}{16} \times 11\frac{11}{16}$ (211 × 297). Two figures on horseback riding away from the spectator in the middle distance centre.

PROVENANCE: Arthur Kay; Kay sale, Christie's, 23 May 1930, Lot 45 bt. P. M. Turner, by whom it was presented (through the National Art-Collections Fund) 1930.

EXHIBITED: Ipswich 1927 (166); Brussels, 1929 (68); *Sixty Years of Patronage*, Arts Council, September–

October 1965 (32 and repr. pl.5a).

BIBLIOGRAPHY: *The Vasari Society*, Second Series, Part 1, Oxford, 1920, p.11 and repr. No.15; C.D. (= Campbell Dodgson), 'Drawings by Gainsborough,' *British Museum Quarterly*, Vol.v, No.2, 1930, p.66; Laurence Binyon, *Landscape in English Art and Poetry*, London, 1931, p.71 and repr. fig.14; Woodall 177 and pp.76–7; Iolo A. Williams, *Early English Watercolours*, London, 1952, p.71 and repr. fig.129.

The handling of wash and the shadowy treatment of the riders are closely related to the landscape with riders owned by Mrs Williamson (Cat. No.796). Also mentioned on pp.22, 24 and 52.

801 Wooded Landscape with Figures, Cottages and Cow
National Gallery of Canada, Ottawa (2886)

Black chalk, touches of white chalk, and grey wash. $7\frac{7}{16} \times 9\frac{9}{16}$ (189 × 243). Two figures in the foreground right; a cow on a bank in the middle distance left; two cottages, the nearer with a lean-to shed, by the side of a track in the middle distance centre.

PROVENANCE: Charles Fairfax Murray; with Parsons, from whom it was purchased 1922.

EXHIBITED: *The Eighteenth Century Art of France and England*, Montreal Museum of Fine Arts, April–May 1950 (50); *Five Centuries of Drawings*, Montreal Museum of Fine Arts, October–November 1953 (237).

BIBLIOGRAPHY: *Parsons Catalogue No.37* (105 repr.); Kathleen M. Fenwick, 'The Collection of Drawings', *The National Gallery of Canada Bulletin*, Vol.2, No.2, 1964, p.1 and repr. fig.17.

The loose handling of wash is closely related to the landscape with riders in the British Museum (Cat. No.800). It is interesting to compare Gainsborough's late wash drawings of this description with Constable's even sketchier late watercolours and wash drawings.

802 Wooded Landscape with Figures, Cottage and Cow
Richard S. Davis, New York

Black chalk and grey and grey-black washes, heightened with white. $10\frac{1}{2} \times 15\frac{1}{4}$ (267 × 387). A cottage in front of trees in the middle distance centre, with three of four figures outside; a figure and child in the foreground right; a cow in the foreground left.

Inscribed in a later hand bottom right: *Gainsborough* Unidentified collector's mark *C.L.* bottom right.

PROVENANCE: With Vose Galleries, from whom it was purchased 1952.

The treatment of the tree trunks and foliage is very similar to the landscape with riders owned by Mrs Williamson (Cat. No.796), but the handling of wash and the rather lumpish cow are more closely related to the wooded landscape with cottages in Ottawa (Cat. No.801).

803 Wooded Landscape with Figures
Plate 349
Mr and Mrs Paul Mellon, Oak Spring, Virginia

Black chalk and stump with some red chalk, and grey and brown washes, on buff paper, touched with bodycolour. $15\frac{1}{2} \times 12\frac{1}{2}$ (394 × 317).
A woman holding a baby and accompanied by another child, with a woodcutter sitting on a log, in the foreground right; a pool in the foreground left; hills visible between trees in the distance centre.
Collector's mark of T. E. Lowinsky bottom right.
PROVENANCE: T. E. Lowinsky; by descent to Justin Lowinsky, from whom it was purchased.
EXHIBITED: *La Peinture Anglaise*, Louvre, 1938 (199); *Three Centuries of British Water-Colours and Drawings*, Arts Council, 1951 (74); *Drawings by Old Masters*, R.A., August–October 1953 (444); Arts Council 1960–1 (57, p.7 and repr. pl.VI.).
BIBLIOGRAPHY: Woodall 208.
REPRODUCED: *The Illustrated London News*, 21 January 1961.

Study for the *Peasant Smoking at a Cottage Door* in the University of California at Los Angeles (Waterhouse 1011, repr. pl.285) (Plate 350), painted in the spring of 1788. The essentials of this grandest of all Gainsborough's landscape conceptions are already present in this composition sketch, but in the finished picture the trees were varied slightly and added to on the left, an extra child and dog surrounded the mother with her baby, and the woodcutter seated on a pile of faggots was replaced by a figure with a jug in one hand and a pipe in the other seated on the steps of a sequestered cottage. A full figure study for the seated woodman is in the collection of Mrs Keith (Cat. No.852). The loose atmospheric treatment of the tree trunks and foliage is closely related to the landscape with riders owned by Mrs Williamson (Cat. No. 796). Also mentioned on pp. 32, 39, 46, 52 and 102.

804 Rocky Wooded Landscape with Waterfall, Castle and Mountain
British Museum, London (1910-2-12-259)

Black chalk and stump, heightened with white. $8\frac{7}{8} \times 12\frac{9}{16}$ (225 × 319).
A stream with a small waterfall in the foreground left; a castle in the distance left mostly hidden by trees; a figure in the foreground centre; a mountain in the distance centre.
PROVENANCE: George Salting; bequeathed 1910.
BIBLIOGRAPHY: Woodall 174.

One of the most sensitive tonally of Gainsborough's late drawings (see p.46). The handling of the foliage and the atmospheric treatment of the whole landscape are closely related to the wooded landscape with a woodman and his family in the Mellon collection (Cat. No.803).

805 Rocky Wooded Landscape with Figures and Bridge over a Stream
Graves Art Gallery, Sheffield (2284)

Black chalk and stump on grey paper, heightened with white. $10 \times 12\frac{3}{8}$ (254 × 314).
A figure on horseback crossing a stone bridge over a stream in the foreground left; a figure walking along a track in the foreground right, with high rocks behind him in the middle distance centre and right.
PROVENANCE: Rev. Gainsborough Gardiner; by descent to Edward Netherton Harward; Harward sale, Christie's, 11 May 1923, Lot 100 bt. P. M. Turner; Charles Henry Maleham, who bequeathed it 1934.
EXHIBITED: Ipswich 1927 (139); Oxford 1935 (28); *Festival of Britain Art Exhibition*, Graves Art Gallery, Sheffield, May–October 1951 (385).
BIBLIOGRAPHY: Woodall 318 and p.69.

The handling of the foliage and rocks and the atmospheric treatment throughout are closely related to the rocky landscape with waterfall in the British Museum (Cat. No.804).

806 Wooded Landscape with Castle
Plate 234
Mr and Mrs Paul Mellon, Oak Spring, Virginia (62/5/22/13)

Black chalk and stump and white chalk on grey paper. $10\frac{5}{16} \times 12\frac{7}{8}$ (262 × 327).
A castle gateway in the middle distance right; buildings and mountains in the distance centre.
PROVENANCE: Anon. sale, Sotheby's, 15 April 1953, Lot 6 (with another) bt. Colnaghi, from whom it was purchased by William Selkirk; Selkirk sale,

Sotheby's, 3 May 1961, Lot 87 bt. Colnaghi, from whom it was purchased.
EXHIBITED: *English Drawings and Water Colors from the collection of Mr. and Mrs. Paul Mellon*, National Gallery of Art, February–April 1962 (34).

The treatment of the foliage and the bank on the right is closely related to the rocky landscape in Sheffield (Cat. No.805). Also mentioned on pp.51 and 102.

807 Wooded Landscape with Ruined Church and Figures Plate 303
John Nicholas Brown, Providence, R.I.

Black chalk and stump, brown, orange–brown and white chalks, and brown and grey washes, on buff paper. $9\frac{9}{16} \times 12\frac{3}{8}$ (243×314).
A horseman travelling down a slope between rocks in the foreground left; a figure standing outside a ruined church in the foreground right; low hills in the distance left and centre.
PROVENANCE: Samuel Woodburn (?); with Colnaghi, from whom it was purchased in the 1920's.
BIBLIOGRAPHY: Woodall 440.

The handling of the foliage, the atmospheric treatment of the middle distance and distance, and the bold highlights in white chalk are closely related to the mountain landscape with castle in the Mellon collection (Cat. No.806). Also mentioned on p.63.

808 Wooded Landscape with Herdsman, Cows and Cottage Plate 235
Mr and Mrs Paul Mellon, Oak Spring, Virginia

Black chalk and stump and white chalk, with some pale brown and blue chalks, on blue paper. $12\frac{7}{8} \times 10\frac{3}{8}$ (327×264).
A herdsman on horseback driving five cows down a slope in the foreground centre and right; a cottage among trees in the middle distance centre.
Collector's mark of T. E. Lowinsky bottom left.
ENGRAVED: W. F. Wells, published by Wells and Laporte 1 March 1804 (as in the collection of Baroness Lucas).
PROVENANCE: Philip, 2nd Earl of Hardwicke; by descent to Amabel, Baroness Lucas; Lucas sale, Sotheby's, 29 June 1926, Lot 32 bt. Sabin; T. E. Lowinsky; by descent to Justin Lowinsky, from whom it was purchased.
BIBLIOGRAPHY: Woodall 211.

The atmospheric treatment of the foliage and the bold highlights in white chalk are closely related to the mountain landscape with ruined church owned by John Nicholas Brown (Cat. No.807). Also mentioned on p.93.

809 Wooded Landscape with Cow standing beside a Pool Plate 236
Ehemals Staatliche Museen, Berlin-Dahlem (4666)

Black and brown chalks, with grey and grey-black washes, heightened with white. $9\frac{1}{2} \times 14\frac{11}{16}$ (241×373).
A cow standing beside a pool in the foreground centre.
Collector's mark of the Earl of Warwick bottom right.
PROVENANCE: George Guy, 4th Earl of Warwick; possibly Warwick sale, Christie's, 20 May 1896, Lot 139 bt. Shepherd; presented by an unknown donor 1912.
BIBLIOGRAPHY: Woodall 411, pp.75–6 and repr. pl.102; Woodall 1949, p.104 and repr. p.115.
ALSO REPRODUCED: *Der Cicerone*, November 1929, p.611; *The Illustrated London News*, 1 July 1939, p.34.

One of Gainsborough's most brilliant late drawings. The treatment of the tree trunks, branches and foliage is closely related to the wooded landscape with herdsman, cows and cottage in the Mellon collection (Cat. No.808), and the vigorous handling of wash to the landscape with cottages in Ottawa (Cat. No.801). The touch in the foliage is also very close to Gainsborough's handling of oil paint in the lay-in of some of his later canvases (compare the unfinished landscape with herdsman and cows owned by Sir Martyn Beckett, repr. Woodall pl.100).

Mythological Drawings

Gainsborough is not known to have attempted more than one subject drawn from classical mythology, a scene from the story of Actaeon, the huntsman; and even this picture he left partially unfinished. It was later acquired for the Prince of Wales at the Dupont sale in 1797, and is still in the royal collection. Gainsborough's choice of episode, the moment when Actaeon stumbled unwittingly on the woodland bathing place used by Diana and her attendants, may have been prompted by Zoffany's canvas (now at Petworth) or by Wheatley's *Bathers by a Waterfall* (in the collection of Mr and Mrs Paul Mellon), which is signed and dated 1783 (Plate 347). His turning to mythology at all was part of that very self-conscious attempt to demonstrate the variousness of his style characteristic of the early to mid 1780's, for the *Diana and Actaeon* must, on stylistic grounds, have been painted about 1784–5 (and thus fairly close in date to the only other large canvas surviving with a figure group of comparable complexity, *The Mall* in the Frick Collection, painted in the latter months of 1783). Three composition studies survive for the *Diana and Actaeon*, and provide the fullest opportunity there is available for studying in detail the development of one of Gainsborough's important designs.

810 Study for the *Diana and Actaeon*
Plate 343
The Marchioness of Anglesey, Plâs Newydd

Black and white chalks and grey and grey-black washes on buff paper. 10 1/16 × 13 1/8 (256 × 333). Diana and a group of ten or eleven nymphs at a wooded bathing place in the foreground left centre and right, surprised by Actaeon, standing in the foreground left.
PROVENANCE: Probably Sir Richard Wallace, bequeathed to Sir John Murray Scott, and given by him to Josephine, 3rd Lady Sackville, who bequeathed it to her grandson, Nigel Nicolson; given by him to the present owner 1952.
EXHIBITED: Bath 1951 (53); Arts Council 1960–1 (58 and repr. pl.v).
BIBLIOGRAPHY: Woodall 242; Oliver Millar, *The Later Georgian Pictures in the Collection of Her Majesty The Queen*, London, 1969, Vol.1, p.43 and repr. fig.11.

The first design for the picture in the royal collection (Waterhouse 1012, repr. pl.288) (Plate 346) painted about 1784–5. The scene is one of confusion, some of the figures turning away in embarrassment, one hurriedly putting on some clothes, and another climbing up the bank to the right; Diana is seen in the centre about to throw a handful of water at the intruding huntsman. The sense of confusion is heightened by the vigorously sketched tree trunks, spiralling in different directions above the figures, and the whole conception is close in treatment to the *Greyhounds Coursing a Fox* in the collection of the Earl of Rosebery (Waterhouse 823, pl.289), which, with Actaeon substituted for the fox, might almost be the sequel. The pose of the figure bathing her foot is a variant of that used for '*Musidora*' in the Tate Gallery (Waterhouse 814), itself based on a statuette by Adriaen de Vries known to have been copied by eighteenth-century draughtsmen and used, with variations, by both Watteau and Boucher. The wiry tree trunks and bold handling of wash are closely related to the rocky landscape with horsemen descending to a pool at Bedford (Cat. No.759). Also mentioned on pp.19, 40, 45–6, 51 and 62.

811 Study for the *Diana and Actaeon*
Plate 344
Henry E. Huntington Library and Art Gallery, San Marino (61.27)

Grey and grey-black washes and white chalk on buff paper. $11 \times 14\frac{7}{16}$ (279×367).
Diana and a group of six nymphs at a wooded bathing place in the foreground centre and right, surprised by Actaeon, standing in the foreground left.
Inscribed in pencil on the old mount bottom right: *Gainsboro.*
Unidentified collector's mark (a lion facing left) bottom right.
PROVENANCE: Sir Thomas Lawrence (?); with Meyer, who sold it to Appleby's, from whom it was purchased by Canon F. H. D. Smythe 1940; Smythe sale, Christie's 13 March 1961, Lot 62 (repr.) bt. Agnew, from whom it was purchased 1961.
EXHIBITED: *English Watercolours from the collection of the Rev. Canon F. H. D. Smythe*, Worthing Art Gallery, 1954 (35); Huntington 1967–8 (14 and repr. f. title page).
BIBLIOGRAPHY: Oliver Millar, *The Later Georgian Pictures in the Collection of Her Majesty The Queen*, London, 1969, p.43 and repr. fig.12.

The second design for the picture in the royal collection (Waterhouse 1012, repr. pl.288) (Plate 346), painted about 1784–5. In this drawing, there are fewer figures and greater cohesion. The figures are arranged broadly in a semi-circle, and the movement to the right created by the two reclining figures is counter-balanced by the sturdy tree trunk which frames the scene and by the strong diagonal emphasis of the mass of foliage. The figure putting on her clothes in the right foreground of the Anglesey drawing is still seen here, though rather altered; Diana has been moved to the left, and Actaeon is shown trying to protect himself from the handful of water with which the goddess will turn him into a stag – unsuccessfully, however, as the horns can already be seen sprouting from his head. The bold treatment of wash is closely related to the rocky landscape with horsemen descending to a pool at Bedford (Cat. No.759). Also mentioned on pp.19, 40, 45, 51 and 62.

812 Study for the *Diana and Actaeon*
Plate 345
Cecil Higgins Art Gallery, Bedford (P.118)

Black chalk with grey, grey-black and brown washes and bodycolour. $10\frac{13}{16} \times 14$ (275×356).

Diana and a group of seven or eight nymphs at a wooded bathing place in the foreground centre and right, surprised by Actaeon, standing in the foreground left.
PROVENANCE: Sir Thomas Lawrence (?); C. R. Rudolf; with Spink, from whom it was purchased 1957.
EXHIBITED: *European Masters of the Eighteenth Century*, R.A., November 1954–February 1955 (548); *Watercolours from the Cecil Higgins Art Gallery Bedford*, Agnew's, October–November 1962 (16 and repr. pl.II); *Primitives to Picasso*, R.A., January–March 1962 (356); *English Watercolours from the Cecil Higgins Art Gallery Bedford*, Reading Museum and Art Gallery, January–February 1965 (17).
BIBLIOGRAPHY: Oliver Millar, *The Later Georgian Pictures in the Collection of Her Majesty The Queen*, London, 1969, Vol.1, p.43 and repr. fig.13.

The final design for the picture in the royal collection (Waterhouse 1012, repr. pl.288) (Plate 346), painted about 1784–5. This drawing is the most restrained in treatment: neither the figures nor the trees suggest agitation. Actaeon is shown recoiling instead of leaning forward, and the compositional relationship between him and Diana is less dramatic than in the Huntington drawing. The two standing figures shown arm-in-arm in the Huntington drawing remain, but rather altered, and the reclining figure to their left has been replaced in the position originally adopted in the Anglesey drawing. The figure in the right foreground has been removed, and the composition thereby given a more lateral emphasis. This design was substantially that used by Gainsborough for the painting itself. In the latter, however, Actaeon is shown reclining on the bank, in a pose suggesting entreaty, a tree trunk has been introduced above Diana, and a waterfall painted in over the foliage to link together the two groups of bathers more satisfactorily. The figures are all altered slightly in detail, but the grouping is unchanged. The scallops outlining the foliage and treatment of wash are closely related to the rocky landscape with horsemen descending to a pool at Bedford (Cat. No.759). Also mentioned on pp.19, 40, 45, 51 and 62.

Figure Drawings

Almost all of Gainsborough's surviving figure drawings date either from the early part of his career or else from the 1780's: the two important exceptions are the sketch for the figure arrangement in *The Harvest Waggon*, and an elaborate drawing of a peasant family going to market, which was executed in the early 1770's. Of his early drawings few remain, many, like the shepherds and ploughmen he gave to his friend Thicknesse, having now disappeared from sight. Those we do possess are mainly sketches of rustic figures intended for use in his landscape compositions, two of them probably being direct studies for particular works. The later drawings, chiefly studies of beggar children (done from a variety of models), of woodmen or of mothers surrounded by their children, are for the most part to be associated either with his fancy pictures or his 'cottage door' landscapes.

Mid to Later 1740's

813 A Boy with a Book and a Spade
Plate 6
Pierpont Morgan Library, New York (III,59b)

Pencil. $7\frac{7}{16} \times 5\frac{7}{8}$ (189×149).
Whole-length of a young boy standing facing the spectator, wearing a tricorne hat, holding a book in his left hand, and with his right arm resting on a spade.
Signed with initials in pen and brown ink bottom right: *TG*.
Squared for enlargement.
PROVENANCE: Sir J. C. Robinson; Robinson sale, Christie's, 21 April 1902, Lot 131 bt. Charles Fairfax Murray; purchased from Fairfax Murray by J. Pierpont Morgan 1910.
EXHIBITED: *The Art of Eighteenth Century England*, Smith College Museum of Art, January 1947 (29).
BIBLIOGRAPHY: *J. Pierpont Morgan Collection of Drawings by the Old Masters formed by C. Fairfax Murray*, Vol. III, London, 1912, No.59b (repr.).

Since the drawing is squared up, presumably intended for enlargement and use in a picture, though the actual size of the drawing is very similar to the average size of the little figures in his early landscapes. The combination of book and spade is a puzzling feature. The soft pencilwork is characteristic of Gainsborough's very early drawings, such as the landscape with a cow on a bank in the Witt Collection (Cat. No.70). Also mentioned on p.55.

814 A Youth with a Muff
D. L. T. Oppé, London (1019)

Pencil. $7\frac{3}{16} \times 5\frac{13}{16}$ (183×148).
Whole length of a youth in a slightly reclining posture facing a little to right, but with his head turned downwards and half-left, wearing a tricorne hat and holding a muff in his lap; no background.
PROVENANCE: With Brall, from whom it was purchased by A. Paul Oppé 1920.

Drawn from an articulated doll, and probably intended for use in a figure composition. The slightly reclining posture is characteristic of Hayman's conversation pieces or portrait groups, for example, the figure on the left in *The Jacob Family* owned by Major Gerard Buxton. This sheet is close in character to the study of a man in a tricorne hat in the British Museum (Cat. No.818), but is more elegant and languid in pose; the contours and soft pencilwork are identical with the study of a boy with a book and spade in the Morgan Library (Cat. No.813).

815 Study of a Young Girl walking
Plate 15
Ownership unknown

Black chalk and stump, white chalk and pencil on brown paper. $15\frac{1}{8} \times 9\frac{3}{8}$ (383×238).

Whole-length of a young girl walking to the left, her head turned towards the spectator; no background (from a photograph).
PROVENANCE: Henry J. Pfungst; Pfungst sale, Christie's, 15 June 1917, Lot 40 bt. Sir George Donaldson; Henry Schniewind, Jr.; Schniewind sale, Sotheby's, 25 May 1938, Lot 138 bt. Adams.
EXHIBITED: Cincinnati 1931 (60 and repr. pl.52).
BIBLIOGRAPHY: E. S. Siple, 'Gainsborough Drawings: The Schniewind Collection', *The Connoisseur*, June 1934, p.355.

A study from life, possibly for a milkmaid or shepherdess for one of Gainsborough's early pastorals. She is wearing a white dress and hat, with a black shawl. The costume, in particular the single ruffles to the sleeves and the massive heels of the shoes, indicates a date of about 1745–50. The chalkwork and carefully drawn contours are closely related to drawings of the late 1740's such as the landscape with donkeys owned by T. R. C. Blofeld (Cat. No.82).

816 A Boy holding a Whip Plate 18
Donald Towner, London

Black chalk. $6\frac{1}{4} \times 5\frac{3}{4}$ (159 × 146).
A boy standing facing slightly to the right, his head turned to the spectator, with a whip in his left hand and his right hand in his pocket, wearing a tricorne hat with a long pigtail, and a sword; another head with a tricorne hat, only partially sketched, top left; no background.
Signed in brown ink bottom right: *T Gainsborough*
PROVENANCE: Given by the artist to Joshua Kirby; thence by descent to F. E. Trimmer; Trimmer sale, Sotheby's, 22 December 1883, Lot 357 (with four others) bt. Edward Bell; thence by descent to Mildred Glanville, who presented it to the present owner in 1963.
BIBLIOGRAPHY: Mrs Bell, repr. f. p.72.

The pose, and especially the awkwardness of the right arm, suggests that the figure was drawn from one of Gainsborough's articulated dolls. Presumably a study for use in a landscape painting. The stance is similar to that in several of Gainsborough's early portraits in little. An alternative head is sketched on the left. The soft shading is related to the wooded landscape also owned by Donald Towner (Cat. No.87). Also mentioned on p.55.

817 Study of a Head
Royal Academy of Arts, London
(Jupp extra-illustrated R.A. Catalogues, Vol.1, f.57: verso)

Pencil. $4\frac{3}{8} \times 7\frac{3}{16}$ (111 × 183).
A woman's head, facing frontally, top centre; embellishments by a later and distinctly youthful hand right.
Inscribed in ink by William Esdaile bottom left: *Gainsboro/1822 WE G Frost's coll N* (*number illegible*).
PROVENANCE: George Frost; William Esdaile; Esdaile sale, Christie's, 20–1 March 1838; Rev. Dr Wellesley; Wellesley sale, Sotheby's, 28 June 1866, Lot 692 (with another) bt. James; Edward Basil Jupp, who bequeathed it.

The treatment of the head is related to the study on the left in the drawing of a boy with a whip owned by Donald Towner (Cat. No.816).

818 A Man in a Tricorne Hat Plate 242
British Museum, London (1910–2–12–256: verso)

Black chalk and stump on grey-green paper.
$5\frac{7}{16} \times 7\frac{5}{16}$ (138 × 186).
Whole-length of a man reclining backwards slightly and facing half-left, with his arms on his hips, and wearing a tricorne hat; no background.
Inscribed in pencil bottom left: *59*.
Recto: study of burdock leaves (Cat. No.86).
PROVENANCE: Sir J. C. Robinson; Robinson sale, Christie's, 21 April 1902, Lot 130 (with another) bt. George Salting; bequeathed 1910.
BIBLIOGRAPHY: Woodall 170.

Drawn from an articulated doll, and evidently intended to be seated on a bank. Presumably for use in a figure composition or in one of his early landscapes. The soft contours and modelling are identical with the study of a boy with a whip owned by Donald Towner (Cat. No.816). Also mentioned on p.56.

1750's

819 Study of a Peasant on Horseback
Plate 36
British Museum, London, (G.g.3–388)

Pencil. $6\frac{5}{8} \times 7\frac{1}{2}$ (168 × 190).
A man riding side-saddle on a horse loaded with a large pannier, facing left.
Collector's mark of the Rev. C. M. Cracherode bottom right.

PROVENANCE: Rev. C. M. Cracherode; bequeathed 1799.
BIBLIOGRAPHY: Binyon 24c; Gower *Drawings*, p.12 and repr. pl.xv.

A study from life. The pencilwork is related to landscape drawings like the study of cottages also in the British Museum (Cat. No.144).

820 Study of a Young Girl seated
Plate 46
British Museum, London (O.o.2–21)

Pencil. $7\frac{3}{4} \times 5\frac{7}{8}$ (197 × 149).
Three-quarter-length of a young girl with a basket on her right arm, seated facing the spectator.
PROVENANCE: From the sketch-book purchased by Richard Payne Knight at the Gainsborough sale, 11 May 1799, Lot 85; bequeathed 1824.
BIBLIOGRAPHY: Binyon 8b; Gower *Drawings*, p.11 and repr. pl.1.

A study from life for the girl with a basket of eggs in the landscape in the City Art Museum, St Louis (Waterhouse 834, repr. pl.47), painted about 1754–6. In the finished picture the pose of the left arm is different. The loose pencilwork is related to landscape sketches such as the study of a woodland path also in the British Museum (Cat. No.205). Also mentioned on p.39.

821 A Peasant Boy
The Hon. Christopher Lennox-Boyd, London

Black chalk and stump. $7\frac{15}{16} \times 6\frac{5}{16}$ (202 × 160).
Whole-length of a peasant boy standing facing half-left, with his head turned towards the spectator and holding a hat in his left hand.
PROVENANCE: Anon. sale, Christie's, 3 March 1970, Lot 83 (repr.) bt. Sanders.

The rhythmical treatment of line and the shading are related to the study of a boy with a whip owned by Donald Towner (Cat. No.816).

822 Study of a Woodcutter
Ehemals Staatliche Museen, Berlin-Dahlem (4694)

Black chalk and pencil. $7\frac{9}{16} \times 5\frac{15}{16}$ (192 × 151).
A woodcutter walking half-left, carrying a bundle of faggots over his left shoulder; no background.
PROVENANCE: From one of the sketch-books purchased by George Hibbert at the Gainsborough sale, Christie's, 11 May 1799, Lot 82, 84 or 88; by descent to the Hon. A. H. Holland-Hibbert; Holland-Hibbert sale, Christie's,

30 June 1913, Lot 22 (with another) bt. Leggatt; presented by an unknown donor 1913.

A study from life. The crisp touch in the faggots and the pencilwork generally are related to such landscape drawings as the donkeys in a church-yard in the Oppé collection (Cat. No.189).

823 Study of a Woodcutter seen from behind Plate 48
British Museum, London (1914–4–6–7)

Black chalk and stump. $7\frac{1}{2} \times 5\frac{7}{16}$ (190 × 138).
A woodcutter facing half left, carrying a bundle of faggots over his left shoulder, walking away from the spectator; no background.
PROVENANCE: From one of the sketch-books purchased by George Hibbert at the Gainsborough sale, Christie's, 11 May 1799, Lot 82, 84 or 88; by descent to the Hon. A. H. Holland-Hibbert; Holland-Hibbert sale, Christie's, 30 June 1913, Lot 22 (with another) bt. Leggatt, from whom it was purchased 1914.

A study from life. The pencilwork is identical with the drawing in Berlin (Cat. No.822), to which it is a companion.

824 A Milkmaid climbing a Stile
Keith Wallis, London

Pencil. $6\frac{1}{8} \times 7\frac{3}{8}$ (156 × 187).
Whole-length of a milkmaid in a bergère hat climbing over a stile, facing half-right, her head turned to the spectator, and with both hands gripping the stile; her carrier is over her shoulders, but her two milk pails are on the ground, left and right; trees in the background.
PROVENANCE: Probably George Baker and Baker sale, Sotheby's, 16 June 1825 ff., 3rd Day, Lot 354 (with two others) bt. White; Northwick sale, Sotheby's, 6 July 1921, Lot 130 bt. Agnew.
BIBLIOGRAPHY: John Hayes, 'The Gainsborough Drawings from Barton Grange', *The Connoisseur*, February 1966, p.89.

Probably a study for the milkmaid crossing a stile in the landscape owned by Earl Howe (Waterhouse 845), painted about 1755–7, though in the finished painting the milkmaid is shown crossing facing towards the left. The bold modelling of the figure is comparable with the portrait of Captain van Gieront in Edinburgh (Cat. No.11), though the looped scallops of the foliage relate more to landscape drawings of a later period, such as the landscape with figures and donkey owned by Donald Towner (Cat. No.240), and to the landscape backgrounds in

the portrait studies of the early 1760's. Also mentioned on p.40.

Later 1760's

825 Figure Study for *The Harvest Waggon*
Plate 329
Mrs Mark Hodson, Hereford

Black and white chalks on grey-blue paper. 9$\frac{13}{16}$ × 11$\frac{1}{4}$ (249 × 286).
A harvest waggon drawn by two horses, with a mother and two children one of which she is holding and two other figures seated at the back, a man drinking from a leather water bottle standing in the centre with a woman reaching towards him, another man leaning over the side and helping a woman up over the rear wheel, a further figure seated in the front of the waggon and suggestions of another figure behind him; rough suggestions of trees behind on the left.
Collector's mark of William Esdaile bottom right. Inscribed on the verso in Esdaile's hand in ink bottom left: *1828 WE N 63x* and bottom centre: *Gainsborough.*
PROVENANCE: William Esdaile; Esdaile sale, Christie's, 21 March 1838, Lot 819 bt. Rev. Dr Wellesley; Wellesley sale, Sotheby's, 28 June 1866, Lot 698 bt. Francis Palgrave; thence by descent.
EXHIBITED: Aldeburgh 1949 (16); Bath 1951 (47).
BIBLIOGRAPHY: Woodall 85, pp.44 and 56, and repr. pl.41; Woodall 1949, p.92.
ALSO REPRODUCED: *The Illustrated London News*, 1 July 1939, p.34.

A composition study for the figure arrangement for *The Harvest Waggon* in the Barber Institute (Waterhouse 907, repr. pl.99), (Plate 330), almost certainly the picture exhibited at the Society of Artists 1767. In the finished picture, the figure group is more closely integrated and the pyramidal structure more clearly emphasized; the group on the left is replaced by two women only, of whom the girl on the right is looking upwards towards the man drinking, the man drinking is holding a rake, and the figure in front, who is looking over his shoulder away from the main group, is holding a hoe. The rapid chalkwork is related in technique to the sketch of a music party in the British Museum (Cat. No.47), and the modelling of the figures to the landscape with milkmaid and cows in the Ashmolean Museum (Cat. No.328). A study for the waggon is in the possession of Viscount Knutsford (Cat. No.284). Also mentioned on pp.38 and 99.

Early 1770's

826 A Peasant Family going to Market
Plate 119
Lord Clark, Saltwood Castle

Black chalk and stump and white chalk on brown paper. 16 × 20$\frac{3}{4}$ (406 × 527).
A peasant holding a stick, accompanied by a dog, leading a donkey upon which a woman holding a child is riding side-saddle, in the foreground centre; another donkey, ridden by a boy holding a stick, with two children in a basket on its right side and another child in a basket on its left, in the foreground right; high rocks behind centre and right.
PROVENANCE: Among the drawings left by the artist to his wife, which descended through Margaret Gainsborough to Henry Briggs, if (as seems probable) it can be identified with Briggs sale, Christie's, 25 February 1831, Lot 107 bt. Johnson; Walter, 4th Baron Northbourne; Northbourne sale, Sotheby's, 12 December 1945, Lot 45 (repr.) bt. Cooper; with Leger Galleries.
EXHIBITED: Arts Council 1949 (23); *Three Centuries of British Water-Colours and Drawings*, Arts Council, 1951 (73 and repr. pl. vb); *European Masters of the Eighteenth Century*, November 1954–February 1955 (545).
ALSO REPRODUCED: *The Illustrated London News*, 22 September 1951, p.452.

An unusually elaborate treatment (for a drawing) of the theme of travelling to and from market, with which Gainsborough was particularly preoccupied in the early 1770's. The woman is closely related in type to the beautiful redhead, and the cherubic children to the child on the left, in the painting of *Peasants Going to Market* at Royal Holloway College (Waterhouse 911, repr. pl.115), painted before July 1773 (the date of payment). The treatment of the foliage is identical in technique with Gainsborough's landscape drawings of the early 1770's, such as the landscape with cows being driven downhill in Colonel Wright's collection (Cat. No.346). A copy is in the Fogg Museum (1943.707); and another, on canvas, probably by Dupont, in view of the provenance from descendants of the Gainsborough family, is in the Tate Gallery (1488). Also mentioned on p.50.

Early 1780's

827 Study of a Beggar Boy seated
Plate 296
National Gallery of Victoria, Melbourne
(3018/4)

Black chalk and stump and white chalk on buff
paper. 8×8½ (203×216).
A young boy squatting on the ground, looking
down to right.
PROVENANCE: The Hon. Mrs Fitzroy Newdegate;
Newdegate sale, Christie's, 14 March 1952, Lot 227
(with another) bt. Colnaghi, from whom it was
purchased through the Felton Bequest 1953.
EXHIBITED: *Old Master Drawings*, Colnaghi's, April–
May 1952 (51 and repr. pl.iv).

A study from life, one of a series of studies of
beggar children, influenced by Murillo (see
also Cat. No.830, 831, 832, 833, 834 and 835).
Probably a first idea for the painting of *A
Shepherd* (Waterhouse 797) exhibited R.A. 1781,
now lost and known only from the engraving
by Earlom, 1781 (Plate 297): the model seems
to be the same boy (according to a contempor-
ary newspaper, a beggar boy of St James's
Street: see Whitley, p.238), the pose of the legs
is identical, and there is a similar hole in the
boy's rags at the right knee, but in the painting
the body is upright and the head gazing up-
wards. The sketch for this picture in black and
white chalks, recorded in the collection of
George Baker (his sale, Sotheby's, 16 June 1825
ff., 3rd Day, Lot 359 bt. Thane), may be the
study for the head formerly in the Esdaile
collection (see Cat. No.828). The loose sum-
mary contours in black chalk are related to
landscape drawings of the 1780's such as the
mountain scene with buildings owned by Mr
and Mrs James Burnham (Cat. No.628). Also
mentioned on pp.31, 39, 52 and 63.

828 Study of a Boy's Head for *A Shepherd*
Plate 298
Victoria and Albert Museum, London,
(Dyce 693)

Black chalk and stump and white chalk on buff
paper. 12 7/16 × 10 1/16 (316×256).
Head of a young boy, facing upwards and half-left.
Collector's mark of William Esdaile bottom right.
PROVENANCE: Probably George Baker and Baker
sale, Sotheby's, 16 June 1825 ff., 3rd Day, Lot 359
bt. Thane; William Esdaile; Esdaile sale, Christie's,

20–1 March 1838; Rev. Alexander Dyce, who
bequeathed it to the South Kensington Museum
1869.
BIBLIOGRAPHY: *Dyce Collection Catalogue*, London,
1874, pp.21 and 101.

A study from life for the head in the painting of
A Shepherd (Waterhouse 797), exhibited R.A.
1781 (see Cat. No.827): the pose and lighting
are influenced by Murillo. The model was
apparently a beggar boy of St James's Street
(Whitley, p.238). The drawing was used again
later for the head of the boy on the right in the
painting of *Beggar Boys* in the Duke of Newcastle
sale, Christie's, 7 July 1967, Lot 107 repr.
(Waterhouse 802), painted in the spring of
1785. The bold use of stump is related to the
study of a beggar boy in Melbourne (Cat. No.
827). Also mentioned on pp.39, 52 and 63.

829 Study of a Shepherd Boy
Victoria and Albert Museum, London
(Dyce 675)

Black chalk and stump and white chalk on buff
paper. 11 7/8 × 9½ (302×241).
A shepherd boy standing facing half-left, looking
upwards, and holding his hat in front of him; no
background.
The shepherd's crook and the sheep on the left,
which are sketched in in pencil, appear to be by a
later hand, possibly Dupont (see below).
PROVENANCE: Rev. Alexander Dyce, who be-
queathed it to the South Kensington Museum 1869.
BIBLIOGRAPHY: *Dyce Collection Catalogue*, London,
1874, p.99.

A study from life. The pose of the head is
influenced by Murillo. The chalkwork is closely
related to the study of a beggar boy in Mel-
bourne (Cat. No.827). This figure was used in
reverse by Gainsborough Dupont for the pose of
the shepherd in his painting of *A young gentleman
in the character of a shepherd's boy* exhibited R.A.
1794 (179), now in the collection of Lord
Blakenham; Dupont's composition includes
some sheep on the left, and the shepherd holds a
crook, and it is possible therefore that it was he
who sketched these features in in pencil on
Gainsborough's drawing.

830 Beggar Girl seated

Henry E. Huntington Library and Art Gallery, San Marino (59.55.556)

Black chalk and stump and white chalk on buff paper. $9\frac{5}{16} \times 7\frac{1}{4}$ (237 × 184).
A young girl seated on a flat rock, facing left, with her hands on her knees and her head turned towards the spectator, watching a frying pan. Collector's mark of Gilbert Davis top right.
PROVENANCE: William Young Ottley; Arthur Kay; Kay sale, Christie's, 23 May 1930, Lot 57 bt. Parsons; Gilbert Davis, from whom it was purchased 1959.
EXHIBITED: Ipswich 1927 (180); Huntington 1967–8 (11).
BIBLIOGRAPHY: *Parsons Catalogue*, No.48, 1932 (59 repr).

A study from life, one of a series of studies of beggar children, influenced by Murillo (see also Cat. Nos.827, 831, 832, 833, 834 and 835). Possibly a first idea for the little girl in the *Girl with Pigs* owned by George Howard (Waterhouse 799, pl.245), exhibited R.A. 1782. In the painting, the pose of the girl is somewhat different, and she is placed on the left of the composition. A similar little girl, carrying a bowl of milk, is the principal subject of the fancy picture in the South African National Gallery, Cape Town (Waterhouse 805, pl.284), painted in the late summer of 1786. The stumpwork and use of broken highlights in white chalk are closely related to the study of a beggar boy in Melbourne (Cat. No.827).

831 Study of Beggar Children

City Museum and Art Gallery, Birmingham (194'53)

Black chalk and stump and white chalk on buff paper. $9\frac{5}{16} \times 8\frac{3}{8}$ (237 × 213).
A young boy holding something in his hand seated in profile facing to the left; a girl with her arms crossed standing behind and looking down at him, facing the spectator; no background.
PROVENANCE: Sir George Clausen; Clausen sale, Sotheby's, 2 June 1943, Lot 97 bt. Wheeler; J. Leslie Wright, who bequeathed it 1953.
EXHIBITED: *Masters of British Water-Colour: the J. Leslie Wright Collection*, R.A., October–November 1949 (70).

A study from life, one of a series of studies of beggar children (see also Cat. Nos.827, 830, 832, 833, 834 and 835). The head of the girl is only suggested, in stump. The treatment of the shadows, the broad hatching in white chalk on

the right, and the chalkwork in the figures are all closely related to the study of a beggar boy in Melbourne (Cat. No.827).

832 Study of a Beggar Boy seated

Ashmolean Museum, Oxford

Black chalk and stump and white chalk on buff paper. $9\frac{13}{16} \times 7\frac{5}{8}$ (249 × 194).
A young boy seated on the ground with his legs tucked beneath him; his head in profile and looking down to right.
PROVENANCE: The Hon. Mrs Fitzroy Newdegate; Newdegate sale, Christie's, 14 March 1952, Lot 227 (with another) bt. Colnaghi, from whom it was purchased.
EXHIBITED: *Old Master Drawings*, Colnaghi's, April–May 1952 (47).
BIBLIOGRAPHY: *Ashmolean Museum Report 1952*, p.56 and repr. pl.XIII.
ALSO REPRODUCED: *English Drawings in the Ashmolean Museum*, n.d., pl.10.

A study from life, one of a series of studies of beggar children (see also Cat. Nos.827, 830, 831, 832, 833, 834 and 835). The stumpwork and bold contours in black chalk are closely related to the study of a beggar boy in Melbourne (Cat. No.827).

833 Study of Two Beggar children

Ownership unknown

Black chalk and stump and white chalk. Size unknown.
A girl seated facing the spectator on the left, turning to talk to a boy squatting facing left on the right; no background (from a photograph).
PROVENANCE: With Parsons 1935.

A study from life, one of a series of studies of beggar children (see also Cat. Nos.827, 830, 831, 832, 833, 834 and 835). The stumpwork, bold contours in black chalk and white chalk highlights are closely related to the study of a beggar boy in Melbourne (Cat. No.827).

834 Study of a Beggar Boy seated

Plate 158
Mrs W. W. Spooner, Bath

Black chalk and stump and white chalk on buff paper. $8\frac{9}{16} \times 7\frac{3}{8}$ (217 × 187) (a small strip of paper has been added on the left).
A young boy squatting on the ground, looking down to left, and playing marbles; no background.

PROVENANCE: John F. Keane; Keane sale, Sotheby's, 3 December 1947, Lot 78 (with another) bt. Spink, from whom it was purchased by H. B. Milling 1948.
EXHIBITED: *Early English Water Colours*, Leeds City Art Gallery, October–November 1958 (36); Arts Council 1960–1 (59).

A study from life, one of a series of studies of beggar children (see also Cat. Nos.827, 830, 831, 832, 833, and 835). The bold broken contours in black chalk and the loose highlights in white chalk in the head are closely related to the study of a beggar boy in Melbourne (Cat. No.827). Gainsborough painted two canvases, both of them unfinished, now in the collection of Colonel E. J. S. Ward (Waterhouse 812 and 813), in which beggar children of this type are the principal subject; in one a girl is shown picking mushrooms, and in the other a girl is sitting down investigating a penny which she is holding in the palm of her left hand. Also mentioned on pp.31 and 63.

835 Study of a Beggar Boy
Victoria and Albert Museum, London (Dyce 673)

Black chalk and stump and white chalk on buff paper. $10\frac{13}{16} \times 7\frac{5}{8}$ (275 × 194).
A young boy seated on a mound facing half-left and looking downwards.
PROVENANCE: Rev. Alexander Dyce, who bequeathed it to the South Kensington Museum 1869.
BIBLIOGRAPHY: *Dyce Collection Catalogue*, London, 1874, p.99.

A study from life, one of a series of studies of beggar children (see also Cat. Nos.827, 830, 831, 832, 833 and 834). Although executed almost entirely in stump, without strengthening in chalks except in the head, the treatment is similar to the study of a beggar boy in the Spooner collection (Cat. No.832).

836 Study of Beggar Children Plate 157
John Barnfield, Bristol

Black and white chalks on grey paper.
$8\frac{5}{8} \times 4\frac{11}{16}$ (219 × 119).
A young girl seated facing right, with her head turned towards the spectator and looking downwards; a younger child behind her on the right looking out at the spectator.
PROVENANCE: William Young Ottley; Arthur Kay; Kay sale, Christie's, 23 May 1930, Lot 58 bt. P. M.

Turner; with Fine Art Society, from whom it was purchased 1943.
EXHIBITED: Ipswich 1927 (168); Oxford 1935 (32); Arts Council 1960–1 (62).

A study from life, probably for one of Gainsborough's fancy compositions of the 1780's. The stumpwork and broken contours in black chalk are closely related to the study of a beggar boy in the Spooner collection (Cat. No.832).

Mid to Later 1780's

837 Figure Study for *The Housemaid*
Plate 361
Tate Gallery, London (5400)

Black chalk and stump and white chalk on grey paper. $13\frac{5}{8} \times 9\frac{5}{8}$ (346 × 244).
A housemaid facing half-right, her head turned slightly left, sweeping out a doorway, holding the broom in both hands; the open door visible behind and part of a window left.
ENGRAVED: Richard Lane, published 1 January 1825 (not in reverse).
PROVENANCE: Among the drawings left by the artist to his wife, which descended through Margaret Gainsborough to Henry Briggs; Briggs sale, Christie's, 25 February 1831, Lot 108 bt. Colnaghi; the Earls of Northbrook; Sir George Donaldson; Donaldson sale, Puttick and Simpson, 6 July 1925 ff., 2nd Day, Lot 214; with P. M. Turner, who presented it 1943.
EXHIBITED: Ipswich 1927 (170); Oxford 1935 (45 repr.); Sassoon 1936 (44).
BIBLIOGRAPHY: Gower, repr. f. p.74; Mary Chamot, *The Tate Gallery British School: A Concise Catalogue*, London, 1953, p.74; *The Collections of the Tate Gallery*, London, 1960, p.33.

A study from life for the unfinished *The Housemaid* in the Tate Gallery (Waterhouse 811), painted about the mid-1780's. The close similarity in the features and pose of the head and neck between the picture (but not the drawing) and the portrait of *The Hon. Mrs. Graham* (Waterhouse 323, repr. pl.173), exhibited R.A. 1777, have prompted the tradition that Mrs Graham is the subject of Gainsborough's composition, in much the same way as some of Reynolds's sitters are represented as characters from mythology or literature; but *The Housemaid* was executed some years after this portrait, and the resemblances are probably accidental. If the head could be established as a portrait, the subject might be interpreted in terms of aristocratic longing for the simple life, something

analogous to Marie Antoinette's absorption in her *laiterie*. Gainsborough also used this pose for the figure of the girl sweeping in the *Cottage Door with Girl and Pigs* owned by Mrs H. Scudamore (Waterhouse 1001, pl.246), painted in the summer of 1786. The rough broken highlights in white chalk and decisive hatching are characteristic of the mid-1780's: compare, for example, the woodland scene at Holker Hall (Cat. No. 606). Also mentioned on pp.46, 52, 66 and 103.

838 Study of a Woman seated, with Children and Cat Plate 201
Victoria and Albert Museum, London
(Dyce 672)

Black chalk and stump and white chalk on grey paper. $13 \times 9\frac{1}{2}$ (330 × 241).
A young woman wearing a mob cap seated facing half-right, but with her head turned half-left, and with her chin resting on her left arm; a child standing and clutching at her on the right; a baby and cat sketched in on the left.
ENGRAVED: Richard Lane, published 1 January 1825.
PROVENANCE: Among the drawings left by the artist to his wife, which descended through Margaret Gainsborough to Henry Briggs; Briggs sale, Christie's, 25 February 1831, Lot 113 bt. Tiffin; Rev. Alexander Dyce, who bequeathed it to the South Kensington Museum 1869.
BIBLIOGRAPHY: *Dyce Collection Catalogue*, London, 1874, pp.21 and 99; *Victoria and Albert Museum Catalogue of Water Colour Paintings by British Artists*, London, 1927, p.219.

A study from life. The broken highlighting in white chalk and treatment of the background are closely related to the study of a housemaid in the Tate Gallery (Cat. No.837). The loose sketchy technique may also be compared with portrait drawings of this period such as the lady seated in Berlin (Cat. No.56).

839 Study of a Woman seated, with Three Children Plate 202
British Museum, London (1901-1-4-1)

Black chalk and stump, with some brown chalk, on buff paper, heightened with white.
$15\frac{1}{2} \times 11\frac{3}{4}$ (394 × 298).
A mother seated on some steps holding a baby, with two small girls, one in a bonnet standing and the other seated, and a cat.
Inscribed in pencil bottom left in a later hand: *T Gainsborough*.
The inscription bottom right is now illegible.
Collector's mark of William Esdaile bottom right.

PROVENANCE: William Esdaile; possibly Esdaile sale, Christie's, 20 March 1838, Lot 673 bt. in; Henry Vaughan, who bequeathed it 1901.
BIBLIOGRAPHY: Gower *Drawings*, p.11 and repr. pl.v.

A study from life. Related in theme to Gainsborough's 'cottage door' subjects of 1778 onwards, and probably a study for one of these compositions. The bold contours and rich highlighting are closely related to the studies for *The Richmond Water-walk* (compare especially Cat. No.62). Also mentioned on pp.46 and 52.

840 Studies of Girls carrying Faggots
Plate 203
Mr and Mrs Paul Mellon, Oak Spring, Virginia

Black chalk and stump on buff paper, heightened with white. $13\frac{7}{16} \times 12\frac{5}{16}$ (341 × 313).
On the left a young girl carrying a bundle of faggots seated facing half-right with her head in profile; on the right another young girl carrying a bundle of faggots standing facing half-left with her head inclined downwards; no background.
Collector's mark of T. E. Lowinsky bottom right.
PROVENANCE: Henry J. Pfungst; Pfungst sale, Christie's, 15 June 1917, Lot 42 bt. Sir George Donaldson; Henry Schniewind Jr.; Anon. (=Schniewind) sale, Sotheby's, 25 May 1938, Lot 146 bt. Adams; T. E. Lowinsky; by descent to Justin Lowinsky, from whom it was acquired.
EXHIBITED: Colnaghi's 1906 (58); Cincinnati 1931 (53 and repr. pl.68); *Five Centuries of Drawings*, Montreal Museum of Fine Arts, October–November 1953 (234).
BIBLIOGRAPHY: E. S. Siple, 'Gainsborough Drawings: The Schniewind Collection', *The Connoisseur*, June 1934, p.356 and repr. p.354.

A study from life, one of a series of studies of beggar children gathering faggots related to Gainsborough's fancy pictures of the 1780's. (see also Cat. Nos.841, 842 and 843). A girl with a bundle of faggots was the principal subject of the picture in the Beaverbrook Art Gallery, Fredericton (Waterhouse 798, pl.255), begun in January 1782. The pose of the girl on the left is similar to that of the little boy in *The Cottage Children* in the Metropolitan Museum (Waterhouse 807, pl.281), painted in the autumn of 1787; and the girl on the right is close in type to the seated girl in the group of a mother with her children in the British Museum (Cat. No.839). The bold hatching and contours and broad stumpwork are characteristic of Gainsborough's very late drawings, and closely related to the drawing in the British Museum (Cat. No.839). Also mentioned on p.100.

841 Study of Beggar Children
Courtauld Institute of Art, Witt Collection,
London (2893)

Black chalk and stump, heightened with white.
$10\frac{1}{8} \times 12\frac{5}{8}$ (257 × 321) (the drawing is torn across
the top and again irregularly at the bottom, and
at some time in the past it has been laid down on
a fresh sheet of paper and the missing portions of
the composition filled in).
A young girl seated facing half-right with her head
turned towards the left; beside her, a slightly older
girl facing half-left and carrying a bundle of
faggots.
Collector's mark of Sir Robert Witt bottom left.
PROVENANCE: Henry Schniewind Jr.; Anon.
(=Schniewind) sale, Sotheby's, 25 May 1938,
Lot 151 bt. Colnaghi, from whom it was purchased
by Sir Robert Witt; bequeathed to the Courtauld
Institute 1952.
EXHIBITED: Cincinnati 1931 (56 and repr. pl.67);
*Some British Drawings from the Collection of Sir Robert
Witt*, Arts Council, 1948 (28 and repr. pl.IV);
Aldeburgh 1949 (25); *Some British Drawings from the
Collection of Sir Robert Witt*, National Gallery of
Canada, Ottawa, 1949 and American Federation
of Arts, 1951 (26); Arts Council 1960–1 (60, and
p.6); *Master Drawings from the Witt and Courtauld
Collections*, Whitworth Art Gallery, Manchester,
November–December 1962 (7).
BIBLIOGRAPHY: E. S. Siple, 'Gainsborough
Drawings: The Schniewind Collection', *The
Connoisseur*, June 1934, p.356; *Hand-List of the
Drawings in the Witt Collection*, London, 1956, p.22.

A study from life, one of a series of studies of
beggar children with faggots related to Gains-
borough's fancy pictures of the 1780's (see also
Cat. Nos.840, 842 and 843). The stumpwork
and bold contours in black chalk are closely
related to the studies of a girl carrying faggots in
the Mellon collection (Cat. No.840). The
Mellon study was the drawing formerly in the
Pfungst collection, and not the present sheet, as
erroneously stated by myself in the Arts Council
catalogue (*op. cit.*).

842 Studies of Girls with Faggots
Ownership unknown

Black chalk and stump and white chalk on buff
paper (apparently). Size unknown.
A girl leaning to the left on a bundle of faggots,
her head turned downwards; a second study on the
right showing her seated on the bundle of faggots,
facing the spectator, with her head turned half-right
and looking downwards, and her hands clasped in
front of her; no background (from the print).

ENGRAVED: Richard Lane, published 1 January
1825.
PROVENANCE: Among the drawings left by the
artist to his wife, which descended through
Margaret Gainsborough either to Henry Briggs or
via Sophia Lane to Richard Lane.

A study from life, one of a series of studies of
beggar children with faggots related to Gains-
borough's fancy pictures of the 1780's (see also
Cat. Nos.840, 841 and 843). The technique
seems to be closely related to the studies of girls
carrying faggots in the Mellon collection (Cat.
No.840), and the girl on the right could well be
taken from the same model as the girl on the
left in the latter drawing.

843 Study of a Girl seated on a Bundle
of Faggots
Ownership unknown.

Black chalk and stump (apparently). Upright.
Size unknown.
A young girl seated on a bundle of faggots facing
left, her head turned towards the spectator and
slightly downwards; trees on the right behind (from
the print).
ENGRAVED: Richard Lane, published 1 January
1825.
PROVENANCE: Among the drawings left by the
artist to his wife, which descended through
Margaret Gainsborough either to Henry Briggs or
via Sophia Lane to Richard Lane.

A study from life, probably one of a series of
studies of beggar children with faggots related
to Gainsborough's fancy pictures of the 1780's
(see also Cat. Nos.840, 841 and 842). The
rather wistful figure type is similar to the studies
in the Mellon and Witt collections (Cat. Nos.840
and 841), but the technique appears to be
considerably tighter and related more to the
style of the late 1750's. Final judgement on
the question of date will have to be suspended
until the reappearance of the original drawing.

844 Study of Shrimpers Plate 228
Detroit Institute of Arts, Detroit (34.113)

Black chalk and stump, with grey and some
grey-black washes, on pale buff paper. $10\frac{5}{8} \times 14\frac{3}{16}$
(270 × 363).
Two girls with shrimping nets over their left
shoulders, the girl on the left in profile facing to
the right, the girl in the centre facing the spectator;
beside them, centre, a girl kneeling, facing upwards
to the left; on the right, a girl in profile facing to

the right, only the upper half of her body drawn; no background.

Collector's mark of William Esdaile bottom right. Inscribed on the original mount in Esdaile's hand in ink bottom left: *120*; bottom centre: *Gainsborough*; and verso: *1825 WE Baker Sale N 120 Gainsborough*.

PROVENANCE: George Baker; Baker sale, Sotheby's, 16 June 1825 ff., 3rd Day, Lot 359 (with another) bt. Thane; William Esdaile; Esdaile sale, Christie's, 20–1 March 1838; Arthur Kay; Kay sale, Christie's, 23 May 1930, Lot 23 bt. Colnaghi, from whom it was purchased 1934.

EXHIBITED: Colnaghi's 1906 (72); Ipswich 1927 (136); *Peinture Anglaise*, Musée Moderne, Brussels, October–December 1929 (70); *Old Master Drawings from Midwestern Museums*, Detroit Institute of Arts, June–September 1950 (15).

BIBLIOGRAPHY: Gower, repr. f. p.22.

A sheet of figure studies drawn from life: the figures are not logically connected in any way. The girl on the right is an alternative study for the shrimper on the left. The object on the extreme right is difficult to identify. The summary contours reinforcing the stumpwork are characteristic of Gainsborough's very late drawings and may be compared with the group of a mother and her children in the British Museum (Cat. No.839). Also mentioned on pp.52, 97 and 101.

845 Study of a Woman seated, with Three Children Plate 229
Pierpont Morgan Library, New York (III, 59)

Black chalk and stump on pale buff paper, heightened with white. $14 \times 9\frac{1}{2}$ (356×241).
A woman holding a baby facing the spectator, both of them wearing hats; a small girl on the left facing right; a small girl on the right wearing a hat facing left; no background.

PROVENANCE: Charles Fairfax Murray, from whom it was purchased by J. Pierpont Morgan 1910.

EXHIBITED: *The Art of Eighteenth Century England*, Smith College Museum of Art, January 1947 (28).

BIBLIOGRAPHY: *J. Pierpont Morgan Collection of Drawings by the Old Masters formed by C. Fairfax Murray*, Vol.III, London, 1912, No.59 (repr.).

A study from life. Related in theme to Gainsborough's 'cottage door' subjects of 1778 onwards. The way in which the figures are blocked out in stump and the summary outlines in black chalk are identical with the study of shrimpers in Detroit (Cat. No.844). Also mentioned on p.24.

846 Study of a Young Girl holding a Child
Mr and Mrs Paul Mellon, Oak Spring, Virginia (66/1/3/24)

Black and white chalk and stump on pale buff paper. $15\frac{1}{8} \times 11\frac{5}{16}$ (383×287).
A young girl facing right, with her head turned towards the spectator and holding a baby in her arms; the baby has its arms round the girl's neck, and also has its head turned towards the spectator.

PROVENANCE: Mrs Clifton; with Agnew, from whom it was purchased by Mrs Richard Warde; Warde sale, Christie's, 2 April 1965, Lot 5 bt. Colnaghi, from whom it was purchased 1965.

EXHIBITED: *English Drawings and Watercolours*, Colnaghi's, July–August 1965 (43 and repr. pl.VIII).

A study from life. Possibly a first idea for the young girl holding a child in *The Cottage Children* in the Metropolitan Museum (Waterhouse 807, pl.281), painted in the autumn of 1787. The way in which the figures are blocked out is closely related to the group of a mother and her children in the Morgan Library (Cat. No.845).

847 Study for *The Haymaker and Sleeping Girl at a Stile* Plate 230
British Museum, London (1906–7–7–1)

Black chalk and stump. $8\frac{7}{8} \times 13\frac{7}{8}$ (225×352).
A haymaker leaning over a stile right and holding his hat in his left hand; a girl, accompanied by a dog asleep, reclining on the stile centre and right.

ENGRAVED: Richard Lane, published 1 January 1825 (not in reverse).

PROVENANCE: Among the drawings left by the artist to his wife, which descended through Margaret Gainsborough either to Henry Briggs or via Sophia Lane to Richard Lane; Henry J. Pfungst, who presented it (through the National Art-Collections Fund) 1906.

EXHIBITED: Colnaghi's 1906 (20).

BIBLIOGRAPHY: Woodall 159.

Preparatory study for *The Haymaker and Sleeping Girl* in the Museum of Fine Arts, Boston (Waterhouse 815, pl.277), painted in the late 1780's. In the finished painting the format has been altered to an upright shape, the poses of the girl and dog are changed, the haymaker is holding a rake and the girl a basket of eggs. The broad scallops of the foliage and pervasive diagonal hatching are characteristic of Gainsborough's very late figure sketches, and the summary contours of the figures are closely related to the study of shrimpers in Detroit (Cat. No.844).

848 A Girl seated with a Pitcher of Water
Ownership unknown

Red chalk and stump (apparently). Upright.
Size unknown.
A girl seated with a pitcher of water facing
half-right, her head turned towards the spectator
and downwards; two sheep on a bank behind her
on the left; a tree behind her on the right; a pool
at her feet on the right (from the print).
ENGRAVED: Richard Lane, published 1 January
1825.
PROVENANCE: Among the drawings left by the
artist to his wife, which descended through
Margaret Gainsborough to Henry Briggs; Briggs
sale, Christie's, 25 February 1831, Lot 112 bt.
Johnson.

Related in subject to *The Cottage Girl with Dog
and Pitcher* in the Beit collection (Waterhouse
803, repr. pl.273), painted in the spring of 1785.
The technique, especially the background
foliage, seems to be related to the study for *The
Haymaker and Sleeping Girl* in the British Museum
(Cat. No.847).

849 Study a of Woodman
Ownership unknown

Black chalk and stump and white chalk on buff
paper (apparently). Upright. Size unknown.
A woodman standing facing the spectator, looking
downwards to left, clasping a stick in his right hand
and a tuft of his hair in the left; no background
(from the print).
ENGRAVED: Richard Lane, published 1 January
1825.
PROVENANCE: Among the drawings left by the
artist to his wife, which descended through
Margaret Gainsborough either to Henry Briggs or
via Sophia Lane to Richard Lane; either this or
the other study of a woodman lithographed by
Lane (see below) was probably Briggs sale,
Christie's, 25 February 1831, Lot 110 bt. Powell.

A study from life. One of several studies of
woodmen taken from the same model used for
The Woodman (Waterhouse 806), painted in the
summer of 1787, and possibly therefore a re-
jected idea for this picture. The model was 'a
poor smith worn out by labour ... Mr. Gains-
borough was struck by his careworn aspect and
took him home; he enabled the needy wanderer
by his generosity to live – and made him im-
mortal by his art!' (Whitley, p.285). The tech-
nique seems to be closely related to the studies of
beggar children in the Mellon collection and
lithographed by Lane (Cat. Nos.840 and 842).

The elaborate study of a woodman in the
Birmingham City Art Gallery (P28'53), though
clearly the original from which Lane made his
other lithograph of this subject, is entirely
uncharacteristic of Gainsborough's late drawing
style or methods; the fact that it is squared up
indicates that it was intended for engraving, and
the treatment throughout is sufficiently close
to the similar drawings of *Francis Rawdon Hastings*
in Worcester (repr. in *Master Drawings*, Vol.3,
No.3, 1965, pl.9) and *Sir Henry Bate Dudley* (repr.
in *Christie's Review of the Year 1967/1968*, London,
1968, p.52), both by Dupont, to suggest that this
is the correct attribution.

850 Study of a Woodman carrying
Faggots Plate 233
The Hon. K. R. Thomson, Toronto
(on permanent loan to the Art Gallery of
Ontario)

Black chalk and stump on buff paper, heightened
with white. $20\frac{1}{4} \times 12\frac{1}{16}$ (514 × 306).
A woodman walking half-left, carrying a bundle of
faggots over his left shoulder.
Inscribed in pencil bottom left: *Tho.^s Gainsborough
Del.^t*
PROVENANCE: William Willes; with Marshall Spink,
from whom it was purchased.
EXHIBITED: *Romantic Art in Britain*, Detroit Institute
of Arts and Philadelphia Museum of Art,
January–April 1968 (24 repr.); *Drawings in the
Collection of the Art Gallery of Ontario*, March–April
1970 (34).

A study from life. One of several studies of
woodmen (see also Cat. Nos.849, 851 and 852)
taken from the same model used for *The Wood-
man* (Waterhouse 806), painted in the summer of
1787, and possibly therefore a rejected idea for
this picture. The rough contours in black chalk
and rich highlighting are identical with the
studies for *The Richmond Water-walk* (compare
especially Cat. No.62). Also mentioned on pp.
19, 31, 39, 46, 52 and 63.

851 Study of a Woodman seated on a
Bundle of Faggots Plate 232
Norman Mackenzie Art Gallery, University of
Saskatchewan, Regina (28–2)

Black chalk and stump on buff paper, heightened
with white. $20\frac{1}{8} \times 12\frac{3}{4}$ (511 × 324).
A woodman seated on a bundle of faggots, facing
half-right, with his head in profile, and holding a
knife in his right hand.

Inscribed bottom left in a later hand *T.G.*
PROVENANCE: Unknown.

A study from life. One of several studies of woodmen (see also Cat. Nos.849, 850 and 852), taken from the same model used for *The Woodman* (Waterhouse 806), painted in the summer of 1787, and possibly therefore a rejected idea for this picture. The stumpwork, the rough contours in black chalk and the rich highlighting are identical with the woodman carrying faggots owned by K. R. Thomson (Cat. No.850). Also mentioned on pp.19, 31, 39, 46, 52 and 63.

852 Study of a Woodman seated on a Bundle of Faggots Plate 231
Mrs Cecil Keith, Rusper

Black chalk and stump on buff paper, heightened with white. $18\frac{11}{16} \times 11\frac{1}{2}$ (475×292).
A woodman seated on a bundle of faggots, facing half-left, with his hands clasped in front of him.
PROVENANCE: Guy Bellingham Smith; Henry J. Pfungst; Pfungst sale, Christie's, 15 June 1917, Lot 44 bt. Sir George Donaldson; Henry Schniewind, Jr.; Anon. (=Schniewind) sale, Sotheby's, 25 May 1938, Lot 141 bt. Colnaghi, from whom it was purchased by J. Leslie Wright; thence by descent.
EXHIBITED: Cincinnati 1931 (74 and repr. pl.74); Aldeburgh 1949 (36); *Masters of British Water-Colour: The J. Leslie Wright Collection*, R.A., October–November 1949 (78 and repr. pl.1); *Three Centuries of British Water-Colours and Drawings*, Arts Council 1951 (72); Bath 1951 (49); *The Romantic Movement*, Arts Council (Tate Gallery), July–September 1959 (699); Arts Council 1960–1 (63, and p.6); *English Watercolour Drawings from the collection of Mrs. Cecil Keith*, Worthing Art Gallery, March 1963 (6).
BIBLIOGRAPHY: E. S. Siple, 'Gainsborough Drawings: The Schniewind Collection', *The Connoisseur*, June 1934, pp.356–7 and repr. p.355; Geoffrey Grigson, *English Drawing*, London, 1955, p.175 and repr. pl.49.

A study from life. One of several studies of woodmen (see also Cat. Nos.849, 850 and 851), taken from the same model used for *The Woodman* (Waterhouse 806), painted in the summer of 1787, and possibly therefore a rejected idea for this picture. Gainsborough used this pose for the figure on the right in his first design (Cat. No. 803) for his last great landscape composition, the *Peasant Smoking at a Cottage Door* (Waterhouse 1011, pl.285) (Plate 350), painted in 1787 or 1788. The stumpwork, the rough contours in

black chalk, the broad hatching in the background, and the sketchy treatment of the bundle of faggots are identical with the seated woodman in Regina (Cat. No.851). Also mentioned on pp.31, 39, 46, 52, 61, 63, 100 and 101).

853 Study of a Rustic Figure
Mrs Albert R. Broccoli, London

Black chalk and stump and white chalk on buff paper. $17\frac{1}{8} \times 12\frac{1}{4}$ (433×311).
A rustic figure seated on a boulder facing left, wearing an overcoat and holding a hat in his right hand; suggestions of foliage in the background top left.
PROVENANCE: Since the drawing is noted on the back of the mount as having been bought at the Gainsborough sale at Christie's, 11 May 1799, possibly part of Additional Lot 1 *6 drawgs of Woodmen* bt. Morris; Thomas Winstanley; George Fardo; Anon. sale, Christie's, 3 March 1970, Lot 84 (repr.) bt. Broccoli.
EXHIBITED: *Works by the Old Bath Artists*, Victoria Art Gallery, Bath, Spring 1903 (174).

A study from life. The rough broken contours outlining the figure, the stumpwork and the treatment of the background foliage are closely related to the study of a woodman in Regina (Cat. No.851), and the model is the same as that used for *The Woodman* (Cat. No.849).

Animal Drawings

With one or two exceptions, such as the composition sketch owned by Sir Siegmund Warburg, Gainsborough's animal studies seem to have been done direct from life, rather than from the plaster models he is known to have made. Certain of these drawings, notably the enchanting sheet of studies of a cat in the Rijksmuseum, were done with no ulterior purpose in mind, but most of them were executed with the idea of using them in his landscape compositions, and some as direct studies for particular landscapes. He continued to make studies of animals—mainly cows, goats and sheep—for this purpose throughout his career.

Mid to Later 1740's

854 Study of a Greyhound asleep
Sir Edmund Bacon, Raveningham

Pencil. $8 \times 12\frac{1}{8}$ (203×308).
A greyhound asleep.
Verso: wooded landscape with a cow on a bank (Cat. No.71).
PROVENANCE: Rev. Dr Wellesley (?); Sir Hickman Bacon.

A study from life. Probably executed in the mid-1740's, the date of the landscape on the verso.

Early to Mid 1750's

855 Study of a Cow Plate 317
British Museum, London (O.o.2–16)

Pencil. $5\frac{13}{16} \times 7\frac{3}{4}$ (148×197).
A cow standing in profile, facing left.
PROVENANCE: From the sketch-book purchased by Richard Payne Knight at the Gainsborough sale, Christie's, 11 May 1799, Lot 85; bequeathed 1824.
BIBLIOGRAPHY: Binyon 23b; Gower *Drawings*, p.11 and repr. pl.III.

A study from life. Almost identical in pose to the cow in the centre of the drawing owned by F. Bulkeley Smith (Cat. No.158), and probably a study used for that composition. The soft shading is characteristic of Gainsborough's style of the early to mid 1750's and may be compared with the study of a mossy bank in the British Museum (Cat. No.139). Also mentioned on p.28.

856 Study of a Goat Plate 35
British Museum, London (O.o.2–15)

Pencil. $5\frac{13}{16} \times 7\frac{11}{16}$ (148×195).
A goat standing on rising ground facing the spectator.
PROVENANCE: From the sketch-book purchased by Richard Payne Knight at the Gainsborough sale, Christie's, 11 May 1799, Lot 85; bequeathed 1824.
BIBLIOGRAPHY: Binyon 23a.

A study from life. The hatching is related to sketches like the study of a mossy bank also in the British Museum (Cat. No.134).

857 Study of a Donkey's Head
British Museum, London (O.o.2–14)

Pencil. $3\frac{1}{2} \times 2\frac{9}{16}$ (89×65).
A donkey facing the spectator, the head only sketched; no background.
PROVENANCE: From the sketch-book purchased by Richard Payne Knight at the Gainsborough sale, Christie's, 11 May 1799, Lot 85; bequeathed 1824.
BIBLIOGRAPHY: Binyon 24a.

A study from life. The pencilwork is comparable with the study of a goat also in the British Museum (Cat. No.856).

858 Study of Horses, Cows, a Donkey and a Pig Plate 55
Major Michael Ingram, Driffield

Pencil. $7\frac{1}{2} \times 9\frac{1}{8}$ (190×232).
Studies of a donkey (top), a cow, a horse and a pig

(centre), a horse's head and a cow (bottom), all seen in profile, and all facing left except the last named; suggestions of landscape background. Collector's mark of Major Michael Ingram on the verso top left.
PROVENANCE: Mrs G. Blois; with Colnaghi, from whom it was purchased 1957.

Studies from life. The pencilwork and scallops outlining the foliage are related to the study of trees in the British Museum (Cat. No.169).

859 A Horse, with Trees behind
Ehemals Staatliche Museen, Berlin-Dahlem (4699)

Pencil. $5\frac{11}{16} \times 7\frac{5}{16}$ (144 × 186).
A horse reclining facing left in the foreground centre; trees sketched in behind.
PROVENANCE: From one of the sketch-books purchased by George Hibbert at the Gainsborough sale, Christie's, 11 May 1799, Lot 82, 84, or 88; by descent to the Hon. A. H. Holland-Hibbert; Holland-Hibbert sale, Christie's, 30 June 1913, Lot 39 (with another) bt. Hofer; presented by an unknown donor 1913.
BIBLIOGRAPHY: Woodall 412.

The loose scallops outlining the foliage, the shading, and the pencilwork generally are closely related to the study of trees owned by Charles Monteith (Cat. No.168).

Later 1750's

860 Study of a Cow Plate 316
D. L. T. Oppé, London (2132)

Pencil on brown-toned paper. $6 \times 7\frac{7}{16}$ (152 × 189).
A cow reclining, facing right.
PROVENANCE: Earl of Warwick; Warwick sale, Sotheby's, 17 June 1936, Lot 164 (part of a parcel of miscellaneous drawings) bt. Holloway, from whom it was acquired by A. Paul Oppé 1936.
EXHIBITED: Arts Council, 1960–1 (71B).
LITERATURE: John Hayes, 'The Gainsborough Drawings from Barton Grange', *The Connoisseur*, February 1966, p.89 repr. fig.6.

A study from life for the reclining cow in the drawing owned by F. Bulkeley Smith (Cat. No. 158). The open hatching is characteristic of drawings of the later 1750's, such as the landscape with distant church tower in the Huntington Art Gallery (Cat. No.187). Also mentioned on pp.27–8 and 39.

861 Study of a Cow Plate 45
D. L. T. Oppé, London (2131)

Pencil on brown-toned paper. $5\frac{11}{16} \times 7\frac{7}{16}$ (144 × 189).
A cow reclining, facing right; landscape background.
PROVENANCE: Earl of Warwick; Warwick sale, Sotheby's, 17 June 1936, Lot 164 (part of a parcel of miscellaneous drawings) bt. Holloway, from whom it was acquired by A. Paul Oppé 1936.
EXHIBITED: Arts Council, 1960–1 (71A).

A study from life. The crisp touch and slightly curving strokes in the foliage are closely related to drawings of the later 1750's, such as the landscape with distant church tower in the Huntington Art Gallery (Cat. No.187).

862 Study of a Cow Plate 44
Private Collection, England

Pencil. $5\frac{7}{16} \times 7\frac{1}{8}$ (138 × 181).
A cow reclining, facing left, its head turned towards the spectator; no background.
PROVENANCE: F. M. Nichols; thence by descent.

A study from life. This pose occurs in the landscape with cattle only known from the engraving by Vivares 1765 (Waterhouse 888), painted in the mid to late 1750's. The modelling and pencilwork generally are identical with the studies in the Oppé collection (Cat. Nos.860 and 861).

863 Study of Two Sheep Plate 324
Ehemals Staatliche Museen, Berlin-Dahlem (4696)

Black and white chalks on grey paper. $6\frac{1}{8} \times 8\frac{1}{4}$ (156 × 210).
One sheep reclining facing right, the other behind, standing and facing half-left, but with its head turned towards the spectator; no background.
PROVENANCE: From one of the sketch-books purchased by George Hibbert at the Gainsborough sale, Christie's, 11 May 1799, Lot 82, 84 or 88; by descent to the Hon. A. H. Holland-Hibbert; Holland-Hibbert sale, Christie's, 30 June 1913, Lot 28 (with another) bt. Hofer; presented by an unknown donor 1913.

A study from life for the two sheep on the left in the drawing owned by Sir Siegmund Warburg (Cat. No.865): in the Warburg drawing the sheep are still less particularized, but the poses are identical except for the head of the sheep on the left, which has been raised slightly. Also mentioned on pp.27 and 40.

864 Study of a Sheep Plate 323
Ehemals Staatliche Museen, Berlin-Dahlem
(4698)

Black and white chalks on grey paper. $5\frac{9}{16} \times 7\frac{1}{4}$
(141×184).
A sheep reclining facing left; suggestions of grass.
PROVENANCE: From one of the sketch-books
purchased by George Hibbert at the Gainsborough
sale, Christie's, 11 May 1799, Lot 82, 84 or 88;
by descent to the Hon. A. H. Holland-Hibbert;
Holland-Hibbert sale, Christie's, 30 June 1913,
Lot 33 (with another) bt. Hofer; presented by an
unknown donor 1913.

A study from life for the sheep on the right in
the drawing owned by Sir Siegmund Warburg
(Cat. No.865): in the Warburg drawing the
sheep is less particularized, but the pose is
identical. The black and white chalkwork is
identical with the previous drawing (Cat. No.
863). Also mentioned on pp.27. and 40.

865 Shepherd Boy with Three Sheep
Plates 256 and 325
Sir Siegmund Warburg, London

Black and white chalks on blue paper. $9\frac{11}{16} \times 12\frac{7}{16}$
(246×316).
A shepherd boy standing holding his crook in front
of him and facing the spectator, on the left; three
sheep, two of them reclining, behind him;
suggestions of grass.
PROVENANCE: Anon. sale, Sotheby's, 9 February
1955, Lot 24 bt. Colnaghi, from whom it was
purchased.
EXHIBITED: *Old Master Drawings*, Colnaghi's,
April–May 1955 (47); Arts Council 1960–1 (70).

Study for the landscape with shepherd boy and
sheep in the Toledo Museum of Art (Waterhouse
836, pl.34) (Plate 326), painted about 1757–9.
The pose of the shepherd boy was used unaltered
but the sheep, though grouped in the same
relationship to the figure, are not of the same
breed and are quite differently arranged. The
modelling of the sheep is related to the two
studies in Berlin (Cat. Nos.863 and 864), but
much rougher in character. Also mentioned on
pp.27, 40, 58 and 68.

866 Study of a Sheep
Ehemals Staatliche Museen, Berlin-Dahlem
(4697)

Black and white chalks on grey paper. $6\frac{9}{16} \times 7\frac{11}{16}$
(167×195).

A sheep reclining, facing half-left; suggestions of
grass.
PROVENANCE: From one of the sketch-books
purchased by George Hibbert at the Gainsborough
sale, Christie's, 11 May 1799, Lot 82, 84 or 88;
by descent to the Hon. A. H. Holland-Hibbert;
Holland-Hibbert sale, Christie's, 30 June 1913,
Lot 33 (with another) bt. Hofer; presented by an
unknown donor 1913.

A study from life. The modelling is identical
with the two other studies of sheep in Berlin
(Cat. Nos.863 and 864).

867 Study of a Goat
Ehemals Staatliche Museen, Berlin-Dahlem
(4695)

Black and white chalks on grey paper. $6 \times 8\frac{3}{16}$
(152×208).
A goat reclining, in profile facing right.
PROVENANCE: From one of the sketch-books
purchased by George Hibbert at the Gainsborough
sale, Christie's, 11 May 1799, Lot 82, 84 or 88;
by descent to the Hon. A. H. Holland-Hibbert;
Holland-Hibbert sale, Christie's, 30 June 1913,
Lot 28 (with another) bt. Hofer; presented by an
unknown donor 1913.

A study from life. The chalkwork is closely re-
lated to the study of two sheep also in Berlin
(Cat .No.863).

868 Study of a Cow
Ehemals Staatliche Museen, Berlin-Dahlem
(4701)

Black, red and white chalks on grey paper.
$6\frac{9}{16} \times 8\frac{1}{4}$ (167×210).
A cow standing in profile, facing left, feeding;
no background.
PROVENANCE: From one of the sketch-books
purchased by George Hibbert at the Gainsborough
sale, Christie's, 11 May 1799, Lot 82, 84 or 88;
by descent to the Hon. A. H. Holland-Hibbert;
Holland-Hibbert sale, Christie's, 30 June 1913,
Lot 42 bt. Hofer; presented by an unknown
donor 1913.

A study from life. The chalkwork is closely re-
lated to the study of two sheep also in Berlin
(Cat. No.863).

869 Study of a Cow
Mrs I. A. Williams, London

Black and white chalks on brown paper. $5\frac{5}{8} \times 7$ (143×178).
A cow facing right; no background.
PROVENANCE: Earl of Warwick; Warwick sale, Sotheby's, 17 June 1936, Lot 164 (in a parcel of miscellaneous drawings) bt. Holloway, from whom it was purchased by Iolo A. Williams 1936.
EXHIBITED: *Early English Watercolours and other Drawings selected from the collection of Iolo A. Williams*, Graves Art Gallery, Sheffield, 1952, National Library of Wales, Aberystwyth, 1953, and Museum and Art Gallery, Reading, 1959 (108).

A study from life. The soft chalkwork is closely related to the study of two sheep in Berlin (Cat. No.863).

870 Study of a Cow
Mrs I. A. Williams, London

Black and white chalks on brown paper. $6 \times 7\frac{7}{16}$ (152×189).
A cow facing left; no background.
PROVENANCE: Earl of Warwick; Warwick sale, Sotheby's, 17 June 1936, Lot 164 (in a parcel of miscellaneous drawings) bt. Holloway, from whom it was purchased by Iolo A. Williams 1936.
EXHIBITED: *Early English Watercolours and other Drawings selected from the collection of Iolo A. Williams*, Graves Art Gallery, Sheffield, 1952, National Library of Wales, Aberystwyth, 1953, and Museum and Art Gallery, Reading, 1959 (107).

A study from life. The soft chalkwork is identical with the study of a cow facing right also in the Iolo Williams collection (Cat. No.869).

871 Study of a Cow
Ownership unknown

Pencil on brown prepared paper. $5\frac{3}{4} \times 7\frac{1}{4}$ (146×184).
A cow standing in profile, facing right.
Collector's mark of Sir Bruce Ingram on the verso bottom left.
PROVENANCE: Sir Bruce Ingram.

A study from life.

872 Study of a Bull-terrier Plate 71
Ehemals Staatliche Museen, Berlin–Dahlem
(4436)

Black, red and white chalks on buff paper, heightened with white. $12\frac{7}{16} \times 9\frac{5}{8}$ (316×244).

A bull-terrier seated on its haunches facing the spectator; no background.
Collector's mark of Barthold Suermondt.
Verso: study of the coat of a man standing facing left (Cat.No. 14).
PROVENANCE: Barthold Suermondt; source of requisition unknown.

A study from life. The bold contours and hatching in the background are identical with the study for the portrait of the Hon. Richard Savage Nassau also in Berlin (Cat. No.13), so that the drawing is datable to the later 1750's. No artist could be more remote from the aesthetic of the Middle Ages than Gainsborough, but the no doubt accidentally hieratic treatment of this study is strangely reminiscent of Villard de Honnecourt's famous drawing of a lion.

Mid to Later 1760's

873 Study of a King Charles's Spaniel
Plate 458
Captain R. J. Beech, Barnard Castle

Coloured chalks on brown paper. $9\frac{1}{4} \times 12\frac{5}{16}$ (235×313).
A brown and white King Charles's spaniel curled up facing right, with its head turned to the spectator; no background.
PROVENANCE: Henry J. Pfungst; Pfungst sale, Christie's, 15 June 1917, Lot 19 bt. Sir George Donaldson; Henry Schniewind, Jr.; Anon. (=Schniewind) sale, Sotheby's, 25 May 1938, Lot 153 bt. Wheeler; C. R. Rudolf; with Spink, from whom it was purchased 1950.
EXHIBITED: Colnaghi's 1906 (39); Cincinnati 1931 (52 and repr. pl.53).
BIBLIOGRAPHY: Gower, p.122 and repr. f. p.112; 'The Gainsborough Exhibition in Cincinnati', *The Burlington Magazine*, August 1931, p.86; E. S. Siple, 'Gainsborough Drawings: The Schniewind Collection', *The Connoisseur*, June 1934, p.355.

A study from life. The pose is similar to that of the dog in the sketch for *The Haymaker and Sleeping Girl* in the British Museum (Cat. No. 847), but the chalkwork and the hatching in the background are closely related to the study of a woman with a rose in the British Museum (Cat. No.29), which dates from the mid-1760's. Also mentioned on p.90.

874 Studies of a Cat Plate 99
Rijksmuseum, Amsterdam (52.114)

Black chalk and stump and white chalk on buff
paper. 13$\frac{1}{16}$ × 18$\frac{1}{16}$ (332 × 459).
Studies of a cat in six different poses; no
background.
Signed bottom right: *T. Gainsborough.*
PROVENANCE: Presented by the artist to an
ancestor of a Colonel Ward, to whom it descended;
Sir George Donaldson; Henry Schniewind, Jr.;
Anon. (=Schniewind) sale, Sotheby's, 25 May
1938, Lot 142 bt. Black.
EXHIBITED: Cincinnati 1931 (51 and repr. pl.57).
BIBLIOGRAPHY: 'The Gainsborough Exhibition in
Cincinnati', *The Burlington Magazine*, August 1931,
p.86; E. S. Siple, 'Gainsborough Drawings: The
Schniewind Collection', *The Connoisseur*, June 1934,
repr. p.357; Geoffrey Grigson, *English Drawing*,
London, 1955, p.174 and repr. pl.40.

Studies from life, traditionally supposed to have
been sketched in a country house and presented
to his hostess (Schniewind sale cat., *op. cit.*).
One of Gainsborough's very rare fully signed
drawings. This drawing is difficult to date with
any precision, but the comparatively tight handl-
ing is related to the study of a spaniel owned by
Captain R. J. Beech (Cat. No.873), which
suggests the 1760's rather than later. Sheets of
studies of this description are common in the
history of European drawing from Pisanello
onwards. Also mentioned on pp.9 and 25.

Later 1770's

875 Study of a Cow and Sheep Plate 144
The Hon. Mrs Alan Clark, Seend Park

Black chalk. 9$\frac{3}{8}$ × 13$\frac{9}{16}$ (238 × 344).
A cow facing right, its head turned towards the
spectator; a sheep reclining, facing left; trees in
the background.
PROVENANCE: Arthur Kay; Kay sale, Christie's,
23 May 1930, Lot 37 bt. Meatyard; Sir Michael
Sadler; with Leicester Galleries; Lord Clark, who
gave it to his daughter-in-law.
EXHIBITED: Arts Council 1960–1 (73).
BIBLIOGRAPHY: Woodall 284.

The soft greasy touch and pervasive hatching
are characteristic of Gainsborough's chalkwork
of the late 1770's, and closely related to the
landscape with country cart in Manchester
(Cat. No.407).

876 Study of a Goat
Mr and Mrs L. Davis, New York

Black chalk and stump and white chalk on buff
paper. 6$\frac{5}{8}$ × 9$\frac{13}{16}$ (168 × 249).
A goat reclining, facing right; no background.
PROVENANCE: Henry S. Reitlinger; Reitlinger sale,
Sotheby's, 27 January 1954, Lot 145 bt. Colnaghi;
Slatkin Gallery, from whom it was purchased.
EXHIBITED: *The Artist as Draughtsman*, Seiferheld
Galleries, December 1960–January 1961; *Animal
Drawings from the XV to XX centuries*, Seiferheld
Galleries, December 1962 (repr.)

A study from life. The soft chalkwork is related
to the study of a cow and sheep owned by Mrs
Clark (Cat. No.875).

Early to mid 1780's

877 Study of a Goat Plate 226
Alan D. Pilkington, London

Black and white chalks on buff paper. 6$\frac{1}{4}$ × 9$\frac{9}{16}$
(159 × 243).
A goat reclining, in profile facing right, its head
turned slightly to the spectator.
Inscribed bottom right in a later hand: *Gainsbro'*.

PROVENANCE: Edgar Osborne; Anon. (=Osborne)
sale, Christie's, 15 July 1958, Lot 222 (with
eleven others) bt. Colnaghi, from whom it was
purchased.
EXHIBITED: Arts Council 1960–1 (72); *English
Drawings and Watercolours in memory of the late
D. C. T. Baskett*, Colnaghi's, July–August 1963
(17 and repr. pl.vi.).

A study from life. The hatching and the bold
broken chalkwork are related to the portrait of
a lady in a mob cap in the Mellon collection
(Cat. No.54). Also mentioned on pp.31 and 59.

Later 1780's

878 Study of Two Goats Plate 227
Victoria and Albert Museum, London
(Dyce 688)

Black and white chalks on buff paper. 7$\frac{1}{4}$ × 8$\frac{7}{8}$
(184 × 225).
Two goats facing left, one above the other, the
lower of the two reclining and with its head
turned towards the spectator.

PROVENANCE: Rev. Alexander Dyce, who bequeathed it to the South Kensington Museum 1869.
BIBLIOGRAPHY: *Dyce Collection Catalogue*, London, 1874, p.101.

A study from life. The modelling in broad highlights is characteristic of Gainsborough's later style, an example being the upland landscape with horseman crossing a bridge in the Tate Gallery (Cat. No.788), and these studies are probably related to a late unpublished painting of *The Prodigal Son*, formerly with Colnaghi, in which goats are a prominent feature. Also mentioned on pp.22 and 31.

List of Present Owners

Aberdeen Art Gallery 381, 382

Agnew, Thomas & Sons Ltd. 740

Albertina 721, 786

Andresen, Eva 487

Anglesey, the Marchioness of 810

Anonymous 3, 25, 40, 44, 45, 46, 60, 188, 236, 274, 294, 341, 349, 352, 359, 362, 369, 453, 471, 474, 475, 558, 618, 623, 624, 629, 656, 714, 726, 748, 763, 780, 862

Argenti, Mrs N. 424

Ashmolean Museum, Oxford 30, 265, 266, 268, 314, 315, 328, 370, 404, 596, 603, 710, 729, 761, 832

Auckland City Art Gallery 622

Bacon, Sir Edmund, Bt. 71, 101, 279, 854

Baker, Walter C. 335

Barber Institute of Fine Arts, Birmingham 386

Barker, Nicholas 91

Barlow, Miss Helen 508, 599

Barnfield, John 836

Beattie, L. H. 580

Beech, Captain R. J. 873

Benson, George F. 151

Berlin-Dahlem Ehemals Staatliche Museen 13, 14, 17, 48, 56, 174, 175, 250, 251, 252, 286, 438, 493, 657, 687, 693, 722, 792, 809, 822, 859, 863, 864, 866, 867, 868, 872

Binyon, Mrs Laurence 579

Birmingham City Art Gallery 249, 255, 310, 333, 344, 387, 439, 445, 450, 451, 465, 477, 479, 593, 667, 685, 686, 730, 738, 772, 798, 831

Blaiberg, Edgar 338, 542, 666, 673

Bloch, Mr and Mrs Robert W. 179

Blofeld, T. R. C. 82, 133

Bolton Museum and Art Gallery 481

Boston Museum of Fine Arts 691

Bowlby, Dr John 787

Boymans-Van Beuningen Museum, Rotterdam 484, 640, 670, 703, 708, 709

Bradfer-Lawrence, the executors of the late H. L. 690

Bradfer-Lawrence, Colonel Philip 762

Bradford City Art Gallery 366, 383, 581

Brandt, W. A. 301, 426, 563

Bristol City Art Gallery 683

British Museum 8, 10, 12, 16, 20, 21, 26, 29, 34, 35, 36, 37, 41, 47, 50, 51, 52, 58, 59, 62, 67, 68, 83, 84, 85, 86, 88, 89, 95, 97, 102, 122, 125, 127, 134, 135, 138, 139, 140, 141, 142, 143, 144, 145, 146, 147, 148, 159, 160, 169, 184, 185, 196, 197, 198, 204, 205, 207, 208, 209, 211, 212, 213, 214, 215, 216, 218, 219, 220, 221, 224, 225, 226, 239, 241, 242, 244, 245, 253, 254, 282, 307, 326, 396, 413, 414, 415, 416, 417, 418, 419, 420, 431, 433, 434, 442, 506, 511, 585, 586, 587, 671, 679, 728, 800, 804, 818, 819, 820, 823, 839, 847, 855, 856, 857

Broccoli, Mrs Albert R. 853

Brodick Castle, Isle of Arran (National Trust for Scotland) 350, 351, 371

Bronfman, Gerald 92

Brown, John Nicholas 355, 406, 522, 807

Budapest Museum of Fine Arts 422, 616

Burnett, R. L. 485

Burnham, Mr and Mrs James 628

Caccia, Lady 789

California Palace of the Legion of Honor, San Francisco 561, 732

Catroux, Tristran 663

Cavendish, Richard 598, 606, 627, 635, 636

Cecil Higgins Art Gallery, Bedford 564, 652, 759, 812

Chasseloup Laubat, le Marquis de 459, 520, 783, 784

Christie, James 320

Cincinnati Art Museum 435

Clark, the Hon. Mrs Alan 875

Clark Art Institute, Williamstown 736, 737

Clark, Colin 114

Clark, Lord 388, 826

Cleveland Museum of Art 325

Clive, P. J. B. 108

Colnaghi, P. & D. & Co. Ltd. 66

Concordance

NOTE: In the present context 'Untraced' means that neither the location nor an illustration of the relevant Woodall No. has been discovered. Some of these may well turn out to be identifiable with drawings I have catalogued.

Woodall Nos.	Present Catalogue	Woodall Nos.	Present Catalogue	Woodall Nos.	Present Catalogue
1	476	36	Untraced	66	716
2	288	37	Dupont	67	722
3	401	38	Monro	68	732
4	620	39	Will be catalogued under *Landscape Paintings*	69	399
5	Untraced			70	777
6	750			71	602
7	Untraced			72	363
8	765			73	599
9	Dupont	40	509	74	543
10	621	41	507	75	336
11	280	42	508	76	Untraced
12	Untraced	43	182	77	533
13	579	44	183	78	Jackson?
14	772	45	773	79	377
15	386	45a	Frost	80	400
16	666	46	478	81	683
17	542	47	536	82	531
18	338	48	537	83	165
19	Untraced	49	372	84	785
20	383	50	Untraced	85	825
21	366	51	723	86	62
22	581	52	367	87	59
23	544	53	Imitation	88	307
24	540	54	368	89	728
25	Untraced	55	Imitation	90	511
26	787	56	758	91	326
27	Copy	57	687	92	Copy
28	564	58	617	93	586
29	789	59	Imitation	94	585
30	Untraced	60	Untraced	95	587
31	Untraced	61	425	96	254
32	650	62	Untraced	97	95
33	361	63	569	98	Frost
34	659	64	745	99	Imitation
35	256	65	283	100	506

Woodall Nos.	Present Catalogue	Woodall Nos.	Present Catalogue	Woodall Nos.	Present Catalogue
101	Imitation	154	89	206	609
102	138	155	141	207	Dupont
103	127	156	208	208	803
104	207	157	88	209	Copy
105	125	157a	10	210	532
106	185	158	58	211	808
107	122	159	847	212	Imitation
108	199	160	679	213	Copy
109	184	161	282	214	Imitation
110	418	162	253	215	Imitation
111	419	163	442	215a	Imitation
112	420	164	Imitation	216	421
113	415	165	434	217	339
114	416	166	414	218	Copy
115	417	167	413	219	711
116	433	168	102	220	328
117	140	169	84	221	761
118	146	170	86, 818	222	370
119	144, 145	171	85	223	404
120	224	172	83	224	727
121	215	173	671	225	637
122	225	174	804	226	365
123	211	175	396	227	80
124	197	176	431	228	519
125	196	177	800	229	407
126	205	178	767	230	799
127	139	179	794	231	Copy
128	67, 68	180	781	232	91
129	169	181	776	232a	100
130	220	182	788	233	Untraced
131	219	183	409	234	646
132	244	184	403	235	120
133	245	185	541	236	655
134	160	186	Imitation	237	Untraced
135	134	187	669	238	782
136	212	188	292	239	548
137	213, 214	189	661	240	353
138	142	190	153	241	Imitation
139	147	191	Dupont	242	810
140	241	192	384	242a	704
141	239	193	491	243	642
142	135	194	769	244	658
143	97	195	468	245	488
144	159	196	Frost	246	577
145	209	197	675	247	189
146	143	198	Imitation	248	575
147	226	199	231	249	Dupont
148	221	200 (=186)	Imitation	250	Dupont
149	216	201	Imitation	251	206
150	218	202	Imitation	252	314
151	242	203	161	253	315
152	148	204	Unidentified	254	Untraced
153	198	205	Imitation	255	Untraced

Woodall Nos.	Present Catalogue	Woodall Nos.	Present Catalogue	Woodall Nos.	Present Catalogue
256	**512**	308	**654**	361	Untraced
257	**523**	309	**510**	362	**751**
258	Untraced	310	**756**	363	**515**
259	**435**	311	**757**	364	**631**
260	**720**	312	**471**	365	**678**
261	**719**	313	Imitation	366	**473**
262	Untraced	314	**9**	367	**77**
263	Dupont	315	Imitation	368	**662**
264	**309**	316	**517**	369	Untraced
265	Barker	317	**456**	370	Untraced
266	**470**	318	**805**	371	**131**
267	**124**	319	**399**	372	**724**
268	Copy	320	Untraced	373	**760**
269	**746**	321	Dupont	374	**304**
270	**114**	322	Dupont	374a	Untraced
271	**487**	323	Dupont	375	**299**
272	**168**	324	Dupont	376	**312**
273	**171**	325	Dupont	377	**316**
274	**177**	326	**582**	378	**445**
275	**516**	327	**497**	379	**446**
276	**477**	328	**583**	380	**387**
277	Untraced	329	Imitation	381	**310**
278	Untraced	330 (=329)	Imitation	382	**626**
279	Untraced	331	**500**	383	**255**
280	**441**	332	Untraced	384	**465**
281	**563**	333	**132**	385	**593**
282	**347**	334	**82**	386	**333**
283	**730**	335	**458**	387	**796**
284	**875**	336	**499**	388	**249**
285	Untraced	337	Untraced	389	**686**
286	Untraced	338	Untraced	390	**634**
287	Untraced	339	**99**	391	**346**
288	Untraced	340	Untraced	392	Dupont?
289	**227**	341	**289**	393	**329**
289a	Imitation	342	**166**	394	**479**
290	**574**	343	Untraced	395	**439**
291	**603**	344	**317**	396	**685**
292	**389**	345	**729**	397	Imitation
293	**457**	346	**700**	398	**798**
294	**460**	347	**718**	399	**388**
295	**390**	348	Untraced	400	**378**
296	**462**	349	**469**	401	**451**
297	**495**	350	**604**	402	**667**
298	**393**	351	**775**	403	**345**
299	**489**	352	**210**	404	Untraced
300	**60**	353	**170**	405	Imitation
301	**464**	354	**545**	406	**493**
302	Untraced	355	**233**	407	**286**
303	Untraced	356	**573**	408 (=67)	**722**
304	**643**	357	Untraced	409	**438**
305	**674**	358	Imitation	410	Imitation
306	**668**	359	**281**	411	**809**
307	**747**	360	**697**	412	**859**

Woodall Nos.	Present Catalogue	Woodall Nos.	Present Catalogue
413	**175**	465	**672**
414	**174**	466	**397**
415	**250, 251**	467	**260**
416	**252**	468	**694**
417	**687**	469	**432**
418	**792**	470	**360**
419	Monro	471	**480**
420	**657**	472	**526**
421	**693**	473	**525**
422	**600**	474	**524**
423	Dupont	474a	Jackson?
424	Dupont		
425	**576**	*Attributed*	
426	**615**	*Drawings*	
427	**463**		
428	**786**	475	Imitation
428a	**721**	476	**67, 68**
429	**709**	477	**89**
430	**640**	478	Frost
431	**484**	479	Imitation
432	**708**	480	Frost
433	**703**	481	Frost
434	**534**	482	Frost
435	**472**	483	Imitation
436	Frost	484	Imitation
437	**691**	485	**248**
438	**522**	486	Frost
439	**406**	487	Copy
440	**807**	488	Imitation
441	**355**	489	Imitation
442	Frost	490	**266**
443	Copy	491	**265**
444	**325**		
445	**624**		
446	**623**		
447	**735**		
448	**337**		
449	Untraced		
450	**644**		
451	**664**		
452	**72**		
453	**111**		
454	**150**		
455	**81**		
456	**128**		
457	**660**		
458	**356**		
459	**443**		
460	**641**		
461	**297**		
462	**6**		
463	**7**		
464	Dupont		

Other Drawings
Attributed to Gainsborough
in Public Collections

Aurora, N.Y.: Wells College
Landscape with Figure and Cows

Baltimore: Museum of Art
Landscape (Monro)

Bedford: Cecil Higgins Art Gallery
Landscape with Figures and Donkey
(Barker)

Belfast: Ulster Museum and Art Gallery
Landscape with Figures and Donkeys
(Barker)

Berlin: Ehemals Staatliche Museen
4551 (Woodall 410)
9357 (Lady Farnborough)
12149 (Monro) (Woodall 419)
12969

Besançon: Musée des Beaux-Arts
170D
171D

Birmingham: City Museum and Art Gallery
P1.50 (Dupont)
P28.53 (Dupont?)
191'53 (Dupont)
205'53 (Woodall 397)
206'53
213'53 (Dupont?) (Woodall 392)

Boston: Museum of Fine Arts
83.28 (Frost) (Woodall 436)
15.1265 (Frost)
48.1106 (Dupont)

Bradford: City Art Gallery
2-28

Bremen: Kunsthalle
48/165

Budapest: Museum of Fine Arts
1935-2622 (Dupont)
1935-2637

Cambridge: Fitzwilliam Museum
1724 (Dupont)

Cambridge, Mass.: Fogg Art Museum
1932.183
1024.1934
1940.317
1943.707
1953.91

Cardiff: National Museum of Wales
1383

Chicago: Art Institute
22.1229 (Woodall 443)
22.1230 (Frost) (Woodall 442)
22.1232
22.1233
22.1236 (Monro?)
22.1237
22.1238 (Frost)
22.1681 (Monro)
22.3257

Cleveland: Museum of Art
40.731 (Barker?)

Copenhagen: Royal Museum of Fine Arts
Landscape with Rocks
Landscape (Dupont)

Dresden: Staatliche Kunstsammlungen
C 1937-297

Dundee: Museum and Art Gallery
Wooded Landscape with Figures and
Buildings

Dunedin: Public Art Gallery
Self-portrait
Market Cart
Landscape with Figures
Landscape with Cattle Drinking

Edinburgh: National Gallery of Scotland
D 497 (Frost) (Woodall 45a)
D 1358

Florence: Uffizi (Horne Foundation)
12298

Frankfurt: Städelsches Kunstinstitut
6972

Glasgow: City Art Gallery
62-5

Glasgow: University
Mountain landscape (Woodall 27)

Ipswich: Museums
1906-27
1917-12.1
1917-12.2
1917-12.4

1928–29
1930–9
1953–35
1953–96

Leeds: City Art Gallery
10.1/35 (Jackson?) (Woodall 78)
13.107/53 (Dupont)
13.110/53 (Woodall 218)

Liverpool: Walker Art Gallery
William Pitt

London: British Museum
G.g.3–389 (Woodall 475 as attributed)
O.o.5–35 (Woodall 92)
Anderdon *Edwards* Vol.2, f.306 (Woodall 99)
1868–3–28–314 (Frost) (Woodall 98)
1874–12–12–155
1878–4–13–35 (Woodall 101)
1879–3–8–12
1902–6–17–7 (Woodall 164)
1917–5–12–3
1946–4–13–183 (Hoppner)
1961–5–13–10 (Hoppner)

London: Royal Academy
Jupp Vol.1., f.54/6 (a)
Jupp Vol.1., f.54/6 (b)
Jupp Vol.1., f.55/7

London: Tate Gallery
1488 (Dupont)

London: Victoria and Albert Museum
Dyce 674 (Woodall 483 as attributed)
Dyce 677 (Dupont) (Woodall 191)
Dyce 682 (Woodall 186)
Dyce 683 (Woodall 479 as attributed)
Dyce 685 (Frost) (Woodall 196)
Dyce 686 (Woodall 198)
Dyce 689 (Frost) (Woodall 480 as Frost)
Dyce 690 (Woodall 201)
Dyce 691 (Frost) (Woodall 482 as Frost)
Dyce 692 (Frost) (Woodall 481 as Frost)
Dyce 694 (Frost) (Woodall 478 as attributed)
Dyce 695 (Woodall 202)
Dyce 696
1436–1874
Circ. 1639–1888 (Monro)
E5647–1910
E4030–1919 (Woodall 484 as attributed)
E 39–1920
E 839–1922 (Wallis)
E 840–1922 (Wallis)

London: Witt Collection
(Courtauld Institute of Art)
76 (Dupont)
590 (Dupont)
1062
1064
1065
1193 A–J
1402

1403
1404
1405
1406
1407
1414
1415
1416
1858 (Dupont)
1868
1869
1870
3329 (Dupont)
3878
3911
3938
4459 (Dupont)

Manchester: Whitworth Art Gallery
791
1453 (Frost) (Woodall 486 as attributed)
1509 (Woodall 487 as attributed)
1741

Melbourne: National Gallery of Victoria
2329/4

New Haven: Yale Art Gallery
1940.25
1961.9.27 (Dupont)
1961.9.28 (Dupont)
1961.9.29 (Dupont)
1961.9.30 (Dupont)
1961.9.31 (Dupont)
1961.9.32 (Dupont)
1961.9.33 (Dupont)
1961.9.34 (Dupont)

New Haven: Yale University Library
Denham Album f.67

New York: Metropolitan Museum
11.66.1 (Dupont) (Woodall 464)
11.66.2 (Woodall 489 as attributed)

New York: Pierpont Morgan Library
III.1
III.1A (Dupont?)
III.48 (Frost)
III.51A (Frost)
III.54 (Frost)
III.64 (Dupont)
III.64A

Newcastle: Laing Art Gallery
Milkmaid
Landscape with Timber Waggon (Woodall 488 as attributed)

Newport, Mon.: Museum and Art Gallery
206 (Barker)

Norfolk, Va.: Museum
50.48.38 (Dupont)
50.48.39

Norwich: Castle Museum
Landscape with Cow and Pool

Oxford: Ashmolean Museum
Landscape with Family on Horseback
(Barker)

Paris: Louvre
RF 6907

Philadelphia: Museum of Art
28–42–4020

Princeton: Art Museum
42.101
44.286
44.415
44.416
44.417
44.418
44.419
44.420
62.45 (Dupont)

Regina, Saskatchewan:
Norman Mackenzie Art Gallery
27–2a
Misc. G

Rotterdam: Boymans –
Van Beuningen Museum
River Landscape

Sackville, New Brunswick: Owens Art
Gallery
Group of drawings

San Marino, California:
Huntington Art Gallery
59.55.548 (Dupont)
59.55.549 (Dupont)
59.55.550 (Dupont)
59.55.551 (Dupont)
59.55.552 (Barker?)
59.55.553 (Frost)
59.55.554 (Dupont)
59.55.555 (Dupont)
59.55.557
59.55.558
59.55.559
59.55.562
59.55.564 (Dupont) (Woodall 324)
59.55.565 (Dupont)
59.55.566 (Dupont)
59.55.568 (Dupont) (Woodall 321)
59.55.569 (Dupont) (Woodall 323)
59.55.570 (Dupont) (Woodall 325)
59.55.571 (Dupont) (Woodall 322)

Sheffield: Graves Art Gallery
1983
1985
2296 (Woodall 289a)

Stuttgart: Staatsgalerie
C 1964/1361

Swansea: Glynn Vivian Art Gallery
515
516
517
518

Truro: County Museum and Art Gallery
Figure study
275 (Woodall 313)

Washington, D.C.: National Gallery of Art
Two Girls in a Wooded Landscape

Worcester, Mass.: Art Museum
1940.137 (Frost)
1941.24 (Dupont)

Bibliography

Had Gainsborough been a Continental artist, his drawings would certainly have been studied in detail long since. As it is, we are still at the stage of assembling the material which will form the basis of fruitful research, and it is very much to be expected that future investigation into particular aspects of Gainsborough's work will lead to modifications of the conclusions and the chronology suggested in this volume.

It is remarkable, considering the genius of the man, that no serious study of Gainsborough's drawings appeared until 1939, when Mary Woodall published her catalogue of the landscapes. The way for this, however, was paved by the formation of Sir Robert Witt's library of photographs and by a number of Gainsborough exhibitions which included substantial groups of drawings, at Ipswich in 1927, Cincinnati in 1931, and London (No.45 Park Lane) in 1936; an exhibition devoted entirely to the drawings was held at the Oxford Arts Club in 1935. But by this time Gainsborough's drawings were already widely scattered, and the scholar was required to add the skills of detection to those of connoisseur and art historian.

Nor had the task been lightened by the existence of ample documentary or literary resources. To start with, Gainsborough was not a methodical man – far from it. He seems never to have kept letters, and such account or sitter books as he may have used have not survived. Receipts for payments are to be found in various private archives, and we are reasonably well informed about his financial affairs: there are drafts for payments out addressed to his banker James Unwin 1754–60, and his accounts with Hoare's Bank 1762–85 and Drummond's Bank 1782–8 can be studied in those firms' ledgers. About a hundred of his own letters, probably the merest fraction of those he actually sent, have been traced and collected into an edition by Mary Woodall, and some of these are informative about his work as a draughtsman. The catalogues of the sale at Schomberg House in 1789, the subsequent sale of 1792, the Dupont sale of 1797, the Mrs Gainsborough sale of 1799 and the Lane-Briggs sale of 1831 help by adding a quantity of drawings of unimpeachable provenance to the small number of drawings signed or stamped. There are a number of useful references in the contemporary press, notably *The Morning Herald*; conversations with Margaret Gainsborough, Gainsborough Dupont and others close to Gainsborough are recorded in the pages of *The Farington Diary*; short but invaluable memoirs were published by Sir Joshua Reynolds, Philip Thicknesse and William Jackson, the last two writers being friends of long standing; and anecdotes

from other sources, some of which, by gossip-writers such as Henry Angelo and W. H. Pyne, have to be treated with some caution, are scattered in early nineteenth-century books and periodicals (many of these can be unearthed by consulting the Whitley Papers).

The following list includes all publications cited in the text and catalogue entries with the exception of sale catalogues, reports, museum, private collection and exhibition catalogues (unless informative about, or devoted largely to, Gainsborough), and articles of a trivial nature in the press and elsewhere which do no more than mention a Gainsborough drawing:

Aldeburgh Festival: exhibition of *Drawings by Thomas Gainsborough*, June 1949.

Angelo, Henry: *Reminiscences*, London, 2 vols, 1828–30.

Anon.: 'Observations on the Rise and Progress of Painting in Water Colours', *The Repository of Arts*, February and April 1813.

Anon.: 'The Rise and Progress of Water-Colour Painting in England', *The Somerset House Gazette*, 13 and 20 December 1823.

Anon.: 'The Gainsborough Exhibition in Cincinnati', *The Burlington Magazine*, August 1931.

Anon.: *Drawings by Wilson, Gainsborough and Constable*, Leeds Art Calendar, Autumn 1956.

Armstrong, (Sir) Walter: *Thomas Gainsborough*, London, 1894 (also contained in *The Portfolio*, September 1894.)

Armstrong, Sir Walter: *Gainsborough & his Place in English Art*, London, 1898.

Armstrong, Sir Walter: *Gainsborough and his Place in English Art*, London, 1904.

Armstrong, Sir Walter: *Thomas Gainsborough*, London, 1906.

Armytage, George J. (ed.): 'The Register of Baptisms and Marriages at St George's Chapel, May Fair', *The Harleian Society*, London, 1889.

Arts Council: exhibition *Thomas Gainsborough*, May–October, 1949.

Arts Council: exhibition of *Gainsborough Drawings*, November 1960–February 1961.

Arts Council: exhibition *The Art of Claude Lorrain*, September–December 1969.

Bach, C. P. E.: *Essay on the true Art of Playing Keyboard Instruments* (ed. and trans. William J. Mitchell, 2nd edn, 1951).

Banks, M. A.: 'The Radeke Collection of Drawings', *Bulletin of the Rhode Island School of Design*, October 1931.

Barbier, C. P.: *William Gilpin*, Oxford, 1963.

Barker, Thomas: *Forty Lithographic Impressions from Drawings by Thomas Barker, selected from his studies of Rustic Figures after Nature*, Bath, December 1813.

Barker, Thomas: *Thirty Two Lithographic Impressions from Pen Drawings of Landscape Scenery, by Thomas Barker*, Bath, 1814.

Barrington, the Hon. Daines: 'On the Progress of Gardening', *Archaeologia*, Vol. VII., 1785.

Bath: exhibition of *Paintings and Drawings by Thomas Gainsborough*, Victoria Art Gallery, May–June 1951.

Bath: exhibition *Barker of Bath*, Victoria Art Gallery, June 1962.

Bean, Jacob: *100 European Drawings in the Metropolitan Museum of Art*, New York, n.d. (=1964).

Beckett, R. B.: *John Constable and the Fishers*, London, 1952.

Beckett, R. B.: 'Constable's Early Drawings', *The Art Quarterly*, Vol.XVII, No.4, Winter 1954.

Beckett, R. B.: 'John Constable's Correspondence', *Suffolk Records Society*, Vol.6, 1964 and Vol.8, 1965.

Bell, Mrs Arthur: *Thomas Gainsborough: A Record of his Life and Works*, London, 1897.

Bemrose, William: *The Life and Works of Joseph Wright, A.R.A.*, London, 1885.

Benson, A. C.: *Memories and Friends*, London, 1924.

Binyon, Laurence: *Catalogue of Drawings by British Artists . . . in the British Museum*, London, Vol.II, 1900 and Vol.III, 1902.

Binyon, Laurence: *Landscape in English Art and Poetry*, London, 1931.

Birch, Thomas: *The Heads of Illustrious Persons of Great Britain*, London, 2 vols., 1747 and 1752.

(Borenius, Tancred): 'Gainsborough's Collection of Pictures', *The Burlington Magazine*, May 1944.

Boulton, William B.: *Thomas Gainsborough His Life, Work, Friends, and Sitters*, London, 1905.

Boydell, J.: *A Collection of Views in England and Wales*, London, 1790.

British Museum (see Binyon).

Brown, Frank: *Frost's Drawings of Ipswich and Sketches in Suffolk*, Ipswich, 1895.

Caw, Sir James L.: *The Collection of Pictures formed by Andrew T. Reid of Auchterarder*, Glasgow, 1933.

Chamberlain, Arthur B.: *Thomas Gainsborough*, London, n.d. (=1903).

Chambers, Sir William: letter to Lord Grantham, 29 April 1774 (British Museum Add. MSS.41, 135).

Chamot, Mary: 'Gainsborough as a Landscape Painter', *Country Life*, 29 February 1936.

Cincinnati: exhibition of *Paintings and Drawings by Thomas Gainsborough, R.A.*, Cincinnati Art Museum, May 1931.

Clifford, Derek and Timothy: *John Crome*, London, 1968.

Collobi, Licia Ragghianti: *Disegni Inglesi della Fondazione Horne*, Pisa, 1966.

Colnaghi, Messrs. P. & D. & Co.: exhibition of *A Selection of Studies & Drawings by Thomas Gainsborough, R.A.*, May 1906.

Cundall, H. M.: 'The Norwich School', *The Studio*, 1920.

Cundall, H. M.: 'The Victor Rienaecker Collection', *The Studio*, September 1922.

Cunningham, Allan: *The Lives of the most eminent British Painters, Sculptors and Architects*, London, 1829 (Colonel Cunningham's annotated copy in the Victoria and Albert Museum Library contains manuscript notes by Gainsborough's niece, Mrs Sophia Lane).

Defoe, Daniel: *A Tour Thro' . . . Great Britain*, London, 1724–7, Vol.1.

Detroit: exhibition *Romantic Art in Britain*, Detroit Institute of Arts and Philadelphia Museum of Art, January–April 1968.

Diary, The: 2, 8 and 18 April 1789.

(Dodgson, Campbell): 'Drawings by Gainsborough', *British Museum Quarterly*, Vol.v, No.2, 1930.

Edwards, Edward: *Anecdotes of Painters*, London, 1808.

Edwards, Owain: 'Revolution in 18th-Century Music', *History Today*, November 1968.

Farington, Joseph: *The Farington Diary* (a full typescript is deposited in the British Museum Print Room).

Fenwick, Kathleen M.: 'The Collection of Drawings', *The National Gallery of Canada Bulletin*, Vol.2, No.2, 1964.

Ford, Brinsley: *The Drawings of Richard Wilson*, London, 1951.

Fry, Roger: *Reflections on British Painting*, London, 1934.

Fulcher, George Williams: *Life of Thomas Gainsborough, R.A.*, London, 1856 (2nd edn, revised, also 1856).

Gainsborough, Thomas: letters (*see* Woodall).

Gainsborough, Mrs Thomas: will, proved 10 January 1799 (Somerset House Registry).

Garlick, Kenneth: 'The J. Leslie Wright Collection of English Water-colours', *Apollo*, April 1968.

Gentleman's Magazine, The: August 1816 and July 1821.

Gessner, Solomon: *A Letter . . . on Landscape Painting*, Edinburgh, 1798.

Gilpin, William: *Observations on the River Wye*, London, 1782.

Gilpin, William: *Observations . . . on . . . the Mountains, and Lakes of Cumberland, and Westmoreland*, London, 1786.

Girouard, Mark: 'English Art and the Rococo', *Country Life*, 13 and 27 January, and 3 February 1966.

Goldsmith, Oliver: *The Deserted Village*, London, 1770.

Gower, Lord Ronald Sutherland: *Thomas Gainsborough*, London, 1903.

Gower, Lord Ronald Sutherland: *Drawings of Gainsborough*, London, n.d. (=1906).

(Graves, Richard): *Recollections of some particulars in the life of the late William Shenstone, Esq.*, London, 1788.

(Green, Thomas): 'The Diary of a Lover of Literature', *The Gentleman's Magazine*, February 1835.

Greig, James (*see* Menpes and Greig).

Grigson, Geoffrey: *English Drawing*, London, 1955.

Hammelmann, H. A.: 'A French Master of English Illustration: Gravelot's Years in London', *Country Life*, 3 December 1959.

Hammelmann, H. A.: 'First Engraver of the Royal Academy', *Country Life*, 14 September 1967.

Hardie, Martin: *Water-colour Painting in Britain 1. The Eighteenth Century*, London, 1966.

(Harington, Sir Edward): *A Schizzo on the Genius of Man*, Bath, 1793.

Harrison, Sydney E.: 'New Light on a Gainsborough Mystery', *The Connoisseur*, January 1922.

Haverkamp-Begemann, Egbert: *Drawings from the Clark Institute*, New Haven, 1964.

Hawcroft, Francis W.: 'The "Cabinet" at Felbrigg', *The Connoisseur*, May 1958.

Hayes, John: 'Gainsborough and Rubens', *Apollo*, August 1963.

Hayes, John: 'The Holker Gainsboroughs', 'Notes on British Art 1', *Apollo*, June 1964.

Hayes, John: 'The Trinity House Group Portrait', *The Burlington Magazine*, July 1964.

Hayes, John: 'Some Unknown Early Gainsborough Portraits', *The Burlington Magazine*, February 1965.

Hayes, John: 'The Drawings of Gainsborough Dupont', *Master Drawings*, Vol.3, No.3, 1965.

Hayes, John: 'The Gainsborough Drawings from Barton Grange', *The Connoisseur*, February 1966.

Hayes, John: 'British Patrons and Landscape Painting: 2. Eighteenth-century collecting', *Apollo*, March 1966.

Hayes, John: 'The Drawings of George Frost', *Master Drawings*, Vol.4, No.2, 1966.

Hayes, John: 'Gainsborough and the Bedfords', *The Connoisseur*, April 1968.

Hayes, John: 'Gainsborough's "Richmond Water-walk"', *The Burlington Magazine*, January 1969.

Hayes, John: 'The Ornamental Surrounds for Houbraken's Illustrious Heads', 'Notes on British Art 13', *Apollo*, January 1969.

Hayes, John: 'English Painting and the Rococo', *Apollo*, August 1969.

Hayes, John: 'William Jackson of Exeter', *The Connoisseur*, January 1970.

Hayes, John: 'Gainsborough and the Gaspardesque', *The Burlington Magazine*, May 1970.

Hazlitt, William: *Criticisms on Art*, London, 1843.

(Heseltine, J. P.): *Original Drawings in the Collection of J. P. H.*, London, 1902.

Hoare, Prince: *Epochs of the Arts*, London, 1813.

Hogarth, William: *The Analysis of Beauty* (ed. Joseph Burke, Oxford 1955).

Holmes, (Sir) Charles: *Constable, Gainsborough and Lucas*, privately printed, 1921.

Hone, William: *The Every-Day Book*, London, 1830.

(Hoppner, John): review of Edwards' 'Anecdotes of Painters' in *The Quarterly Review*, February 1809.

Hulton, Paul: 'A Little-known Cache of English Drawings', *Apollo*, January 1969.

Humphry, Ozias: *Memorandum Book 1772–97* (British Museum Add. MSS.22,949).

Humphry, Ozias: 'Biographical Memoir', MSS., c.1802 (*Original Correspondence of Ozias Humphry, R.A.*, Vol.1: Royal Academy Library).

Hunt, W. Holman: *Pre-Raphaelitism and the Pre-Raphaelite Brotherhood*, London, 1905.

Huntington Art Gallery: exhibition *John Constable Drawings & Sketches*, Henry E. Huntington Library and Art Gallery, San Marino, November–December 1961.

Huntington Art Gallery: exhibition *Gainsborough and the Gainsboroughesque*, Henry E. Huntington Library and Art Gallery, San Marino, November 1967–February 1968.

Hussey, Christopher: *The Picturesque*, 2nd edn, London, 1967.

Hutchison, Sidney C.: 'The Royal Academy Schools, 1768–1830', *The Walpole Society*, Vol.xxxviii, 1962.

Ipswich: *Bicentenary Memorial Exhibition of Thomas Gainsborough, R.A.*, Ipswich Museum, October–November 1927.

Ipswich Journal, The: 20 October 1759 and 9 February 1760.

Jackson, William: *The Four Ages; together with Essays on Various Subjects*, London, 1798.

Jackson, William: 'Autobiography', *The Leisure Hour*, May–September 1882.

(Jupp, E. B.): *A Descriptive List of Original Drawings, Engravings, Autograph Letters, and Portraits illustrating the Catalogues of the Society of Artists of Great Britain ... in the possession of Edward Basil Jupp, F.S.A.*, 1871.

Kay, Arthur: *Treasure Trove in Art*, Edinburgh, 1939.

Kitson, Michael: *J. M. W. Turner*, London, 1964.

Knoedler, M. & Co.: exhibition of *Drawings by Thomas Gainsborough*, New York, January 1914.

Knoedler, M. & Co.: exhibition of *Pictures by Gainsborough*, New York, December 1923.

Lane, Richard: *Studies of Figures by Gainsborough*, London, 1825.

Lane, Sophia: will, proved 5 January 1821 (Somerset House Registry).

Laporte, J. (*see* Wells and Laporte).

Leicester Galleries: exhibition *From Gainsborough to Hitchens*, January 1950.

Leporini, Heinrich: *Die Stilentwicklung der Handzeichnungen*, Vienna, 1925.

Leporini, Heinrich: *Handzeichnungen Grosser Meister: Gainsborough*, Vienna and Leipzig, n.d. (=1925).

Leslie, C. R.: *Memoirs of the Life of John Constable*, ed. Jonathan Mayne, London, 1951.

London Chronicle, The: 7–9 August 1788.

London Gazette, The: 16–20 October 1733.

Long, Basil S.: 'English Drawings in the Collection of Mr. Archibald G. B. Russell', *The Connoisseur*, July 1924.

Long, Charles: letter to George Cumberland, 10 April (1789) (British Museum Add. MSS.36,496).

Lugt, Frits: *Répertoire des Catalogues de Ventes Publiques*, The Hague, Vol.I, 1938, Vol.II, 1953 and Vol.III, 1964.

Lugt, Frits: *Les Marques de Collections de Dessins & d'Estampes* with *Supplément*, The Hague, 1956.

Manwaring, Elizabeth Wheeler, *Italian Landscape in Eighteenth Century England*, New York, 1925.

Mayne, Jonathan: 'Thomas Gainsborough's Exhibition Box', *Victoria and Albert Museum Bulletin*, Vol.1, No.3, July 1965.

Menpes, Mortimer and James Greig: *Gainsborough*, London, 1909.

Millar, Oliver: *Thomas Gainsborough*, London, 1949.

Millar, Oliver: *The Tudor Stuart and Early Georgian Pictures in the Collection of Her Majesty The Queen*, London, 2 vols., 1963.

Millar, Oliver: *The Later Georgian Pictures in the Collection of Her Majesty The Queen*, London, 2 vols., 1969.

M'Lean, E. and C.: *Drawing Book, being Studies of Landscape*, London, 1823.

(Moore, Edward): *Fables for the Female Sex*, London, 1744.

(Morgan, J. P.): *J. Pierpont Morgan Collection of Drawings by the Old Masters formed by C. Fairfax Murray*, Vol.III, London, 1912.

Morning Chronicle, The: 8 August 1788.

Morning Herald, The: 14 September 1782, 20 October 1785, 4 August 1788, 11 August 1788, 25 August 1788, 24 September 1788, 10 October 1788, 11 June 1789, 27 June 1789, 9 June 1792 and 8 May 1795.

Morning Post, The: 30 August 1788, 5 September 1788 and 6 April 1798.

Musgrave, E. I.: 'The Agnes Lupton Bequest', *Leeds Art Calendar*, Spring 1952.

Newspaper Cuttings: Art 1744–1822 (Colnaghi's Library).

Nicolson, Benedict: 'Current and Forthcoming Exhibitions', *The Burlington Magazine*, October 1969.

Norris, W. Foxley: 'Dr. Monro', *The Old Water-Colour Society's Club*, Vol.2, 1925.

Nottingham: exhibition of *Landscapes by Thomas Gainsborough*, Nottingham University Art Gallery, November 1962.

Oppé, A. P.: *English Drawings . . . at Windsor Castle*, London, 1950.

Oppé, A. P.: *Alexander and John Robert Cozens*, London, 1952.

Oxford: exhibition of *Drawings by Thomas Gainsborough*, Oxford Arts Club, June–July 1935.

Papendiek, Mrs: *Court and Private Life in the Time of Queen Charlotte*, ed. Mrs V. D. Broughton, London, 1887.

Park, Marlene: 'A Preparatory Sketch for Gainsborough's "Upland Valley with Shepherd, Sheep and Cattle" ', *The Art Quarterly*, Summer 1962.

Partridge, C.: 'Gainsborough's Paternal Ancestry', *The East Anglian Times*, January–February 1929.

Pfungst, Henry J.: *Catalogue of the Pfungst Collection of Drawings & Sketches by Thomas Gainsborough*, London, 1915 (typescript with numerous illustrations which appeared at Sotheby's, 11 November 1969, Lot 432 withdrawn).

Philadelphia: *see* Detroit.

Portalis, Baron Roger: *Henry-Pierre Danloux Peintre des Portraits et Son Journal durant l'Emigration*, Paris, 1910.

Power, D'Arcy and W. R. Le Fanu: *Lives of the Fellows of the Royal College of Surgeons 1930–51*, London, 1953.

Press Cuttings from English Newspapers on Matters of Artistic Interest 1686–1835 (Victoria and Albert Museum Library).

Price, Sir Uvedale: *Essays on the Picturesque*, London, 1810.

Price, Sir Uvedale: letter to Sir George Beaumont, 17 September 1816 (Morgan Library).

(Pyne, W. H.): *Wine and Walnuts*, London, 2 vols, 1823 (2nd edn, 1824).

(Pyne, W. H.): *The Somerset House Gazette*, 6 March and 10 April 1824.

(Pyne, W. H.): 'The Greater and Lesser Stars of Pall Mall', ch.2, *Fraser's Magazine*, November 1840.

Reitlinger, Henry Scipio: *Old Master Drawings*, London, 1922.

Reveley, Henry: *Notices Illustrative of the Drawings and Sketches of Some of the most Distinguished Masters in all the Principal Schools of Design*, London, 1820.

Reynolds, Graham: *Constable the natural painter*, London, 1965.

Reynolds, Sir Joshua: *Discourses on Art*, ed. Robert R. Wark, San Marino, 1959.

Rhyne, Charles: 'Fresh Light on John Constable', *Apollo*, March 1968.

Rimbault, Edward F.: 'Gainsborough as a Musician', *Notes and Queries*, 13 January 1871.

Ritchie, M. T.: *English Drawings*, London, 1935.

Roberts, W.: 'Mr. J. Pierpont Morgan's Pictures: The Early English School II', *The Connoisseur*, November 1906.

Roberts, W.: *Pictures in the Collection of J. Pierpont Morgan*, London, 1907.

Roget, J. L.: *A History of the 'Old Water-Colour' Society*, London, 1891.

Rowlandson, Thomas: *Imitations of Modern Drawings*, c.1788.

Royal Academy: exhibition *Masters of British Water-Colour: The J. Leslie Wright Collection*, October–November, 1949.

Sabin, Arthur K.: 'Notes on Dr. Monro and his Circle', *The Connoisseur*, November 1917.

Sassoon, Sir Philip: exhibition *Gainsborough*, 45 Park Lane, London, February–March 1936.

(Shebbeare, John): *Letters on the English Nation*, London, n.d. (=1756).

Siple, E. S.: 'Gainsborough Drawings: The Schniewind Collection', *The Connoisseur*, June 1934.

Smith, H. Clifford: *Buckingham Palace*, London, n.d. (=1931).

Smith, J. T.: *Nollekens and his Times*, ed. G. W. Stonier, London, 1949.

Smith, J. T.: *A Book for a Rainy Day*, London, 1845.

Story, Alfred T.: *The Life of John Linnell*, London, 1892.

Survey of London, Vol. XXIX.: *The Parish of St. James Westminster: Part One: South of Piccadilly*, London, 1960.

Thicknesse, Philip: *A Sketch of the Life and Paintings of Thomas Gainsborough, Esq.*, London, 1788 (the MS. owned by Colonel J. H. Constable, of which a photostat is in the East Suffolk Record Office, contains no significant variations from the printed text).

Thomson, Gladys Scott: 'Two Landscapes by Gainsborough', *The Burlington Magazine*, July 1950.

Thornbury, Walter: *The Life of J. M. W. Turner, R.A.*, London, 2 vols., 1862.

Times, The: 6 July 1877, 20 March 1925 and 2 January 1939.

Town and Country Magazine, The: September 1772.

Turner, Dawson: *Etchings of Views in Norfolk by the late John Crome . . . together with a Biographical Memoir*, Norwich, 1838.

Turner, Dawson: *Outlines in Lithography*, Yarmouth, 1840.

Vasari Society, The: Second Series, Part I, Oxford, 1920.

Vertue, George: 'Note Books', Vol.3, *The Walpole Society*, Vol.XXII, 1934.

Victoria and Albert Museum: *Catalogue of the Dyce Collection*, London, 1874.

Wark, Robert R.: *Rowlandson's Drawings for the English Dance of Death*, San Marino, 1966.

Waterhouse, Ellis: 'The Sale at Schomberg House 1789', *The Burlington Magazine*, March 1945.

Waterhouse, Ellis K.: 'Gainsborough's "Fancy Pictures"', *The Burlington Magazine*, June 1946.

Waterhouse, E. K.: 'Preliminary Check List of Portraits by Thomas Gainsborough', *The Walpole Society*, Vol.XXXIII, Oxford 1953.

Waterhouse, Ellis: *Gainsborough*, London, 1958.

Wells, W. F. and J. Laporte: *A Collection of Prints, illustrative of English Scenery: from the Drawings and Sketches of Gainsborough: In the various Collections of the Right Honourable Baroness Lucas: Viscount Palmerston; George Hibbert, Esq., Dr. Monro, and several other Gentlemen*, London (1802–5).

(Whitbread, S., ed.): *Southill A Regency House*, London, 1951.

Whitley, William T.: *Thomas Gainsborough*, London, 1915 (MSS. revisions for a second edition, and innumerable notes and slips of paper recording the sources for the biography, which was printed without footnotes, are contained among the Whitley Papers in the British Museum Print Room).

Whitley, William T.: 'The Gainsborough Family Portraits', *The Studio*, August 1923.

Whitley, William T.: *Artists and their Friends in England 1700–1799*, London, 1928.

Wildenstein, Georges: *The Paintings of Fragonard*, London, 1960.

Wilkins, Charles: will, proved 7 February 1791 (Somerset House Registry).

Williams, Iolo A.: *Early English Watercolours*, London, 1952.

(Williams, John): *Memoirs of the Royal Academicians*, London, 1796.

Wolf, Edwin: 'Gravelot as Designer of Engraved Portrait Frames', *Print Collectors Quarterly*, March 1950.

Woodall, Mary: 'A Note on Gainsborough and Ruisdael', *The Burlington Magazine*, January 1935.

Woodall, Mary: *Gainsborough's Landscape Drawings*, London, 1939.

Woodall, Mary: *Thomas Gainsborough: His Life and Work*, London, 1949.

Woodall, Mary: 'Gainsborough's use of models', *Antiques*, October 1956.

Woodall, Mary: 'Gainsborough Landscapes at Nottingham University', *The Burlington Magazine*, December 1962.

Woodall, Mary, ed.: *The Letters of Thomas Gainsborough*, London, 2nd edn, revised, 1963.

Index

References in roman type are to page numbers; those in bold figures are to catalogue entries. Exhibitions at which Gainsborough drawings were shown and Past Owners of the drawings are grouped under those headings.

Z*

PAST OWNERS (continued):

Gow, Dr Leonard, 334 361

Gower, George Granville Leveson, Earl (later 1st Duke of Sutherland), 98 527 528 529

Graham, the Hon. Mrs Thomas, ?278

Grassi, Signora, 94

Graves, Henry and Co., 585 586 736

Graves, Lucy Anne Mary, 55

Graves, Rev. Richard, 55

Green, Elizabeth, 97 668

Green, H. C., 563

Green, Miss R. H., 498 610 625 643 654 668 674 747 756 757

Green, Thomas, 741

Green, W. T., 253 282

Gregory, Dr H. A. C., 683 689 748 774 779

Greig, T. P., 131

Greville, Sir Charles, 99 ?28 60 62

Grubb, Rev. Mr, 737

Gutekunst, Otto, 344 374 400 411 439 519 591 725

Haden, Francis Seymour, 431

Hale, John, 181

Hamilton, the Dukes of, 350 351 371

Hamilton, Colonel James, 94 98

Hardcastle, A. B., 740

Hardcastle, Thomas, 740

Hardwicke, Philip, 2nd Earl of, 93 150 256 477 695 790 808

Hark, 279

Harrowby, the Earls of, 394 395

Harvard, Michael, 373

Harward, Edward Netherton, 80 533 637 642 805

Hawkins, C. H. T., 469 729 ?736

Hawkins, John Heywood, 99 100 96 402 404 470 484 487 525 531 534 542 593 736 746 765

Hayward, F., 470

Hedgman, W. J., 601

Hely-Hutchinson, F. W., 589

Heseltine, J. P., 17 18 19 23 368 385 646 687 735 737 758 759

Hetherington, W., 425 617

Hibbert, Mrs, 451 512

Hibbert, George, 22 95 96 96n 97 108 165 166 167 168 170 172 173 174 175 176 178 190 191 192 193 194 195 200 201 206 210 223 230 234 235 237 250 251 252 281 284 285 287 305 306 ?488 496 538 539 545 546 547 548 549 550 551 552 553 554 555 556 557 559 560 561 562 565 566 567 568 569 570 572 594 ?602 633 766 795 822 823 859 863 864 866 867 868

Hingeston, Rev. Mr, 92

Hirsch, Robert von, 472

Hirschl and Adler, 750

Hodgkins, M., 63

Hodgkins Galleries, 343

Hofer, Franz, 174 175 250 251 252 859 863 864 866 867 868

Hofer, Philip, 742

Hogarth, 58

Holburne, Sir Thomas William, Bt., 280

Holland-Hibbert, the Hon. A. H., 165 166 167 168 170 172 173 174 175 176 178 190 191 192 193 194 195 200 201 206 210 223 230 234 235 237 250 251 252 281 285 538 539 545 546 547 548 549 550 551 552 553 554 555 556 557 559 560 561 565 566 567 568 569 570 572 594 633 822 823 859 863 864 866 867 868

Holloway, 724 860 861 869 870

Home, the Earls of, 314 315 521

Hoppner, John, 30 80 99 610

Horne, Herbert, 90 91 118 296 406 699 752 764

Horton, Alistair, 408 483 578 768

Howard, 490

Hunter, John, 638 645

Huth, C. F., 61

Independent Gallery, 497 582 583

Ingram, Sir Bruce, 273 313 428 507 513 514 639 702 871

Innes, Ernest C., 102 378 425 445 446 603 666 667 700

Jacks, Mrs Russell Emily, 66

Jackson, William, 94

James, 24 78 79 817

James, 447 448

Jardine, Dr M. K., 698

Jay, Mrs John, 331 332

Johnson, 826 848

Johnson, John G., 358

Johnson, Oscar and Peter, 64 *See also* Lowndes Lodge Gallery

Jupp, Edward Basil, 57 78 79 817

Kay, Arthur, 101 330 328 370 401 402 431 446 456 490 500 515 531 542 589 683 765 800 830 836 844 875

Keane, John F., 53 689 834

Kennedy, 368

Kilderbee, Samuel, 92 348

Kirby, Joshua, 57 92 87 240 816

Knight, Major Eric, 774 779

Knight, Richard Payne, 27 77 96 8 10 12 67 68 88 89 97 122 125 127 134 135 138 139 140 141 142 143 144 145 146 147 148 159 160 169 184 185 196 197 198 199 204

PAST OWNERS (continued):

Thane, John, 464 513 514 532 672 679 680 681 682 694 697 708 709 844

Thibaudeau, A. Wyatt, 17 19 24 64

Thicknesse, Philip, 27 92

Thompson, Dr William, 379 381 382 733

Thomson, Croal, 621 637

Thomson, G. D., 453 512 523 644 772

Thorne, Miss A., 97 510 643 654 668 674 747 756 757

Tiffin, Walter Benjamin, 29 480 838

Tooth, Arthur & Sons Ltd, 361

Toppin, Aubrey, 471

Treacher, Miss, 276

Trimmer, Mrs, ?369

Trimmer, F. E., 87 240 816

Trimmer, Rev. Kirby, 57 92 87 240 816

Turner, P. M., 9 82 99 132 166 289 456 458 497 499 500 502 517 582 583 589 642 658

Turner, S. Sydney, 750

Turner, Walter, 646

Underdown, H. W., ?168 173 206 361 539 548 549 550 553 556 561 572 725

Upper Ossory, John, 2nd Earl of, 95

Vaughan, Henry, 442 839

Vogel, Mrs William D., 620

Vose Galleries, 405 647 759 802

Walker's Galleries, 248 310 354 407 502 562

Wallace, Sir Richard, Bt., ?810

Waller, Thomas William, 57

Walpole, Sir Hugh, 535

Ward, 487

Ward, Colonel, 874

Ward, W., 47

Warde, Mrs Richard, 846

Warmington, L. C., 700 718 729

Warren, Miss Charlotte, 447 448

Warren-Codrington, Mrs, 447 448

Warwick, George, 2nd Earl of, 95

Warwick, George Guy, 4th Earl of, 99 100 23 28 60 62 318 330 524 526 809 860 861 869 870

Wass, C. W., 299 312 316

Weirdale, Philip James Stanhope, Baron, 304

Weldon, Mrs W. F. R., 265 266 314 315

Wellesley, Rev. Dr Henry, 99 ?71 78 79 817 825 ?854

West, Benjamin, 687

Wethered, Vernon, 469 592 604

Wharton, Charles, 9th Baron, 257 267

Wheatley, Francis, 644

Wheeler, W. and Son Ltd., 54 831 873

White, William Benoni, 17 19 ?24 672 687 824

Wigstead, Henry, 84 94

Wilkins, Charles, 95

Willes, William, 537 850

Williams, 775

Williams, C. R., 152

Williams, Iolo A., 333 170 210 869 870

Williams, Lady Stuart, 290 291

Williams-Wynn, Sir Watkin, Bt., 466 467 638 645

Wilson, Sir Harry, ?575

Wilson, Miss Judith E., 35 36 37

Winkfield, 408

Winstanley, Thomas, 853

Winthrop, Grenville L., 259 521

Witt, Sir John, 545 561

Witt, Sir Robert, 102 70 77 131 164 165 166 281 304 473 498 515 538 559 570 588 631 662 678 697 717 724 760 841

Wolfe, Thomas Birch, 403 409 767 776 781 788 794

Wolifson, H., 697

Wood, Edmund W. H., 299

Wood, Sir John, 312 316

Woodburn, Samuel, 609 ?807

Worsley, Sir William, Bt., 478 564 665 739

Wray, Charles, 95 670

Wright, J. Leslie, 101–2 249 255 310 329 333 345 346 347 378 387 388 439 445 446 450 451 465 477 479 593 626 634 667 685 686 730 738 796 798 831 852

Wright, John, 408 578

Yakaloff, 258

Young, Miss E. L., 345 346

Young, Mrs E. M., 607

Pearce, William, 29 94 59. *See also* Past Owners

Peep-show. *See* 'Exhibition Box'

'Picturesque, the', 10–11 18 28n 51 53 62–3

Piles, Roger de, 'Principles of Painting', 27

Pisanello, Antonio, 874

Pope, Alexander, 518

Poussin, Nicolas, 12

——, Gaspard. *See* Dughet

Present owners of Gainsborough drawings, 105. *See* separate list, 315–18

Price, Sir Robert, Bt., 30 59

——, Sir Uvedale, Bt., 16 28 30 52 58–9 332 248

——, Uvedale Tomkyns, portrait of, 233